artists
THEIR LIVES AND WORKS

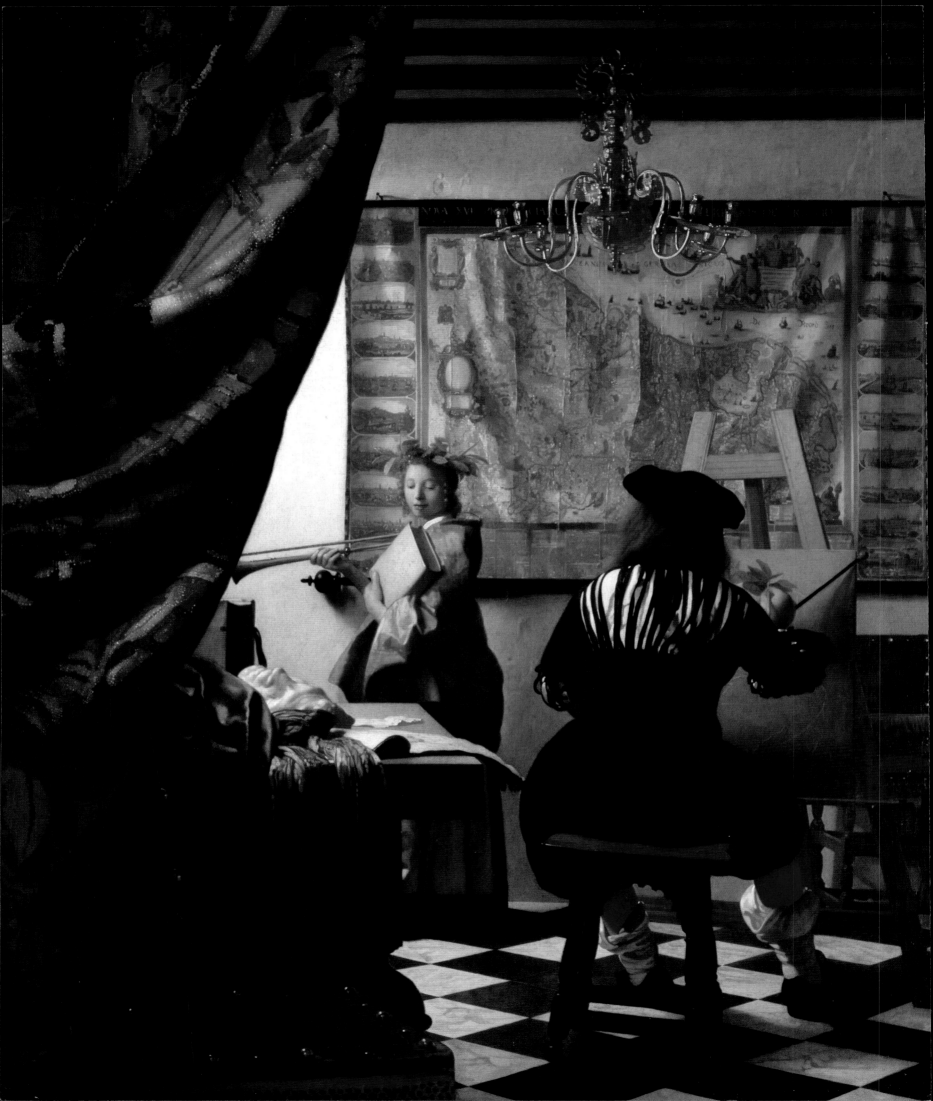

artists

THEIR LIVES AND WORKS

Jacket Editor Claire Gell
Pre-production Producers
Nikoleta Parasaki, Catherine Williams
Senior Producer Mandy Inness
Associate Publishing Director Liz Wheeler
Publishing Director Jonathan Metcalf
Art Director Karen Self

Produced for DK by

cobaltid

www.cobaltid.co.uk

Art Editors
Paul Tilby, Darren Bland, Paul Reid

Editors
Marek Walisiewicz, Diana Loxley,
Johnny Murray, Martin Donahue,
Kirsty Seymour-Ure

A CIP catalogue record for this book
is available from the British Library.

ISBN: 978-0-2412-2618-6

Printed and bound in China

All images © Dorling Kindersley Limited
For further information see:
www.dkimages.com

A WORLD OF IDEAS:
SEE ALL THERE IS TO KNOW

www.dk.com

CONTRIBUTORS

George Bray
is a writer and artist. Since
completing his studies at Central
Saint Martins College of Art, he has
contributed to several publications,
writing about art history and
contemporary visual culture.
He lives and works in London.

Caroline Bugler
has a degree in History of Art
from Cambridge University and
an MA from the Courtauld Institute
in London. She has written several
books and numerous articles. She
has also worked as an editor at
the National Gallery, London, and
at the Art Fund.

Nick Harris
is an Oxford graduate and former
teacher and publishing editor. He has
written many books and articles on
the arts and history, for both adults
and young people.

Diana Loxley
is a freelance editor and writer,
and a former managing editor of
a publishing company in London,
England. She has edited and
contributed to many books on
cultural theory and the arts – as
well as to several titles in DK's
Big Ideas series – and has a
doctorate in literature from the
University of Essex.

Kirsty Seymour-Ure
has a degree from the University
of Durham. She is an experienced
freelance writer and editor
specializing in art, architecture,
design, and related fields.

Jude Welton
has a first-class degree in Art History
and English. She has authored and
contributed to many popular works
on art history. Her books for DK
include *Impressionism*, *Monet*,
and *Looking at Paintings*.

Iain Zaczek
studied at Oxford University and
at the Courtauld Institute in London.
A specialist in Celtic and Pre-
Raphaelite art, he has authored
more than 30 books.

FOREWORD
Andrew Graham-Dixon
is a leading art critic and presenter
of arts. He has presented numerous
landmark series on art for the BBC,
including the acclaimed *A History
of British Art*, *Renaissance* and *Art
of Eternity*, as well as numerous
documentaries on art and artists.

Foreword

I often go to my local museum, which happens to be one of the best: the National Gallery in London. Increasingly it seems to me that many, and perhaps even most, visitors are not actually experiencing (let alone thinking about) the paintings that surround them. What are they doing instead? Taking selfies. The process is simple: stand in front of well known masterpiece; check the alignment of self with painting on cellphone screen; take a photograph, and move on. At no point during this manoeuvre does the person taking the selfie actually need to face the painting in question. Observing the choreography of their actions, it strikes me that in a sense the painting itself, whether by Leonardo, or Raphael, or Michelangelo, or whoever, is not terribly important. It has become no more than a generic Famous Thing, while the selfie exists simply to prove that the person who took it was, however briefly, in the same physical space as that Famous Thing. The selfie is therefore both a form of evidence and a kind of trophy. But it also betrays a perfect lack of understanding of why great works of art are worth bothering with in the first place. They are not things to be seen *with*. They are things to be *seen*, and reflected on. They deserve more than to be turned into mere slivers of visual information, whirled round in the kaleidoscope of modern narcissism.

This book is among other things a reminder of that. It might be described as a kind of portable museum, devoted to the lives and works of a select number of the greatest painters and sculptors in world history. Each entry offers a concise but illuminating account of a given artist, viewed in the context of his (or her) own time,

juxtaposed with illustrations carefully chosen to demonstrate the full range and genius of their works. The book may stop there, but that is not the end of it. It is up to the reader to complete the picture, by actually going to see whichever works they can in the flesh: seeking them out, engaging with them, finding their own meanings and perhaps inspiration in them. Every work of art is remade afresh, every time it is seen, in the mind and eye of the beholder. So each entry here is both a beginner's guide to a particular artist's work, and a door waiting to be opened. On the other side of every door there is a world to be discovered. That world might be the bloodthirsty Rome of the Baroque period, the Rome of Caravaggio or Bernini; it might be the floating world of Japan during the Edo period; or it might be heatstruck Provence, *mise-en-scène* for the brilliant tragedy of Vincent van Gogh's last years.

Its design might be new, but the basic structure of this book is anything but original. In fact, its structure goes back some five hundred years, to the very first work of art history written in postclassical times: Giorgio Vasari's *Lives of the Painters, Sculptors and Architects*, the second and final edition of which was published in 1568. Vasari's book, rightly considered the Bible of art history, is divided into a multitude of chapters, each one of which tells the life story of a particular artist and describes the major works of that artist, often in considerable detail (after all, there were no photographs then). In Vasari's time, it must be said, it was considerably harder to come by information than it is now. Even though his focus was solely on Italian artists (mostly Tuscans),

and only on those who had lived and worked from the early 14th century to his own time, it took Vasari more than 30 years to gather his research materials. He travelled up and down the irregular boot of Italy, visiting artists' workshops, making copies of apprenticeship contracts and talking, talking, talking, to anyone who might help him in his quest. Does anyone in town know anything about Piero della Francesca? Who can tell me about that woman with the mysterious smile, the one painted by Leonardo da Vinci? How often did Michelangelo change his socks? Never? Really? Tell me more...

No question was too small for Vasari, who was a man of boundless curiosity. But the ambition behind his compendium of artists' lives was immense. He wanted to establish the visual arts, above all the arts of painting and sculpture, as a serious subject of interest and debate. Until Vasari's time, only poetry, drama, and philosophy were truly considered to be liberal arts. Those who made paintings and carved sculptures were looked down on as mere craftsmen: people who did manual work, and got dirty doing it. It was Vasari's contention – and he was of course right – that painting and sculpture were themselves forms of philosophy, poetry, and drama, profound expressions of thought and feeling. From there, he argued that the greatest artists deserved to be placed alongside all the other intellectual heroes of civilization.

Many of Vasari's contemporaries regarded him as eccentric but he has, most certainly, had the last laugh. I sometimes think that we in our time have gone almost too far, in our notion of the artist as hero – especially when I see a painting by a living artist change

hands for enough money to purchase an entire street of houses. Perhaps Vasari is distantly responsible for all this, just as he is for the cult of art and artists that has given rise to the phenomenon of the Old Master selfie. But that is not to say that he is to blame for it.

The book you are holding in your hands is certainly an ancestor of Vasari's *Lives*, although it is rather less partisan than his great book – Vasari was in the habit of inventing tall tales to discredit painters he had a grudge against – and considerably broader in scope. Its main focus might be western art, but art from many other places receives plenty of attention too. So as well as amounting to a portable museum, it is a world museum too. Above all, it is a way into art – and therefore, I would argue, a passport to open-mindedness, something which seems to be in regrettably short supply, these days. When we look at the art created by people from places and times other than our own, we escape from our own culture, or at least set it into a larger perspective. We rise above the self-obsession of the selfie-taker. We shed our prejudices and realize, with renewed humility, how many other ways there are of seeing than our own.

Andrew Graham-Dixon

BEFORE 1500

CHAPTER 1

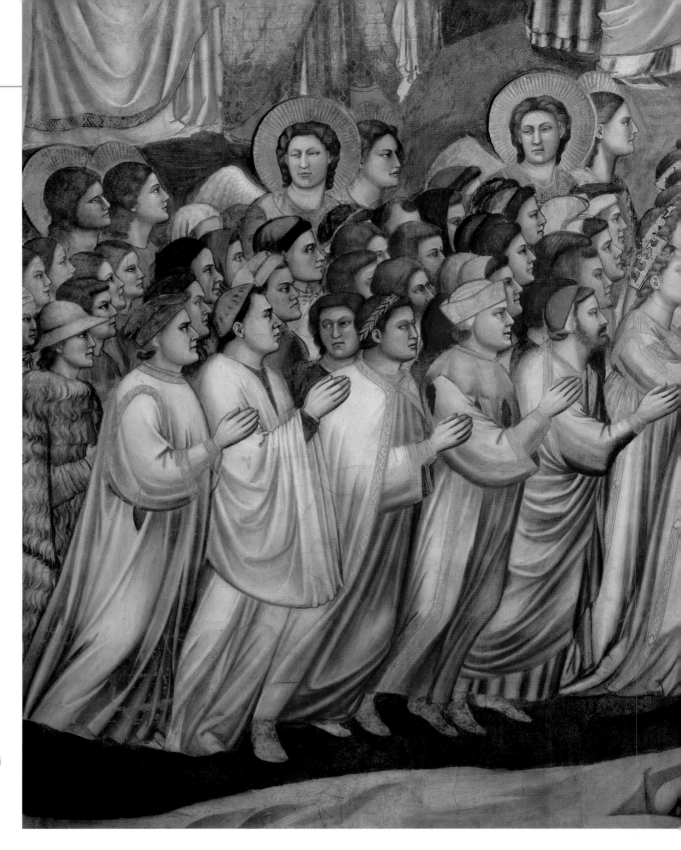

▷ **AMONG THE CHOSEN**
This detail from *The Last Judgement*, part of Giotto's scheme for the Scrovegni Chapel, Padua, shows the ranks of the chosen – those who will be escorted to Heaven. Some scholars believe that the figure wearing a golden cap in the front row is the artist himself.

Giotto

c.1270–1337, ITALIAN

The towering figure who stands at the head of Italy's glorious tradition of painting, Giotto set art on new paths with his naturalistic vision and wealth of human feeling.

Giotto was the first artist since the days of the ancient Greeks to become widely famous in his own lifetime. He worked mainly in Florence, but the demand for his services took him to many other places in Italy and possibly to Avignon in France. His contemporaries acknowledged him as the greatest painter of the day. However it was not until much later that anyone tried to write a methodical account of his achievements.

Uncertain origins

Giotto's pioneering biographer was Giorgio Vasari. His famous *Lives of the Artists* was first published in 1550, more than two centuries after the artist's death. Much of Vasari's information is questionable, and our knowledge of Giotto's life and work remains fragmentary. For example, Vasari writes that "this great man" was born in 1276, but a source much closer to Giotto's time states that he was 70 when he died in 1337, and so suggests he was born in 1266 or 1267. Some recent scholars prefer a date of 1270.

Discovery by Cimabue

The place of Giotto's birth is also uncertain; it may have been Colle di Vespignano, a village about 24km (15 miles) northeast of Florence. His father is said to have been a farmer named Bondone, and Vasari states that the young Giotto helped him to look after his sheep. This leads him

"Because **he revealed an art** that had been **lost for centuries...** he deserves to be called one of the lights of **Florentine glory.** "

GIOVANNI BOCCACCIO, *THE DECAMERON*, c.1350

into a charming story of how the boy's artistic talent was discovered. One day, aged about 10, he was sketching a sheep on a slab of stone when Cimabue, a leading painter from Florence, passed by. He was so amazed by the child's skill that he immediately asked Giotto's father if he could take him on as a pupil.

Building a career

Such sentimental childhood stories are common in biographies of artists and are no doubt largely fictional. Indeed, new documentary evidence published in 1999 suggests that Giotto's father was not a farmer but a blacksmith living in Florence. However, the essential point about this story – that Giotto was taught by Cimabue – is entirely plausible. Cimabue was probably the foremost painter in Italy at this time, so talented youngsters would have been attracted to his workshop, and contemporaries undoubtedly regarded Giotto as his direct successor. This is shown particularly by a passage in Dante's celebrated poem *The Divine Comedy* (completed c.1320): he writes that

"Cimabue thought he held the field in painting, and now it is Giotto who is acclaimed, so that the glory of the former is dimmed".

Giotto probably spent most of the 1280s serving his apprenticeship, a training that typically began when a boy was aged about 12 to 14, and lasted for six or more years. Little is known of his life until his name appears in a record in 1301, when he is mentioned as owning a house in Florence. Later documents that refer to Giotto are also concerned with property and investments, and although they reveal little of his character, they testify to his notable wealth, bearing out stories that he was a shrewd businessman.

The Scrovegni Chapel

The first surviving work that can safely be attributed to Giotto – and the only one that can be reasonably accurately dated – is the series of frescos covering virtually the whole interior of the Scrovegni (or Arena) Chapel in Padua. The chapel was built for Enrico Scrovegni, one of the city's wealthiest citizens, on land that had previously been occupied by an ancient Roman amphitheatre or arena, hence the building's popular name. Scrovegni bought the land in 1300 and the chapel was consecrated five years later; by this time, Giotto was probably well advanced in his work on the frescos and they are usually dated c.1303–06.

SELF-PORTRAIT, GIORGIO VASARI, c.1566–68

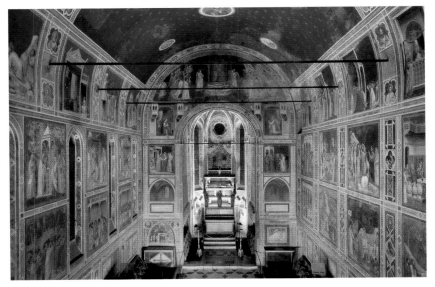

◁ **FRESCO CYCLE**
The interior of the Scrovegni Chapel is covered with Giotto's masterly frescos that extend to the ceiling. Three main levels of imagery tell the narrative of the lives of Mary and Jesus.

△ **THE VIRGIN AND CHILD IN GLORY, c.1310**
Giotto anchors the figures of Madonna and Child in a three-dimensional space, adding to the sense of reality created by his refined human figures.

ON TECHNIQUE
Fresco

Giotto was the first great exponent of fresco. This is a key aspect of his reputation as the "father" of Italian painting – for centuries after his death many of the leading Italian artists regarded the technique as a supreme test of their skill. A fresco (meaning "fresh") painting is done on wet plaster, freshly applied to a wall or ceiling. As the plaster dries, the paint becomes an integral part of the wall, producing a durable finish. This technique demands great sureness of hand, as alterations are difficult to make once the paint is applied.

FRAGMENT OF FRESCO FROM THE BASILICA OF ST FRANCIS IN ASSISI

Topped by a vaulted ceiling decorated with a starry sky, the frescos in the Scrovegni Chapel are devoted mainly to events in the lives of Christ, the Virgin Mary, and her parents, St Anna and St Joachim. The scenes are varied in feeling, and through his mastery of gesture and facial expression Giotto shows an unprecedented ability to depict the emotions appropriate to each story – from the tenderness of the Nativity to the overwhelming grief of the mourners around Christ's body.

Giotto's figures have an entirely new feeling of volume and weight, and they are placed in settings that give a convincing appearance of recession, in contrast to the flat, otherworldly Byzantine style that had previously prevailed. The artist combined his empirical sense of perspective with plausible representations of the body and gestures, and a more realistic rendering of the folds of fabric in clothing to create believable and tangible characters in his paintings.

Giotto's contemporaries recognized that his naturalism and sense of three dimensions had created a revolution in painting. His achievement was most memorably summed up by the Florentine painter Cennino Cennini, when he wrote, in about 1400, that "Giotto translated the art of painting from Greek [that is, Byzantine] into Latin and made it modern".

Credit and controversy
In addition to Padua, Giotto is said to have worked in about 10 other art centres in Italy, including Lucca, Milan, Rimini, Rome, and Urbino. But the early references to his work in these places are vague and cannot be safely tied to any surviving paintings. There is particular debate among historians as to his involvement with the famous frescos in the Upper Basilica of St Francis in Assisi.

Work on this church, which is sited near the burial place of St Francis, was begun soon after Francis's death and canonization. The church was consecrated in 1253, and between about 1260 and 1320 it was decorated with frescos by some of the finest artists of the day. Giotto was probably among them, and is said by some to have painted the church's most impressive frescos – a series of 28

> " He **surpassed** not only the **masters of his epoch** but **also** those of **many** centuries before him. "
>
> LEONARDO DA VINCI, *CODEX ATLANTICUS*, c.1500

scenes from St Francis's life – although other scholars believe they are by another hand or hands. The church and its frescos were badly damaged by earthquakes in 1997, and the restoration has been criticized for being heavy-handed. According to Vasari, Giotto also worked in Avignon for Pope Clement V, a Frenchman who had transferred his court there from Rome in 1309, but this claim is also unsubstantiated. Apart from the Scrovegni Chapel, there are only two major surviving works that are universally accepted as Giotto's: the damaged but still highly impressive frescos in the church of Santa Croce, Florence; and the magnificent panel painting the *Ognissanti Madonna*, now in the Uffizi Gallery in Florence.

Artist and architect

Giotto is thought to have married twice, and to have had at least eight children. Little is known about his character, although the 14th-century writer Giovanni Boccaccio (author of the famous *Decameron*) says that he was good-natured and witty.

The best-documented part of Giotto's life is the period he spent in Naples from 1328 to 1333 working for the city's king, Robert of Anjou. He had an honoured place at court, but only fragments remain of the works he carried out there. By 1334 he had returned to Florence, where he was appointed city architect, and in this role he designed the campanile (bell tower) of the cathedral. Only the first storey had been completed by his death in 1337 and the design was later altered, but the building is still sometimes known as Giotto's Tower.

Giotto was given a public funeral by the city of Florence and was buried in the cathedral – the first time an artist had received such honour. Through his work and personality he opened a new era: after Giotto the history of art becomes increasingly the history of great artists.

△ **GIOTTO'S TOWER**
Late in his life, Giotto took on the design of the campanile of Florence Cathedral. Its surface of coloured marble gives the 85m (280ft) tower the appearance of having been painted.

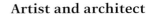

◁ **SCENES FROM THE LIFE OF ST FRANCIS, 1325–28**
Giotto's frescos in the Bardi Chapel, in the church of Santa Croce, helped to make him one of the first great personalities of Florentine art.

KEY MOMENTS

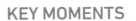

c.1303–06	c.1309–14	c.1310	c.1320–30
Paints his masterpiece, the fresco cycle in the Scrovegni Chapel, Padua.	Possibly works in Avignon for Pope Clement V, although no known paintings by him survive from this time.	Paints *The Virgin and Child in Glory* (the *Ognissanti Madonna*) for the high altar of Ognissanti (All Saints), Florence.	Paints frescos in the Bardi and Peruzzi chapels (belonging to two banking families) in Santa Croce, Florence.

Jan van Eyck

c.1385–1441, NETHERLANDISH

Hugely influential and highly regarded throughout Europe, Jan van Eyck showed how oil paint could depict the colours and textures of the natural world with extraordinary richness and subtlety.

Jan van Eyck was the most illustrious painter of the 15th century in northern Europe, and was highly regarded even in Italy (where non-Italian artists were usually disparaged). In his *Liber de viris illustribus* (*Book of Famous Men*), written in about 1455, the Italian scholar Bartolomeo Facio went so far as to state that "Jan van Eyck is considered the greatest painter of our times". A century later, in his *Lives of the Artists*, Giorgio Vasari credited him with being the inventor of oil painting. We now know this is untrue (the origins of the technique are obscure), but van Eyck did bring oil painting to a pitch of refinement far in advance of anything that had been seen before. The sheer illusionistic skill with which he used the medium has always been the basis of his resounding fame.

Early life and influences

Although he was famous in his lifetime, little is known of van Eyck's early years and his date of birth can only be estimated. He is first recorded in 1422, by which time he was a well-established artist, so he is unlikely to have been much under 30. Marriage, a family, and two decades of activity lay ahead of him, so he was probably not much older than 40 at the time of this record, which puts his likely year of birth between 1380

and 1390. His place of birth is likewise undocumented, but there is a tradition dating back to the 16th century that he came from the town of Maaseik, which is now in Belgium.

Van Eyck is said to have had two painter brothers, Hubert and Lambert, and a sister, Margaret, also a painter.

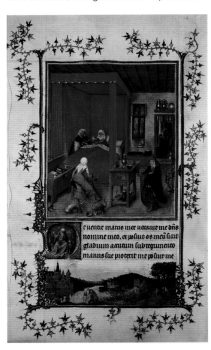

△ **THE TURIN HOURS**
The Birth of St John the Baptist (above) is one of the few surviving illustrations from *The Turin Hours*. It is so exquisite that some scholars believe it may be by Jan van Eyck or his brother Hubert.

Nothing is known about his schooling or artistic training, although the miniaturist delicacy of his brushwork suggests that he may have begun his career as a manuscript illustrator. *The Turin Hours*, a remarkable book completed in around 1447 and later damaged by fire, has pictures that have plausibly been attributed to him.

Van Eyck must have been highly intelligent and socially accomplished because he was held in high esteem, and well paid, by his main employer, Philip the Good, Duke of Burgundy. Philip valued van Eyck not just for his artistic skills, but also as a diplomat, sending him on many missions abroad.

Artist and diplomat

Jan van Eyck's first known employer was John of Bavaria, Count of Holland, for whom he is recorded working in 1422, in The Hague. John died in January 1425, and soon afterwards van Eyck moved south to Bruges, where he entered the service of Philip the Good (see right). He worked for Philip for the rest of his life, mainly in Bruges, but also in his residences elsewhere, and abroad. The most important of his diplomatic missions was to Portugal in 1428–29, when he helped to negotiate a marriage between Philip and Princess Isabella, daughter of John I of Portugal.

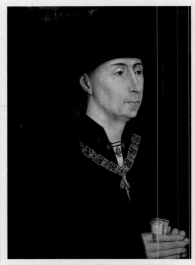

PHILIP THE GOOD, AFTER ROGIER VAN DER WEYDEN, c.1450

> " The **king** of painters, whose **perfect** and **accurate** works shall **never** be **forgotten.** "
>
> JEAN LEMAIRE DE BELGES, *LA COURONNE MARGARITIQUE,* c.1505

▷ **PORTRAIT OF A MAN, 1433**
An inscription on the frame of Jan van Eyck's work reads "*Als Ich Can*" (As I/Eyck Can) – the pun suggesting it may be a portrait of the artist himself.

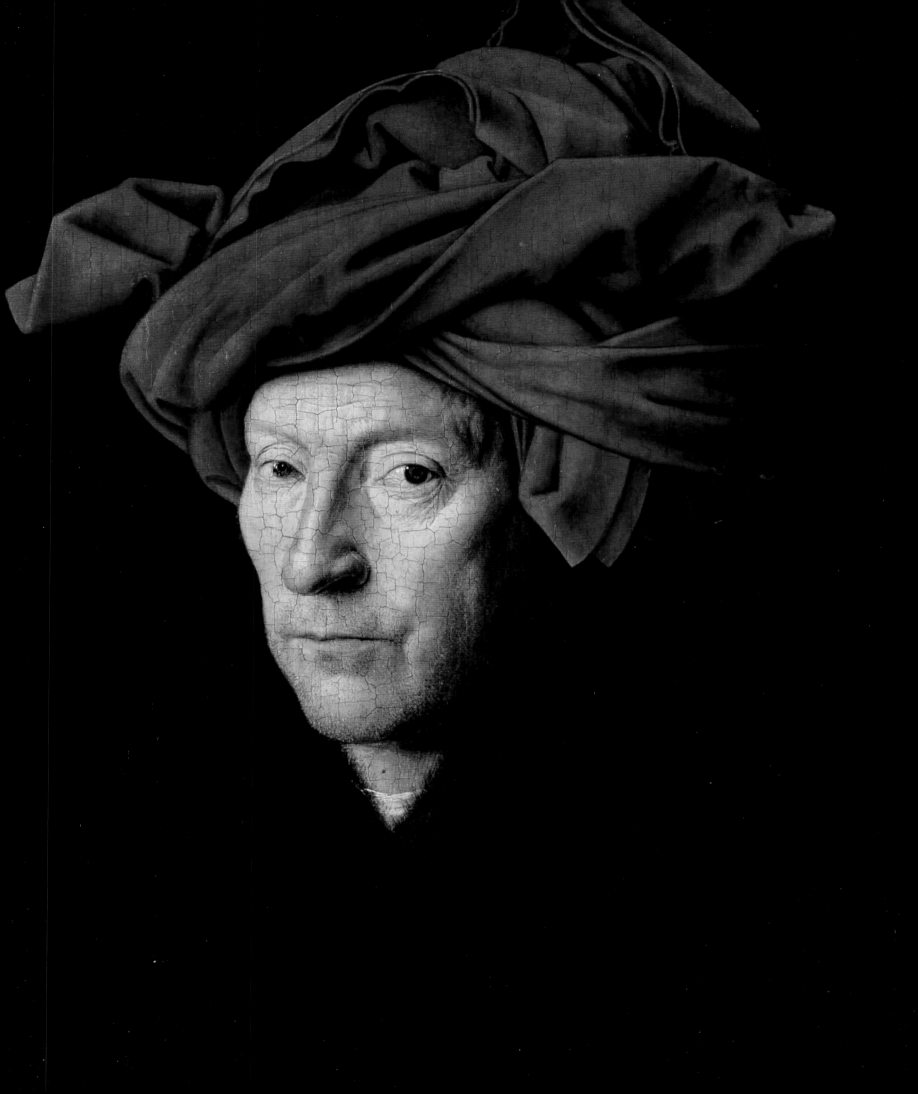

KEY MOMENTS

1429

Paints portrait of Princess Isabella of Portugal (Philip the Good's prospective bride).

1432

Completes the Ghent Altarpiece, which had been begun several years earlier by his brother Hubert.

1434

Paints his double portrait of the wealthy Italian merchant Giovanni di Nicolao Arnolfini and his wife.

1439

Paints portrait of his wife, Margaret, his last known dated work.

In 1432, van Eyck bought a house in Bruges; he probably married around the same time. In 1434, a child of his was baptized, with Duke Philip acting as godfather – an indication that Philip felt personal affection as well as professional regard for the painter.

The van Eycks in Ghent

Van Eyck had patrons other than Philip, including the Church and merchants in Bruges (then a centre of international trade. His most famous work was created for the cathedral in Ghent, about 50km (30 miles) from Bruges at the expense of a wealthy businessman, Jodocus Vyd, who later became mayor of Ghent. It is a huge and complex altarpiece made up of 12 oak panels, eight of which are painted on both sides, making 20 images in all. The main panel depicts the Adoration of the Lamb, showing the Lamb of God spilling its blood into a chalice, symbolizing Christ's sacrifice on the cross. The Ghent Altarpiece is not only one of the most celebrated works in the history of art, but also one of the

▷ **THE GHENT ALTARPIECE, 1432**
The huge altarpiece measures around 4.6 x 3.5m (15 x 11½ft). It has been suggested that clockwork mechanisms were used to move the hinged panels.

ON TECHNIQUE
Painting in oil

Oil holds colour more effectively than egg tempera, the medium that had prevailed during the 15th century. It also dries more slowly, thereby allowing for blending and reworking over time. Van Eyck used linseed mixed with nut oils in his paint. By building up layers of paint and working detail into them with the use of fine brushwork, he created tactile, three-dimensional images with luxurious textures or polished surfaces; this is evident in his famous *Arnolfini Portrait*.

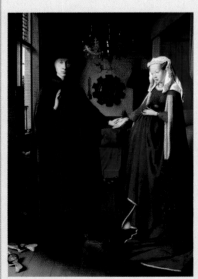

THE ARNOLFINI PORTRAIT, 1434

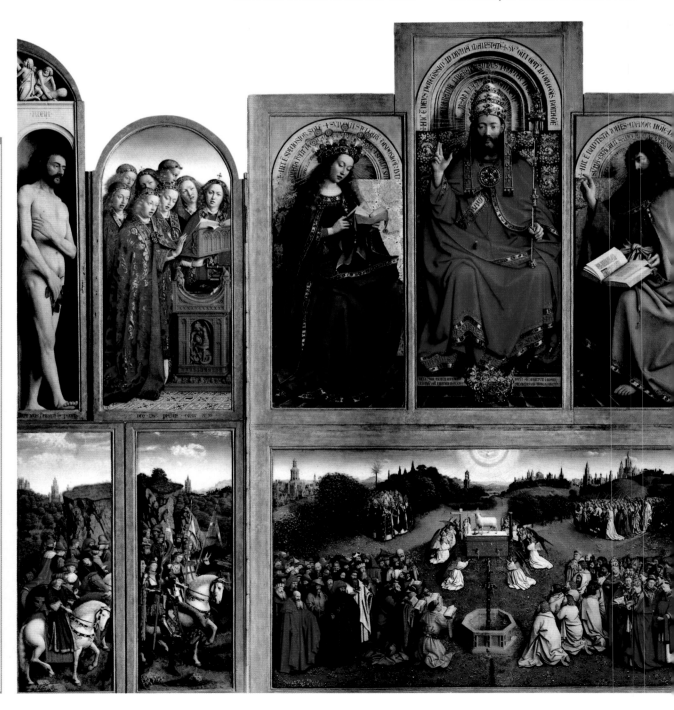

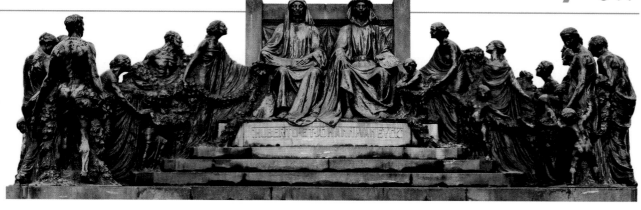

most debated, primarily over van Eyck's precise role in its creation. According to an inscription on the frame, it was begun by his brother Hubert and finished by van Eyck himself in 1432. Hubert is thought to have died in 1426, and it is unclear just how advanced the work was at this time: Hubert may have been responsible for the overall design and Jan for its execution.

There is no doubt, however, about the historical importance of the altarpiece, which is the first major demonstration of the qualities of oil paint in representing natural appearances and in achieving great clarity and luminosity. Van Eyck seems to have developed a carrying medium (the liquid in which the powdered colours were mixed) which was thinner than previous types and therefore quicker to dry, making it possible to superimpose several layers of paint. By building up a painting in this way, remarkably rich and subtle effects could be produced. Underlying layers of paint modified the appearance of semi-transparent layers, known as glazes, laid on top of them, creating a depth and radiance that was impossible to achieve by physically mixing the colours together.

Detail and symbolism

Improved materials were only part of van Eyck's achievement; they would have counted for little without his unrivalled powers of observation and superlative craftsmanship. From the stubble on a man's chin to tiny details of a distant vista, he saw and depicted everything with the same exactitude. However, he was not just concerned with representing appearances. His paintings are rich in symbolic meaning and feature inscriptions in several languages – they were meant to be pondered as well as admired. Even so, the wealth of details never swamps the paintings, which achieve a balance of grandeur and delicacy. Albrecht Dürer summed up van Eyck's great powers when he described the Ghent Altarpiece as "a stupendous painting, full of intelligence".

Most of van Eyck's two dozen known pictures come from later in his life, and all of his dated works belong to the period 1432–39. Only a few undated works – religious paintings or portraits – may be earlier. Sometimes van Eyck combined the two genres, showing, for example, an eminent courtier adoring the Virgin and Child. He is known to have produced paintings on other subjects, as well as costumes and decorations, in his role as chief artist at Philip the Good's court, but these works have not survived.

Jan van Eyck died in Bruges in June 1441. Philip showed his continuing admiration for the artist by giving his widow a substantial payment "in consideration of her husband's services and in commiseration with her and her children's loss". His reputation lived on, and he had a profound influence on his contemporaries and later artists. His sharp observation of the natural world was later reflected in the work of the 17th-century Dutch School.

△ **A GRATEFUL CITY**
A bronze statue commissioned for the 1913 World Expo in Ghent shows the townspeople paying tribute to Hubert (who holds a Bible in his lap) and Jan van Eyck, who stares ahead holding a palette. The statue of the brothers is outside the cathedral where their famous altarpiece is located.

▷ **MARGARET VAN EYCK, 1439**
Van Eyck's intimate portrait of his wife may have been a birthday gift as it is inscribed with the words "My husband Jan completed me on 15 June 1439 / my age was thirty-three".

" In a short while the **fame** of his **invention spread** not only **through Flanders**, but as far as **Italy.** "

GIORGIO VASARI, *LIVES OF THE ARTISTS*, 1568

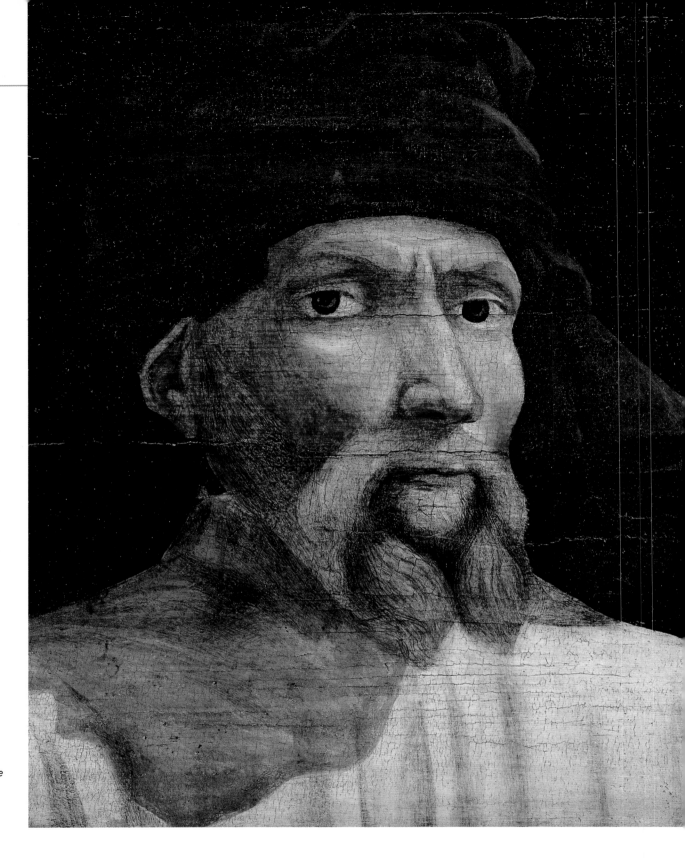

▷ **AN UNCERTAIN PORTRAIT**
There are no certain likenesses of
Donatello, but some scholars believe
that the 15th/16th-century painting *Five
Masters of the Florentine Renaissance*,
probably begun by Paolo Uccello,
includes an image of the artist (shown
in this detail).

Donatello

c.1386–1466, ITALIAN

The greatest sculptor of the 15th century, Donatello had a long,
varied, and fruitful career. His work includes some of the most
famous masterpieces of Italian Renaissance art.

Donatello stands head and shoulders above all other European sculptors of the 15th century. None of his contemporaries approached him in versatility, inventiveness, or emotional range and power. He was equally adept working on a huge or a tiny scale, and with sculpture in the round or in relief. He carved in marble and other stone, and also in wood, which he sometimes painted in naturalistic colours; he modelled in wax, clay, and stucco, and worked eloquently in bronze; he even experimented with casting sculptures in glass, although no examples survive. His services were in great demand in his native Florence and in other centres of artistic excellence in Italy – notably Padua, Pisa, Rome, and Siena.

A proto-bohemian

Donatello's long career is recorded in many contemporary documents. The little evidence that exists about his personal life indicates that he was devoted to his work and something of a proto-bohemian – simple in his tastes, proud, impulsive, rough-edged, and free with his money.

Work with Ghiberti

Donato di Niccolò, known as Donatello (Little Donato), was born in Florence, in about 1386. His father worked as a wool comber – a common job in Florence, where there was a thriving textile industry.

It is possible that Donatello gained early artistic inspiration from a visit he made to Rome in around 1402 with his friend Filippo Brunelleschi, the great pioneer of Renaissance architecture (although the trip is not documented). From about 1403 to 1407, he is known to have been among the apprentices and assistants who worked with Lorenzo Ghiberti on the first of two sets of bronze doors for the baptistery of Florence Cathedral, commissions of great complexity and enormous prestige that attracted many young artists to his workshop. Ghiberti was a specialist in goldsmithery and bronze, and did not work in stone, so Donatello presumably learned to carve in another workshop.

Stylistic development

From 1407, aged about 20, Donatello began working independently, carving marble statuary for the cathedral. His first notable commission was a life-size marble statue of David (1408–09), originally intended to

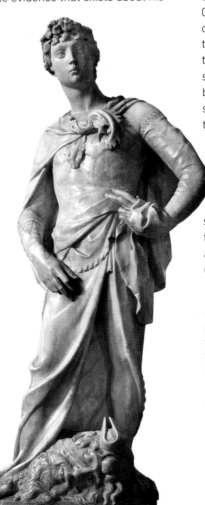

◁ *DAVID*, 1408–09
Donatello's early work owes much to the International Gothic style of Ghiberti, which was marked by a courtly elegance and delicate detail.

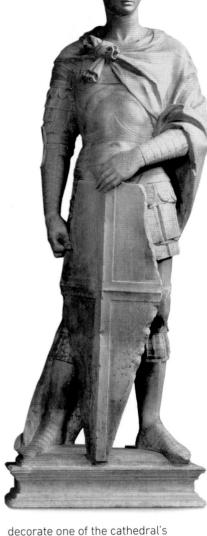

◁ *ST GEORGE*, c.1415–17
Turning away from the artifice of the Gothic, Donatello imbued the figure of St George with character and realism. The saint's square stance and frown help to convey his determination.

decorate one of the cathedral's buttresses but never put in place there; instead, it was bought by the city council and displayed in the town hall (now called the Palazzo Vecchio), an indication that Donatello was already building a reputation. The sculpture has a swaying Gothic elegance indebted to Ghiberti, but Donatello soon cast off this influence: his style became weightier, more naturalistic, and more individual in characterization – qualities now considered typical of Renaissance art.

The most famous of Donatello's early sculptures is the marble figure of St George (c.1415–17) he made for

ON TECHNIQUE
Drawing in stone

In some of his sculptures – especially those intended to be viewed from a distance – Donatello was extremely bold in the creation of his forms, and in his late work his handling is often expressionistically rough. However, he could also be extraordinarily delicate and he invented a technique called *rilievo schiacciato* (flattened or squashed relief) in which the marble is carved so subtly that it has been likened to drawing in stone. Michelangelo's earliest known sculpture, *The Madonna of the Stairs*, was done in this technique as a kind of homage to Donatello.

THE MADONNA OF THE STAIRS, MICHELANGELO, c.1490

" **He alone** by the multitude of his works brought **sculpture** back to **marvellous perfection** in our own age. "

GIORGIO VASARI, *LIVES OF THE ARTISTS*, 1568

> " The **crowning** point of his **development...** not only for its **grandeur**, but as a wonderful technical **achievement.** "

MAUD CRUTWELL ON THE *GATTAMELATA* STATUE, IN *DONATELLO*, 1911

▷ *ST LOUIS OF TOULOUSE*, c.1423
This larger than life-size bronze statue was a remarkable technical achievement in its time. Donatello shows St Louis as a gentle and very human figure carrying his pastoral staff.

IN PROFILE
Cosimo de' Medici

Donatello's most constant patron was Cosimo de' Medici (1389–1464), who from 1434 was in effect the ruler of Florence, although nominally he was just an ordinary citizen. He not only commissioned work from Donatello, but also provided him with workshop accommodation at a peppercorn rent and generally looked after his interests. On his deathbed he is said to have asked his son Piero to make sure the sculptor was well cared for during his old age. Cosimo also patronized Donatello's business partner Michelozzo, who designed the Medici Palace (begun in 1445).

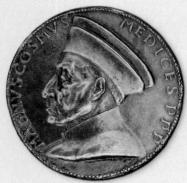

BRONZE COIN STRUCK WITH AN IMAGE OF COSIMO DE' MEDICI

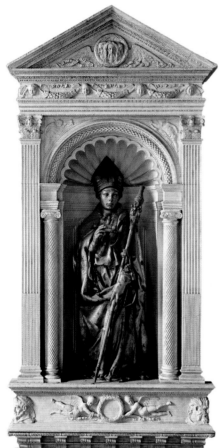

Orsanmichele, one of the most important buildings in Florence, which combined the functions of church and grain market. It was a focus of civic pride, and the various guilds (trade organizations) of Florence competed with one another in erecting statues of their patron saints in niches adorning the building's exterior. *St George* was made for the guild of armourers and sword makers, and the statue was

originally adorned with real accoutrements, including a helmet and a sword or lance that jutted out into the street. The figure is remarkable for the intensity and subtlety with which the young hero is depicted: he stands proudly and resolutely, but there is also a feeling of nervous tension in his expression, as he awaits the forthcoming combat.

Donatello made several other imposing statues for Orsanmichele and the cathedral, including his first major figure in bronze, *St Louis of Toulouse* (c.1423). Bronze is a far more expensive material than marble, and using it to create a large figure requires great technical expertise. To help him in the task, Donatello recruited Michelozzo di Bartolommeo, an experienced metalworker who had also worked for Ghiberti. Michelozzo was an architect as well as a sculptor, and he was probably responsible for the architectural surround of the statue.

In partnership
From about 1424 to 1433, Donatello and Michelozzo formed a partnership and created several major works, including the tomb of antipope John XXIII (1424–28) in the baptistery. As well as their workshop in Florence, Donatello and Michelozzo for a time had premises in Pisa, near the marble quarries at Carrara, and in 1430–33 they worked together in Rome.

After Donatello returned to Florence, the impact of the ancient art he had seen in Rome became visible in his new commissions. For example, the Cantoria (singing gallery) he made for the cathedral in 1433–39 features a wealth of classical architectural ornament and a frieze of dancing baby angels recalling the *putti* (chubby winged infants) so often found in antique art. Donatello's famous bronze figure of David – the first free-standing nude statue of the Renaissance – was

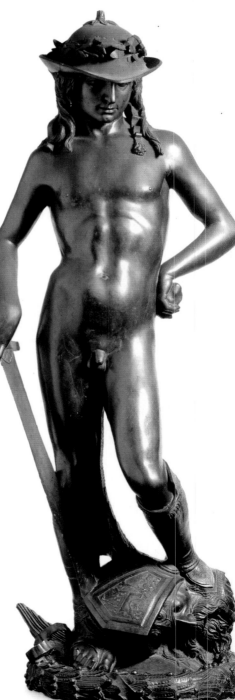

▷ *DAVID*, c.1440–60
A *contrapposto* pose (with the weight on one leg and a slight twist in the body and head) brings David's bronze form to life. David had been adopted as a symbol of the Florentine republic and of the status of the Medici family.

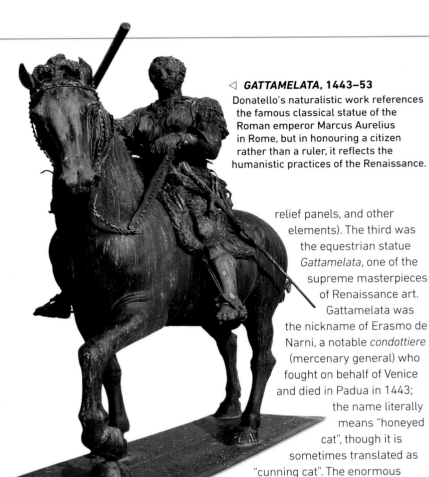

◁ **GATTAMELATA, 1443–53**
Donatello's naturalistic work references the famous classical statue of the Roman emperor Marcus Aurelius in Rome, but in honouring a citizen rather than a ruler, it reflects the humanistic practices of the Renaissance.

relief panels, and other elements). The third was the equestrian statue *Gattamelata*, one of the supreme masterpieces of Renaissance art. Gattamelata was the nickname of Erasmo de Narni, a notable *condottiere* (mercenary general) who fought on behalf of Venice and died in Padua in 1443; the name literally means "honeyed cat", though it is sometimes translated as "cunning cat". The enormous statue was financed by Erasmo's widow and approved by the Venetian government. It was the first great bronze equestrian statue since antiquity – a momentous technical feat – and has inspired countless others throughout the world. None of them, however, has surpassed *Gattamelata* in grandeur and dignity.

When he left Padua in 1453, Donatello was in his late sixties, but he was still artistically vigorous and productive. In 1457–59, he worked in Siena, but his final years were spent mainly in Florence, where he was a favourite artist of the Medici family. It was for the Medici parish church, San Lorenzo, that he made his final works, which remained unfinished at the time of his death and were

probably also inspired by his visit to Rome, as it recalls ancient statues of athletes (although some scholars think that it dates from much later in Donatello's career).

Work in Padua

From 1443 to 1453, Donatello worked in Padua, a northern Italian city that was ruled by Venice at the time. He carried out three major commissions there, all in bronze, which became his preferred material in his later career. Two were for the city's main church, Sant'Antonio: a life-size crucifix and the high altar (an elaborate work featuring free-standing sculptures,

completed by his assistants. These are a pair of pulpits decorated with bronze relief panels, mainly depicting scenes from Christ's life, which show the extraordinary emotional intensity and expressive freedom of Donatello's late style.

Death and legacy

Donatello died on 13 December 1466 and was buried in San Lorenzo, near the tomb of Cosimo de' Medici, his chief patron. He had a huge influence on contemporary Italian artists – not just sculptors, but also painters, who were impressed by the mastery of perspective he showed in his reliefs, as well as by the strength and naturalism of his statues. His reputation has fluctuated over the years, reflecting changes in taste, but he is still revered as one of the greatest of all sculptors.

▽ **SOUTH PULPIT, c.1460–66**
This pulpit – one of two for the church of San Lorenzo in Florence – shows scenes from Christ's Passion. The pulpit was placed on its colourful marble columns long after Donatello's death.

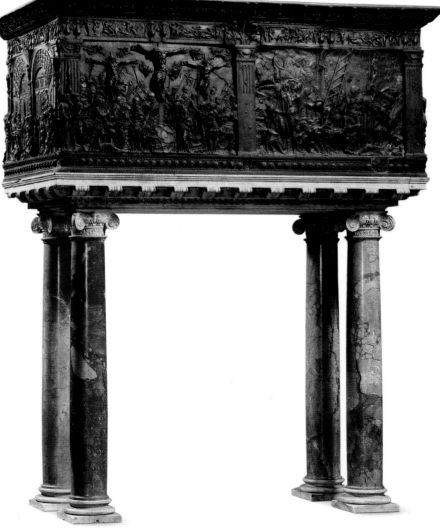

KEY MOMENTS

c.1415–17
Makes *St George*, the most famous of his early works, remarkable for its sense of life and character.

1433–39
The Cantoria for the cathedral in Florence clearly shows the influence of antique art on Donatello's work.

1453
Completes *Gattamelata*, the first major bronze equestrian statue since ancient Roman times.

c.1460–66
Makes a pair of pulpits for San Lorenzo, which are notable for their raw emotional power.

Masaccio

1401–1428, ITALIAN

In a career that lasted only a few years, Masaccio revolutionized painting, using his mastery of perspective and lighting to create a coherent sense of three dimensions.

In his *Lives of the Artists* (1568), Giorgio Vasari divided Italian painting into three periods, and he named Giotto, Masaccio, and Leonardo da Vinci as their respective heroic founders. Posterity has endorsed this view of Masaccio's importance, and he is celebrated as one of the key figures of Renaissance art – indeed of European art as a whole.

"Masaccio" is an affectionate nickname meaning "Sloppy Tom". Vasari says the painter earned it because he was so absorbed in art that he showed no concern for everyday matters, including how he dressed. His real name was Tommaso di Ser Giovanni di Mone Cassai. He was born in 1401 on 21 December (the feast of St Thomas, after whom he was named) in Castel San Giovanni, a town just south of Florence.

Early innovation

Masaccio's father was a notary and the family was prosperous, but little more is known about the artist's early life. In 1422, he became a member of the painters' guild in Florence, and his first known work comes from that year – a triptych of *The Virgin and Child Enthroned with Angels and Saints*. It shows that even at the age of 20 Masaccio was formidably independent in spirit. At a time when most Florentine painting featured pretty colours and decorative details, he revived the noble grandeur of Giotto.

◁ **THE TRINITY, c.1427–28**
The painting shows the crucified Jesus flanked by Mary and St John, and supported by God the Father. The painted coffers on the vault behind the figures seem to converge, giving a sense of depth.

He must have been mature beyond his years, as is suggested by his friendships with the appreciably older Brunelleschi and Donatello, respectively the greatest architect and sculptor of the time.

Key works

In the next five or six years, Masaccio created three great works: a multi-panelled altarpiece for a church in Pisa (only parts of which survive); and two fresco commissions in Florence – those of the Brancacci Chapel in Santa Maria del Carmine (with Masolino) and *The Trinity* in Santa Maria Novella. In these works, Masaccio developed a coherent and logical way of representing volume and space on a flat surface. He did this through mastery of perspective and the use of a single, consistent light source. Although based on rigorous observation and calculation, his paintings are not merely technical demonstrations – they have immense dignity and spiritual authority.

In 1427–28, Masaccio left for Rome and died there soon afterwards of unknown causes. His work made little immediate impact, but it was later enormously influential: Vasari lists 25 artists who studied his frescos in the Brancacci Chapel, among them Leonardo, Michelangelo, and Raphael.

THE VIRGIN AND CHILD, 1426, CENTRAL PANEL OF THE *PISA POLYPTYCH*

▷ **THE TRIBUTE MONEY, c.1425–28**
This detail from Masaccio's fresco in the Brancacci Chapel is thought to include a self-portrait of the artist, standing at the far right of the group (in the role of Thomas the Apostle).

" He carried out **singlehanded** the greatest **revolution** ever known **in painting**. "

EUGENE DELACROIX, *REVUE DE PARIS*, 1830

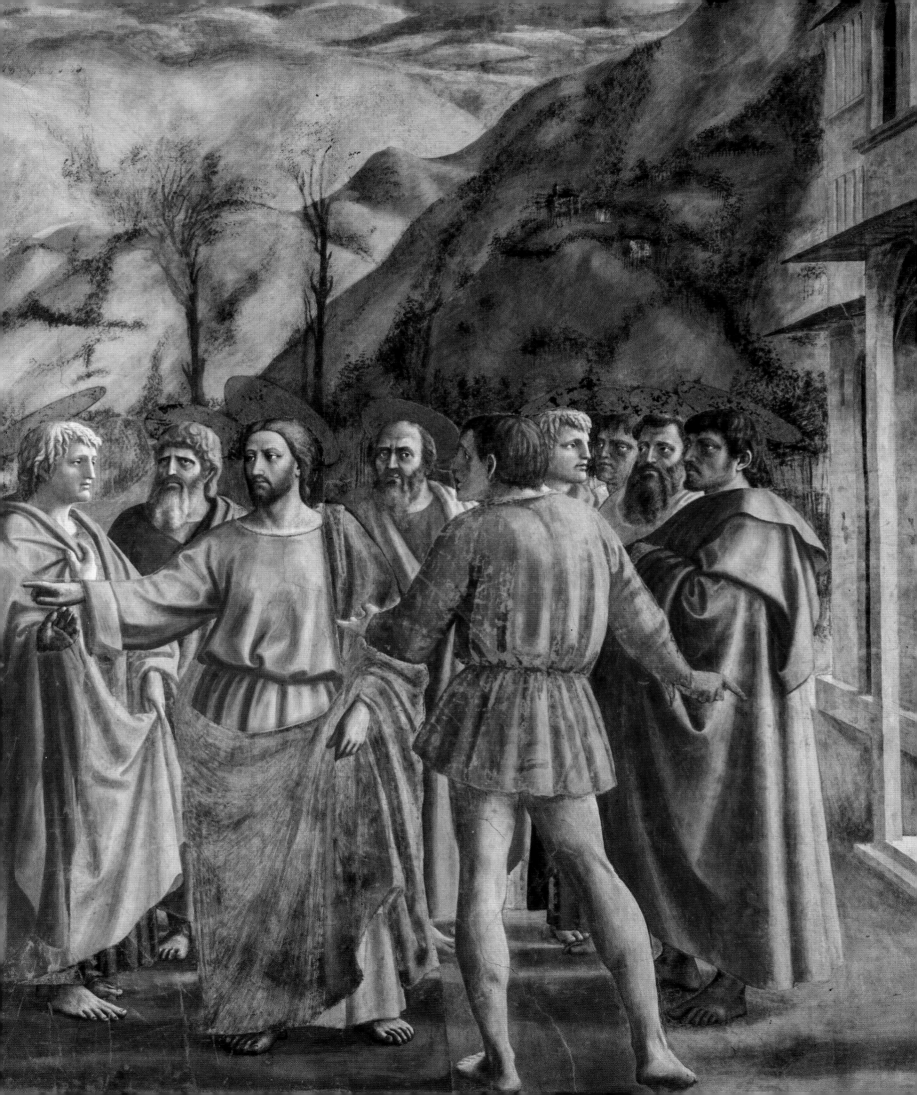

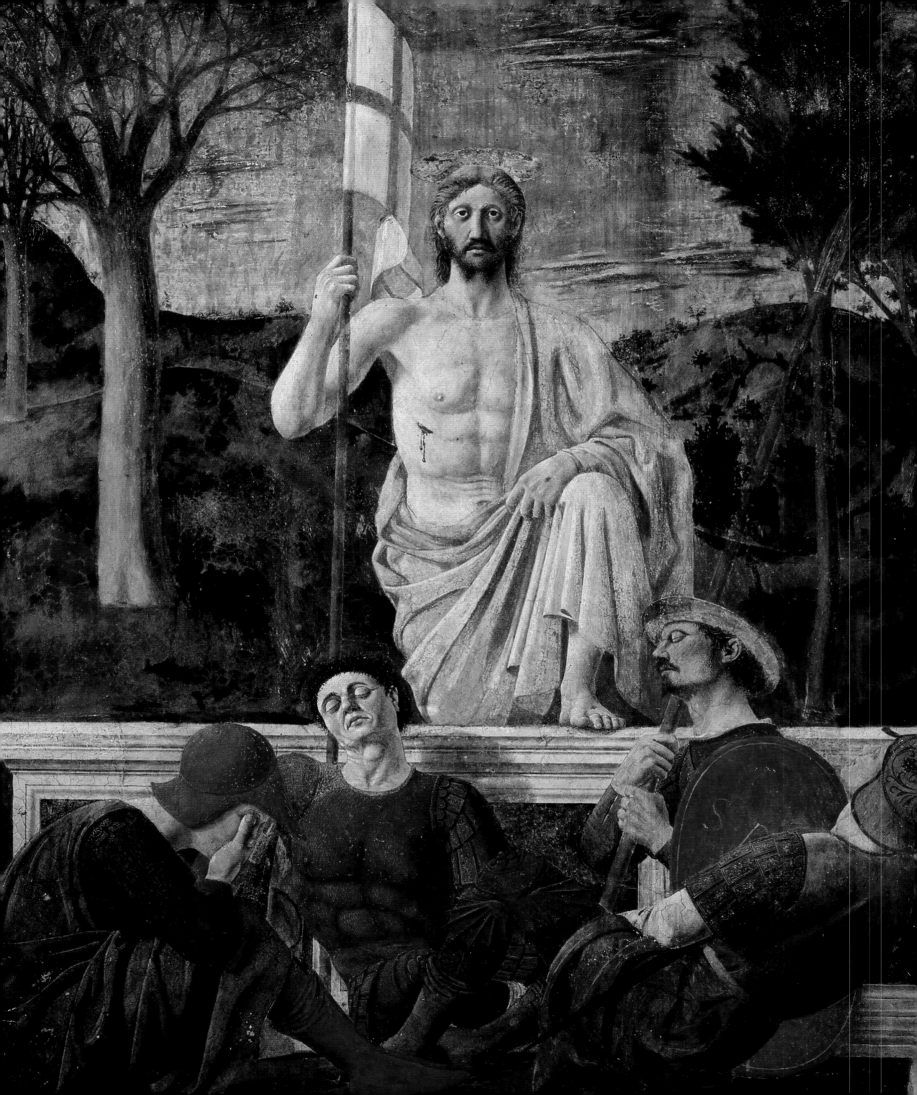

Piero della Francesca

c.1412/15–1492, ITALIAN

Piero is one of the most admired of all 15th-century Italian painters. He was also an extraordinarily gifted mathematician, whose fascination with geometry and proportion underlies the solemn beauty of his art.

Piero della Francesca is now regarded as one of the greatest of all Renaissance painters, yet surprisingly few details of his life are known. Interest in his art declined after his death, partly because he did not often work in Italy's main artistic centres, and most of his major paintings were situated off the beaten track. He was remembered as a mathematician, but as an artist he was neglected for centuries until a revival of interest began in the late 19th century.

Early life

Piero was born in the small town of Borgo San Sepolcro (now Sansepolcro), which lies about 110km (70 miles) southeast of Florence, most probably between 1412 and 1420. It is thought that he was the oldest of six children. His ancestors were artisans and merchants who made and sold leather goods, and it seems that Piero's father, Benedetto, sought to elevate the family's status by adding tax collecting to their enterprises.

Piero probably attended the local grammar school for a few years and, according to Vasari in his *Lives of the Artists* (1568), "applied himself to mathematics" in his youth (possibly

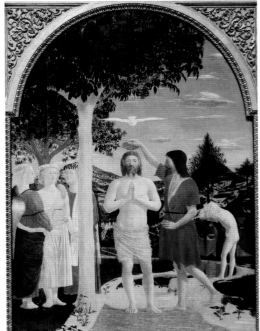

△ *THE BAPTISM OF CHRIST, c.1436–39*
This early masterpiece has an almost hypnotic quality of stillness and quiet gravitas. Its sense of balance and order derives from the geometric shapes that underlie its composition.

doing commercial accounts). Although he would have learned some Latin at school, it is not clear how he gained his knowledge of mathematics and geometry, but it is possible that he was introduced to the works of

Euclid (the ancient Greek "father of geometry") by Niccolò Tignosi, who worked as a doctor in Sansepolcro in the 1430s.

Artisan and artist

Piero had decided to take the path of a painter by his mid-teens. In the 1430s, he assisted Antonio d'Anghiari, a local artist who made paintings for churches. Piero earned extra money from artisanal work, such as making flags, and was briefly employed by officials in his home town painting the insignia of Pope Eugenius IV (whose forces had retaken control of Sansepolcro) on walls and towers.

Although the exact chronology of his activities is unclear, it seems that by the end of the 1430s, Piero had begun to dedicate himself to more ambitious projects. He is known to have lived for periods in Florence, where he assisted Domenico Veneziano in painting a series of frescos, and encountered the work of the masters of the Early Renaissance, including Fra' Angelico, Brunelleschi, and Masaccio (see pp.24–25), whose sculptural forms and rigorous use of mathematical perspective to construct the illusion of depth evidently influenced his art.

ON TECHNIQUE
Piero's treatises

Piero was gifted with a remarkable intellect, combined with an acute visual sensibilty. Despite limited formal education, he wrote three important mathematical treatises: *Treatise on the Abacus*, *On Perspective in Painting*, and *The Little Book on the Five Regular Bodies*, which deals with complex Euclidian geometry. It has often been suggested that the mathematical ratios in Piero's art were intended to reflect divine proportion. But Piero's writings express little interest in such metaphysical ideas, suggesting rather that his brilliant mind saw the world in terms of numerical relationships and geometric forms.

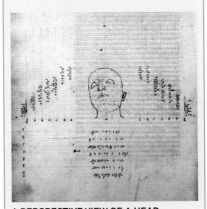

A PERSPECTIVE VIEW OF A HEAD FROM *PIERO'S TREATISE ON PERSPECTIVE IN PAINTING*

◁ *THE RESURRECTION, c.1460–62*
This awe-inspiring fresco was painted for the town hall of Piero's birthplace, Sansepolcro. In his *Lives of the Artists*, Giorgio Vasari claims that the sleeping soldier second from the left is a self-portrait of Piero.

" I must show how this **science** [perspective] is **necessary** for painting... **perspective...** **discerns** all objects **proportionately.** "

PIERO DELLA FRANCESCA, *ON PERSPECTIVE IN PAINTING*, 1470s

▷ **ADORATION OF THE HOLY WOOD AND THE MEETING OF SOLOMON AND THE QUEEN OF SHEBA, c.1452–60**
This solemn double scene shows the Queen of Sheba recognizing the True Cross and then informing Solomon. To create visual and narrative continuity, Piero reused and reversed his cartoons (full-size designs), so that the same figure appears more than once, sometimes as a mirror image.

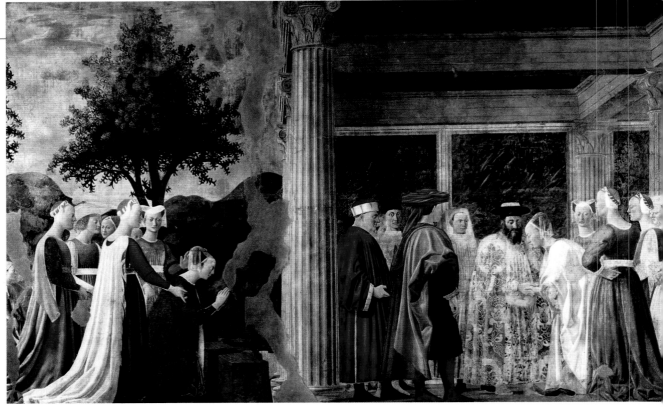

IN CONTEXT
The court of Urbino

The small hillside city of Urbino was home to the court of Piero's patron, Federigo da Montefeltro (1422–1482). Federigo had gained renown as a professional military commander, but became a major patron of the arts who laid great emphasis on learning. He ruled over one of the most significant secular courts in 15th-century Italy. A magnet for artists and scholars, Urbino was the inspiration for the famous *Book of the Courtier* by Baldassare Castiglione, which describes the ideal lifestyle for a courtier. The ducal palace boasted the best library in Italy, and was an ideal intellectual environment for such an artist as Piero.

THE DUCAL PALACE, URBINO

While his work often took him away from home, Piero always maintained strong links with Sansepolcro, carrying out commissions in the town, joining the town council, and – in his later years – supporting his brothers and sisters, and their many children.

The art of geometry

The image of his birthplace appears in the background landscape of several paintings, including *The Baptism of Christ*, which may have been his first major commission, possibly begun between 1436 and 1439.

The Baptism of Christ displays many distinctive elements that characterize Piero's style – its balanced design, the limpid quality of the light, and the solemn grandeur of the figures, with their calm, impassive gazes. However, it shows many notable differences from his later paintings. Working in tempera (pigment mixed with egg yolk) on a wooden panel, Piero applied a traditional green underlayer (*terra verde*, or green earth) beneath the

flesh tones, a technique he did not use after about 1450. He created its appearance of depth by eye, rather than by using a systematic, mathematically determined system of perspective, as he did in later works. Its composition, however, is based on precise mathematical proportions, using halves and thirds, and is arranged according to pure geometric shapes, including circles and triangles – reflecting Piero's fascination with Euclidian geometry.

Beyond Sansepolcro

In 1445, Piero was commissioned to paint a polyptych (a large multi-panelled altarpiece) for the Compagnia della Misericordia (Brotherhood of Mercy) in Sansepolcro, with the contract stipulating that the work be carried out within three years. However, Piero was a notoriously slow worker and it was not finished until 1462. For much of this time, the artist was busy on commissions outside his native town. He is

thought to have worked in Ferrara at the court of Leonello d'Este, and certainly painted in Rome and at the courts of Rimini and Urbino (see box, left), working for Sigismondo Malatesta and for Federigo da Montefeltro. In these courtly environments, he would have seen oil paintings by Flemish artists, and he borrowed from their techniques in his later works, increasing the luminosity of his surfaces by using oil paint, sometimes in combination with egg tempera.

Frescos and cartoons

During the 1450s, Piero spent long periods in Arezzo, a city close to Sansepolcro. Here he painted a magnificent fresco cycle showing the story of the True Cross in the church of San Francesco – a work that took some eight years to complete. Now regarded as one of the masterpieces of Renaissance art, the fresco cycle reveals Piero's extraordinary ability to organize a complex narrative

> " **Painting** is nothing but a **representation** of **surfaces and shapes** diminished or enlarged on the **picture plane**. "
> PIERO DELLA FRANCESCA, *ON PERSPECTIVE IN PAINTING*, 1470s

and shows him adapting traditional techniques to suit his slow working method. When painting frescos (see p.14), the usual practice was to apply only as much plaster as could be painted on that day, but Piero sometimes applied wet cloths to the plaster to keep it workable for longer.

He was also one of the first to adopt the technique of using "cartoons" to transfer a design on to the wall. He produced full-sized drawings and pricked small holes in the outlines of drawn features; charcoal dust held in a cloth bag was then dabbed (or "pounced") through the holes onto the wet, plastered surface, leaving the outlines of the image on the wall.

Later years

Piero probably lived and worked in Urbino on and off during the 1460s and '70s, painting some of his most celebrated works, including the enigmatic *Flagellation of Christ*, the double-portrait of Battista Sforza and Federigo da Montefeltro, and the *Madonna and Child with Saints and Angels*, in which Piero's use of perspective creates a mathematically precise illusion of space.

The intellectual climate of Urbino and the resources of Federigo's vast library would have given Piero the

opportunity to develop the ideas for his mathematical treatises, and he concentrated on these from the mid-1470s, perhaps because of failing eyesight (although he painted his late masterpiece *The Nativity* during the 1480s). His final treatise, *The Little Book on the Five Regular Bodies*, opens with a letter of dedication to Federigo's son Guidobaldo da Montefeltro, who had become duke of Urbino in 1482 after Federigo's death. The elderly Piero writes affectionately to the young duke, offering him "this little work in the last mathematical exercise of my old age", which he has undertaken "lest the mind should become torpid with inactivity".

For the last six years of his life, Piero remained at the family home in Sansepolcro, where he died in October 1492. He once wrote

that he was "zealous" for the fame that he would derive from his art. However, his work fell into obscurity for centuries and it was not until the latter part of the 19th century that interest in it revived, and later in the 20th century that his greatness was fully recognized.

KEY MOMENTS

1445
Accepts commission for the Misericordia Altarpiece in the town of Sansepolcro; does not complete the work until 1462.

c.1450–72
Paints *The Flagellation of Christ*, an enigmatic masterpiece with a meaning that baffles scholars.

1451
Paints the fresco of *Sigismondo Malatesta before his Patron St Sigismundus*. It was the most important work he painted in Rimini.

1452–60
Creates his largest work, the fresco cycle *The Legend of the True Cross*, at Arezzo.

1480s
Paints his final work, *The Nativity*, which remains in the della Francesca family until the 19th century.

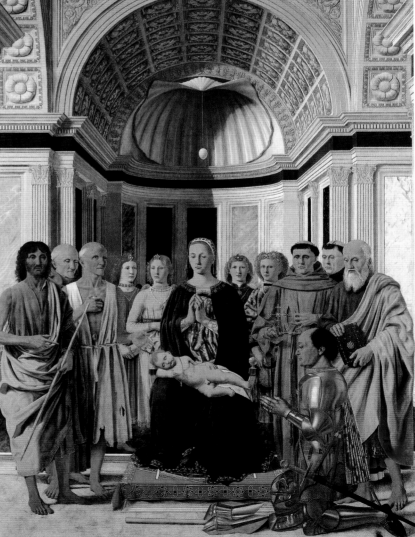

▽ **MADONNA AND CHILD WITH SAINTS AND ANGELS, c.1475–77**
Federigo da Montefeltro, who commissioned this painting, kneels before the Madonna and Child. The emotional disconnection of the figures, allied to the pure geometry of the forms and the painting's symmetry, creates a timeless, otherworldly quality.

▷ **MATHEMATICS AND SYMBOLISM**
Piero's illustration shows his mastery of the revolutionary tool of linear perspective. He used the system in the *Madonna and Child with Saints and Angels* to produce the illusion of depth. He also made use of traditional religious symbolism in the painting: the ostrich egg above the Madonna's head symbolizes the Virgin birth.

Giovanni Bellini

c.1430/35–1516, ITALIAN

Over the course of a long career, Bellini transformed painting in Venice, giving it a new identity and reputation. He pioneered new techniques in oil painting and helped to train many successors, notably Titian.

At the beginning of Bellini's career, Venice could not compete in the field of painting with the artistic powerhouse of Florence. By the time of his death, the city's art boasted an international reputation. This radical transformation was based largely on the work and example of Bellini. He not only brought Venetian painting to prominence, but he also gave it a distinct character, stressing the importance of colour and atmosphere in contrast to the emphasis on line that was typical of Florentine art.

The art historian Kenneth Clark summed up Giovanni Bellini's position in the history of Venetian art by stating that "No other school of painting is to the same extent the creation of one man". Furthermore, over his long career, which spanned more than 60 years, Bellini inspired the upcoming generation of Venetian painters, for whom his workshop was the principal training ground.

△ **SANTI GIOVANNI E PAOLO**
Giovanni and Gentile Bellini were buried with honour in this huge Venetian church, which also contains the tombs of many Doges (rulers) of the city.

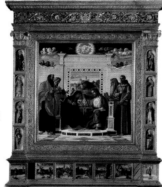

△ **THE CORONATION OF THE VIRGIN, c.1472–75**
Bellini created an altarpiece for San Francesco in Pesaro; this was one of his few major commissions from outside Venice.

A son of Venice

Despite Bellini's great achievements, few details are known about his life. His career can be followed only in broad outline, partly because he seldom dated his works – especially in his early years – and few can be reliably dated on other evidence. His life appears to have been outwardly uneventful and mainly devoted to his art. He seems to have enjoyed a steady rise in success and status (his appointment as official painter to the Republic of Venice in 1483 being a rare biographical landmark), but as far as is known, he rarely travelled far from his home city and was usually reluctant to produce work for patrons further afield, even if they were wealthy, eminent, and persistent.

Bellini's birth is not documented, but most likely took place in Venice in the first half of the 1430s. His father, Jacopo Bellini (c.1400–70/71), who was the leading Venetian painter of his time, had three other documented children. Giovanni's elder brother, Gentile (c.1430–1507), became a distinguished artist and his sister, Niccolosia, married Andrea Mantegna (c.1431–1506), a young painter from Padua who had already achieved considerable success. Gentile and Giovanni almost certainly trained in Jacopo's workshop, and all three worked together on at least one commission.

CRUCIFIXION, PEN AND INK DRAWING, JACOPO BELLINI, c.1450

> " His **feelings**... are controlled by an **exquisite** and **instinctive** judgment. "
>
> ROGER FRY, *GIOVANNI BELLINI*, 1899

▷ *PORTRAIT OF A MAN (GIOVANNI BELLINI)*, 1505–15
This gentle portrait of Bellini was by his pupil Vittore di Matteo. He assumed the name "Belliniano" in honour of his master, whose style he closely followed.

Stylistic influences

By the late 1450s, Bellini was living in his own house in Venice and had presumably embarked on an independent career. His early paintings were strongly influenced by the linear elegance of his father's work and by the incisive clarity of Mantegna, his brother-in-law. However, his style gradually became broader and more mellow, with a wonderful feeling for warm light. A significant influence on him in this respect was the Sicilian artist Antonello da Messina, who visited Venice in 1475–76. Antonello was the most important pioneer of oil painting in Italy, and although Bellini had very probably started to experiment with oils before his visit, from this point he used them increasingly, creating richer and more atmospheric effects than were possible with traditional tempera paint.

KEY MOMENTS

c.1472–75

Paints *The Coronation of the Virgin*, one of his few major commissions from outside the Veneto.

c.1501–04

Paints his best-known portrait – of Doge Leonardo Loredan.

1505

Paints *The Madonna and Child Enthroned with Saints*, the most majestic of all his altarpieces.

1514

Paints *The Feast of the Gods* (later altered by Titian) for Alfonso d'Este, Duke of Ferrara.

Exploring texture

Bellini began to combine tempera and oils in his work, usually beginning a painting in tempera and finishing it in oils. By his final years, however, he seems to have worked exclusively in oils, which allowed him to create extraordinarily subtle tonal variations in his paintings.

In a parallel development, most of his earlier paintings were on wooden panels, but in his later years he sometimes used canvas. His career thus embraced the change from the period when tempera on panel was the normal technique for portable paintings, to the time when oil on canvas was beginning to take over.

Bellini was one of the first artists to explore the textural possibilities of oil paint, notably in his portrait of Doge Leonardo Loredan, where he used

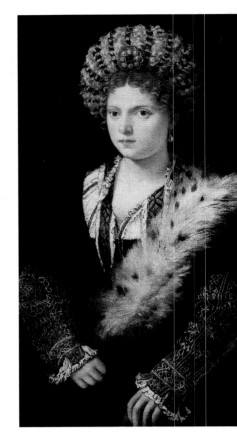

△ *ISABELLA D'ESTE*, **1534–36**
This portrait was painted by Bellini's student Titian. Isabella was a powerful political force in Renaissance Italy and a demanding patron of the arts. She desperately wanted to acquire a grand work by Bellini, but he baulked at her specific demands and eventually provided her only with a small Nativity scene.

slightly rough paint to suggest light catching gold thread in the sitter's sumptuous costume. His interest in texture was taken much further by his pupil Titian (see pp.66–71) – one of the ways in which Bellini's influence persisted.

Personal qualities

Bellini was liked and respected by his many pupils, who probably included Giorgione and Sebastiano

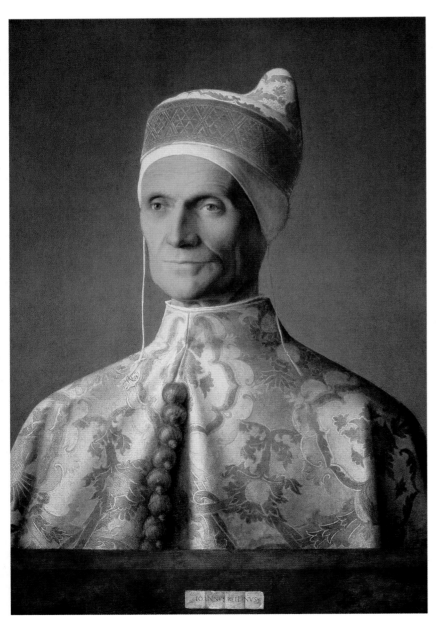

◁ *DOGE LEONARDO LOREDAN,* **c.1501–04**
Bellini's portrait shows the doge (the ruler of the city-state of Venice) in his official robes. The artist helped to popularize the art of portraiture in Venice.

del Piombo as well as Titian. The German artist Albrecht Dürer, who visited Venice in 1505–07, testified warmly to Bellini's talent, writing that Giovanni was "very old and yet he is the best painter of all", and also to his teacher's benign temperament. For while the majority of Venetian artists were hostile to Dürer and other foreigners, seeing them as unwelcome competition, Bellini was courteous and helpful, praising his work and recommending him to potential patrons.

Besides this small insight, little is recorded of Bellini's personal life, but it is known that he had a wife (who had died by 1498) and a son (who seems to have died young). It is possible he married again later, but the evidence is inconclusive.

Genre preferences

Bellini was primarily a religious painter, with a preference for calm and contemplative subjects, above all the Virgin and Child. He treated this theme again and again, in ways ranging from wistful intimacy to lofty solemnity, with the figures set in majestic architectural surroundings. He also often used beautiful landscape settings to enhance the atmosphere of a painting – another feature of his work that was adopted by his pupils.

In other fields, Bellini was one of the best portraitists of his time, and he painted some large historical scenes in the Doge's Palace, Venice, although these were destroyed by fire in 1577. Late in his career, he also produced a few pictures on mythological subjects, but he had little taste for the elaborate allegories that interested some of the intellectual patrons of the time. One such patron, Isabella d'Este, Duchess of Mantua, tried for years to get Bellini to paint an allegory for her study, but

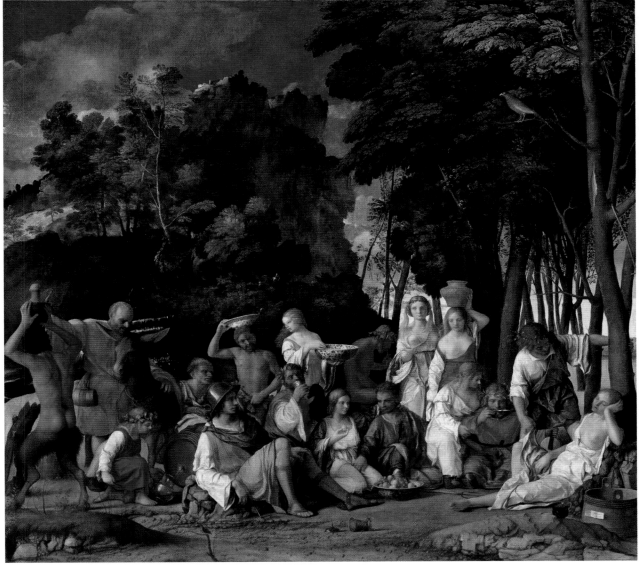

eventually had to settle for a religious picture. (We know this because correspondence survives between Isabella and her agents in Venice; she first approached Bellini in 1496 and finally received the religious painting in 1504.)

Death and burial

Bellini died in November 1516, probably aged between 80 and 85, and was buried with ceremony in

Santi Giovanni e Paolo, one of Venice's greatest churches, alongside his brother Gentile, who had died in 1507. Marin Sanudo, a Venetian nobleman of the time, made a solemnly appropriate entry in his diary to mark the great man's passing: "We learned this morning of the death of Giovanni Bellini, the best of painters... His fame is known throughout the world, and old as he was, he continued to paint excellently."

△ **THE FEAST OF THE GODS, 1514 AND 1529**
The mythological painting illustrates a scene from Ovid's poem *Fasti*, in which the gods frolic in a woodland glade. Painted by Bellini two years before his death, it was later altered by his former pupil Titian, evidently to make it harmonize better with other pictures by Titian hanging in the same room.

" The **only man** who seems to me to have **united** the most **intense feeling** with all that is **great in the artist** as such. "

JOHN RUSKIN, LETTER TO HENRY LIDDELL, 1844

Sandro Botticelli

c.1445–1510, ITALIAN

Botticelli was a Florentine painter and one of the greatest artists of the Early Italian Renaissance. He enjoyed the patronage of the Medici, but his reputation declined until he was rediscovered in the 19th century.

Botticelli was a native of Florence and worked there during one of the most glorious periods in the city's history. He was born Alessandro Filipepi. Sandro was the shortened form of Alessandro, while Botticelli (Little Barrel) was originally the nickname of his older brother, suggesting that he was somewhat rotund. Sandro was also using the name by 1470 and it was later adopted as the family name.

Botticelli's father, Mariano, was a tanner, working in the Ognissanti (All Saints) district of the city – a working-class area, mainly inhabited by weavers and tanners. Sandro remained there for virtually his whole life and was eventually buried in the local church.

Training and independence

In his *Lives of the Artists* (1550), Giorgio Vasari claimed that Botticelli was first apprenticed to a goldsmith, but this cannot be verified. By the 1460s, he had begun his training in the workshop of Fra Filippo Lippi (c.1406–69) – an intriguing master. Orphaned at an early age, Lippi was raised in a friary and took his vows at the age of 16; he later became a painter and gained notoriety when he had a scandalous affair with a nun.

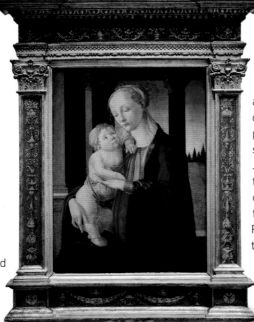

△ **MADONNA AND CHILD, c.1470**
Like his teacher, Filippo Lippi, Botticelli painted many versions of this scene throughout his life, seeking to depict the ideal of feminine grace.

The couple had two children, one of whom – Filippino – became Botticelli's chief pupil. Regardless of controversy, Lippi was a fine teacher. His style was linear and decorative, and he enjoyed painting wistful Madonnas – all these factors had a significant influence on the young Botticelli.

Botticelli probably remained with Lippi until around 1467; by 1470, he had set up his own workshop and secured his first important commission; in 1472, he joined the Compagnia di San Luca, a confraternity of artists. From the outset, work seems to have been plentiful and Botticelli's reputation soon spread beyond Florence. In January 1474, he travelled to Pisa, to begin work on a fresco for the cathedral; by 1481, he was so famous that he was summoned to Rome by the pope, to help decorate the walls of the Sistine Chapel.

Versatility of genre

By the standards of the time, Botticelli was a prolific and varied artist. He painted religious and mythological scenes, allegories, and portraits, and made reference to literary themes in his work. He was employed by the Church, civic authorities, and the leading princely families of the day. The greatest of these was the Medici, who, for much of the 15th century, effectively ruled Florence. Under figures such as Cosimo (1389–1464) and Lorenzo the Magnificent (1449–92), they wielded immense power and influence. They were also lavish patrons, employing all of the major artists of their time.

ON TECHNIQUE
Tondo

Botticelli made something of a speciality of producing circular paintings of the Virgin and Child. This format, known as a *tondo*, became very fashionable in 15th-century Florence. It could have evolved from the *desco da parto* (tray of childbirth), a decorated tray, frequently presented with wine and sweetmeats, which was given as a symbolic gift to mothers who had come safely through childbirth. The link with childbirth probably explains why the Madonna and Child was the most popular subject for a *tondo*.

The Madonna of the Magnificat is one of Botticelli's most beautiful portrayals of the Virgin. In this *tondo*, the Virgin is writing the *Magnificat*, a text from the Gospel of St Luke, which is sometimes also known as the "Song of Mary", while angels place a starry crown upon her head.

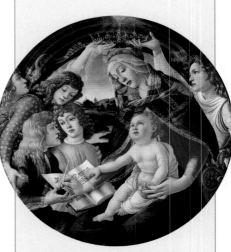

THE MADONNA OF THE MAGNIFICAT, c.1483–85

▷ **THE ADORATION OF THE MAGI (DETAIL), c.1475**
Botticelli is thought to have included a self-portrait in this painting for Giovanni del Lami, who was an official in the Guild of Moneychangers. The artist, dressed in a yellow robe, stares out of the picture plane at the viewer.

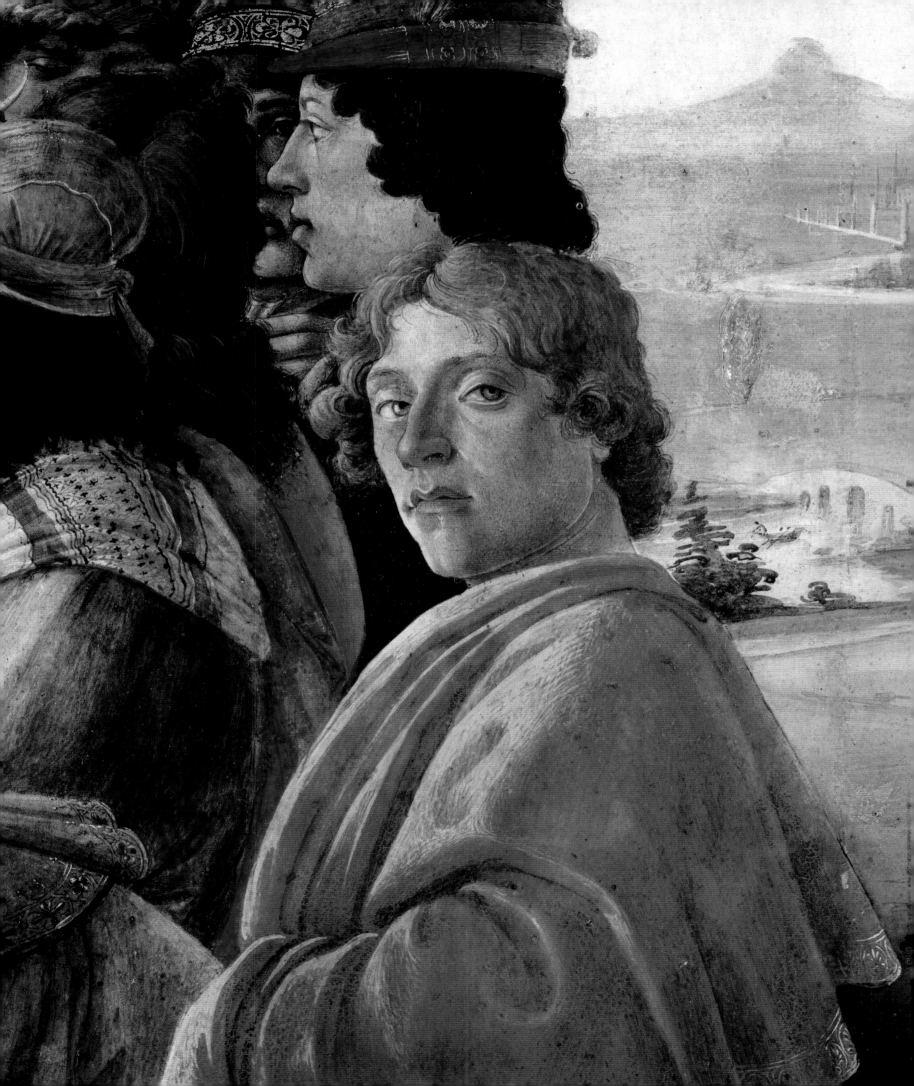

▷ *PRIMAVERA*, c.1477–82
Botticelli's painting shows Venus, goddess of love (centre); to her right are the Three Graces (personifying beauty and charm), who are dancing in an eternal circle; to her left is Flora, goddess of spring (*primavera*), who is scattering blossoms.

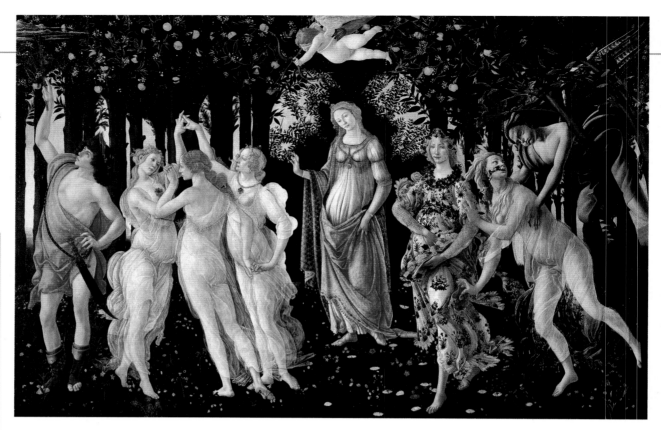

IN CONTEXT
Girolamo Savonarola

Botticelli is believed to have been influenced by the Dominican preacher Savonarola, who created utter turmoil when he arrived in Florence in 1490, becoming prior of the monastery of San Marco. A great orator, Savonarola attracted huge crowds with his fiery, doom-laden sermons on the Medici and their corrupt followers. Florence, he cried, was heading for destruction: his prophecies seemed to be coming true when French troops invaded northern Italy. In 1497, he staged a spectacular "bonfire of the vanities", ecouraging citizens to publicly burn their cards, dice, jewellery, cosmetics, and even paintings in a fire in the main piazza. However, Savonarola went too far when he denounced the pope as the Antichrist. In 1498, he was arrested and burned as a heretic.

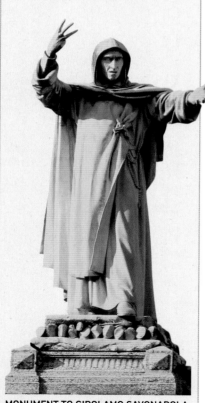

MONUMENT TO GIROLAMO SAVONAROLA IN FERRARA, NORTHERN ITALY

Botticelli soon caught the eye of the Medici. His first documented commission – a panel, *Fortitude* (1470) – came from an associate of theirs, who gave him the job even though he had previously promised it to another artist.

This was to be the start of a lengthy relationship with the Medici, and over the next 20 years, Botticelli produced a wide variety of work for different members of the family. In 1475, for example, Giuliano (Lorenzo's brother) asked him to paint a standard for a spectacular joust that was held in the centre of the city. Three years later, Giuliano was killed during the Pazzi Conspiracy, when a rival family tried to usurp the Medici. The conspirators were swiftly caught and executed, and, as part of the bloody aftermath, Botticelli was hired to paint the corpses of the hanged men on the doors of a public building, as a warning to other potential enemies. Botticelli's chief patron was Lorenzo di Pierfrancesco de' Medici (second cousin to Lorenzo the Magnificent). He is thought to have commissioned the mythological scenes – *Primavera*, *Pallas and the Centaur*, and *The Birth of Venus* – that have since become Botticelli's most popular creations.

Allegory and Neoplatonism
Scores of articles have been written about these mythological paintings by scholars debating their meaning. Certainly, they are not straightforward depictions of ancient legends, but complex allegories, designed to show the sophistication and learning of the patron. The main elements of the compositions were not chosen by the artist, but by Lorenzo's advisers.

On the simplest level, the symbols were often flattering references to the family. The Greek name for the goddess of wisdom (Pallas Athena) was selected, rather than the Roman one (Minerva), as a punning reference to the supporters of the Medici – the *palleschi*. In addition, the family's personal symbol – three interlocking rings – was used as a decorative pattern on the goddess's dress.

The mythological paintings also reflected the vogue for the Neoplatonic teachings of Lorenzo's tutor, Marsilio Ficino. He reinterpreted the ancient legends as moral lessons for the present day. For him, Venus represented *humanitas*, a perfect union of sensual and spiritual love (Ficino invented the term "platonic love"). In *The Birth of Venus*, the sensuous part of this equation is represented by the embracing figures of Zephyr (the west wind) and Chloris (the goddess of flowers), who waft Venus ashore, where the chaste personification of spring is waiting to cover her nakedness.

Poetry of form
Botticelli was working at a key moment in the Renaissance, when the scientific study of anatomy and perspective enabled artists to produce highly realistic images of the world

" ... in a certain sense like **angels**, but with... the **wistfulness of exiles**... and with a sentiment of **ineffable melancholy.** "

WALTER PATER (DESCRIBING BOTTICELLI'S FIGURES), *STUDIES IN THE HISTORY OF THE RENAISSANCE*, 1873

around them. While he was certainly well aware of these developments, he sometimes chose to ignore them. When painting buildings, Botticelli demonstrated a flawless sense of perspective, but in his *Birth of Venus* the figures are almost as large as trees and there is nothing solid about them – they appear to float in space. The figure of Venus is loosely based on an antique statue, yet Botticelli ignored its classical proportions, preferring to elongate the torso, with arms that are as long as her legs. And, at a time when painters were producing illusionistic landscapes, he was content to convey the foaming sea through a series of gentle, rhythmic stylizations.

Botticelli was a superb draughtsman; nevertheless, everything in his art was subordinated to his taste for graceful, poetic forms. The historian Bernard Berenson acclaimed him as "the greatest artist of linear design that Europe has ever had".

KEY MOMENTS

1470
Completes his first recorded work, *Fortitude*, a panel that represents one of the Seven Virtues in Catholic doctrine.

c.1475
Paints *The Adoration of the Magi*, in which several of the figures are portraits of the Medici family, while the right-hand figure is Botticelli himself.

1481
Produces a series of frescos for the newly completed Sistine Chapel, along with several other distinguished artists.

c.1485–86
Paints *The Birth of Venus*. It is owned by the Medici and, along with his *Primavera* and *Pallas and the Centaur*, is displayed at the Villa di Castello.

1500
The *Mystic Nativity* is his only signed and dated painting. By this time, his style is going out of fashion.

Later life
Botticelli's style fell out of favour in the 1490s – it may have seemed archaic when compared with the work of contemporaries such as Leonardo. Vasari ascribed Botticelli's decline to his falling under the influence of the fiery preacher Girolamo Savonarola (see box, left): while there is no direct evidence that Botticelli was one of his followers, this might explain the added intensity of some of his later religious paintings, as well as the strange, apocalyptic imagery in his *Mystic Nativity*. In any event, Botticelli seems to have had difficulty finding work in his final years. Vasari says he became a cripple, moving around with the aid of crutches, before his death in 1510.

Botticelli's reputation declined soon after his death, partly because his masterpieces were hidden away in private collections. It was revived in the 19th century, when artists such as the Pre-Raphaelites came to appreciate the beauty of his work.

▽ **THE BIRTH OF VENUS, c.1485–86**
According to classical myth, which Botticelli interpreted in this painting, Venus was born from the foaming sea and was carried to shore in a giant scallop shell.

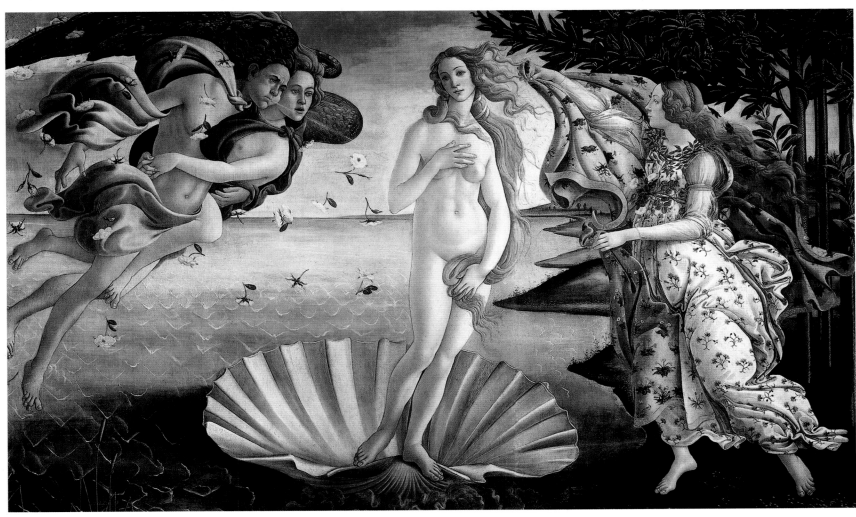

Hieronymus Bosch

c.1450–1516, NETHERLANDISH

Perhaps the greatest of all painters of fantasy subjects, Bosch created unforgettable works that continue to fascinate and perplex viewers 500 years after his death.

◁ **THE GARDEN OF EARTHLY DELIGHTS, c.1495–1505**
Bosch employs fantasy in this triptych to show the perils of earthly indulgence and its frightening consequences in the context of Christian faith.

Bosch is one of the most immediately recognizable of all great painters. His monstrous creatures and nightmarish landscapes appear in popular as well as in high culture, and have become part of our common currency of ideas and images. Because his work is so strange and powerful, because little is known of his career, and because he was virtually forgotten for centuries, his character and the motives for his art have become subjects of intense speculation since his rediscovery at the end of the 19th century. Bosch has been presented by some as a madman, a devil-worshipper, or a debauched drug addict. At the other extreme, he has been characterized as an artist-sage who uses his work to explore esoteric realms of Christian thought. In contrast to such colourful theories, the sober evidence indicates that he held quite orthodox religious beliefs and was a respected member of society – not an eccentric, a recluse, or a heretic.

As far as is known, Bosch spent all his life in the town of 's-Hertogenbosch, from which he adopted the name he occasionally used to sign his paintings. His real name was Jerome van Aken; Hieronymus is simply the Latin form of Jerome, and Bosch a shortened version of the town's name.

Now in the southern Netherlands, near the border with Belgium, 's-Hertogenbosch was at the time one of the main towns in the Duchy of Brabant, part of the territories

△ **HOME TOWN**
A statue of Bosch, palette in hand, stands in the Markt (market) of 's-Hertogenbosch in front of the house (now painted green and much modified) where he once lived.

> " Who can describe all the **wondrous** and **strange** fantasies that... Bosch **conceived** in his mind and **expressed** with his brush? "
>
> KAREL VAN MANDER, *THE BOOK OF PAINTERS*, 1604

▷ **FACE OF THE ARTIST**
The face of the fantastical tree man in the third panel of *The Garden of Earthly Delights*, which depicts Hell, is believed by some art historians to be a self-portrait.

ON TECHNIQUE
Drawings

Around 20 or so of Bosch's drawings survive, and these works show that he was an outstanding draughtsman. In addition to preparatory studies for paintings, his drawings include imaginative compositions that were intended as independent works of art. Typically, Bosch used a brush or quill pen, with ink and/or bistre (a brown pigment produced by boiling soot from burnt wood). Bruegel and Rembrandt were among the artists who continued the tradition of pen and ink drawing that Bosch began in the Netherlands.

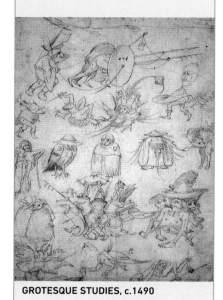

GROTESQUE STUDIES, c.1490

▷ **ECCE HOMO, c.1500**
In this painting, Bosch depicts Pontius Pilate presenting Jesus to an angry mob (the title means "Behold the Man"). The ghostly outlines to the left are the artist's patrons, who had been overpainted, but were exposed when the work was restored in the 1980s.

ruled by the dukes of Burgundy. A thriving provincial centre, it was home to many religious institutions, notably the huge Gothic church of St John, which was elevated to cathedral status in 1559 and still dominates the town today.

There is no record of Bosch's birth, but he is first documented in 1474 and was probably born around the middle of the century. His father, grandfather, great-grandfather, and other relatives were painters, but sadly almost nothing survives of their work, so it is impossible to tell what Bosch may have learned from them. Little, indeed, is recorded of Bosch's

life in general, although we do know that around 1480 he married a woman who came from a rich local family and was appreciably older than him.

Gaining wealth and status

Bosch's marriage made him a wealthy man, and he probably did not need to paint for a living. Documents in the 's-Hertogenbosch municipal archives show that he and his wife owned a good deal of property, and tax records indicate he was among the richest 10 per cent of the town's citizens. The other main source of documentation on Bosch comes from his long involvement (from 1486 until his

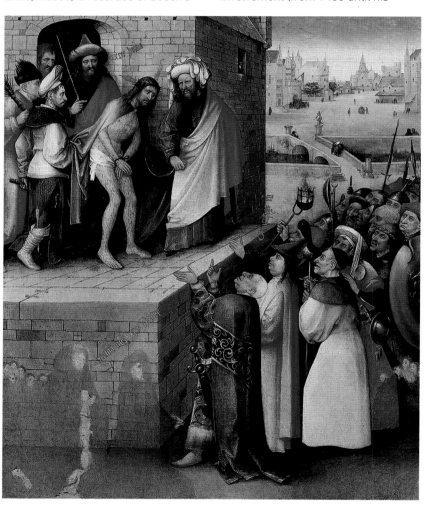

death) with a religious organization in 's-Hertogenbosch – the Brotherhood of Our Lady – which was dedicated to venerating the Mother of God, a practice that centred on a statue of the Virgin housed in the church of St John. The Brotherhood's records do not provide any personal details about Bosch, but they show that he enjoyed high social status: he was the only artist among the "sworn members" – the organization's elite. The Brotherhood is also known to have paid for Bosch's elaborate funeral in St John's church in August 1516 (the exact date of his death is unknown).

Christian iconography

Bosch produced several works for the Brotherhood, but none has survived, and most of his other paintings mentioned in contemporary or near-contemporary sources have likewise disappeared. In spite of our fragmentary knowledge, it is clear that Bosch was an admired and successful painter.

By the end of his life, his reputation had spread to Italy and Spain: Queen Isabella of Castile, who died in 1504, owned three of his works, and later in the century he became a favourite artist of Philip II of Spain. Philip's admiration for Bosch is in itself enough to quash any idea that his work went against orthodox Christian teaching, for the king was a rigorously devout Catholic.

Some of Bosch's paintings are fairly straightforward depictions of traditional religious subjects, such as the Crucifixion. Others deal with general moral issues, including greed and depravity. Almost all his works include grotesque aspects, but only a few are dominated by the type of nightmarish imagery for which he later became famous. Although they

" His pictures are like books of great **wisdom** and artistic **value**. If there are **absurdities** in his work, they **are ours**, not his. "

JOSE DE SIGUENZA, *HISTORY OF THE ORDER OF ST JEROME*, 1605

are inventive and packed with symbolism, even his most complex paintings have overall themes that are fairly easy to grasp. The celebrated *Garden of Earthly Delights*, for example, is a huge work with scores of figures spread over its three panels, but its essential idea seems to be fairly that the sins of the flesh have led men and women away from their God-given earthly Paradise towards the horrors of Hell.

Inspiration and isolation

Bosch worked in a town that was fairly remote from the major centres of Netherlandish art, and much of his imagery relates more to the folklore and popular culture of his age than to the artistic mainstream. He would have seen illustrated manuscripts as well as religious pageants and plays; these included scenes in which saints were tempted or tormented by demons, and they sometimes involved performers wearing grotesque masks.

Bosch's paintings are individual in technique, too. He did not use the extremely polished brushwork typical of the time (inspired by the example of Jan van Eyck). Instead, his handling is lively and varied: in some places the paint is applied thinly and delicately,

but in others his brushwork is palpable and juicy. Bosch's relative isolation helps to explain why his paintings are hard to date – there are no contemporary local artists with whom he can reasonably be compared. None of his extant paintings bears a date, and there are few other clues to help in this respect. From 2010 to 2015, the Bosch Research and Conservation Project used sophisticated technology to examine most of the works plausibly attributed to him or his studio, but even this investigation left many questions unanswered.

Surrealist legacy

Bosch's work was much copied, imitated, and reproduced in prints during the 16th century (influencing artists including Bruegel), but thereafter he was largely forgotten for almost 300 years, although his

reputation survived longer in Spain. He was rediscovered at the end of the 19th century, and from the 1920s appealed to the Surrealists, who saw him as a kindred spirit. His current popularity can be gauged from the success of the exhibition held in his home town in 2016 to mark the 500th anniversary of his death: it attracted more than 400,000 visitors in its three-month run and the opening hours were extended four times, up to 24 hours a day.

◁ **BOSCH'S BROTHERHOOD**
Bosch enjoyed a privileged position in society, in part through his membership of the illustrious Brotherhood of Our Lady, which was organized around a carved wooden image of the Virgin Mary in the church of St John, 's-Hertogenbosch.

▽ *THE WAYFARER*, **c.1510**
This painting is rich in Christian symbolism, but its full meaning has been a subject of intense debate. Some believe the figure represents the Prodigal Son; others that the work represents the choice men make between good and evil.

◁ **GROTESQUE INSPIRATION**
The hideous creatures that inhabit Bosch's works have counterparts in the weird beasts he would have seen as gargoyles on Gothic churches.

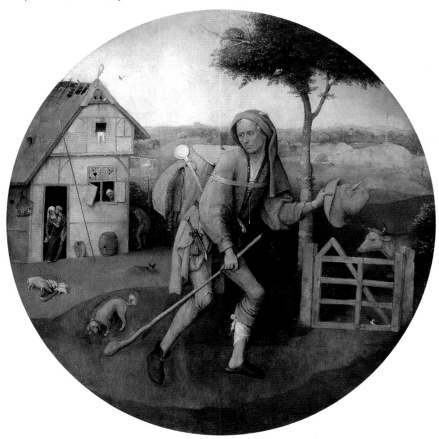

Directory

Duccio di Buoninsegna

c.1250/60–1318/19, ITALIAN

Duccio was the leading painter of his time in Siena. As far as is known, he spent his entire career in the city, although some scholars believe he may also have worked in Florence and Assisi.

Duccio's place in Sienese painting is comparable to that in Florentine painting of his contemporary Giotto, breaking away from austere Byzantine conventions to create a more humane, naturalistic idiom. However, whereas Giotto produced his greatest work in fresco, and excelled in grandeur of form and intensity of emotion, Duccio concentrated on panel painting and his style was characterized by sensitivity of line, intimacy of feeling, and beauty of colouring. His work was enormously influential in Siena throughout the 14th century and into the 15th century.

KEY WORKS: *Rucellai Madonna*, 1285; *Maestà*, 1308–11; *Virgin and Child with Saints*, c.1310-15

Claus Sluter

c.1350–1405/06, NETHERLANDISH

Sluter was the leading European sculptor of his period outside Italy. He was born in Haarlem in Holland and spent part of his early career in Brussels, but all his known work was produced in Dijon; this is now in eastern France, but at the time it was the capital of Burgundy, a powerful state ruled by Duke Philip the Bold, who was Sluter's main patron.

Like Jan van Eyck – whose work appeared later – Sluter broke from medieval conventions to create a more realistic style. His figures, often swathed in majestic draperies,

have a commanding sense of physical presence and are vividly characterized. Originally, his sculptures were painted in naturalistic colours, but little of the paint has survived. Sluter's work was an influence not only on other sculptors, but also on painters of Jan van Eyck's generation.

KEY WORKS: Portal sculpture of Chartreuse de Champmol, c.1390–06; *Well of Moses*, 1395–1403; Tomb of Philip the Bold, begun 1404 (completed after Sluter's death)

Andrei Rublev

c.1360/70–1430, RUSSIAN

Rublev is by far the most famous of early Russian painters, but there is little solid information about his life. The first documentary reference to him records him working in Moscow in 1405, and he seems to have spent his career mainly in and around the city. He is known to have carried out wall paintings in collaboration with other artists, but he is most famous for his icons (religious paintings, typically on panels, of saints and other holy figures), particularly the celebrated *Old Testament Trinity*.

In this work, God appears before Abraham in the form of three otherworldly strangers, who represent the Father, the Son, and the Holy Spirit. The figures are assembled around an altar, on which stands a filled chalice, representing the Eucharist. The work is widely acclaimed as the supreme masterpiece of Russian icon painting, remarkable for its lyrical gracefulness of line, tenderness of feeling, and exquisite colour. Rublev was a monk, and in 1988 he was canonized as a saint by the Russian Orthodox Church.

KEY WORKS: *Old Testament Trinity*, c.1411; *Christ the Saviour*, c.1410–20

▽ Lorenzo Ghiberti

c.1380–1455, ITALIAN

A sculptor, goldsmith, designer, and writer, Ghiberti was one of the key figures in Florentine art in the early 14th century, in the period of transition from Gothic to Renaissance. His career centred on two sets of bronze doors he made for the baptistery of Florence Cathedral – works of such complexity and exquisite craftsmanship that they occupied him for half a century. Each door is divided into panels, with figures in high relief illustrating biblical scenes. On the first door, each of the 28 scenes is framed by a Gothic quatrefoil, and the figures have a flowing elegance. On the second door, the scenes are larger (there are only 10), with naturalistic settings showing a sophisticated use of perspective. Several distinguished artists had part of their training in Ghiberti's workshop, including Donatello and Uccello.

KEY WORKS: North doors of Florence Cathedral baptistery, 1402–24; Statue of St John the Baptist, 1413–17; East doors of Florence baptistery, 1425–52

Pisanello

c.1394–1455, ITALIAN

Pisanello is a nickname, meaning "the little Pisan", by which the artist Antonio Pisano is known. It probably indicates he was born in Pisa, but he began his career in Verona and subsequently worked in several other leading art centres, mainly in the north of Italy but also as far south as Naples. He was one of the outstanding exponents of the graceful International

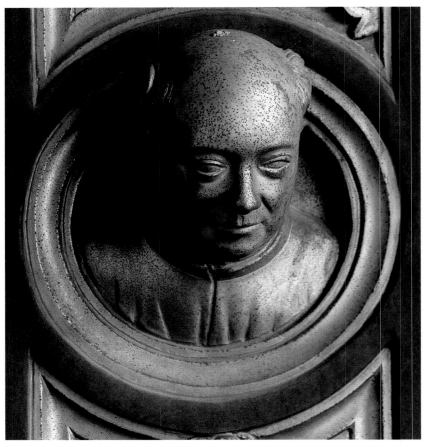

△ **SELF-PORTRAIT ON A ROUNDEL, FROM THE FRAME OF THE GATES OF PARADISE (EAST DOORS OF FLORENCE CATHEDRAL BAPTISTERY), LORENZO GHIBERTI, 1425–52**

△ **PRESUMED SELF-PORTRAIT IN** *ST LUKE DRAWING THE VIRGIN* **(DETAIL),
ROGIER VAN DER WEYDEN, c.1435–40**

Gothic style, and his extensive travels reflect the demand for his services at the sophisticated courts where the style chiefly flourished. Little of his large-scale work has survived, but there are several panel paintings and numerous drawings from his hand, as well as about two dozen portrait medals. Pisanello was the inventor and greatest exponent of this art form, the fashion for which quickly spread throughout Italy and then to other countries.

KEY WORKS: *St George and the Princess*, c.1433–38; Portrait medal of Emperor John VIII, c.1438–39; *The Vision of St Eustace*, c.1450

△ Rogier van der Weyden

c.1399–1464, NETHERLANDISH

Van der Weyden was born and trained in Tournai in the Low Countries, but he spent the majority of his career in Brussels, which he helped to turn into one of the major cultural centres of northern Europe. He was the greatest Netherlandish painter of his time – a worthy successor to Jan van Eyck.

Although he was an outstanding portraitist, he excelled chiefly as a religious painter, his work showing remarkable emotional intensity, especially in scenes depicting the drama and tragedy of Christ's Passion.

He ran a busy workshop, in which his assistants produced numerous versions of his paintings, many of which were exported (to France, Germany, Italy, and Spain). In this way, he became one of the most influential painters of his time, and his work was copied and adapted right up until the 16th century.

KEY WORKS: *Descent from the Cross*, c.1440; *Last Judgement* altarpiece c.1445–50; *Seven Sacraments* altarpiece, c.1450–55

Jean Fouquet

c.1420–c.1481, FRENCH

Fouquet was the outstanding French painter of the 15th century, and – very unusually – he excelled equally as a panel painter and manuscript illuminator. He may have trained in Paris, but he spent most of his career in his native city of Tours, which at this time was home to the French court; his patrons included Charles VII and his successor Louis XI. In 1446–48, Fouquet visited Rome, and he brought Italian Renaissance influence back to France, notably showing an interest in perspective and the details of classical architecture. However, in his searching realism and loving precision of detail he remained true to his northern heritage. Most of his work was on religious and historical subjects, but he was also a superb portraitist.

KEY WORKS: Self-portrait, c.1450; *Hours of Etienne Chevalier*, c.1450–60; *Melun Diptych*, c.1452

Andrea Mantegna

c.1431–1506, ITALIAN

Mantegna was exceptionally precocious, producing outstanding works when he was still in his teens, and for more than half a century he was one of the dominant artists in northern Italy. He spent his early career in Padua, where he was adopted by the painter Francesco Squarcione. In 1460, he moved to Mantua, where he was court painter to the ruling Gonzaga family for the rest of his life. He glorified his patrons in scenes that combine grandeur with domestic detail, and he also painted traditional religious subjects, portraits, and mythological themes.

He was passionately interested in antiquity and was strongly influenced by ancient Roman art, but although his work has a statuesque dignity, it also has vivid dramatic life and often a quality of fanciful wit. Mantegna had a great influence on several of his contemporaries, including his brother-in-law, Giovanni Bellini.

KEY WORKS: San Zeno Altarpiece, c.1457–60; *The Agony in the Garden*, c.1460–65; *The Triumphs of Caesar*, c.1460–80

Martin Schongauer

c.1440–1491, GERMAN

Schongauer was one of the leading German painters of his day, but he is most important as a printmaker. He was the first major artist to work mainly in copper engraving (which was invented around the middle of the 15th century) and ranks as the greatest exponent of the technique before Dürer.

Few surviving paintings are certainly by Schongauer, but more than a hundred of his engravings are known. These are mainly religious, but he also produced scenes of everyday life. They are more imaginative and more inventive technically than earlier engravings, creating a rich variety of tones and textures. Schongauer spent most of his career in Colmar, Alsace. The young Dürer visited the city in 1492, hoping to meet the master, but he had died (probably of plague) the previous year.

KEY WORKS: *Death of the Virgin*, c.1470–75; *Temptation of St Anthony*, c.1470–80; *Madonna in the Rose Garden*, 1473

16th
CENTURY

CHAPTER 2

Leonardo da Vinci

1452–1519, ITALIAN

Gifted in both arts and sciences, Leonardo was a brilliant polymath, a genius of his age. The beauty and majesty of his few completed paintings astonished contemporaries and took art into a new era.

Leonardo was born in or near the village of Vinci, some 40km (25 miles) from Florence. His father was a notary, conducting legal business, his mother was a peasant girl, and their offspring, Leonardo, was illegitimate. Little is known of his early years until he was apprenticed to the artist Andrea del Verrocchio in Florence. At the age of 20, Leonardo was registered with the local painters' guild as a qualified master, but he stayed in Verrocchio's workshop for another four years, and started out independently from 1476.

Early masterpieces

Leonardo's activities during the 1470s (and at many other times in his life) cannot be dated with certainty. An early *Annunciation* was probably done in collaboration with Verrocchio; and when the artists each painted one angel in Verrocchio's *Baptism of Christ* (1472–75), Leornardo's sublime figure far outshone his master's.

Only one painting of the period, the portrait *Ginevra de' Benci*, is all Leonardo's work, finished, and in something like the condition in which he left it. His first surviving and characteristic masterpiece, *The Adoration of the Magi*, dates from 1481–82. The painting shows the Mother and Child at the still centre of a wildly agitated crowd, but its difficult, ambitious composition is managed with complete control.

This fascinating painting was left unfinished – as was a harrowing *St Jerome*, which may date from the same period.

A restless art

The fate of these works was shared by many of Leonardo's undertakings. His perfectionism, and his many diverse

DETAIL FROM *THE VIRGIN AND CHILD WITH ST ANNE*, 1508–13

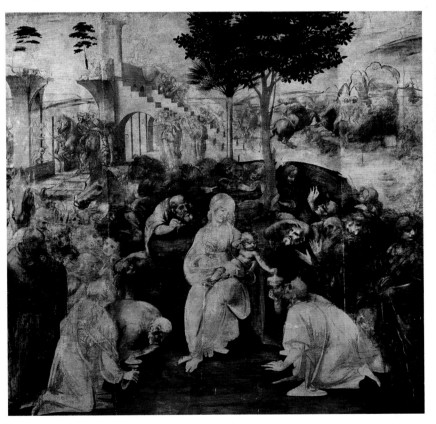

◁ **SELF-PORTRAIT, c.1512-15**
This drawing in red chalk, made when Leonardo was about 60, is believed to be a self-portrait. At least one eye-witness described the artist as prematurely aged, which accords with the image.

◁ **THE ADORATION OF THE MAGI, 1481–82**
Here, the Adoration, usually shown as a relatively intimate scene, is depicted as a tumultuous public event, filled with carefully individualized characters and lively action.

" Besides a **physical beauty** that cannot be too **highly praised**, he displayed an **infinite grace** in all he did. "

GIORGIO VASARI, *THE LIFE OF LEONARDO*, 1560

△ **ANATOMICAL DRAWING**
These meticulous studies of a man's neck and shoulders are typical of the many anatomical drawings in Leonardo's notebooks, often based on dissections that he carried out himself.

▽ **MANNED FLIGHT**
Leonardo's sketches of flying machines have inspired modern enthusiasts to turn them into models, such as the one below. It is a manned craft with flapping wings (an ornithopter) worked by the pilot. Perhaps wisely, Leonardo also designed a parachute.

interests, led him to work on his projects for such a long time – often years – that they became singularly vulnerable to the effects of time and chance. To the great dismay of his patrons, many were unfinished, lost, or destroyed; others were ruined because of problems that arose in the course of his numerous technical experiments. No other great artist has so few fully completed works.

Leonardo seems to have treated his patrons' complaints with remarkable coolness, simply following his own impulses. His single-mindedness, astonishing ability, and unprecedented fame helped to raise the profile of the artist in society; and Leonardo himself was seen by his contemporaries not merely as a dedicated craftsman, but as a formidable and wholly unique individual – a genius, in fact.

The notebooks

In 1482, Leonardo left Florence to work for the Milanese ruler Ludovico Sforza (see box, right). Around this time he began a lifelong practice of filling notebooks with his studies, experiments, and inventions. These would eventually consist of thousands of pages, on topics such as anatomy, botany, military and civil engineering, architecture, optics, hydraulics, topography, and of course painting and sculpture.

There were also imagined inventions such as tanks and flying machines, apocalyptic visions of worldwide catastrophes, and even jokes and riddles. The pages are filled with

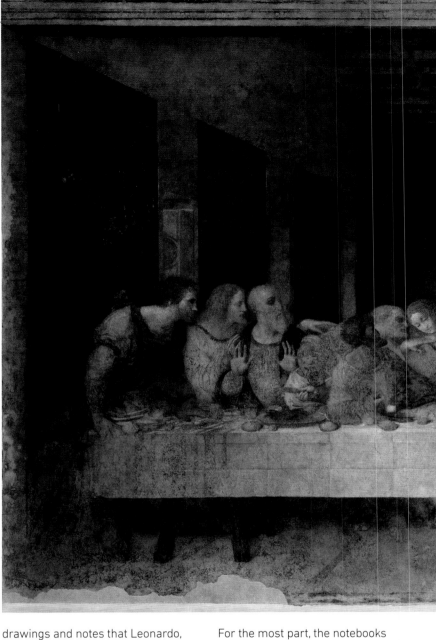

drawings and notes that Leonardo, who was left-handed, wrote from right to left with the letters reversed. This "mirror writing" may have helped keep his writings private, but it also prevented him smudging his script.

For the most part, the notebooks represent an extraordinary, sustained effort to understand the workings of nature, using direct observation and scientific experimentation.

The Milanese years

Leonardo spent 17 busy years in Milan. Much of his time was taken up working for Ludovico and his court, whether devising colourful festivities, designing buildings, or surveying the city's defences. Soon after arriving,

" I can **do** in painting **whatever can be done,** as well as **any other**, whoever he may be. "

LEONARDO, WRITING TO LUDOVICO SFORZA

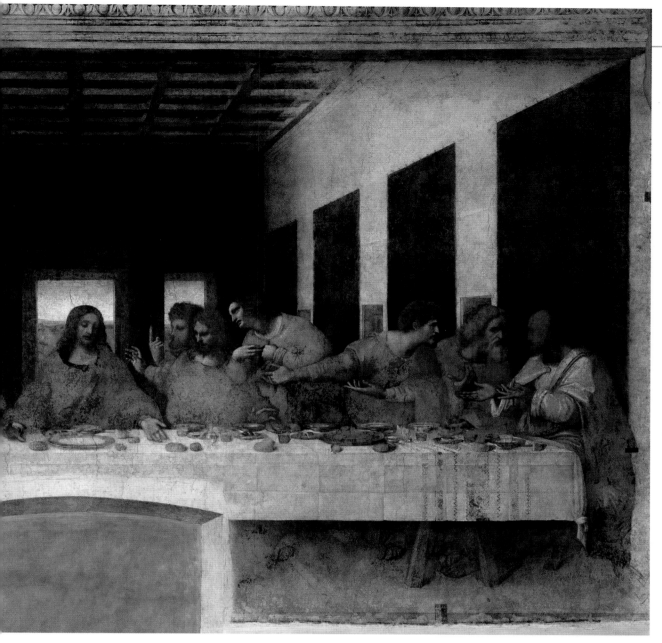

◁ **THE LAST SUPPER, 1496–98**
The painting shows the moment when Jesus tells the Apostles that one of them would betray him. Their reactions of shock, disbelief, sorrow, and (in one instance) guilty tension bring home the shattering nature of the revelation.

IN PROFILE
Ludovico Sforza

Ludovico (1451–1508), Leonardo's employer for 17 years, was the second son of a mercenary soldier who had made himself duke of Milan. In 1476, Ludovico seized power, ruling as regent for his nephew and later as duke. A cultivated patron and builder, Ludovico transformed Milan into a major cultural centre. During the struggles between the Italian states, he encouraged the French to enter Italy, initiating an era of foreign interventions of which he himself became a victim. In 1499, Louis XII of France captured Milan, and Ludovico spent the rest of his life as a prisoner.

however, Leonardo painted a coolly beautiful portrait of Ludovico's principal mistress, *The Lady with the Ermine* (1483–85). Other projects took longer to come to fruition. One was to create a sculpture of a giant bronze horse for a monument to Ludovico's father. Leonardo eventually made a full-sized clay model, but by the time it was ready to be cast in bronze, Milan was under threat from French forces and Ludovico needed all available metal for weapons.

Described by contemporaries as a marvel, Leonardo's "great horse" was used for target practice by archers of the French army that captured the city in 1499, and soon fell to pieces.

The most sublime and unfortunate painting of Leonardo's Milanese years was *The Last Supper*, commissioned for the refectory wall of a Dominican convent, Santa Maria delle Grazie. After three years' work, Leonardo had finished it, to general acclaim. But he had discarded the established

fresco method of wall painting, which involved rapid work and broad effects rather than long-meditated labours and subtle details. Instead, he devised an experimental medium, with disastrous results. *The Last Supper* began to deteriorate in his lifetime. Over the centuries, a series of inept repairs and restorations was carried out (the most recent controversial effort was made in 1999). Despite this, the magnificent composition and geometry of the work, its sense

GOLD DUCAT DEPICTING THE HEAD OF LUDOVICO SFORZA

" No **labour** is sufficient to **tire** me. "

LEONARDO, NOTEBOOKS

▷ **THE VIRGIN AND CHILD WITH ST ANNE AND ST JOHN THE BAPTIST**, c.1500–01
This is a full-size preparatory drawing (cartoon) for a painting that Leonardo is never known to have executed. Cartoons were used as "transfers": their drawn lines were pricked and dusted with charcoal, making guideline dots on the panel or canvas. This cartoon survived because it was never used (and effectively destroyed) in this way.

of tension and drama, and complete mastery of gesture and movement make it one of the most celebrated examples of religious painting.

Return to Florence

The French occupation of Milan left Leonardo without a patron, and he soon moved out of the city. He spent some time in Mantua, Venice, and Florence, then worked in central Italy as an engineer for the notorious warrior-prince Cesare Borgia. Then he returned to Florence, where he made designs for a plan to divert the River Arno (see box, below). The project failed, but Florence remained the centre of Leonardo's creativity during the early 1500s.

Figure groupings

Around 1500–01, he made a large and very beautiful cartoon of *The Virgin and Child with St Anne and St John the Baptist*. It displays Leonardo's developing interest in closely grouped and monumental figures, with the mysteriously smiling faces that would become an increasingly pronounced feature of his work. This – or another comparable cartoon by Leonardo – is said to have been put on show for two days in Florence, when large, wonder-struck crowds queued to see it.

Leonardo was evidently fascinated by the possibilities of the subject and grouping, which reappeared in similar form in the *Virgin and Child with St Anne* painting that he finished some years later in Milan. In this, St John has been replaced with a lamb that Jesus strains forward to embrace. The sense of motion in the scene is accentuated by the figure of the Virgin, sitting on the lap of her mother, St Anne, but her body is bent forwards at an oblique angle, creating a daring composition that draws the viewer into the scene.

Great projects

In Florence, Leonardo began his most famous work, the *Mona Lisa*. The woman's relaxed pose and enigmatic smile have mesmerized viewers over the centuries. It is tempting to believe that Leonardo felt the same, since the sitter's husband never owned the work he commissioned – Leonardo kept it for the rest of his life.

In 1503, Leonardo was offered a major commission. He was to depict a great Florentine victory, the battle of Anghiari, on a wall in the Great Chamber of the Florentine centre of government, the Palazzo Vecchio. The task turned into an unpleasant competition when the city's rising young star, Michelangelo, was invited to paint another battle scene on the opposite wall. In the event, both artists abandoned their projects for different reasons – and both works were lost in a later refurbishment of the chamber.

Unfinished business

Leonardo now returned to some long-unfinished business. In 1483, at the beginning of his first stay in Milan, he had contracted to paint an altarpiece for the Confraternity of the Immaculate Conception. It was never installed and became the subject of a legal wrangle that lasted 23 years. The dispute was settled only after he had arranged to settle again in Milan, and he then completed the painting now known as *The Virgin of the Rocks* (1506-08). An earlier version of the

IN CONTEXT
A visionary project

One of Leonardo's most useful contacts in Florence was Niccolò Machiavelli, an important official who wrote the notorious classic *The Prince*, which defined the ruthless means needed to win and hold on to power. In 1503, while still in office, Machiavelli put Leonardo in charge of planning a project to divert the river Arno so that Florence would have direct access to the sea, bypassing its rival, Pisa. Among a number of proposals, Leonardo drew a fascinating map of the region and marked the route he suggested for the diversion.

LEONARDO'S MAP OF NORTHWEST TUSCANY, 1503

◁ **MONA LISA, c.1503–08**
The sitter is almost certainly Madonna Lisa Gherardini, wife of the Florentine cloth merchant Francesco del Giocondo. "Mona" is a contraction of "Madonna", meaning "Lady" or "Madame".

△ **CHATEAU DU CLOS LUCE**
In his last years, Leonardo lived and worked in this 15th-century house (then called Château de Cloux) near Tours in France. It now houses a museum devoted to the artist's life.

was mainly notable for a curious *St John the Baptist*, portraying the normally ascetic figure as a full-fleshed, smiling young man.

Prematurely aged but still active, Leonardo travelled to France at the invitation of the French king, Francis I. Treated as a cultural icon and housed luxuriously at Cloux, he died there two years later, in 1519 – according to Vasari, "in the arms of the king". He was buried in the nearby church of St-Florentin, Amboise.

Little is known about the artist's private life, but he remained unmarried and it is presumed that he was homosexual. His closest friendships seem to have been with two of his pupils, Melzi and Salaì, both of whom were beneficiaries of his will. Melzi was the principal heir and executor – and it was to him that Leonardo left his paintings, along with money, and other personal belongings.

work already existed, but it is not known when Leonardo painted it. Comparisons between the two works reveal much about Leonardo's artistic development. The earlier version has greater warmth and humanity; the 1506–08 painting, like much of Leonardo's later work, anticipates the grand, solemn compositions of High Renaissance art, of which Leonardo, along with Michelangelo and Raphael, were the masters. Apart from the completion of *The Virgin and Child with St Anne*, Leonardo's second stay in Milan was disappointing and his subsequent residence in Rome

KEY MOMENTS

c.1475
Paints an angel in his employer Verrocchio's *Baptism of Christ* that reveals his immense promise.

1481–82
Produces *The Adoration of the Magi*, which is left unfinished when he leaves Florence for Milan.

1496–98
Spends three years creating *The Last Supper*, still an intensely moving work despite many restorations.

1499
His gigantic clay model the "great horse", is ruined by French soldiers before it can be cast in bronze.

c.1500–01
Makes a chalk and charcoal drawing, *The Virgin and Child with St Anne and St John the Baptist*.

c.1503–08
Creates the famous female portrait *Mona Lisa*, which he will take with him when he finally settles in France.

1503–06
Paints a large mural, *The Battle of Anghiari*, which is unfinished and later destroyed.

1506–08
Completes *The Virgin of the Rocks*; it is now in London's National Gallery.

▷ **THE PEACH BLOSSOM
SPRING, 1524**
This detail from a work that is based
on an 8th-century poem by Wang Wei
shows how Wen Zhengming combines
mountains and trees defined in clear, bold
lines with delicate graded ink washes that
increase the sense of depth and distance.

Wen Zhengming

1470–1559, CHINESE

Wen Zhengming was one of the Four Great Masters – the finest artists of
the Ming dynasty (1368–1644) in China. He was known for his landscape
paintings in ink, sometimes with atmospheric colour washes.

◁ **A LOVER'S FAREWELL**
Wen collaborated with artist Qiu Ying on this ink illustration on silk (c.1540), which depicts a scene from the play *The Story of the Western Wing* and shows a student waving goodbye to his lover.

Wen Zhengming was born near Suzhou, eastern China, in 1470. He was the second son of Wen Lin, an official and magistrate in whose professional footsteps he was expected to follow. However, he performed poorly in the competitive civil-service examinations and served only briefly as an official before retiring and returning home.

Wen Zhengming may have taken after his mother, who was reputedly an accomplished artist, although she died when he was just six years old. In 1489, Wen began to study with Shen Zhou, a founding member of the Wu school of painting based in Suzhou; its name comes from the Kingdom of Wu, the ruling power in southeastern China in the 3rd century. This was not a formal school, but a group of like-minded "gentleman-scholar" artists from well-to-do families; the members were often poets and calligraphers as well as artists. Rejecting official sponsorship and finding private patrons, these artists excelled in refined landscape painting using ink that was applied with a brush.

Nature and gardens

Wen Zhengming became one of the most celebrated painters of the Wu school. He was much influenced by his master, but did not copy him slavishly and produced paintings of a variety of subjects and in diverse styles, using black ink alone or combining it with blue or green washes. Natural scenes and landscapes, gardens, and plants such as bamboo and epidendrum were favourite subjects. It is also likely that Wen's style was informed by the work of Xia Chang – a famous artist respected for his ink paintings of bamboo – who was his wife's uncle. In Ming China, gardens were seen as microcosms of the natural world, and garden design was a high-status art.

The Humble Administrator's Garden, begun in 1509, was the most famous garden in Suzhou. Its designer, Wang Xianchen, gave Wen Zhengming a studio at the site, and in 1535, the artist completed an album of 35 ink views of the garden; a set of a further eight views followed in 1551. Each was accompanied by a poem and an explanatory inscription.

Later work

In his later work, Wen fell under the influence of the artists of the earlier Yuan dynasty (1271–1368). His images became more austere, featuring craggy rocks and gnarled trees set in minimal landscapes or placed in virtually blank backgrounds. The range of his work – from the lush early landscapes to these later, far sparer studies – together with his reputation as the most refined of the period's scholar-artists, made Wen one of the most greatly admired painters in China by the time of his death in 1559.

ON TECHNIQUE
The Three Perfections

The artists of the Wu school embraced a trio of related arts – poetry, painting, and calligraphy – that were known in China as the "Three Perfections". They valued each of these prized arts equally and combined them to produce a single, unified work of art, writing a poem on the same scroll of paper as a painting, so that the painting illustrated the writing and the poetry complemented the image. Painting was regarded as "silent poetry", and poetry as "painting with sound", and scholars trained from an early age in calligraphy. Works combining the forms had been created since the Tang dynasty (618–907).

A MOUNTAIN SCENE, WEN ZHENGMING

◁ **FAN PAINTING, c.1550**
From the middle of the Ming dynasty, paper fans decorated with painting and poetry, such as this example by Wen Zhengming, were carried by men and women as elegant forms of expression.

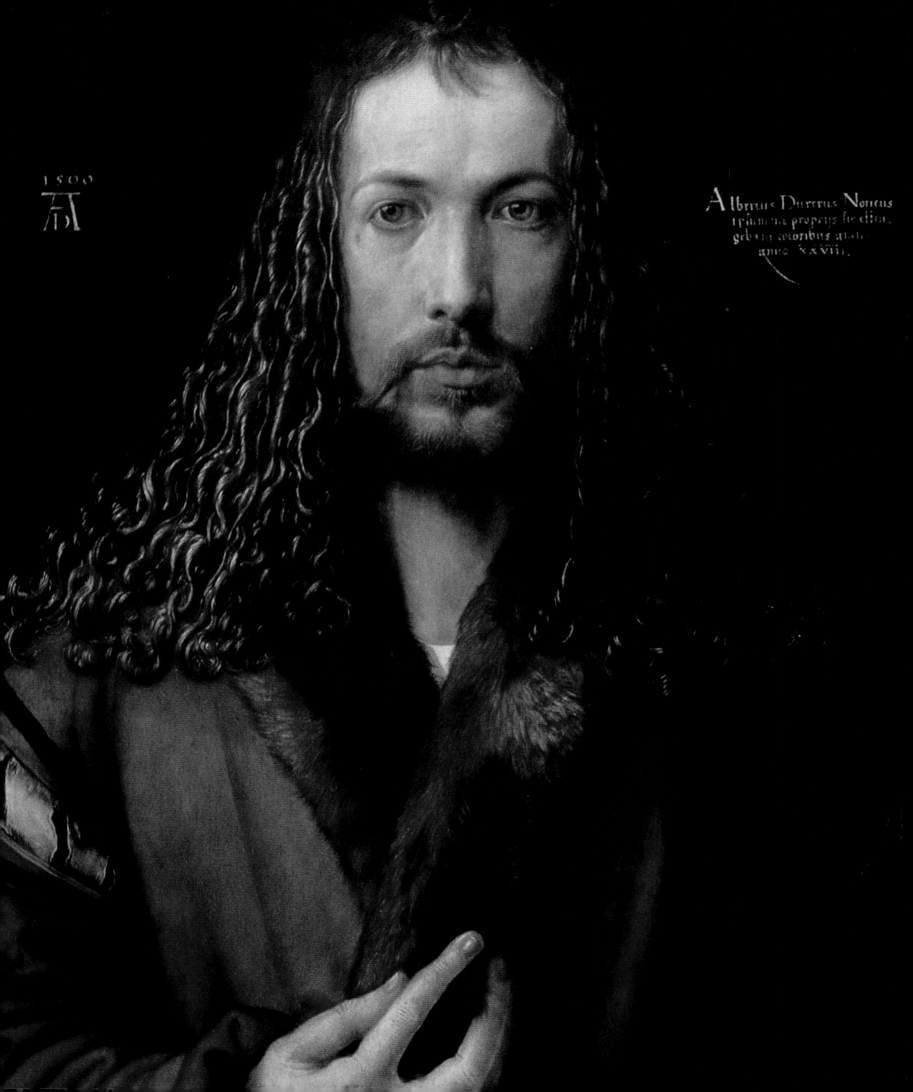

Albrecht Dürer

1471–1528, GERMAN

The foremost artist of his time in northern Europe, Dürer combined superb technical skill with a powerful intellect, which he expressed in paintings, prints, drawings, and treatises.

Albrecht Dürer was an immensely significant artist in various ways. He was the most renowned German painter of his time, but he was even more famous for his prints, and he was the first artist of such eminence to work mainly in this medium. He made two visits to Italy and played a major role in bringing the ideas of the Renaissance to northern Europe – not only stylistically, but also in his desire to raise the intellectual and social status of the artist. His reputation endured after his death and he was one of the first artists to become a national hero.

Apprenticeship and travel

Dürer was born in Nuremberg on 21 May 1471, the third of 18 children. His father, also called Albrecht Dürer, was a goldsmith, and his mother was the daughter of a goldsmith, so fine craftsmanship was in his blood. He initially trained as a goldsmith with his father, but in 1486, aged 15, he was apprenticed to Michael Wolgemut, one of the city's leading painters. Wolgemut was also a prolific book

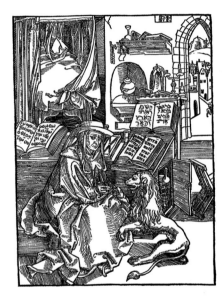

◁ **SELF-PORTRAIT, 1500**
In this powerful work, painted when he was 28, Dürer depicts himself in full-frontal pose, conveying a sense of great seriousness and solemnity.

illustrator, and he presumably taught Dürer how to make woodcuts, which were the standard form for such illustrations in the late 15th and early 16th centuries.

In 1490, with his apprenticeship, complete, Dürer left Nuremberg and embarked on a period of travel that lasted four years. Such *"Wanderjahre"* ("years of wandering") were common among young artists (and craftsmen) at the time, giving them a chance to see something of the world and test their skills before settling down.

Dürer visited various places in Germany and neighbouring countries, including Basel in Switzerland, a

◁ **ST JEROME CURING THE LION, 1492**
Dürer's woodcut shows the scholar St Jerome in his study, pulling a thorn from a lion's paw. It was the frontispiece to a collection of St Jerome's letters.

leading publishing centre, where he picked up a good deal of work making book illustrations.

A lacklustre marriage

By May 1494, Dürer was back in Nuremberg, and a few weeks later, on 7 July, he made an arranged marriage to Agnes Frey, daughter of a wealthy metalworker, who brought him a substantial dowry. She was about 19; he was 22. The union lasted until Dürer's death – but it was childless and seems to have involved scant affection. Dürer's friend Willibald Pirckheimer described Agnes as "nagging, shrewish, and greedy", but a kinder interpretation is that she was an unremarkable woman who had little in common with the genius to whom she found herself married. She helped to sell his prints at various markets and fairs (as did his mother), but she had none of his intellectual interests, which embraced scientific as well as artistic matters and also, in later life, the religious debates of the Reformation (he admired Martin Luther but was moderate in his views).

> " He is an **artist** worthy of **eternal fame**. "
>
> ERASMUS OF ROTTERDAM, LETTER TO WILLIBALD PIRCKHEIMER, 19 JULY 1523

After his marriage, Dürer left Nuremberg for a study visit to northern Italy, which lasted from autumn 1494 to spring 1495. He spent most of the time in Venice – a major art centre that also had strong trading links with Germany.

Soon after returning to Nuremberg, Dürer was launched on a busy and successful career. For example, in 1496, he completed a portrait of Frederick the Wise, elector of Saxony, who was his first aristocratic patron and became one of the most loyal, commissioning several paintings from the artist over the years.

Establishing a name

However, it was with prints rather than paintings that Dürer secured his reputation. Made in multiple impressions and easy to transport, prints carried his name throughout Europe; he was acclaimed even in Italy, where foreign artists were usually lightly regarded.

His first triumph as a printmaker was a set of 15 woodcuts on the Apocalypse, published in 1498 (the subject was topical, as many people feared the world would end in 1500). These contain powerful symbolic imagery that had never been seen before in woodcuts. In his early career, Dürer probably cut the wooden blocks himself, but as he became busier he limited himself to making the design, leaving the process of cutting – with knives, gouges, and chisels – to assistants or hired specialists.

Most of Dürer's prints were woodcuts, but he reached even greater heights in the newer technique of copper engraving. This was more difficult than woodcut, as metal is much harder to work than wood. But it had the advantage of producing finer detail and more varied and

△ **PRINTING PRESS FOR WOODCUTS**
This printing press for woodcuts was reconstructed from one of Dürer's drawings. It is on display in his house in Nuremberg.

△ *THE KNIGHT, DEATH, AND THE DEVIL*, 1513
A magnificent, complex work, bursting with symbolism, this is one of Dürer's most accomplished engravings. His initials are visible on the plaque at bottom left.

subtle effects. By the end of the 16th century, it had superseded woodcut for most purposes. Dürer was the supreme master of the process both technically and imaginatively. He created extraordinarily rich effects of light, shade, and texture, and he

sometimes used subject-matter of his own invention – in *The Knight, Death, and the Devil* (1513), for example, a haunting allegory of the strength of Christian faith, depicting a resolute warrior prevailing over the forces of darkness.

Renaissance man

Such a work shows how Dürer moved away from the medieval idea of the artist as a mere craftsman, diligently carrying out a patron's instructions, to the Renaissance conception of the artist as someone

" Without **proportion**, no **picture** can ever be **perfect**, even if it is made with all **possible care.** "

ALBRECHT DÜRER, *FOUR BOOKS ON HUMAN PROPORTION*, 1528

KEY MOMENTS

1484
Draws an exquisite self-portrait in silverpoint; it is an astonishing achievement for a boy of 13.

1498
Publishes 15 woodcuts on the theme of the Apocalypse; this series marks his first real success as a printmaker.

1502
Paints *Young Hare*; it is to become his most famous watercolour.

1506
Creates the altarpiece *The Feast of the Rose Garlands* for the church of San Bartolomeo, Venice, Italy.

1513
Engraves *The Knight, Death, and the Devil*, acknowledged as one of the masterpieces of printmaking.

1526
Presents *The Four Apostles*, arguably his greatest painting, to the city council of Nuremberg.

who works with the mind as much as the hands. It is one of the qualities he had in common with his great Italian contemporary Leonardo da Vinci, with whom he is often compared. Both of them looked far beyond the usual subjects of art, using their drawings to explore different aspects of the world around them.

Silencing the competition

From summer 1505 to early 1507, Dürer was once again in Italy. He spent most of the time in Venice, where he was praised by the great Giovanni Bellini but met with hostility from other local artists, who resented foreign competition. For the church of San Bartolomeo, which was administered by the German community in Venice, he painted one of his most ambitious altarpieces, *The Feast of the Rose Garlands* (1506). He was aware that Venetian painters prided themselves on their sense of colour, and in this resplendent work he set out beat them at their own game, "to silence those who said

DRAFT DEDICATION TO PIRCKHEIMER, c.1523, IN DÜRER'S *FOUR BOOKS ON HUMAN PROPORTION* (1528)

◁ **THE FEAST OF THE ROSE GARLANDS, 1506**
This magnificent oil painting shows the enthroned Virgin holding the infant Jesus while distributing rose garlands to worshippers. The child places a garland on the head of Pope Julius, while Mary crowns the emperor Frederick III.

I was good as an engraver but did not know how to handle the colours in painting".

After his return to Nuremberg, Dürer consolidated his position as the leading artist in Germany, and in 1509, he marked his success by purchasing a large house (which is now a museum devoted to him). In 1512, the Holy Roman Emperor Maximilian I visited the city and was impressed with Dürer's work. He gave Dürer several commissions, for which he generally avoided paying, as he was constantly in financial difficulties. However, Maximilian compensated for this by ordering the municipal authorities of Nuremberg to pay the artist a quite significant annual allowance.

When Maximilian died in 1519, these payments were stopped, so Dürer determined to meet his successor, Charles V, in the hope that he would be able to persuade him to renew the allowance. Dürer attended Charles's coronation in Aachen in 1520, and the new emperor agreed to reinstate the payment. This visit to Aachen was part of a tour of cities in Germany and the Netherlands that Dürer made from mid-1520 to mid-1521.

▽ **FOUR APOSTLES, 1526**
This monumental diptych was the last of Dürer's large works. It shows, left to right: St John (book), St Peter (key), St Mark (scroll), and St Paul (book and sword).

ON TECHNIQUE
Watercolours

Watercolour did not become widely popular until the 18th century, when it was much favoured by landscape painters, and Dürer was the first major artist to realize its potential. Sometimes he used watercolour merely to apply a delicate tint to a drawing in ink, but he also employed it much more richly, as in his famous painting *Young Hare*. This work uses both transparent watercolour and the opaque type that is known as gouache or bodycolour. The texture of the hare's soft fur is rendered with consummate skill.

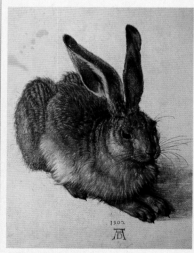

YOUNG HARE, 1502

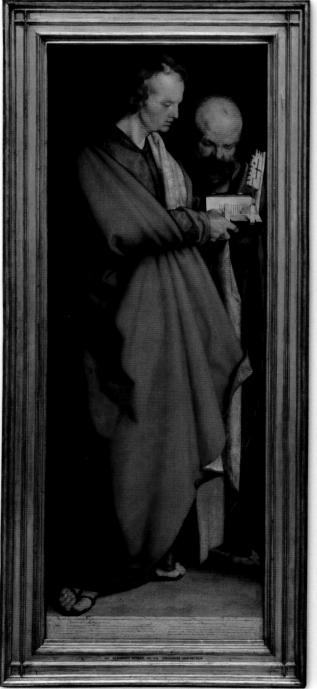

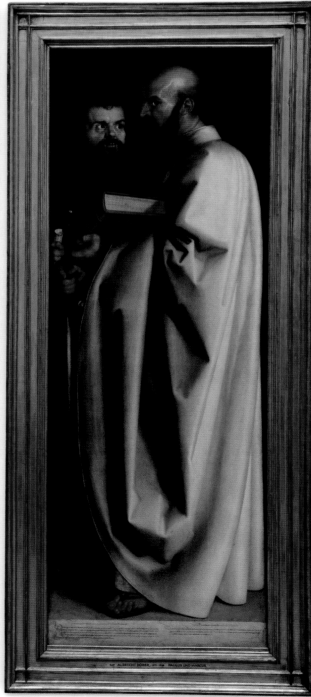

> " His delight was in **representing men** as they **really existe**d all around him. "

WILHELM WACKENRODER, *OUTPOURINGS FROM THE HEART OF AN ART-LOVING MONK, 1797*

A growing reputation

Dürer caught a fever during his travels and after he returned to Nuremberg he was often debilitated by illness. Although the quantity of his work declined, the quality did not, and in 1526 he painted a pair of panels of the Four Apostles that rank among his greatest masterpieces.

Early in his career, his work had been full of exquisitely observed detail and often pulsated with energy. However, under the influence of Renaissance art, his work gradually became grander and simpler in form, and more restrained in emotion. In *The Four Apostles* he achieved a majestic dignity that is a match for anything in contemporary Italian art.

Artist and writer

Although he was less active as an artist in his final years, Dürer was busy as a writer. Earlier in his career, he had begun an instructional manual for artists, but had not completed it. In 1525, however, he published his first book, *Treatise on Measuring*, which includes a discussion of perspective. It was the first book on art theory in the German language. A book on

△ **PERSPECTIVE DRAWING OF A LUTE, 1525**
This woodcut is taken from Dürer's *Treatise on Measuring*, about the application of geometry to art.

fortification followed in 1527; and *Four Books on Human Proportion* was published six months after he died, aged 56, in April 1528. He felt there were "many forms of relative beauty" and illustrated body types to help artists depict "the widest limits of human nature and... all possible kinds of figures".

An enduring legacy

Dürer had a huge influence on his contemporaries. He was an outstanding teacher and the many pupils he trained helped to spread knowledge of his style. His prints, often signed with his AD monogram, were much imitated and copied in his lifetime (sometimes with fraudulent intent) and they continued to be reproduced and adapted for generations after his death. By the early 19th century, he had become a national hero in Germany, unchallenged as the country's greatest-ever artist.

On 6 April 1828 – the 300th anniversary of his death – the foundation stone of a monument to Dürer was laid in Nuremberg. Inaugurated in 1840, it was the first public monument ever to be erected to an artist.

▷ **THE EMPEROR CHARLES V, 1521**
Dürer designed this beautifully crafted silver medal to mark the first parliament in Nuremberg under the newly crowned Holy Roman Emperor, Charles V, in 1521.

△ **STATUE OF DÜRER, 1840**
More than three centuries after his death, this statue was erected in Nuremberg, Dürer's birthplace and home for most of his life.

Michelangelo

1475–1564, ITALIAN

The greatest artist of his age, Michelangelo reigned supreme as sculptor, painter, and architect, and had a huge influence on his contemporaries as well as on later generations.

Michelangelo's stupendous career lasted virtually three-quarters of a century, from his first surviving drawings, made when he was scarcely into his teens, to the sculptural group he left unfinished at his death at the age of 88. For most of this time he had no real rival as the most famous and accomplished artist in Europe. His contemporaries looked on him with awe, and this still seems an appropriate response to someone whose masterpieces, in painting, sculpture, and architecture, rank among the most familiar landmarks in world art.

Early years

Michelangelo Buonarroti was born on 6 March 1475 in the small town of Caprese (now renamed Caprese Michelangelo in his honour) in Tuscany. His father, Ludovico, was mayor of the town at the time, but a few weeks after Michelangelo's birth the family moved back to their home in Florence, about 100km (60 miles) away. Ludovico, who was a mediocre character, believed that he had aristocratic blood in his veins and, because of this, tried to suppress Michelangelo's early artistic inclination – painting and sculpture were generally considered to be manual trades and therefore unfit pursuits for a gentleman.

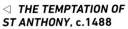

◁ **THE TEMPTATION OF ST ANTHONY, c.1488**
Based on an engraving by Martin Schongauer, this small painting is thought by some art historians to be Michelangelo's earliest surviving work.

However, he eventually gave in to the strong-willed boy, who in 1488 was apprenticed to Domenico Ghirlandaio, one of the leading painters in Florence.

From Florence to Rome

The next year, Michelangelo moved to an informal academy of sculpture sponsored by Lorenzo de' Medici (Lorenzo the Magnificent), effectively the ruler of Florence. The academy was overseen by Bertoldo di Giovanni, who was a former pupil and assistant of Donatello and a specialist in bronze. Michelangelo favoured marble over other materials, and it is unclear where he learned his skill in carving it. In later life, he liked to give the impression that his talent was God-given. It is possible that he was largely self-taught in sculpture, but in painting he probably learned at least the basics from Ghirlandaio, who was an excellent craftsman and a highly efficient workshop manager.

Michelangelo became a firm favourite of Lorenzo, who gave him accommodation in the Medici Palace. When Lorenzo died in 1492, the political situation in Florence became unstable. Michelangelo left the city in 1494 and spent most of the next year in Bologna. He returned to Florence late in 1495, but the city's problems now included famine and plague, so

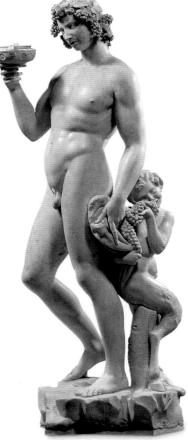

△ **BACCHUS, 1496–97**
The soft-bodied figure of Bacchus seems unsteady on his feet in Michelangelo's classically inspired vision of the Roman god.

▷ **MICHELANGELO, c.1550**
Daniele de Volterra, a friend and follower of Michelangelo, drew this likeness of his teacher; his own work was often based on drawings supplied by Michelangelo.

" So **long** as the world endures, the **fame** **of his works** will **live gloriously**. "

GIORGIO VASARI, *LIVES OF THE ARTISTS*, 1550

IN CONTEXT
Carrara marble

The most famous marble quarries in Italy are at Carrara, about 100km (60 miles) northwest of Florence. They have provided stone for statues and buildings since ancient Roman times and marble from the quarries is still exported worldwide. Michelangelo liked to visit the quarries himself to supervise the cutting of marble blocks for his sculptures, sometimes spending months there, rather than relying on intermediaries to choose his material.

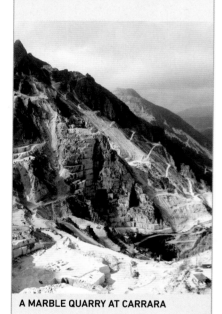

A MARBLE QUARRY AT CARRARA

in 1496 he relocated to Rome to seek better career prospects. He was just 21 years of age.

The work that Michelangelo had produced so far had generally been small in scale, but while in Rome he established his reputation with two large marble sculptures, each commissioned by a cardinal: a statue of Bacchus (the Roman god of wine, fertility, and revelry); and the famous *Pietà* (Mary lamenting over the dead Jesus), which was immediately acclaimed as a masterpiece. In 1501, he returned to Florence (which was now under a more stable republican government) and began a huge statue of the biblical hero David. Standing 5m (17ft) high, and carved from a single block of Carrara marble (see box, left), the piece was completed in 1504, and was considered a triumph for its astonishing beauty and detail and the grace and elegance of the pose. Although intended for the

cathedral, the statue was placed outside the town hall as a proud symbol of the new republic.

Rivalry of the greats

Michelangelo's next large commission was for the council chamber of the Palazzo Vecchio. He was to paint a vast mural of the Battle of Cascina (a Florentine victory over Pisa) to accompany an equally large painting of the Battle of Anghiari (a Florentine victory over Milan), on which Leonardo da Vinci was working.

Leonardo was the most famous artist of the time, but Michelangelo was emerging as a serious rival. The men disliked one another, and the scene was set for an artistic clash of the titans. However, neither artist finished his mural. Leonardo abandoned his work after an experimental technique (using oil paint applied on a thick undercoat)

failed. Michelangelo produced a full-size cartoon (preparatory drawing) for his scene, but in 1505 – before he could begin the actual painting – he was summoned to Rome by Pope Julius II (see right) to make the pope's tomb, which was intended to be the most magnificent ever created in the Christian era.

The project became what one of Michelangelo's pupils called "the tragedy of the tomb": Julius lost his enthusiasm for the work, and after his death in 1513, negotiations with his heirs dragged on for three decades until – eventually – a much reduced monument, carved largely by Michelangelo's assistants, was finished in 1545.

▽ **DAVID, 1501–04**
Unlike many earlier artists, who portrayed David standing over a slain Goliath, Michelangelo shows him before his battle, slingshot over his shoulder.

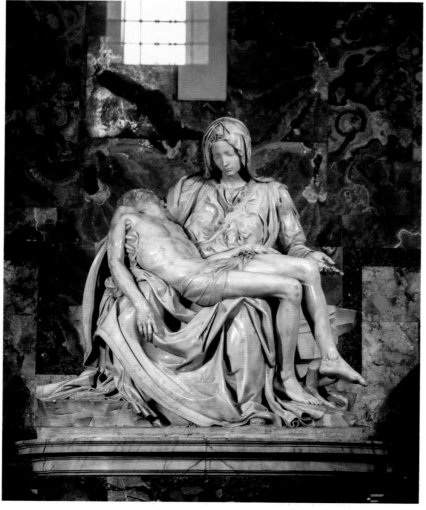

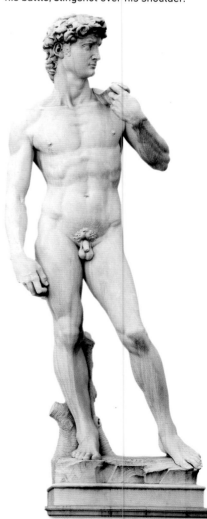

▷ **PIETÀ, 1497–1500**
The rich folds in the Virgin's robe and her intensely expressive features introduced an unprecedented naturalism to Renaissance sculpture.

KEY MOMENTS

c.1490
Makes his first (known) drawings – copies of figures by Giotto and Masaccio.

1497–1500
Carves the *Pietà*, the work that above all establishes his reputation.

1501–04
Makes a gigantic statue of David, which becomes his first public triumph in Florence.

1508–12
Paints the ceiling of the Sistine Chapel, Rome, with scenes from Genesis and other subjects.

1519
Begins work on the Medici Chapel. It is left unfinished when he settles permanently in Rome in 1534.

1536–41
Paints *The Last Judgement* on the altar wall of the Sistine Chapel.

1546
Is appointed architect to St Peter's.

c.1555
Begins the *Rondanini Pietà* (named after a family that once owned it), which is unfinished at his death in 1564.

The Sistine Chapel

Julius's other major commission for Michelangelo was to become the artist's supreme achievement. The ceiling of the Sistine Chapel (1508–12) was acclaimed as a work of sublime beauty and grandeur, and elevated Michelangelo – still only 37 – to the status of the world's greatest artist. The dozens of figures on the ceiling show Michelangelo's mastery in depicting the human body, particularly the male nude. His biographer and friend Giorgio Vasari wrote that "he refused to paint anything except the human body in its most beautifully proportioned forms and the greatest variety of attitudes, thereby to express the wide range of the soul's motions". In his sense of heroic breadth and his rejection of unnecessary detail, Michelangelo was inspired by his great predecessors Giotto and Masaccio; he was also influenced by

IN PROFILE
Pope Julius II

Julius II (reigned 1503–13) was among the most powerful and ruthless of all popes. By diplomatic and military means, he aimed to make the papacy the dominant power in Italy, personally leading his armies on campaigns to extend its territories. He was also the greatest art patron of his day, beginning the new St Peter's (originally under the architect Bramante) and employing Michelangelo and Raphael on major works. Despite his spending on war and art, he kept the papacy in a sound financial state.

MEDAL PORTRAYING POPE JULIUS II

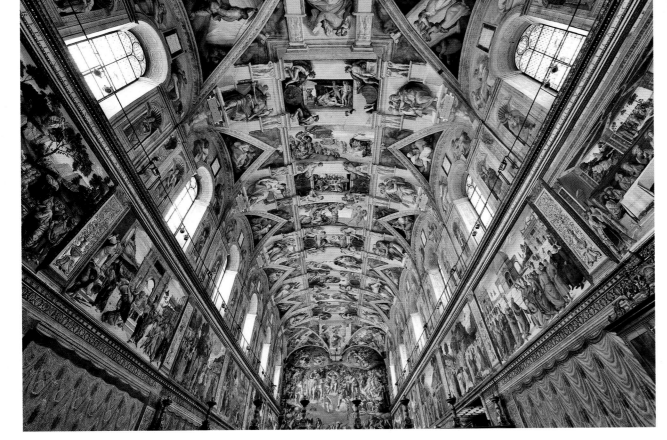

◁ **CEILING OF THE SISTINE CHAPEL, 1508–12**
Michelangelo accepted the commission to paint the ceiling of the Sistine Chapel reluctantly, considering himself a sculptor rather than a painter.

" The **divine** Michelangelo Buonarroti, prince of **sculptors** and **painters**. "

BENVENUTO CELLINI, *AUTOBIOGRAPHY*, c.1560.

the dignity and anatomical mastery of ancient Roman sculpture. However, Michelangelo's figures had an entirely new and resplendent energy, grace, and spirituality.

Their impact on contemporary artists was immense, and they exerted an enduring influence on subsequent generations – for good and ill. Great artists have used them as a spur to the imagination (for example, Michelangelo's muscular figures informed some of the greatest work of Peter Paul Rubens a century later), but lesser painters and sculptors were often overawed into feeble mimicry.

Continued patronage

Julius II was succeeded as pope by Leo X, who was the son of Lorenzo de' Medici. Michelangelo continued to receive Medici commissions in Florence, notably the Medici Chapel (begun 1519) in the church of San Lorenzo, and a library (begun 1525) in the cloisters of this church to house the family's famous collection of books and manuscripts. In 1527 the Medici were driven out of Florence, but they returned and captured the city in 1530. Michelangelo had been in charge of the besieged city's fortifications and he now feared for his life, but Pope Clement VII (another Medici, a nephew of Lorenzo the Magnificent) ordered that he should not be harmed.

In 1534 Michelangelo returned permanently to Rome, where Clement had commissioned him to paint a fresco of the Resurrection on the altar wall of the Sistine Chapel. However, Clement died only days after Michelangelo arrived, and his successor as pope, Paul III, changed the subject to the Last Judgement. At more than 13m (42ft) high, this was the largest painting in the world at

the time, and it occupied most of Michelangelo's efforts until it was unveiled in 1541. The dramatic work shows Christ as the judge of human souls, presiding over the separation of the blessed and the damned. The pope is said to have fallen to his knees when he saw it, and Vasari wrote that it was greeted with "wonder and astonishment" by "the whole of Rome, or rather the whole world".

Michelangelo painted two further frescos for Paul III, in his chapel in the Vatican – *The Conversion of St Paul* (1542–45) and *The Crucifixion of St Peter* (1546–50). Like *The Last Judgement*, these are also different in style from the Sistine Ceiling, with grimly powerful figures that convey inner experience rather than outward beauty. They were Michelangelo's last paintings, carried out – in Vasari's words – "with great effort and fatigue".

The architect of St Peter's

In his later years, Michelangelo worked mainly as an architect, and in 1546 was put in charge of the new St Peter's in Rome, the most important building project in Christendom, which had been begun by Julius II in 1506. Michelangelo had always insisted that he was a sculptor first and foremost and he took on the job of architect to St Peter's "completely against his will", according to Vasari.

In spite of this initial resistance and his advancing age, he tackled the work with characteristic energy, galvanizing the project, on which progress had previously been slow. He replaced some of the rather fussy designs of his predecessors with one of boldness and vigour. The building was still far from complete when Michelangelo died in 1564, but it owes more to him than to any other architect.

▷ **THE TOMB OF LORENZO DE' MEDICI, 1520–34**
Michelangelo sculpted this tomb for the Medici Chapel in the church of San Lorenzo, Florence. It shows a thoughtful Lorenzo, seated above reclining figures of Dusk and Dawn.

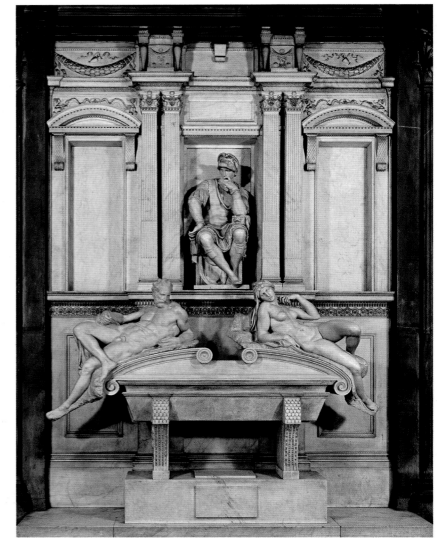

▷ **THE LAST JUDGEMENT**, 1536–41
Populated by angels, demons, and massive, threatening figures, the work conveys the power of the body, and also a sense of great spiritual desolation.

Up to a few days before his death, on 18 February 1564, Michelangelo continued working on his final, unfinished sculpture – a stark, intensely spiritual marble group of the *Pietà*. He left instructions that he wished Florence to be his final resting place and he was buried there in the church of Santa Croce on 10 March, followed four months later by a memorial service, attended by leading citizens and 80 artists. The monument over his grave was designed by Vasari and is appropriately adorned with figures representing Painting, Sculpture, and Architecture lamenting the death of the great artist.

△ **MODEL OF THE DOME OF ST PETER'S**, c.1560
Michelangelo produced many sketches for the dome of the basilica, from which a wooden scale model was made. The dome is celebrated as one of the architectural glories of the world.

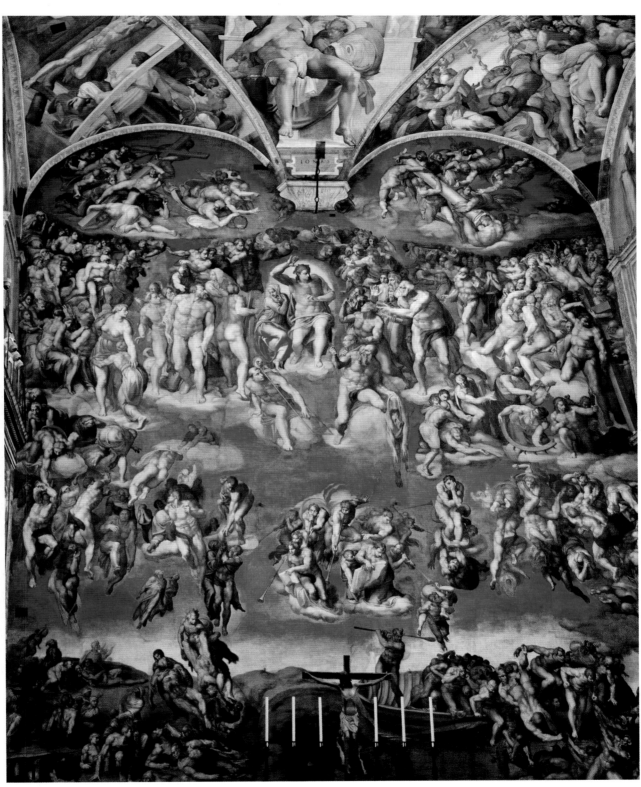

" Painters of **each generation** in turn have been **exalted and lifted** beyond themselves by the study of Michelangelo. "

EUGENE DELACROIX, *JOURNAL*, 1850

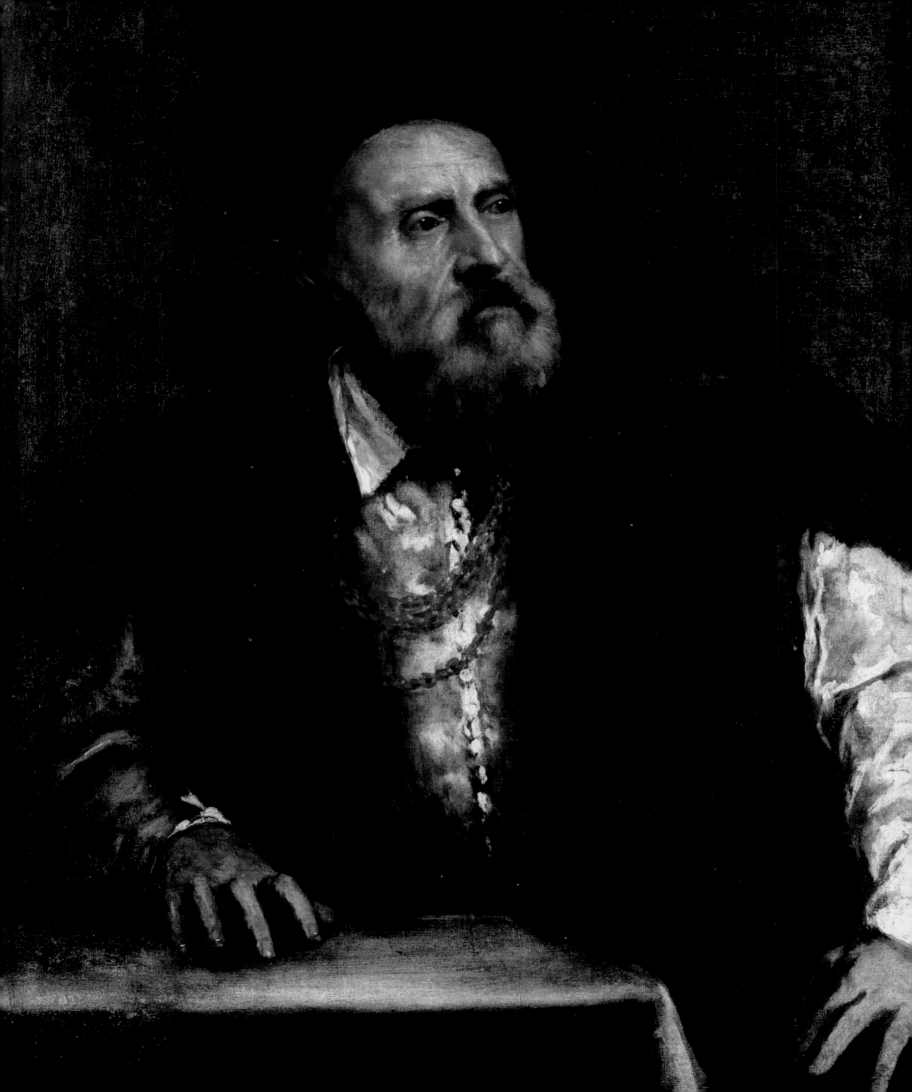

Titian

c.1485–1576, ITALIAN

Prolific, versatile, and enormously influential, Titian dominated Venetian art during its most glorious period and revolutionized the technique of oil painting with his expressive brushwork.

Titian's contemporaries acknowledged him as a supremely great painter, and his reputation as one of the giants of world art has endured unbroken to the present day. His international fame in his lifetime was based particularly on his portraits, but he was no less dazzling as a painter of mythological and religious subjects, in which he ranged with equal conviction from voluptuous eroticism to the depths of tragedy. His influence has been profound and widespread, and his admirers have included such diverse artists as Rubens, Poussin, van Dyck, Velázquez, and Rembrandt.

Early life

Tiziano Vecellio, known in the English-speaking world as Titian, was born in Pieve di Cadore, about 110km (70 miles) north of Venice. His early years are obscure and there has been much scholarly discussion about his date of birth, which was probably around 1485 but may have been as late as 1490. His family seems to have been prosperous and respected locally, his father holding various civic

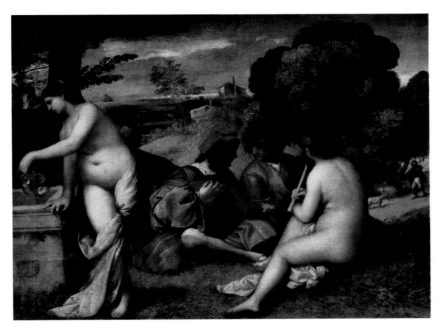

⊲ **THE PASTORAL CONCERT, c.1509**
One of several paintings disputed between Titian and Giorgione (scholars now favour Titian), this work is perhaps an allegory of poetry.

⊲ **SELF-PORTRAIT, c.1560–62**
In this dignified self-portrait, Titian wears the golden chain that signifies the knighthood conferred on him by Charles V.

posts. Nothing is known about the boy's education, but it likely to have been fairly basic because he could not read Latin, which was the foundation of all serious learning at the time. In later life, however, he became friendly with some of the leading writers of the day (notably the poet and prominent satirist Pietro Aretino), so it is likely that he was intelligent and at ease in a cultured environment.

There was no artistic tradition in the Vecellio family, but Titian and his brother Francesco were sent to Venice to study painting when they were very

young. Titian is thought to have studied initially with a minor artist called Sebastiano Zuccato, then with Gentile Bellini (see pp.30–33), and finally with Gentile's brother Giovanni. There is no firm evidence for this, but there is little reason to doubt the traditional view that Titian was a pupil of Giovanni Bellini – who was not only the greatest Venetian painter of the day but also a renowned teacher. It was probably at this time that Titian met and befriended another follower of Bellini, Giorgio da Castelfranco (later referred to as Giorgione).

ON TECHNIQUE
Drawings

Drawings by Titian are fairly scarce, but those that are known to be from his own hand reveal him to have been a superb draughtsman. He used various media, all with great vigour: charcoal (as in the study for San Bernardino below), chalk, and pen and ink. A few of his drawings are preparatory studies for paintings, although he usually worked directly onto the canvas, without such preliminaries. Among the drawings attributed to him are some landscapes, which are more highly finished than the figure drawings and were intended as independent works of art.

DRAPERY STUDY FOR SAN BERNARDINO, c.1525

> " There is a sort of **senatorial dignity** about him. "

SIR JOSHUA REYNOLDS, *DISCOURSE FOUR*, 1771

◁ *ASSUMPTION OF THE VIRGIN,* **1516–18**
Painted for the church of Santa Maria Gloriosa in Venice, Titian's huge work is alive with movement, giving it an explosive sense of drama.

Work with Giorgione

In 1508, Titian began work with the slightly older Giorgione on a prestigious commission – the the first known milestone of Titian's career. The collaboration involved painting frescos on the exterior of the Fondaco dei Tedeschi, the headquarters of the German merchants in Venice. Unfortunately, the paintings – which were of large classical figures – were badly suited to the damp Venetian atmosphere, and only ruined fragments remain.

Giorgione died of the plague in his early 30s, but his dreamy, enigmatic style had a strong influence on Titian, who is said to have completed several pictures that Giorgione left unfinished. Indeed, the styles of the two men were so similar for a time that the authorship of a few paintings is still disputed.

Rise to prominence

In 1511, Titian painted his first surviving dated works – three murals depicting incidents from the life of St Antony of Padua in the Scuola del Santo, Padua. These are large and impressive works – bold, dignified,

△ **EMPEROR CHARLES V**
Titian was principal painter to the court of Charles V. This coin, designed by Albrecht Dürer and minted in 1521, shows the emperor's head; on the reverse is the eagle of the Holy Roman Empire.

and full of life – but they are not typical of Titian in that they are in fresco, a medium he rarely used again.

Another event of great significance to Titian's career occurred in 1511. The only other young painter in Venice who could be considered his serious rival – Sebastiano del Piombo – left the city and settled permanently in Rome. With Giorgione dead and Sebastiano gone, only Giovanni Bellini (who worked well into his old age) blocked Titian's path to supremacy, and when Bellini died in 1516, Titian's pre-eminence in Venice was secured. It remained virtually uncontested until his own death 60 years later.

Titian made a ringing declaration of his artistic authority with an immense altarpiece (the largest painted in Venice up to this time), *The Assumption of the Virgin*. The painting's dynamic composition and gloriously eloquent colouring show that Titian had by now completely broken away from Giorgione's intimate pastoral idiom.

He followed this with other great altarpieces in the 1520s, and also executed major secular commissions, including a series of mythological paintings (among them the celebrated *Bacchus and Ariadne*) for Alfonso d'Este, duke of Ferrara. In addition, Titian painted a portrait of Alfonso, and aristocratic portraiture became a major strand of his work as his circle of eminent patrons widened.

Imperial portraits

Titian became the leading portraitist of his time, not only because of the quality of his work and the importance of his sitters, but also because of the role he played in enlarging the range of portraiture beyond the head-and-shoulders type that dominated until the early 16th century (see box, right).

The most eminent of Titian's sitters was Charles V, the Holy Roman Emperor. They first met in 1530, when Charles was visiting Italy, and in 1533, he ennobled Titian as count palatine and knight of the Golden Spur – an unparalleled honour for an artist. According to a story told in *The Marvels of Art* (1648) by Carlo Ridolfi, Titian once dropped a brush when he was painting Charles, who picked it up for him. This may seen like a trivial incident, but at a time when rulers were considered almost divine, the anecdote was meant to show the huge respect Titian enjoyed.

ON TECHNIQUE
Developing the portrait

Titian was not the first artist to paint half-length, three-quarter-length, or full-length portraits, but he did more than anyone else to popularize them. He often used accessories, such as a classical column, a musical instrument, or a dog (he painted animals superbly), and he posed his subjects in natural-looking ways – showing a hand casually resting on a chair or sword hilt, for example, or holding a book or a glove. Such devices, which helped to animate his portraits and sometimes to suggest the interests of the sitter, had an enormous influence on his contemporaries and successors.

PORTRAIT OF A LADY, TITIAN, c.1510–12

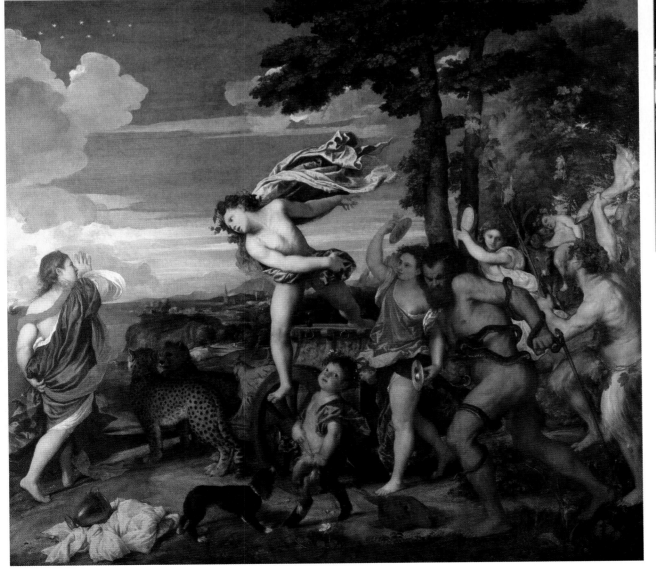

◁ *BACCHUS AND ARIADNE*, 1521–23
Ariadne is confronted by a lovestruck Bacchus leaping from his chariot, in a composition in which all the figures appear to be in motion.

IN PROFILE
Philip II

Philip (1527–98) became king of Spain in 1556, when his father, Charles I (Emperor Charles V), abdicated. Philip ruled until his death. He was a passionate art lover, admiring Titian above all painters of his own time and Hieronymus Bosch among earlier artists. In other ways, however, he lived austerely – devoted to religion and working obsessively at state paperwork. Spain's vast empire reached its greatest extent during his reign, but by the time of his death, the country was in steep decline.

PHILIP II, TITIAN, c.1559

▷ *THE DEATH OF ACTAEON*, c.1565
The looseness of Titian's brushwork helps to create a dreamlike atmosphere in this image. It depicts Actaeon, who, having seen Diana naked, is turned into a stag as punishment, then is hunted by his dogs and by the goddess herself.

Poetry in paint

Charles was also king of Spain and he invited Titian there to paint portraits of the royal family. Titian declined, reluctant to make anything other than short journeys from Venice. Eventually, though, he began to travel more widely, visiting Rome at the invitation of Pope Paul III, Augsburg in Germany to work at Charles's court, and Milan to paint a portrait of Charles's son Philip (see box, left), who, in 1556, succeeded his father as king of Spain. Philip also succeeded his father as Titian's most important patron. Philip was a devout Catholic, and Titian painted numerous religious pictures for him, as well as court portraits.

Philip also greatly enjoyed secular subjects, and Titian's finest work for him – ranking among the artist's supreme achievements – was a series of seven large mythological paintings inspired by the poetry of the ancient Roman writer Ovid.

Titian referred to these mythological paintings as *poesie* (poems) and they are indeed intensely poetic in spirit, conjuring up entrancing visions of goddesses and nymphs.

The seven paintings occupied much of Titian's time from about 1550 to 1562; the last work in the series, *The Death of Actaeon*, was probably not sent to Spain and was perhaps not finished to the artist's complete satisfaction at the time of his death.

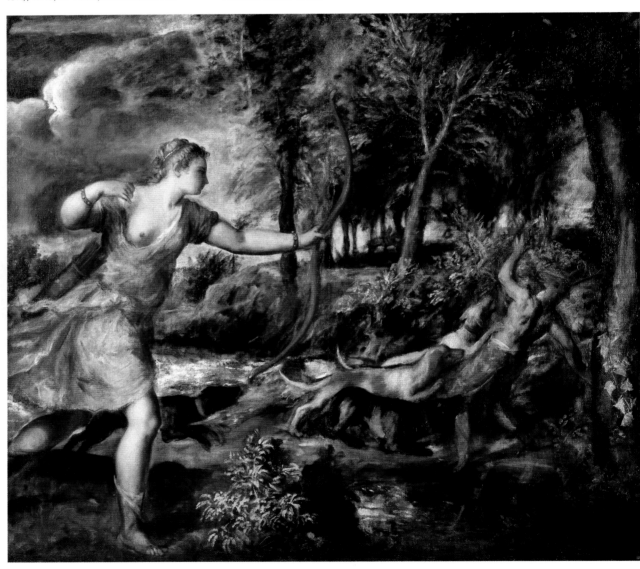

> "Of **Titian's art** it may be said that it reaches the highest perfection of **sensuous beauty**."

SIR HERBERT COOK, IN *BRYAN'S DICTIONARY OF PAINTERS AND ENGRAVERS*, VOLUME 5, 1905

Revolutionary brushwork

The mythological paintings show the unprecedented freedom of brushwork typical of Titian's late work. He was the first artist to demonstrate the expressive versatility of oil paint, creating a lively pictorial surface in which every touch of the brush reveals the artist's individuality – his "handwriting".

This was one of the most influential developments in the history of painting. Previously, most painters had been content with an anonymous surface polish to their works, but Titian liberated brushwork so that paint could be rough or smooth, detailed or sketchy, as it suited the artist.

Working on canvas

In his early career, Titian often painted on wooden panels, but he came to prefer canvas in which the grain of the weave was suited to his vigorous handling. In his later years, he used fairly coarse types of canvas, in which prominent weave shows through the brushwork and is part of the surface texture. According to one account, in the final stages of a painting, Titian "worked more with his fingers than his brush".

Failing eyesight and weakness of hand may have contributed to the roughness of handling seen in his very late works, but in 1575 the Marquis of Ayamonte (governor of Milan) commented that "a blotch by Titian will be better than anything by another artist".

Titian continued working until the end of his long life. He died on 27 August 1576, possibly of the plague, which was raging in Venice, but perhaps simply of old age. He was buried in the church of Santa

Maria Gloriosa dei Frari, which houses two of his most magnificent works: *The Assumption of the Virgin* and the Pesaro Altarpiece (1519–26). He left unfinished an awe-inspiring painting of the *Pietà* that he wanted to have

placed above his tomb, but this did not happen. The kneeling figure on the right (probably St Jerome) is said to be a self-portrait of Titian, who gazes into the face of the dead Christ as his own death approaches.

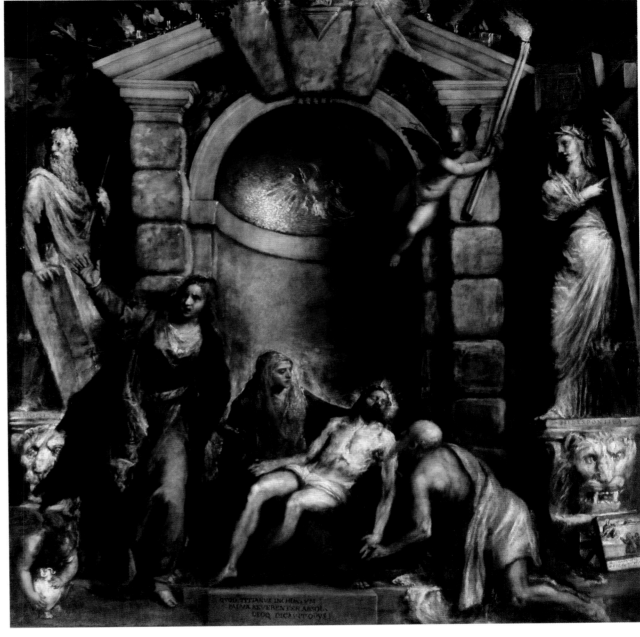

△ *PIETA*, c.1570–76
Titian's sublime painting shows Christ with Mary, Mary Magdalene, and, probably, St Jerome (kneeling). These figures are framed by Moses (left), and the prophet Sybil (right) from classical antiquity.

KEY MOMENTS

1508
With his friend Giorgione, Titian paints frescos at the Fondaco dei Tedeschi, Venice.

1511
Paints his first surviving documented works in the Scuola del Santo, Padua.

1518
Completes *The Assumption of the Virgin*, the first of his great altarpieces for churches in Venice.

1522–23
Paints *Bacchus and Ariadne*, one of a series of mythological paintings for Alfonso I.

1537–38
Paints *The Battle of Cadore* (destroyed by fire in 1577) for the Doge's Palace, Venice.

1548
Paints *Charles V on Horseback*, the largest of his portraits.

c.1556–9
Paints *Diana and Actaeon*, one of a series of mythological scenes for Philip II of Spain.

1576
At his death, the *Pietà* (intended for his own tomb) is left unfinished.

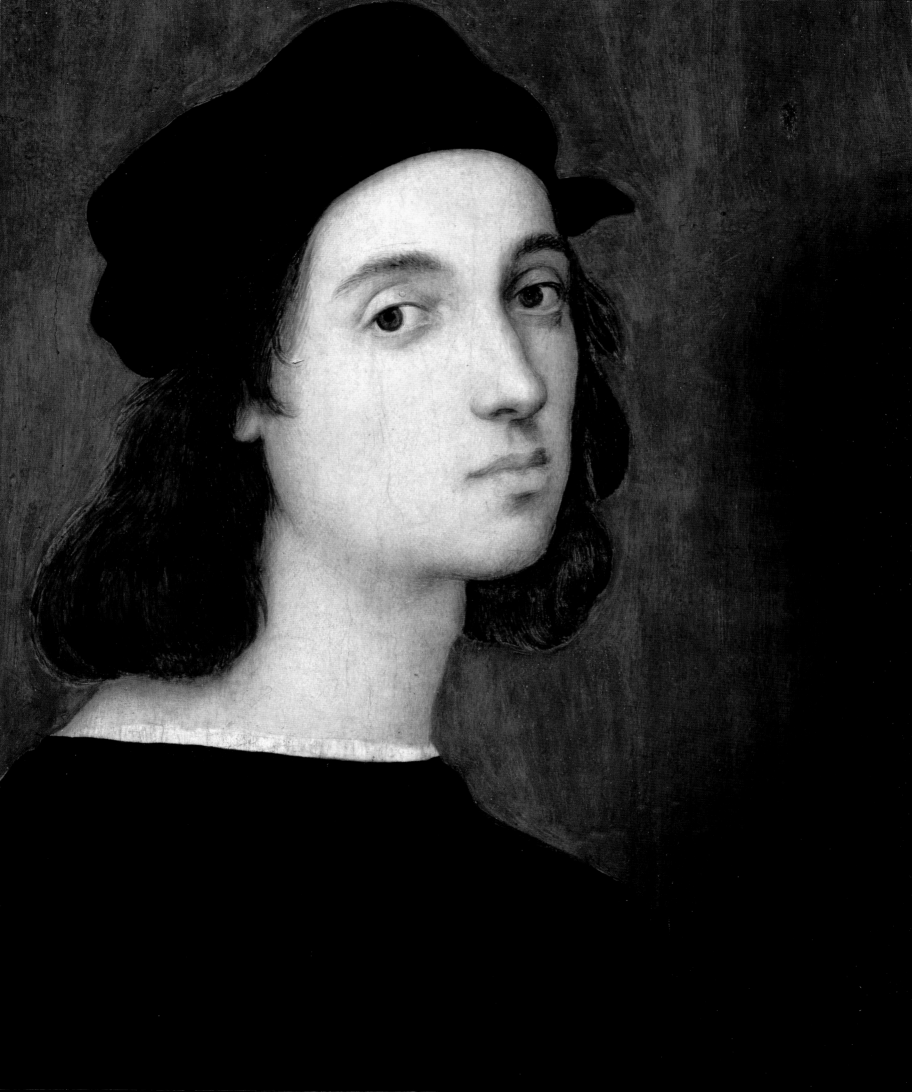

Raphael

1483–1520, ITALIAN

One of the giants of the Renaissance, Raphael achieved an immense amount in his short life, and for centuries afterwards was revered as an inspiration by other artists.

Raphael is traditionally bracketed, along with his older contemporaries Leonardo da Vinci and Michelangelo, as one of the supreme figures of the High Renaissance – the brief period in the early 16th century when Italian art reached a peak of grandeur and harmony. Whereas Leonardo and Michelangelo are considered the innovators of the time, Raphael is generally regarded as its synthesizer – someone who built on the ideas of others, which he blended and refined into a superbly graceful unity.

He did not have Leonardo's great intellectual intensity or Michelangelo's awesome power, but the balance and humane dignity of his work – its very lack of extremes – made him a more approachable model for succeeding generations of artists.

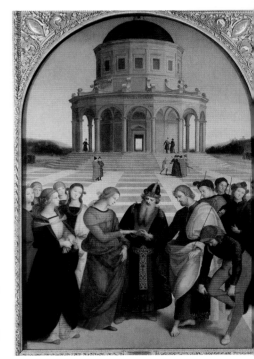

▷ **RAPHAEL IN URBINO**
In the 15th century, Urbino became a centre for art and humanist philosophy. Raphael's early links with the town are celebrated in a monument to the artist by 19th-century sculptor Luigi Belli.

Cultivated upbringing

Raffaello Sanzio, known in the English-speaking world as Raphael, was born in spring 1483 in the hilltop town of Urbino in the Umbria region of Italy. For most of its history Urbino has been of only local significance, but at the time of Raphael's birth it was enjoying a brief golden age as one of the foremost centres of Renaissance culture. Raphael's father, Giovanni Santi, was a painter who worked at the court of the dukes of Urbino. He was an undistinguished artist, but he was intelligent and cultivated, and through him Raphael no doubt gained an early familiarity with court life that provided a good background for his career among sophisticated patrons. Giovanni presumably gave his son his first instruction in art, but he died in 1494, when the boy was only 11. After this, the dominant influence on Raphael's early paintings was the sweet, elegant, polished style of Pietro Perugino, who at this time was one of the leading painters in Italy.

Raphael probably had some kind of association with Perugino, who was based some 80km (50 miles) from Urbino in the city of Perugia, but it is not clear if he was ever formally his pupil.

A master in the making

Raphael was a precocious youth. At the age of 17, he was referred to as *magister* (master), and four years later, in 1504, when he painted an altarpiece, *The Marriage of the Virgin*, for a church in Città di Castello, he had surpassed everything Perugino could teach him. The altarpiece is based on a painting by Perugino, but outshines its model in lucidity, grace, and fluency. Raphael achieves great balance and harmony in this work – in particular, between the temple in the background (a supreme symbol of perfection and symmetry) and the elegant figures in the foreground. His exceptional skill in the arrangement of groups of people was to become a notable feature of his later work.

At the age of 21, Raphael moved to Florence, which offered unrivalled stimulation for a young and ambitious painter, particularly in the work of Leonardo and Michelangelo, the two most charismatic artists of the age. Under their influence, Raphael's work became grander in form and

△ **THE MARRIAGE OF THE VIRGIN**, 1504
Raphael composed this work according to mathematical relations of proportion. His aim was to "make things not as Nature makes them, but as Nature should".

◁ **SELF-PORTRAIT, 1504–06**
This panel shows Raphael as a young man of modest appearance. A similar self-depiction appears in *The School of Athens* (see over), where Raphael takes on the guise of the Greek painter Apelles.

" Pope Leo and all Rome look upon him as a **god sent** down **from heaven** to restore the Eternal City to its **former majesty**. "

CELIO CALCAGNINI, c.1519

▷ *THE SCHOOL OF ATHENS*, 1510–11
Through the careful use of linear perspective, Raphael created a realistic three-dimensional space in which to accommodate the figures of philosophers and mathematicians, including Aristotle and Socrates, mingling with contemporary artists in the guise of classical thinkers.

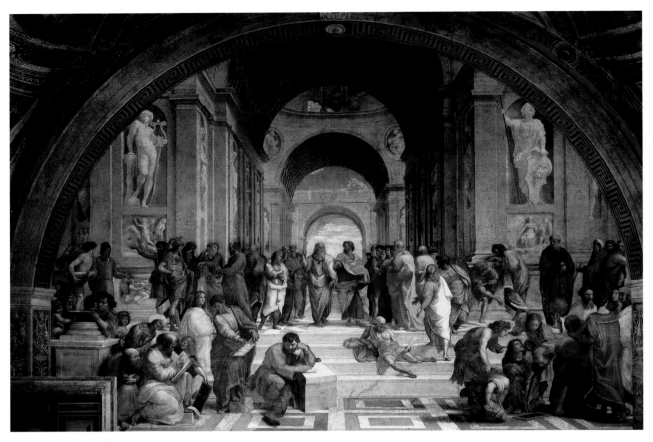

IN CONTEXT
Courtly life

Raphael was well versed in the manners and skills needed to thrive in society. His courtly grace helped win him wealthy and influential patrons and friends, including Baldassare Castiglione (1478–1529), ambassador from the duke of Urbino to the court of Leo X. Castiglione is best known for his book *The Courtier* (1528), which describes the qualities of the perfect gentleman. One of the most popular books of the 16th century, it was translated into several languages and became the standard guide to courtly life – and the art of succeeding in society – across Europe for many years to come.

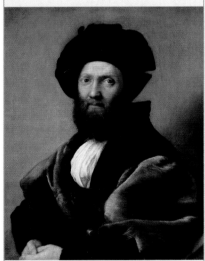

CASTIGLIONE, RAPHAEL, c.1514–15

richer in feeling. He was based in Florence until 1508, while travelling and working in parts of central Italy.

Grand commissions

The great turning point in Raphael's career came in 1508, when he settled in Rome and began working for Pope Julius II, the outstanding art patron of the period. Julius was having rooms in his Vatican apartments remodelled and Raphael was commissioned to paint frescos in the Stanza della Segnatura (Room of the Signature), which was probably used to house Julius's personal library. Raphael had never previously been entrusted with such a large and prestigious undertaking and had rarely worked in fresco, but he rose to the challenge with magnificent self-assurance,

creating in this room one of the most celebrated masterpieces of Renaissance art – *The School of Athens*, which shows a gathering of ancient philosophers, their noble figures harmoniously arranged in a majestic architectural setting. A celebration of human knowledge, the fresco depicts the great pagan thinkers in lively debate or solitary contemplation, their outward grace and elegance a reflection of their inner wisdom. Raphael has left the middle foreground of the painting clear to herald the approach of two major figures: Plato (left) and Aristotle (right).

After *The School of Athens*, Raphael worked principally for Julius and then for his successor, Leo X, becoming the leading artist in Rome. He was central to many papal projects in the visual

arts beyond just painting: in 1514, for example, he was put in charge of rebuilding St Peter's; and in 1517 he became Rome's superintendent of antiquities, surveying the city's ancient monuments. His huge workload meant that he had to rely on a team of assistants, which he managed with great efficiency. This reflected not only his artistic skills but also his generous personality: he was admired for his charm as well as his talent, and aroused little professional jealousy.

Designer and architect

Beside the popes, Raphael's most important patron was the enormously wealthy Agostino Chigi, Europe's leading banker. Raphael's work for Chigi included mythological frescos at his villa, just outside Rome's city walls,

“ Raphael always **succeeded** in doing what **others longed** to do. ”

JOHANN WOLFGANG VON GOETHE, *ITALIAN JOURNEY: 1786–88*, 1816–17

and the design of his burial chapel in the church of Santa Maria del Popolo. The chapel (begun in 1512) is one of Raphael's most inventive conceptions, combining architecture, painting, sculpture, stuccowork, and mosaics to create a lavish decorative ensemble in a way that anticipates the Baroque idiom of the 17th century.

The chapel was left unfinished when Raphael and Chigi died within a week of each other in April 1520. According to his near-contemporary biographer Giorgio Vasari, Raphael's death was caused by a fever brought on by sexual overexertion. The artist was deeply mourned by the papal court and was buried (in accordance with his wishes) in the Pantheon, the only major building that had survived almost intact from Roman times – a fitting resting place for an artist whose work had rivalled the glories of ancient art.

Reputation and influence

Raphael achieved remarkable wealth, fame, and status in his short life, and his work was already influential at the time of his death. His influence spread far and wide, mainly because he collaborated with an outstanding engraver, Marcantonio Raimondi, who made prints of his paintings and other designs. Such reproductions were a novel idea, but many other artists took up the practice. Raphael's influence continued to grow after his death, and for the next three centuries he was generally regarded as the greatest painter of all time. Later generations of artists reacted against this idolatry, and in 1851 Delacroix dared to make the "blasphemous" suggestion that Rembrandt would one day be rated higher than Raphael.

During the 20th century, dutiful respect for Raphael had replaced ecstatic admiration, in part because he suffers from comparison with Leonardo and Michelangelo, whose lives and personalities are more in tune with what the modern world expects of artistic heroes. Nevertheless, Raphael remains one of the most admired figures in Western art. "Leonardo da Vinci promises us heaven," commented Pablo Picasso, but "Raphael gives it us."

KEY MOMENTS

1500–01
Makes his first substantial documented work, the Altarpiece of St Nicholas of Tolentino; only parts survive.

1504
Paints *The Marriage of the Virgin*, one of his first masterpieces, in which he surpasses his model Perugino.

c.1510–11
Paints *The School of Athens*, which marks one of the summits of his career.

1512
Begins a commission to design the burial chapel for Agostino Chigi in Rome.

1520
The Transfiguration, Raphael's final great altarpiece, remains unfinished at the time of his death.

△ **THE CHIGI CHAPEL, 1512–20**
Rapahel's design for the burial chapel of Agostino Chigi was inspired in part by the Pantheon in Rome. Its cuboid form is topped by a windowed cylinder that supports a dome, decorated with a mosaic created from Raphael's cartoons.

ON TECHNIQUE
Tapestry cartoons

The term "cartoon", from the Italian *cartone*, meaning a large piece of paper, describes a full-size drawing made for a work in a different medium. In 1515–16, Raphael designed a set of 10 huge tapestries to hang in the Sistine Chapel; the subjects were scenes from the lives of St Peter and St Paul. His cartoons were sent to Brussels, where they were to be used as templates for the weaving of tapestries. The fragile cartoons were painted in a kind of watercolour on numerous sheets of paper. Remarkably, seven of the cartoons have survived – badly worn but still impressive.

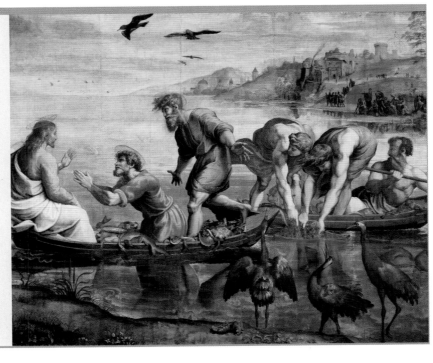

THE MIRACULOUS DRAUGHT OF FISHES
CARTOON, 1515–16

Hans Holbein

c.1497–1543, GERMAN

Holbein excelled in many fields, from painting murals and miniatures to designing prints and decorative pieces, but he is remembered mainly for his portraits, particularly of Henry VIII and his court.

Hans Holbein the Younger is most famous for the indelible record he created of the court of the English king Henry VIII. He captured its atmosphere of danger as well as its glamour in his vivid and exquisitely detailed portraits. These images, however, represent only one aspect of his varied career, and even if he had never set foot in England, he would still rank among the leading artists of the German Renaissance.

Diverse output

Holbein painted some notable religious pictures, decorated public and domestic buildings, was an outstanding book illustrator, and drew designs for a wide range of objects, ranging from buttons to architectural features. It is harder to appreciate his achievements outside portraiture because little of his output in other fields has survived intact. For example, only a few fragments of his murals remain, and some of his work, such as designs for pageantry, was inherently impermanent.

Birth and early life

Holbein was born in Augsburg, southern Germany, probably in 1497. Art was in his blood. His father (Hans Holbein the Elder), uncle (Sigmund), and elder brother (Ambrosius) were

△ **THE ARTIST'S FAMILY, c.1528**
Holbein's scrupulous attention to texture and surface qualities gave some of his portraits an atmosphere of detachment, but this depiction of his wife and children is deeply human and personal.

all painters, and it is most likely that Hans the Younger and his brother were taught by their father. By 1515, the brothers had moved to Basel in Switzerland, following the traditional pattern in Germany whereby ambitious young artists set out to see the world as soon as they had finished their apprenticeships.

Ambrosius is thought to have died young, but Hans quickly found success. In 1516 – when still in his teens – he painted portraits of Jacob Meyer (the mayor of Basel) and his wife. These works already show some of the sharpness of observation and precision of handling that characterize his mature work. From 1517 to 1519, Holbein helped his father to paint murals at the chief magistrate's house in Lucerne. He is thought to have visited Italy, and there studied the frescos of Italian masters, such as Andrea Mantegna.

From Basel to England

Holbein settled in Basel. He became a citizen of the city in 1520, joined the painters' guild, and married Elsbeth Schmid, with whom he had four children, the first born in 1521. He visited France in 1524 but otherwise lived and worked in Basel for the next few years and established himself as the city's leading artist. His work included portraits and murals, as well as altarpieces, designs for stained glass, and book illustrations – the city was a centre of publishing at the time.

The Protestant Reformation (a split from the Catholic Church) was beginning to cause conflict in Basel, and demand for religious painting declined. In 1526, these events

△ **DESIGN FOR A CUP, c.1536**
Holbein produced designs for many decorative pieces, including this intricate gold cup to be given by Henry VIII to Jane Seymour. The piece was made and later sold in Holland by Charles I.

> " I should **scarcely** be able to **see you better** if I were **with you.** "

ERASMUS, LETTER TO SIR THOMAS MORE (ON SEEING HOLBEIN'S DRAWING OF THE MORE FAMILY), 1529

▷ **SELF-PORTRAIT, c.1542**
This detailed image in pen and coloured chalk – rather than paint – is a self-portrait. Its golden background was added later by another artist.

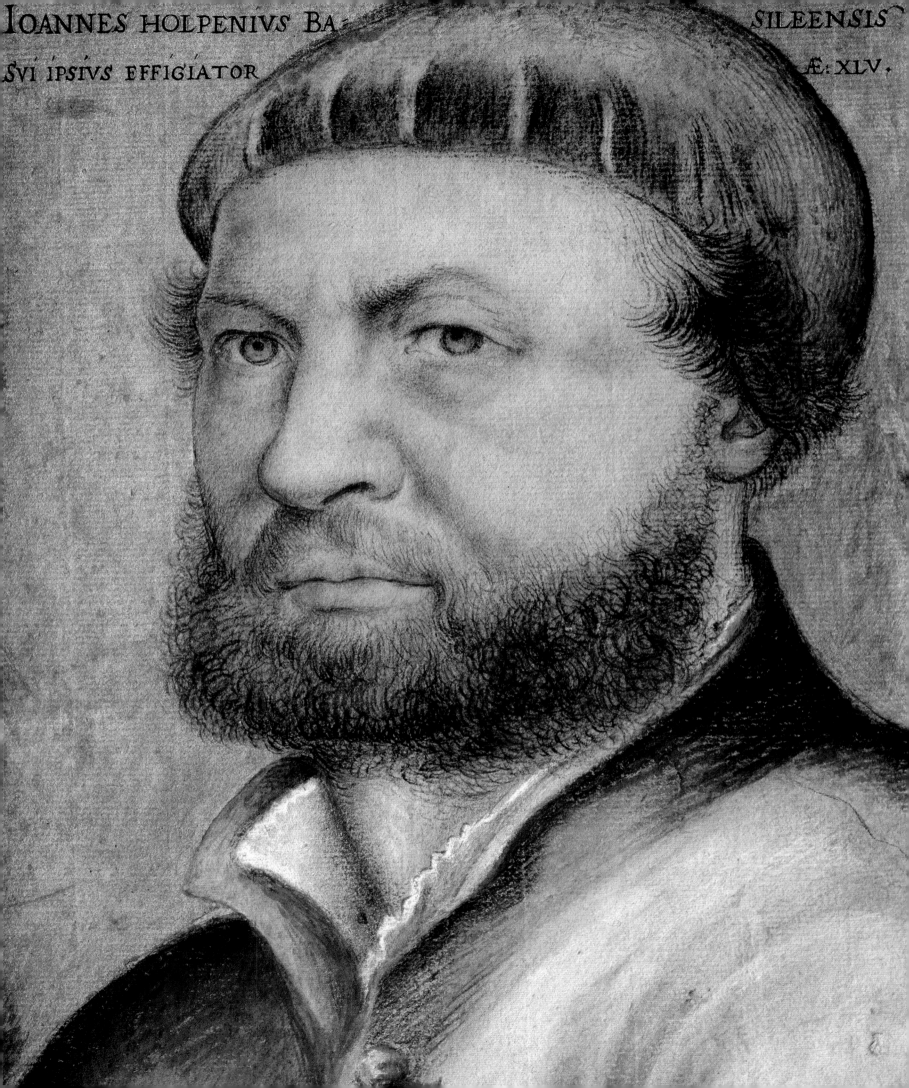

IOANNES HOLPENIVS BA- SILEENSIS

SVI IPSIVS EFFIGIATOR Æ: XLV.

△ **THE MEYER MADONNA, c.1526–28**
One of Holbein's last religious works, this painting shows the patron, Jakob Meyer (left), and family members (living and dead) with the Virgin and Child. The work unites the spiritual – the crowned Madonna framed by a scallop shell, a symbol of divine femininity – with the intensely human: the expensive carpet rucked by the feet of the children.

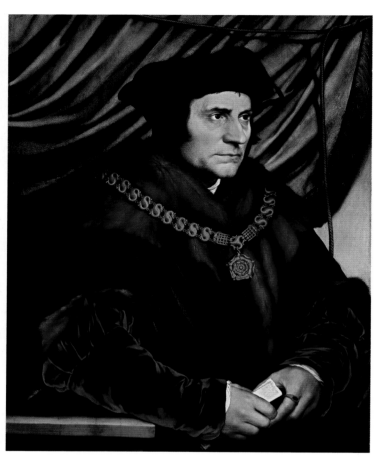

◁ **SIR THOMAS MORE, 1527**
Holbein painted this portrait of his first notable patron in England. More (1478–1535) was a lawyer, scholar, and statesman. After refusing to take an oath rejecting the authority of the pope, he was convicted of treason (on perjured evidence) and executed.

In 1528, Holbein returned to Basel, most probably because his long stay abroad put him in danger of losing his citizen's rights. He soon bought a new house there (a reflection of how much he had prospered in England) and renewed his busy career, notably with a prestigious commission to paint murals in the town hall.

A return to England

In 1532, religious strife in Basel once again prompted Holbein to depart for England, leaving his family behind, as he had done on his first visit. This time his move was permanent. Although he probably made a few visits to Basel, London became his home, and he evidently had a second family there, as his will mentions his two infants.

Holbein quickly found clients among the German merchant community in London, and his English patrons included Thomas Cromwell, Henry VIII's chief minister, whose portrait he painted in about 1533. It was perhaps Cromwell who introduced Holbein to court circles and to Henry himself. By 1538 he was receiving a court salary.

prompted Holbein to depart for England – an attractive destination since it was both prosperous and short of good painters. He was provided with letters of introduction by the Dutch scholar Erasmus, whose portrait he had painted. Erasmus had taught in England, where he had influential friends, including the statesman (and later lord chancellor of England) Sir Thomas More, who provided Holbein with his first lodgings in the country.

Innovation in portraiture

Holbein was soon in demand. He painted portraits of distinguished figures, including the archbishop of Canterbury, and depicted Thomas More both singly and with his family – the first informal group portrait in European art. "Your painter is a wonderful artist," More wrote to Erasmus; and to English eyes, accustomed to the flat and stiff portraits of native painters, Holbein's pictures must indeed have appeared astonishingly lifelike, with their powerful characterization, convincing sense of three dimensions, and wealth of precise detail, which was particularly evident in the faces and clothing of the sitters.

Holbein's technical mastery is visible in *Lady with a Squirrel and a Starling* (c.1527), where he paints wet-in-wet to suggest the squirrel's toffee-like fur; and his portraits are renowned for their objectivity – outward appearance reflecting the mood of his sitters.

> " **Holbein's manner** have I ever imitated, and hold it for **the best**. "
>
> NICHOLAS HILLIARD

▷ **"THE ARMS OF DEATH", 1538**
This woodcut is from Holbein's book *The Dance of Death*, which includes 41 of his woodcuts that were made between 1523 and 1526 but were not published in book form until 1538. The illustrations satirize religious and secular figures and the folly of human pride and greed.

He painted several portraits of the king, the finest of which was in a mural at Whitehall Palace – one of the monarch's residences – depicting the king with his parents and third wife, Jane Seymour. The painting was destroyed by fire in 1698, but part of Holbein's cartoon remains, showing Henry in a formidably assertive pose.

After Jane Seymour's death in 1537, Holbein was sent abroad to paint prospective brides for Henry, resulting in portraits of Christina of Denmark and Anne of Cleves. Anne became Henry's fourth wife in 1540, but the marriage was annulled the same year. Popular legend holds that Holbein's portrait was so flattering that it misled Henry; however, it is likely that the king was more disappointed by Anne's personality than by her looks.

By this time, Holbein concentrated more on creating clear contours in his portraits than on accurately depicting three-dimensional space, with the result that his later portraits are flatter and more decorative than before.

Many of Holbein's portrait drawings survive to this day. Some were made as independent pieces, but others were intended as preparatory works for paintings to be completed in the sitter's absence. This is indicated by annotations in Holbein's own hand, one of which reads *wis felbet* (white velvet) – providing the artist with a written reminder about the fabric of the sitter's clothing.

Death and legacy

Holbein died in October or November 1543, probably of plague, which was rife in London that year. Many copies were made of his portraits in his own time or soon afterwards, but his style was too sophisticated and his work simply too accomplished to inspire imitation in England. However, he was the first notable exponent in England of the miniature portrait and in this more restricted field he was influential, beginning the country's distinguished tradition in the art and in particular inspiring its greatest exponent, Nicholas Hilliard.

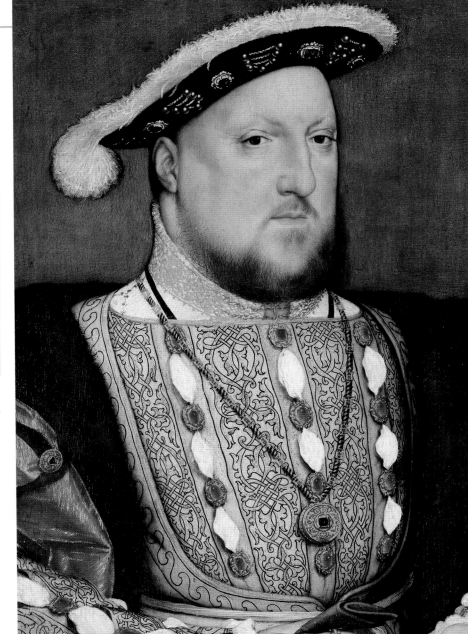

△ **KING HENRY VIII**, 1537
This is the only surviving painting of Henry VIII that is undoubtedly from Holbein's own hand. The portly monarch is in regal pose, yet the artist reveals a hint of menace in his small, cruel mouth.

KEY MOMENTS

1516
Paints portraits of Jacob Meyer and his wife. These are Holbein's first certain dated works.

1521–22
Paints *Christ in the Tomb*, perhaps his most famous religious painting and a work of haunting power.

c.1526–28
Paints the *Meyer Madonna*, the most handsome of his altarpieces, for Jacob Meyer, the onetime mayor of Basel.

1533
Paints *The Ambassadors*, which shows two full-length figures in a complex interior setting. It is Holbein's largest surviving portrait.

1536–37
Paints a mural of Henry VIII, with his wife and parents, in Whitehall Palace: it is an image of overwhelming authority.

Pieter Bruegel the Elder

c.1525–1569, NETHERLANDISH

Bruegel was one of the finest Northern Europe artists of the 16th century. He excelled as a painter, draughtsman, and designer of prints, and is feted for his contribution to early landscape painting.

In spite of his renown today, very little is known for certain about Pieter Bruegel's life. It is certain that he enrolled in the Antwerp painters' guild in late 1551 or early 1552, that he married and moved to Brussels in 1563, and that he died there in 1569. There are no surviving journals or letters, and no first-hand accounts about his upbringing or his beliefs.

Comic reputation

The nearest contemporary source of information about Bruegel is a brief biography in Karel van Mander's *Book of Painters* (1604). Although van Mander included some intriguing anecdotes about the artist, he also dubbed Bruegel "Pieter the Droll", giving the unfortunate impression that he was little more than a painter of comic peasant scenes. This was understandable, because van Mander would not have seen Bruegel's major paintings, which were held in private collections, and probably only knew his work through prints. In fact, it is clear that Bruegel was an educated man and that many of his pictures are full of serious moral content.

Van Mander asserted that Bruegel took his name from his birthplace, a village near Breda, but no such place has yet been identified; he also stated that – before he joined the guild –

△ **SCHILDER-BOECK**
Karel van Mander's *Book of Painters* is one of the most important sources of information about art in the Low Counties in the 16th century.

Bruegel was apprenticed to Pieter Coecke van Aelst (1502–50). If true, the latter's Italianate style left no mark on his work. Nevertheless, Bruegel did eventually marry Coecke's daughter, Mayken, so the connection is possible.

After having completed his training, Bruegel embarked on a lengthy tour of Italy – a standard practice for any ambitious young artist. He visited Reggio Calabria and probably also Naples and Messina, before arriving in

Rome in 1553. There, he made contact with a distinguished miniaturist, Giulio Clovio, who acquired four of his paintings.

The visit to Italy seems to have made little impression on Bruegel, but his journey across the Alps certainly did. Indeed, it is possible that the mountain scenery was the main attraction for Bruegel, since he chose a circuitous route via Lyon and east to the Innsbruck area. While in the mountains, he made many detailed drawings – unusual for the time, because there was virtually no market for pure landscape, which tended to feature as a backdrop for historical or religious subjects.

Beginnings in print

By 1555, Bruegel was back in Antwerp, working for Jerome Cock, a printmaker. Bruegel must have already accrued a reputation in his field, as he was immediately employed to produce designs for a series, *Twelve Large Landscapes* (c.1555–58). Significantly, Bruegel added figures and buildings to his views, to make them more saleable.

Cock was a shrewd entrepreneur and he soon diverted Bruegel into other, more commercial fields. He exploited the public's insatiable appetite for the grotesque fantasies

CHRIST AND THE WOMAN TAKEN IN ADULTERY, 1565

> " The most **perfect painter** of his century. "
>
> ABRAHAM ORTELIUS, *ALBUM AMICORUM*, 1573

▷ **THE PAINTER AND THE BUYER, 1565**
This work in brown ink is believed to be a self-portrait by Bruegel, showing the dishevelled artist and patronizing buyer in gentle caricature.

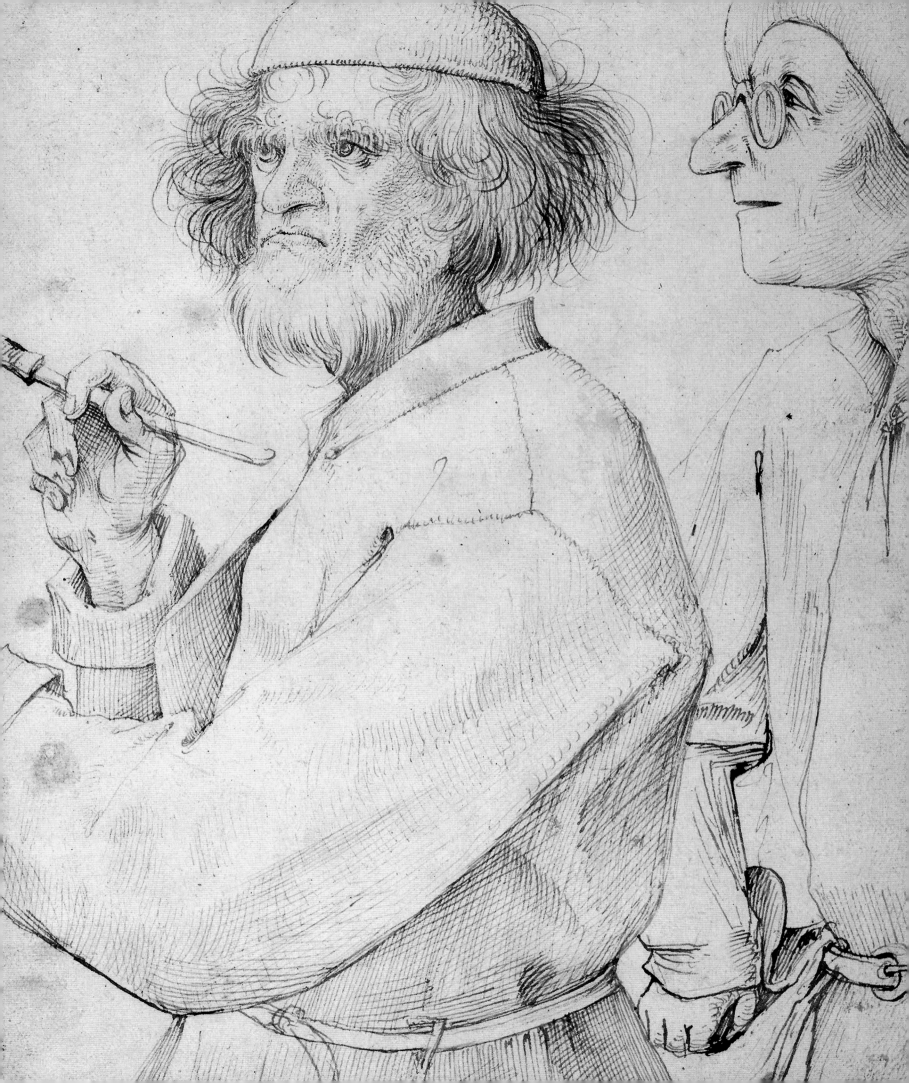

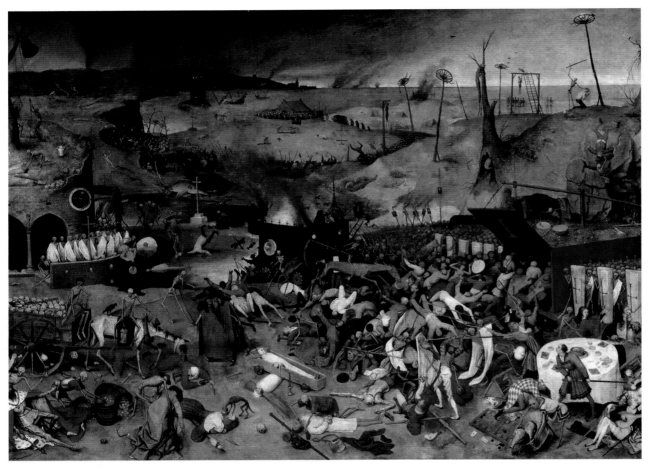

Accordingly, he began to paint more, and although these works would be seen by fewer people, they would take his career to the next level.

Many of the paintings that Bruegel completed while in Antwerp were like outsized versions of his prints. Some drew on the moralizing peasant scenes (*The Fight between Carnival and Lent*, *Netherlandish Proverbs*), while others recalled his Bosch-like designs (*The Triumph of Death*, *Mad Meg*).

A move to Brussels
Bruegel's career underwent a seismic change in 1563 when he married Coecke's daughter and moved to Brussels. Intriguingly, van Mander intimated that Bruegel's mother-in-law insisted on the move in order to separate the artist from another woman, but it is equally possible that Bruegel simply went in search of more lucrative commissions. Brussels, as the seat of government, could certainly provide these.

Almost immediately, Bruegel's style began to change. He dispensed with his overcrowded scenes, opting instead for compositions that were simpler and more naturalistic. His figures, too, were different. They were much larger, appearing solid and monumental, a change that reflected the taste of his more distinguished patrons.

Epics and peasants
In his last few years, Bruegel produced definitive versions of some of his favourite themes. His love of landscape painting, for example, found its fullest expression in the *Months*, a series of paintings commissioned by a wealthy Antwerp merchant, Nicolaes Jonghelinck. These derive ultimately from the miniature calendar scenes in books of hours (illustrated devotional texts), but enlarged to an epic scale.

△ **THE TRIUMPH OF DEATH, c.1562**
Bruegel's painting depicts a burning, barren landscape crowded with individual episodes of death and destruction. It is a visual lesson in the inevitability of death, regardless of human will or social status.

of Hieronymus Bosch (see pp.38–41). Bruegel proved equal to the task and was soon producing imaginative scenes swarming with monsters and demons. His images were so close to the spirit of the old master's works that Cock was tempted to pass them off as originals. Suspiciously, Bosch's name appears as the designer on one of Bruegel's most famous prints, *Big Fish Eat Little Fish*.

The Antwerp paintings
Bruegel did indeed produce the humorous peasant scenes to which van Mander had referred, but these prints were not created solely for their comedy value; they were meant as moral lessons, highlighting the

folly and sinfulness of humankind. Peasants, as the lowest class in the social order, were made the butt of these jokes – the people most likely to commit folly. The episodes themselves were based on popular sayings and proverbs, which were collected in books such as Sebastian Brant's *Ship of Fools* (1494) and the *Adages* of the Dutch scholar Erasmus, which had been published in Paris in 1500.

Bruegel's prints sold well, not just in the Netherlands but also in France, Italy, and Germany, which certainly helped to spread the artist's name and cement his reputation. Unfortunately for Bruegel, the profits made from the sale of prints had to be shared with the engraver and the publisher.

" It was said of him... that he **swallowed** all the **mountains and rocks** and spat them out again... **onto his canvases** and panels. "

KAREL VAN MANDER, *BOOK OF PAINTERS*, 1604

KEY MOMENTS

1556

Designs *Big Fish Eat Little Fish* in the style of Bosch. His pen drawing is engraved by Pieter van der Heyden.

1559

Produces *Netherlandish Proverbs*, a large painting that illustrates a collection of moral sayings and proverbs.

1564

Following his move to Brussels in the previous year, starts employing larger figures in his compositions.

1565

Is commissioned to paint a series of paintings of each month of the year. The works usher in a proud tradition of landscape painting.

1568

As the political situation in his homeland worsens, his *Parable of the Blind* carries a pessimistic message.

(see box, right)

The finest of the series, *Hunters in the Snow*, probably represents January. This can be deduced from the singeing of a pig to remove its bristles – a typical activity for this month.

Bruegel primed the oak panel with a chalky undercoat of white plaster and glue, before sketching in the outlines of the trees and the figures. He then gradually built up the picture with layer upon layer of thinly applied paint, each modifying the tone of the succeeding coat. The picture's brilliant evocation of the bright winter chill, for example, is partly due to the startling lemon-yellow that was used in one of the early layers.

Strife at home

Bruegel conferred the same epic grandeur on his peasant subjects. With *The Fall of Icarus* and *The Parable of the Blind*, he took two episodes that had appeared as tiny vignettes in his *Netherlandish Proverbs* and reinvented them entirely. The image of the blind men leading each other into a ditch may well be the most poignant of all his works and the subject undoubtedly reflects the violence that was tearing the Netherlands apart (see box, right). Historians have tried in vain to gauge Bruegel's opinions on the crisis, but he prudently kept his own counsel.

Bruegel had completed scores of paintings by the time of his death in 1569, but only 45 survive. His legacy was first taken up by his two painter sons – Pieter the Younger (1564–1638) and Jan (1568–1625) – but influenced almost all Flemish landscape painters who followed.

IN CONTEXT
Revolt of the Netherlands

Bruegel's greatest paintings were produced during a time of turmoil in his homeland. Calvinism was on the rise in the Netherlands, which was at that time ruled by Roman Catholic Spain. The famine of 1566 brought the Low Countries out in open revolt. The Spanish army arrived in Brussels in 1567, and suppressed the rebellion. The ringleaders were punished at a tribunal called the Council of Troubles.

THE COUNCIL OF TROUBLES, PRESIDED OVER BY THE DUKE OF ALBA

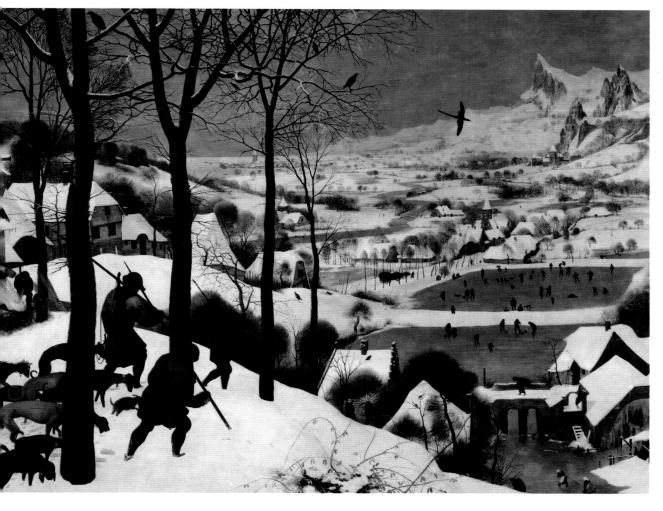

◁ **HUNTERS IN THE SNOW, 1565**
Bruegel grafted Alpine peaks onto the flat Netherlandish countryside in what was to become his most famous painting. The scene bustles with activity: villagers are pictured skating, curling, tobogganing, and, in the distance, rushing to put out a house fire.

El Greco

c.1541–1610, GREEK/SPANISH

The first great personality in the history of painting in Spain, El Greco created an intensely personal, ecstatic style that expressed the religious fervour of the country.

With their elongated, flame-like forms, flickering lighting, and eerily intense colouring, El Greco's paintings are among the most distinctive in the history of art. Indeed, his work is so personal that fanciful explanations have sometimes been proposed to account for it – that his eyesight was defective, for example, or even that he was insane.

While many of El Greco's artistic contemporaries may have considered his work somewhat unconventional, it was certainly not seen as outlandish (a fact borne out by the constant demand for his output). In fact, his passionate interpretations of religious scenes were in tune with the intensity of belief in Spain at the time and particularly in Toledo, where he made his home. Stylistically, El Greco's distorted figures were paralleled in the work of other painters of the period, and the elongated forms, twisted poses, and exaggerated gestures seen in his paintings were consistent with the Mannerist style that flourished in the 16th century. What separated El Greco's work from that of his contemporaries was its emotional force and intense humanity.

Venetian education

Domenikos Theotókopoulos, who came to be known by his nickname El Greco (the Greek), was born in or about 1541 at Candia (now Iraklion), the capital of Crete, the largest of the Greek islands. His father was a tax collector. Crete had been under Venetian rule for centuries, and after training on the island as an

△ **CHRIST CLEANSING THE TEMPLE, c.1570**
El Greco probably painted this scene while still in Venice. His use of perspective shows how far he had moved from the Byzantine style prevalent in his native Crete.

icon painter, El Greco moved to Venice in 1567 or 1568. The city was at the height of its artistic glory, with Titian, Tintoretto, and Veronese all flourishing.

In 1570, El Greco was described as a "disciple" of Titian, which could mean "pupil" or just someone who tried to imitate the master. Among Venetian artists, he probably learned most from Tintoretto, responding to his sense of drama and movement. He rethought his style completely after his arrival in Venice, coming to terms with a naturalistic tradition that was far from the medieval idiom he knew on Crete.

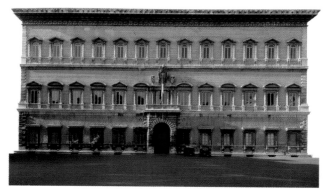

▷ **FARNESE PALACE**
Under Cardinal Alessandro Farnese (who became Pope Paul III), the Farnese Palace was a centre of cultural and intellectual activity in Rome. Today, the building houses the French Embassy.

> " The **softest brush** ever to give **soul** to panel, **life** to canvas. "
> LUIS DE GONGORA, "FUNERAL LAMENT TO EL GRECO", 1614

▷ **PORTRAIT OF AN OLD MAN, 1595–1600**
Presumed to be a self-portrait, this painting employs a simple, direct composition that draws attention to the eyes of the sitter, which convey a knowing melancholy.

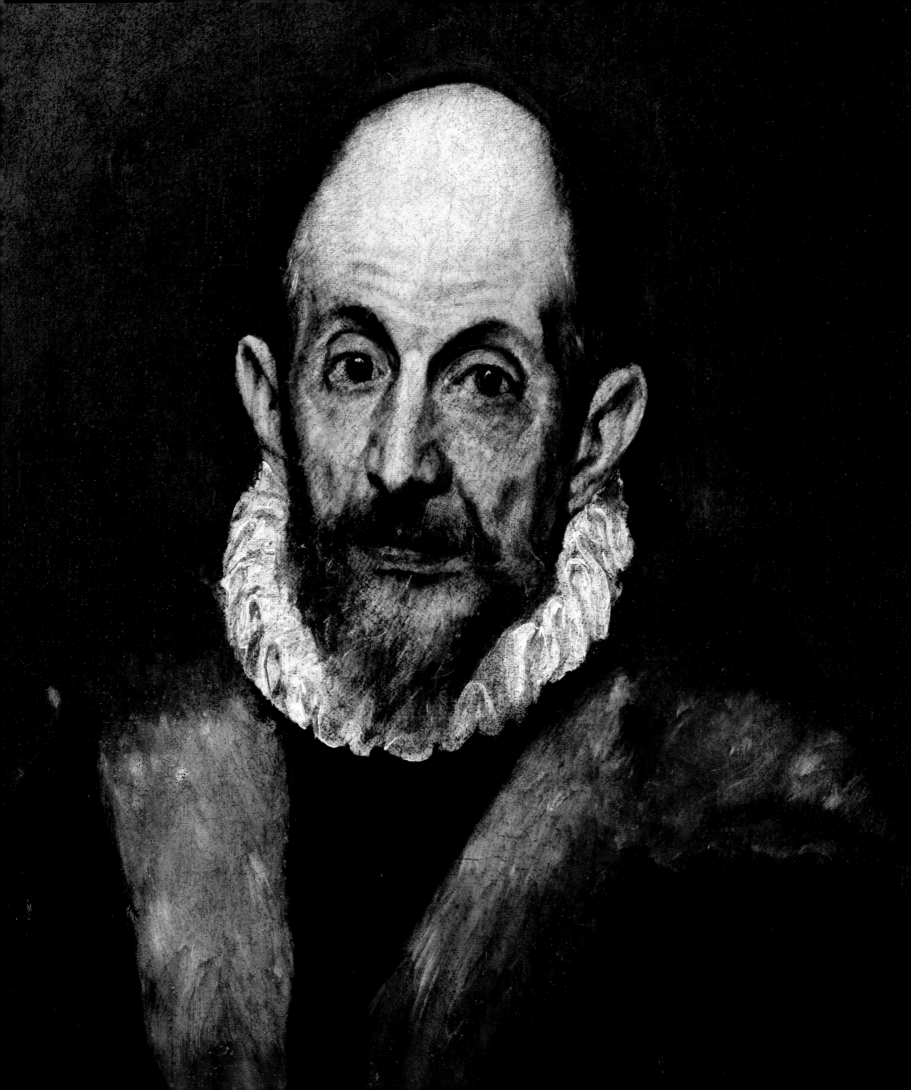

"He was as **individual** in everything as he was **in painting.**"

FRANCISCO PACHECO, *ART OF PAINTING*, 1649

△ *EL ESPOLIO*, 1577–79
Painted for Toledo Cathedral, this image shows Christ being stripped of his clothing before his crucifixion. Christ's serene expression and upward gaze contrast starkly with the ugly faces and violent activity of those around him.

Search for success

By November 1570, El Greco had moved to Rome, where he became a friend of Giulio Clovio (see box, p.84), who obtained accommodation for his new friend in the family palace of his main patron, Cardinal Alessandro Farnese, and also introduced him to potential clients. In spite of such excellent connections, El Greco made little impact on the highly competitive art market of Rome, and his lack of success must have led him to consider a fresh start.

By 1576, he had moved to Spain and in the following year (now in his mid-thirties) he settled in Toledo, where he was to spend the rest of his life. The choice of this city – which was once the seat of the Holy Roman Emperor – probably reflects El Greco's friendship in Rome with Luis de Castilla, a young Spanish priest whose father was dean of Toledo Cathedral (and who later helped El Greco secure various commissions).

At this time, Toledo was one of the largest and most prosperous cities in Spain, with a population of about 60,000 and a lively, cosmopolitan atmosphere. It was the country's spiritual capital (the archbishop of Toledo was Spain's senior churchman) and had more than 100 religious establishments (churches, hospitals, convents, and so on). This environment proved to be the ideal breeding ground for El Greco's art.

▷ *VIEW OF TOLEDO*, c.1600
El Greco's brooding painting of his adopted city is almost Impressionist in its use of colour and treatment of light. The remarkably dramatic landscape has been described as a "hymn to the forces of nature".

Grand works

The transformation in El Greco's work after he moved to Spain is astonishing. In Italy, he had never received a public commission and had always worked on a modest scale. But in Toledo, he immediately began producing huge and commanding altarpieces for major buildings. The first of these paintings to be finished, in 1577, was *The Assumption of the Virgin* for the church of Santo Domingo el Antiguo, and in the same year, he began one of his most celebrated masterpieces, *El Espolio* (*The Disrobing of Christ*, 1577–79), for Toledo Cathedral.

The artist's workshop

El Greco soon put down roots in Toledo, setting up home with a woman called Jerónima de Las Cuevas, with whom he had a son, Jorge Manuel, born in 1578. He lived with Jerónima for the rest of his life, but they never married. Jorge Manuel later became his father's chief assistant and took over his workshop after his death. El Greco's workshop seems to have been very busy, producing numerous copies and versions of the master's works. Some of his pictures exist in so many repetitions that they must have been in regular demand. For example, there are at least two small versions of *El Espolio* that are believed to be by El Greco himself and more than a dozen others from his workshop.

In addition to religious works, El Greco painted some outstanding portraits and occasionally tackled other subjects, such as landscapes. He also made some sculpture and designs for the architectural framework of elaborate altarpieces.

Professional pride

El Greco's work brought him a good income, and from 1585 he lived in spacious quarters in part of a palace rented from the Marquis of Villena.

Little is known of his personality, but he was certainly intelligent and well read (an inventory of his possessions lists books in Greek, Latin, Italian, and Spanish). He had a strong feeling for the dignity of his profession and frequently engaged in legal disputes over payments for commissions. One

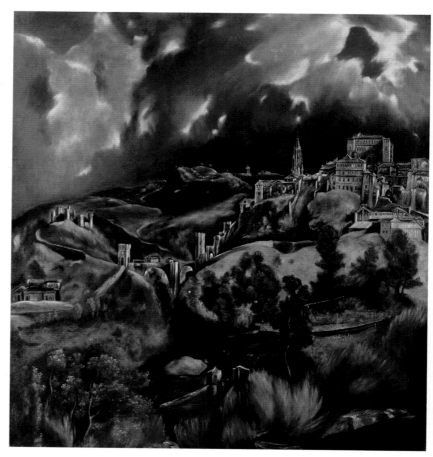

such dispute was settled to his disadvantage in 1607, causing him financial problems: in 1611 he was two years in arrears with his rent.

Late works

El Greco died on 7 April 1614 and was buried in the church of Santo Domingo el Antiguo, where his career in Toledo had started. For his own tomb he had painted *The Adoration of the Shepherds*, incorporating a self-portrait in the shepherd who kneels in reverence in front of the Virgin and Child. It is one of the most intensely spiritual of all his paintings, showing his tendency in his late works to move still further away from conventional naturalism into a visionary world: the extraordinarily elongated figures have lost all normal sense of physical substance and the colours shimmer in a spectral light.

Reputation and revival

El Greco's work was too quirky to inspire imitation after his death and his reputation declined. In his *Lives of the Spanish Painters* (1724), Antonio Palomino wrote that El Greco was a good painter early on, but that his later works were "contemptible and ridiculous, as much for his disjointed drawing as for the unpleasant colour".

When Spain's national art museum, the Prado, opened in Madrid in 1819, not a single work by El Greco was on display. However, his reputation revived among artists and critics during the 19th century (Delacroix was an early admirer). His rise to popular fame began in the early 20th century, when his work was in tune with the non-naturalistic trend of modern art and was championed by the Expressionists.

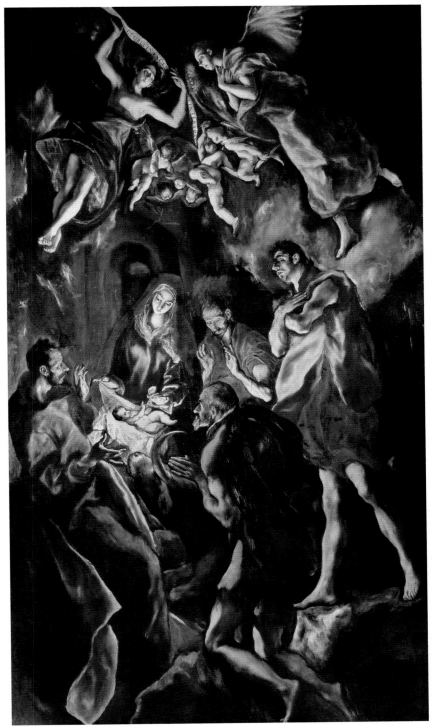

◁ **THE ADORATION OF THE SHEPHERDS, c.1612–14**
In this work, El Greco moves towards a representation of the spiritual world. The space occupied by the figures seems to exist beyond any geometrical reality and the scene is apparently illuminated by light emanating from the Christ child.

IN CONTEXT
El Escorial

El Escorial is a monastery-palace near Madrid, built in 1563–84 for Philip II, the king of Spain. It is so large and so richly decorated that it kept a small army of artists and craftsmen occupied for decades. Numerous painters came from Italy to find work there, and El Greco may have had this in mind when he moved to Spain. In 1580–82, he was commissioned to paint a large altarpiece for the building, but it was rejected by Philip, who thought it did not sufficiently "inspire devotion". El Greco never worked for Philip again.

VIEW OVER EL ESCORIAL

KEY MOMENTS

c.1571
Paints a portrait of his friend Giulio Clovio, who tries to advance his career in Rome.

1577–79
Works on *El Espolio* (*The Disrobing of Christ*), one of his greatest paintings. It is begun soon after he arrives in Toledo.

1580
Is commissioned by Philip II to paint an altarpiece, *The Martyrdom of St Maurice*, for El Escorial, the king's palace near Madrid.

1586–88
Paints *The Burial of the Count of Orgaz*, arguably his supreme masterpiece. People clamour to see the painting at the church of Santo Tomé.

1608
Receives his last major commission, for altarpieces in the Hospital of St John the Baptist in Toledo.

Directory

▷ Lucas Cranach

1472–1553, GERMAN

One of the most versatile German painters of his time, Cranach achieved success in a number of distinct fields. Early in his career, he produced some magnificent religious works, several of which have beautiful landscape settings, and also excelled as a portraitist. His later work included mythological paintings and hunting scenes. A supporter of the Reformation, he painted several portraits of his friend Martin Luther and designed propaganda prints for him. However, he was a shrewd businessman and had no qualms about working for Catholic patrons. Cranach worked mainly in Wittenberg, where he became a wealthy and honoured man. His large studio was run after his death by his son Lucas Cranach the Younger (1515–86).

KEY WORKS: *The Rest on the Flight into Egypt*, 1504; *Venus and Cupid*, 1509; *Apollo and Diana*, 1530

Mathis Grünewald

c.1475/80–1528, GERMAN

Grünewald was the greatest of Dürer's German contemporaries, but unlike Dürer, he belonged essentially to the Middle Ages rather than the Renaissance. He continued to work in a late medieval style, concentrating on religious subjects, particularly from Christ's Passion, which he treated with an extraordinary emotional intensity.

He had a fairly successful career, working as court painter to two successive archbishops of Mainz, but he was quickly forgotten after his death and his reputation did not seriously revive until the early 20th century, when the expressive

△ SELF-PORTRAIT, LUCAS CRANACH, 1550

distortions in his work won favour in the wake of modern art. His masterpiece is a huge altarpiece painted for the hospital church of Isenheim Abbey in Alsace, the central feature of which is one of the most powerful depictions of the Crucifixion ever created.

KEY WORKS: *The Mocking of Christ*, c.1503; *Isenheim Altarpiece*, c.1510–15; *Virgin and Child (Stuppach Madonna)*, c.1515–20

Giorgione

c.1477–1510, ITALIAN

Few details of Giorgione's life are certain. Neither the date of his birth nor the year in which he left his native Castelfranco for Venice are known, but despite his early death from the plague and his small output, Giorgione – a nickname meaning "Big George" – was among the most influential artists of his time.

He was one of the first painters to concentrate on intimate works for private collectors and the first for whom the creation of mood was more important than the ostensible subject of a picture. He probably trained under Giovanni Bellini and he developed his master's interest in atmosphere and landscape and his subtle handling of oil paint. In turn, he influenced the young Titian (with whom he had a close working relationship) and many other painters of the period, in Venice and elsewhere. Watteau was among the later painters who responded to the dreamy romanticism of Giorgione's work.

KEY WORKS: Castelfranco Altarpiece, c.1500–05; *The Tempest*, c.1505–10; *Sleeping Venus*, c.1510

Correggio

c.1490–1534, ITALIAN

Correggio is a small town in northern Italy and its name was adopted by the painter Antonio Allegri, who was born and died there. Although he worked outside the major art centres (mainly in his native town and in the nearby city of Parma), he ranks among the most inventive and sophisticated artists of the Renaissance. Little is known about his education, but it is thought that he studied with his uncle, Lorenzo Allegri.

His work ranged from large dome frescos, in which he demonstrated a brilliant mastery of foreshortening in depicting figures soaring overhead, to small and intimate pictures for private collectors. Most of his work was on religious subjects, but he also painted some outstanding mythological pictures. His reputation was strong in the 17th century, and particularly in the 18th century, when his fluid, sweetly sensuous style was in tune with the spirit of Rococo art.

KEY WORKS: *Virgin of St Francis*, 1514–15; *Assumption of the Virgin* (dome of Parma Cathedral), 1526–30; *Jupiter and Io*, c.1530–32

Benvenuto Cellini

1500–1571, ITALIAN

As famous for his autobiography as for the craftsmanship of his works, Benvenuto Cellini was, by turns, an engraver, sculptor, musician, and soldier. Considered violent, arrogant, and ruthless by many of his peers, he committed more than one murder, and was also imprisoned twice for the crime of sodomy. Originally a pupil of Michelangelo, he travelled widely in Italy, spending time in Siena, Bologna, Pisa, and Rome. In Rome he worked as metalworker and played the flute in the Pope's court; he also fought in the sack of the city in 1527. After several years in Fontainebleau, France, he returned to Florence, where he spent the last two decades of his life under the patronage of Cosimo I de' Medici.

KEY WORKS: *Perseus with the Head of Medusa*, 1545–53; *Portrait Bust of Cosimo I de' Medici*, 1545; *Saltcellar of Francis I*, 1539–43

Jacopo Tintoretto

c.1518–1594, ITALIAN

Tintoretto's death marked the end of Venice's golden age of painting in the 16th century. He was an excellent portraitist and he produced a range of secular pictures (on mythological, historical, and allegorical subjects), but he was above all a religious painter. Renowned for his energy and speed, he created a vast amount of work for the churches and other buildings of Venice, most of which remains in situ. His style has great vigour and emotional intensity, typically featuring broad brushwork and brooding lighting effects, although when he worked for aristocratic patrons he generally favoured brighter – more expensive – colours and a more polished finish.

KEY WORKS: *St Mark Rescuing the Slave*, 1548; *The Crucifixion*, 1565; *The Last Supper*, 1594

Germain Pilon

c.1525–90, FRENCH

The greatest French sculptor of the 16th century, Pilon enjoyed a varied and highly successful career, even though he lived at an inauspicious time for his country's art, his maturity coinciding with a period of disastrous civil war (1562–98).

He worked in marble, bronze, and terracotta, and his output included tomb sculpture, religious figures, portrait busts, and the design of coins and medals (in 1572, he was appointed controller general of the royal mint in Paris). His busy workshop also produced garden sculpture and architectural features such as chimney pieces. Stylistically, he is broadly part of the courtly Mannerist tradition, his figures characteristically being graceful and elongated. But his work also has a strong element of naturalistic observation and sometimes a powerful emotional charge.

KEY WORKS: Tomb of Henry II and Catherine de' Medici, c.1561–70; *Charles IX*, c.1574; Tomb of Valentine Balbiani, c.1580

Giambologna

1529–1608, NETHERLANDISH

Although Netherlandish by birth (he was originally called Jean Boulogne), Giambologna spent most of his career in Italy and is recognized as the greatest Italian sculptor in the period between Michelangelo and Bernini.

He went to Rome to study in 1550 and two years later settled in Florence, where he was court sculptor to three successive Medici grand dukes of Tuscany. His work – elegant, polished, and showing a mastery of elongated, twisting forms – represents the finest

expression of the Mannerist style in sculpture. Giambologna worked equally successfully in marble and bronze and on a large and small scale. Some of his statuettes (particularly his extraordinarily graceful figure of the flying Mercury) were reproduced again and again, helping to spread his reputation throughout Europe.

KEY WORKS: *Samson Slaying a Philistine*, c.1561–62; *Mercury*, c.1565; *Equestrian statue of Duke Cosimo I de' Medici*, 1587–95

▽ Nicholas Hilliard

c.1547–1619, ENGLISH

Hilliard was the greatest of all exponents of the portrait miniature and was largely responsible for establishing it as a specialist art form in England. He trained as a goldsmith (his father's profession) and worked as one throughout his life in addition to painting. It is uncertain how he learned to paint miniatures, but his earliest known examples were produced when he was little more than a child and he is thought to have been mainly self-taught. Hilliard became the queen's painter, and in 1572 he painted the first of several miniatures of Elizabeth I. His other sitters included some of the most famous figures of the age, including Sir Francis Drake, Sir Walter Raleigh, and Mary, Queen of Scots.

His style was extremely delicate but also vivid in characterization. Hilliard is known to have painted large-scale portraits, but no certain examples have survived.

KEY WORKS: Self-portrait, 1577; *Young Man among Roses*, c.1588; *George Clifford, 3rd Earl of Cumberland*, c.1590

◁ **SELF-PORTRAIT, NICHOLAS HILLIARD, 1577**

17th
CENTURY

CHAPTER 3

Caravaggio

1571–1610, ITALIAN

In a short and stormy career, Caravaggio overwhelmed his contemporaries with the power and originality of his art, but he also outraged them with his violent personality.

At the time of his death in 1610, Caravaggio was the most influential artist in the whole of Europe, and his work continued to inspire widespread imitation for decades afterwards. He made such a powerful mark because he broke away decisively from the elegant but artificial Mannerist style that had dominated Italian painting in the late 16th century, replacing it with a bold and compelling naturalism.

Michelangelo Merisi – later known as Caravaggio – was baptized in Milan on 30 September 1571; he was probably born on the previous day – the feast of the Archangel Michael, from whom his forename derives. His father, Fermo Merisi, was a master builder in the service of a young nobleman, Francesco Sforza, who had homes in Milan and in Caravaggio, a small town about 40km (25 miles) to the east. It was there that Michelangelo Merisi grew up, and from it he took the name by which he has become famous.

Roman adventures

In 1584, Caravaggio was apprenticed for four years to the Milanese painter Simone Peterzano; nothing is known of his next few years. By 1590, both his parents had died, and in 1592 their estates were divided between Caravaggio, his brother, and his sister.

With enough money to support himself modestly for a few years, he set out to make his way in life. His destination was Rome – the artistic capital of the world at the time – and he probably arrived there in 1592, although his presence in the city is not documented for another two or three years.

Caravaggio endured hardship during his early days in Rome, but after earning his keep by assisting other artists, he began to find buyers for his own paintings. In about 1595, he met his first important patron, Cardinal Francesco del Monte, the duke of Tuscany's ambassador at the papal court, who gave him accommodation in his palace for several years. Del Monte had homosexual tastes, and several of Caravaggio's early works clearly reflect this, showing alluring, flimsily dressed boys in various guises. Caravaggio himself seems to have been bisexual.

Del Monte probably recommended Caravaggio for his first public commission – two large canvases, *The Calling of St Matthew* and *The*

▷ **THE MUSICIANS, 1595**
This secular tableau shows four young musicians (one styled as Cupid) in rehearsal. It was hung in the private chambers of Caravaggio's patron, Cardinal del Monte.

Martyrdom of St Matthew, for the side walls of the Contarelli Chapel in San Luigi dei Francesi, the French church in Rome. They were painted in 1599–1600 and are his first securely documented works.

Stylistic advances

The success of these works marked a radical change of direction in Caravaggio's art – of subject, scale, character, and style. From this point, he put his main effort into large,

△ **MEDUSA, 1597**
Mounted on a wooden shield, this painting shows the mythological snake-haired Gorgon just after her head had been severed. Caravaggio's masterly technique gives her fear and horror a human reality.

" He considered it the **highest** achievement in art **not to be bound** by the rules of art. "

GIOVANNI PIETRO BELLORI, *LIVES OF THE PAINTERS*, 1672

▷ **PORTRAIT OF CARAVAGGIO, c.1621**
Caravaggio painted himself as a character in a number of his works, but the only straightforward near-contemporary portrait of him is this drawing by Ottavio Leoni.

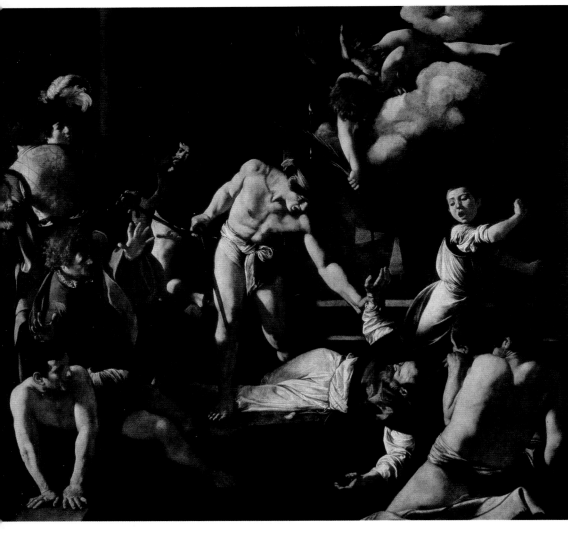

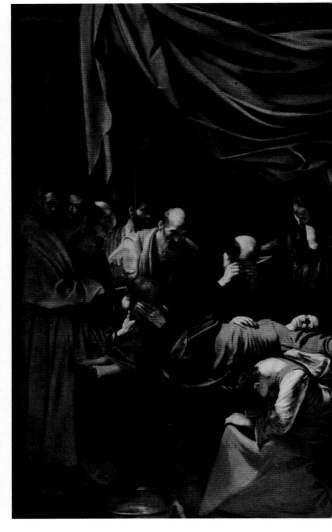

△ **THE MARTYRDOM OF ST MATTHEW, 1599–1600**
Caravaggio painted this work – which helped cement his reputation – from live models in a contemporary setting (the bystanders on the left are wearing 16th-century clothing).

serious, religious pictures for public settings, rather than chamber works painted for connoisseurs.

Caravaggio gave up the clear illumination of his early works in favour of dark backgrounds and powerful chiaroscuro (contrast of light and shade), which help create the emotional intensity that characterizes his mature paintings. Together with this dramatic treatment of light, the most revolutionary feature of Caravaggio's art was his reimagining of biblical scenes as events that took place among flesh-and-blood people.

His characters are not the idealized beings of traditional religious art, but look as if they could have stepped straight from the streets of Rome. Caravaggio brought them – complete with their imperfections – close to the front of the picture space and they stand out with great boldness against the dark background, producing a feeling of physical presence.

Caravaggio worked quickly, and rather than making preliminary drawings, he marked his compositions directly onto the canvas, adding to the immediacy of his work.

△ **THE DEATH OF THE VIRGIN, 1606**
Caravaggio's use of deep red drapery emphasizes the carnality of death and its effect on the onlookers. He includes none of the traditional indicators of Mary's holiness – an omission that caused intense controversy.

Changing reputation
Many viewers were gripped and won over by Caravaggio's dramatic new vision. Painters – including the many foreign visitors to Rome – began to imitate him, exporting his novel style to their own countries,

" His figures inhabit **dungeons**, **illuminated** from above by only a single and **melancholy ray**. "
LUIGI LANZI, *HISTORY OF PAINTING IN ITALY*, 1792

KEY MOMENTS

c.1595
Paints *The Musicians*, one of the first works commissioned from Caravaggio by his patron Cardinal del Monte.

1599–1600
A pair of paintings on the life of St Matthew in San Luigi dei Francesi, Rome, is his first public commission.

1600–01
Completes two of his greatest works – *The Crucifixion of St Peter* and *The Conversion of St Paul* in Santa Maria del Popolo, Rome.

1606
His *Death of the Virgin* is rejected by church authorities for alleged disrespectful treatment of the subject.

1608
Completes his largest painting, *The Beheading of St John the Baptist*; it is the only painting he ever signed.

and by 1604 his reputation had spread as far as the Netherlands. He is mentioned in *Het Schilder-Boeck* (*The Book of Painters*), in which the author writes about "Michael Angelo of Caravaggio, who is doing remarkable things in Rome".

Some contemporaries, however, thought Caravaggio disrespectful for bringing religious subjects down to earth, and between 1602 and 1606 three of his major altarpieces were turned down by the churches for which they had been commissioned. Particular outrage was caused by *The Death of the Virgin*, painted for Santa Maria della Scala in Rome. One of Caravaggio's early biographers, the painter and art historian Giovanni Baglione, wrote that the painting was refused because the artist "showed the Madonna swollen up and with bare legs"; others went further, claiming that the figure of the Virgin had in fact been modelled by a common prostitute.

A violent temperament

In addition to attracting extreme admiration and criticism for his work, Caravaggio became notorious for his violent personality. Between November 1600 and October 1605, he was in trouble with the authorities on 11 documented occasions for breaches of the law, including assault, wounding, and carrying a sword and dagger without a licence. On 29 May 1606, he got into an argument about a wager and killed a man in the ensuing fight. He fled Rome, becoming a fugitive, and by October had moved to Naples, far from Roman jurisdiction. He then travelled to Malta (1607–08), Sicily (1608–09), and back to Naples (1609–10), painting major works in each location and having a strong influence on local artists.

His pattern of dangerous living continued: in August 1608, he was imprisoned for wounding one of the Knights of Malta (see box, right); he escaped, but in October 1609 was attacked and seriously wounded outside a tavern in Naples. He remained there until summer 1610, when he sailed to Porto Ercole, near Rome, confident that his influential supporters were close to securing him a papal pardon for his crime. On landing, he was arrested in mistake for someone else, and by the time he was released, the boat had left. Thinking that his possessions were still on board (in fact they had been put into storage), he chased along the beach trying to catch up with the vessel. His exertions under the hot sun gave Caravaggio a fever, which led to his death on 18 July 1610.

Legacy of light

Caravaggio's style began to go out of fashion in Rome during the 1620s, but persisted in other parts of Italy and elsewhere in Europe. It survived longest (into the 1650s) in Sicily, Utrecht in the Dutch Republic, and Lorraine in northeast France, where Georges de La Tour was perhaps the greatest of all Caravaggio's followers. Most imitators either coarsened or sweetened the master's style, missing its immense grandeur and emotional depth, but La Tour's finest paintings have great dignity and are extraordinarily sensitive in their treatment of nocturnal light effects.

IN CONTEXT
The Knights of Malta

The Knights were an ancient military and religious order, founded in the 11th century, that had ruled Malta since 1530. Caravaggio sought membership of the order thinking it would help him win a papal pardon for the murder he had committed. He was ordained after painting *The Beheading of St John the Baptist* for the order, but was jailed and expelled after wounding another knight. On the island, he painted one of his few portraits – of Alof de Wignacourt, the Grand Master of the Knights.

POT WITH THE KNIGHTS OF MALTA'S COAT OF ARMS, 16TH CENTURY

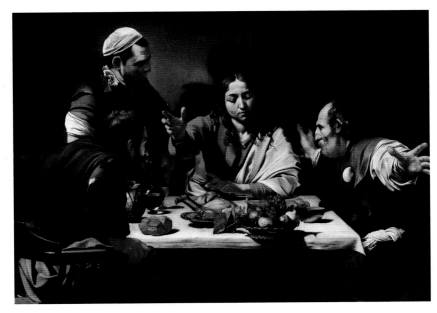

◁ **THE SUPPER AT EMMAUS, 1601**
Caravaggio here depicts the resurrected Christ breaking bread with his disciples. The life-size figures and the emphasis on the food serve to humanize the scene, almost inviting the viewer to the meal.

Peter Paul Rubens

1557–1640, FLEMISH

The most famous painter of his age, Rubens lived his hugely productive life on an international stage, travelling widely and working as a diplomat as well as an artist.

Rubens was one of the most versatile and productive of all artists. As well as his enormous number of paintings, which ranged over virtually every type known in his lifetime, he created a wealth of designs, notably for book illustrations, pageantry, and tapestries. This extraordinary fecundity was part of the immense energy and love of life that characterized everything he did.

Early years

Peter Paul Rubens was born in Siegen, Westphalia (now in Germany), on 28 June 1577; the day after his birth was the feast of St Peter and St Paul, which explains his parents' choice of names. His father, Jan, was a lawyer, whose Protestant sympathies led him to flee his native Antwerp because of religious persecution. Following Jan's death in 1587, his widow, Maria, returned to Antwerp with Peter Paul, aged 10, and two of his siblings. Three years later, Rubens started work as a page to a noblewoman, but he soon left to begin his training as a painter.

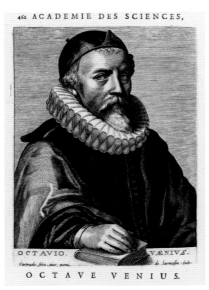

462 ACADEMIE DES SCIENCES,

OCTAVIO. VÆNIVS.
OCTAVE VENIUS.

▷ **OTTO VAN VEEN**
One of Rubens's teachers, Otto van Veen, was the dean of the painters' guild in Antwerp. He was successful in the city, best known for his portraits, illustrations, and altarpieces.

From 1591 to 1598, Rubens studied successively under Tobias Verhaecht, Adam van Noort, and Otto van Veen. All are now considered minor figures, although van Veen was well regarded at the time and probably played a significant role in shaping his pupil's artistic outlook. A cultivated man, he had spent several years in Rome, and his great knowledge of ancient and Renaissance art no doubt inspired the young Rubens to see such works for himself. After qualifying as a master in the Antwerp painters' guild in 1598, Rubens worked in van Veen's studio for two years, before leaving for Italy in May 1600, aged 22.

Rubens was based in Italy for the next eight years and became so steeped in the country's culture that in later life he preferred to write in Italian rather than Flemish and usually signed himself "Pietro Paolo Rubens". Soon after arriving in Italy, he was fortunate to find work with Vincenzo Gonzaga, duke of Mantua, a great art-lover. His duties included travelling to art centres, such as Florence and Venice, to make copies of famous paintings for Vincenzo's collection. He also visited Spain in 1603–04 as part of a diplomatic mission taking gifts from Vincenzo to Philip III.

Roman years

Rubens's most significant years in Italy were those he spent in Rome from 1601 to 1602 and from 1605 to 1608. In the city, he studied ancient sculpture, the great creations of the Renaissance, such as the Vatican frescos of Michelangelo and Raphael, and the best contemporary painting, notably the works of Caravaggio and Annibale Carracci. These sources undoubtedly fired the energy and heroic grandeur evident in Rubens's works, but he added his own highly distinctive warmth to became one of the finest exponents of the Baroque style that came to dominate much of 17th-century art.

> " My **talents** are such that I have never lacked **courage** to undertake any enterprise, however **vast** in size or **diversified** in subject. "

PETER PAUL RUBENS, LETTER TO WILLIAM TRUMBULL, 1621

▷ **SELF-PORTRAIT, c.1638**
In this stately portrait, Rubens depicts himself not as an artist but as a knight of Charles I. His precisely executed features show him aged and weary.

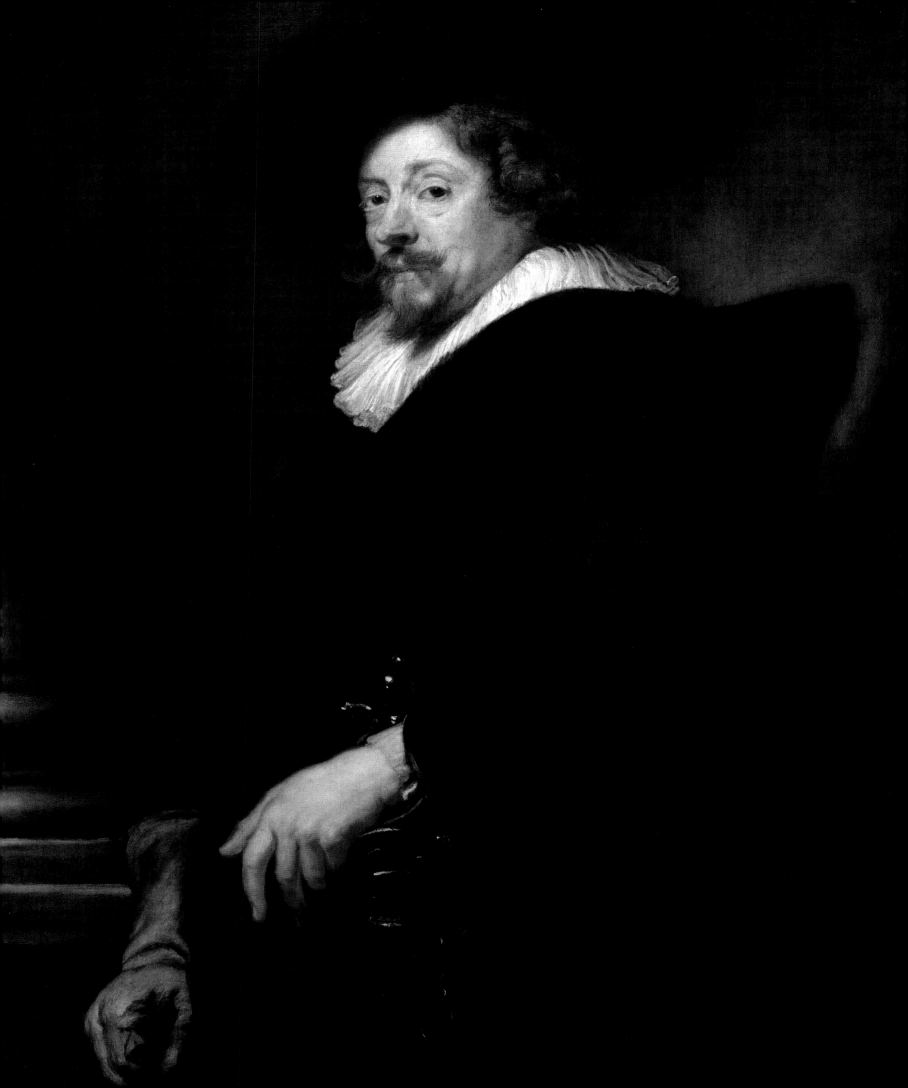

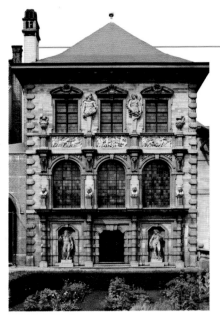

△ **RUBENS'S HOUSE, ANTWERP**
Rubens bought a substantial house in Antwerp in 1610, and remodelled it to his own designs. He lived there for the rest of his life. Today it houses a museum.

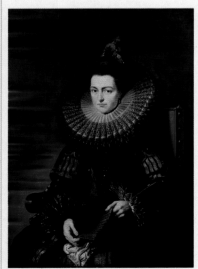
Return to Antwerp

In October 1608, Rubens received news that his mother was seriously ill. He hurried to Antwerp, but she died before he arrived. Although he intended returning to his beloved Italy, he became so successful in Antwerp that he remained there. In September 1609, he was appointed court painter to the archduke Albert and his wife Isabella (see box, left), who governed the country on behalf of Spain. The following month, he married Isabella Brant, the 17-year-old daughter of a lawyer. This was an extremely happy union, and the couple had three children.

Rubens put down further roots in Antwerp in 1610, when he bought a large house, which he extended and rebuilt in an Italianate style inspired by palaces he had seen in Genoa. His additions included a spacious studio and an internal courtyard. His return to the city was timely because a change in Antwerp's political situation now enabled art and architecture to flourish. The city was part of the Southern or Spanish Netherlands (sometimes loosely called Flanders, and roughly equivalent to modern Belgium), which had long been at war with its neighbour, the Northern Netherlands (roughly equivalent to the modern Netherlands). From 1609 to 1621, however, there was a period of truce, during which a great deal of reconstruction and redecoration was carried out on buildings – particularly churches – that had been damaged in the fighting.

▷ *THE HONEYSUCKLE BOWER*, c.1609
Rubens depicts himself with his first wife, Isabella Brandt, in this full-length portrait. The honeysuckle and the garden are both symbols of love.

In the decade following his return from Italy, Rubens painted many works for such churches, scoring his first great triumph with the huge *Raising of the Cross* (1610–11) for St Walburga (it is now in Antwerp Cathedral). The majestic figures demonstrate how much he had learned in Italy, but in other respects the altarpiece shows his Flemish heritage: it is a triptych with folding wings (a type that had gone out of fashion in Italy), and it is on a wooden panel, whereas canvas was then more popular with Italian artists. Rubens used canvas when it was convenient to do so, but he preferred panel, which suited his fluid brushwork well. He never painted in fresco, which was used by many of the most illustrious Italian artists but was not ideal in the damper climate of northern Europe.

Working methods

In addition to religious images, Rubens painted many other kinds of picture, and he was soon in such demand that

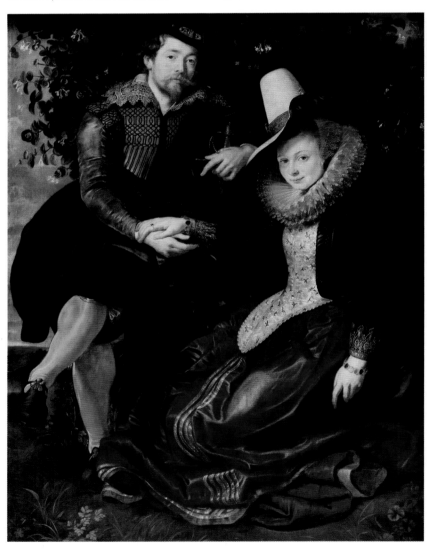

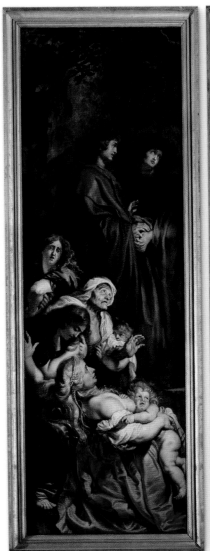
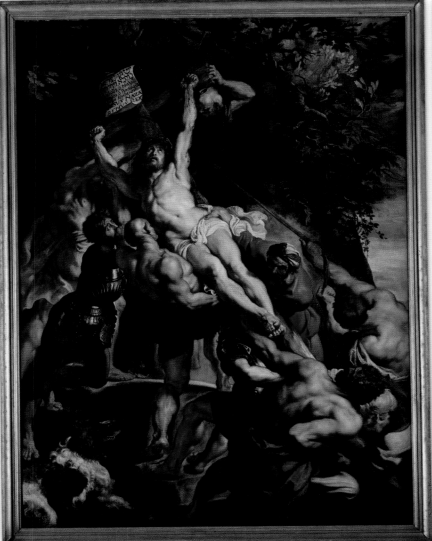

in 1611 he told a friend he was having to turn away would-be pupils as he could not cope with any more. He got through his enormous workload only because he was so efficient at managing his well-trained assistants. When working on a large commission, Rubens usually made an oil sketch of his desired composition. His assistants would then carry out much of the actual brushwork before the master applied the finishing touches. He was open about his

methods, charging his clients according to the degree of his personal involvement. He also collaborated with established artists, including as his friend the animal painter Frans Snyders; and he employed outstanding engravers to make prints of his work.

International success
Rubens's reputation spread beyond Flanders, and his international clientele outshone that of any other

artist of his time. His patrons included the royal families of England, France, and Spain, as well as a host of aristocrats and senior churchmen. Rubens also came into contact with royalty in another way, for the archduchess Isabella (who ruled alone after her husband's death) employed him as a diplomat as well as a painter. When the 12-year truce between Flanders and Holland ended in 1621, he was involved in trying to secure peace between the two countries.

△ **THE RAISING OF THE CROSS, 1610–11**
The central panel of Rubens's enormous triptych depicts the struggle to lift the crucified Christ into the vertical position. The diagonal composition is dynamic, and the dramatic painting was designed to inspire awe in Catholics.

" The **facility** with which he invented, the **richness** of his composition, the **luxuriant harmony** and **brilliancy** of his **colouring**... dazzle the eye. "

SIR JOSHUA REYNOLDS, *DISCOURSE FIVE*, 1772

ON TECHNIQUE
Oil sketches

During his years in Italy, Rubens adopted the practice of making preparatory oil sketches for major works, and they became a distinctive feature of his creative process. Some oil sketches were done very rapidly, working out first thoughts, but others were much more considered, giving a clear idea of how the finished picture was intended to look. The vigorous and nimble brushwork of Rubens's sketches has appealed greatly to modern taste, as it is so obviously done by his own hand, whereas the paintings based on them are often largely by assistants.

ARRIVAL OF PRINCE FERDINAND, OIL SKETCH, 1634

Although unsuccessful in this task, he did achieve the preliminary step of brokering peace between Spain, Flanders's overlord, and England, Holland's ally.

Outstanding talents

Rubens had many qualities that made him suitable for the role of diplomat. He was highly intelligent and polished in manners, as well as very familiar with court life. He was also an accomplished linguist: in addition to Flemish and Italian, he knew French, German, Latin, and Spanish.

In the course of his diplomatic work, Rubens visited Spain and England, where he won great admiration for his skills as a diplomat. He was knighted by Charles I, king of England, in 1630, and also by Philip IV of Spain in 1631. Both kings were art lovers and gave Rubens major commissions.

For Charles I, his main work was the decoration of the ceiling of the Banqueting House (part of Whitehall Palace) with canvases celebrating the reign of his father, James I. For Philip, his studio produced more than a hundred mythological and animal paintings for the Torre de la Parada (a royal hunting lodge) near Madrid.

Following the death of his wife in 1626, Rubens found welcome distraction in his diplomatic work, but after spending almost two years

in Spain and England (leaving his children in the care of relatives) he said he wanted to "remain home all my life". In 1630, he married again. His bride, Hélène Fourment, who was 16 at the time, was the sister-in-law of his first wife. This second marriage was just as happy as the first and

produced five children. Hélène became Rubens's favourite model, her pretty, plump features appearing in his religious and mythological pictures, as well as in tender portraits.

In 1635, Rubens's domestic contentment increased when he bought a country house, the Château

▷ **CEILING OF THE BANQUETING HOUSE, LONDON**

The Banqueting House was designed in Italianate style by architect Inigo Jones. Rubens's ceiling canvases were painted in his Antwerp studio before being shipped to London.

KEY MOMENTS

"Glory to that **Homer of painting**, that father of **warmth** and **enthusiasm**."

EUGENE DELACROIX, *JOURNAL*, 20 OCTOBER 1853

de Steen (Het Steen), near Antwerp. He spent several months there every year, and his life as a country gentleman inspired him to make some magnificent landscape paintings – gloriously ripe works done for his own pleasure, which show the broadening and softening of style typical of his later output. These are now among Rubens's most popular works, as they convey very directly the joy he took in nature, without the intellectual trappings that some find off-putting in his grandiose figure compositions.

Artistic legacy

When Rubens died on 30 May 1640, aged 62, the whole of Antwerp mourned its most illustrious citizen. His impact in 17th-century Flanders was so pervasive that virtually no significant artist was left untouched by it, and his fame and influence endured.

His work was so multifaceted that it inspired all manner of artists. In the 18th century, for example, Antoine Watteau, the most exquisite of Rococo painters, responded to his more lyrical aspect; in the 19th century, Eugène Delacroix, a passionate Romantic, praised his vibrant colour and colossal energy. "Admirable Rubens! What a magician!" Delacroix wrote in 1860, and summed up his greatest quality as his "astonishing vitality".

▷ **A MAN OF ANTWERP**
Rubens is immortalized in a bronze statue by William Geefs (1840) in his home city of Antwerp; it stands in front of the Cathedral of Our Lady, which houses some of the artist's works, including *The Raising of the Cross*.

▽ **CHATEAU DE STEEN WITH HUNTER, c.1636**
Rubens's autumnal landscape includes a view of Het Steen (Stone House) where he spent the summer months later in his life. He made the painting for his personal satisfaction, rather than for a commission.

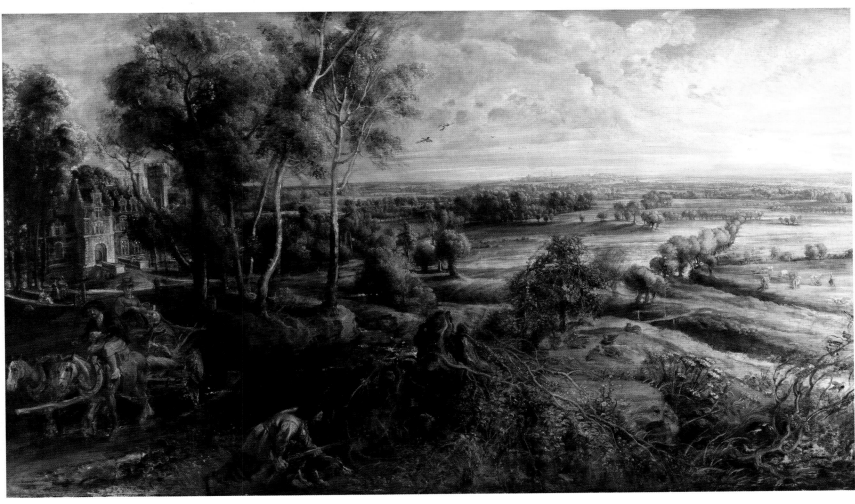

Artemisia Gentileschi

1593–c.1653, ITALIAN

Baroque artist Gentileschi overcame personal trauma and scandal to become a successful professional painter. She was renowned for her history paintings depicting strong, sensual women.

Born in 1593, Artemisia Gentileschi grew up in Rome, where her father, Orazio, was a well-known artist of the Caravaggiste school. She learned to paint in her father's workshop, and was then tutored by the artist Agostino Tassi. The first painting known to be hers, *Susanna and the Elders* (1610), was originally attributed to her father because of its precocious assurance.

In 1611, Tassi raped Gentileschi. He then promised to marry her to restore her honour, but this was a hollow gesture, not least because he was already married. Orazio brought a court case against Tassi, during which Artemesia was tortured with thumbscrews to test the veracity of her evidence. Ultimately, Tassi was convicted, although he never served his sentence; Orazio then married his daughter off to an older man, a Tuscan painter named Pietro Stiattesi.

Success from adversity

Gentileschi's art has often been interpreted in the light of her rape; indeed, one of her most compelling paintings, which dates to around this time, is *Judith Slaying Holofernes* (1612–13). Many have seen this painting as an embodiment of the artist's anger, but others view such an interpretation as reductive. In either case, Gentileschi was compelled by the biblical episode and painted the same scene again in 1620.

After her marriage, Gentileschi left Rome for Florence, where she bore four children, only one of whom, her daughter Prudentia, survived beyond childhood. Her professional life flourished in the city; in 1616, she was the first woman to be accepted into Florence's Academy of Design and received several commissions from the Medici court and from Michelangelo Buonarroti (great-nephew of Michelangelo).

Unusually for a woman, she did not focus on portraits or still lifes but on history painting, specializing in strong female figures such as Judith, Susanna, Bathsheba, and Mary Magdalene – women who had been wronged but who refused to bow to pressure or convention.

Later travels

Gentileschi was a respected artist in Florence, but her husband ran up steep debts and in 1621 she returned to Rome without him. She also spent time in Venice seeking commissions, and became known there as a portraitist. In 1630 she relocated to Naples, a city with a rich artistic life, in search of new patrons.

Apart from a period in England when she worked at the court of Charles I (her father had become court painter there), she remained in Naples for the rest of her life. Little is known of her last years, but she died in the city around 1653.

◁ *JUDITH SLAYING HOLOFERNES,* **1612–13**
Extreme chiaroscuro (strong tonal contrast) underlines the horror of the scene, which is rendered with an almost shocking naturalism: pale flesh and the opulent colours of blood and luxuriant fabrics stand out in the darkness.

SELF-PORTRAIT, SOFONISBA ANGUISSOLA, 1556

" My **illustrious lordship,** I'll show you what **a woman** can do. "

ARTEMISIA GENTILESCHI

▷ **SELF-PORTRAIT, 1615–17**
Gentileschi's determination to succeed in a male-dominated world is visible in her expression in this self-portrait, which owes a debt to the psychological realism and dramatic chiaroscuro of Italian painter Caravaggio.

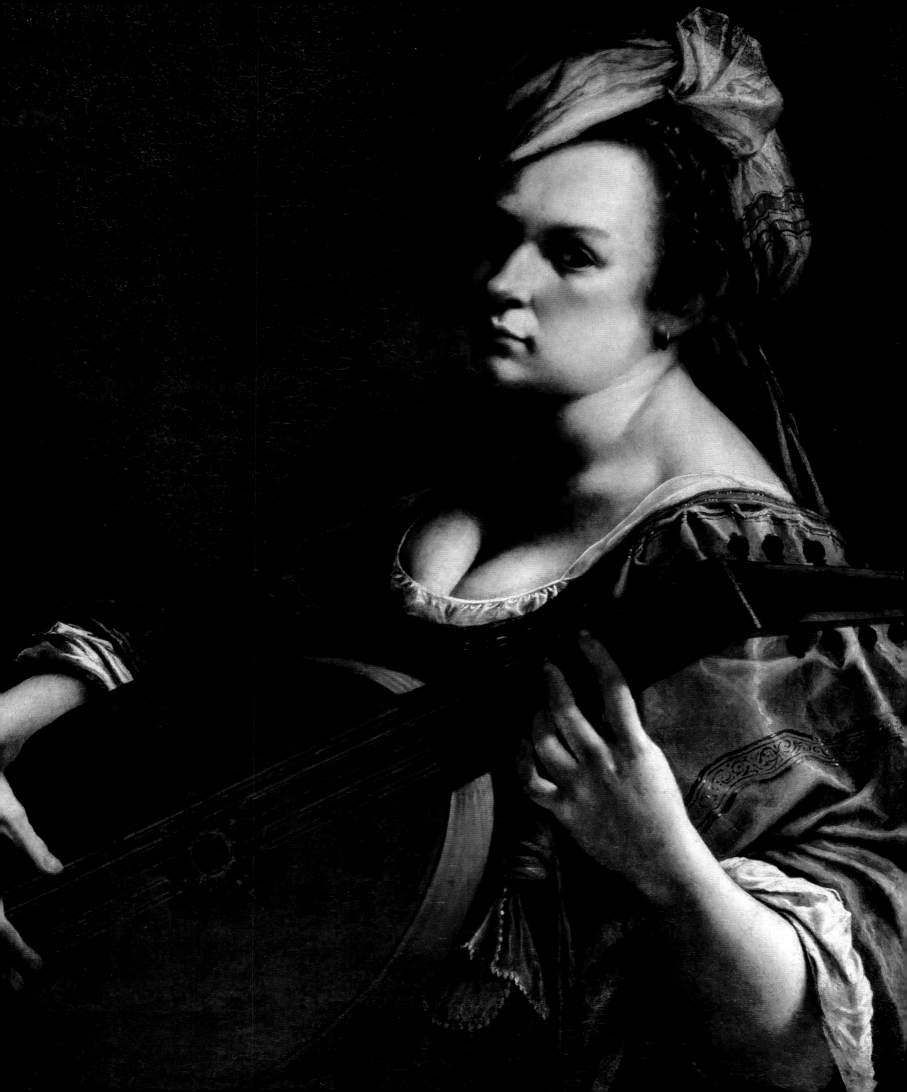

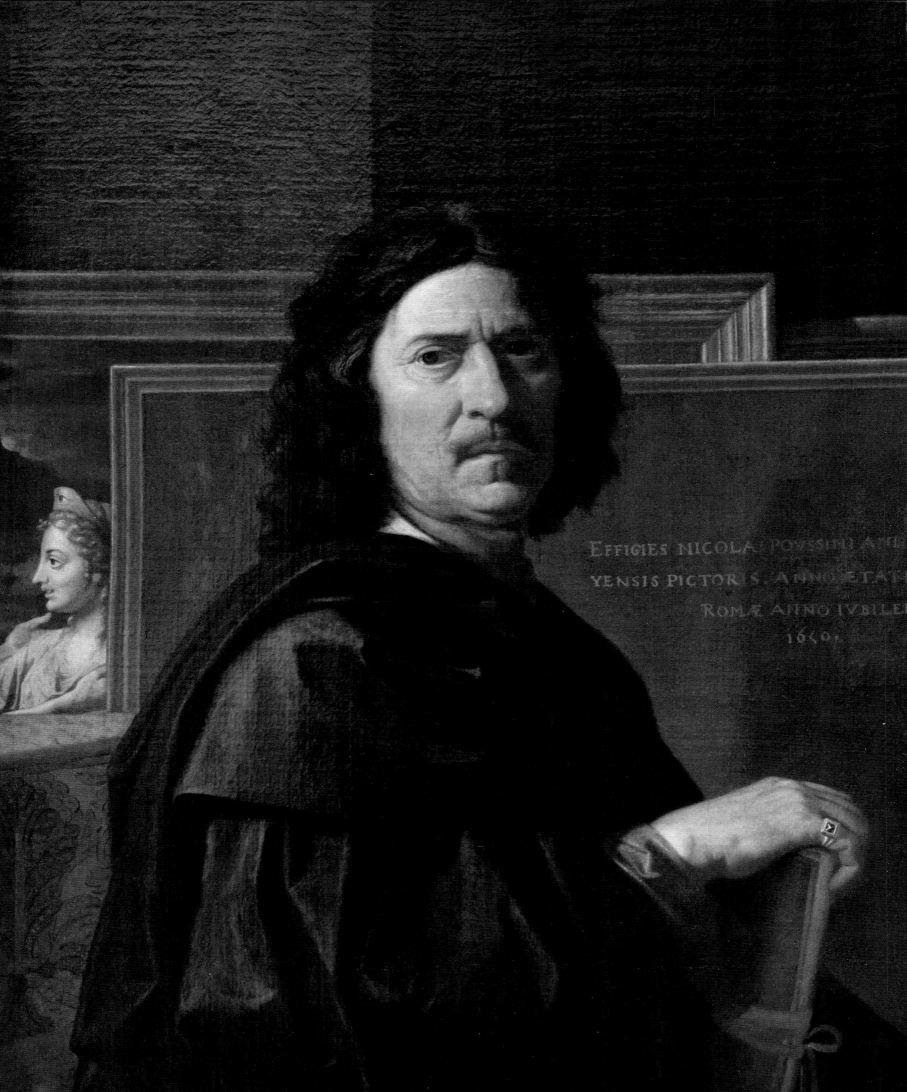

EFFIGIES NICOLAI POVSSINI ANDE
YENSIS PICTORIS. ANNO ETAT
ROMÆ ANNO IVBILEI
1650.

Nicolas Poussin

1594–1665, FRENCH

The most celebrated French painter of the 17th century, Poussin created a style of classical dignity and harmony, which was to inspire artists such as David, Ingres, and Cézanne.

Nicolas Poussin became an inspiration to generations of French artists, yet he spent virtually his whole creative life in Rome. His art was shaped by ancient rather than modern Rome, for in classical culture he found guiding moral principles as well as stylistic models for his work. The English artist Sir Joshua Reynolds, one of the founder members of the Royal Academy, summed up Poussin's outlook by saying he had "a mind thrown back two thousand years and, as it were, naturalized in antiquity".

Early life

Poussin was born in June 1594 in or near the small town of Les Andelys in Normandy, northern France. His parents came from families of local distinction, and although they were experiencing hardship by the time of their son's birth, he had a respectable education. His interest in art was fired when a painter called Quentin Varin visited Les Andelys in 1612 to make three altarpieces for the church of Notre Dame. Varin – now considered a mediocre artist – inspired the young Poussin, who left home for Paris, intent on becoming an artist himself.

The road to Rome

Little is known about the next 12 years of Poussin's life, and few of his works from this period survive. He lived in Paris, spent some time in Lyon, and made two aborted attempts to travel to Rome – the goal of many ambitious artists at the time. He reached the city in March 1624, a few months before turning 30, and with the exception of a brief stay in Paris in 1640–42, it was to be his home for the rest of his life.

Poussin endured hardship in his early days in Rome, but his fortunes changed dramatically in 1627, when he won an important commission from Cardinal Francesco Barberini (see box, right), for whom he painted *The Death of Germanicus*.

This painting shows the Roman general Germanicus on his deathbed, and is the first work in which Poussin revealed his distinctive artistic personality. He chose the subject himself – no one had previously painted it – and with the picture he virtually created the theme of a hero on his deathbed.

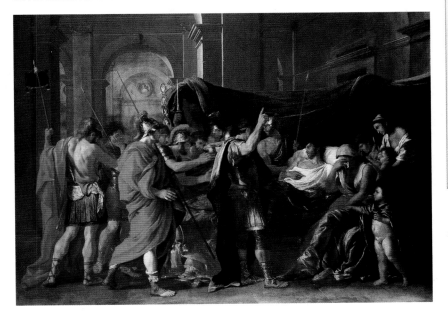

◁ **SELF-PORTRAIT, 1650**
Poussin made this portrait for one of his patrons, the collector Paul Fréart de Chantelou. He depicts himself as the consummate artist, a black toga signalling his classical inspiration.

◁ **THE DEATH OF GERMANICUS, 1627**
Poussin's great history painting gives shape to his moral principles. Germanicus confronts death with stoicism, flanked by groups of figures expressing grief and compassion.

" The most **accomplished** and most **perfect** painter among all **the moderns.** "

ROLAND FREART DE CHAMBRAY, *IDEA OF THE PERFECTION OF PAINTING*, 1662

IN CONTEXT
Stoicism

The notable balance and equanimity of Poussin's art reflects his keen interest in Stoicism, a system of moral philosophy associated with some of the eminent thinkers of ancient Greece and Rome, such as Seneca the Younger. Stoics claimed that peace of mind made a wise person indifferent to misfortune or even death – able to "stand firm and remain unmoved before the assaults of mad, blind fortune", as Poussin put it in a letter to Paul Fréart de Chantelou, one of his patrons.

STATUE OF
SENECA THE
YOUNGER

His treatment too was innovative: he used a shallow arrangement of figures – rather like a classical bas-relief that would have adorned a Roman sarcophagus – to give a tragic event from history nobility, and to convey the quiet heroism of the scene.

Changing fortunes

In 1628, Barberini recommended Poussin for an even more prestigious commission – an altarpiece, *The Martyrdom of St Erasmus*, for St Peter's Basilica – but when it was unveiled, it received a lukewarm reception. Poussin had another setback when he competed unsuccessfully for a fresco commission in San Luigi dei Francesi, the French church in Rome.

Now convinced that his talent was not suited to large public works, Poussin concentrated on pictures of a more modest size for private collectors, and he moved away from the rhetorical Baroque style he had shown in *St Erasmus* to a more restrained classical idiom that consciously recalled the forms of ancient Roman sculpture. Coinciding with this crisis in his art, Poussin became seriously ill (with venereal disease, according to one of his early biographers), but he was nursed back to health by the family of Jacques Dughet, a French-born pastry cook. After he had recovered

▷ **THE MARTYRDOM OF ST ERASMUS, 1628–29**
An executioner pulls the intestines from a dying Erasmus, who is killed for refusing to worship the idol (top right in the painting). *Putti* descend, carrying a crown and a palm – the traditional symbols of martyrdom.

from the illness, he married Dughet's daughter, Anne-Marie, in 1630. Her brother, Gaspard Dughet, became Poussin's pupil and had a successful career as a landscape painter.

A summons to France

Poussin began to prosper in the 1630s, his growing success owing much to his friendship with Cardinal Barberini's secretary, Cassiano dal Pozzo, a man of wide scholarly interests. As well as commissioning many paintings from Poussin, he introduced him to other patrons with similar tastes and gave him access to his huge collection of drawings and prints, which formed a kind of visual encyclopedia of the ancient world. He called it his "paper museum".

By the mid-1630s, Poussin's reputation had spread to his home country, and by the end of the decade, Cardinal Richelieu – Louis XIII's chief minister – was determined to bring the artist back to France to work for

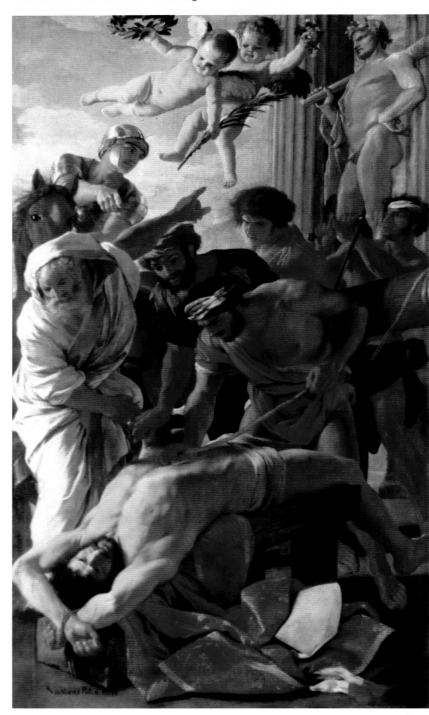

KEY MOMENTS

1627
Paints *The Death of Germanicus*, generally considered his first masterpiece.

1629
Completes *The Martyrdom of St Erasmus*, a large altarpiece for St Peter's, Rome.

1648
At the peak of his classical grandeur, paints a pair of pictures on the death of Phocion.

1664
Illness and infirmity prevent Poussin from completing his final painting, *Apollo and Daphne*.

◁ **LANDSCAPE WITH THE ASHES OF PHOCION**, 1648
Here, Poussin portrayed the ideal world of classical antiquity through well-proportioned buildings set in a harmonious landscape. The figures tell the story of Phocion, an Athenian general renowned for his virtue, who was falsely accused of treason, executed, and cremated ignominiously outside the city walls. His widow, in the centre foreground, stoops to collect his ashes.

the king. Poussin did not want to leave Rome, but was constantly pressed by Richelieu to do the king's bidding. He arrived in Paris in December 1640 and remained there, unhappily, for almost two years. He eventually managed to leave in September 1642, on the pretext that he wanted to fetch his wife. Richelieu and the king died soon afterwards, so Poussin was not pressurized into returning.

His stay in Paris was not entirely negative. He met discerning admirers of his work there, and from this time, his major paintings were done mainly for French rather than Italian patrons.

Style and subject

Poussin worked slowly, and unlike many painters of the time, he never used assistants, preferring to work in complete solitude. Everything he did was methodical and carefully calculated. In addition to making numerous preparatory drawings for his paintings, he also created small wax figures that he placed on a kind of miniature stage, moving them around so that he could study the effects of composition and lighting.

Poussin had painted romantic literary subjects early in his career, but his later material was invariably serious, taken from the Bible, ancient history, or mythology. From about 1640, he sometimes used landscape settings in his paintings, and he composed them with the same sense of order that he brought to his figures, turning natural elements into forms of almost geometrical clarity. The finest include a pair of paintings (1648) illustrating the death of Phocion – a loyal and brave statesman in ancient Athens who was unjustly executed. The sombre and majestic landscapes are perfectly attuned to this story of self-sacrifice and cruel fortune.

Late works

In the final decade of Poussin's life, his style changed, taking on an almost mystical flavour, expressed through wild, rugged landscapes and silvery, ethereal colouring. In old age, he was troubled by trembling hands, which sometimes prevented him from working. He became a virtual recluse, seeing only his closest friends.

In spite of his retiring nature, small output, and the fact that he worked mainly for middle-class patrons rather than aristocrats, his status as one of the greatest artists of his age was unchallenged at the time of his death on 19 November 1665 at the age of 71.

Following his death, Poussin was enshrined as one of the guiding lights of French art. To the Royal Academy of Painting and Sculpture (founded in Paris in 1648), he was the embodiment of the belief that art should be morally uplifting and should also involve the rational application of skills. Although Poussin's artistic reputation declined somewhat in the 19th century after the onset of Romanticism (with its emphasis on high emotion and self-expression), he continued to inspire intellectually minded artists as varied as Cézanne and Picasso.

▽ **POUSSIN'S STATUE AT THE INSTITUT DE FRANCE IN PARIS**
The formal, analytical qualities of Poussin's work exerted a powerful effect on the Academic tradition of painting and he was commemorated by the nation's learned institutions.

" He **studied the ancients** so much that he acquired a habit of **thinking** in their way. "

SIR JOSHUA REYNOLDS, *DISCOURSE FIVE*, 1772

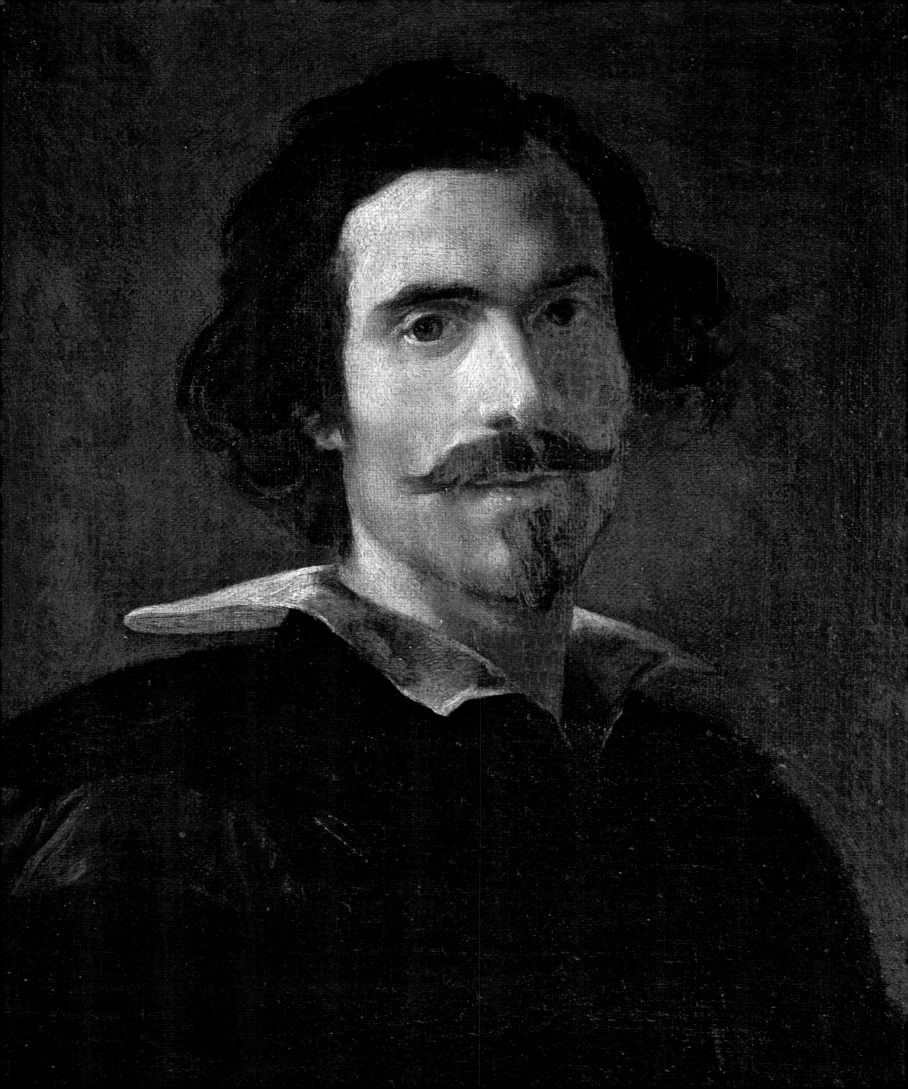

Gianlorenzo Bernini

1598–1680, ITALIAN

The colossus of Italian Baroque art, Bernini had a larger and more enduring impact on the appearance of Rome than any other artist, before or since.

Bernini's contemporaries thought of him as a second Michelangelo, and the comparison is apt in view of the range, power, and impact of his work. He was by far the greatest sculptor of the 17th century and ranks high among the architects of the age. Although he painted only as a recreation, he was so talented in this field that his pictures have sometimes been mistakenly attributed to artists of the calibre of Poussin and Velázquez.

Like Michelangelo, Bernini had a fiery temperament, intense religious belief, extraordinary energy, and a consuming passion for art, even in old age (both men lived into their eighties). However, there were also striking differences between the two artists. Michelangelo was solitary by nature and usually worked alone, whereas Bernini was outgoing and ran a busy studio. And while Michelangelo lived austerely and showed no interest in money as an end in itself, Bernini loved the trappings of success and died an immensely wealthy man.

The master of marble

Gianlorenzo Bernini was born in Naples on 7 December 1598, the son of a sculptor, Pietro Bernini (1562–1629). The family soon moved to Rome, and Gianlorenzo lived there for the rest of his life, his only notable absence from the city being a visit to in Paris in 1665.

Bernini's father was a skilled carver in marble, and Gianlorenzo quickly followed in his footsteps, producing his first sculptures when he was still a child. Although he used various materials during his long career,

IN PROFILE
Bernini's mistress

One of Bernini's greatest portrait busts is of Costanza Bonarelli, with whom he had a passionate love affair. She was the wife of one of his assistants, Matteo Bonarelli. In 1638, when Bernini discovered that his brother Luigi Bernini was also having an affair with Costanza, he attacked him in a savage frenzy, and sent a servant to slash her face with a razor (a common act of ritual revenge at the time). Luigi fled, the servant was exiled, and Bernini escaped with a fine (which he never paid). Costanza's marriage survived and Bernini himself married in 1639.

BUST OF COSTANZA BONARELLI, c.1636–38

marble remained his favourite, and even when he was in his seventies, he would carve it for many hours at a stretch. People who saw him at work reported that he seemed to be in a kind of ecstasy, and when his assistants tried to get him to rest from the hard physical labour he would say, "Leave me alone. I'm in love with it."

Borghese marbles

Bernini's reputation as a boy wonder brought him to the attention of the Barberini and Borghese families, who were among the leading art patrons in Rome and who did much to foster his career. Between 1618 and 1625, he carved a series of four spectacular, larger than life-size marbles for Cardinal Scipione Borghese, which established him firmly as the most brilliant and inventive sculptor of the day.

One of these sculptures is *David*, which makes for fascinating comparison with the treatment of the same subject by Donatello and Michelangelo, the greatest sculptors of the 15th and 16th centuries. While

△ *DAVID*, 1623–24
Bernini's marble sculpture of David shows him poised to launch his slingshot at the giant Goliath. The artist captures the tension of the moment in David's coiled limbs and body and in the determination of his expression.

◁ **SELF-PORTRAIT, c.1635**
Bernini painted a large number of self-portraits, set against bare backgrounds. They are characterized by their sombre tones and chiaroscuro.

" We **hope** that one day **this boy** will become the **Michelangelo** of his century. "

POPE PAUL V, c.1615, CITED IN FILIPPO BALDINUCCI, *LIFE OF BERNINI*, 1682

their figures are shown in repose, Bernini's is in violent motion, about to hurl a stone from his sling. It exemplifies the dynamism of the Baroque style, of which Bernini was one of the supreme exponents.

Unmatched expressiveness

David's straining sinews and his look of fierce concentration demonstrate Bernini's virtuosity as a carver, which enabled him to represent a range of surfaces,

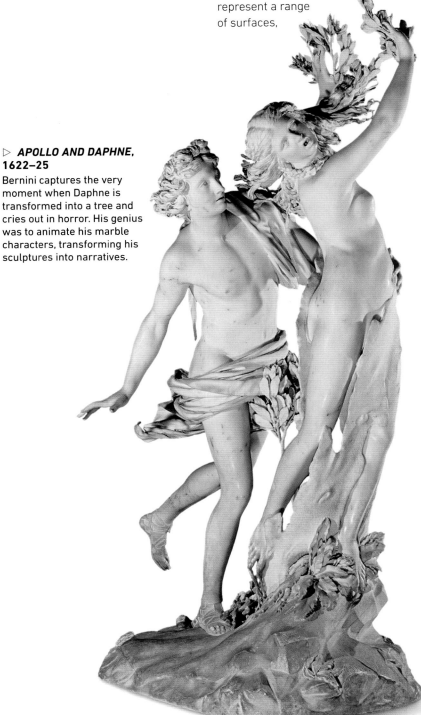

▷ **APOLLO AND DAPHNE, 1622–25**
Bernini captures the very moment when Daphne is transformed into a tree and cries out in horror. His genius was to animate his marble characters, transforming his sculptures into narratives.

textures, and expressions with a vividness that had never been achieved before in marble. Bernini's biographer Filippo Baldinucci wrote that it seemed as if his chisel was "cutting wax rather than stone".

The other three Borghese sculptures are similarly remarkable in technique: in *Aeneas, Anchises, and Ascanius*, Bernini depicts the contrasting musculatures of a child, a young man, and an old man; in *Pluto and Proserpina*, he shows the abducted Proserpina struggling ineffectually against the brutal figure of Pluto, her face streaked with tears and her soft flesh yielding under his powerful grasp; and in *Apollo and Daphne*, he captures the nymph's expression of horror as she transforms into a tree, tying to evade the longing Apollo.

Architect to St Peter's

In 1623, Maffeo Barberini was elected pope as Urban VIII, and Bernini quickly became the dominant artist at the papal court and in Rome as a whole. He was appointed architect to St Peter's in 1629, but even before then he had started on a series of great works for the enormous church.

The first was the Baldacchino (1624–33) – a huge bronze canopy over the high altar that ranks as one of his most original creations. It was followed by a dramatic marble statue of St Longinus (1629–38) and by Urban's tomb (1628–47).

In addition to such papal projects, Bernini produced a range of other works, including portrait busts and the design of the façade of the church of Santa Bibiana, Rome (1624–26), his first architectural commission. His output was not confined to the visual arts. He loved the theatre and wrote many comic plays and composed music for the stage.

△ **TOMB OF URBAN VIII, 1628–47**
This harmonious pyramidal monument has the pope in bronze, flanked by the figures of Charity and Justice in marble. The skeleton (Death) writes the pope's name on a scroll.

An arranged marriage

Some commentators have pointed to Bernini's sexual promiscuity and his libertine bachelorhood. But the huge scandal surrounding his stormy love affair with Constanza in 1638 (see box, p.109) was smoothed over in May the following year, when the artist, aged 40, married Caterina Tetzio, the 22-year-old daughter of a well-respected family from Rome. Although it was, by all accounts, an arranged marriage, the couple had 11 children and remained married for 34 years, until Caterina's death in 1673.

Papal patronage

After the death of Urban VIII in 1644, Bernini's status at the papal court declined. This was partly because

> " **Bernini** was made for **Rome** and Rome **for Bernini**. "
>
> POPE URBAN VIII, c.1640

the new pope, Innocent X, had more conservative artistic tastes than his predecessor, and partly because of a rare but embarrassing mistake. Bernini had added a pair of bell towers to the façade of St Peter's, but they had to be demolished in 1646 because one of them was structurally unsound. Bernini's jealous rivals rejoiced at this, but in spite of the setback he kept his position as architect at St Peter's.

St Teresa

The decline in papal patronage gave Bernini more freedom to take on private commissions, and this led to perhaps his most celebrated masterpiece, the marble group of *The Ecstasy of St Teresa* (1647–52) that forms the centrepiece of the Cornaro Chapel in the church of Santa Maria della Vittoria, Rome. Commissioned by the hugely wealthy Cardinal Federico Cornaro in honour of his family and the recently canonized St Teresa of Avila, the chapel is fairly small but very lavish. One of the characteristics of Baroque art at its highest pitch is the fusion of various arts to create an overwhelming emotional impact, and here architecture, sculpture, painting, marble decoration, gilt bronze, and natural lighting from a hidden window combine to create a breathtaking

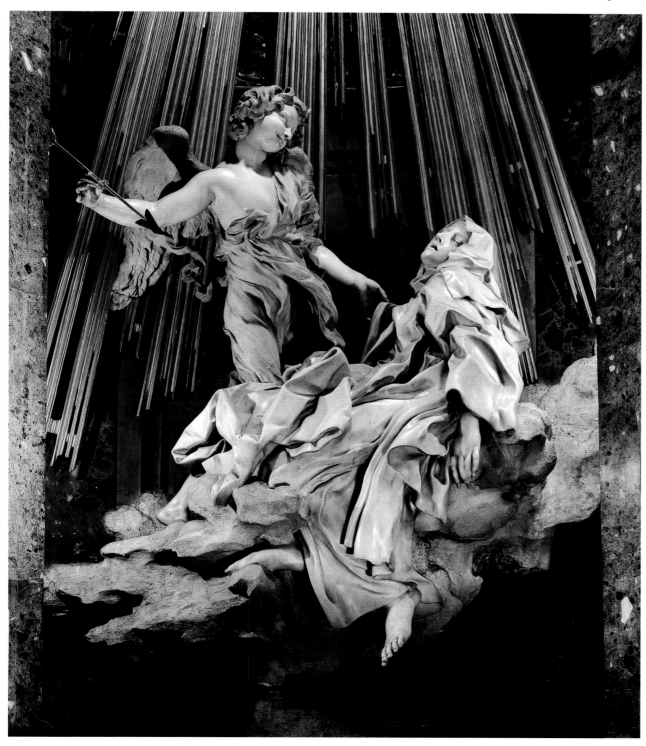

ON TECHNIQUE
Caricatures

The invention of caricature, as we now usually understand the term, is generally credited to the Italian painter Annibale Carracci (1560–1609), who is said to have met Bernini as a boy and predicted a great future for him. Bernini too became a brilliant caricaturist. His son Domenico described how "as a joke he exaggerated some defect in a person's appearance, without destroying the resemblance". Bernini worked quickly, using just a few lines to create these works. He usually depicted "important personages, since they enjoyed recognizing themselves and others".

CARICATURE OF POPE INNOCENT XI

◁ ***THE ECSTASY OF ST TERESA, 1647–52***

In her memoir, the Carmelite nun and mystic St Teresa of Avila described a passionately spiritual encounter with an angel carrying "a long spear of gold tipped with fire". Bernini's depiction of the episode captures her exalted emotions.

▷ **COLONNADE, ST PETER'S, 1656–67**
The two swooping arms of Bernini's colonnade enclose a huge oval piazza in front of the basilica of St Peter's.

IN CONTEXT
Rome's fountains

Rome is said to have more fountains than any other city in the world, and Bernini designed some of the most memorable of them. Fountains were more than just attractive features of the urban landscape. Maintaining a good water supply (partly through the upkeep of ancient Roman aqueducts) was a high priority for public health, and the popes used fountains as ostentatious, self-congratulatory symbols of their beneficence.

DETAIL OF THE *FOUNTAIN OF THE FOUR RIVERS*, 1648–51

vision of the saint in a rapturous swoon as she experiences mystic union with God.

Although Innocent X was generally unsympathetic to Bernini, he realized his vast talent should not be wasted and employed him on certain works, most notably the *Fountain of the Four Rivers* (1648–51) in Piazza Navona, the most magnificent of several fountains that the artist designed in Rome.

When Alexander VII succeeded Innocent X in 1655, Bernini was restored to full papal favour and soon began work on his architectural masterpiece – the majestic colonnade (1656–67) that encloses the piazza in front of St Peter's. Bernini compared the building's spectacular, sweeping architectural forms to the motherly, all-embracing arms of the Church.

In the service of the king

In 1665, Bernini paid a visit to Paris to work for Louis XIV, the French monarch. Louis' "invitation" was really more of a command: he was the most powerful man in Europe and the pope could not risk offending him. The visit was not a success, mainly because of the hostility of French artists to Bernini's ideas. Bernini's main task was to make designs for the east front of the Louvre,

▷ **BUST OF LOUIS XIV, 1665**
Bernini's depiction of the absolutist French "Sun King" flatteringly emphasizes his authority and heroism.

which was a royal palace at the time, but these were rejected in favour of French plans. However, he did carve a superb bust of Louis XIV (with some difficulty, as he found French marble brittle compared with Italian marble).

The major commissions of Bernini's final years included a series of 10 larger than life-size figures of angels carrying the symbols of Christ's Passion to decorate the Ponte Sant'Angelo – the main bridge across the River Tiber. They were commissioned by Pope Clement IX, a highly cultured man, who became a close friend of Bernini's.

" Not only the **best sculptor** and **architect** of his age, but, to put it simply, its **greatest man** as well. "
CARDINAL PIETRO SFORZA PALLAVICINO, QUOTED IN FILIPPO BALDINUCCI, *LIFE OF BERNINI*, 1682

KEY MOMENTS

c.1610–15
Makes *The Goat Amalthea Nursing the Infant Jupiter*, his first surviving sculpture.

1623–24
David, one of a series of sculptures for Cardinal Scipione Borghese, helps to establish Bernini's fame.

1624–33
Makes the Baldacchino, an immense bronze canopy over the high altar in St Peter's, Rome.

c.1636–38
Sculpts a private portrait bust of his mistress, which anticipates the informality of 18th-century portraiture.

1647–52
Creates *The Ecstasy of St Teresa*, his most famous sculpture and an archetypal work of Baroque art.

1648–51
Makes his most spectacular fountain, the *Fountain of the Four Rivers*, for Rome's Piazza Navona.

1656–67
Designs the colonnade enclosing the piazza in front of St Peter's – his greatest work as an architect.

1671–78
Creates his last major public work, the tomb of Pope Alexander VII in St Peter's.

Two of the angels were carved by Bernini himself, the others by collaborators to his designs. They show the increasing spirituality of Bernini's late work: there is less concern with naturalism (forms are expressively elongated) and the swirling draperies reflect the exalted inner states of the angels. His final great project was the tomb of Pope Alexander VII in St Peter's basilica (1671–78).

A sovereign of art

Bernini died in Rome of a stroke on 28 November 1680, a week short of his 82nd birthday. He was buried, with little ceremony, in a modest family vault in the Basilica di Santa Maria Maggiore. It was not until 1898, more than two hundred years after his death, that a small bust and plaque were placed on the front of his house on the Via della Mercede in public recognition of his life and work: "Here lived and died Gianlorenzo Bernini, a sovereign of art, before whom popes, princes, and a multitude of peoples reverently bowed."

Bernini's work had an immense impact on Italian sculpture of his own time and it continued to be highly influential in Italy – and in many other Catholic countries – well into the 18th century. However, the artist's reputation declined with the growth of the Neoclassical movement, which valued rationality and decorum over energy and emotion. His work fell out of favour in the 19th century (like Baroque art in general), as it seemed vulgar and insincere to the Victorians. It was not until the second half of the 20th century that Bernini regained his status as one of the true giants of world art.

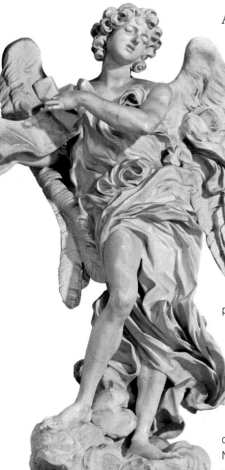

△ **ANGEL WITH THE SUPERSCRIPTION, 1667–69**
Carved by Bernini's own hand, this angel carries the sign attached to the Cross inscribed with the letters INRI, denoting "Jesus of Nazareth, King of the Jews".

▽ **TOMB OF POPE ALEXANDER VII, 1671–78**
Bernini's monument includes a bronze skeleton, representing Death, who holds an hourglass to symbolize the transitory nature of human life.

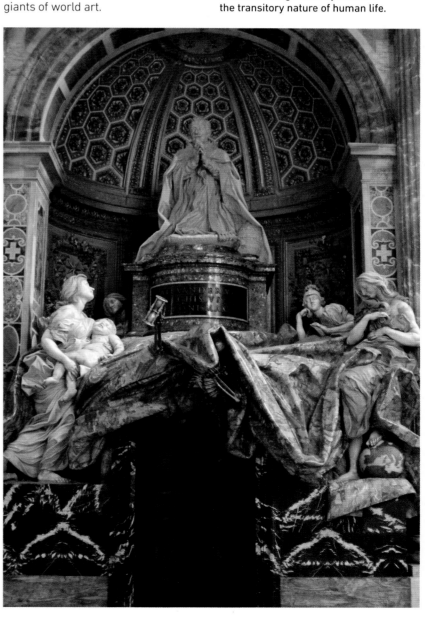

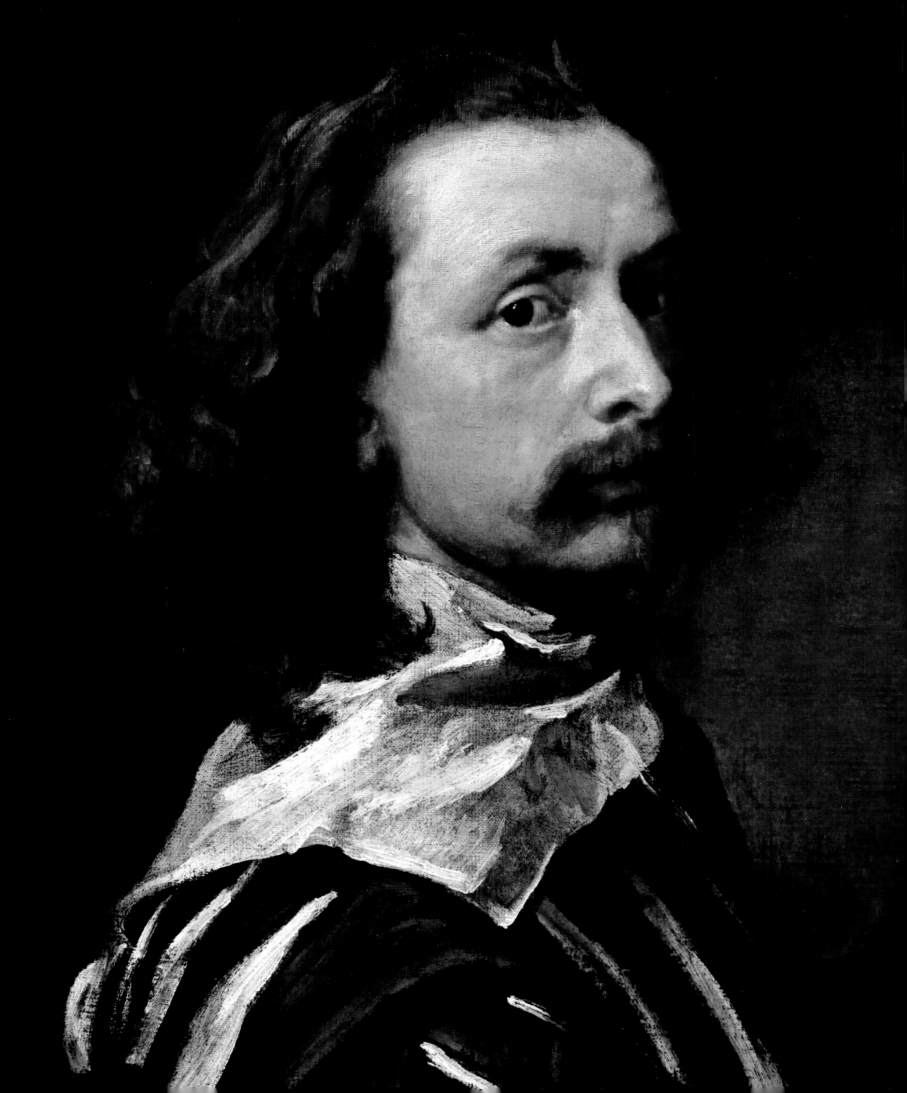

Anthony van Dyck

1599–1641, FLEMISH

Renowned as one of the world's greatest portrait painters, van Dyck created images of matchless grace and aristocratic refinement that inspired other artists for centuries.

Anthony van Dyck ranks second only to Rubens among 17th-century Flemish painters. While still in his teens, he became Rubens's chief assistant, working on huge decorative schemes for churches and palaces, and throughout his career he sought opportunities to test himself in the same arena. However, his portraits were so much in demand that they eventually took up almost all his working life. He ended his career as painter to Charles I of England, and created such seductively glamorous images of the king, his family, and his courtiers that they have helped to determine posterity's view of the era.

Early career

Van Dyck was born in Antwerp on 22 March 1599, the son of a prosperous textile merchant. There was artistic blood on both sides of the family, for his mother was a skilled embroiderer and his paternal grandfather had been a painter before turning to commerce. In 1609, aged 10, he was apprenticed to Hendrick van Balen, a leading Antwerp painter, and he was registered as a

△ **THE JESUIT CHURCH, ANTWERP, SEBASTIAN VRANCX, 1630**
This painting shows the interior of the St-Carolus Borromeus church in Antwerp. Its ceiling paintings were destroyed by fire in 1718.

◁ **SELF-PORTRAIT, 1640**
Painted in the last year of van Dyck's life, this intimate and engaging image shows the artist at work. It is the last of his seven known self-portraits.

master in the city's painters' guild in February 1618, a month before his 19th birthday. By this time, he was probably already working for Rubens and soon became his right-hand man. In 1620, Rubens was commissioned to supply 39 ceiling paintings for the Jesuit Church in Antwerp; the contract specified that although he would make the designs himself, the execution would be mainly by "van Dyck and certain other of his disciples" (no other assistant is mentioned by name).

Imitating the master

Van Dyck became so skilful at imitating Rubens's style that even experts can have difficulty in deciding which artist was responsible for certain paintings, or parts of them. In his independent works of this period (mainly religious pictures), van Dyck similarly painted in a thoroughly Rubensian manner (there is no discernible influence from his teacher

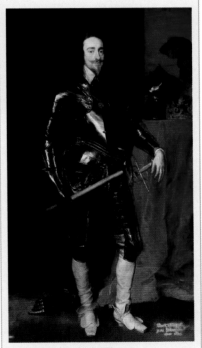
" **Van Dyck** is still with Signor Rubens, and his works are **hardly less esteemed** than those of his **master**. "

FRANCESCO VERCELLINI, IN A LETTER TO HIS MASTER, THE EARL OF ARUNDEL, 1621

▷ **SAMSON AND DELILAH, c.1618–20**
This painting shows the biblical hero Samson asleep on his lover Delilah, and about to have his hair shorn. Van Dyck's composition was obviously guided by Rubens's take on the scene from 1609–10.

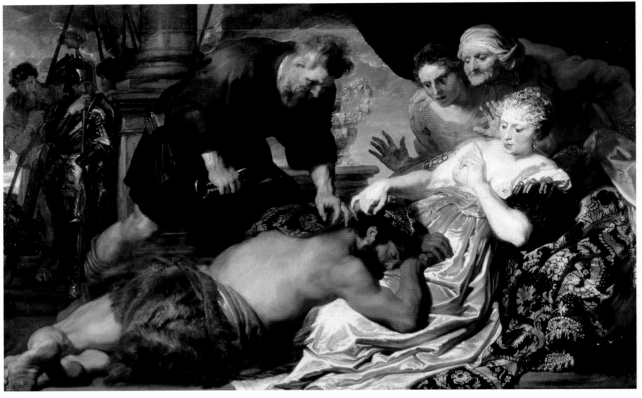

IN CONTEXT
The Italian sketchbook

During his years in Italy (1621–27), van Dyck took a sketchbook with him, making rapid drawings, mainly in pen and brown ink, of works of art that interested him. (The sketchbook is now in the British Museum, London.) Sometimes he added technical notes or words of admiration. He drew the work of Titian more often than that of any other painter. In 1624, in Palermo, Sicily, he met the painter Sofonisba Anguissola, then aged about 90, and drew her portrait, shown below.

SOFONISBA ANGUISSOLA, FROM VAN DYCK'S ITALIAN SKETCHBOOK, 1624

van Balen). But from the very start of his career, van Dyck's paintings often show a febrile sensitivity – reflecting his highly strung temperament – that distinguishes them from the more energetic and robust work of his tutor, Rubens.

As well as absorbing so much from Rubens stylistically, van Dyck seems to have deliberately imitated his mentor's aristocratic bearing and conduct. Although he had great charm, van Dyck sometimes irritated people with his lordly airs: one of his early biographers, Giovanni Pietro Bellori, describes him as "proud by nature and anxious for fame. He wore fine fabrics, hats with feathers and bands, and chains of gold across his chest, and he maintained a retinue of servants." This flamboyance is evident in his numerous self-portraits, in which he flaunts his good looks and success.

Launching a solo career
In October 1620, van Dyck struck out on his own, going to England, where he remained until March 1621. He worked for two aristocrats – the Duke of Arundel and the Duke of Buckingham – and also for James I. After returning to Antwerp for six months, he set off for Italy in October 1621, where he remained for six years. At the beginning of this period, he regarded himself as primarily a painter of grand figure compositions, but by the time of his return north, he was working mainly as a portraitist.

Van Dyck travelled widely in Italy, but he was based mainly in Genoa, perhaps following the advice of Rubens, who had worked there and knew that the city – famous for its banking industry – had many wealthy potential clients. Rubens had painted some magnificent full-length portraits of the Genoese nobility and van Dyck continued where he had left off. His Genoese portraits are just as imposing as those Rubens painted, but they have an added quality of aristocratic elegance that is now inseparable from van Dyck's name.

The influence of Titian
An even greater influence on van Dyck's portraits was Titian, whose work he studied closely in Italy, learning from his variety of poses, his sumptuous colouring, and his vigorous brushwork. Like Titian, van Dyck almost always painted on canvas and used panel only occasionally for smaller works, whereas Rubens preferred to work on panel. In contrast to Rubens's liquid brushwork, which often skims over the smooth wood, van Dyck's handling of paint is usually drier and rougher – more like Titian's.

> " We are all **going to heaven**, and **van Dyck** is of the **company**. "
> ATTRIBUTED TO THOMAS GAINSBOROUGH, ON HIS DEATHBED, 1788

KEY MOMENTS

1613
Paints *Portrait of a Man Aged 70*, his earliest dated work, at the age of only 14.

c.1618–20
Creates *Samson and Delilah*, a splendidly full-blooded biblical work, showing van Dyck at his most Rubensian.

1623
Paints *Marchesa Elena Grimaldi*, one of the greatest of the aristocratic portraits that he produced in Genoa.

1628
Ecstasy of St Augustine is his first major altarpiece for an Antwerp church.

1635–36
His portrait *Charles I in Three Positions* is sent to Gianlorenzo Bernini in Rome to enable him to make a sculpted bust of the king.

Spirituality

In autumn 1627, van Dyck returned to Antwerp, perhaps because he had learned that his sister Cornelia was seriously ill. She died before he arrived and her death seems to have caused him to reflect on spiritual matters. He came from a devout Catholic family (one of his brothers was a priest and one of his sisters a nun), and over the next two or three years he produced some of his most impressive sacred works. During this time, he was the outstanding artist in Flanders, as from 1628 to 1630 Rubens was in Spain and England on diplomatic missions. After Rubens's return, however, van Dyck was once more in his shadow (although they always seem to have remained on the best of terms personally) and he started to look elsewhere for opportunities.

After spending the winter of 1631–32 in The Hague, working at the court of Prince Frederick Henry of Orange, in March 1632 van Dyck moved to London, where Charles I appointed him "principal painter". Although he married one of the queen's ladies-in-waiting, van Dyck never really settled in England. Charles was a passionate art lover and greatly admired his work, honouring him with a knighthood in 1632, but he was often in arrears with payments and van Dyck continued to explore openings on the Continent. He was away in Flanders for almost a year in 1634–35, and the death of Rubens in May 1640 opened the way for him to become the leading artist there.

A model and an inspiration

In September or October 1640, van Dyck returned to Antwerp and by December he was in Paris, where he hoped to win the commission to decorate the Grande Galerie of the Louvre (which went instead to Nicolas Poussin). He was back in London by May 1641, then after another visit to the Continent, he returned finally to England in November. His health had been declining during his travels, and when he reached London he was mortally ill. He died on 9 December 1641, aged 42, and was buried in St Paul's Cathedral. His tomb, which bore

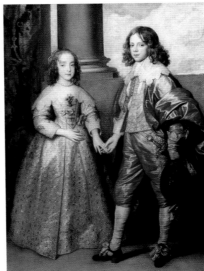

the inscription "Anthony van Dyck, who, while he lived, gave to many immortal life", was destroyed when the building was gutted during the Great Fire of London in 1666.

With their air of relaxed, confident authority and effortless elegance, van Dyck's portraits became an inspiration and a model for countless other artists, especially in Britain. Thomas Gainsborough in the 18th century and Thomas Lawrence in the 19th century were among the eminent portraitists who particularly revered him, and the last of his great disciples was John Singer Sargent, who continued his tradition into the 20th century.

◁ **ROYAL COUPLE, 1641**
Van Dyck's portrait of Princess Mary (1631–60), daughter of Charles I of England, and Prince William II of Orange (1626–50) shows the couple at the time of their marriage in 1641.

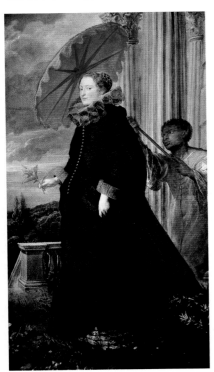

◁ **MARCHESA ELENA GRIMALDI, 1623**
In this painting – made during van Dyck's period in Genoa – the haughty *marchesa* strolls on her terrace, attended by a black slave, a reference to the human trade from Africa to Genoa.

△ **STATUE OF VAN DYCK**
This statue, made in white marble by the Belgian sculptor Léonard De Cuyper in 1856, stands as a tribute to Anthony van Dyck in Antwerp, the city of his birth.

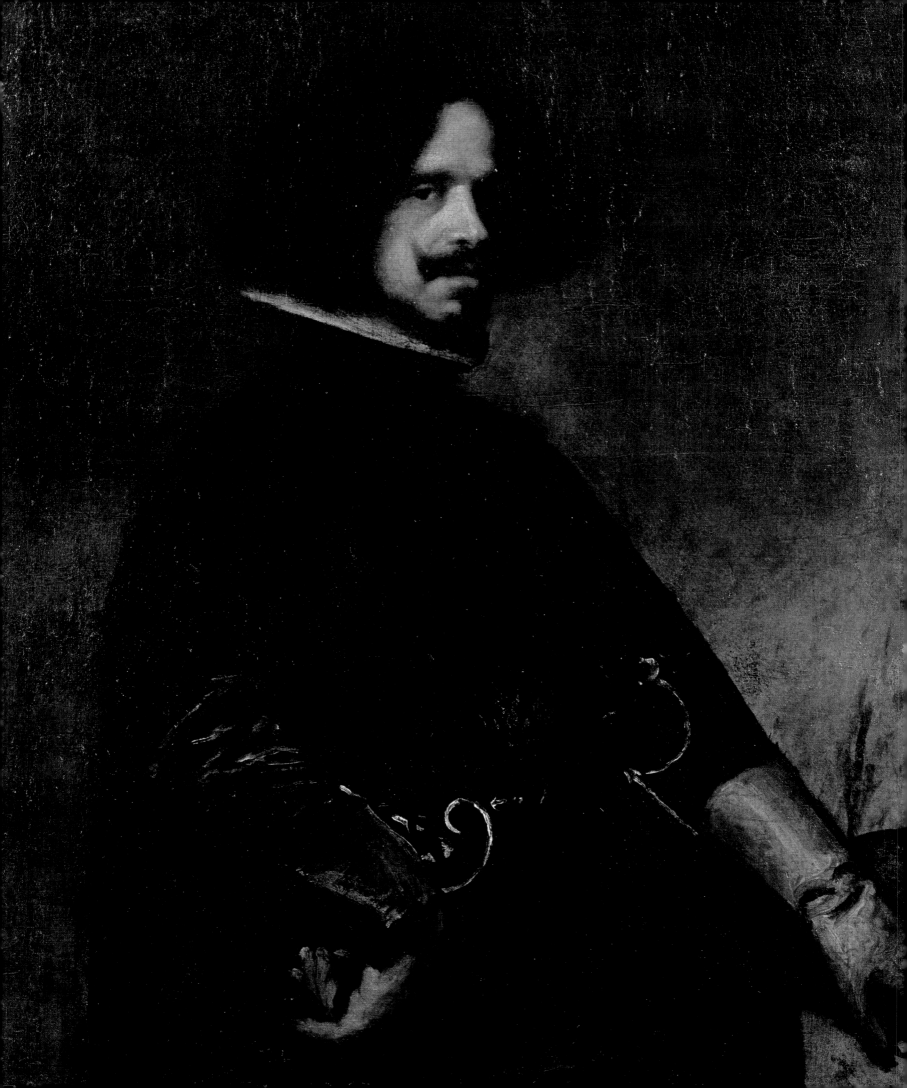

Diego Velázquez
1599–1660, SPANISH

The greatest of all Spanish painters, Velázquez is celebrated mainly for his portraits, which were acclaimed on his travels in Italy as well as at the court of Philip IV in Madrid.

Diego Velázquez enjoyed a life of smooth and continual success, without any of the setbacks that characterize the careers of so many great artists. While still in his teens, he created powerful and original works. By the age of 24, he was the king's favourite painter, and he ended his career with a knighthood – a great honour for a Spanish artist.

Stylistically too, Velázquez developed in a steady, unruffled way, with no striking changes of direction in his career. There are, nevertheless, huge differences between his earliest and his latest works, reflecting the increasingly subtle ways in which he observed and depicted the world over his 40-year working life.

Early life
Velázquez was born in Seville, in June 1599, to moderately prosperous parents. He excelled at school but his chief interest was always art, and at

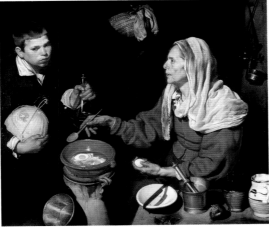

△ **AN OLD WOMAN COOKING EGGS**, 1618
This scene was painted when Velázquez was 18 or 19 years old. His skill in depicting texture, and the effects of light on surfaces, is already evident.

the age of 12 he was apprenticed to the painter (also poet and scholar) Francisco Pacheco. At 17, Velázquez qualified as a master painter, and a year later he married Pacheco's 15-year-old daughter, Juana. Pacheco was a rather conventional artist, but he was a sympathetic teacher and encouraged Velázquez to "go to nature for everything". That Velázquez took his advice is evident in his earliest surviving paintings, done when he was still in his teens.

Velázquez painted few portraits in his early years, concentrating more on religious images and *bodegones* (scenes of everyday life in taverns or similar humble settings). *Bodegones* usually feature prominent still-life details, in which Velázquez showed an extraordinary ability to depict different surfaces and textures with a sense of almost tangible reality. However, these paintings were not mere exercises in technical virtuosity: they have a seriousness and self-assurance that are remarkable in such a young artist.

From Seville to Madrid
At this time, Seville was one of Europe's most prosperous cities, with a vigorous cultural life. It offered the prospect of a highly successful career to someone as precociously talented as Velázquez, but he had higher ambitions, wishing to succeed in the capital, Madrid. He made a visit there in 1622, impressed various noblemen with his dignified bearing as well as his skill, and the following year was invited to return to paint a portrait of Philip IV. The portrait has not survived, but Philip was so delighted with it that Velázquez was appointed one of his royal painters.

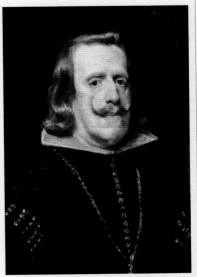

PHILIP IV, VELAZQUEZ, c.1656

▽ **AT THE PRADO**
A bronze of Velázquez stands guard over an entrance to the Prado Museum in Madrid, which holds may of the artist's most famous works.

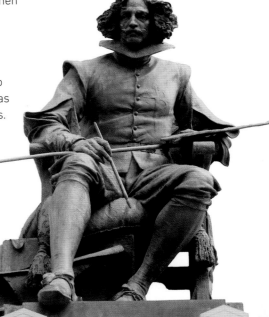

◁ **SELF-PORTRAIT, 1644–52**
This portrait, from Velázquez's workshop, shows him in three-quarter view, gazing out confidently at his audience. He is depicted dressed in black, with a sword, gloves, and a key on his belt.

" This is what I've been **searching** for so long, this **firm** yet **melting impasto**. "

EUGENE DELACROIX, *JOURNAL*, 11 APRIL 1824

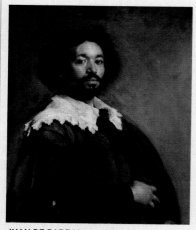
" He is the **greatest** painter there **ever** was. "
EDOUARD MANET, LETTER TO CHARLES BAUDELAIRE, 1865

Royal portraits

Velázquez settled in Madrid, and from then on most of his paintings were done for Philip IV, his family, or members of his court. He now focused almost exclusively on portraits: he gave up *bodegones* and only occasionally produced religious works or other figure compositions.

Philip allowed no other artist to paint his portrait, and he treated Velázquez more as a friend than a servant – a familiarity that was astonishing at the stiflingly formal Spanish court. Philip also expressed his admiration by appointing Velázquez to various administrative posts. These carried great prestige but, in hindsight, could be viewed as a waste of the great artist's time when he should have been busy painting.

The king had a superb art collection, particularly rich in works by Titian (the favourite artist of his grandfather, Philip II). Under their influence, Velázquez's style and technique began to change. In his early work, his colours were mainly dark and earthy, and his paint was thick and supple. Now, however, his colours began to lighten and his brushwork became more fluid. Another important influence on him around this time was Peter Paul Rubens, who in 1628–29 spent a year in Madrid on diplomatic business. He became a friend to Velázquez and encouraged him to see the art treasures of Italy. The king granted Velázquez leave and the artist was away in Italy from 1629 to 1631. His style became even looser as he saw more works by Titian and the other great Venetian masters.

History painting

After his return to Spain, Velázquez remained unchallenged as the king's favourite and entered the most fruitful period of his career. In addition to painting numerous royal portraits, including some magnificent large equestrian pictures, he depicted other members of the court, including the "fools" kept to amuse the king. These sympathetic portraits of people who often had disabilities are among Velázquez's most poignant and original works.

He also made some memorable excursions into other fields, notably with a great masterpiece of history painting – *The Surrender of Breda* (1634–35), one of a series of pictures depicting Spanish military victories that he and other court artists produced for the Buen Retiro Palace in Madrid.

Travels in Italy

Between November 1648 and June 1651, Velázquez again visited Italy, where his duties included buying works of art for the royal collection. In Rome, he painted one of his most famous works – a portrait of Pope Innocent X that was exhibited in the Pantheon and acclaimed by Italian artists for its vivid sense of life and character. The pope himself is said to have acknowledged how penetrating the portrait was by remarking that it was "too truthful", and he presented Velázquez with a gold medal and chain in recognition of his genius.

In his final decade, Velázquez's output dropped. He was always a slow and thoughtful worker, but his time was now also taken up with supervising the decoration of royal palaces. However, his art continued to grow in depth and subtlety. He retained his compelling sense of reality, but increasingly subordinated detail to overall effect. In his final paintings, his brushwork is a marvel of sparkling freedom. His early biographer Antonio Palomino (1724) summed it up when he wrote: "One cannot understand it if standing too close, but from a distance it is a miracle." Velázquez cared greatly about status, and although he was honoured and wealthy,

◁ **THE CROSS OF SANTIAGO**
The Order of St James was founded in the 12th century to protect Christian pilgrims from the Moors. Its knights wore the emblem of a sword combined with a fleur-de-lys.

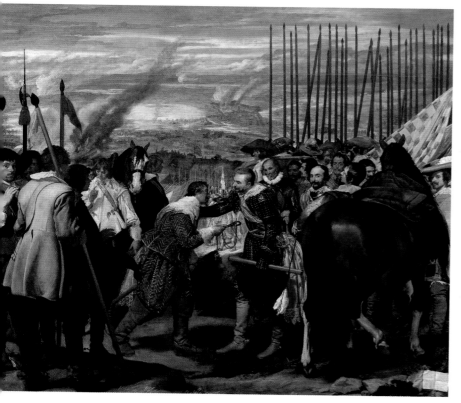

◁ ***THE SURRENDER OF BREDA,*** 1634–35
Velázquez's painting shows the Dutch surrender of the city of Breda to Spanish forces in 1625. The Spanish general Spinola places a consoling hand on the shoulder of his defeated enemy as smoke rises from the city behind.

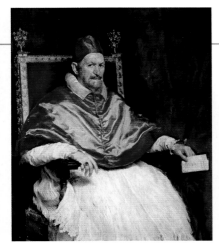

△ **POPE INNOCENT X, 1650**
Perhaps the most famous of all papal portraits, Velázquez's image of Pope Innocent X depicts a man whose papacy was riddled with scandal and who was considered ill-tempered and scheming.

he craved the crowning glory of a knighthood. However, it was not easy for Philip to bestow such a title, as the criteria were extremely strict. Initially, Velázquez's nomination was rejected, but Philip gained special permission from Pope Alexander VII, and Velázquez was made a Knight of Santiago on 28 November 1659. He portrayed himself wearing the order's red cross emblem (right).

Legacy and reputation

Velázquez did not have long to enjoy his new title – he died in Madrid on 6 August the following year. His work had little immediate influence, as most of it was hidden from general view in royal palaces. However, the opening of Spain's national art museum, the Prado, in 1819, made his work publicly accessible and he became a hero to progressive artists, who were inspired by the freedom of his brushwork. Edouard Manet, for example, considered Velázquez to be the greatest of all painters.

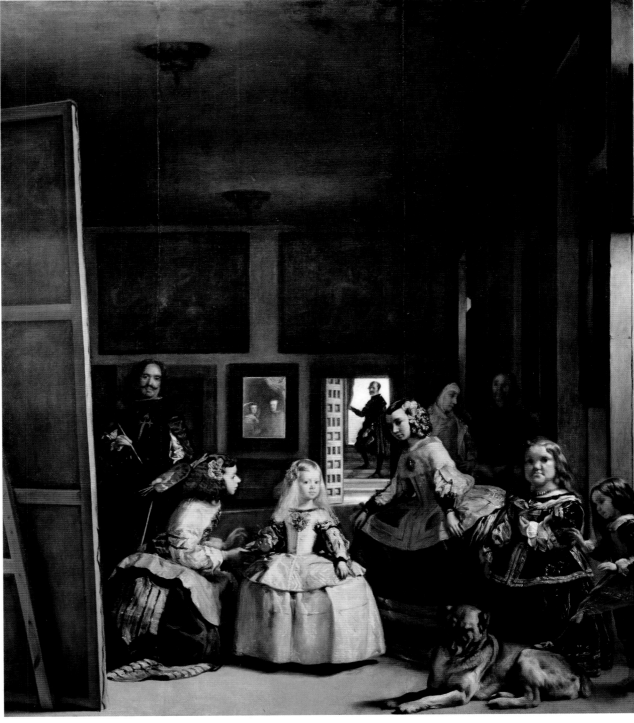

△ *LAS MENINAS*, 1656
On the simplest level, this is a portrait of the royal family and their servants. But its calculated arrangement of figures, symbols, and a mirror – together with Velázquez's depiction of himself busy at work on a painting (left) – has aroused immense scholarly debate on questions of reality, illusion, and representation in art.

KEY MOMENTS

1618
Paints *An Old Woman Cooking Eggs*, an early work that is among the most impressive of his scenes of everyday life.

c.1631–32
Produces *Philip IV in Brown and Silver*, one of the finest of many portraits of his royal master.

1635
Completes *The Surrender of Breda*, a masterpiece of contemporary history painting, showing the capture of a town in the Netherlands.

1650
Paints *Pope Innocent X*. This portrait is one of his few that were well known outside Spain in the 17th and 18th centuries.

1656
Completes *Las Meninas* (*The Maids of Honour*), his most famous and complex painting, showing him at work on a royal portrait.

Kanō Tan'yū

1602–1674, JAPANESE

A painter of the Kanō school, a family that dominated Japanese art for generations, Kanō Tan'yū was known for his mastery of opulent animal and landscape paintings and for his subtle works in single-colour ink.

The Kanō school was established by Kanō Masanobu (1434–1530), the son of a samurai painter. It prevailed for more than 300 years, evolving and diversifying from its Chinese-inspired roots. Patronized by the shogunate, the school became the source of official art that reflected the cultural and moral philosophies of the nobility.

Kanō Tan'yū was born into the family tradition (unrelated artists would also train in the school's workshops); his given name was Morinobu. His grandfather was Kanō Eitoku, one of the most celebrated painters of his time, and his father was Kanō Takano, another major Kanō-school painter whose work was popular at court. When he was 10, Kanō Tan'yū had an audience with Tokugawa Ieyasu, the first of the Tokugawa shoguns, and five years later he was appointed official painter to the shogunate.

Castles and temples

In 1621, Kanō Morinobu moved from Kyoto to Edo (modern Tokyo), which had become Japan's administrative capital. Here, he led his own branch of the Kanō school, emphasizing the Chinese method of copying the work of past masters. He began to produce paintings not only for Edo Castle and the imperial palace at Kyoto, but also for other castles such as Nijō

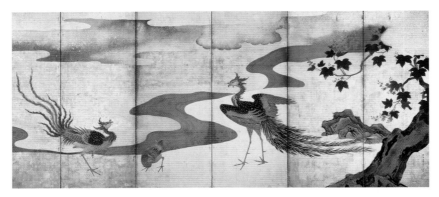

△ **PHOENIXES BY PAULOWNIA TREES, c.1640–50**
Meticulous detail, harmonious use of line, and large areas of gilding distinguish Kanō Tan'yū's large screen painting.

and Nagoya, and for temples. These works – many executed in the Momoyama style (see box, right) – include large panels and screens depicting subjects such as trees, tigers, and birds, with a generous use of gold leaf in the backgrounds.

In 1636, the shogun ordered Morinobu to shave his head like a monk, an indication that he was to withdraw from the world to devote himself to his art. After this, Morinobu adopted the artistic name Tan'yū and produced one of his most famous works – a hand scroll depicting the life of Tokugawa Ieyasu. This shows his mastery of a style very different

from that of the castle paintings: restrained in technique, painted in a single colour of ink, it drew on the influence of the Tosa school of Kyoto.

Kanō Tan'yū worked as a highly respected painter for the rest of his life and was awarded the title of *Hōin* (the highest available rank for an artist) in 1665. By the end of his life, he was considered one of the "three famous brushes" of the Kanō school, along with his grandfather Eitoku and Kanō Motonobu.

> " Peak of the **brush**, great **layman** of the **faith** "

INSCRIPTION ON A SEAL SENT TO KANO TAN'YU BY THE EMPEROR GO-MIZUNOO

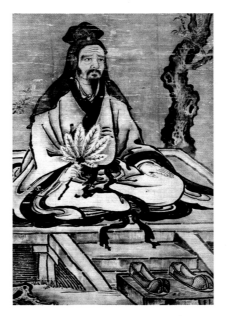

◁ **CONFUCIUS, MID-17TH CENTURY**
Kanō Tan'yū was famous for his ink paintings; his bold line was said to embody the highest Confucian moral qualities. This painting of the philosopher, on silk, is part of a set of three panels.

IN CONTEXT
Momoyama style

Momoyama (Peach Hill) is the place in Kyoto where the feudal lord Toyotomi Hideyoshi built Fushimi Castle. After lengthy wars, Hideyoshi completed the unification of Japan and brought about the Tokugawa shogunate. The artistic style favoured by the shogunate, with bold, natural subjects against a gilded background, was very fashionable in the late 16th and early 17th centuries. Its opulence and the reflective nature of the gilding (which made the rooms in castles seem brighter) appealed to patrons.

A REPLICA OF HIDEYOSHI'S CASTLE STANDS NEAR THE ORIGINAL SITE

▷ **PORTRAIT OF KANO TAN'YU**
This portrait, attributed to Momoda Ryūei (1647–98), shows Kanō Tan'yū in old age, when he was a respected elder statesman of Japanese art and still at work, brush in hand.

Rembrandt

1606–1669, DUTCH

The greatest of all Dutch artists, Rembrandt was remarkable for the range and depth of his work, and was supreme as an etcher and draughtsman as well as a painter.

Rembrandt's career coincided with the golden age of Dutch painting, a brief but extraordinarily rich flowering of art in a region that had previously been something of a cultural backwater. This explosion of creativity was an expression of the pride and optimism that the Dutch felt about their new country, which had won independence from Spain in 1609 after a long, bloody struggle and then quickly developed into the most affluent nation in Europe.

Most painters of the golden age were specialists in depicting subjects from their surroundings – landscapes, everyday life scenes, still lifes, and so on. Rembrandt was the exception. He was highly versatile and excelled at imaginative as well as naturalistic subjects, although portraiture was the backbone of his career.

Early life

Rembrandt Harmensz van Rijn was born in Leiden on 15 July 1606, the son of a prosperous miller ("van Rijn" refers to a branch of the River Rhine overlooked by the family mill).

He was the second youngest of 10 children and presumably the brightest, as he was the only one to attend Leiden's Latin School. At the age of about 13, he was apprenticed to an undistinguished local painter,

△ **THE REMBRANDT HOUSE**
The artist lived and worked in this impressive building in the heart of Amsterdam for more than 20 years. It now houses a museum devoted to him.

Jacob van Swanenburgh, but the most significant part of his training was a period of six months or so in Pieter Lastman's studio in Amsterdam in around 1624. Lastman had spent several years in Italy and specialized in small-scale figure compositions on subjects from history, mythology, and religion. Rembrandt was inspired

to tackle the same kind of subjects – very different from those favoured by most Dutch artists – and his early work was strongly influenced by Lastman's style. He imitated his teacher's dramatic lighting, glossy finish, and vigorous, sometimes exaggerated gestures and expressions.

Leiden to Amsterdam

Aged about 19, Rembrandt returned to Leiden, where over the next few years he built up a reputation as an outstandingly gifted young artist. For a while, he worked closely with another promising local painter, Jan Lievens, who was a year younger. They shared models and perhaps a studio, and they painted similar subjects in a kind of friendly rivalry.

◁ **ARMS OF THE DUTCH EAST INDIA COMPANY**
The boom in the Dutch economy in the early 17th century depended heavily on sea trade, such as that carried out by the Dutch East India Company, which was founded in 1602.

GIRL SLEEPING, REMBRANDT, c.1654

▷ *SELF-PORTRAIT WITH BERET AND TURNED-UP COLLAR, 1659*
This portrait, made after Rembrandt had suffered financial setbacks, depicts the artist as sober and dignified. The image references Raphael's famous portrait of Baldassare Castiglione.

> " He said one should **be guided** by **nature** and by **no other rules**. "
>
> JOACHIM VON SANDRART, *GERMAN ACADEMY OF THE NOBLE ARTS*, 1675

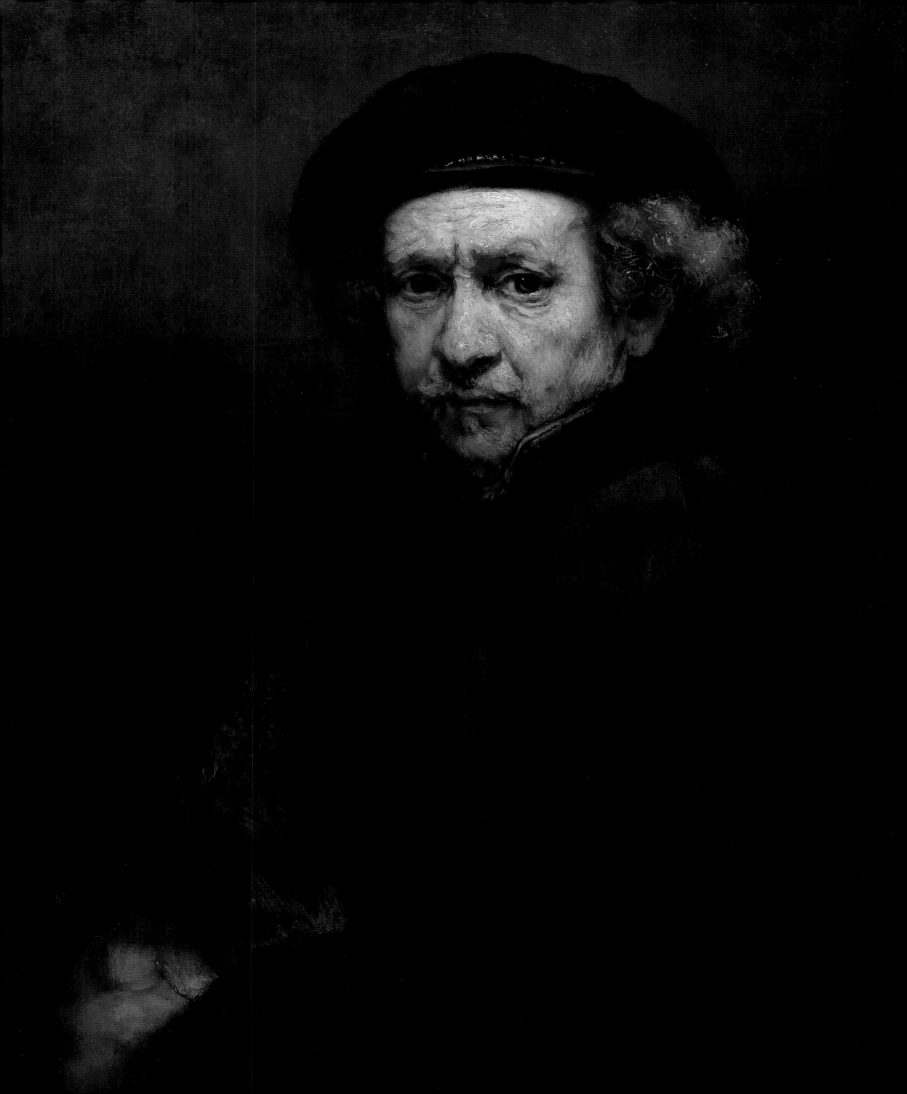

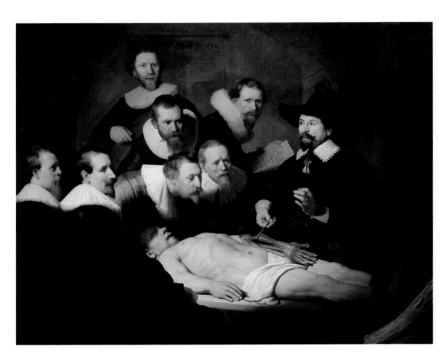

△ **THE ANATOMY LESSON OF DR NICOLAES TULP, 1632**
This group portrait (a type of painting that was extremely popular in the Dutch Republic) was made for the Guild of Surgeons in Amsterdam. While many such portraits were traditionally static, Rembrandt brings animation and drama to this scene of a public dissection.

▷ **SELF-PORTRAIT WITH SASKIA, 1636**
In this affectionate and intimate etching, Rembrandt and his wife wear historical costume, while Rembrandt holds a drawing tool. Saskia's figure is etched in a lighter weight than the artist's, suggesting distance.

Contemporaries sometimes had difficulty distinguishing the work of one from the other, and a few paintings still divide the opinions of modern scholars.

At the time, Leiden was the second largest town in the Dutch Republic. However, it was decidedly provincial compared with Amsterdam, which was becoming one of the world's major centres of commerce and so offered far better prospects for an ambitious young artist. Rembrandt moved there in 1631 or 1632, by which time he had begun to paint commissioned portraits – an endeavour that quickly brought him success. Rembrandt outshone his competitors with his vivid characterization and the sharp-focus technique with which he depicted the details and textures of the expensive clothes his wealthy sitters wore. The painting that most clearly announced his superiority was a group portrait, *The Anatomy Lesson of Dr Nicolaes Tulp* (1632). Instead of the stiff formality common in such paintings, Rembrandt created a striking and fluent composition in which each figure was individualized.

Marriage and prosperity

Rembrandt's personal life also blossomed in Amsterdam. In 1634, he married Saskia van Uylenburgh. Saskia's wealthy parents had died when she was young, leaving her a substantial inheritance, but Rembrandt's tender portrayals of her leave no doubt that he married for love, not money. After living in various temporary homes, in 1639 he bought an impressive house that showed off his success. He also spent lavishly on art and curios, including Renaissance paintings, arms and armour, prints and drawings, and Oriental artefacts.

Between 1635 and 1640, Saskia had three babies, each of whom lived only a few weeks. In 1641, her fourth and final child, a son called Titus, was born. He survived, but Saskia herself died – probably from tuberculosis – the following year, aged just 29.

This year, 1642, was a key one in Rembrandt's life professionally as well as personally, because it was when he completed his largest and most famous painting, *The Night Watch*, which shows a group of militiamen

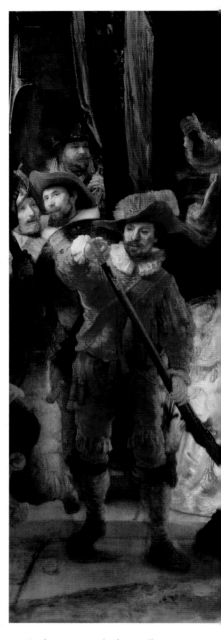

preparing to march. According to popular myth, the militiamen disliked the painting, and their disapproval led to Rembrandt's downfall. In fact, contemporary evidence leaves no doubt that the painting was well received, but Rembrandt's worldly success did – coincidentally – start to diminish from about this time.

" The **ugly** and **plebeian face** with which he was **ill-favoured** was accompanied by **untidy** and **dirty clothes**. "
FILIPPO BALDINUCCI, *COMMENCEMENT AND PROGRESS OF THE ART OF COPPER ENGRAVING*, 1686

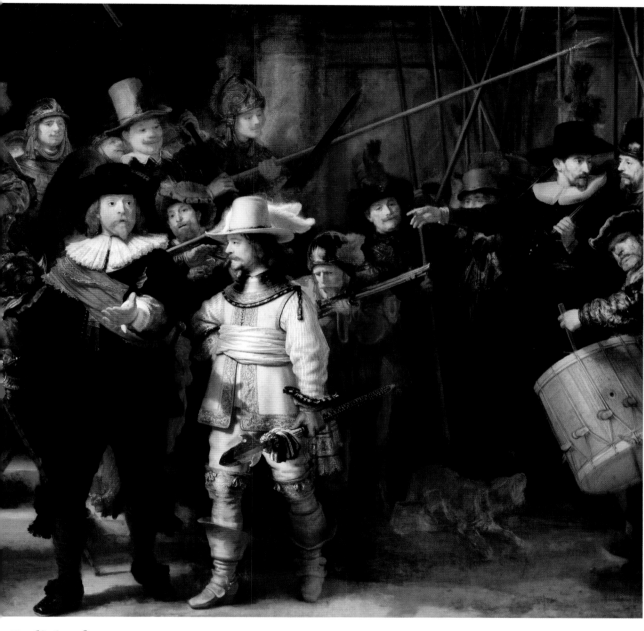

◁ ***THE NIGHT WATCH, 1642***
This huge canvas, in which the figures are almost life-size, shows a company of militia – men who would defend the city of Amsterdam from attack or suppress civil disturbances. The restlessness of the company as they prepare to move is evident in Rembrandt's composition, which uses extremes of light and shade and variations in paint texture to bring the scene to life.

IN CONTEXT
Rembrandt's pupils

Rembrandt was the most renowned art teacher of his time. He was only 21 when he took his first apprentice, Gerard Dou (1613–75), in February 1628; and his last pupils included Aert de Gelder (1645–1727), who studied with him in the 1660s and devotedly continued working in his style into the 18th century. His other pupils included the brilliant but tragically short-lived Carel Fabritius (1622–54), who died in a gunpowder explosion in Delft, the great landscape painter Phillips de Koninck (1619–88), and Nicolaes Maes (1634–93), an eminent genre and portrait painter.

SELF-PORTRAIT, CAREL FABRITIUS, c.1645

Declining fortunes
The death of Rembrandt's beloved wife – just two years after the loss of his mother – perhaps made him seek solace in religion. Certainly, in the 1640s he turned more to the biblical scenes that had been his first love (and also to landscape, in paintings, etchings, and drawings) and devoted much less attention to the lucrative routine of portraiture. At the same time, his style began to change – his work became more inward-looking and his technique broadened out.

Rembrandt's early works often featured strong contrasts of lighting and attention-grabbing effects, but he became much more subtle in his handling of light and shade, warmer and softer in his use of colour, and generally more contemplative in mood. In his youthful self-portraits, he had often represented himself in flamboyant costume, but in his later images he typically wears studio apparel, stressing the dignity of his profession.

▷ **THE SYNDICS, 1662**
Rembrandt's unusual point of view gives this group portrait a strong horizontal dynamic that draws attention to the brilliantly realized expressions on the faces of the guild members.

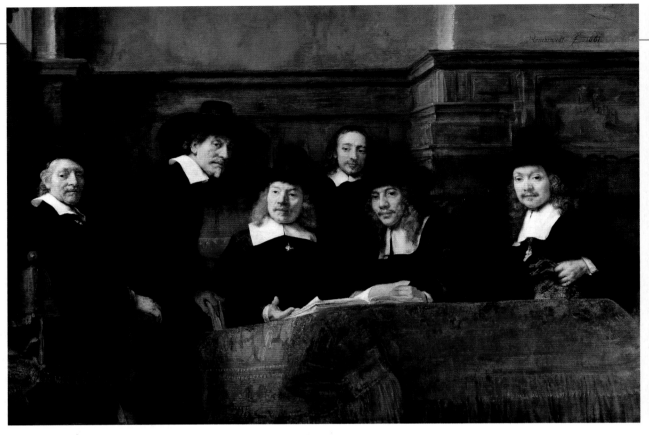

ON TECHNIQUE
Etching

Rembrandt is acknowledged as the greatest of all exponents of etching – a printmaking technique invented in the early 16th century. The artist uses a steel etching "needle" to draw a design on a thin layer of wax covering a metal plate. The plate is then immersed in acid, which eats into the plate only where the metal has been exposed by the drawing process (the wax protecting the other parts). When the wax is cleaned off, the plate is inked and prints are taken from it in a press. Rembrandt used the process to create prints of unrivalled richness and subtlety, as below.

DETAIL FROM *THE WINDMILL*, 1641

Rembrandt hired a widow, Geertge Dircx, as a nurse for his son, Titus. For a time she was Rembrandt's lover, but their affair ended acrimoniously when she was replaced in his affections by Hendrickje Stoffels, a younger woman who had entered the household as a servant. Hendrickje eventually became Rembrandt's wife in all but name – he was prevented from remarrying by a clause in Saskia's will. Rembrandt and Hendrickje had two children, one of whom, Cornelia, was the only one of the artist's six children to outlive him.

During the 1650s, Rembrandt began to have financial problems. This was partly due to the extravagant lifestyle he had maintained after turning away from the profitable art of portraiture, but the Dutch Republic's war against England (1652–54) had also damaged the country's economy in general and the art market in particular.

By 1656, Rembrandt was unable to stave off his creditors and was declared insolvent. He narrowly avoided the worse fate of bankruptcy, which carried a risk of imprisonment, and although his possessions were sold, he was able to continue living in his house until around 1660. After this, he moved to more modest accommodation in Amsterdam.

Mature works

The popular image of Rembrandt after his insolvency is that he was reduced to poverty and obscurity, but this is far from the truth. Despite his problems, he continued to be a highly respected artist whose work was still in demand. Indeed, in 1661–62, he painted two of his largest and most prestigious pictures: the powerful *Conspiracy of Claudius Civilis* (a scene from the ancient history of the Netherlands) for the newly built Amsterdam Town Hall; and a majestic group portrait (*The Syndics*) for the city's Cloth-Workers' Guild. Moreover, Hendrickje and Titus (now a young man) devised an ingenious scheme to prevent Rembrandt's creditors from making claims on his earnings: in 1660, they formed an art-dealing partnership, with Rembrandt technically their employee, meaning that the earnings were legally theirs.

" When he **worked** he would not have **granted** an audience to the **first monarch** in the world. "

FILIPPO BALDINUCCI, *COMMENCEMENT AND PROGRESS OF THE ART OF COPPER ENGRAVING*, 1686

KEY MOMENTS

1625
Makes his first known dated painting, *The Stoning of St Stephen*, which is influenced by Caravaggio.

1632
Paints *The Anatomy Lesson of Dr Nicolaes Tulp*, a key work in establishing his reputation in Amsterdam.

1636
Paints *Danaë*, a great mythological scene and one of the best female nudes in 17th-century art.

1642
Completes *The Night Watch*, the culminating work of the Dutch tradition of group portraits of civic militia.

c.1645–50
Paints *The Mill*, his most famous landscape.

c.1655
Paints the romantic *Polish Rider*, showing an enigmatic youthful warrior on horseback.

1661–62
Makes *The Conspiracy of Claudius Civilis*, an allegory of the Dutch rebellion against Spain.

c.1669
Paints *The Return of the Prodigal Son*, one of his most poignant religious works.

Biblical scenes

Rembrandt's final years were clouded by the deaths of Hendrickje in 1663 and Titus in 1668. Nevertheless, he continued working with undiminished powers to the very end of his life. His last paintings include two self-portraits, in which he shows himself careworn but dignified, and *The Return of the Prodigal Son*, in which he depicts the famous biblical story of repentance and forgiveness with unforgettable poignancy. Rembrandt died on 4 October 1669, aged 63, and was buried four days later in the Westerkerk, his local church.

Rembrandt's fame endured after his death, and brief accounts of his work were published in German, Italian, and French before a substantial biography appeared in Dutch (in Arnold Houbraken's *Great Theatre of Netherlandish Painters*, 1718–21).

Legacy and influence

Because Rembrandt had been so prolific, his paintings and etchings often appeared on the art market, keeping his name in the public eye. Although he was extolled for his mastery of light and shade, some critics thought his work was tainted by coarseness – based as it was on real life rather than on the conventions of Academic art – and they were dismayed that in his later years the artist had abandoned the polished finish of his early work for a rougher, more spontaneous approach. In 1707, for example, Gérard de Lairesse, a leading Dutch writer on art, described Rembrandt's paint as being "dripped like muck along the canvas".

However, during the 19th century, such critical attitudes were upended: in the wake of Romanticism, qualities that had earlier counted against Rembrandt – emotional candour, disregard for convention, boldness and spontaneity of technique – became the basis of renewed acclaim for his work. By the early 20th century, he had reached a pinnacle of esteem as perhaps the most revered of all painters, and it became routine to compare him with Shakespeare for his range and depth of human feeling.

◁ **THE CONSPIRACY OF CLAUDIUS CIVILIS, 1661–62**
This enormous canvas depicts the revolt of the Batavians (the ancient people of the Netherlands) against Roman occupation. Their leader is the one-eyed Claudius, who dominates Rembrandt's composition.

▷ **REMBRANDT SQUARE**
The artist is honoured in Amsterdam in a square that bears his name. An iron sculpture, made in 1852, occupies a central position in the square.

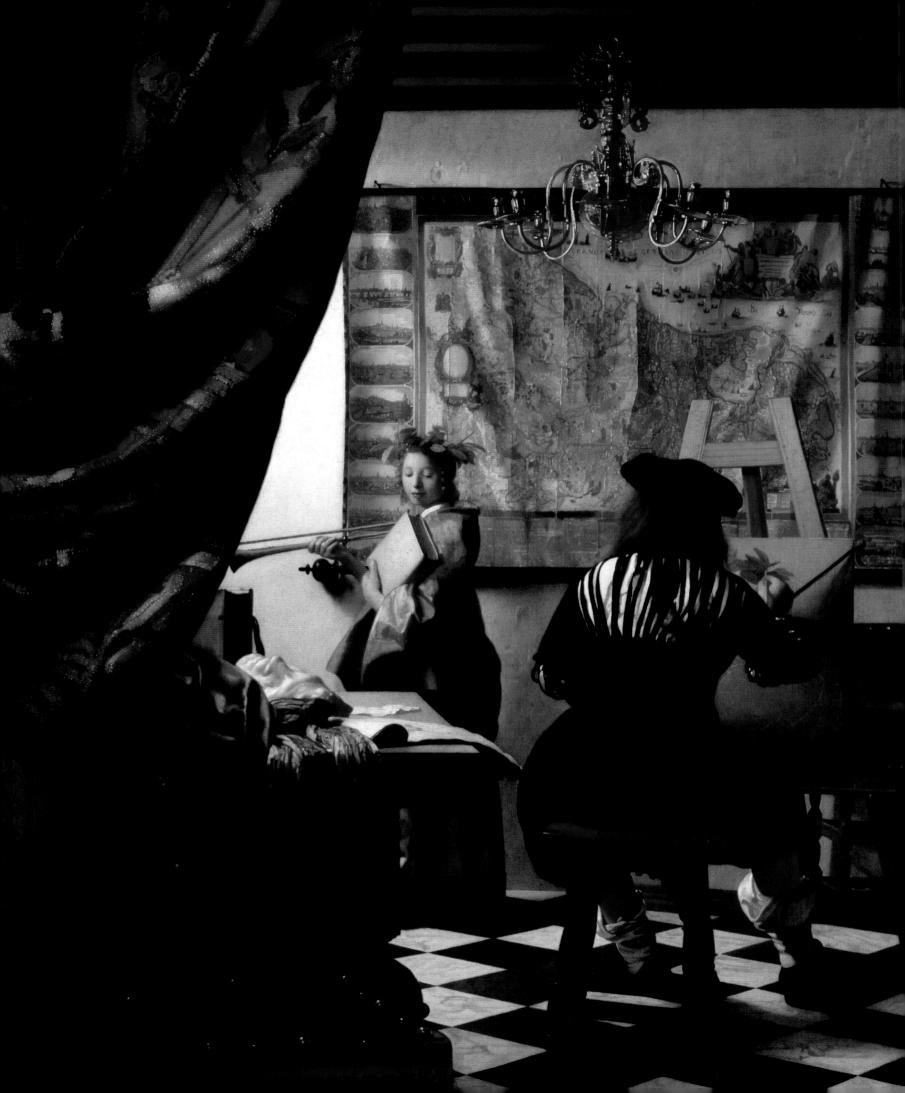

Jan Vermeer

1632–1675, DUTCH

Famous for his careful depictions of everyday life and for the calm luminosity of his uncannily realistic compositions, Vermeer is acclaimed as one of the greatest painters of Holland's golden age.

Jan Vermeer's early years and artistic development are shrouded in uncertainty. His name appears in numerous legal documents in his home town of Delft, but these convey nothing of his personality, beliefs, or the way in which he created his masterpieces. Vermeer was not widely known in his own day – partly because he worked for just a small circle of patrons – and his work was largely forgotten for 200 years before being rediscovered in the 19th century.

Family and education

Jan (or Johannes) Vermeer was born in Delft and baptized there on 31 October 1632. He was the second child of Reynier Jansz Vos and Digna Baltens. Reynier, who began using the name Vermeer in around 1640, worked first as a silk weaver and then as an innkeeper, while dealing in pictures as a sideline. He enjoyed some success, as records show that in 1641 he was able to buy the Mechelen, a large inn in Delft's main square.

Vermeer may have been inspired in some way by his father's picture business, but the details of his training are a matter of some speculation. It is possible that he was taught (or at least influenced) by Carel Fabritius – a gifted painter who himself had studied under Rembrandt – or by Leonaert

Bramer, a prolific artist and designer who was a friend of Vermeer's family. If Bramer was Vermeer's teacher, however, his style left no mark at all on the young man's work.

Artist and dealer

Reynier died in 1652 and Jan inherited his businesses. He continued to live in Mechelen, but it is unclear exactly how he made his living. His output as an artist was remarkably small; only 36 of his paintings have survived and there are many reasons to suppose that the number completed was not much higher.

It seems probable that Vermeer worked extremely slowly, given the meticulous detail in his pictures, and it is likely that he had another occupation besides painting to support his large – and growing – family (he went on to have 15 children). There are strong indications that he carried on his father's trade as a picture dealer. Records show, for example, that he was consulted about the worth of certain paintings and that, in 1672, he travelled to The Hague to give his appraisal of pictures attributed to Raphael, Holbein, Titian, and Giorgione.

△ **DELFTWARE**
The production of ceramics in Delft increased significantly in Vermeer's lifetime, when new firing and glazing techniques were introduced. Delftware designs were used on kitchen utensils, plates, and especially on tiles, examples of which can be seen on the base of the wall in Vermeer's *The Milkmaid*.

IN CONTEXT
Delft

In the 17th century, the small city of Delft was an active hub for business, culture, and craft. Rich tapestries, silver objects and ornaments, and the famous blue-and-white pottery were produced there. The city was home to a loose affiliation of artists, including Vermeer, Pieter de Hooch, Carel Fabritius, and Nicolaes Maes who belonged to one guild, and who would have known and perhaps been influenced by each other's work. These and other artists of the so-called Delft School were known principally for their domestic scenes, cityscapes, and landscapes.

VIEW OF DELFT (DETAIL), VERMEER, c.1660–61

◁ **THE ARTIST'S STUDIO, 1666**
This was Vermeer's favourite work – an allegory of painting, featuring Clio, one of the nine muses of Greek mythology. Many historians have speculated that the figure of the painter is Vermeer himself.

" He is an **enigma** in an epoch in which **nothing resembled** or **explained** him. "

MARCEL PROUST, 1921

ON TECHNIQUE
Camera obscura

Vermeer's working methods are unknown, but some believe that he used a camera obscura (dark chamber). This was an optical aid that allowed artists to project an image on to a drawing surface, so that its outline could be traced. The scientific principle had been known since ancient times, but portable examples with a lens were in use from the late 16th century.

A TENT-DESIGN CAMERA OBSCURA

In April 1653, Vermeer married Catharina Bolnes. Her mother, Maria Thins, was a wealthy Catholic divorcee and Vermeer appears to have converted to Catholicism at around this time. Maria had her concerns about the marriage owing to Vermeer's financial situation – in December 1653, when he was registered as a master painter, he was unable to pay the guild's entrance fee of six guilders. In any event, his problems with Maria eased and she gave the couple her support later on, when they ran into money troubles.

The golden age

The chronology of Vermeer's art is a matter of some speculation because only three of his paintings are dated. It seems clear that his biblical work, *Christ in the House of Mary and Martha*, and *Diana and her Companions*, a scene from Greek mythology, are early works because their subject-matter and their Italianate style differ from his more familiar pieces. However, by the time of his earliest dated work, *The Procuress* (1656), Vermeer had found his true direction. With few exceptions, the remainder of his paintings are scenes of everyday life, usually set in a domestic interior.

In other European countries, this type of picture – often described as a genre painting – was regarded as a minor art form, unworthy of the highest plaudits. However, the market in Holland was very different. The country was a new republic, having recently gained independence from Spain. Its trading contacts, spearheaded by the Dutch East India Company (founded in 1602), brought wealth and ushered in the nation's "golden age". In this milieu, the chief demand was not for large, imposing paintings that were destined to be

△ **THE PROCURESS, 1656**
In this scene, a young prostitute takes a coin from a client, watched by an older procuress. Vermeer's remarkable ability to capture great detail (especially in drapery) and to depict the vibrancy in the fleeting gestures of the characters, gives the image its graceful character.

hung in palaces or churches. Instead, most clients came from the affluent mercantile class, and wanted smaller pictures to decorate their townhouses. As a rule, they did not seek elaborate scenes from history or mythology, but unpretentious images of the world they saw around them – landscapes, still lifes, flower pieces, or scenes of everyday life.

Genre painting

Some Dutch genre scenes could appear crowded and busy, but Vermeer's are tranquil and serene. He usually portrayed just one or two

figures, bathed in a soft light from a nearby window. Some are engaged in simple activities, such as sewing lace or playing music, while others are lost in thought, like the geographer who looks up from his books or the girl reading a letter. The rooms are relatively uncluttered, but each object is depicted with such astonishing skill that the Goncourt brothers (French critics and historians), writing in 1861, described Vermeer as "the only master who has made a living daguerrotype" (an early type of photograph).

Hidden symbols

The realism in Vermeer's paintings can sometimes be misleading. In the Low Countries, there was a long tradition of using disguised symbolism, so even an everyday scene might contain a symbolic object, which added an extra layer of meaning. In *The Milkmaid*, for example, there is a curious wooden

" Do you know an **artist** called Vermeer... ?
This **strange** painter's **palette** consists of blue,
lemon yellow, pearl grey, black and white. "

VINCENT VAN GOGH, LETTER TO EMILE BERNARD, 1888

box positioned rather incongruously on the floor. This foot warmer is a traditional symbol of a lover's desire for constancy. Immediately to its left, there is a tile with an image of Cupid. Contemporary viewers would instantly have understood from this that the pensive maid was thinking about love.

Dutch realities

Vermeer's working techniques remain somewhat mysterious, as none of his drawings has survived. It may be significant that in his painting *The Artist's Studio*, the painter is working directly on to the canvas. X-ray examinations confirm that Vermeer made many changes to his pictures.

Vermeer's true mastery lay in his ability to convey the fall of the light, and the way that this affected the appearance of different textures and materials. Unlike some of his contemporaries, he did not paint objects in microscopic detail. Instead, he achieved his illusion of reality through incredibly subtle variations in tone. He also used tiny globules of light-coloured paint to show light reflecting off different surfaces, which led one critic to compare the texture of his brushwork to "crushed pearls melted together".

The exquisite quality of Vermeer's work was recognized during his lifetime. He was appointed *hoofdman* (leader) of his guild on four occasions, and visitors to Delft commented on the very high prices of his paintings. Despite this, the worsening economic conditions – particularly after the French invasion of 1672 – caused him severe financial problems, which may have contributed to his premature death. His widow was declared bankrupt just a few months later, and Vermeer's reputation soon faded into obscurity.

▷ **THE MILKMAID, c.1658–60**
Vermeer is best known for his elegant interiors, but he was equally adept at portraying poorer households. Here he revels in painting the shabby paintwork, the cracked window pane, and the dirt above the tiles.

KEY MOMENTS

c.1654
Paints his only known biblical subject, *Christ in the House of Mary and Martha*, at around the time of his marriage to Catharina Bolnes.

c.1660–61
Paints an atmospheric view of his home town, Delft. Two years later, he is be appointed *hoofdman* (leader) of his guild for the first time.

c.1666
Completes *The Artist's Studio*, which was perhaps intended to hang in the headquarters of the painters' guild in Delft.

1669
Completes *The Geographer*, one of a pair of single-figure studies. It is one of only three of his surviving dated works.

c.1670–75
The aftermath of the French invasion of Holland in 1672 makes it hard to sell paintings and he ends his life in serious financial difficulties.

聲名勤帝都造化入畫棄
本原眼琅開代興桶四妙
耕煙翁僊賛雲泉書

▷ **PORTRAIT OF WANG HUI, 1800**
This portrait of the artist as an old
man, by the Chinese painter Weng
Luo, was painted in ink on paper
long after the death of Wang Hui.

Wang Hui

1632–1717, CHINESE

One of the great artists of the late Ming and early Qing dynasties in China,
Wang Hui was celebrated for his exquisite landscape painting; he studied
the masters of earlier periods to produce a distinctive style of his own.

"I must use the **brush** and **ink** of the Yuan to move the **peaks** and **valleys** of the Song..."

WANG HUI

Wang Hui was born in 1632 in Yushan in Jiangsu, an eastern province of China. His family included many artists – his great grandfathers, grandfather, father, and uncles were all painters, and he learned to paint as a boy. When he was 15 years old, Wang Hui was introduced to the renowned painter Wang Shimin, who invited him to his stay at his home in Taicang. He remained there in the 1660s and '70s, studying and copying his host's extensive collection of old master paintings; he also visited many of the older man's friends to copy paintings in their collections too, and it was in this way that he found his inspiration (see box, right).

By the 1680s, Wang Hui had begun to apply his own style to works of increasing ambition. He painted landscapes on long scrolls, combining highly expressive brushwork with techniques such as ink blotting, with which he could capture the effect of mist and create richly atmospheric scenes. He made extensive use of dots to create tonal accents, add texture and pattern, and soften the outlines of hills. His misty scenes were enlivened with buildings or figures drawn with greater precision.

Imperial scroll

In 1684, Wang Hui produced an impressively large work – a landscape scroll some 18.3m (60ft) long – for the prominent and well connected civil servant, Wu Zhengzhi. The favourable reception it received led in turn to commissions from the imperial court and – eventually – the chance to paint a scroll that commemorated the emperor's tour of the southern provinces in 1689.

Wang Hui's painting of the Kangxi emperor's southern tour covered 12 long silk scrolls, and he produced it with the help of several assistants. The painting, which includes more than 30,000 figures and has a total length of 225.5m (740 ft), was not finished until 1698. It portrays a panoramic and atmospheric landscape of mountains, valleys, woods, and water, punctuated with beautifully drawn towns and temples; it also shows the winding road along which the emperor and his retinue travelled. The brightly dressed figures (mainly in blues and reds) stand out against the overall greens and browns of the landscape to catch the viewer's eye and provide an ever-changing focus to these enormous paintings.

Works such as this led to Wang Hui's reputation as one of China's greatest artists, and his inclusion (with his master Wang Shimin, Wang Jian and Wang Yuanqi) in the prestigious group of late Ming and early Qing artists known as the Four Wangs.

△ **FISHING IN WILLOW BROOK**, 1706
This landscape handscroll is painted in ink on silk, in Wang Hui's mature style. It shows his mastery of brushwork, as well as his skill at making a balanced composition within a narrow scroll.

ON TECHNIQUE
Copying the masters

Chinese artists trained by copying works by artists of the past, so a young artist needed access to good private collections in order to succeed. Wang Hui was particularly impressed by the landscape painters of the Yuan dynasty (1271–1368); he copied their highly expressive brushwork (which was inspired by calligraphy) and used it to add vitality to landscapes. He also admired the work of artists of the earlier Song dynasty (10th–13th centuries), again emulating their treatment of landscapes, but modifying their style and changing their composition to produce a style of his own.

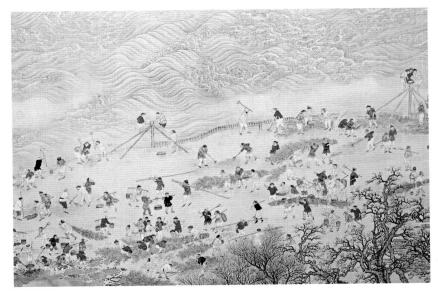

◁ **EMPEROR KANGXI'S TOUR OF INSPECTION IN THE SOUTH**, c.1689
In this scene from Wang Hui's epic scrolls, Emperor Kangxi inspects the dams of the Yellow River. It is unlikely that Wang visited the sites depicted in the scrolls; he based his designs on maps and prints, and imaginary landscapes.

INK DRAWING FROM ALBUM AFTER OLD MASTERS, **WANG HUI, 1650–1717**

Directory

Annibale Carracci

1560–1609, ITALIAN

The outstanding member of a prominent family of artists from Bologna, Annibale spent his early career in northern Italy; from 1595, he lived in Rome, where he was the greatest of Caravaggio's contemporaries. Like Caravaggio he broke away decisively from the artificiality of the Mannerist style, but he did so in a very different way. His paintings revived the grandeur and solidity of the High Renaissance, but they had a new exuberance that placed them among the pioneering works of Baroque art. Annibale was mainly a painter of heroic figure compositions, but he also excelled in other fields. Most notably, he is regarded as the inventor of both the caricature portrait and the ideal landscape (which in the work of Claude and Poussin became a major strand of 17th-century art).

KEY WORKS: *Resurrection of Christ*, 1593; Ceiling of the Farnese Gallery, c.1597–1600; *Landscape with the Flight into Egypt*, c.1604

Juan Martínez Montañés

1568–1649, SPANISH

Acclaimed by his contemporaries as *el dios de la madera* (the god of wood), Montañés was the most famous Spanish sculptor of the 17th century. As his nickname suggests, he worked mainly in wood – the favoured material for sculpture in Spain, whereas stone and bronze were generally preferred in other parts of Europe. The wood was usually painted in naturalistic colours and sometimes the realism was accentuated with features such

as glass eyes and ivory teeth. Almost all of Montañés' sculpture is on religious subjects. It is often very intense in emotion, but also has great dignity. He spent most of his career in Seville, the main port for the trade with the American colonies, to which much of his work was exported.

KEY WORKS: *Christ of Clemency*, 1603–06; *Virgin of the Immaculate Conception*, 1628; *St Bruno*, 1634

▽ Guido Reni

1575–1642, ITALIAN

The most acclaimed Italian painter of his time, Reni spent part of his early career in Rome but worked mainly in his native Bologna, where he was received into the guild of painters. This city was home to a distinctive tradition in Italian painting (the Bolognese School), in which the

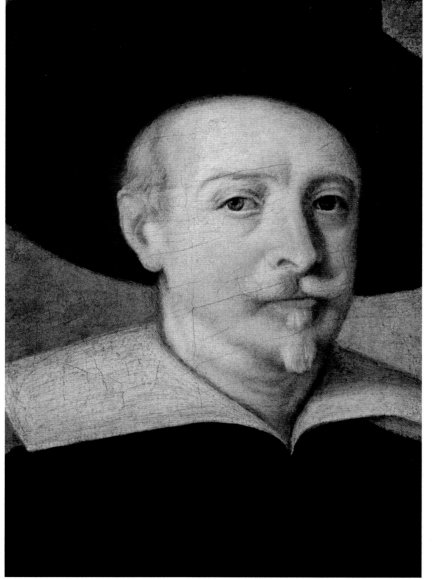

△ SELF-PORTRAIT (COPY), GUIDO RENI, c.1630

rhetoric and emotionalism of the Baroque style was tempered by a classical dignity and gracefulness, and an emphasis on idealized proportions.

Reni ran an immensely successful workshop (mainly producing paintings based on religious and mythological themes), with a highly distinguished international clientele, and for about two centuries after his death he was generally considered to be one of the greatest of all painters – extolled as "the Divine Guido". However, his reputation crumbled during the 19th century, when he was dismissed as vulgar and sentimental, and did not revive until the later 20th century.

KEY WORKS: *The Massacre of the Innocents*, 1611; *Aurora*, 1614; *The Abduction of Helen*, 1627–30

Adam Elsheimer

1578–1610, GERMAN

Elsheimer was the most significant German painter of the 17th century, but he spent virtually all his short career in Italy, first Venice and then Rome, where he settled in 1600. In spite of his brief life and unsuccessful career (he died in poverty at the age of 32), he ranks as one of the most important figures in the development of landscape painting. He is especially revered for his highly atmospheric and innovative use of light, particularly in nocturnal scenes.

There are only about 40 known paintings by Elsheimer, and many of these are very small in size. His limited output may have been due in part to his perfectionism, but also to his indolence. In any event, Elsheimer's influence was spread by prints of his work, and he had a significant impact on major artists such as Rubens (who was a friend), Rembrandt, and Claude, as well as on a host of lesser painters.

KEY WORKS: *Landscape with St John the Baptist Preaching*, c.1599; *St Paul Shipwrecked on Malta*, c.1604; *The Flight into Egypt*, 1609

Frans Hals

1582/3–1666, DUTCH

Hals was the first great figure in 17th-century Dutch painting. He was Flemish by birth, but his parents left war-torn Antwerp when he was a child and settled in Haarlem, where he spent all his career. Although he was easily the leading portraitist in the city and had numerous important commissions, he found it difficult to support his large family and was often in debt. His portraits are remarkable for their lively spontaneity of pose and expression and their vigorous, loose handling. During the 18th century, his work was generally considered rough and unfinished, but from about 1860 he was rediscovered, his sparkling brushwork appealing greatly in the age of Impressionism.

KEY WORKS: *Banquet of the Officers of the St George Militia Company*, 1616; *The Laughing Cavalier*, 1624; *Regents of the Old Men's Alms House*, c.1664

▷ Simon Vouet

1590–1649, FRENCH

Vouet played a central role in the revival of his country's art following the disruptions of civil war. He was born in Paris but from 1613 to 1627 he lived in Italy, before being summoned to the French capital by Louis XIII to be his court painter.

Vouet was industrious and versatile, working in diverse fields. While in Italy, he had learned from many of the leading contemporary artists, blending their influences into a fluent style that had something of the energy of the Baroque idiom but also a suave gracefulness that now seems quintessentially French. He ran a busy workshop in which he trained many of the leading painters of the next generation, notably Charles Le Brun.

KEY WORKS: *The Fortune Teller*, c.1620; *The Presentation in the Temple*, 1641; *Allegory of Peace*, c.1648

△ **SELF-PORTRAIT, SIMON VOUET, c.1615**

José de Ribera

1591–1652, SPANISH

Ribera was Spanish by birth, but he spent all his known career in Italy, working in Parma and Rome before settling in Naples (which at this time was a Spanish possession) in 1616. In his adopted country he was nicknamed *Lo Spagnoletto* (the Little Spaniard). He was mainly a religious artist, but he also painted number of secular subjects.

Initially, he worked in a powerful Caravaggesque vein, and later in a softer and more colourful style. Many of his paintings were exported to Spain. The high reputation he enjoyed in his lifetime continued after his death. During the 18th century Spain was on the margins of European affairs, and at this time Ribera and Murillo were among the few Spanish artists whose work was known outside their own country.

KEY WORKS: *Drunken Silenus*, 1626; *Martyrdom of St Philip*, 1639; *Adoration of the Shepherds*, 1650

Jacob Jordaens

1593–1678, FLEMISH

After Rubens and van Dyck, Jordaens was the leading Flemish painter of large figure compositions during the 17th century. Following the deaths of Rubens and van Dyck, in 1640 and 1641 respectively, Jordaens was the dominant artist in the field, and for the next 20 years or so he was one of the most sought-after painters in northern Europe. He rarely left his native city of Antwerp, but he received commissions from other countries, including England, Sweden, and the Dutch Republic.

His vigorous style was influenced by Rubens, whom he sometimes assisted on large projects, but he was much more down to earth. He painted religious, mythological, allegorical, and moralizing scenes, and became well known for large genre paintings based on proverbs. He also designed tapestries, and was an excellent (but infrequent) portraitist.

KEY WORKS: *Allegory of Fruitfulness*, c.1623; *Martyrdom of Apollonia*, 1628; *Diogenes in Search of a Man*, c.1642

François Duquesnoy

1597–1643, FLEMISH

With the huge exception of Bernini, Duquesnoy was perhaps the most acclaimed European sculptor of his time. He was Flemish by birth but settled in Rome in 1618 and spent almost all the rest of his life there; he died on his way to Paris, where he had been appointed court sculptor.

Duquesnoy worked as an assistant to Bernini for a while, but his style was much more restrained and classical. He produced only a few large public sculptures, but his reputation was enhanced by smaller works, including statuettes of religious and mythological themes. These were copied again and again and became part of the standard equipment in artists' studios throughout Europe for more than a century – regarded as inspiring models in the spirit of antique art.

KEY WORKS: *Bacchus*, c.1626–27; *St Susanna*, 1629–33; *St Andrew*, 1629–40

Francisco de Zurbarán

1598–1664, SPANISH

Zurbarán was one of the most powerful and distinctive Spanish painters of the 17th century – the golden age of his country's art. He spent most of his career in Seville but also worked in Madrid, and paintings from his busy studio were sent to many other places in Spain and also to the South American colonies.

His work included a few portraits and still lifes, as well as some mythological scenes for Philip IV, but he was above all a religious painter. He is best known for his austere figures of monks and saints – works of great spiritual intensity that are perfectly in tune with the religious fervour characteristic of Spain. By the end of his career, however, taste had turned in favour of the much softer, sweeter style of Murillo.

KEY WORKS: *Christ on the Cross*, 1627; *Hercules and Antaeus*, 1634–35; *St Francis*, 1639

▽ Philippe de Champaigne

1602–1674, FRENCH

Champaigne was Flemish by birth, but he spent virtually his entire career in Paris, where he settled in 1621. He had trained in Brussels as a landscape specialist, but became an outstanding religious painter and the greatest French portraitist of the 17th century. His sitters included some of the most eminent French personalities of the time, notably Cardinal Richelieu (Louis XIII's chief minister), whom he portrayed several times, creating the incisively characterized images by which he is known to posterity.

His style combined Baroque grandeur with classical dignity and precise brushwork. From the 1640s his work became more austere – a reflection of his involvement with Jansenism, a Catholic sect of great severity (his daughter was a nun in a Jansenist convent).

KEY WORKS: *Triple Portrait of Cardinal Richelieu*, 1642; *Christ on the Cross*, 1647; *Ex-Voto* (*Two Nuns of Port-Royal*), 1662

△ COPY OF PHILIPPE DE CHAMPAIGNE'S SELF-PORTRAIT BY JEAN BAPTISTE DE CHAMPAIGNE

Claude Lorrain

c.1605–1682, FRENCH

Claude is one of the most important figures in landscape painting – and undoubtedly the most influential exponent of ideal landscape, a style in which the artist creates serene and harmonious visions of nature, often peopled with small figures from mythological or religious stories.

This type of landscape originated soon after 1600 and enjoyed great popularity until well into the 19th century. Claude was born in Lorraine (then an independent duchy, now in northeast France), but he spent almost all of his career in Rome. During the 1630s, he became established as the major landscape painter in Europe, working for Pope Urban VIII, Philip IV of Spain, and other distinguished clients. Until about 1850 (when some critics began to find his work repetitive) he was generally acclaimed as the greatest of all landscape painters.

KEY WORKS: *The Mill*, 1631; *The Enchanted Castle*, 1664; *Ascanius and the Stag*, 1682

Bartolomé Esteban Murillo

1617/18–1682, SPANISH

Murillo, who spent virtually his whole life in Seville, was the most famous Spanish painter of his period. His work included sentimental scenes of street urchins and a few excellent portraits (in a much more sombre vein), but he was primarily a religious artist. In his mature paintings his style was light, colourful, and tender.

His favourite subject was the Immaculate Conception – the Catholic doctrine that the Virgin Mary was conceived free of the "original sin" that tainted all other humans, an idea that was usually represented by a full-length portrayal of Mary accompanied by baby angels and various symbolic details. In the 18th and early 19th

△ SELF-PORTRAIT, JAN STEEN, c.1670

centuries, Murillo was considered one of the greatest of all painters, but his reputation later plummeted and he was dismissed as overly sentimental.

KEY WORKS: *The Vision of St Anthony of Padua*, 1656; *The Return of the Prodigal Son*, c.1667–70; *Self-Portrait*, c.1670

Charles Le Brun

1619–1690, FRENCH

Le Brun was the dominant artist in France during the long reign of Louis XIV, not only because of his own work but also because of the key role he played in supervising various major royal enterprises in the visual arts.

Louis appreciated the propaganda value of art, and Le Brun's talents were well suited to promoting his image as a wealthy and powerful king through decorative schemes and paintings that are full of Baroque pomp and splendour.

Le Brun worked at the Louvre and Versailles, and was director of the Gobelins tapestry factory (which supplied furnishings for royal palaces) and of the Académie Royale de Peinture et de Sculpture (which trained artists to work in an approved idiom suitable to glorifying the king).

KEY WORKS: *Hercules and the Horses of Diomedes*, c.1640; *Alexander the Great's Triumphal Entry into Babylon*, c.1662–68; *The Adoration of the Shepherds*, c.1689

◁ Jan Steen

1626–1679, DUTCH

Although he died fairly young, Steen left behind a large body of work on many different subjects, including religion (he was a Catholic). He is, however, most famous for his detailed, lively, and animated scenes of everyday life – paintings that have made him one of the most popular figures of the golden age of Dutch art. Some of these works have inscriptions underlining a moral meaning relating to human frailty or folly, but Steen is usually a wry observer rather than a stern preacher. He worked in his native Leiden, as well as in Delft and Haarlem. In spite of his skill, versatility, and productivity, he often had difficulty earning a living through painting: for a time he ran a brewery, then an inn.

KEY WORKS: *Skittle Players outside an Inn*, c.1660–62; *The Dissolute Household*, c.1663–65; *Merrymaking in a Tavern*, c.1670–75

Jacob van Ruisdael

c.1629–1682, DUTCH

Ruisdael was the greatest of all Dutch landscape painters, unmatched in the variety and power of his work. He painted a wide range of landscape subjects, including views of rivers, woodland, country roads, panoramas, winter scenes, and so on. He stands apart even more in the emotional force of his work, in which he conveys the grandeur and mystery of nature.

Ruisdael began his career in his native city of Haarlem and settled in Amsterdam in about 1656. He had only one documented pupil (Meindert Hobbema), but he influenced many other Dutch artists, and was revered in both England and France, Thomas Gainsborough and John Constable being among his professed admirers.

KEY WORKS: *Bentheim Castle*, 1653; *The Jewish Cemetery*, c.1660; *The Windmill at Wijk bij Duurstede*, c.1670

18th
CENTURY

CHAPTER 4

▷ *TAKING A REST AFTER READING BOOKS*, **DATE UNKNOWN**
This painting, believed to be a self-portrait, shows the artist relaxing after reading. Even at rest, he is contemplating nature, in the form of two potted plants.

Jeong Seon
1676–1759, KOREAN

Jeong Seon perfected the realistic style of landscape painting. His depictions of Korean scenes helped to free his country's art from the influence of the Chinese style.

"Even if you **visit** the mountain **yourself**... how can your **joy** be compared with what you **feel** upon viewing this **picture**...?"

INSCRIPTION ON PAINTING OF MOUNT GEUMGANG BY JEONG SEON

Jeong Seon (Chong Son) was born into a noble but impoverished family in Cheongun-dong, now part of Seoul, the capital of South Korea. His place of birth was surrounded by magnificent scenery, including peaks such as Mount Inwang and Mount Bugak, and in early life he began to appreciate the natural beauty of his homeland.

Jeong Seon demonstrated an early talent for calligraphy and painting, and was supported by his family when he announced his intention to devote himself to art. As well as the natural beauty of his home region, he was also inspired by literature, especially the work of the poet and Confucian scholar Kim Changheup, who lived in the same area and wrote eloquent descriptions of Korean landscapes.

Korean travels

From the beginning of the 18th century, Jeong Seon spent much time travelling through Korea, painting landscapes as he went. In 1712, he visited Mount Geumgang, one of the country's most famous beauty spots, to see his friend Yi Byeongyeon, who had been appointed magistrate nearby. Jeong Seon painted a series of studies of the mountain; although the resulting album of landscapes was later lost, it was seen and admired by a number of prominent aristocrats at the time, and Jeong Seon's reputation flourished as a result.

Jeong Seon depicted real Korean landscapes rather than the idealized or imagined scenes that had been popular in previous centuries. By depicting well-known places in his homeland, Jeong Seon and his followers created an original and distinctive Korean style of painting.

From the 1720s onwards, Jeong Seon was appointed to a number of local government posts in Cheongha and Chungcheong provinces. This gave him the chance to travel and to develop his style. A period living in a riverside area of Seoul resulted in a series of smoothly rendered waterside scenes.

Jeong Seon enjoyed a long career; at the age of 74 he produced one of his most famous works, *The Album of Sikong Tu's Modes of Poetry*, in which he illustrated the 24 graceful features of verse as expressed by Sikong Tu, a poet of the Chinese Tang dynasty.

An evolving style

In his early work, Jeong Seon would often combine areas of pale ink wash with darker lines, frequently repeated in small strokes, to pick out details or to emphasize shading. Later, his brushwork became bolder, with broad but subtle ink washes and details of people or buildings added in rapid, sometimes sketchy, lines.

Throughout his life, Jeong Seon was able to combine an accurate delineation of natural details with a grandeur that makes his works appeal directly to the emotions. These qualities ensured his status as one of Korea's greatest, most original, and most influential painters.

ON TECHNIQUE
True-view landscapes

Landscape, popular in the Far East generally, was the most favoured subject for painters in Korean art in the 15th, 16th, and 17th centuries. Most of these paintings followed Chinese models and depicted idealized scenery in China, or showed imaginary landscapes. True-view landscape painting, by contrast, depicts real places. This genre became increasingly popular in the 18th century, largely thanks to the work of Jeong Seon, who often painted directly from nature in the open air. The most frequent subject of his true-view paintings was Mount Geumgang, famous for its breathtaking natural beauty.

MOUNT GEUMGANG (KUMGANG), NORTH KOREA

◁ ***INGOK YUGEODO*, c.1742**
This landscape showing a house against a background of mountains and trees demonstrates Jeong Seon's blending of clear line work to pick out the buildings with broader strokes and flecks to create the impression of trees and distant mountain vegetation.

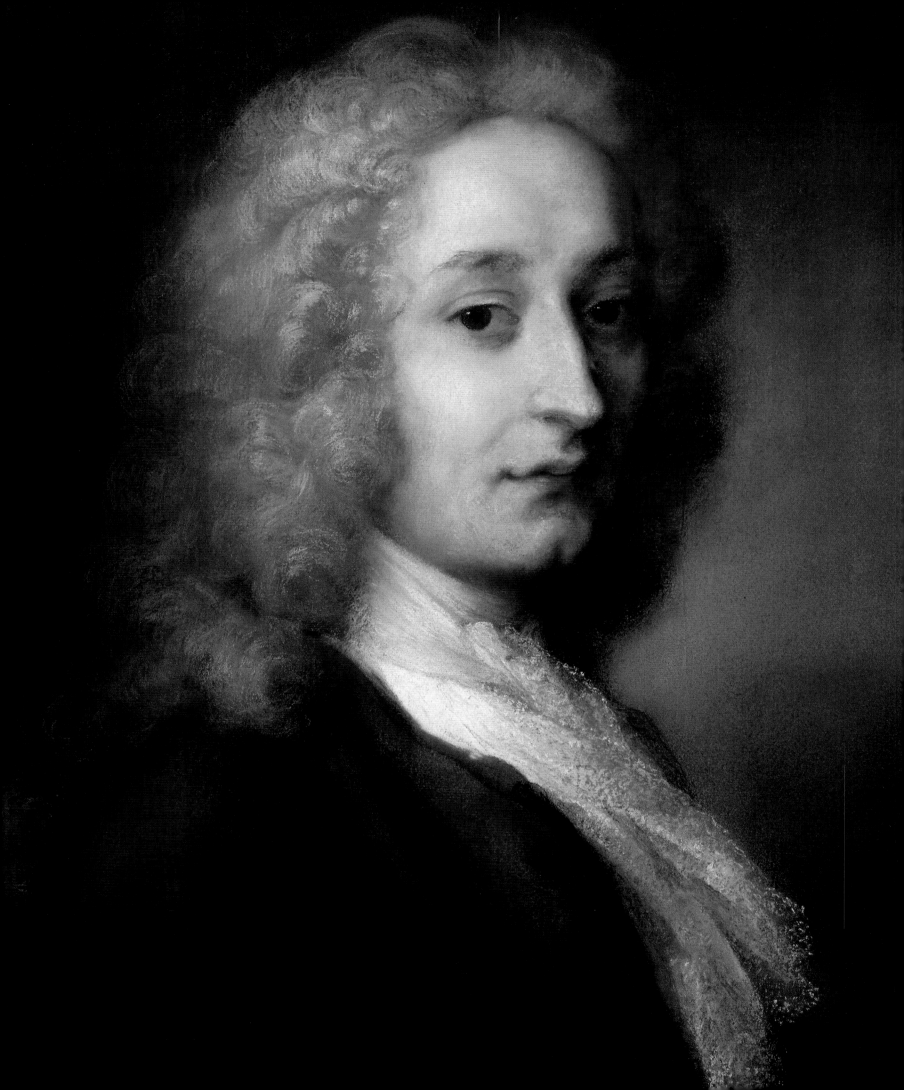

Jean-Antoine Watteau

1684–1721, FRENCH

Watteau was one of the greatest artists of the 18th century and a seminal figure in the development of the Rococo style. Though his career was cut tragically short, he pioneered an entirely new genre: the *fête galante*.

Watteau's artistic temperament seems to come straight out of the pages of a romantic novel. He was restless, irritable, and quarrelsome; he rarely stayed anywhere for long, imposing himself on the hospitality of good-natured friends; and he suffered too. Watteau painted some of his greatest masterpieces while fighting the effects of the tubercular condition that was to kill him.

Jean-Antoine Watteau was born in October 1684 in Valenciennes, northeastern France, a border town that had been recaptured from the Spanish Netherlands. Although Watteau is now considered a French artist, his contemporaries always regarded him as Flemish, a view that was doubtless reinforced by the influence of Rubens on his work.

Early instruction

The son of a roofer, Watteau was apprenticed at a very early age. The identity of his first two masters is still disputed, but they appear to have been Jacques-Albert Gérin and a scene painter called Métayer. The latter took

△ **AUDRAN PLATE, c.1720**
Watteau developed his style under Claude Audran (1658–1734), who was known for his designs of stained-glass windows, carpets, and decorative plates.

◁ **PORTRAIT IN PASTEL, 1721**
This delicate depiction of Watteau in his final year is by Italian portraitist Rosalba Carriera. She worked in pastel, which was very fashionable in the 18th century.

Watteau to Paris, but soon abandoned him. Stranded and without funds, the young artist was forced to take on copyist work, before having the good fortune to meet Claude Gillot. Trained by Jean-Baptiste Corneille, Gillot had been accepted by the Academy as a history painter but worked mainly as a decorative artist and illustrator. He was a magnificent draughtsman, influencing Watteau's drawing style, though his paintings were somewhat stiff and clumsy. He was involved in a wide variety of theatrical work, painting scenes from plays and sets, and he may even have run a puppet theatre. Watteau probably helped him with some of his scenes – the precise nature of his work is unclear. Gillot's real importance, however, lay in introducing him to the theatre

itself, and especially in inspiring Watteau's intense fascination with the *commedia dell'arte* (see right). Watteau was later to take the raw material of this knockabout drama and transform it into the dreamlike fantasy of his *fêtes galantes*.

Rococo influence

In the meantime, however, Watteau had quarrelled with Gillot and moved on to a new master, Claude Audran III. Their association commenced in 1707. Audran was a decorative artist, who was employed in adding grotesques,

> " ... he has **created an ideal world** from the enchanted visions of his own imagination. "
>
> GONCOURT BROTHERS, *FRENCH EIGHTEENTH-CENTURY PAINTERS*, 1859–75

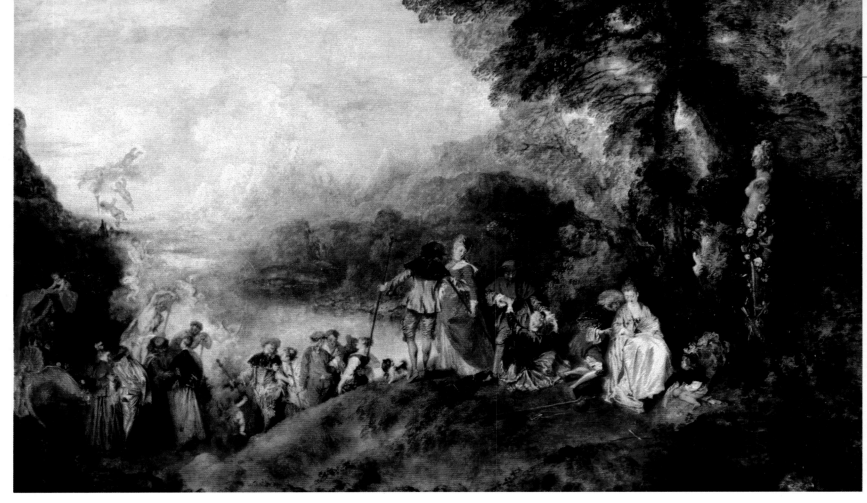

△ PILGRIMAGE TO THE ISLE OF CYTHERA, 1717
On the Greek island of Cythera, the mythological birthplace of the goddess Venus, courting lovers prepare for their homeward journey. One woman gazes back wistfully at the only couple who are still oblivious to the impending departure.

◁ LUXEMBOURG PALACE
The palace where Watteau studied the masters had been the residence of Marie, regent for her son, Louis XIII.

arabesques, chinoiseries, and other flourishes to aristocratic residences. He worked in the new Rococo style, which was light and delicate, and seemed like a breath of fresh air after the ponderous Classicism that had been popular in the reign of Louis XIV.

Watteau absorbed this air of finesse and refinement, incorporating it into his own style, but his association with Audran had another significant benefit. At this time, Audran was curator of the Luxembourg Palace, which contained the magnificent cycle of 24 paintings on the *Life of Marie de' Medici* (wife of Henry IV of France) by the celebrated Flemish painter Peter Paul Rubens. In a period in which almost all art collections were in the hands of wealthy individuals, gaining access to such a rich resource was a tremendous asset in the education of a young artist. Watteau was able to study the paintings at leisure and marvel at Rubens' command of colour.

Learning from the masters

Watteau submitted an application for the Prix de Rome – a scholarship that granted the winner several years of study at the French Academy in Rome. He entered the competition in 1709, but came second. Undeterred, he made further attempts to fund a trip to Italy, but his ambitions were thwarted. However, in about 1712, he was commissioned to paint a set of *Four Seasons* for the house of the banker and art collector Pierre Crozat. With his usual aplomb, Watteau managed to inveigle Crozat into letting him stay at his country estate, where he was able to study the extensive collection of drawings, paintings, and sculptures on display (the collection was later sold to the Hermitage Museum in St Petersburg).

By now, Watteau's own works were in considerable demand. Some were military scenes, painted on a return visit to his home town of Valenciennes, but it was Watteau's highly distinctive theatrical pictures that attracted the most interest from art collectors.

Watteau had become so greatly admired that when he applied for, and was granted, membership of

"What **movement!** What **verve!** What **colours!**"

HONORE DE BALZAC, *COUSIN PONS*, 1846–47

the Academy, the committee took the unprecedented step of allowing him to choose any subject he liked for his presentation piece. It took five years and four reminders before Watteau actually delivered the painting, but it was worth the wait. *Pilgrimage to the Isle of Cythera* was his supreme masterpiece – a bittersweet fantasy in which the modern world encountered classical mythology.

A new genre

Recognizing the work's unique qualities, the Academy honoured it with a brand new classification – an entirely new "type" of painting to stand alongside existing categories such as portraiture, still life, and history painting (which was seen as the highest class of painting). The new classification was the *fête galante*, which has been described as a "courtship party", in which elegant, costumed people enjoy an idealized, outdoor setting, strolling, dancing, and listening to music. *Pilgrimage to the Isle of Cythera* originated as a scene from a minor play by Florent Dancourt titled *The Three Cousins*, which Watteau transformed into a dreamlike vision. An exotic mix of costumes adds to the sense of fantasy. Actors from the *commedia dell'arte* mingle with figures in historical dress – perhaps borrowed from a Rubens painting that Watteau had seen – along with others wearing contemporary ballgowns.

Beautiful melancholy

In common with many of Watteau's theatrical paintings, *Pilgrimage* is tinged with an air of melancholy, as though the figures are aware that the pleasures of this world cannot last for long: it is a lament to loss more than a celebration of life. None of Watteau's many imitators ever managed to

KEY MOMENTS

c.1708
Paints eight decorative panels for the Hôtel de Nointel. The panels consist of tiny, graceful figures contained within arabesque borders.

1709
Wins second place in the Prix de Rome but is not sent to study in Italy. He is accepted into the Academy in 1712.

1717
Submits *Pilgrimage to the Isle of Cythera* to the Academy as his reception piece.

1720
Paints *The Italian Players* in London for his physician, Dr Mead. The figures are unusually realistic.

1721
Completes his final masterpiece, *Gersaint's Shop Sign*. The painting is sold within a fortnight of being put on show.

replicate this delicate mood. Some critics believe that the work's sadness stemmed from the artist's fatal illness, which was gradually getting worse. It is equally possible, however, that the effect resulted from his unusual method of composition: Watteau did not plan out his *fêtes galantes* as a whole – instead, he usually assembled them from individual, unconnected drawings that he had produced. This may explain why the figures in these scenes sometimes appear isolated, ethereal, and wrapped up in their own world.

Watteau's health was certainly deteriorating by the end of the decade. In 1719, he travelled to London to consult the renowned English physician Dr Richard Mead, but this did nothing to improve his condition. He returned to Paris the following year, staying with a friend, the picture dealer Edmé Gersaint. For him, Watteau produced his last great masterpiece: a magnificent shop sign showing the interior of Gersaint's premises bustling with customers. The work displayed a greater sense of naturalism, a hint of the new direction that his art might have taken had he lived, and was a clear indication that his artistic powers remained undimmed, right up to the end. Watteau died on 18 July 1721, aged just 37.

ON TECHNIQUE
Trois crayons

Throughout his career, Watteau sketched tirelessly, making copies of Old Masters and drawing from life. He was a keen observer of people and their changing expressions, and made compellingly spontaneous sketches of those around him – actors, dancers, shopkeepers, and noblemen – almost always isolated from their surroundings.

Watteau employed the *trois-crayons* (three-crayons) technique, using red, white, and black chalks to produce painterly effects. To create flesh tones, he wetted the tip of his finger and used it to blend the chalks convincingly with the colour of the underlying paper.

Rather than producing preparatory sketches for his paintings, Watteau mined his sketchbooks for individual figures, which he then incorporated into his larger works. Some of the sketches appear in several of his large works.

STUDY OF HEADS, c.1715

Giambattista Tiepolo

1696–1770, ITALIAN

Tiepolo was the greatest Italian artist of the 18th century and one of finest exponents of the Rococo style. He was also the last master of fresco painting, continuing a tradition that extended back to Giotto.

Giovanni Battista Tiepolo was born in Venice on 5 March 1696. His first names – the Italian form of John the Baptist – were probably given in honour of his godfather, a nobleman called Giovanni Battista Donà, and are normally shortened to Giambattista. The elevated status of this godfather confirms that Tiepolo came from a respectable family. Sadly, his own father – a prosperous shipping merchant – died just a year after he was born.

Early influences

Virtually nothing is known of Tiepolo's early days, before his apprenticeship to Gregorio Lazzarini in about 1710. Lazzarini was a history painter, well regarded in his day but now largely forgotten. He was a diligent teacher, but his work left no discernible mark on his young student's style.

Instead, Tiepolo was influenced by another Venetian artist, Giovanni Piazzetta (1683–1754), who was known for his religious canvases and enigmatic genre pictures. Hints of Piazzetta's dramatic approach can be seen in one of Tiepolo's early works, *The Sacrifice of Isaac*.

In 1717, Tiepolo qualified as a member of the painters' guild in Venice. He had already been working as an independent artist for some time. As Lazzarini's biographer confirmed, Tiepolo was "all fire and spirit", with a precocious talent that made him far too ambitious to remain in his master's shadow for long.

He gained his first documented commission in 1715 and, in the next year, made a splash with the *Crossing of the Red Sea*, which he showed at the festivities on St Roch's day (at the time, Venice's main public exhibition).

△ **THE SACRIFICE OF ISAAC (DETAIL), 1716**
Tiepolo's first public work is a somewhat sombre rendering of the biblical event in which God asks Abraham to sacrifice his own son, Isaac.

By 1719, Tiepolo felt secure enough to take a bride – Cecilia Guardi, the sister of the famous view painter, Francesco. They married in Tiepolo's local church, Santa Ternita, and went on to have 10 children, two of whom became artists and assisted their father in his large-scale projects.

Wealthy patrons

Tiepolo's career progressed rapidly in the 1720s. His early work had often been in oils, but in 1725 he landed his first known commission for a ceiling fresco – the artistic field that was to become his speciality.

◁ **ALEXANDER AND CAMPASPE IN THE STUDIO OF APELLES (DETAIL), c.1724**
Tiepolo depicted himself as Apelles, the famous painter of antiquity, making a portrait of Campaspe, the concubine of Alexander the Great.

" [Tiepolo] is full of **spirit**... of an incredible **fire**, an astonishing **colouring**, and an amazing **speed**. "
COUNT TESSIN, REPORTING TO THE KING OF SWEDEN

KEY MOMENTS

1716
Wins a competition with his painting *The Crossing of the Red Sea*. Is accepted as a member of the Venice Guild of Painters in the following year.

1727
Paints *Sarah and the Angel,* an Old Testament scene for a series of frescos at the archbishop's palace in Udine.

1740
Paints one of his impressive religious works, *The Road to Calvary* – one of three huge canvases depicting the Passion of Christ.

1750–53
Leaves Italy for the first time to undertake one of his most ambitious projects, the decorations at the palace, Würzburg.

1762
Arrives in Spain to begin work on his last major undertaking, the decoration of the royal palace in Madrid.

At around the same time, he attracted the attention of the Dolfin family, one of the wealthiest families in Venice. Tiepolo carried out several commissions for them. The grandest of these was at Udine, some 95km (60 miles) northeast of Venice. Here, he decorated the staircase, the gallery, and the *Sala Rossa* (Red Room) of the archbishop's palace with a sequence of episodes from the Old Testament. These frescos gained great acclaim, helping to spread Tiepolo's reputation, and he was soon overwhelmed with offers of work. Initially, these came from other Italian cities – Milan, Bergamo, and Vicenza – but by the mid-1730s, the demand for his services extended to the crowned heads of Europe. Tiepolo could barely keep up, writing to one impatient patron that he was "working day and night... without drawing breath".

A master of fresco
Tiepolo's fresco style differed considerably from his earlier oils. He abandoned the darker colouring that he had adapted from Piazzetta, opting instead for lighter, pastel tones. Shadows vanished almost entirely. One near-contemporary commented on a flickering effect, linking the graceful figures that floated across his elaborate compositions. Tiepolo accomplished this "with the use of dull colours adjacent to a few bright touches", which endowed his work with "a vivacity... a sunlight, which perhaps has no equal".

Optical illusions
The key to Tiepolo's success was speed and sureness of touch – a huge advantage because mistakes on quick-drying plaster could not easily be rectified. Not only was he a superb draughtsman but he also displayed a mastery of foreshortening: this was crucial because many of his frescos were seen from below.

Tiepolo rose to the challenge of the medium. He loved adding virtuoso passages – illusionistic details that made spectators look twice, unsure if they were looking at something real or imagined. In his Würzburg decorations, for example, figures dangle their legs over balustrades or seem to be about to tumble off (painted) ledges.

Careful preparation
Tiepolo made numerous drawings before embarking on a fresco. The initial studies were usually drawings in pen and brown ink, with a brown wash. Then, as his composition took shape, he produced oil sketches. The most detailed example – known as a *modello* – was shown to the patron, in order to gain his or her approval before work began. The surviving *modelli* are now regarded as masterpieces in their own right.

Some aspects of Tiepolo's style were more intuitive. He had an outstanding gift for blending the simulated light of his paintings with the real light of the surrounding architecture. His figures seem to float free of the walls and ceilings, but still appear to inhabit a genuine sense of space. Tiepolo also had a tremendous capacity for invention, which served him well in commissions where he was expected to portray some obscure corner of a family's history, or combine an ancestor's exploits with episodes from classical mythology.

▽ **THE BANQUET OF CLEOPATRA AND ANTONY, c.1748**
When Cleopatra entertained Antony, she made a show of her wealth by dissolving a priceless pearl earring in a goblet of wine and then drinking it. Tiepolo painted this theme several times. It was a favourite with patrons who were proud of their riches.

Tiepolo's ceiling painting over the grand staircase of the palace in Würzburg was designed to glorify the newly installed prince-bishop. Personifications of the four continents all pay tribute to him.

ON TECHNIQUE
Illusionism

Tiepolo's frescos were renowned for their convincing illusionistic effects. The idea in most cases was to make a palatial residence seem even larger. Ceilings were transformed into lofty towers and skies while, at ground level, a painted wall might appear at first glance like an open loggia or another chamber. This required teamwork. In common with most other fresco painters, Tiepolo worked with a *quadraturista* – a specialist in painting illusionistic architectural elements. For much of his career, he collaborated with one of the finest exponents of this craft, Gerolamo Mengozzi Colonna (c.1688–1766).

DETAIL OF FRESCO AT VILLA VALMARANA AI NANI, TIEPOLO, 1757

In meeting these challenges, Tiepolo drew inspiration from a number of different sources. He shared a love of pageantry with Paolo Veronese, his illustrious predecessor during the golden age of Venetian painting, and even portrayed many of his figures in exotic, 16th-century dress, to enhance this opulent effect.

Tiepolo's grandest compositions also display a sense of theatre. Opera had developed in Italy as an art form in the previous century. The first commercial opera house opened in Venice in 1637 and, by the end of the century, the city boasted no fewer than 16 theatres. Tiepolo's celestial visions certainly echoed some of the magical stage and light effects that theatre audiences enjoyed so much.

Extravagant schemes

Tiepolo's greatest Italian frescos may well be the decorations at the Palazzo Labia in Venice (c.1745–50). These include the ballroom, with its celebrated depictions of the romance between Antony and Cleopatra.

The Labia were an ostentatious family and, according to rumour, they mimicked an episode from history in which Cleopatra exhibited her extravagant wealth (she reportedly dissolved and drank a precious pearl) by throwing their gold dinnerware into the canal after a banquet; the joke was on their guests as they later retrieved their platters from concealed nets.

As magnificent as they were, the Labia frescos were overshadowed by the scheme that is considered to be Tiepolo's masterpiece – the decorations at the palace of the prince-bishop in the German city of Würzburg. Here, the artist was set the task of glorifying his patron's family – a feat he achieved spectacularly in the huge fresco above the stairwell, where Apollo and the glitterati of the four known continents gathered to pay homage to the prince.

Late in life, Tiepolo was summoned to Spain by Charles III, to decorate the royal palace in Madrid (1762–66). He remained in Spain after the work was completed, taking on further commissions, but his style was falling out of favour, supplanted by the new taste for Neoclassicism. He died in Madrid on 27 March 1770 and was buried in the church of San Martin.

> " Tiepolo is the **ideal artistic athlete**. No stadium was too big or daunting for him to perform in. "
>
> MICHAEL LEVEY, *THE OBSERVER*, 1986

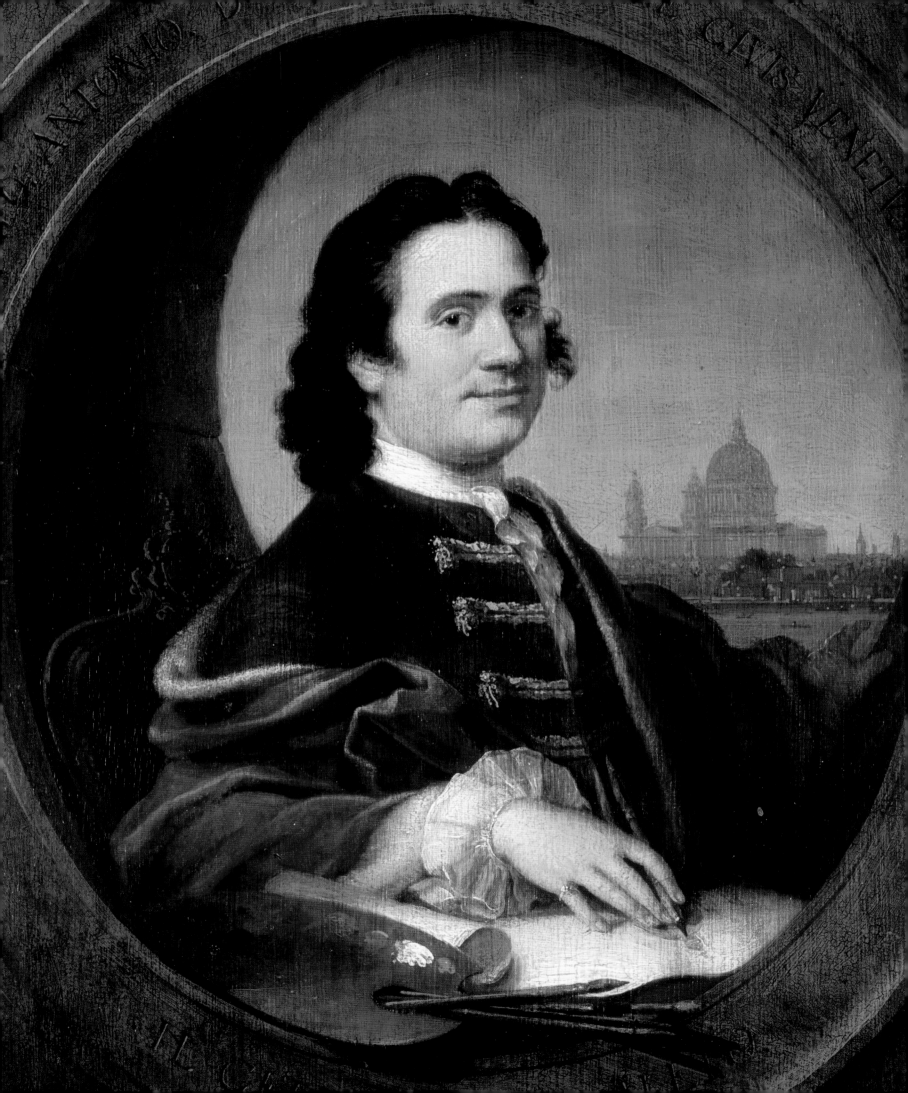

Canaletto

1697–1768, ITALIAN

No artist has captured the glorious views and magical spirit of Venice more effectively than Canaletto. His work was hugely popular in his time, and has never fallen out of favour.

Giovanni Antonio Canal was born in Venice on 28 October 1697. His father, Bernardo, was a highly regarded theatrical scene painter and Antonio undertook his training in the family workshop. He may have decided at this stage to adopt the nickname Canaletto (Little Canal), simply to avoid confusion with his father.

Set decoration

At first, Canaletto worked for several years as Bernardo's assistant. In 1716–18, he helped to decorate sets for operas by the Venetian composer Antonio Vivaldi; he then left for Rome, where he prepared backdrops for two operas by Alessandro Scarlatti. This theatrical work proved an excellent grounding for Canaletto's career. It helped him to master aerial perspective and taught him how to marshal his compositions, pulling together scores of different details into a convincing whole. It also left a distinctive mark on his style: however crowded Canaletto's scenes became, it always seemed as though they were being viewed from a distance. Generally, his most effective pictures were panoramic vistas with relatively little foreground incident. In the theatre, of course, this foreground activity would have been supplied by the actors on the stage.

In Rome, Canaletto made a number of drawings of the city's landmarks, perhaps already considering a change of career. An early source suggests that he found it difficult to work with theatre people but, tantalizingly, does not elaborate. In any event, his name was inscribed in the Venetian guild of painters in 1720 and his new direction probably dates from around this time.

City views

As an independent operator, Canaletto cast his net rather wide. He painted landscapes, both real and imaginary, and his first datable commission (1722) was to collaborate on a series of allegorical pictures of the tombs of

△ **EARLY CITYSCAPES**
While he was working in Rome in 1719, Canaletto produced a series of pen and ink drawings, including this view over the Tiber and the city from the Basilica of San Valentino on the Via Flaminia.

various English worthies. Canaletto gained this commission via the agent and former theatrical impresario Owen MacSwiney, and later acquired most of his work in this manner – through personal introductions rather than by displaying his artwork in a gallery or exhibition.

Gradually, Canaletto narrowed his focus, concentrating on *vedute*, or views, of his native city. Some

ON TECHNIQUE
Capriccio

Taking its name from the Italian word for caprice, a *capriccio* is a painting with an imaginary subject – typically a combination of architectural elements (often from different sites) with a real or fictitious landscape. This type of picture was popular in the 18th century and Canaletto was one of its finest exponents. *Capricci* appealed more to Italians than to tourists and so offered Canaletto an additional market for his works. With their whimsical subjects and invented compositions, they allowed him a freer arena in which to display his artistic virtuosity. It is significant, perhaps, that Canaletto chose a *capriccio* titled *Portico of a Palace* as his reception piece for the Venice Academy. Some of his *capricci* were more fantastical than others, such as the invented landscape below, which was commissioned by a wealthy English artistocrat.

***ENGLISH LANDSCAPE CAPRICCIO WITH A PALACE**, c.1754.*

◁ **PORTRAIT OF THE ARTIST**
This painting, which shows Canaletto painting a scene of St Paul's in London, was once attributed to the artist himself, but was probably executed by an English painter, who copied Canaletto's style in the view of the river behind.

" His **excellency** lies in painting things which fall immediately **under his eye.** "
LETTER FROM OWEN MACSWINEY TO THE DUKE OF RICHMOND, 1727

KEY MOMENTS

c.1720
Paints *The Grand Canal: Looking East from the Campo San Vio*, one of his earliest views over Venice.

c.1725
Early in his career, enjoys painting the shabbier side of the city, rather than the obvious tourist sites.

1729–32
At the height of his career, paints *The Bucintoro Returning to the Molo on Ascension Day*, depicting one of the great ceremonial occasions of the year.

1747
In England, paints *A View of London from Richmond House*; he gravitates towards the river Thames, which reminds him of home.

1763
Is finally elected as a member of the Venice Academy.

historians have suggested that he trained in this rather specialized field in the studio of Luca Carlevaris (1663–1730), the leading painter of Venetian scenes at the time. Canaletto certainly knew of Carlevaris's work and borrowed ideas from it, but their styles and methods were completely different. Carlevaris's somewhat static scenes were composed entirely in the studio, while Canaletto – always a prolific draughtsman – produced sketches outdoors and used these as reference material when he later came to assemble his compositions. As a consequence, his scenes display a freshness and vitality that were

lacking in the work of the older master. Canaletto's exceptional eye for detail is particularly evident in his early views, such as his celebrated painting *The Stonemason's Yard*. Here, the artist depicts the peeling plasterwork on the houses, the untidy balconies with sheets hanging out to dry, and the rickety wooden shed where workmen are cutting and shaping stone.

This picture was almost certainly produced for an Italian client, but it was not long before Canaletto set his sights on a large and lucrative market for his work – wealthy English aristocrats undertaking the Grand Tour (see box, opposite).

The playground of Europe

This flow of visitors to the Continent started as a trickle in the 1650s, but grew into a flood during the following century, with Italy always the high point of the tour. Travellers went to Rome for its antiquities, but to Venice to play. The city was famous for its masked balls, festivals, and coffee-houses. Its *ridotti*, or gaming-houses, attracted everyone from wealthy aristocrats to courtesans, and were the perfect locales for illicit assignations – Venice had a deserved reputation as "the brothel of Europe".

The city was busiest during the carnival, when locals and tourists alike "resign themselves up to joy and liberty, frequently attended with folly and great disorder". Disguised behind carnival masks, carousers would take part in festivities staged by the gondoliers, who were notorious as "the prime managers of intrigue".

Tourist demands

The writer and traveller Lady Mary Montagu described English tourists in Venice as "the greatest blockheads in nature". They were, however, wealthy blockheads, who sought out expensive souvenirs of their adventures. The more cultivated among them opted for scenic paintings – a demand that Canaletto was happy to satisfy. The only difficulty was the language barrier, since most of the tourists retained "an inviolable fidelity to the language their nurses taught them". Canaletto's use of agents allowed him to overcome this difficulty. The most important of his agents was Joseph Smith, the British consul in Venice, who introduced the artist to some of his most distinguished clients, and purchased many of Canaletto's finest works himself, later selling them on to the British monarch, George III.

▽ **THE STONEMASON'S YARD, 1727**
Canaletto had an unrivalled eye for detail, here capturing a scene of everyday life in Venice, away from the sights and festivals sought out by the city's many tourists.

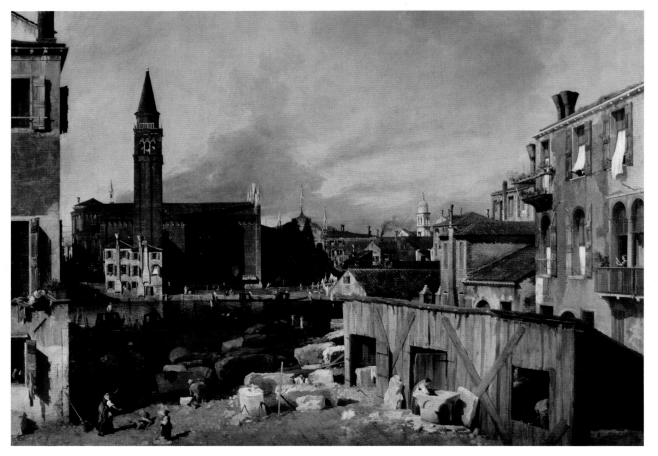

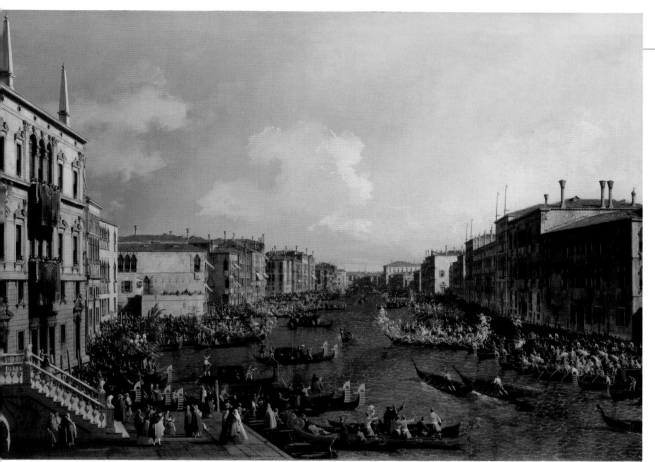

◁ **A REGATTA ON THE GRAND CANAL, c.1740**
The painting depicts a gondola race during the annual carnival regatta. Many of the spectators are wearing the traditional carnival garb of black cape and white mask.

IN CONTEXT
The Grand Tour

Canaletto owed his livelihood to the popularity of the Grand Tour, which flourished throughout the 18th century. This entailed the sons of wealthy aristocrats being sent on an educational tour of the Continent, usually accompanied by a guide or tutor. The itinerary – which often took a year to complete – generally included France, the Low Countries, and a passage through the Alps, but the highlight was always Italy. For some, the tour might not amount to anything more than an extended period of dissipation, but the more serious-minded travellers might return with an expensive collection of souvenirs – an antique sculpture, their portrait painted beside a classical landmark, or a beautiful painting by Canaletto.

BRITISH CONNOISSEURS IN ROME, KATHARINE READ, c.1750

A market for mementos
Canaletto adapted his style to suit the English market. He chose to paint the city's most popular tourist sites and its great ceremonial occasions. He used brighter colours, making his scenes appear warm and sunny (even for events depicted in winter). He also strove to instil a sense of immediacy into his work. In one of his paintings, for example, a workman's bucket hangs prominently in mid-air, creating a "snapshot" effect that personalizes the scene and makes the viewer feel present in the moment.

Canaletto used visual tricks to maintain his illusions of reality and make his paintings more marketable. He would sometimes change the shape and proportion of individual buildings, alter the course of canals, or insert houses that did not exist. Increasing the appeal of his works in this way boosted his profits.

Canaletto's popularity soared, and his prices quadrupled. He took on so much work and became so prolific that some people questioned his methods, suggesting that he used a camera obscura or employed a team of assistants to make paintings. The evidence is inconclusive.

A move to England
Canaletto enjoyed huge success during the 1720s and 1730s, but his fortunes declined after the outbreak of the War of the Austrian Succession (1740–48). Continental travel became difficult and

◁ **DRAWING AID**
Canaletto was accused of using a camera obscura – an instrument that projects an image onto a drawing surface so that its outline can be traced.

his commissions dried up. Undeterred, he moved to England in 1746 and, with the exception of one or two return visits to Venice, remained there for a decade. Initially he made a considerable impact, producing some of his finest canvases for the duke of Richmond, but the quality of his work gradually declined, even sparking rumours that the man in England was an imposter. Canaletto returned to Venice in 1756. He continued painting and was elected to the Venetian Academy, but never quite recovered the reputation of his heyday. He died in the city in 1768.

" He surpasses all before him. His manner is **clear, gay, lively**, and in perspective, with **admirable detail**. "

CHARLES DE BROSSES, LETTER TO DE NEUILLY, 1739

William Hogarth

1697–1764, ENGLISH

An inventor of a new type of painting – the "modern moral subject" – Hogarth not only was a sharp-eyed observer and critic of contemporary society, but actively sought to raise the status of British art.

William Hogarth was born in London, the son of a Latin scholar and former schoolmaster who – at one stage – owned a coffee house that went bankrupt, landing him in the city's Fleet debtors' prison. His father's experiences were of key importance to the young artist, both because he was able to observe the life and characters of the London coffee house at close quarters, and because his father's fate convinced him of the need to secure financial independence.

Early acclaim

Hogarth began his professional life as an engraver of coats of arms on silver plate, studying painting in his spare time. His very first painting, a scene from the popular play *The Beggar's Opera* (which opened in 1728), set the tone for much of what was to follow. It depicts a dramatic incident taking place in a theatre and is filled with naturalistic details, even showing the audience seated on stage, as was the custom of the day. It proved so popular that Hogarth made several versions of the work, and its acute observation

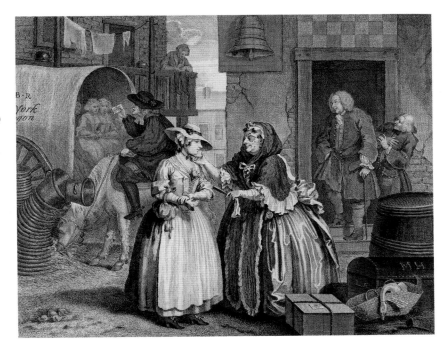

△ *A HARLOT'S PROGRESS: PLATE 1*, 1732
The main protagonist of Hogarth's moral series, Moll Hackabout, is examined by Mother Needham, the brothel keeper.

of character and likeness led to a number of portrait commissions, including "conversation pieces", informal depictions of groups of family and friends engaged in conversation or some other activity.

Around 1731, Hogarth developed the first of the picture series that were to become his trademark – canvases that told a story in several episodes, rather like a novel. Although these paintings are full of humorously observed vignettes that highlight human folly, the intention behind

them was serious: Hogarth wanted to promote social reform and remedy injustice and urban poverty.

His first series was *A Harlot's Progress* (1731), the narrative of a naive country girl who arrives in London, is lured into prostitution by a brothel keeper, and ends up dying

◁ *AS I SEE MYSELF*, 1745
Hogarth helped to define British art; his witty, scathing paintings set him apart from the European tradition. This self-portrait includes his pug dog, Trump.

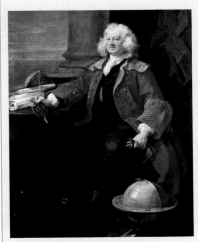

CAPTAIN CORAM, WILLIAM HOGARTH, 1740

" I have endeavoured to **treat my subjects** as a **dramatic writer**: my picture is my stage, and men and women **my players**. "

WILLIAM HOGARTH

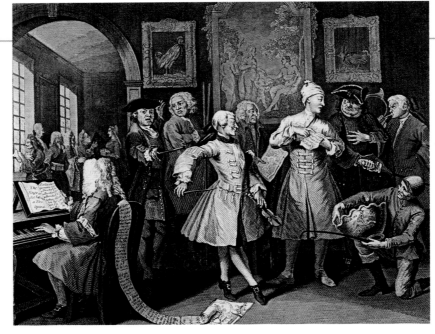

▷ **A RAKE'S PROGRESS,
PLATE 2, 1734**
The engraving of the second scene of Hogarth's series shows the newly rich Tom surrounded by sycophantic companions and instructors in various arts. There is a subtle undercurrent of xenophobia in the comical portrayals of the prancing Italian dancing master, the French fencing instructor, and the Old Master painting on the wall.

ON TECHNIQUE
Caricature versus character

Hogarth often exaggerated the features of the people he painted, but he was keen to rebuff the critics who accused him of caricature. To address their allegations, he produced a print (below) in which he intended to illustrate the difference between character and caricature. At the bottom left are three heads taken from Raphael (character) while at the bottom right are heads based on the work of other artists, including Leonardo, showing the distorted features that illustrate caricature. In the space above, Hogarth has depicted a series of his own "character" profiles.

**CHARACTERS AND CARICATURAS,
WILLIAM HOGARTH, 1743**

from venereal disease. The paintings were destroyed by fire in 1755, but we know what they looked like because Hogarth also produced them as prints, a venture that turned out to be highly lucrative. This success encouraged him to undertake several further series of paintings, all of which were later turned into prints. Concerned to protect his living against cheap pirate versions of his prints, Hogarth began a campaign to grant copyright to engravers.

A very British artist
Hogath's next "moral history" series, *A Rake's Progress* (1732–33), consisted of eight canvases charting the rise and fall of Tom Rakewell, a young man about town who inherits a fortune and then squanders it on luxuries, gambling, and prostitutes, before being thrown into debtors' prison and ultimately descending into madness. Full of wit and satirical detail, the paintings – and the prints made afterwards – provide an astringent commentary on the social customs of the day, critique snobbishness and selfishness, and lampoon the faddishness of fashions adopted from abroad. The series was a success.

Hogarth was passionately patriotic and loathed the taste for foreign art, even though he often borrowed motifs and compositions from European Old Masters in his own work. For him, it was deplorable that British collectors bought such works at a time when native artists were finding it difficult to make a living. Fuelled by a desire to champion British art, he decided to set up his own London drawing academy in 1735, which was to be run along democratic lines.

Class commentaries
The social habits of the aristocracy were targeted for satire in Hogarth's next big series, *Marriage A–la–Mode*. The six canvases portray an ill-matched couple who have been brought together in a loveless arranged marriage. The son of the impoverished Earl Squander is paired off with the daughter of a wealthy city merchant, but the union inevitably ends badly. Its decline encompasses

▷ **MARRIAGE A-LA-MODE: THE
MARRIAGE SETTLEMENT, 1745**
The palette and composition of Hogarth's work deliberately recall French Rococo art, boosting the work's satirical impact.

infidelities, syphilis, a duel, and a suicide. The first picture (*The Marriage Settlement*) sets the symbolic tone for the rest: the aged earl is shown with his family tree and the new house he is having built is seen through the window. The merchant holds the marriage contract, while his daughter behind him listens to a young lawyer, Silvertongue. The earl's son, the viscount, admires his own reflection in a mirror more than his potential bride. Two dogs, chained together in the bottom left corner symbolize the marriage, while the paintings on the walls comment on the action. A grand portrait in the French manner on the rear wall faces a Medusa head, denoting horror, on the side wall.

Hogarth's wit was not always directed at the upper classes. His print series *Industry and Idleness* (1747) and *Beer Street* and *Gin Lane* (1751) cast

> "One of the most **useful Satyrists** any Age **hath produced**."

HENRY FIELDING, 1740

an equally critical eye over working-class vices. He also took on the political system in a later satirical series, *An Election* (c.1755). The four canvases portray the bribery, corruption, and mob violence that frequently attended election campaigns, and were probably inspired by newspaper reports that Hogarth had read of real events of the Oxford election.

KEY MOMENTS

1721
Paints the first of his "modern moral" subjects: *The Harlot's Progress.*

1729
Marries Jane Thornhill, daughter of his one-time mentor, James Thornhill.

1735
Re-establishes a drawing school in London, formerly run by his father-in-law.

1740
Donates £120 and his portrait of Captain Coram to the new Foundling Hospital.

1748
Is arrested for spying in France while sketching in Calais. Paints *O The Roast Beef of Old England* in revenge.

1753
Publishes a treatise about art, *The Analysis of Beauty.*

History painting

In 1757, Hogarth was made sergeant-painter to the king, a position that provided him with a good income from supervising decorative works. He must have been delighted with the appointment to an office previously held by James Thornhill, his deceased father-in-law. Thornhill had been a history painter, and Hogarth had long wanted to follow in his footsteps and paint in the grand manner, but the attempts he made to do so were far less successful than his intimate compositions and portraits. His *Sigismunda Mourning over the Heart of Guiscardo* (1759), illustrating a scene from the stories of the *Decameron* (a medieval collection of 100 tales by the Italian Giovanni Boccaccio), was a deliberate attempt to show that an English painter could engage with heroic themes as convincingly as the Italian masters of the High Renaissance. However, the picture was rejected by the man who had commissioned it and was so harshly criticized by the public that Hogarth almost completely abandoned painting for the last years of his life.

Late work

Modern viewers might feel that Hogarth's genius is more aptly revealed in the small, informal sketches he made showing his servants, or the study of a shrimp girl he had seen selling shellfish in Billingsgate Market, a basket perched on her head. Freely painted, such studies were not made for sale, but their freshness and spontaneity reveal Hogarth's talent for capturing the qualities that make each person unique.

△ **MASONIC BADGE**
Hogarth is thought to have designed this silver badge for the Grand Lodge in London. Becoming a Freemason gave Hogarth access to new tiers of society, and he incorporated Masonic themes into a number of his works.

◁ *THE SHRIMP GIRL,* **c.1740–45**
This late, unfinished work shows Hogarth loosening his brushwork to create a sensual, energetic portrait.

Jean-Siméon Chardin

1699–1779, FRENCH

Largely self-taught, Chardin produced quiet still lifes and intimate genre scenes that won him a place at the elite French Royal Academy. His genius lay in capturing the beauty of everyday episodes.

Jean-Siméon Chardin was born in Paris on 2 November 1699, the eldest child of Jean, an accomplished cabinet-maker whose customers included Louis XIV. He grew up in an atmosphere in which skilled craftsmanship was highly prized, but he chose not to follow his father's profession. At the age of 18, Chardin became apprenticed to a court painter, although for the most part he was self-taught as an artist.

Success at the Academy

By his mid-20s, Chardin had established himself as a painter of still lifes, but he struggled financially and often had to make do with adding details to paintings by other artists. His fortunes took a turn for the better in 1728, when his paintings attracted the eye of the famous painter Nicolas de Largillière, who encouraged him to show his work at the Royal Academy, and to apply for membership.

◁ **SELF-PORTRAIT WITH SPECTACLES, 1771**
This self-portrait in pastel was shown at the Salon of 1771, by which time Chardin was in poor health.

Chardin's election to the Academy as "a painter of flowers and fruit" was a remarkable tribute to his skill, given that he had not trained there and his specialism was still life, which was the least prestigious branch of painting. By the 1730s, Chardin had begun to turn away from still life towards figure scenes – perhaps in the hope that they would increase his income. His pictures, which typically featured just one, two, or three figures, depicted

◁ **GRACE BEFORE DINNER, c.1740**
Chardin presents a slice of everyday life: a mother dishes out soup to one of her daughters, while the other daughter looks toward her mother, clasping her hands in prayer. The pot filled with charcoal (bottom right) is a charming still life in its own right.

episodes from everyday life: the daily routine of cooks or laundresses or the "above stairs" activities of middle-class households. These are quiet masterpieces, in which there is no conflict to upset the equilibrium, and colour and tone work together in harmony.

The figure scenes were successful, and Chardin prospered. He was elected treasurer of the Academy by his peers in 1755, and also won numerous royal commissions, including the decoration of the salon at the Château de Choisy, a royal residence, in 1764.

Chardin returned to still-life painting in later life, and as his sight began to fail him, he took to working in pastels. He focused on perfecting the art of depicting what he saw in front of him, communicating the pleasures of light, atmosphere, and texture. Chardin died in Paris in 1779, at the age of 80.

△ **CELEBRATING THE ORDINARY**
Chardin's modest canvases featured items found in every home – copper pans, pewter plates, or ingredients – a stark contrast to Academic "set piece" still lifes.

IN CONTEXT
Royal lodgings

Louis XV (1710–1774), the French king, was an admirer of Chardin's work and helped advance his career. The artist presented him with his painting *Saying Grace* when they met in 1740, and in 1752 the king – as a measure of his admiration – granted Chardin an annual allowance of 500 francs. In 1757 he gave him lodgings in the Louvre, which at that time was a royal palace rather than a museum.

COLONNADE OF THE LOUVRE PALACE, 18TH-CENTURY ETCHING

> " I must **particularly** try to **imitate...** general **masses**, **tones** and **colour**, roundness, effects of **light** and **shade**. "

JEAN-SIMEON CHARDIN

▷ **THE THIRTY-SIX IMMORTAL POETS (DETAIL), 1798**
In this series of panel screens, Itō Jakuchū treats a traditional theme (the most venerated Japanese poets) with considerable humour and daring, portraying his subjects at play.

Itō Jakuchū
1716–1800, JAPANESE

The painter Itō Jakuchū was celebrated for his detailed and colourful depictions of birds (especially roosters) and flowers. He combined the fine detail of his predecessors with bold new decorative effects.

"Painters... [are] contented **only by skill**... yet nobody can go beyond skill... **I am different.**"

ATTRIBUTED TO ITO JAKUCHU

Itō Jakuchū was the eldest son of a successful merchant who ran a business selling wholesale food in Kyoto. He was fortunate to be born during the peaceful Edo period of Japanese history, when major cities such as Kyoto enjoyed a flourishing and vibrant cultural life. He joined the family business when he was a young man, working in it until he was in his late thirties, while also pursuing his keen interest in art.

Little is known about his artistic training. Some say he was a pupil of a noted flower and bird painter, Ōoka Shunboku, but he was probably self-taught. Around the time he left the business, Itō Jakuchū built himself a studio and became acquainted with a monk, Daiten Kenjō, through whom he was able to study a collection of Chinese and Japanese paintings in the Shōkoku-ji temple, where Kenjō became abbot. It is likely that copying paintings in Buddhist temples was the way in which Itō Jakuchū taught himself to paint and draw.

Vivid nature

In 1757, Itō Jakuchū started work on a series of paintings that was to make his name. The series, *Dōshoku Sai-e* (*The Colourful World of Living Beings*), is a group of 30 scrolls, vividly painted on dyed silk, and featuring the natural world, especially plants, insects, birds, reptiles, and fish. The artist did not finish all of the paintings until 1765, but by then their vibrant colours, superb draughtsmanship, fine detail,

and carefully balanced compositions were impressing everyone who saw them. This vivid way of painting plants and animals was one of the two styles for which Itō Jakuchū became famous.

Zen influences

Through his friendship with Daiten Kenjō and other connections in the city of Kyoto, Itō Jakuchū mixed with many of the city's intellectuals, and accompanied them on some of their journeys. These travels inspired him to make further paintings of natural scenes and his friends encouraged this aspect of his art.

Itō Jakuchū was a religious man, and developed another way of working – a looser, less detailed style of ink painting – influenced by his interest

in Zen Buddhism (see box, right). He also experimented with printmaking, especially using woodblocks.

A spiritual life

The elderly Itō Jakuchū withdrew from intellectual life in Kyoto and retired to a Buddhist temple, devoting himself to spiritual matters. He did not give up his art, however, and was still painting in his last year. He took the name Tobeian (Bushel Monk) as he was reputedly paid for his works with bushels of rice.

He is remembered and celebrated for both of his styles of painting, although it is his vivid depictions of plants and birds in particular that make him one of the most appealing of all Japanese artists.

IN CONTEXT
Zen Buddhism

Although it originated in China, the Zen school of Buddhism became popular in Japan. It emphasizes self-control and meditation, and has encouraged a simplified but beautifully composed aesthetic, as in the harmony and serenity of Zen gardens, in rituals like the Japanese tea ceremony, and in short, concentrated poems such as haiku. When Itō Jakuchū retired to live as a Buddhist monk, his simple but carefully composed monochrome paintings, capturing the essence of an animal or a scene, reflected this philosophy.

POT USED IN THE JAPANESE TEA CEREMONY, 18TH CENTURY

▷ **THIRTEEN ROOSTERS, c.1757–66**
Part of the *Dōshoku Sai-e* series, to which the artist devoted 10 years, this scroll is a dazzling display of Itō Jakuchū's talent for close observation, detail, and use of colour (he is known to have experimented with new pigments).

◁ **HANSHAN AND SHIDE, c.1763**
Itō Jakuchū depicts the figures of Hanshan and Shide, Buddhist monks at a temple on China's sacred Mount Tiantai. His ink paintings point to his devotion to Zen and typically juxtapose open space with bold, dramatic form.

Thomas Gainsborough

1727–1788, ENGLISH

Gainsborough was one of Britain's greatest ever portrait painters. He carved out a glittering career in Bath and London, even though his real ambition was to become a successful landscape artist.

Thomas Gainsborough was born in the spring of 1727, in the market town of Sudbury. This is situated in the county of Suffolk in southeastern England, an area that had long been associated with the wool trade. Gainsborough's family had been involved in this industry for generations and his father worked as a cloth merchant until the 1730s, when his business ran into difficulties. Thomas was one of nine children and, as a boy, he spent much of his time sketching in the nearby countryside. He was certainly gifted for, at the age of 13, his parents allowed him to go up to London, to pursue a career as an artist.

Influences in the capital

In London, Gainsborough entered the studio of Hubert Gravelot (1699–1773), a French painter and engraver working in the Rococo style. Gravelot was chiefly employed as an illustrator and Thomas probably assisted him in this. Through his mentor, he made contact with two other influential

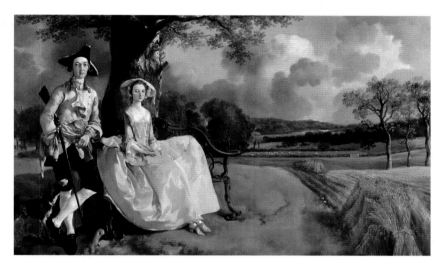

figures – Francis Hayman and William Hogarth. Hayman was an early exponent of the conversation piece – a form of group portraiture that placed the emphasis on an air of informality – while the painter and social critic Hogarth (see pp.156–59) provided the young man with one of his earliest commissions (a small painting, *The Charterhouse*).

Gainsborough set up his own studio in 1745, after Gravelot left London, and tried to earn his living as a landscape artist. It soon became obvious that there was insufficient demand for this, as he was obliged to take on restoration work. Fortunately, Gainsborough was in no danger of starving because in July 1746, he

entered into a clandestine marriage in a discreet, private chapel in Mayfair. His bride was Margaret Burr, the illegitimate daughter of the duke of Beaufort. Her illegitimate status was presumably the reason for the secrecy (Thomas's parents were God-fearing Methodists), but her substantial income eased his money worries.

A country retreat

In 1748, soon after his father's death, Gainsborough returned to Sudbury. Almost immediately, he received the commission for one of his best-loved paintings, *Mr and Mrs Andrews*. The daring format that he employed for this canvas suited his talents perfectly: half of the canvas was devoted to the

◁ **MR AND MRS ANDREWS**, 1748
Most probably commissioned to commemorate the marriage of this wealthy couple, Gainsborough's painting follows the conventions of the conversation piece.

IN CONTEXT
Bath

Gainsborough's decision to settle in Bath in 1759 was a shrewd business move. In the 1760s, it was the most fashionable resort in the country. The city's rise had begun with the royal visit of Queen Anne in 1702 and was then consolidated through the genius of "Beau" Nash who, as Bath's official Master of Ceremonies, transformed the entertainments on offer there. In theory, visitors came to the city for the medicinal waters, but in practice they came for the balls, plays, and concerts. Gainsborough's success in Bath can be measured by the fact that he was able to move into the Circus, the most prestigious building scheme in the city.

THE CIRCUS, BATH

◁ **SELF-PORTRAIT, 1758–59**
Gainsborough painted this image when he was living in Suffolk. Its easy grace indicates a break from more ostentatious European styles, the oak leaves in the background emphasizing its Englishness.

" His cranium is so **crammed with genius** of **every kind** that it is in danger of **bursting** upon you, like a steam engine **overcharged**. "

ATTRIBUTED TO DAVID GARRICK, ACTOR

KEY MOMENTS

1748
While in Suffolk, begins work on *Mr and Mrs Andrews*, his first genuine masterpiece.

c.1756
Experiments with different types of composition in images of his children such as *The Painter's Daughters Chasing a Butterfly*.

1767
Paints *The Harvest Wagon* while living in Bath. The following year, he becomes a founder member of the Royal Academy.

1775—77
Creates *The Hon. Mrs Graham* – a portrait of fragile beauty shown at the Royal Academy to great acclaim. Sadly, the sitter later dies young.

1785
Organizes annual exhibitions in his own studio following an argument with the Royal Academy.

happy couple, while the other half featured a view of the lush Suffolk countryside. There was a logic to this. The landscape presented the couple's extensive estate and also included a distant view of the church where they had recently been married. Sadly, this formula did not appeal to many other clients, who sought more conventional portraits.

No other commissions of this quality came Gainsborough's way in Sudbury, so in 1752 he moved to Ipswich, the county town of Suffolk. Although this town was larger and more prosperous, pickings remained slim. The landscapes that the artist sold in Ipswich were mainly overmantels (technically, furniture-pieces rather than pure landscapes), while the majority of his portrait clients were clerics or professional men, who tended to prefer a plain, "no frills" approach in their pictures. Gainsborough looked enviously at his rivals in London, who were able to charge twice as much as him. There was no other option: he had to move again.

◁ **GAINSBOROUGH IN SUDBURY**
A bronze statue of the artist made in 1913 by the Australian sculptor Sir Bertram Mackennal stands in Market Hill, Sudbury, the town of Gainsborough's birth.

▷ *MRS RICHARD BRINSLEY SHERIDAN*, 1785–87
In this portrait of the singer and society beauty Elizabeth Sheridan, Gainsborough uses a loose brush style to impart a sense of windblown romance.

Rising reputation

Gainsborough did not yet have the confidence to compete at the highest level in London, so instead he moved to Bath. He arrived there in 1759 and, almost overnight, became a huge success. There were two main reasons for this. Firstly, there was virtually no competition – the only other portraitist of note was William Hoare, an artist of very limited ability. Secondly, the influx of wealthy tourists brought him a greater variety of work.

Suddenly, Gainsborough was no longer spending the majority of his time on cheap, half-length portraits. Increasingly, he was working on life-size and full-length pieces. His prices rose rapidly, too. A head went from eight to 20 guineas; a half-length rose from 15 to 40 guineas; and he was now able to charge 60 guineas for a full-length. He felt no compunction about charging high prices for a genre of art that he found tedious. His letters are full of half-joking references to "the curs'd Face Business" and "picking pockets in the portrait way".

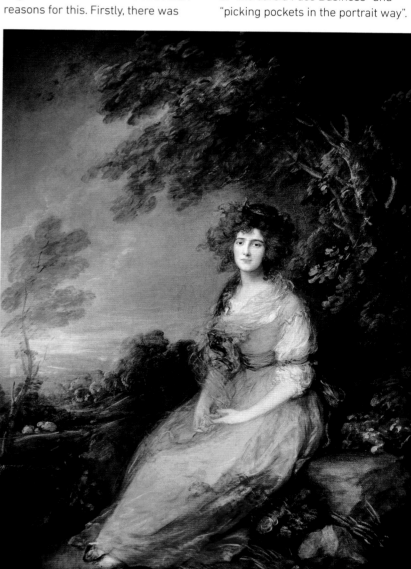

Success in London

New opportunities to exhibit allowed Gainsborough to get a foothold in the London market. The Society of Artists was formed in 1760 and he began showing his work there the following year. Then Gainsborough was invited to become a founding member of the Royal Academy – the only portraitist living outside London to be accorded this honour, which was a clear measure of his high reputation.

A natural style

Gainsborough's style reached maturity during his years in Bath, thanks in part to the number of private art collections that he was able to study. The most important of these was at Wilton House, which belonged to the earls of Pembroke and included portraits by Anthony van Dyck (see pp.114–17); Gainsborough was keen to instil some of their bravura into his own work and even depicted some of his sitters in period Van Dyck costumes, notably in his celebrated portraits *The Blue Boy* and *The Pink Boy*.

The key to his success, however, lay in the natural, informal tone of much of his work. Unlike his rival, Joshua Reynolds, Gainsborough avoided classical or literary themes. And he was also distinctive in forgoing the use of a drapery painter – most portraitists of the time employed a specialist to execute the sitter's outfit, but Gainsborough preferred to treat his composition as an organic whole.

Painting techniques

In his prime, Gainsborough developed a very individual manner of working. He liked painting in subdued lighting, particularly at the outset, when he was establishing the tonal relationships in his compositions. He was also fond of working by candlelight, which helps to account for the flickering effect in much of his paintwork. In addition, Gainsborough preferred to keep the same distance between his canvas and the sitter. In order to do this, he placed his easel at right angles to the subject and attached long sticks to his brushes. Then, using pigments that were heavily diluted with turpentine, he executed his painting with short, dabbing brushstrokes. Reynolds used to gaze with astonishment at the rough surfaces of his canvases, with "all these odd scratches and marks". To him, they seemed chaotic and yet, "by a kind of magic", he had to admit that they worked.

The shimmering appearance of Gainsborough's portraits increased still further in his final years. In late masterpieces such as *Mrs Richard Brinsley Sheridan* and *The Morning Walk*, the figures seem inseparable from their wispy, windblown settings, merging into a gentle, romantic haze.

Late years

Right up until his death, Gainsborough continued to experiment in his work – trying out new subjects, new artistic aids, and new techniques. Then, in April 1788, he began to develop the cancerous growth in his neck that would eventually kill him.

Just a few days before he died, Gainsborough summoned Reynolds to his bedside and the two old rivals were finally reconciled. Reynolds was one of the six artists who acted as pallbearers at Gainsborough's funeral, and in the next *Discourse* that he delivered to his students, he placed Gainsborough in the highest rank of English painters.

◁ **THE MORNING WALK**, 1785
This painting depicts an elegantly dressed young couple – William Hallett and Elizabeth Stephen – strolling through a leafy landscape. Such portraits were commissioned by the wealthy as symbols of status, or to celebrate weddings.

ON TECHNIQUE
Fancy pictures

In the early 1780s, Gainsborough pioneered a new genre of painting – the fancy picture. This usually consisted of a young ragamuffin depicted in a lyrical, pastoral setting. To modern eyes, these paintings can often seem overly sentimental, but the theme proved enormously popular at the time. Gainsborough gained his original inspiration from seeing Murillo's painting *St John the Baptist as a Child*. He was certainly happy with the results, as he charged high prices for his fancy pictures, and they remained popular after the artist's death, taking pride of place at his retrospective exhibition in 1814.

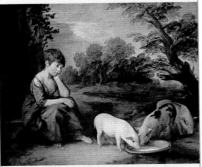

GIRL WITH PIGS, GAINSBOROUGH, 1782

" This **chaos**, this **uncouth** and **shapeless** appearance, by a kind of **magic**, at a certain distance assumes **form**. "

SIR JOSHUA REYNOLDS, *DISCOURSES*, 1769–90

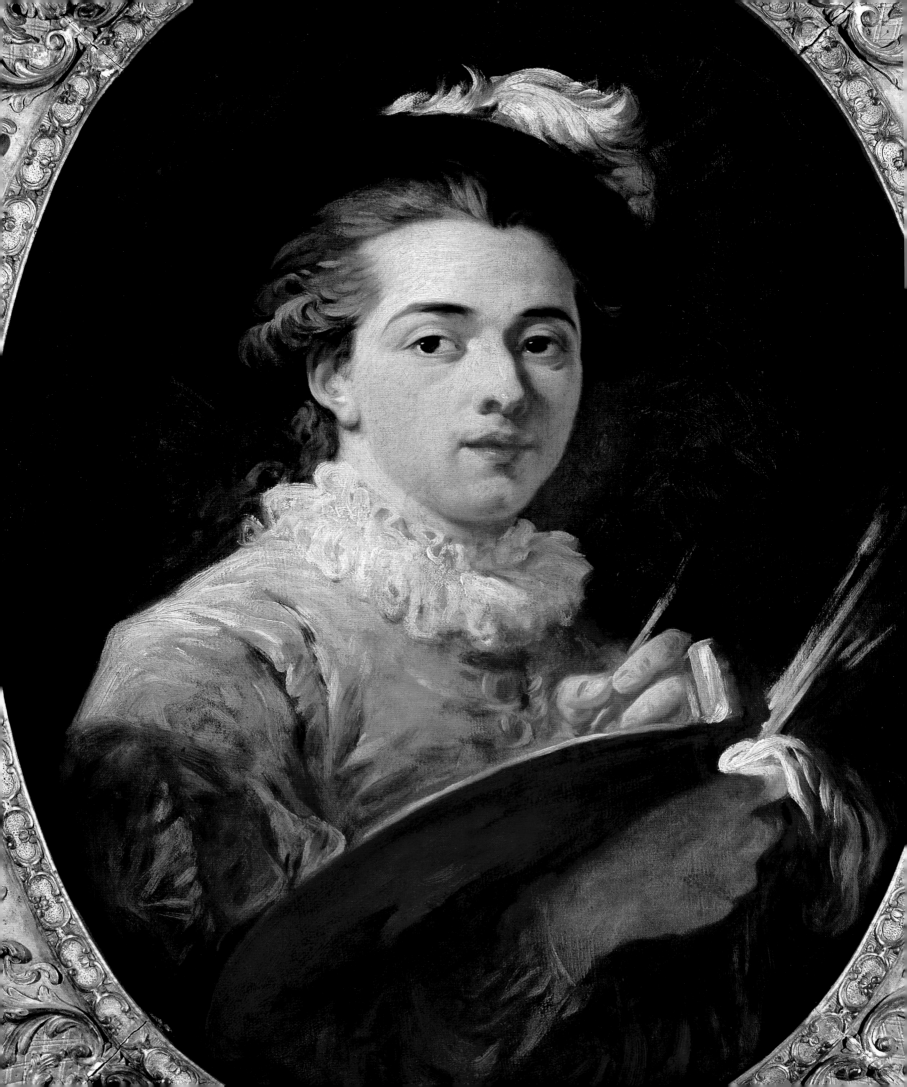

Jean-Honoré Fragonard

1732–1806, FRENCH

Fragonard was the last great master of the Rococo style in France. His light-hearted and often erotic paintings epitomized the pampered lifestyles of a regime that was soon to be swept away.

Fragonard was born in 1732 in Grasse, southeastern France. Today, it is a perfume capital, but in Fragonard's day it was known for its tanneries, so the stench of animal hides rather than the scent of jasmine would have filled the air.

In 1738, Fragonard moved with his family to Paris. Little is known about his early days other than that he worked briefly in a law office, before persuading his parents to let him train as an artist. His first master was Jean-Siméon Chardin (see pp. 160–61), who specialized in sober still lifes and genre scenes. However, it soon became clear that Fragonard was unsuited to such serious subject-matter, so he continued his studies under François Boucher, which proved to be an excellent choice.

The art of decoration

Boucher was the leading Rococo painter of the day, and was well connected, with a string of notable patrons, the most important being Madame de Pompadour, the mistress of Louis XV. Boucher taught his pupil the value of pure decoration, and his mythological scenes were convenient pretexts for arranging beautiful nudes into attractive compositions. Fragonard learned quickly, and by

1752 was deemed good enough to enter for the prestigious Prix de Rome (see right). Technically, he was not yet sufficiently qualified for this, but Boucher was adamant, declaring, "It does not matter – you are *my* pupil". Fragonard duly applied, winning the competition with his version of the set theme – *Jeroboam Sacrificing to the Idols*. The winner was entitled to a period of study at the French Academy in Rome, but before he left for Italy,

◁ **RETURN TO GRASSE**
The year before taking up his studies at the French Academy in Rome, Fragonard painted *Christ Washing the Feet of the Apostles*, which now hangs in the cathedral in the artist's home town.

Fragonard attended the Ecole Royale des Elèves Protégés for four years (1753–56). The institution was effectively a kind of finishing school for prizewinners.

Influential friendships

Fragonard was initially daunted by the experience of Rome, convinced that he could never acquire the skills to compete with the Old Masters. Rather than concentrating on ancient art, he spent much of his time copying more recent Italian painting, such as the works of Pietro da Cortona and Giambattista Tiepolo. Nevertheless, Charles-Joseph Natoire, director of the Academy in Rome, recognized his talent and "natural fire", while also noting that he could be impatient and careless.

When in Rome, Fragonard made two important contacts. He befriended the landscape painter Hubert Robert (1733–1808), a fellow student at the French Academy. The two men went out sketching together and exerted a

IN CONTEXT
Prix de Rome

From 1666, France's leading art institution, the Royal Academy of Painting and Sculpture, offered a scholarship – the Prix de Rome – to its most promising student. The winner was given accommodation for up to five years at the French Academy in Rome (located first at the Palazzo Mancini, and from 1803 at the Villa Medici), during which time they received a thorough grounding in classical and Renaissance art to equip them for a successful Academic career. The prize carried great kudos.

STATUE OF LOUIS XIV, FIRST SPONSOR OF THE PRIX DE ROME

◁ **SELF-PORTRAIT, c.1770**
Fragonard was one of the most prolific painters of the 18th century. His large output included portraits, landscapes, and even religious scenes.

" **Sensuality!** It is the very **essence** of the eighteenth century; its **secret**, its **charm**, and its **soul.** "

GONCOURT BROTHERS, *LA FEMME AU DIX-HUITIEME SIECLE*, 1887

▷ **THE LOVER CROWNED, 1772**
This painting was one of a set of four works that rank among Fragonard's finest; they illustrate a young couple's blossoming romance.

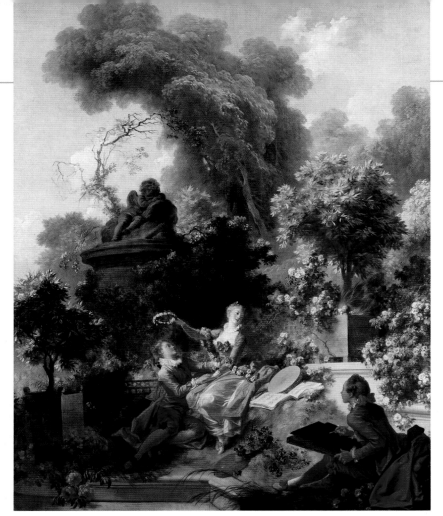

ON TECHNIQUE
"Fantasy" portraits

Fragonard could vary his style considerably, but he generally painted very quickly, creating a spontaneous, flickering effect with his brushwork. This is particularly evident in his "fantasy portraits" – a series of half-length portraits in exotic fancy dress. On the back of this depiction of his friend the Abbé de Saint-Non, there is an old label stating that it was painted in just one hour. It is certainly a *tour de force*, with the paint applied vigorously in broad brushstrokes.

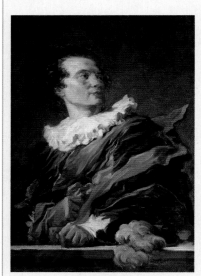

PORTRAIT OF THE ABBOT RICHARD DE SAINT-NON, 1769

strong influence on each other. At times, it is hard to tell their drawings apart. More importantly, perhaps, Fragonard also met Jean-Claude Richard, better known as the Abbé de Saint-Non, a wealthy collector and amateur printmaker. Saint-Non became a major patron for both men, helping to shape their careers.

Funded by Saint-Non, the three artists spent the summer of 1760 at the Villa d'Este in Tivoli, sketching the magnificent gardens on the estate. This experience left an indelible mark on Fragonard, and memories of the villa's lush foliage can be seen in the settings of many of his subsequent paintings. The following year, the trio toured Italy. Fragonard visited Venice and Naples, before returning to Paris with Saint-Non in the autumn of 1761. Now almost 30, Fragonard seemed perfectly placed to launch a successful

Academic career. This appeared all the more likely after his first major exhibit at the Salon caused a sensation.

Coresus Sacrificing Himself to save Callirhoe was a huge – 4m (13ft) across – if somewhat melodramatic history painting, illustrating an obscure legend from ancient Greece. Nevertheless, it delighted the critics, who hailed Fragonard as the new star of the French school. The picture secured him membership of the Academy and, soon after, was bought by the Crown. There were even plans to use the composition as the basis for a large tapestry, which would be woven at the famous Gobelins factory.

There was a fly in the ointment, however, where royal patronage was concerned: payment could be slow. It took eight years before the account for *Coresus* was settled, and the promise of a tapestry never materialized.

Romance and frivolity

In the meantime, Fragonard was seduced away from history painting by lucrative commissions from private patrons. The fashion was for risqué pictures of amorous subjects, which were designed to hang in the boudoirs or dressing rooms of the affluent.

The Swing is Fragonard's masterpiece in this vein. In essence, the theme is cuckoldry. An ageing husband pushes his wife on a swing, while her lover hides in the shrubbery, hoping for a glimpse of her legs. In many eras, this type of subject would have been conveyed with a moralizing tone, but at the height of the Rococo period such judgement was absent. Seduction, infidelity, and lust could be portrayed in purely decorative terms. This suited Fragonard's lively, spontaneous style perfectly because he was adept at rendering flickering light and movement. In *The Swing*, you can almost hear the swish of petticoats and the rustling of the leaves.

Marriage and home

Fragonard also tackled other themes in his paintings. After his marriage to Marie-Anne Gérard in 1769, he produced charming domestic scenes and pictures of children; and he painted sparkling portraits and delightful pastoral scenes typified by expansive, Italianate landscapes. From the numerous engraved copies of his work, however, it is clear that the public associated him chiefly with his amorous themes: lovers hiding in cupboards or chasing after each other; cupids stealing the clothes of young women or helping them to write love letters. In Fragonard's paintings the tone of these themes was playful and vivacious, sometimes mildly erotic but never coarse, and conveyed without a trace of moral censure.

" He was content to **shine** in the **boudoir** and the **closet**. "

LOUIS PETIT DE BACHAUMONT, *MEMOIRES SECRETS*, c.1780

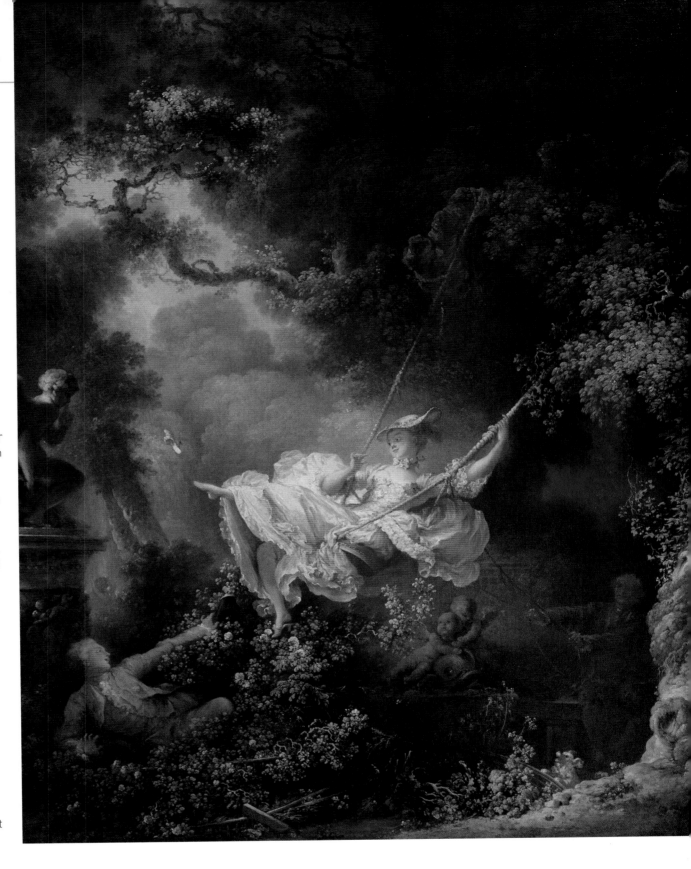

▷ *THE SWING*, 1767
In Fragonard's most delightful and famous painting, a girl playfully kicks her slipper into the air while, in the right-hand corner, a yapping dog tries to alert his owner. Even the statue of Cupid appears drawn into the intrigue, raising a finger to his lips.

The march of revolution

The upper echelons of the art world were dismayed by the path that Fragonard had chosen, believing that he was betraying his Academic training. More significantly, the tide of public opinion was changing. For many, the frivolity of Rococo art, and its overwhelming emphasis on decoration, were inseparably linked with the Ancien Régime – the old order of the king and the aristocracy – which was now approaching its final phase. Tastes in art had changed by the 1770s. There was a preference for the severity, the heroism, and the moral strictures of Neoclassicism, and although Fragonard adapted his style, making his figures more polished and solid, he retained his subject-matter, and his work fell out of favour.

Many of his friends and patrons were exiled or executed during the French Revolution, and – finding himself somewhat isolated – Fragonard had to rely on the friendship of Jacques-Louis David (see pp. 180–83) to aid him during the upheavals of the rebellion.

David managed to secure an administrative post for Fragonard at the newly founded Museums Commission in the Louvre. He stayed there until 1800 and died in relative obscurity in Paris in August 1806. The fate of *The Swing* was rather more dramatic. Its owner was guillotined and the painting was confiscated by the state.

KEY MOMENTS

c.1761
Paints *The Little Park* after his return from Italy. Its luxuriant foliage is based on the sketches he made at the Villa d'Este.

1765
Exhibits *Coresus Sacrificing Himself to Save Callirhoe* at the Salon. The scene from ancient legend wins him membership of the Academy.

1767
Completes *The Swing*: pictures of swings – a light-hearted metaphor for inconstancy – were very fashionable at the time.

1771–72
Begins an ambitious cycle of paintings entitled *The Progress of Love*, which is commissioned by Louis XV's mistress, Madame du Barry.

c.1780
Responds to the rise of Neoclassicism by adopting a more robust, highly finished style.

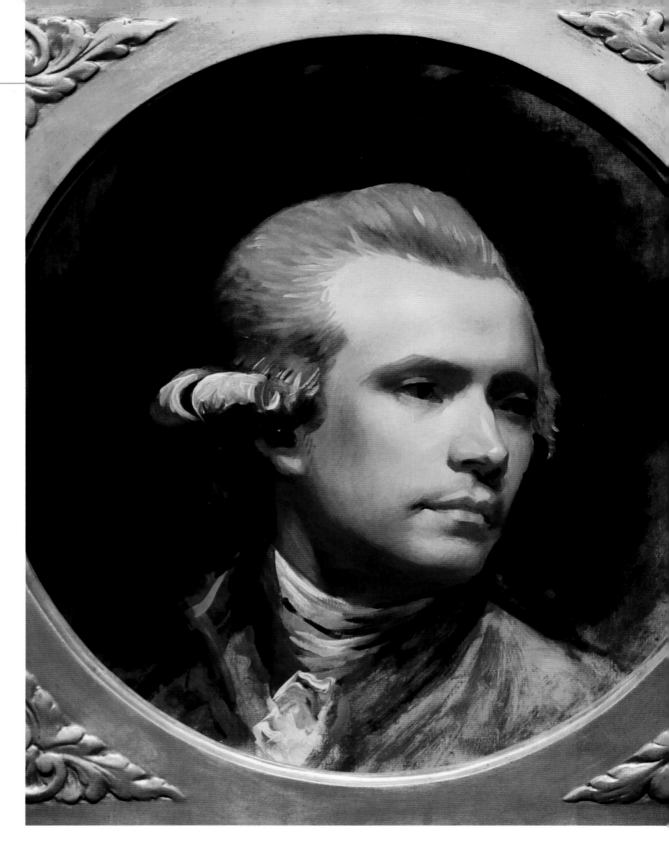

▷ **SELF-PORTRAIT, 1780–84**
Copley completed this portrait when in
the first flush of his success in England,
where he painted both portraits and
historical scenes.

John Singleton Copley

1738–1815, AMERICAN

Copley was the finest American painter of the 18th century and one of
the first to make his mark in Europe. There, he pioneered important
new developments in the genre of history painting.

Copley was born in Boston, the son of Irish immigrants. His father, a tobacconist, died in 1748, and his mother was married again to Peter Pelham (c.1695–1751), a prominent mezzotint engraver. He taught Copley the rudiments of his craft and also introduced him to John Smibert (1688–1751), who owned an extensive collection of copies of Old Masters that he had painted in Europe. This was an important connection, because few American artists of this period had the opportunity to study European art.

Portraiture

Both Pelham and Smibert died in 1751, so Copley was largely self-taught. However, he developed fast and began an artistic career at the age of just 15. His ambition was to become a history painter, but there was no market for such work in the colonies, so he concentrated on portraiture instead, and soon gained a solid reputation in this field. Copley learned portraiture by copying styles and poses from black-and-white prints, and his inexperience with colour prompted him to use strong tonal contrasts. To European eyes, his early portraits would have seemed old-fashioned, but Copley's American clients admired their refreshingly frank realism.

Move to England

In 1766, Copley exhibited a portrait of his half-brother in London, where it was extremely well received. Notable artists, including Joshua Reynolds (who would become the first president of Britain's Royal Academy) and Copley's compatriot Benjamin West (who had modernized history painting with his masterpiece of 1759, *The Death of Wolfe*), urged him to come to England to receive a proper artistic training. Without it, they claimed, he could never reach his full potential. Copley knew they were right, and yet he hesitated – his position in Boston was unrivalled and he was earning extremely good money. In the end, however, events forced his hand. War between Britain and its American colonies was looming (see right) and although his loyalties were torn, Copley finally left for Europe in 1774, never to return to his homeland.

History painting

Copley spent several months studying in Rome before settling in London. As before, he continued to acquire new skills quickly. While his portraits lost some of their originality, Copley finally mastered the compositional techniques that were essential for history painting.

Watson and the Shark (1778) brought Copley fame and even earned him membership of the Royal Academy. However, his undoubted masterpiece was *The Death of Major Peirson* (1783). With this work, he updated the entire genre of history painting by choosing a recent subject and incorporating actual portraits. The topicality of the subject captured the imagination of a public anxious for an image of patriotic success.

Copley also produced bigger and more complex history paintings: his *Siege of Gibraltar* (1782), for example, was so large that it had to be shown in a specially constructed marquee. Although he continued painting in his later years, his work fell out of favour and he sank into debt. He suffered a stroke and died in 1815.

◁ *THE DEATH OF MAJOR PEIRSON*, 1783
Copley's painting is a celebration of British nationalism, in which a young major loses his life in the defence of the island of Jersey against French invaders.

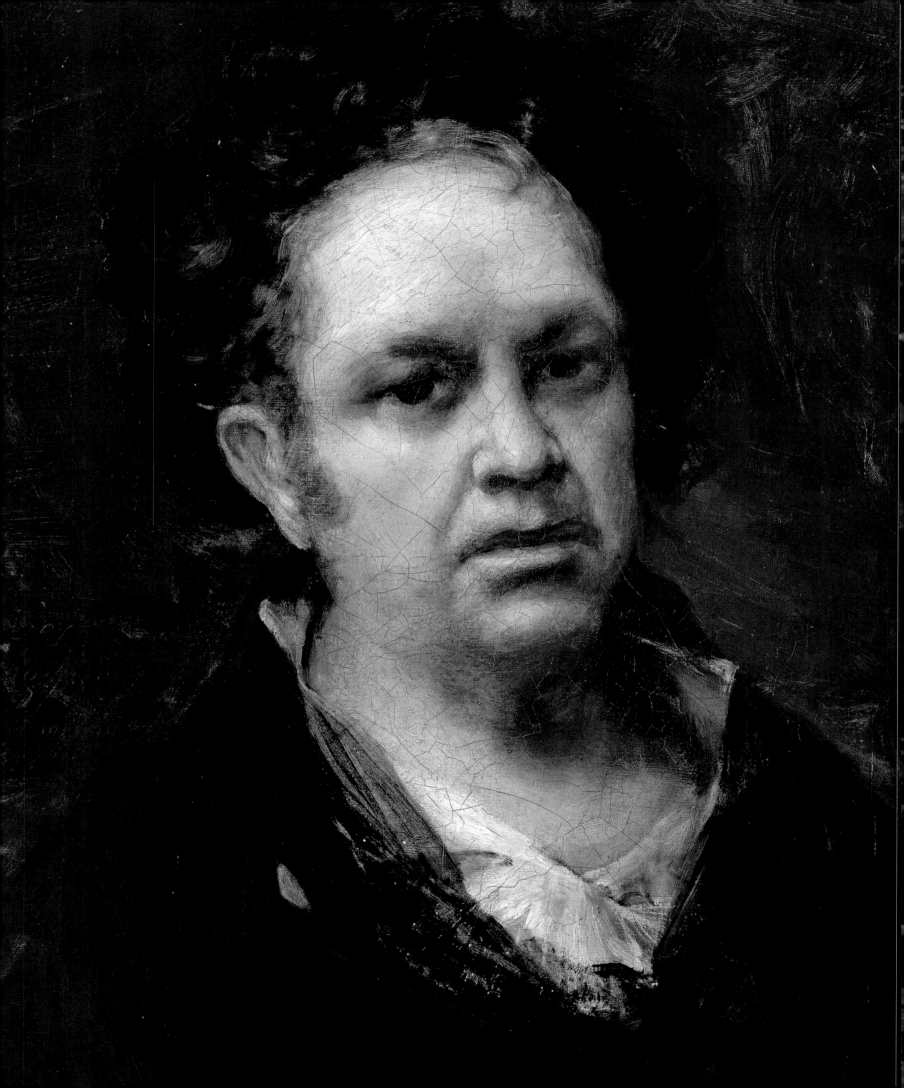

Francisco de Goya

1746–1828, SPANISH

The leading Spanish artist of his day, Goya produced portraits of penetrating psychological insight and darkly imaginative works that echoed the turbulent times in which he lived.

Francisco José de Goya y Lucientes was born on 30 March 1746 in Fuendetodos, a village set in the arid countryside of northeastern Spain. His father, José, was a master gilder, and soon after Francisco's birth the family moved to the city of Zaragoza, most probably to improve José's prospects of finding work. At the age of about 13, Francisco was apprenticed to a local painter, José Luzán; he remained with him for about three years, spending most of this time copying prints in order to develop his drawing skills.

Travels and commissions

In 1763, Goya moved to Madrid, where he made two unsuccessful attempts to win a scholarship to the Academy of San Fernando, the country's leading art school. Following his rejection, he began studying with the painter Francisco Bayeu, who had himself once been a pupil of Goya's former teacher, Luzán, in Zaragoza. In 1769, he undertook what was a rite of passage for all ambitious artists – a tour of Italy, during which he saw the work of Raphael and Michelangelo, Tiepolo and Correggio.

By July 1771, Goya was back in Spain, his style transformed and his ambitions heightened. In 1772, he produced his first large-scale work –

a ceiling fresco for the Basilica of El Pilar in Zaragoza – and a year later was commissioned to paint a series of scenes on the Life of the Virgin for the Charterhouse of Aula Dei just outside Zaragoza. Within just a few years, he had risen from obscurity to become well known in his home city.

▷ **BASILICA OF EL PILAR, ZARAGOZA**
The Baroque church on the banks of the Ebro in Zaragoza houses Goya's fresco *The Adoration of the Name of God*. The cathedral was and remains a major destination for Roman Catholic pilgrims.

◁ **PORTRAIT OF CHARLES III, KING OF SPAIN, c.1787**
Goya made two portraits of Charles III. This painting, which shows the king in hunting costume, was influenced by the portraits by his idol, Velázquez.

Move to Madrid

In 1773, he married Maria Josefa, Francisco Bayeu's sister, with whom he had several children. All died in infancy apart from Javier, who later attempted to follow in his father's footsteps as an artist, but without notable success.

Goya moved to Madrid, where Bayeu – by now one of the city's leading artists – helped him find work designing tapestries to decorate the royal palaces in and around the Spanish capital. These textiles depicted the pastimes and fiestas of Madrid in a playful Rococo style, and working on them taught Goya to be an acute and

THE NUDE MAJA, c.1797

◁ **SELF-PORTRAIT, 1815**
Goya painted numerous self-portraits throughout his life. Here, on the brink of old age, he appears tired and untidily dressed. His wig has slipped, revealing wisps of grey hair beneath.

" I see only **forms** that are lit up and forms that are not. There is only **light and shadow**. "

FRANCISCO DE GOYA

ON TECHNIQUE
Painting by candlelight

Goya's output was prodigious; around 700 of his paintings and 300 of his prints are believed to survive. According to his son, Javier, when painting portraits of his friends, Goya sometimes created the work in a single session that could last 10 hours. He also reported that Goya, unlike most painters, often worked at night. This practice is documented in a self-portrait (below) in which the artist wears a hat with candles around the crown. Candlelight evidently helped him to create dramatic effects of light and shade.

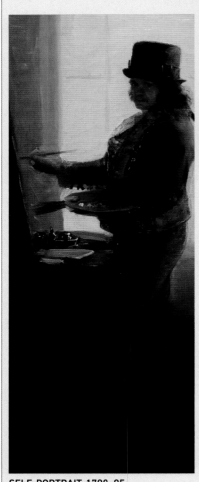

SELF-PORTRAIT, 1790–95

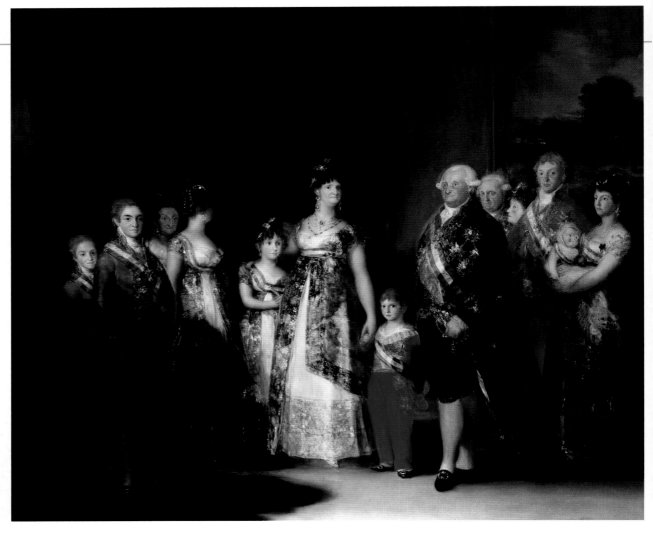

△ **CHARLES IV OF SPAIN AND HIS FAMILY**, 1800
As painter to the king, Goya was commissioned to produce this huge canvas. The artist cleverly used light and tonality to indicate hierarchy within the royal family.

accurate observer of society – a skill that was key to his development as a portraitist.

Goya's status in Madrid grew throughout the 1780s, and he began to move in royal and aristocratic circles. He received portrait commissions from the Spanish king, Charles III, and from the king's brother, the Infante Don Luis de Borbón, whose philandering ways had led to his banishment from the court in Madrid. Goya even stayed with Don Luis and his family while they were living in internal exile in a small town outside Madrid and painted their portraits.

Goya's royal likenesses are astonishingly candid. Although he invested his sitters with dignity, he did not generally flatter them or idealize any unlovely features. Unlike many contemporary portraitists, he was more interested in capturing the inner life of a person than in their worldly role or status. His bold and free technique – which was unusual in court portraiture of the time – created a sense of animation.

In 1786, Goya was appointed one of the painters to the king, and in 1789 received the more prestigious title of painter to the royal household. He celebrated his new rank by adding the aristocratic "de" to his name and buying a two-wheeled English carriage (the equivalent of a sports car today), which he promptly crashed after driving it at a furious pace. By the beginning of the 1790s, Goya had achieved a high degree of worldly success. He was the most sought-after painter in Spain and the portraitist of choice for the rich and influential. In the winter of 1792–93, however, his world was turned upside down when he suffered a devastating and mysterious illness while visiting a friend, the collector Sebastián Martínez, in Cádiz. The illness rendered him unable to work for several months and left him totally deaf for the rest of his life.

" First be a **magnificent** artist and then you can do whatever. But **art** must be **first**. "

FRANCISCO DE GOYA

KEY MOMENTS

1771
Receives his first important commission for a fresco, showing the Adoration of the Name of God.

1775
Starts producing designs for the Royal Tapestry Factory of Santa Barbara. He provides some 45 compositions.

1798
Paints frescos in the church of San Antonio de la Florida in Madrid, finishing in record time.

1799
Is promoted to first court painter to Charles IV and produces his first print series, *Los Caprichos*.

1810
Begins his print series *The Disasters of War*, which reflect the violent events of the Peninsular War.

1814
Paints canvases recording an uprising and its brutal suppression by occupying French troops in Madrid.

1820
Begins covering the walls of his home with imaginary scenes now known as the Black Paintings.

1824
Flees to Bordeaux in France, where he bases himself for the rest of his life.

During his lengthy convalescence, Goya painted a series of small pictures, the purpose of which was, in his own words, "to occupy my imagination, vexed by consideration of my sufferings, and... to make observations that normally are given no place in commissioned works, where caprice and invention cannot be developed". These pictures showed scenes of bullfighting, *commedia dell'arte* actors, (see p.145) and natural disasters; there was one scene depicting lunatics and another set in a prison. Goya may have tackled these subjects to show that he was more than just a court painter, and to make some comment on the social situation of his day. Whatever his motivation, they mark something of a watershed in his career, as from then on he turned increasingly to subjects that explored the darker and more sinister aspects of life and the bizarre or morbid workings of the imagination. His illness seems in some mysterious way to have liberated his art, giving it greater scope and power.

Secular and religious works

Goya's illness may have robbed him of his hearing but it diminished neither his ability nor his ambition, and he continued to make advances in his

△ *A HEROIC FEAT! WITH DEAD MEN!*, 1810–20
This shocking etching from *The Disasters of War* shows mutilated bodies hung as a warning on a tree. Goya's work was intended as a graphic challenge to the romanticization of conflict.

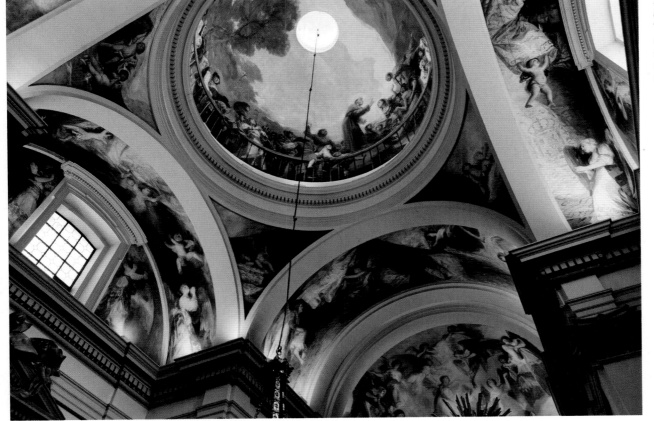

◁ **SAN ANTONIO DE LA FLORIDA**
Goya decorated the dome of this Neoclassical chapel in Madrid with frescos representing the miracle of St Anthony. The artist's remains (less his skull, which was stolen from his original grave in France) were reburied in the chapel, just in front of the altar.

professional life. In 1799, he was appointed first court painter to the royal household. He was the first painter to hold the title since his great idol Velázquez, and there is no doubt that Goya saw himself as Velázquez's artistic heir.

His output of portraits and religious works remained prodigious. In 1798, he painted a series of frescos for the church of San Antonio de la Florida, Madrid, covering the interior of the dome and other parts of the building in just three months. He also turned to printmaking, publishing his first major series, *Los Caprichos*, in 1799. This consists of 80 plates that deal with the ills of society, some in realistic fashion, others in a more fantastic manner. He was to follow this with a further print series, *The Disasters of War* – images that were so disturbing and politically inflammatory that Goya was unable to publish them in his own lifetime.

Spanish conflicts

The Disasters of War reflected the increasingly turbulent period of Spanish history in which Goya lived. Charles IV (reigned 1788–1808) was a weak king, who was dominated by his wife María Luisa and her favourite, Manuel Godoy, who became prime minister in 1792. Godoy misruled the country and became immensely unpopular. In 1808 he was forced out of power in an uprising and Charles abdicated in favour of Ferdinand VII, his son. Ferdinand reigned for only a few weeks, however, because Napoleon Bonaparte lured him to France, imprisoned him, and – on the pretext of saving Spain from revolution – sent his troops into Madrid. Some Spaniards initially welcomed the French invaders as liberators from royal tyranny, but there was also violent opposition; and a revolt in Madrid on 2 May 1808 was put down with great savagery by French soldiers.

Napoleon installed his brother, Joseph Bonaparte, as king of Spain on 6 June and the French remained in power in Spain until 1813, when, after five years of conflict (known as the Peninsular War), they were driven out by a combination of British, Portuguese, and Spanish forces led by the duke of Wellington.

▽ **THE THIRD OF MAY 1808,** 1814
Commissioned by Spain's provisional government, Goya's painting is a blunt depiction of the brutal suppression of Spanish rebels by the French army. It draws on Christian iconography – most obviously in the pose of the work's central figure – to enhance its message.

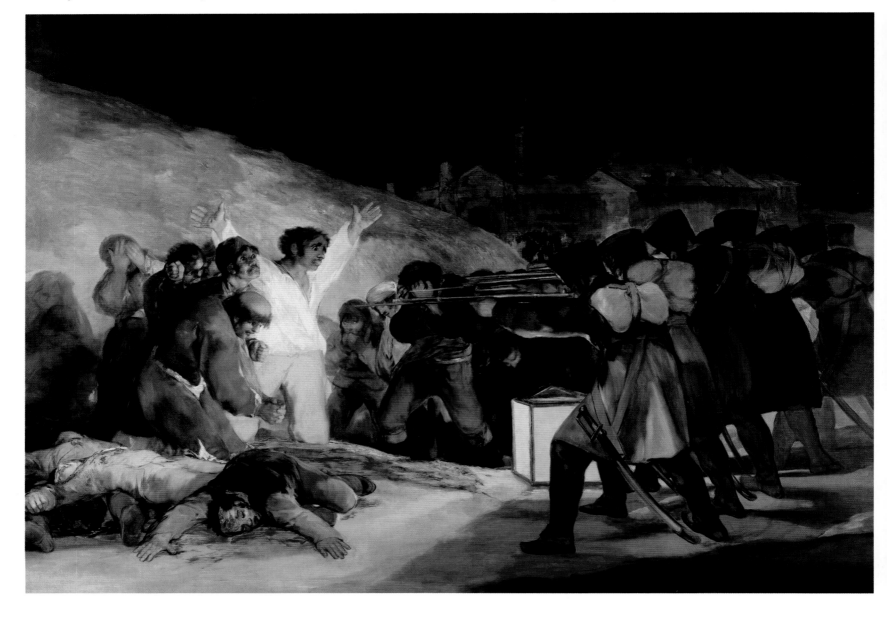

◁ **THE QUINTA DEL SORDO**
Goya bought this large country house to distance himself from the court in Madrid. He covered its walls with murals, later known as the Black Paintings. These were untitled and not intended to be displayed. The house was destroyed in 1909.

Thoughout these upheavals, Goya sensibly kept his political inclinations to himself. During the French occupation, he continued to work as court painter to Joseph Bonaparte; in the course of the war he painted Joseph's eventual conqueror, the duke of Wellington; and then in 1814 he painted two large pictures commemorating Spain's "glorious insurrection" against Napoleon – *The Second of May 1808* and *The Third of May 1808*.

Retreat from Madrid

By now, Goya was in his late 60s. After the death of his wife in 1812, he took a younger woman (recently separated from her husband) as his companion and housekeeper – Leocadia Weiss. Their relationship caused much gossip, and her youngest child, Rosario, is thought to have been Goya's daughter. While continuing to hold his court post, Goya virtually withdrew from public life, and in 1819 bought a country house – the Quinta del Sordo (House of the Deaf Man) – situated just outside Madrid. In the same year he fell seriously ill again; after his recovery he decorated the walls of his house with a series of horrific scenes now known as the Black Paintings.

Exile in France

By the time Goya finished these pictures in1823, many liberal-minded Spaniards were leaving the country because of Ferdinand VII's repressive regime. In 1824 Goya was granted permission to visit France, ostensibly for health reasons but in fact to become an exile himself. He settled in Bordeaux with Leocadia but twice returned to Spain. On the second visit, in 1826, he resigned his court post and was awarded a generous pension. After suffering a stroke, he died in Bordeaux on 16 April 1828, aged 82.

Legacy and influence

During his life, Goya had few pupils, collaborators, or imitators, and his immediate influence was fairly limited. Towards the end of his career, his highly personal style was starting to lose popularity in favour of more polished and Academic work. By the middle of 19th century, however, painters from various other countries, particularly France, were beginning to rediscover his work – among them the French artists Delacroix and Manet, who drew inspiration from his paintings. But the full range of Goya's work became widely only appreciated in the 20th century, with the advent of such art movements as Expressionism, which focused on extreme emotional states, and Surrealism, which sought to investigate the workings of the subconscious mind. With modern reappraisal, Goya has come to be acknowledged as one of the greatest artists who ever lived.

ON TECHNIQUE
The Black Paintings

Between 1820 and 1823, Goya decorated two large rooms in his Madrid home with a series of pictures that are now known as the Black Paintings because of their sombre tones and nightmarish subjects. Some of these paintings are based on religious or mythological scenes, but most seem to have had no other source than Goya's imagination. Among them are a scene of two men fighting with clubs as they sink into the ground and a picture of a dog almost completely submerged in sand. These, and the other scenes, are painted with an almost savage boldness and have been interpreted as reflections on death.

SATURN DEVOURING HIS SON, 1819–23

" He did not **anticipate** any one of our present-day artists – he **foreshadowed** the whole of **modern** art. "

ANDRE MALRAUX, 1957

Jacques-Louis David

1748–1825, FRENCH

David blurred the boundaries between life and art. He involved himself in the turbulent events of both the French Revolution and the Napoleonic era, while acting as a standard-bearer for the Neoclassical movement.

Jacques-Louis David was born in Paris in August 1748. His father, a prosperous tradesman, died in a duel when the boy was just nine – an early omen, perhaps, of the eventful life that he was to lead. He was made a ward of two uncles, both architects, and was initially expected to follow in their footsteps. By 1765, however, David had decided to become a painter. He approached the great Rococo artist François Boucher (1703–70), who was a distant relative, but he did not want to take on any new pupils as his sight was failing. Instead, he recommended Joseph-Marie Vien as a tutor.

This was a good choice. Vien was a former winner of the Prix de Rome and was very enthusiastic about the latest Neoclassical theories. These drew inspiration from the art and literature of the classical world, urging artists to adopt a serious moral tone and reject the frivolous erotic fantasies of the Rococo style.

Classical education

Under Vien's guidance, David determined to win the Prix de Rome. He failed four times, making a half-hearted suicide attempt after the third disappointment, but in 1774 he finally won, with a striking version of *Erasistratus Diagnoses the Illness of Antiochus*. He left for Italy in the

following year, travelling with Vien, who had just been appointed director of the French Academy in Rome.

At the time of his departure, David's work still had many Rococo overtones and he confidently declared that "the Antique will not seduce me". He could not have been more wrong. He was bowled over by the power of classical sculpture, making copious sketches that he would draw upon for the rest of his life; he visited the archaeological remains at Pompeii and Herculaneum, which had recently been excavated; and he marvelled at the work of the

△ *ERASISTRATUS DIAGNOSES THE ILLNESS OF ANTIOCHUS*, 1774
David's painting depicts the Greek physician who, according to legend, cured Antiochus, son of the king of Syria, who was dying of love for his stepmother.

Old Masters, particularly Raphael, Poussin, and Caravaggio. David returned to Paris in 1780. By now, he had purged the Rococo elements of his style and was about to enter the most productive period of his career, but he did so against a backdrop of mounting political unrest.

▷ **SELF-PORTRAIT, 1794**
This portrait was painted while David was imprisoned following the death of his political allies. The artist's expression and clenched grip reflect his agitated state.

" Only the most **sublime passions** of the soul have **attracted me**. No one could call me a blood-thirsty painter. "

JACQUES-LOUIS DAVID

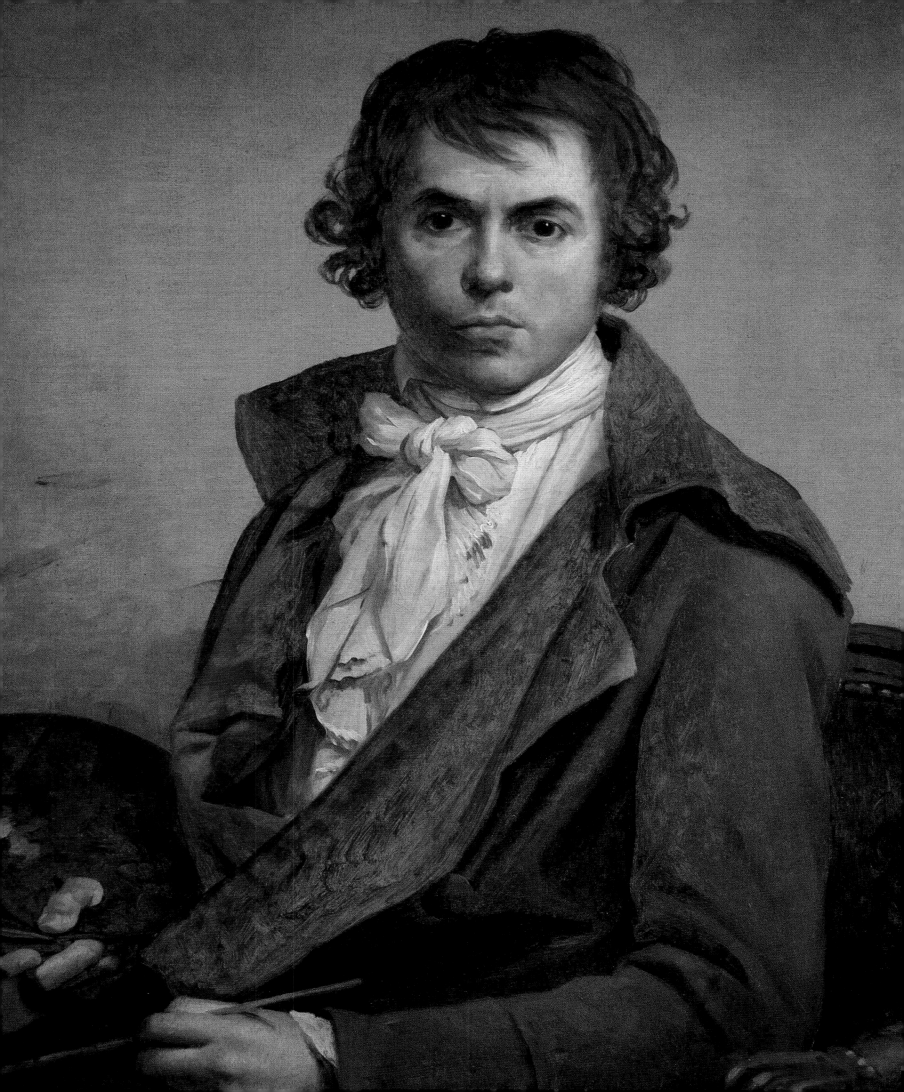

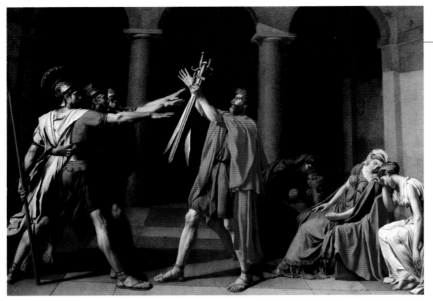

◁ **THE OATH OF THE HORATII, 1784**
David's composition is laid out like a classical frieze, with the life-size figures lined up in the foreground. They are brightly lit, while the background is screened off behind a row of columns and plunged into darkness.

IN CONTEXT
Art and the Revolution

The rigid class structure of Ancien Régime France was mirrored in the hidebound hierachy and inflexible practices of the Academy. The Revolution was to upturn both. David's Neoclassicism sought to educate the people about the noble goals of government. The artist painted pivotal scenes of the Revolution such as the swearing of the Tennis Court Oath.

UNFINISHED STUDY FOR *THE OATH OF THE TENNIS COURT*, 1790–94

At the time, France was burdened with huge debts, exacerbated by its involvement in the American War of Independence. Taxes were high, food shortages were increasing, and there was simmering resentment against the wealth and privilege of the upper orders. All of this was aggravated by the criticisms of the *philosophes* – the Enlightenment intellectuals – who questioned the value of the monarchy, the aristocracy, and the Church.

A new morality

David's new style chimed perfectly with the mood of unease prevalent in France. His paintings were now uncluttered, their pretty, decorative details swept away and replaced by a severe, ordered simplicity. This is evident in his most famous painting, *The Oath of the Horatii*, in which there are no unnecessary details to distract the viewer from the central theme of the picture – duty, patriotism, and self-sacrifice. It depicts three brothers who are swearing to fight for Rome, even though this will pit them against their brothers-in-law (hence the despair of their sisters, on the right of the painting). Rococo artists had tended to choose mythological scenes from antiquity, often as a pretext for painting the nude. Neoclassical

painters, by contrast, preferred to depict subjects from ancient history, particularly those with a moral lesson. This approach was advocated by art critic and *philosophe* Denis Diderot, who had a great influence on David.

The other key element in David's work is drama. He adored the theatre and many of his works were inspired by scenes from the playhouse. In the case of *The Oath of the Horatii*, the storyline came from *Horace* (1640),

a classical drama by Pierre Corneille, while the motif of the oath may have been drawn from a performance of Voltaire's *Death of Caesar*, in which three senators swear on the sword of Brutus. There is no real reason to suppose that David had any political motivation when he painted *The Oath* – it was, after all, commissioned by the Crown – but the picture was interpreted in this way after it was shown at the Salon of 1785. In the powder-keg atmosphere of the times, many regarded it as a call to arms.

▽ **THE DEATH OF MARAT, 1793**
David put his art in the service of Revolutionary ideals in this depiction of Marat, just after his murder by Charlotte Corday, a supporter of the aristocracy.

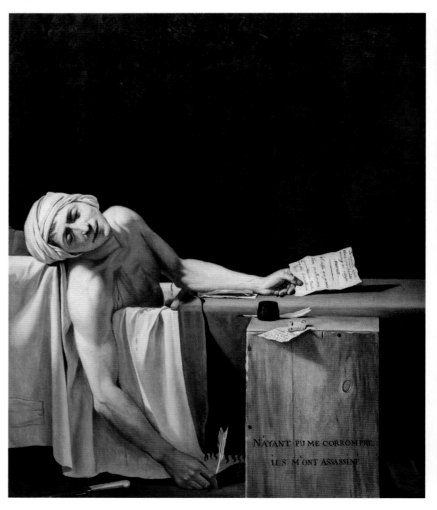

Agent of revolution

After the outbreak of the Revolution in 1789, there was no doubting David's political affiliations. With his customary zeal, he was swept along by the tide of events. He became a deputy in the National Convention (the Revolutionary government), he voted for the death of the king, and he organized and designed festivals and pageants that celebrated the achievements of the Revolution.

David also played a leading role in the abolition of the Academy and the creation of its replacement, taking revenge for his many rebuffs in the Prix de Rome. With all of these commitments, his painting took a back seat and several major projects went unfinished. He did create one supreme masterpiece, however: *The Death of Marat* (1793). Its subject, Jean-Paul Marat, had been one of the most ruthless revolutionary activists, but after his assassination, David produced a touching tribute, which carried echoes of religious painting.

Political engagement

When the Revolution began to unravel, David found himself in danger: in 1794, he was imprisoned, and narrowly escaped the guillotine. He was released only after his estranged, royalist wife interceded for him. The couple were reconciled and remarried in 1796. David's next major work, which he began in 1796 in recognition of his wife's timely assistance, was *The Intervention of the Sabine Women*. This appeared to show David in a calmer frame of mind, but he had not learned his lesson. In 1797, he met Napoleon Bonaparte and his political passions were stirred up again.

David supported Bonaparte's rule with the same fervour that he had shown for the Revolution. He painted

KEY MOMENTS

1771
Enters *The Combat of Mars and Minerva* for the Prix de Rome but only wins second prize with this Rococo-style scene.

1784
His masterpiece *The Oath of the Horatii* creates a sensation at the Salon. Its mood of self-sacrifice presages the outbreak of Revolution.

1793
Paints *The Death of Marat*, a tribute to one of the most notorious Revolutionary leaders, who sent scores of victims to the guillotine.

1800
Embraces the Napoleonic cause with the same fervour that he had once shown for the Revolution.

1817
Paints *Cupid and Psyche*, one of several mythological scenes depicted in a rich, sensual manner.

several iconic images of the French leader, most notably a magnificent equestrian portrait, *Napoleon Crossing the Alps*. Bonaparte had asked to be depicted "calm on a fiery steed" – even though he had actually made the journey on a mule – and was so pleased with the result that he ordered several replicas of the picture.

Bonaparte was well aware of the propaganda potential of David's art and made him his official painter, even though there are indications that he preferred the paintings of

Antoine-Jean Gros. David, however, was unwavering in his commitment to the imperial cause. Unwisely, he signed the *Acte Additionnel*, a declaration of loyalty to Napoleon, which caused him major problems after the latter's defeat at the Battle of Waterloo (1815).

David went into exile, settling in Brussels. He remained there for the rest of his life, continuing to paint and maintain contact with his former pupils. He died on 29 December 1825, but permission to return his body to France was refused.

△ **THE CHARTER OF 1815**
The *Acte Additionnel* was a reframed French constitution that conferred new rights on the populace and curtailed censorship.

◁ *NAPOLEON CROSSING THE ALPS*, 1800–01
David painted five versions of this powerful propaganda piece in which Napoleon is pictured as the archetypal classical hero.

Elisabeth Vigée-Lebrun

1755–1842, FRENCH

Elisabeth Vigée-Lebrun was the last great royal portrait painter in France. Her exceptional talent enabled her to capture both the fashionable elegance and the intimate moods of her distinguished sitters.

Elisabeth Vigée-Lebrun was born in Paris, the daughter of an artist who specialized in pastel portraits, and began her own artistic career while still in her teens. Like many female artists of her day, she did not have access to a formal art education, but received some training and advice from various quarters, including the eminent artist Joseph Vernet.

When Vigée-Lebrun married her art-dealer husband at the age of 20 she began exhibiting her work in their home, and holding salons, where she cultivated contacts with potential patrons. She liked to put portrait sitters at ease by using natural poses, conversing with them, and even singing, which helped give her portraits a relaxed quality.

A trip to the Netherlands and Flanders in 1781 deepened the respect she already had for Peter Paul Rubens, and she began to imitate some of his techniques, using a warmer range of colours and superimposing layers of thin glazes for added brilliance. She often positioned her sitters against plain backgrounds, a practice that emphasized the subjects' faces and heightened the vibrant colours of their costumes, some of which she designed herself.

◁ **SETTING THE STYLE**
Vigée-Lebrun encouraged her sitters to let their hair fall naturally over their foreheads, setting a new fashion in Paris. Marie-Antoinette (shown here) refused, keeping her hair high.

Academy and patronage

Vigée-Lebrun was admitted to the French Royal Academy in 1783, when she was given one of only four places allocated to women. By this time, she had established an impressive list of clients drawn from the highest ranks of French society; the patronage of the queen, Marie-Antoinette, also gave her access to court circles.

However, Vigée-Lebrun's association with the royal family had severe consequences when they fell from grace in 1789, during the French Revolution. The artist fled France with her daughter Julie; her French citizenship was revoked and her property confiscated. Over the next 12 years she led a peripatetic life, travelling round Europe, spending time in Turin, Rome, Naples, Vienna, Prague, Dresden, Berlin, Moscow, and St Petersburg. In each place she was the portraitist of choice among the famous and influential – she was even asked to capture the likeness of the Russian empress, Catherine the Great.

In 1802, she travelled to London, where she painted Lord Byron and the Prince of Wales. She returned to France in 1805, where she continued to paint and committed her thoughts to paper in three volumes of memoirs.

◁ **PORTRAIT OF THE COUNTESS NATHALIE GOLOVINE, 1797–1800**
Vigée-Lebrun painted this intimate portrait of her friend when in exile in Russia. The diagonal lighting and casual pose show the artist's lightness of touch.

▷ **SELF-PORTRAIT IN STRAW HAT, 1782**
Vigée-Lebrun painted a number of self-portraits, which she used to advertise her talents to potential patrons. This one is based on Peter Paul Rubens' portrait of his wife *Le Chapeau de Paille* (1622–25).

> " [**Art**] has **always** been the **means** of bringing me **together** with the most **delightful** and most **distinguished men and women**. "
>
> ELISABETH VIGEE-LEBRUN

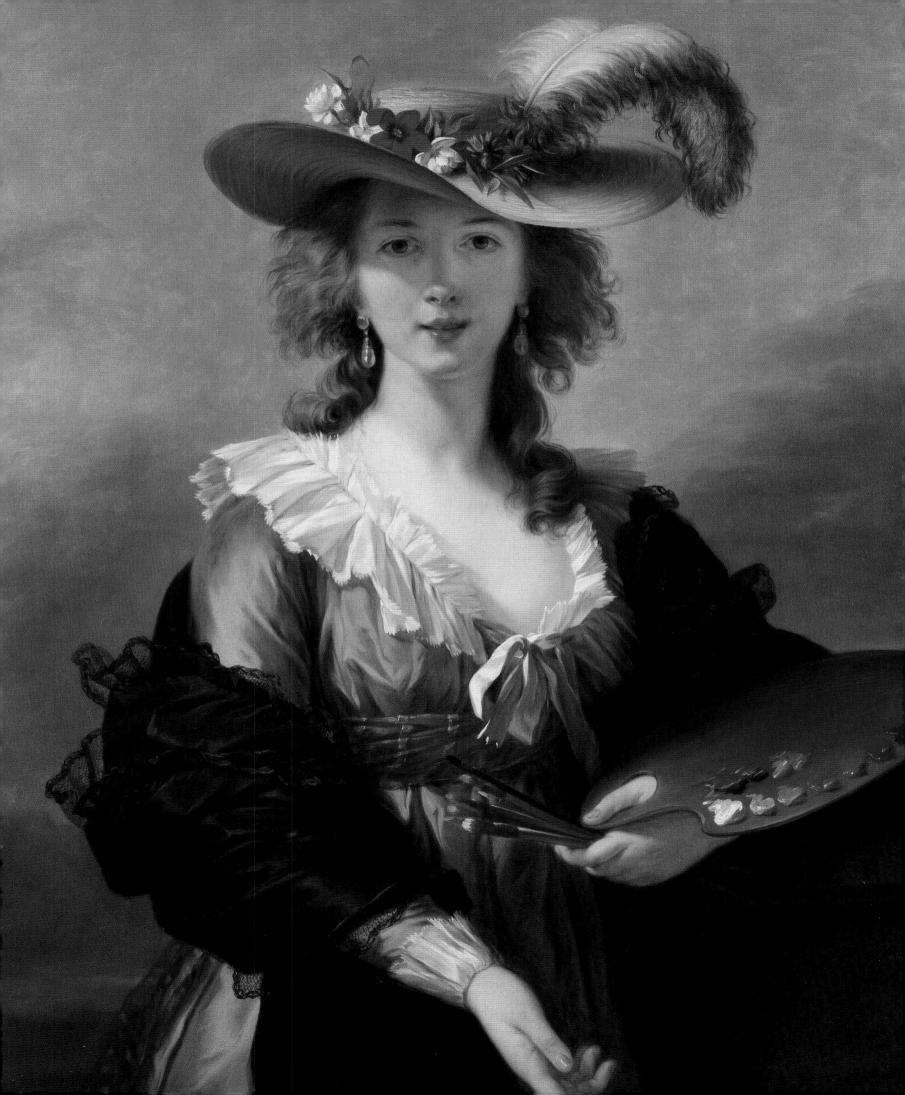

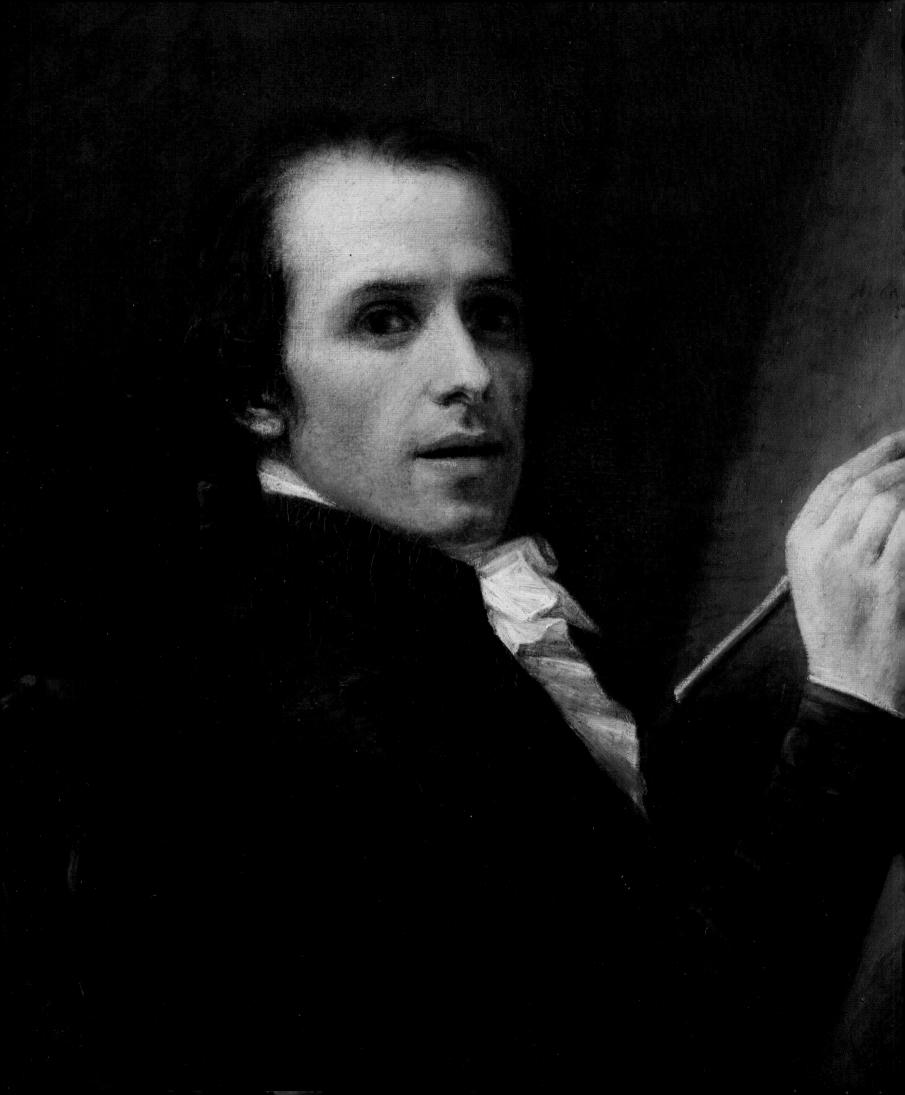

Antonio Canova

ITALIAN, 1757-1822

Canova's life was the most brilliant of success stories. Quickly recognized as supreme among sculptors, he devoted himself to his art and found wealthy and powerful patrons all over Europe.

Antonio Canova was born into a family of stonecutters at Possagno, in what was then the Venetian Republic. Orphaned as an infant, he was brought up by his grandfather and worked under him, revealing an obvious talent for carving that led to apprenticeships with local sculptors. Before he was 20 years old, Canova was working independently, and at 22, he opened his own studio in Venice.

Early influences
Canova's early sculpture, much admired in Venice, was created in the established Baroque and Rococo styles, both highly ornamental in different ways. However, visits to Rome and the still partly buried Roman city of Pompeii opened Canova's eyes to the treasures of ancient art and began to change his thinking. In 1781, he settled in Rome and became involved with a group of artists and scholars who had progressive ideas about art, which were promoted by the German writer Johann Winckelmann (see box, right).

Reacting against the lavish ornament of the Baroque, they advocated a far simpler and more restrained style of painting and sculpture, inspired by the noble, ideal character they believed to be typical of Greek and Roman art. The new style was to become known as Neoclassicism. Canova embraced it enthusiastically and soon became its most brilliant exponent.

◁ **SELF-PORTRAIT, 1790**
Though famous as a sculptor in marble, Canova was also a talented painter. He created a number of self-portraits in both media; this one shows him in the prime of life and with brush in hand.

◁ **THESEUS AND THE MINOTAUR, 1782**
In Greek myth, the Athenian hero Theseus enters the Cretan labyrinth and slays the monstrous, bull-headed Minotaur. True to Neoclassical principles, Canova shows Theseus not in combat but at rest, astride his fallen foe.

Mythological themes
Ancient Greco-Roman history and mythology provided much-favoured subjects for Neoclassical artists, and Canova's first great success in Rome was the myth-based *Theseus and the Minotaur*. Following the advice of the Scottish painter Gavin Hamilton, one of the Neoclassical group of artists living in Rome, Canova depicted Theseus not in ferocious combat with the bull-headed monster, but in the calm following the struggle. *Theseus and the Minotaur* caused a sensation. People took it at first as a copy of an ancient masterpiece and were astounded to learn that it was the work of a young contemporary. Canova's success was followed by major papal commissions that occupied him for some years – tomb monuments for the previous two popes, Clement XIII and Clement XIV, which made Canova internationally famous. From this time, he was never to lack patrons and commissions. Moreover, thanks to his engaging

△ **CANOVA'S VISITING CARD**
Visiting cards were an indispensable part of upper-class etiquette. Canova's card, showing just his name written on the side of a large block of unworked marble, implied that he would need no further introduction.

IN PROFILE
Johann Joachim Winckelmann

The young Canova was greatly inspired by German scholar Johann Joachim Winckelmann (1717–68), who became librarian of the Vatican in Rome. His reinterpretations of Greek and Roman art had a profound influence on a group of artists living in the city, Canova among them. In a phrase that became the touchstone of the developing Neoclassical style, Winckelmann identified "noble simplicity and calm grandeur" as the essential qualities of ancient works.

PORTRAIT OF WINCKELMANN, ANGELICA KAUFFMANN, 1764

" He has a **fine Italian head,** and when he **smiles** the feeling sent forth is **exquisite.** "

BENJAMIN HAYDON, JOURNALS, 1815

personality he was a popular figure whenever he socialized; but for the most part, his life was closely dedicated to his art.

Funeral sculpture remained an important aspect of Canova's art for many years. Neoclassical tombs reflected a change in attitudes towards death: the skeletons and cadavers of the past were replaced by idealized figures of the deceased and an emphasis on mourning for loss rather than on the terrors of death. The finest example of Canova's work is the tomb of the Austrian duchess Maria Christina in Vienna. The sober geometry of the façade sets the mood, and mourners of all ages and conditions pass over an almost liquid carpet into the darkness of the tomb.

Finishing touches

Canova was extraordinarily prolific, employing assistants to perform the mechanical tasks involved in bringing the rough marble close to the ultimate design. However, he always attended personally to the finishing touches that gave his work its distinctive character, adding detail and showing his astounding ability to capture the texture and softness of human skin.

Following the examples of the Greeks and Romans, the nude held a special place in Neoclassical art, and many of Canova's most famous works are male or female nudes, such as *Apollo Crowning Himself* (1781–82) and the two versions of *The Three Graces* (1813–17).

A work that particularly appeals to modern tastes is *Cupid and Psyche*, a tour de force and intended to be displayed as such: it was mounted on a revolving base and viewed under lights, so that every facet of it would be seen as part of a mesmerizing, shifting spectacle.

Portraiture

Canova lived through the period when Napoleon dominated most of Europe, and much of his portrait work consisted of busts and statues executed for the emperor and the Bonaparte family. Canova's semi-nude statue of Napoleon's sister, Princess Pauline Borghese, became a public favourite, but his colossal statue of Napoleon, originally ordered in 1802, had a more chequered history. Napoleon wished to be shown in uniform, but Canova insisted that the emperor could only appear truly sublime and heroic if he was classically nude. The resulting statue, entitled *Napoleon as Mars the Peacemaker*, was delivered after long delays in 1811 and failed to please the emperor, who was now middle-aged. The work was not shown in public until, after Napoleon's fall, it passed into the hands of his great foe, the duke of Wellington.

International demands

Canova's eminence was such that several crowned heads invited him to settle in their dominions; Napoleon was insistent that the artist should live in Paris, "the capital of Europe".

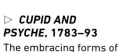

▷ CUPID AND PSYCHE, 1783–93

The embracing forms of *Cupid and Psyche* create an effect both touching and erotic. The work portrays the moment in the story when the god's kiss brings his human lover, Psyche, back to life.

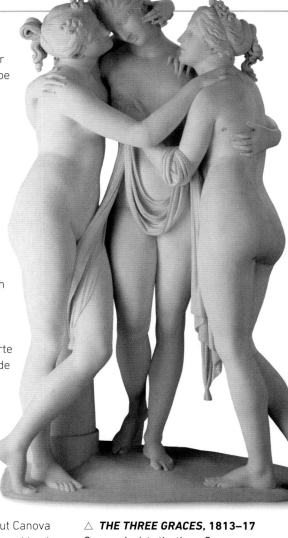

△ **THE THREE GRACES**, 1813–17
Canova depicts the three Graces – mythological personifications of female charm (mirth, elegance, and beauty) – in a delicate embrace. Contemporaries judged the work as "more beautiful than beauty itself".

But Canova resisted and remained in Rome, travelling only when he needed to supervise the installation of an artwork in a foreign city. The most significant interruption in his peacefully industrious existence occurred in 1815, after the final defeat of Napoleon. The pope sent Canova to Paris, which was occupied by the victorious Allies, on a mission to recover the art treasures looted from

"For 30 years, within my own **knowledge**, he has been considered by **all Europe** as **without a rival**."

THOMAS JEFFERSON, IN A LETTER, NOVEMBER 1816

ON TECHNIQUE
Works in progress

When preparing to create a marble sculpture, Canova made a full-sized model of it in a malleable material such as plaster. To make an exact marble copy of the model, he used (and improved) a specialized pointing device. It was attached to the model and measurements were taken from multiple points on the surface (the web of dots) with the needle, making it possible to recreate its dimensions accurately on the marble block. One advantage of this way of working was that assistants could carry out the main work, leaving the master to add the all-important finishing touches.

PLASTER HEAD OF ONE OF THE THREE GRACES WITH A NEEDLE ATTACHED

the Vatican by the French. This was a difficult task because the thefts had been legitimized by a treaty between the pope and the French; and as an extraordinary mark of confidence, Canova was given the authority to make binding agreements on behalf of the pope. He displayed unexpected diplomatic skills and most of the treasures were deftly removed from the Louvre, despite the protests of the French crowds, whose anger made Canova fear for his life. From France, he crossed to England, where he was fêted by the British aristocracy, many of whom later became his clients.

On his return to Rome, Canova was rewarded by being made a nobleman by the pope; and soon afterwards, a commission from across the Atlantic demonstrated the extent of his reputation. The American statesman Thomas Jefferson was asked to recommend a sculptor for a statue of George Washington for the Capitol of North Carolina: he dismissed all American candidates and insisted that Canova was the only man for the job. The statue was made, shipped to the United States, and installed in 1821, only to be destroyed by fire just 10 years later.

△ **CANOVA'S TEMPIO**
Canova laid the first stone of the Tempio in Possagno, a church dedicated to the Holy Trinity. It was completed in 1830, eight years after his death. Above its altar is a painting of the Deposition by Canova.

Final works

In his last years, Canova often visited his native Possagno. He designed the Tempio, an imposing Neoclassical church that is based on the Pantheon in Rome. On his death in 1822, he was buried in the church, and Possagno now also has a museum dedicated to his work and fame.

KEY MOMENTS

1781
Moves from Venice to Rome and falls under the influence of Neoclassical ideas.

1782
Completes *Theseus and the Minotaur*, which becomes his first great success in Rome.

1783
Begins work on the papal tombs that will establish his fame throughout Europe.

1802
Makes a bust of Napoleon, the first of many commissions for the Bonaparte family.

1805
Completes the tomb of Maria Christina, his masterpiece of tomb sculpture.

1815
After the fall of Napoleon, persuades the authorities in Paris that looted artworks should return to Italy.

Directory

▷ Hyacinthe Rigaud

1659–1743, FRENCH

Rigaud was the dominant French court portraitist of his time, running a large studio with numerous assistants. His grand, highly formal style – which was concerned with conveying status more than individual personality – set the pattern for official portraiture in France throughout most of the 18th century, until the revolution of 1789 swept away the world of aristocratic privilege he depicted. Many of his male sitters are shown wearing huge wigs and swathed in voluminous draperies.

Born in Perpignan, Rigaud trained in Montpellier and began his career in Lyon, but settled in Paris in 1681. As well as his formal commissions, he painted more intimate portraits for his own satisfaction. These show the influence of Rembrandt, whose work he collected.

KEY WORKS: *The Artist's Mother*, 1695; *Louis XIV*, 1701; *Cardinal de Bouillon*, 1708

Rosalba Carriera

1673–1757, ITALIAN

Carriera began her career painting miniatures (some of them for snuff-box lids), but by about 1700 she had taken up pastel. This became her preferred medium and she played a central role in popularizing pastel portraits, which enjoyed a great vogue during the 18th century. She spent most of her life in Venice, but her work was known throughout Europe, and she made triumphant visits to Paris (1720–21) and Vienna (1730), being treated as a celebrity in both places. Although her characterization is often somewhat bland, her work was praised for its lightness

△ SELF-PORTRAIT, HYACINTHE RIGAUD, 1701

of touch, elegance, and subtlety of colour. In the 1740s, Carriera began to have problems with her eyesight, which resulted in blindness in 1749. This, along with the death of her sister in 1748, led her into deep depression.

KEY WORKS: *Girl with a Dove*, 1705; *Louis XV as a Child*, c.1720; *Self-Portrait*, c.1744

Louis-François Roubiliac

1702–1762, BRITISH

Born in Lyon in France, Roubiliac probably trained in Germany and France, before settling in London in 1730. He became the foremost sculptor in Britain and was a co-founder of the St Martin's Lane

Academy – a fraternity of like-minded artists that was a forerunner of the prestigious Royal Academy.

Initially he made his reputation as a portraitist, but from the mid-1740s he also achieved great success as a tomb sculptor. His portraits show brilliant skill in characterization, even when he created busts or statues of people who were long dead, and his tombs are remarkable for their inventiveness and sense of drama (especially after he visited Rome in 1752 and saw the work of Bernini, which deeply impressed him). He worked mainly in marble, but he also used terracotta for portrait busts and preparatory models for large works. In spite of his success, and his marriage to a wealthy heiress, he died in debt.

KEY WORKS: Statue of George Frederick Handel, 1738; Statue of Shakespeare, 1758; Tomb of Lady Elizabeth Nightingale, 1758–61

François Boucher

1703–1770, FRENCH

Boucher was the dominant French artist of his time – highly prolific and successful in a variety of fields. He spent almost all his life in Paris, apart from a period in Rome from 1728 to 1731. In addition to his main profession of painting, Boucher was a versatile designer of tapestries, stage sets, porcelain figures, and much else besides. He received many honours, and in 1765 was appointed both director of the Académie Royale de Peinture et de Sculpture and first painter to Louis XV.

Stylistically, Boucher was one of the chief representatives of the Rococo spirit, his most characteristic paintings being delightfully artificial pastoral or mythological scenes, frequently involving beautiful shepherdesses or nymphs. Fragonard was the most important of his many pupils.

KEY WORKS: *Diana after the Bath*, 1742; *Reclining Girl*, 1751; *Madame de Pompadour*, 1756

Pompeo Batoni

1708–1787, ITALIAN

Batoni spent almost all of his career in Rome, and he is regarded as the last Italian painter to play a dominant role in the city. He worked at a time when Italy was beginning to lose its former unchallenged pre-eminence in art, and although Rome was the centre of the burgeoning Neoclassical style, many of its leading exponents came from other countries.

His success initially came with drawings of Roman antiquities and then with religious and mythological paintings, but he achieved his greatest fame as a portraitist. Wealthy foreign visitors to Rome (including young British aristocrats making the Grand Tour) made up much of his clientele. Batoni depicted these sitters with a grandiose dignity that harks back to Baroque portraiture, but his work also has a Rococo charm and delicacy.

KEY WORKS: *The Fall of Simon Magus*, 1746–55; *Colonel William Gordon*, 1766; *Princess Cecilia Mahony Giustiniani*, 1785

Francesco Guardi

1712–1793, ITALIAN

Guardi's view paintings of his native city of Venice are now almost as famous and popular as those of his contemporary Canaletto. However, his career was much less successful in worldly terms than Canaletto's, and it was not until about a century after his death that his genius began to be widely appreciated.

Although his paintings are similar in subject to those of Canaletto, they are notably different in treatment – being atmospheric in mood and free in handling, rather than sharp and precise. In his early career, Guardi's work was largely subsumed in his family's workshop (which produced pictures of many different kinds) and he evidently began to specialize in view paintings only after the death of

his brother Antonio in 1760. The authorship of some impressive religious paintings is disputed between the two brothers.

KEY WORKS: *The Piazza San Marco*, c.1760; *Concert of Girl Musicians*, c.1782; *Fire in the Oil Depot at San Marcuolo*, 1789

▷ Richard Wilson

1713–1782, BRITISH

Wilson was one of the most important figures in the history of landscape painting in Britain, giving the art a new sense of seriousness and ambition. Previously, British landscapes had tended to be essentially decorative or topographical, but Wilson was concerned to explore ideas and emotions. He was born in Wales and trained in London. Initially, he worked mainly as a portraitist, but he turned to landscape during a period in Italy (1750–57), when he was inspired by Claude and by the countryside around Rome where Claude had worked.

Wilson painted both Italianate landscapes (sometimes with historical subjects) and British scenes that are given a classical flavour of poise and dignity. His work was highly influential: he had several pupils and imitators, and his later admirers included Constable and Turner.

KEY WORKS: *Lake Avernus*, c.1752; *Destruction of the Children of Niobe*, 1760; *Snowdon from Llyn Nantlle*, c.1765

Etienne-Maurice Falconet

1716–1791, FRENCH

Falconet was one of the leading French sculptors of the 18th century, and was the one who probably best exemplifies the charm and delicacy of the Rococo style. He worked predominantly in marble and his most characteristic sculptures are fairly small in scale, intimate in subject, and

△ **PORTRAIT OF RICHARD WILSON BY ANTON RAPHAEL MENGS, 1752**

gently erotic in feeling (many were reproduced in porcelain at the famous Sèvres factory). His masterpiece is in an entirely different vein – a huge bronze equestrian statue of Peter the Great in St Petersburg, commissioned by Catherine the Great (Falconet lived in Russia from 1766 to 1778). In 1783, Falconet suffered a stroke that put an end to his career as a sculptor; thereafter he concentrated on revising his writings about art.

KEY WORKS: *Bather*, 1757; *Pygmalion and Galatea*, 1763; Equestrian statue of Peter the Great, 1770–82

Giovanni Battista Piranesi

1720–1778, ITALIAN

Piranesi was born near Venice, where he trained, but he settled in Rome in 1740, where he was apprenticed for a time to Giuseppe Vasi. He spent most

of the rest of his life in the city, working as a designer, architect, archaeologist, and writer. Above all, he was a prolific etcher, specializing in views of ancient and modern Rome.

His etchings combine a practical understanding of construction (his father was a stonemason and his uncle an engineer) with a vivid imagination, depicting the buildings and other monuments with a sense of drama and fantasy. His prints were enormously popular with visitors to Rome as souvenirs, and they also influenced numerous artists and architects. In addition to his topographical prints, Piranesi made etchings of imaginary prisons – nightmarishly sinister interiors that influenced the Gothic literary imagination and, later, the design of sets for horror films.

KEY WORKS: *St Peter's from the Piazza*, c.1748; *The Pantheon*, 1761; *The Piazza Navona*, 1773

Sir Joshua Reynolds

1723–1792, BRITISH

One of the greatest portraitists of the 18th century, Reynolds is important not only for the quality of his work, but also because he elevated the status of art in Britain. In 1750–52 he visited Italy, and he was inspired to create portraits that rose above traditional "face painting" by taking on some of the poetic and intellectual resonances associated with ancient statuary and Renaissance art. His status was confirmed when he became the first president of the Royal Academy of Arts, founded in 1768.

Reynolds showed great versatility in his portraits, equally at home with pictures of men, women, and children, and endlessly inventive in expression, pose, and mood. He was, in addition, an outstanding writer on art.

KEY WORKS: *Commodore Augustus Keppel*, 1753–54; *Three Ladies Adorning a Term of Hymen*, 1773; *Mrs Siddons as the Tragic Muse*, 1784

Franz Anton Maulbertsch

1724–1796, AUSTRIAN

Maulbertsch was the supreme decorative painter of his time in central Europe, working prolifically over a large area of the Holy Roman Empire (in what are now the modern countries of Austria, the Czech Republic, Germany, Hungary, Romania, and Slovakia).

He is particularly well known for his ceiling frescos, but he also painted many altarpieces. Most of his major works are still in the churches and palaces for which they were produced, but examples of his preparatory oil sketches are in numerous galleries. His colourful and exhilarating style represents the final flourishing of the Baroque and Rococo tradition at a time when Neoclassicism was becoming dominant throughout most of Europe (it influenced Maulbertsch's own late work).

△ SELF-PORTRAIT, BENJAMIN WEST, 1819

KEY WORKS: *Assumption of the Virgin*, 1752; *Glorification of the Saints of Hungary*, 1773; *Revelation of Divine Wisdom*, 1794

George Stubbs

1724–1806, BRITISH

Stubbs is renowned as the greatest of all painters of horses, which he depicted in a rich variety of ways, from ferocious scenes of animal combat to pastoral idylls and "portraits" of racers.

He was born in Liverpool and spent his early career in the north of England and the Midlands before settling in London. His mastery of his subject was based on scientific knowledge, for he spent 18 months dissecting horses in preparation for his book *The Anatomy of the Horse* (1766), which is illustrated with his own engravings. He also depicted many other animals, including numerous dogs and exotic beasts such as a moose and a zebra.

KEY WORKS: *Whistlejacket*, 1762; *Cheetah and Stag with Two Indians*, c.1765; *Hambletonian, Rubbing Down*, 1799

◁ Benjamin West

1738–1820, AMERICAN

Although he spent most of his career in England, West is known as "the father of American painting" because he was an inspirational figure to his countrymen who visited Europe, unstinting with help and advice.

He was born near Philadelphia, worked briefly in New York, then after spending three years studying in Italy, settled permanently in London in 1763. In his adopted country he achieved both professional and social success, becoming official history painter to George III in 1772 and succeeding Reynolds as president of the Royal Academy in 1792. Initially, he was mainly a portraitist, but he became best known for large multifigure compositions on historical, literary, and religious subjects.

KEY WORKS: *The Death of Wolfe*, 1770; *Saul and the Witch of Endor*, 1777; *Death on the Pale Horse*, 1817

▷ Angelica Kauffmann

1741–1807, SWISS

Kauffmann was the most famous woman painter of her time, enjoying an internationally successful career. A child prodigy in Switzerland, she then lived in Italy – mainly in Rome – before settling in London in 1766. Two years later, she was one of only two women among the founder members of the Royal Academy of Arts.

Kauffmann first achieved recognition as a portraitist, but later focused more on historical, literary, and (occasional) religious scenes. Her style blends Neoclassical purity of line with Rococo charm. In 1781 she returned to Italy, settling in Rome the following year. She was so admired there that she was given a funeral (planned by the sculptor Canova) befitting a queen.

KEY WORKS: *Hector and Andromache*, 1769; *Self-Portrait*, 1784; *Christ and the Woman of Samaria*, 1796

Jean-Antoine Houdon

1741–1828, FRENCH

Houdon initially achieved success with statues of allegorical, mythological, and religious subjects, but his fame derived from his status as the greatest portrait sculptor of his age.

He spent most of his career in Paris, but lived in Italy from 1764 to 1768 after winning the Prix de Rome. By 1785, he was held in such high regard that he was invited to America to make preparations for a statue of George Washington. The original is in marble (Houdon's preferred material), but several copies were produced in bronze. He continued working into the Napoleonic era, but in about 1814 he suffered a stroke that ended his career.

KEY WORKS: *St Bruno*, 1767; *Voltaire Seated*, 1781; *George Washington*, 1785–92

William Blake

1757–1827, BRITISH

A poet and mystical philosopher as well as a printmaker and painter, Blake was a fiercely independent character who concentrated on imaginative themes in which he created a visionary world of his own. Much of his visual work was devoted to illustrating his writings. His prints and paintings – often made using unconventional techniques – are usually small in size, but lofty in feeling, bold and energetic in form, and resplendent in colour. He struggled to earn a living, supported by a few loyal admirers. It was not until about a century after his death that he was recognized as one of the most remarkable figures in British culture.

KEY WORKS: *Elohim Creating Adam*, 1795; *Satan Arousing the Rebel Angels*, 1808; *The Body of Abel Found by Adam and Eve*, c.1826

◁ **SELF-PORTRAIT,
ANGELICA KAUFFMANN, c.1770–75**

19th
CENTURY

CHAPTER 5

Katsushika Hokusai

1760–1849, JAPANESE

Hokusai was an outstanding painter and draughtsman but above all a master of the woodblock print. His works are among the most famous in Japanese art, and have inspired viewers and artists across the globe.

Katsushika Hokusai was born in October 1760 in Honjo, east of the city of Edo (now Tokyo). His parentage is uncertain, but he was adopted by an artisan called Nakajima, a mirror-maker who worked for the shogun (Japan's military ruler); Hokusai might well have been the mirror-maker's natural son with a concubine.

As was usual for Japanese artists, Hokusai adopted many different names (around 30 in all) with which he signed his paintings at different points in his career. It is customary to refer to him as Hokusai – the best known of his names – even though he did not use it until he was in his late thirties.

The Katsukawa school

In his early teens, Hokusai worked at a bookshop and library. Showing a keen interest in art, he was apprenticed to a woodblock engraver at the age of 15 and three years later became a pupil of Katsukawa Shunshō, an important artist in the field of *ukiyo-e* (floating world) paintings and prints (see box, right). This style was very popular in Edo and usually featured subjects such as beautiful women, erotica, and kabuki actors (for whose portraits Shunshō was especially known).

Hokusai's first published prints were also of actors from the kabuki theatre, but after his marriage in the mid-

◁ *SQUEAKING A GROUND CHERRY*, c.1798
Hokusai's woodblock print of two women, made under the influence of the Katsukawa school, is from a series that is aptly named *Seven Fashionable Useless Habits*.

1780s and the birth of his son and two daughters, he began increasingly to make prints of other subjects, such as children and landscapes.

Growing individuality

Shunshō's death in 1793 marked a major turning point for Hokusai. He started to explore other styles of art, such as European engravings, and to study secretly with artists of the Kanō school – rivals of Shunshō's Katsukawa school. As a result, he was disowned by the Katsukawa school, an event that seems to have given him even more freedom

to develop his own approach. From this time on he turned away from the traditional subjects of *ukiyo-e* art and towards images of daily life.

Surimono prints

In the 1790s, he started to make a living designing *surimono* – poems illustrated with woodblock prints – which he produced in small editions for patrons who would use them as, among other things, invitations and greetings cards. As his *surimono* grew in popularity and started to attract many imitators, he determined to became an independent artist. He relinquished his ties to any one school. and adopted his new "brush name", Hokusai – an abbreviated form of a phrase meaning "north star studio" – in honour of a god of the Buddhist sect of which he was a member. He soon began to receive a diverse range of commissions, such as providing illustrations for historical novels, which brought him back to more traditional themes.

IN CONTEXT
Ukiyo-e

The term *ukiyo-e* (paintings of the floating world – a term that referred to the brothels and theatre districts of Edo Japan) was used to describe the hedonistic art of the merchant class in 17th- to 19th-century Edo. This class relished pictures of geishas, courtesans, and kabuki theatre, especially if they featured female beauty. By the 19th century, artists such as Hokusai made landscape images popular too. The earliest *ukiyo-e* prints were in black ink and often hand-coloured, but later artists used several woodblocks so that they could incorporate rich colours.

THE LIFE OF THE GEISHA WAS A COMMON SUBJECT OF *UKIYO-E*

◁ *SELF-PORTRAIT AS A FISHERMAN*, 1835
Hokusai depicts himself humbly in the guise of a common fisherman. In his later years, he adopted the brush name of "The Old Man Mad About Art".

"Since my sixth year, I have had a **burning desire** to **draw all things**."

HOKUSAI, 1834

> " Until the age of seventy, **nothing** that
> I drew was **worthy of notice**. "
>
> HOKUSAI, 1834

Commercial imperatives

Hokusai's wife died young, and the artist remarried. His eldest son had been accepted as an heir by the wealthy Nakajima family, with which Hokusai was connected by birth. This was a comfort to Hokusai, since not only would his son benefit from a secure position in life, but he – as the boy's father – was also paid a stipend. His son's death in 1812 was therefore a double blow to Hokusai, who was forced to produce commercial work for profit alongside his lavish paintings (for which he was recompensed with "gifts" rather than fees).

His most notable works at this time were his picture books, known as manga, which were intended as practice aids for other artists. They included thousands of drawings of popular themes, including animals, human figures, and religious subjects, which helped to attract pupils and also generated wider publicity.

Hokusai promoted himself through public demonstrations of his artistic skills by, for example, using his fingers or the "wrong" end of the brush to produce a painting, or by drawing a landscape upside-down to impress the crowds. On one occasion, he made a huge painting in front of a large audience, using buckets of paint and a broom. This kind of spectacle brought Hokusai fame and he was even ordered to display his virtuosity before the shogun.

Sadly, Hokusai's personal tragedies continued: in 1828, the artist's second wife died. His favourite daughter O-ei, who was also an artist and his pupil, returned home to look after him.

By this time, Hokusai was a celebrated artist, known especially for his landscapes and for prints of natural subjects such as birds and flowers. Soon, he was to produce his most famous work of all. In 1826, he began to publish the collection of coloured woodblock prints called *Thirty-Six Views of Mount Fuji*, adding supplements that brought the total number of images to 46 by the 1830s. The vivid colours of these prints, together with their immense graphic strength and the sheer drama of

▽ **HOKUSAI MANGA, c.1816**
Hokusai published 12 volumes of drawings, or manga, from 1814 onwards. These were series of woodblock prints in three colours (black, grey, and a pale flesh tint). Vigorously drawn and sometimes humorous, they proved very popular.

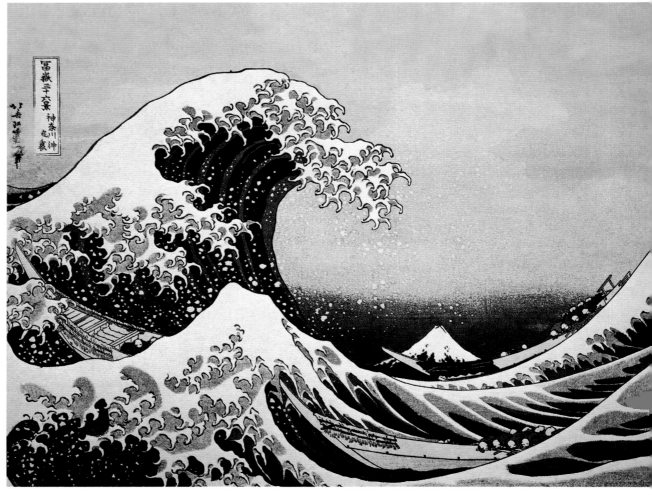

▷ *THE GREAT WAVE OFF KANAGAWA*, **c.1830**
This colour woodblock print was the first in Hokusai's series *Thirty-Six Views of Mount Fuji*. Based on two previous images by the artist, it shows a boat almost overwhelmed by a rogue wave, with the mountain in the background.

scenes such as *The Great Wave off Kanagawa*, attracted contemporary viewers and inspired younger artists, notably Hiroshige.

The sacred mountain

Thirty-Six Views of Mount Fuji was followed in the late 1820s by more series depicting birds, waterfalls, flowers, and bridges, all of which proved popular. In 1834–35, Hokusai turned to Mount Fuji once more, with *One Hundred Views of Mount Fuji*, this time drawn in monochrome. The views encompass a huge variety of subjects, including dramatically composed studies of bamboo and trees, as well as people, boats, and bridges, all in the context of Fuji and its surrounding landscape. Part of the power of the images comes from Hokusai's spiritual outlook. He saw the mountain as a source of immortality,

and hoped that drawing it repeatedly would help him live to the old age that he thought would be necessary for him to achieve his full potential as an artist.

Late works

Another series begun in the 1830s – *Pictures of One Hundred Poems by One Hundred Poets* – was not completed; only 27 prints were released, though more had been started. These images return to the rich colours of *Thirty-Six Views* and range in subject from people looking at cherry blossoms (a recurring theme in Japanese poetry) to old men admiring young women diving for abalone.

The year 1839 saw a final tragedy in Hokusai's life. His studio burned down, and all the paintings and drawings in it were destroyed. Although the artist was by now an old man of 79, the

△ **AUTUMN LEAVES ON THE TSUTAYA RIVER, c.1839**
This print is part of the series *One Hundred Poems by One Hundred Poets*, based upon a hugely popular anthology of poems compiled by Fujiwara no Teika in 1235.

setback almost seemed to spur him on. He worked regularly until the end of his life in 1849, appealing to Heaven on his deathbed for more years of life so that he could become a "true artist".

Soon after his death, Japan was opened to international trade for the first time in centuries, and Hokusai's prints were exported to Europe and America, serving as inspiration to Western artists, notably the Impressionists (Claude Monet alone had 23 of Hokusai's prints). His reputation as one of Japan's greatest and most prolific artists was secure.

ON TECHNIQUE
New colours

In the announcement of the first full edition of the collection *Thirty-Six Views of Mount Fuji*, the publisher described the prints as "decorated with Prussian blue". This type of blue pigment was newly available to printers in Japan at around the time Hokusai made his *Thirty-Six Views* and its unrivalled intensity probably stimulated Hokusai to depict his landscapes and seascapes so vividly. Earlier blue pigments – from plants such as indigo – tended to fade, but the richer, more enduring Prussian blue encouraged the artist to use the colour more lavishly.

PRUSSIAN BLUE PIGMENT

KEY MOMENTS

1779
Produces an early series of prints of kabuki actors, which show a strong graphic line and a restrained palette.

1800
Illustrates *Picture Book of the Sumida River*, a three-volume book showing the sights of Edo bustling with human activity.

c.1830–33
Produces *A Tour of the Waterfalls of the Provinces*, treating each site differently to emphasize its unique character.

1834
Confirms his reputation as a painter of flowers with an untitled series, known as *Small Flowers*, drawn with great clarity.

1835
Makes *Flock of Chickens*, combining fine detail with the intricate patterning of the chickens' heads.

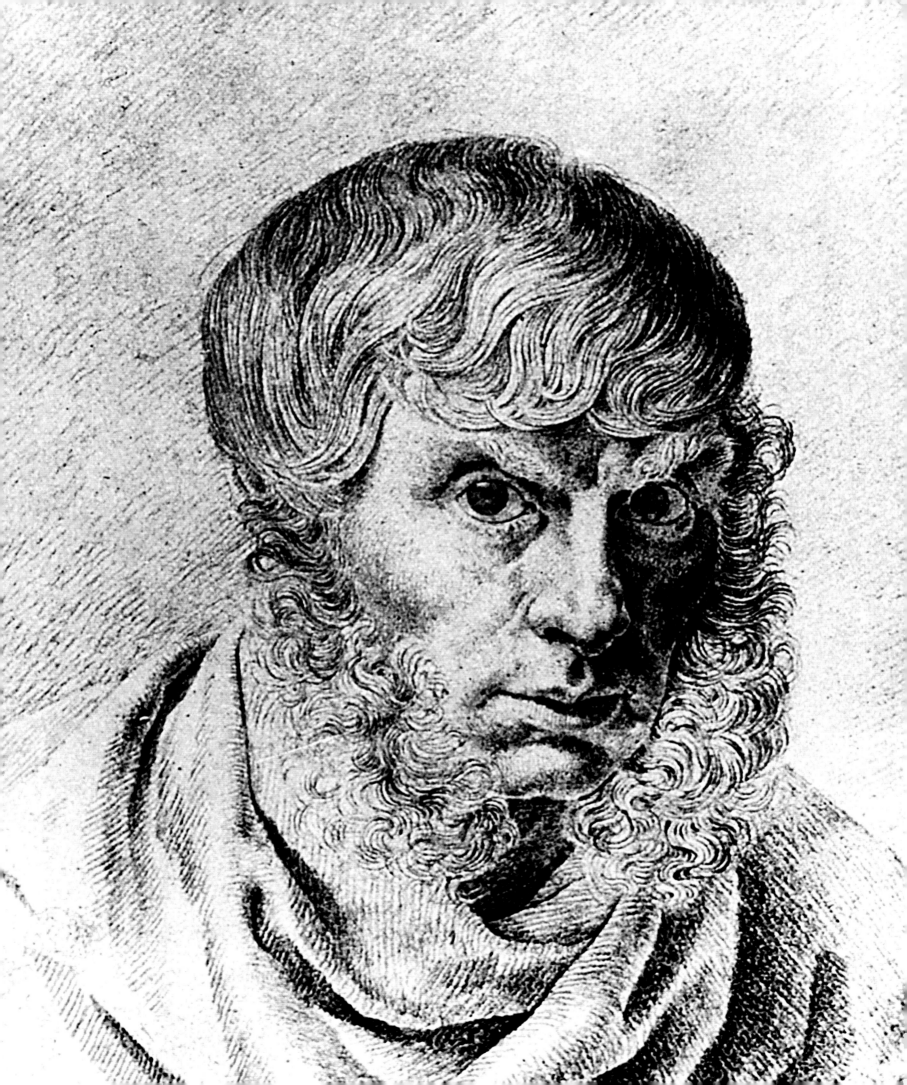

Caspar David Friedrich

1774–1840, GERMAN

A key figure in the Romantic movement in Germany, Friedrich created a series of atmospheric and innovative landscapes that imbued his native countryside with an intense spirituality.

Caspar David Friedrich was born in the harbour town of Greifswald in northeastern Germany, the son of a prosperous soap-boiler and candle-maker who was a devout Protestant. The religious atmosphere of his childhood, combined with the deaths of his mother, two sisters, and brother (who tragically died while trying to save Friedrich in a skating accident) all had an effect on the young artist, contributing to his lifelong preoccupation with religion and death.

The Dresden Romantics

After four years studying art in Copenhagen, where he developed a talent for handling pen and line, Friedrich moved to Dresden to further his studies. The city – which was to remain his base for the rest of his life – was the centre of a group of painters who became known as the "Dresden Romantics". Reacting against rationality, they sought to explore the exotic, irrational, and

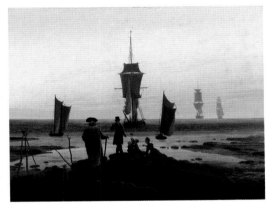

△ **THE STAGES OF LIFE**, 1835
The five ships represent the stages of life of the foreground figures, who were modelled by members of the artist's family. The positions of the ships echo the composition of the figures.

mystical sides of human existence. Friedrich found himself in sympathy with their ideas, and in around 1800 began to introduce mystical and dramatic themes into his pictures.

At this stage, Friedrich was working only in sepia, but he turned to oils when commissioned to paint an altarpiece in 1807. The resulting *Cross in the Mountains* proved controversial; rather than depicting saintly figures, as was traditional, it showed a landscape with an oblique view of the cross. But Friedrich believed strongly that God manifested himself in nature,

so that viewing the natural world, or its depiction, could be seen as an act of devotion.

Religious symbolism

By the time he painted *The Cross in the Mountains*, Friedrich was enjoying the patronage of some influential figures. The crown prince of Prussia bought *Abbey in the Oakwood* (1809), which shows a ruined abbey – a sombre work, possibly emblematic of the declining Christian Church. Some of his most powerful paintings date from the 1820s and 1830s, including *The Great Enclosure*, a panoramic view of an estuary near Dresden, which conveys an extraordinary feeling of melancholy, and the masterly *The Stages of Life*. In this allegory of transience, the artist appears in the foreground wearing a long coat, his figure echoed by the ship that has almost reached the bay. Friedrich suffered a severe stroke shortly after it was painted, and was forced to virtually abandon oil painting.

At the time of his death in 1840, Friedrich's reputation had declined to such an extent that he was almost forgotten, and it was not until the advent of Symbolism at the end of the 19th century that his art came to be appreciated once more.

△ **THE CROSS IN THE MOUNTAINS**, c.1807
Friedrich strives to reveal religion through landscape in this painting, known as the Tetschen Altarpiece.

ON TECHNIQUE
Seen from behind

Friedrich was moved above all by landscape, and when he did place people in his pictures they were invariably viewed from behind. His figures served as intermediaries, inviting the viewer to join them as they meditated on the sublime vista in front of them. Friedrich's landscapes were often laced with religious symbols – in the painting below, for example, the waxing moon may represent Christ.

TWO MEN CONTEMPLATING THE MOON, 1819–20

◁ **SELF-PORTRAIT, c.1810**
Friedrich drew this portrait around the height of his fame, when he was elected to the prestigious Berlin Academy. Later in his life, his melancholy Romanticism fell out of favour with the public.

" I have to **stay alone** in order to fully contemplate and **feel nature**. "

CASPAR DAVID FRIEDRICH

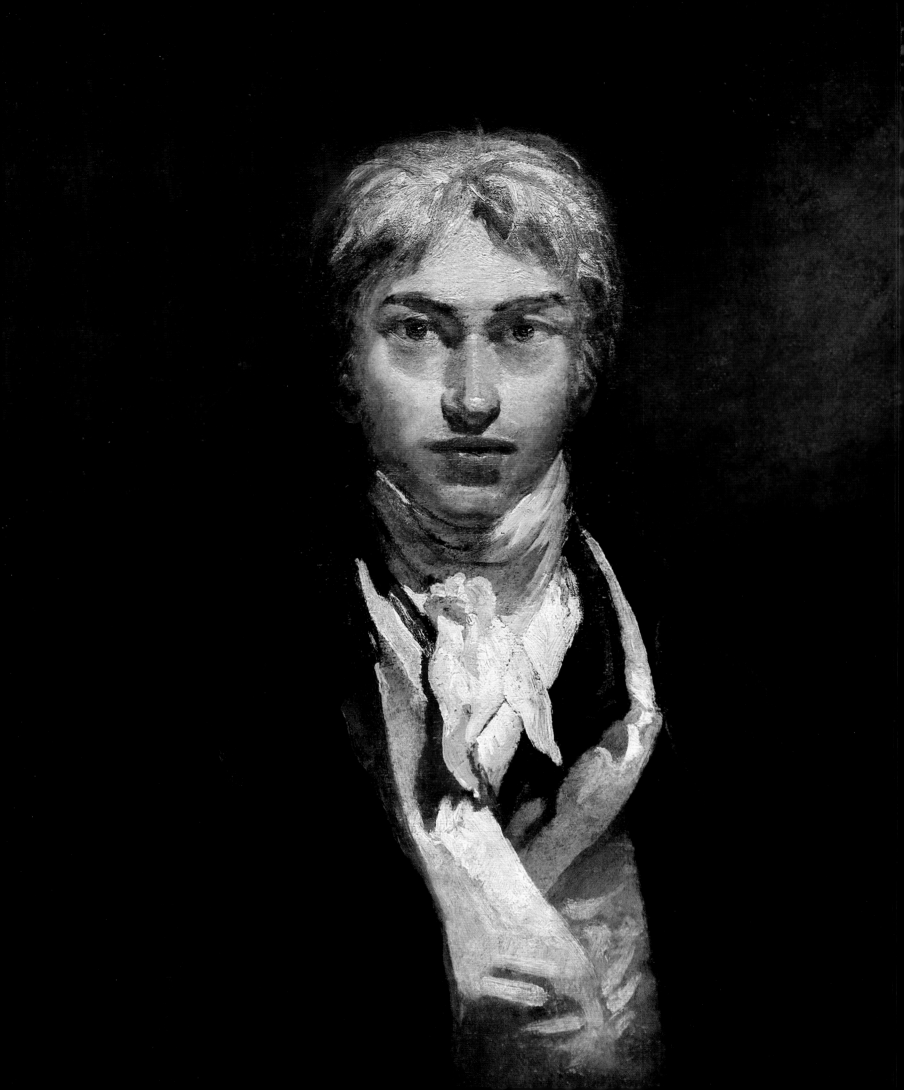

J M W Turner

1775–1851, ENGLISH

Turner was one of Britain's greatest artists. He produced landscapes and history paintings, but is known, above all, for his pictures of the sea. In these, he captured both the beauty and the destructive power of nature.

△ **WATERCOLOUR PAINTBOX**
The creation of portable watercolour "cakes" made life considerably easier for artists. In 1781, the Reeves brothers were awarded a Silver Palette by the Society of Arts for the invention.

Joseph Mallord William Turner was born on 23 April 1775 in Covent Garden, London, the eldest son of a barber and wig-maker. At home, he was called William or Bill, but in the art world he has become better known by his initials, as this was the way he signed his paintings.

Turner's talent became apparent at a very early age. As a boy, he used to colour up engravings, which his father proudly displayed for sale in his shop. Turner was always very close to his father and, in later years, the old man became his studio assistant. Relations with his mother, who suffered from psychological difficulties, were more strained. In 1800, she was admitted to the Bethlem Royal Hospital, an infamous asylum, where she died four years later.

Key influences

At the age of 14, Turner entered the Royal Academy Schools, where he made rapid progress. His first exhibit, a watercolour, appeared at the Academy in 1790 and his first oil painting was shown there in 1796.

◁ **SELF-PORTRAIT, c.1799**
Painted in oil around the time of Turner's election as an Associate Royal Academy, the image shows the young artist as Romantic hero.

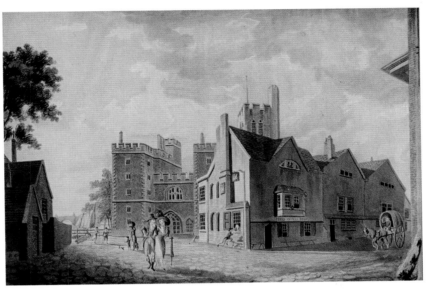

△ *A VIEW OF THE ARCHBISHOP'S PALACE, LAMBETH*, 1790
Turner's watercolour, painted at the age of 15, was the first of his works accepted for the Royal Academy's annual exhibition. His training with Thomas Malton is evident in the detail and accuracy.

Three years later, he was elected an Associate of the Royal Academy and in 1802 he became a full member – the second youngest person to achieve this distinction.

Turner took extra lessons elsewhere. He worked for a time under Thomas Malton – a painter of topography and architecture – gaining expert tuition in drawing and perspective. At first glance, Malton's disciplined street scenes may seem to have little in common with his protégé's expansive style, but Turner later wrote of his teacher in glowing terms, describing him as "my true master". Certainly, he was able to offer valuable advice about preparing work for engraving. Most of Malton's views were published as aquatints (prints that shared some of the tonal qualities of watercolours) and Turner was equally keen to exploit this lucrative market.

Turner also attended the informal academy run by Dr Thomas Monro, who was the king's physician, and

IN PROFILE
John Ruskin

Ruskin (1819–1900) was the most influential English art critic of the 19th century. Early in his career, he championed the cause of Turner, at a time when the painter was producing some of his most controversial work. Ruskin's eloquent defence was published in the opening sections of his monumental, five-volume study *Modern Painters* (1843–60). He first met Turner in 1840, purchased several of his pictures, and eventually became the executor of his will.

JOHN RUSKIN

" He seems to **paint** with tinted **steam**, so **evanescent** and so **airy**. "

JOHN CONSTABLE, CITED IN THE *OXFORD DICTIONARY OF ART*

▷ **THE FIGHTING TEMERAIRE, 1839**
Turner's painting of the *Temeraire* – a warship from the Battle of Trafalgar – being towed to the breaker's yard as the sun sets, is a metaphor for the decline of British naval power.

IN CONTEXT
The Battle of Trafalgar

The Battle of Trafalgar was a key engagement in the Napoleonic Wars, when the British navy – led by Lord Nelson – defeated the combined fleets of France and Spain. Turner's fascination with the sea extended to the exploits of the British navy. He went to inspect the *Victory* (Nelson's ship) immediately upon its return, making numerous sketches on board. These were used for his painting of *The Battle of Trafalgar*, which was exhibited in the following year. Memories of the triumph lingered long in the hearts of patriotic English people and Turner's finest picture on the theme was produced in 1838, when he recorded the final voyage of one of Trafalgar's veterans, the warship *Temeraire.*

NELSON'S COLUMN, TRAFALGAR SQUARE, LONDON

also an amateur artist and collector. He taught youngsters by having them copy watercolours from his collection, and Turner later recalled fondly making "drawings for good Dr. Monro at half a crown apiece and a supper". The doctor's collection included examples by John Cozens, Edward Dayes, and Thomas Hearne. Cozens, in particular, was a major influence on Turner, who learned from his work how to build up tones and forms through layers of tiny brushstrokes.

Rise of watercolour

Watercolour had become fashionable in England in the wake of developments in paint technology, and in 1804, the Society of Painters in Water Colours was founded in London. At the Royal Academy, however, watercolours were still regarded as little more than "tinted drawings" and invariably "skied" (hung very high at shows). Turner helped to transform the medium's reputation. He worked on a larger scale than his contemporaries and achieved amazing effects in his treatment of light and atmosphere.

One of his watercolour boxes has survived, revealing that he used a mix of traditional pigments (including Venetian red, raw sienna, and ochre), modern ones (such as cobalt blue and chrome yellow), and fugitive colours, which faded quickly (such as gamboge, carmine, and quercitron).

Sketching tours

Watercolours featured prominently in the sketching tours that Turner undertook from the start of his career. Unlike Constable, whose landscapes were largely based on his native region, Turner drew much of his inspiration from travel. In the 1790s, he toured around various parts of Britain, including the Bath and Bristol area, North Wales, the Midlands, the Lake District, and Scotland.

He concentrated on topographical scenes, some of which were watercolours for private patrons. However, Turner also made sketches of general interest, which he knew could later be published as prints. In these, he often catered for the fashion for the picturesque, focusing on ruined abbeys and castles, which would have been of particular commercial appeal.

In 1802, he took advantage of a temporary lull in the fighting on the continent to make a tour of France and Switzerland. In addition to his usual topographical work, he made a point of visiting the Louvre, which was crammed full of treasures that Napoleon had looted from other parts of Europe. This was an invaluable

" Beyond doubt the **greatest painter** produced **so far** by the English-speaking peoples. "

SIR JOHN ROTHENSTEIN, *TURNER,* 1963

way of learning from the Old Masters, and Turner filled an entire sketchbook with notes and sketches of canvases by such artists as Titian, Poussin, Caravaggio, Rembrandt, and Rubens.

Academy exhibitions

Turner's most important pictures were exhibited at the Royal Academy. At the time, history painting was regarded as the most prestigious category of art, while landscapes were held in relatively low regard. Turner addressed this problem by following the example of two of his heroes – Poussin and Claude. Like them, he dressed up some of his landscapes as history paintings by adding a few token details in the foreground. His *Hannibal and his Army Crossing the Alps* (1812) for example, is essentially a spectacular portrayal of a violent storm. Turner was on firmer ground with more modern subjects, such as the exploits of Nelson (see box, left). His most popular painting in this genre is *The Fighting Temeraire*.

The Academy exhibitions led to major commissions but, for an artist as prolific as Turner, this was never sufficient. So in 1804, he opened his own gallery, next to his studio in Harley Street, London. Here he exhibited his watercolours and some of his less finished works, which often included the word "Sketch" in the title.

The extraordinary scale of Turner's output can be gauged from the number of

KEY MOMENTS

1796
Exhibits his first oil painting, *Fishermen at Sea*, at the Royal Academy.

1812
Paints the grandiose historical work *Snow Storm: Hannibal and his Army Crossing the Alps*, having been inspired by a violent storm in Yorkshire.

1823
Exhibits *The Bay of Baiae, with Apollo and the Sibyl*, a stunning landscape in oil made during his first trip to Italy.

1838
Witnesses the last voyage of the warship *Temeraire*, which inspires his *Fighting Temeraire*. The painting is judged a great success.

1846
Shows *The Angel Standing in the Sun* at the Royal Academy The reviews are mixed; some lament its lack of solid form.

sketchbooks that he filled, which eventually amounted to more than 260 volumes.

A private life

Turner was a guarded individual, sometimes going under assumed names to escape attention. In 1807, he and designed and built his own villa in Twickenham, near London – a refuge from his artistic life in the city – where he lived with his father for 20 years. Turner never married, but he did have a number of long-term relationships, notably with a widow, Sarah Danby, with whom he had two daughters.

In his later years, he grew ever more interested in conveying the effects of light and portraying the raw power of nature. Before painting *Snow Storm: Steam-boat off a Harbour's Mouth* (1842), he claimed to have asked sailors to lash him to the mast during a storm. In tackling scenes of this kind, Turner adopted a vortex-like composition, in which forms dissolved into a whirlpool of light and colour.

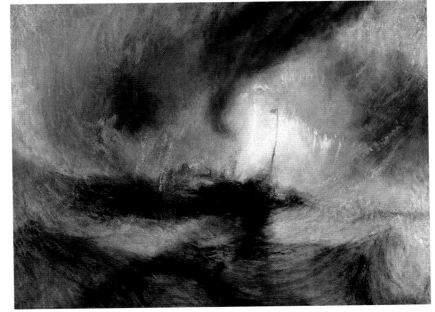

△ *SNOW STORM: STEAM-BOAT OFF A HARBOUR'S MOUTH*, 1842
Turner's most graphic depictions of violent storms brought him to the edge of abstraction. Not surprisingly perhaps, some critics were alarmed by the lack of form. One reviewer likened this work to "a mass of soapsuds and whitewash".

Throughout the 1840s, Turner became increasingly reclusive, and his health began to decline. He eventually died of cholera in 1851, and his body was interred in the crypt of St Paul's Cathedral in London. He bequeathed the contents of his studio to the nation, an enormous legacy of some 300 oil paintings, and 19,000 drawings and watercolours. His will was under litigation for many years, and it took more than a century to iron out the various complexities, but most of his work is now housed at the Clore Gallery in Tate Britain, London.

◁ **A LONDON RETREAT**
Turner designed and built his own villa – Sandycombe Lodge in Twickenham, near London. He enjoyed taking long walks by the River Thames, and fishing its waters.

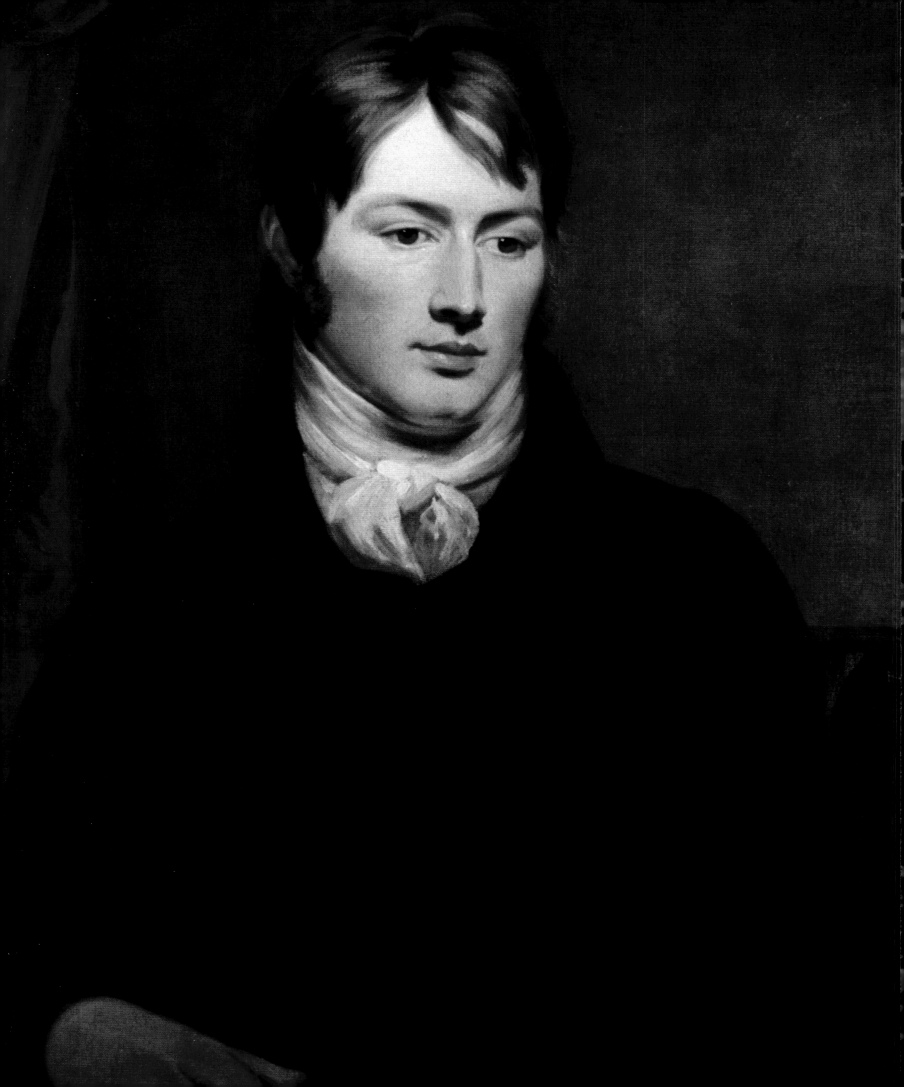

John Constable

1776–1837, ENGLISH

Success came late in Constable's life. The art world was slow to recognize the pioneering quality of his work, but he is now widely regarded as Britain's greatest landscape painter.

△ **PAINTBOX**
Constable used to carry this hinged, portable metal paintbox into the field for his oil sketches. It has 17 compartments.

John Constable was born in East Bergholt, Suffolk, on 11 June 1776. This corner of southeastern England was primarily an agricultural area and his father, Golding, was a wealthy corn merchant and mill owner. John worked briefly for his father, earning the nickname of "the handsome miller", before turning to painting. Early artistic stimulus followed a meeting with a local squire, Sir George Beaumont, who showed Constable his prized possession – the painting *Landscape with Hagar and the Angel* (1646) by Claude Lorrain. Constable was transfixed by the work's gorgeous setting and decided to take informal lessons with Beaumont and another local painter before entering the Royal Academy Schools in 1799.

Focus on landscape

On completing his training in 1802, Constable began exhibiting at the Academy and continued to hone his skills by copying Old Masters and sketching. By 1809, when he began a relationship with Maria Bicknell (see box, right), he was still reliant on the allowance he received from his father and on portrait commissions (which he hated). Success evaded him partly because landscape painting was considered a lowly genre, and partly because of his own stubbornness.

△ *A RUINED COTTAGE AT CAPEL, SUFFOLK, 1796*
From an early age, Constable developed his eye by sketching in his native county. His inscription at the top of the drawing notes that the cottage was the subject of a local legend and had reputedly belonged to a witch.

An uncle financed a tour of the Lake District, in the hope that Constable might try his hand at the fashionable Picturesque style, but the artist was not interested in painting dainty cottages or ivy-clad ruins. He was at his best when depicting the landscapes of his beloved Suffolk.

Maria's family were dismayed at her choice of suitor – a man who had given up a promising career for the life of a painter – and it was only after the death of his father in 1816 that the artist's finances appeared secure enough for marriage.

Sketching in oil

All the while, Constable was diligently developing his ground-breaking style. A sketchbook from 1813 confirms that, in just a three-month period, he produced no fewer than 130 drawings

IN PROFILE
Maria Bicknell

Constable fell in love with Maria Bicknell, a rector's daughter. Her family disapproved – he was 33 to her 21 and had few prospects. Even when the couple finally married seven years later, none of her family attended the service. Maria's health was delicate and, in 1824, she began to develop tuberculosis. Constable did his best to improve her condition, even moving to Brighton – a place he loathed – but she died in 1828, aged just 40. Constable always treasured the portrait he had painted of Maria three months before their marriage.

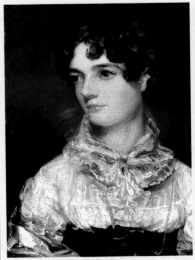

MARIA BICKNELL, 1816

◁ *JOHN CONSTABLE* **BY RAMSAY RICHARD REINAGLE, c.1799**
This portrait by Constable's classmate at the Academy shows him as described in a biography by C R Leslie as "the tall and well formed handsome miller, with a fresh complexion and fine dark eyes".

" ... one brief **moment** caught from **fleeting** time."

JOHN CONSTABLE, DESCRIBING HIS AIMS IN PAINTING

▷ **SKETCH AT HAMPSTEAD, 1820**
Constable often used a palette knife rather than a brush in his oil sketches, flattening thick slabs of pure pigment onto the canvas with the blade. Some modern critics prefer these uninhibited sketches to his finished works.

in his native Suffolk. More radically, he had begun to experiment with a highly unusual approach – painting oil sketches in the open air.

Constable's aim was to capture "the light, dews, breezes, bloom, and freshness, not one of which has yet been perfected on the canvas of any painter in the world". To achieve this goal, he avoided the smooth finish that was popular at the time, preferring to give his paint surface a rough, crumbly appearance that seemed closer to nature. He steered clear of the dull brown varnishes that were ever-present in public exhibitions, and instead of applying broad swathes of pigment, he tried using smaller patches of bright, complementary tones, which created a more luminous effect. He also applied tiny blobs of white paint to trees, gate-posts, and carts to mimic the glistening appearance of sunlight on wet wood, though some critics were not convinced, mockingly describing it as "Constable's snow".

The "six-footers"
Constable faced a problem more serious than criticism of his style: namely his failure, year after year, to gain admission to the Academy. In practical terms, this meant that his pictures were not hung to their best advantage and were thus less likely to impress and sell. Eventually he confronted this issue head-on by painting landscapes that were so big that it was impossible to ignore them.

The first of his giant landscapes, which were later dubbed the "six-footers", was *The White Horse*. When it was shown in 1819, it met with an encouraging response from both the press and the public and, a few months later, Constable was finally elected as an associate of the Royal Academy. For the next few years, he repeated the formula, sending in a huge canvas for the annual show.

The six-footers depicted the countryside that Constable loved – scenes along the river Stour, close to Flatford Mill, which his father had owned. As part of the preparation for painting, he took the unprecedented step of making full-size oil sketches. These were never intended for sale – Constable once remarked that he had "no objection to parting with the corn, but not with the field that grew it" – so they display his handling at its most vigorous and uncompromising.

Success at the Salon
The most famous of the six-footers is *The Hay Wain*, which Constable exhibited (along with *View on the Stour*) at the Paris Salon of 1824. Significantly, he showed it under the title of *Landscape: Noon*, echoing the notations that he put on his cloud studies (see box, right). The paintings caused a sensation, prompting Eugène

▽ **BOAT BUILDING NEAR FLATFORD MILL, 1815**
This scene shows the construction of a barge at Constable's father's boatyard. Constable claimed to have executed the entire canvas outdoors.

"I do not consider myself at work without I am before a **six-foot canvas.**"
JOHN CONSTABLE, 1821

Delacroix (see pp.210–13) to re-paint large segments of his *Massacre at Chios* in imitation of the Englishman's colouring. More importantly, Constable won the gold medal, the highest award at the Salon, and the pictures were sold to a Paris dealer.

Troubles at home

Constable never received this kind of adulation in his native land. His style and subjects struck a chord with the French Romantics, but were not considered to be polished enough for the English art world. Moreover, the topic of agriculture became extremely controversial through the 1820s.

Grain prices had fallen after the end of the Napoleonic wars because armies no longer needed to be fed; soldiers returned home; and the impact of the Industrial Revolution was felt in the fields, where machinery was beginning to replace human toil. None of this was good news for the average agricultural labourer, and simmering discontent eventually led to the Swing Riots of 1830, when rural workers attacked tithe barns and threshing machines. Constable exchanged worried letters with his younger brother about local disturbances and burning hayricks but – as part of the mill-owning class – he omitted this aspect of country life entirely from his paintings.

The Academy, at last

Constable finally gained full membership of the Academy – though only by the margin of a single vote – at the age of 52. Even then, many felt that it was not so much for the quality of his work as out of sympathy for the loss of his beloved Maria, who had died the previous year, leaving her husband responsible for the care of their seven children.

KEY MOMENTS

1802
Enjoys his first taste of success, when a painting, *Dedham Vale*, is accepted for exhibition at the Royal Academy.

1815
Paints *Boat Building* outdoors, stopping work only when he sees smoke rising from a chimney, signalling that supper is being prepared.

1821
The Hay Wain is well received in France. Constable takes a house in Hampstead, north London, and begins sketching on the nearby heath.

1827
Constable stays in Brighton several times in the 1820s; he paints *The Chain Pier* – depicting Brighton's first major pier, built in 1823.

1836
Constable's *Stonehenge* typifies the more intense and turbulent style he adopted in his later years.

It was a fitting honour, but shamefully overdue for a man who was one of England's greatest artists. Constable took the honour in good grace, and became a teacher at the Academy, delivering popular lectures on landscape painting. He died in London on 31 March 1837 and was buried alongside Maria in a cemetery in the northern suburb of Hampstead.

▽ ***THE HAY WAIN*, 1821**
This scene from Constable's native Suffolk shows a horse-drawn cart (hay wain) in a bucolic setting. The work failed to sell when shown in London, but shone at the Paris Salon.

ON TECHNIQUE
Cloud studies

No artist took greater pains to ensure that his landscapes looked realistic. In 1822, Constable wrote to a friend that he had "done a great deal of skying", producing around 50 oil studies of cloud formations. On each of these, he noted the date, the time, and the speed and direction of the wind. In the process, Constable acquired immense meteorological knowledge. Significantly, he did not use these studies in any of his landscapes; their sole purpose was to improve his own technique.

STUDY OF CLOUDS (DETAIL), 1822

Eugène Delacroix

1798–1863, FRENCH

Delacroix was a leading Romantic artist, whose work was infused with struggle and sensuality. He enjoyed a distinguished career and was much admired by the Impressionists for his innovative use of colour.

▷ **SELF-PORTRAIT, 1837**
To Delacroix, the true subject of a painting was found by looking within: "the subject is yourself; they are your impressions, your emotions before nature."

Delacroix's turbulent personality, his energetic compositions, and his insistence on the primacy of the imagination made him the perfect Romantic hero of French art.

He was born in the Parisian suburb of Charenton-Saint-Maurice on 26 April 1798, the fourth son of Charles Delacroix, a French statesman. However, according to rumours, Delacroix's biological father was in fact Charles-Maurice de Talleyrand, a diplomat, who, some speculate, may have pulled strings later on in the artist's career to secure him commissions from the state. Whether or not this is true, Delacroix certainly received a good education and enough funds to pursue his artistic ambitions.

Parisian studies

Aged 17, Delacroix enrolled at the Paris studio of Pierre-Narcisse Guérin, a former recipient of the prestigious Prix de Rome (see p.169); a year later he moved to the Ecole des Beaux-Arts. Like most art students of the time he was set the task of copying Greek and Roman statues and paintings of the

△ **STUDIO AND HOME**
From 1857 to his death in 1863, Delacroix worked from an airy studio on the rue de Furstenberg in Paris, and lived in the adjacent apartment.

High Renaissance, and during visits to the Louvre he particularly admired paintings by Rubens and Veronese for their rich sense of colour. He began to immerse himself in the writings of Goethe, Schiller, Shakespeare, and Byron, which were to provide a rich seam of literary subjects that he drew upon throughout his life.

He made a successful debut at the Paris Salon with a painting showing Dante and Virgil in Hell, but it was not long before he began to focus on more recent events, treating them in the grand manner previously reserved for history painting, emphasizing tragedy and emotions as well as heroism.

During their War of Independence from Turkey in 1822, more than 20,000 Greeks had been massacred on the island of Chios by Ottoman troops; in 1823, Delacroix painted the tragic consequences of this conflict – although he had not seen the war himself, he had heard about it from press reports and witnesses. *The Massacre at Chios* (1824) shows a pile of hapless victims in the

IN CONTEXT
Orientalism

Inspired in part by Napoleon's invasion of Egypt in 1789, many Western artists, including Delacroix and Ingres, became intrigued by life in the Arab world. Popular subjects among these Orientalist painters were nomads, harems, markets, ruins, exotic marriage customs, and primitive transport; or biblical episodes in contemporary Eastern settings. Harem scenes provided an opportunity to marry the erotic with the exotic, while images of battle and animal combat, which underlined a perception of North Africa and the Middle East as places of passion and danger, gave painters a chance to depict fantasies of violence.

PAGE FROM DELACROIX'S SKETCHBOOK FROM NORTH AFRICA, 1832

" The **imagination** takes pleasure in vagueness, spreads itself easily and **embraces vast subjects** only summarily indicated. "

EUGENE DELACROIX

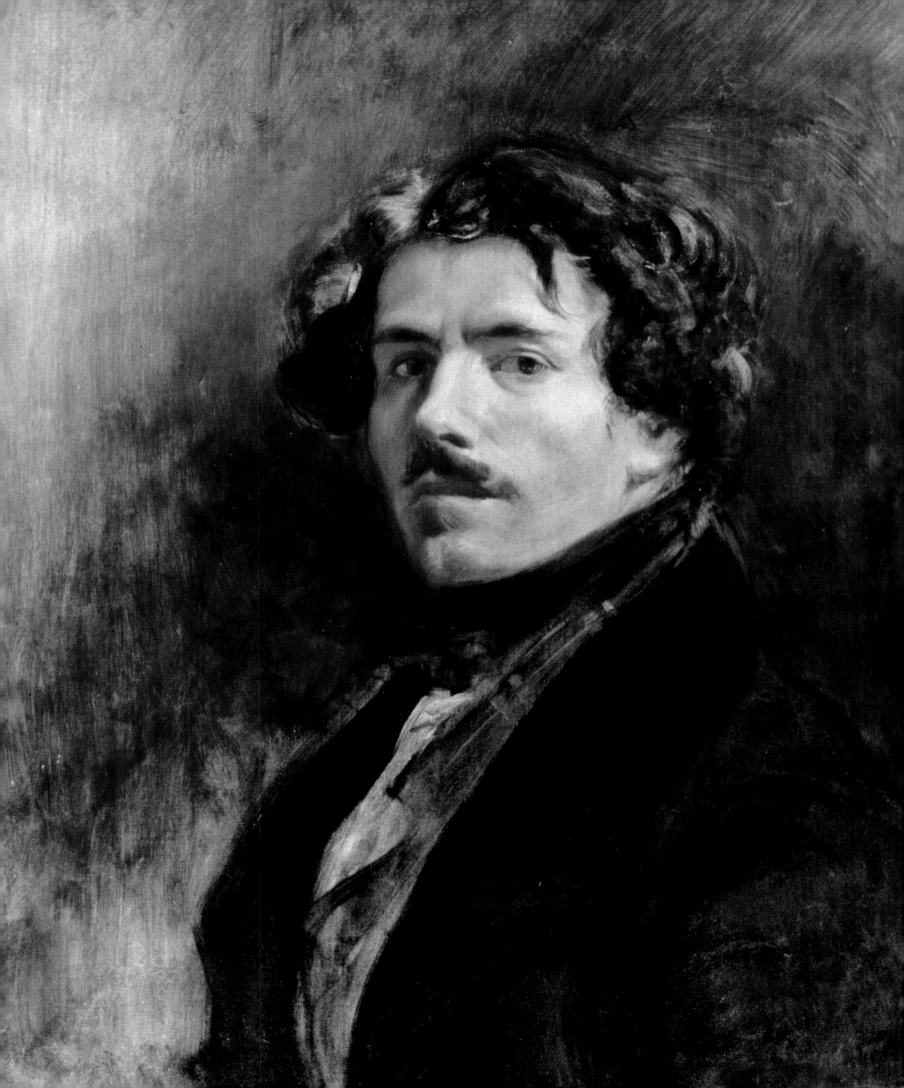

△ *THE DEATH OF SARDANAPALUS*, 1827
One critic described Delacroix's daring brushwork and bold impasto (build-up of layers) as having been painted with a "drunken broom". It captures the wild and sensuous abandon of the suicidal orgy.

and concubines are slaughtered. The painting shocked viewers, who would have been accustomed to the order and rationalism of Neoclassicism – it caused offence and was revolutionary not simply because it showed an orgy that violated rules of decency, but also because of its daring composition, featuring a seething mass of bodies, and its explosive colour combinations and vigorous brushwork.

Political allegory

Delacroix provoked the establishment again with his next important work – a controversial take on contemporary events. *Liberty Leading the People*, exhibited in 1831, was an allegorical representation of a scene that the artist had actually witnessed, when Parisians took to the barricades in the 1830 July Revolution that toppled the monarchy. The bare-breasted figure of Liberty, a working-class woman, brandishing the French flag, storms over a mass of bodies gunned down by royalist forces, flanked by a middle-class man in a top hat and a young boy waving a pistol. Although bought by the government, the inflammatory work was banished to the storeroom for fear that its display would arouse unwelcome revolutionary sentiments. Its unashamedly Romantic vision, in which freedom is exalted against

the forces of oppression, assured Delacroix's pre-eminence among painters opposed to the severe "official" classicism espoused by his rival, Jean-Auguste-Dominique Ingres.

Travels to the East

One year later, Delacroix was invited to accompany the Comte de Mornay on a diplomatic mission to Morocco and Algeria, where his existing fascination with Orientalism and the Arab world was enhanced by first-hand observation of daily life. He was finally able to see scenes he had only been able to imagine before – desert landscapes, Arab warriors, and fighting horses – and he filled his sketchbooks with drawings and notes. Entranced as he was by the brilliant light and colours of North Africa, his palette became lighter, his colours more saturated. Memories of a visit to a harem in the Jewish quarter of Algiers inspired *Women of Algiers in their Apartment* (1834) and *Jewish Wedding in Morocco* (1837–41), both characterized by a luscious sensuality.

On his return to Paris, Delacroix was awarded a series of prestigious official commissions that were to occupy him for the rest of his life. He produced large-scale decorative schemes for the Salon du Roi and the Library of the Bourbon Palace, the Library of the Luxembourg Palace, and the Galerie d'Apollon in the Louvre. A successful, elegant, and witty figure, he moved in high society, frequented the salons of rich art patrons, and contributed articles to the press. Delacroix forged friendships with leading musicians and writers, including Frédéric Chopin, George Sand, and Hector Berlioz. Yet beneath the polished façade was a more troubled soul, described by the poet Charles Baudelaire as "restless, so convulsive, prey to every anxiety".

foreground while a battle rages in the background. It met with success when it was shown at the Paris Salon in 1824. The money Delacroix received from its purchase by the French state enabled him to travel to England; there he met with fellow artists and grew to admire the work of Constable for the way it captured light in the landscape.

Three years later, Delacroix's reputation at the Salon was shaken by *The Death of Sardanapalus*, a work loosely based on a play by Byron that describes how an Assyrian tyrant, Sardanapalus, decides to die on his own funeral pyre when his palace is under siege. Delacroix reinterpreted the episode to show the king on top of a pyre of his riches, watching with indifference while his horses, pages,

IN PROFILE
Théodore Géricault

One of Delacroix's fellow students at the Ecole des Beaux-Arts was the slightly older Théodore Géricault, who impressed him deeply with his canvases full of drama and movement. Delacroix watched him at work on his masterpiece *The Raft of the Medusa*, and even posed for one of the figures. The painting depicted a contemporary tragedy that had occurred following a shipwreck, when the captain of the boat had cast the passengers and crew adrift on a raft, leaving them to perish. Géricault died young, in 1824, but in a sense he passed on the baton of Romantic champion to Delacroix.

THE RAFT OF THE MEDUSA, THEODORE GERICAULT, 1818–19

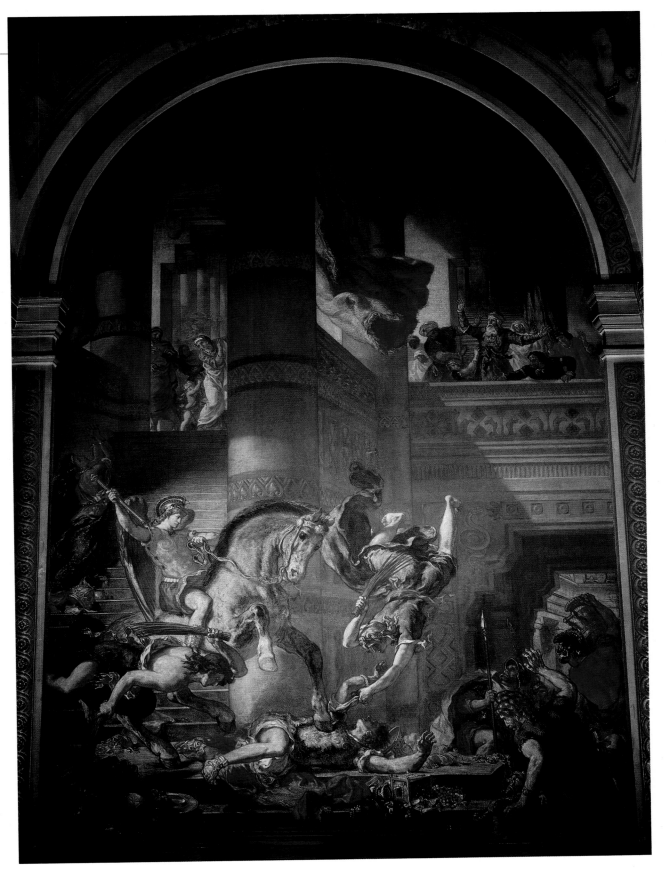

▷ **CHAPELLE DES SAINTS-ANGES**
The violence and chaotic composition of *Heliodorus Driven from the Temple* are tempered by the harmony of the architecture of Saint-Sulpice.

Late works

Delacroix's health was fragile, and in later life he withdrew from the society that lionized him, preferring to spend time in his country home in the forest of Fontainebleau. His last great project, which he took 12 years to complete, was for the Chapelle des Saints-Anges in the church of Saint-Sulpice, Paris. Its panels showing *Heliodorus Driven from the Temple* and *Jacob Struggling with the Angel* are notable for their innovative colour technique and lively, broken brushwork, spectacularly revealed by recent restoration.

Legacy of colour

Delacroix's use of colour was one of his most lasting legacies. He was among the first artists who sought to increase colour intensity by juxtaposing each of the primary colours – red, yellow, and blue – with its "complementary" colour, created by mixing the two other hues. He also used little black, preferring to create shadows from other colours. Delacroix's experiments especially appealed to the younger generation of Impressionist artists. Cézanne would later say: "Delacroix's palette is still the most beautiful in France, and I tell you no one under the sky had more charm and pathos combined than he, or more vibration of colour. We all paint in his language."

A later generation of artists, including the Expressionists, would pick up on other elements of his work, admiring his insistence on his own subjective responses and the passion with which he pursued his vision.

> " Delacroix was passionately in love with passion, and **coldly determined** to seek the means of expressing it in the **most visible** way. "
>
> CHARLES BAUDELAIRE

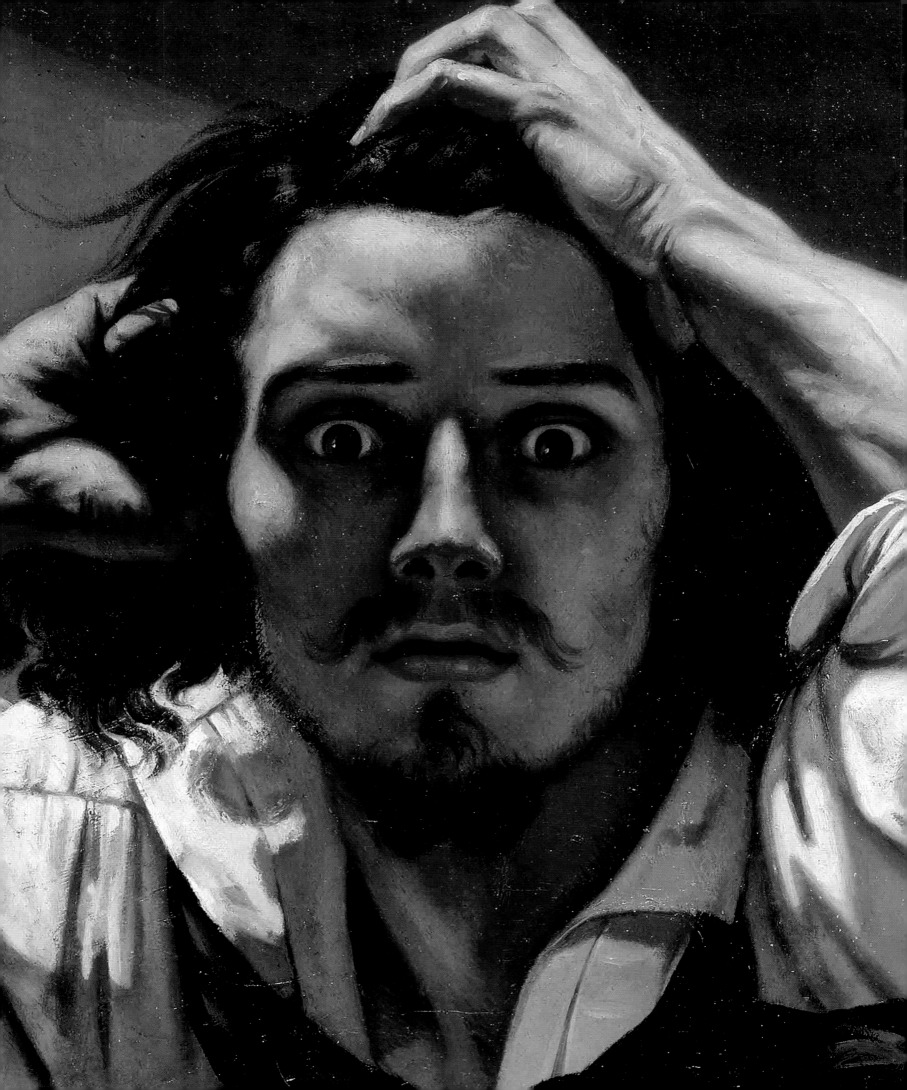

Gustave Courbet

1819–1877, FRENCH

Viewed as a revolutionary firebrand, Gustave Courbet was hailed as the leader of the Realist school of French painting. He sought to present everyday life as he saw it, unencumbered by notions of idealized beauty.

Gustave Courbet was born in Ornans in the Jura in eastern France, the son of well-to-do farmers. His affection for this remote part of rural France lasted his entire life: he visited it often and never tired of painting its distinctive landscape and inhabitants. He resisted his family's attempts to make him study law and, at the age of 20, moved to Paris to enrol at the studio of a now forgotten painter, M. Steuben. Courbet honed his skills by copying paintings by 17th-century naturalist painters such as Velázquez and Caravaggio, and he later directed his efforts towards achieving success at the Salon. This proved elusive: although he submitted 25 works between 1841 and 1847, only three of them were accepted for exhibition.

The Temple of Realism

In 1848, Courbet met a group of artists who gathered at the Brasserie Andler (nicknamed "the Temple of Realism"); among them were the anarchist Pierre Proudhon, the poet Charles Baudelaire, and the author Jules Champfleury. Led by Courbet, the group embraced Realist philosophy – that art and literature should show life as it is, not as an idealized version, and that they should confront social issues. In the same year, Paris was in ferment. Rioting broke out in the streets, the king abdicated, and a republican government was installed; while Courbet did not join in the fighting, his sympathies lay firmly with the revolutionaries.

Courbet's fortunes began to rise as 10 of his paintings were shown at the 1848 Salon, receiving a warm reception from the critics. The next year, *After Dinner at Ornans*, which depicted a gathering at a country inn near Courbet's family home, won a medal and was bought by the government. Heartened by this success, he continued to paint scenes and people from the Jura, and his next major painting, *A Burial at Ornans*, portrayed a funeral taking place just outside his home town and featured 60 of its inhabitants. Courbet was not the first French painter to depict rural life, but his work was revolutionary in that it treated an everyday event on a heroic scale. Although the people were ordinary folk, they were shown as recognizable individuals rather than types, and the nuances of social rank within French provincial society

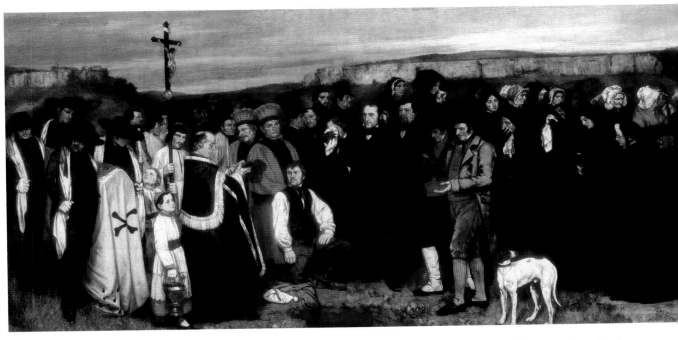

△ *A BURIAL AT ORNANS*, 1849–50
Courbet depicted this everyday event on a surprisingly heroic scale. It features portraits of people he knew, including members of his family.

◁ *THE DESPERATE MAN*, 1843
Courbet painted 20 or so portraits of himself between 1842 and 1855. They amounted to a visual autobiography in which he explored his artistic identity and public image.

" Painting is an **art of sight** and should therefore **concern itself** with **things seen**. "
GUSTAVE COURBET

▷ *THE PAINTER'S STUDIO*, 1855
Courbet's gigantic canvas summed up his artistic philosophy. All the people shown in it served his art in some way, and many of them have been identified.

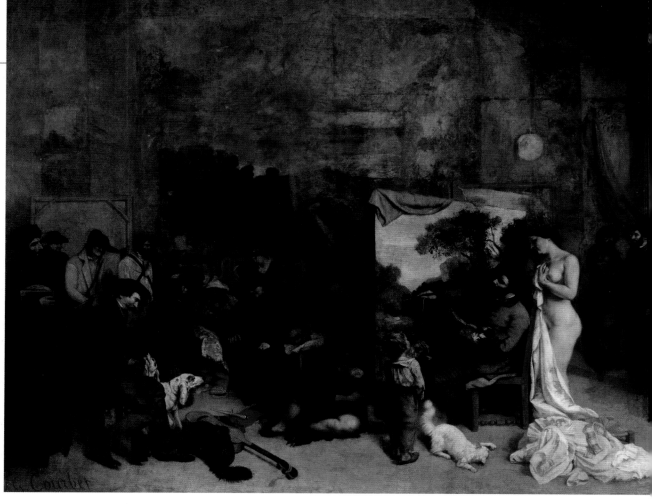

IN PROFILE
Alfred Bruyas

An eccentric banker and art collector from the city of Montpellier in the South of France, Alfred Bruyas became one of Courbet's most important patrons and a lifelong friend. In *The Meeting, or Bonjour Monsieur Courbet*, the artist shows himself being greeted by Bruyas, who is accompanied by his servant. Patron and artist are symbolically placed on the same level, and Bruyas is welcoming the artist, whose pose is based on a popular print of the Wandering Jew, into his world – the sun-drenched Mediterranean countryside. Bruyas's magnificent collection of Courbet paintings can today be seen at the Musée Fabre in Montpellier.

BONJOUR MONSIEUR COURBET, 1854

were carefully observed. The painting was heavily criticized for its apparent vulgarity when it was exhibited at the Salon in 1851; in the aftermath of the 1848 Revolution, this enormous, unflattering, and unprettified vision of peasant life may have seemed uncomfortably threatening.

A portrait of the artist
Now branded a radical, Courbet embarked on a path of increasing independence. In 1855, dissatisfied with the space he had been allocated at the Paris Universal Exhibition, he decided to stage his own private show of work in a "Realist Pavilion". At its heart was *The Painter's Studio*, an enigmatic, allegorical canvas that had taken him seven years to complete, and which amounted to an artistic manifesto. At centre stage in the painting is a nude model standing

beside the artist, who is at work on a landscape of his beloved native countryside. On the right-hand side are the people who supported him in his career – patrons, friends, and even the poet Baudelaire. On the left-hand side is a range of people representing the exploiters and the exploited as well as political figures, including Napoleon III disguised as a hunter. Courbet confessed that the painting's many-layered symbolism would prove hard to understand, but there is no doubt that he intended some political and social critique.

International reception
By this time, Courbet was enjoying significant international success, and was showing his work in Germany, Holland, Belgium, and England, and making friends with other innovative artists, who included James McNeill

Whistler and the young Claude Monet, but his relationship with the French artistic establishment continued to prove problematical.

While many of Courbet's paintings deliberately flouted Academic rules of beauty, in the 1860s he painted a series of nudes that were more conventionally handsome. Some were subversive: *Woman with a Parrot* reclining on a bed clearly showed a courtesan; *Sleepers* showed two slumbering women in a lesbian embrace; and *Origin of the World* showed a fully frontal view of a naked woman that was frankly pornographic. The last two were commissioned by a private patron who collected erotic art, and were not for public exhibition.

Just as Courbet's nudes were rooted in contemporary France rather than the world of classical mythology, so were his landscapes. Like many artists

" I have **never** seen angels. Show me an **angel** and I will **paint** one. "

GUSTAVE COURBET

hunters, reflecting his own great passion for the sport. After 1865, he increasingly painted the sea he observed on the Normandy coast, emphasizing its frightening power and immensity and the way it dwarfed humanity.

Political activism

When the French government fell in 1871, Courbet became involved in the short-lived Paris Commune that replaced it, and was given the role of chairman of the Arts Commission. This was to prove his downfall, for although he was assiduous in protecting many works of art, he was implicated in the demolition of the Vendôme column, which was seen as a symbol of Napoleonic imperialism. He was arrested and sent to prison when the new government took over soon afterwards. Unable to find the 300,000 francs the authorities demanded for the reconstruction of the column in 1873, he fled France and went into exile in Switzerland. He continued to paint, producing an outstanding series of still lifes and views of Lake Geneva. However, his health, which had never been strong, began to fail him, and he died four years later, aged 58.

of his own and later generations, he was keen to break away from the tradition of basing landscape art on some mythical vision of Italy. Instead, he wanted to paint the French countryside, infusing it with memory and personal response. His native Jura, with its magnificent forests, streams, and rocky crags, provided the perfect subject.

Courbet's depictions of the Jura often quite deliberately ignored convention. Rather than constructing a view almost like a theatre set, with a defined foreground, middle, and background, he favoured apparently casual arrangements. He often used a palette knife to lay in great slabs of paint, sometimes mixing in sand to emphasize the physicality of the material. On occasion, he populated his landscapes with animals and

△ **PUBLIC PROFILE**
With his distinctive beard and swaggering demeanour, Courbet was caricatured in the press. He welcomed scandal, since it provided a quick path to prominence.

KEY MOMENTS

1848
Frequents the Brasserie Andler, where he is hailed as the leader of the new Realist movement.

1855
Stages his own one-man exhibition in his Realism Pavilion, featuring *The Painter's Studio*.

1870
Appointed Chairman of the Arts Commission under the Commune, but is imprisoned a year later.

1873
Flees France and goes into exile in Switzerland, where he sets up residence just outside Geneva.

IN CONTEXT
Embracing the ugly

The Bathers, a painting that Courbet exhibited at the 1853 Salon, provoked a storm of outrage because it depicted contemporary, vulgar-looking women with rippling flesh and dirty feet rather than the idealized Venuses or nymphs of earlier Academic art. The woman who has come out of the river has an unusually large rear, while a stocking slips from her companion's leg. They are hardly embodiments of grace, but their inexplicably rhetorical gestures recall mythological works, adding a further layer of subversion. Courbet's work was condemned by some as being ugly, but its raw physicality and rough paint surfaces presented a new art for – and of – the people, and presaged the revolution of modern art.

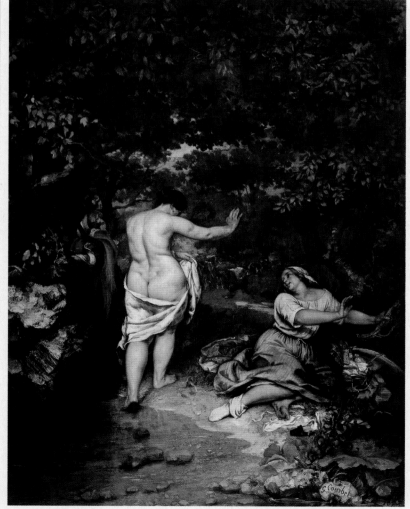

THE BATHERS, 1853

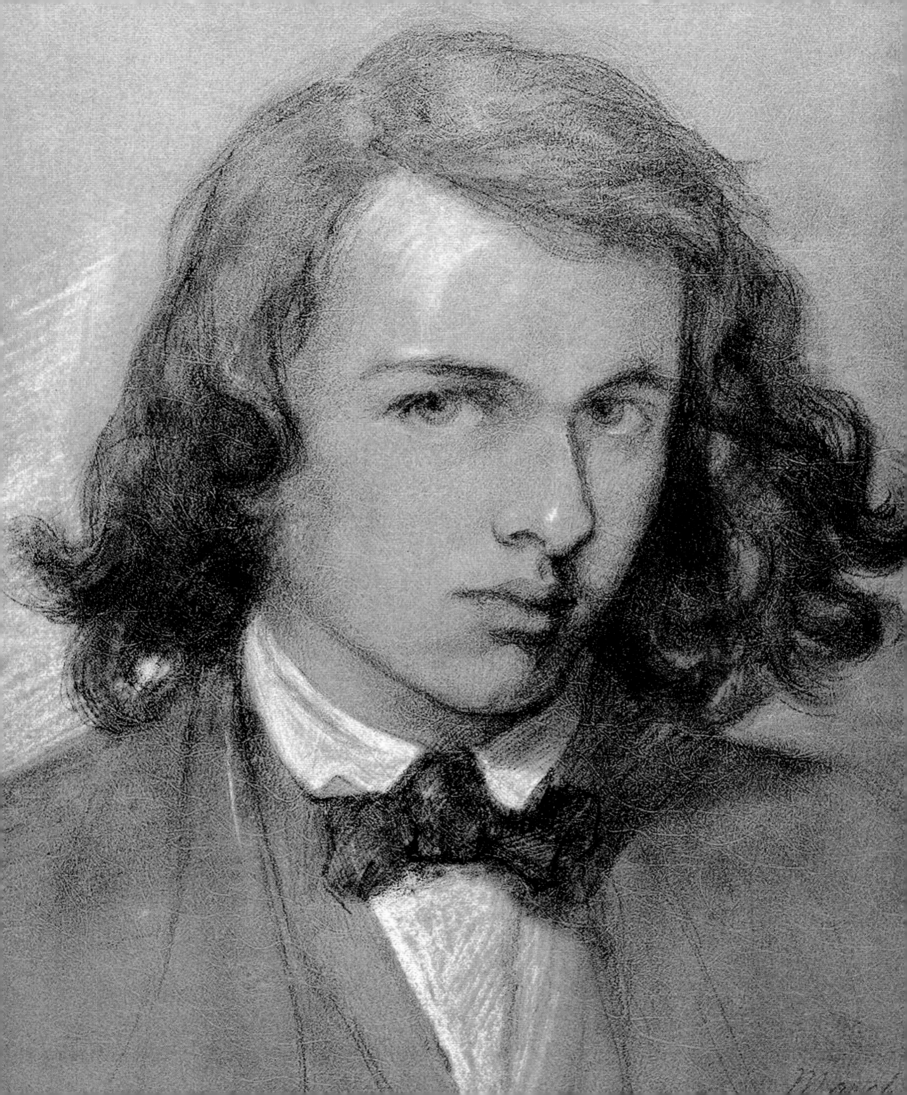

Dante Gabriel Rossetti

1828–1882, ENGLISH

A founder member of the Pre-Raphaelite Brotherhood, Rossetti was both a poet and a painter. His mythological and biblical pictures and notable portrayals of beautiful woman are infused with a lyrical sensibility.

Dante Gabriel Rossetti was born in London, the son of an Italian poet and scholar. At the age of 13, he enrolled in a small art school, later moving to the Royal Academy Schools and seeking tuition from the older English painter Ford Madox Brown.

In August 1848, Rossetti moved into the studio of fellow student William Holman Hunt. The two young men declared that art had entered into terminal decline with Raphael – the revered master of the High Renaissance – and condemned his masterpiece *The Transfiguration* (1516–20) for its "grandiose disregard of the simplicity of truth...".

Convinced that art was in need of greater simplicity and realism, they combined forces with the English painter and illustrator John Everett Millais to form the Pre-Raphaelite Brotherhood. Four other members were soon recruited to the group of idealistic young men: Rossetti's brother, William Michael, Frederick George Stephens, James Collinson, and the sculptor Thomas Woolner.

▷ **ANGEL WITH A CENSER, 1861**
Members of the Brotherhood, including Rossetti, set up a design firm that produced items such as this window for All Saints Church in Selsley, England.

A return to purer values

They were inspired by earlier art, particularly 14th- and 15th-century Italian painting. This can be seen in two of Rossetti's paintings from this early Pre-Raphaelite period, *The Girlhood of Mary Virgin* and *Ecce Ancilla Domine*. These depict the kind of religious subjects tackled by 15th-century Italian artists and adopt many of their stylistic features, including naive perspective, high-key colour, and strong contours. Most importantly, they have none of the "sloshy" brushwork that the Pre-Raphaelites abhorred.

In the 1850s, Rossetti painted a series of small watercolours – remarkable for their gem-like colours and plethora of detail – inspired by myth, medieval lore, biblical scenes, and the poetry of Robert Browning. In the same decade, Rossetti added his paintings of Arthurian legend to

the walls of the Oxford Union (the university's debating society) – a decorative scheme carried out together with other associates of the Pre-Raphaelite movement – William Morris and Edward Burne-Jones.

Gradually, Rossetti's art found a new direction that was quite different from his earlier work, resulting in a series of large oil paintings of voluptuous women, which sold well and brought him prosperity. By 1870, however, Rossetti had descended into serious depression and addiction to chloral hydrate, and he became increasingly reclusive. Nonethleless, the artist continued to paint right up until his death, committing his dreams of ideal feminine beauty to canvas.

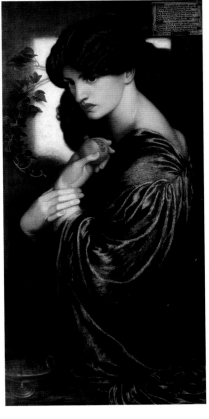

△ **PROSERPINE, 1874**
Rossetti painted this lush and highly decorative image of Proserpine, the captive empress of Hades, using his lover Jane Morris as his model.

◁ **SELF-PORTRAIT, 1847**
Rossetti drew this portrait in pencil and white chalk when he was just 18 years old; he portrays himself as a dashing Romantic hero.

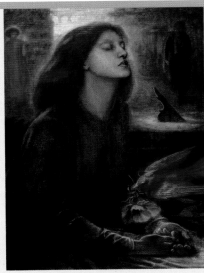

IN CONTEXT
Pre-Raphaelite models

Artists in the Pre-Raphaelite circle favoured models with a soulful look, abundant lustrous hair, long necks, and luscious lips. Often of humble birth, the "stunners" were transformed into goddesses or mythical figures on canvas, and became wives and mistresses in real life. Rossetti's main model in the 1850s (and later his wife) was Lizzie Siddal, whom he immortalized – after her death from an overdose – as Dante's lost love, Beatrice. Seeking comfort in other women, he fell deeply in love with Jane Morris, the wife and muse of the artist William Morris.

BEATA BEATRIX, c.1864–70

"**Beauty** like hers is **genius.**"

DANTE GABRIEL ROSSETTI, *GENIUS IN BEAUTY*, 1870

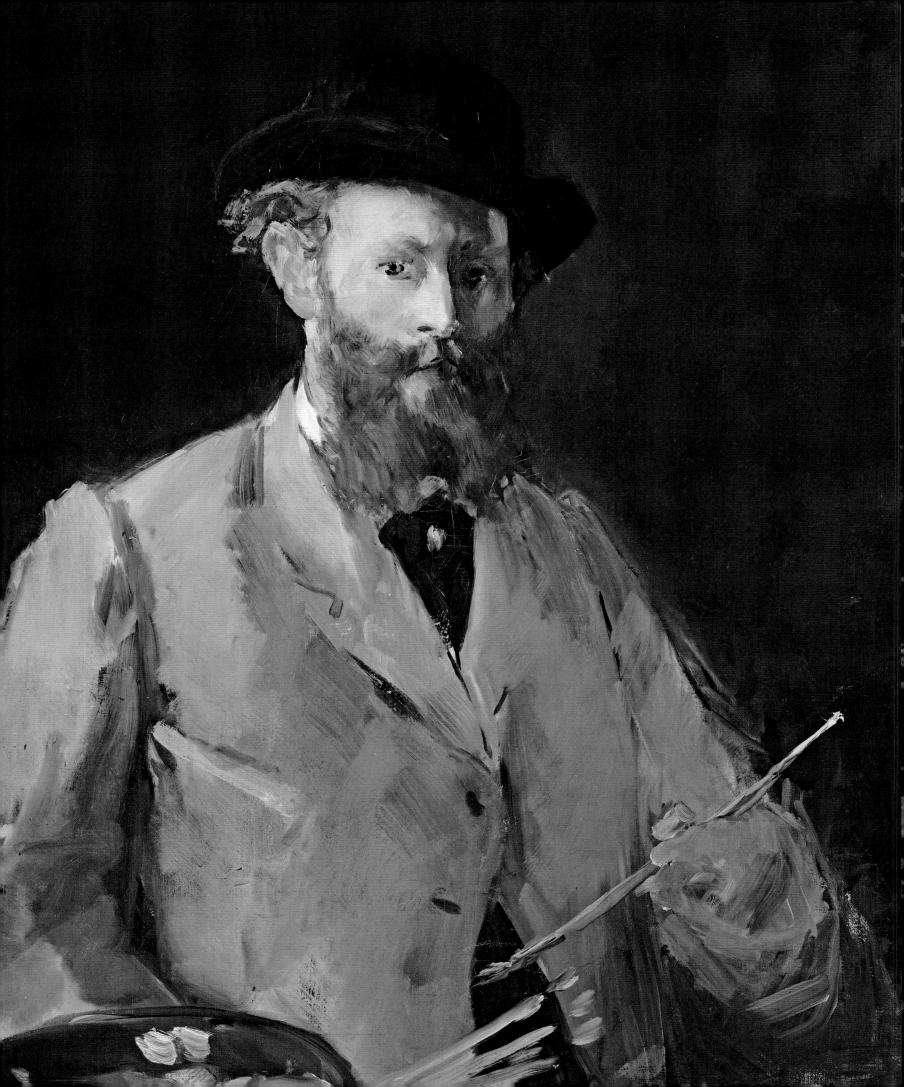

Edouard Manet

1832–1883, FRENCH

Manet revered the art of the past, especially the Spanish Old Masters, yet he was attacked for his shocking modernity, which earned him the admiration of a younger generation of artistic rebels.

Edouard Manet was born in Paris on 23 January 1832 into an affluent, well-connected family. Having failed to enter the navy, he signed up to join the merchant marine at the age of 16. On his return to land a year later, he entered the studio of the established history painter Thomas Couture, and thereafter followed the standard student practice of copying the Old Master paintings in the Louvre.

By 1856, Manet had set himself up as an independent artist with his own studio, and when his father died two years later, the money he inherited ensured that he was able to pursue his career without the financial worries that bedevilled some of his contemporaries. In 1863, he married Suzanne Leenhoff, a slightly older Dutch woman who had been the family's piano teacher. She already had a young son, Léon, whose paternity is uncertain: he may have been Manet's son, or indeed the son of Manet's father. Whatever the case, he appears in a number of paintings by Manet, who frequently used members of his family, and friends, as models.

A modern artist

Manet was a remarkably versatile artist and tackled scenes of everyday life, portraiture, still lifes, religious subjects, and contemporary history.

He worked in oil, pastel, and print, and recorded observations of what he saw around him as spontaneous sketches in his notebooks. He found stylistic inspiration in the work of the Old Masters, particularly Velázquez and Frans Hals, but while he admired their handling of paint and bold tonal contrasts, his subject-matter was fundamentally modern and urban. Like his friend the poet Charles Baudelaire, Manet wanted to capture "the heroism of modern life" – even if reality was frequently less than heroic.

This was certainly the case with *The Absinthe Drinker*, a stark portrait of a drunk rag-picker, which was turned down when Manet submitted it to the Paris Salon, the official exhibiting body of the French Art Academy, in 1859. Another of his paintings of contemporary life, *Concert in the Tuileries Gardens*, was a more lighthearted depiction of fashionable men and women (many of them Manet's friends). It met with the same fate when it was submitted to the Salon in 1862.

The Salon des Refusés

Manet was not alone in having his works turned down by the Salon. In 1863, more than 5,000 submissions were rejected, and the resulting outcry led Napoleon III to set up an alternative exhibition – a "Salon des Refusés" – of the rejected pictures at Paris's Palais de l'Industrie.

△ **THE ABSINTHE DRINKER, 1859**
Manet made this large, full-length portrait – a form reserved for depictions of high-ranking members of society – of a low-life drunk in a cloak and a top hat.

ON TECHNIQUE
A love of black

Unlike the Impressionists, who eliminated black from their palettes, Manet used the colour throughout his career, relishing the drama it creates when placed next to lighter tones. Some of his skilful use of black was no doubt due to his practice as a printmaker, since etchings and lithographs rely for their effect on the striking contrast of black and white.

THE DEAD TOREADOR, 1864

◁ **SELF-PORTRAIT WITH A PALETTE, 1878**
Executed quickly and almost entirely in ochre and black, this loosely painted self-portrait (one of only two that he made) shows Manet as a fashionable Parisian man-about-town, but also asserts his identity as an artist.

" You've got to **belong** to your own **period** and **paint** what you **see.** "

EDOUARD MANET

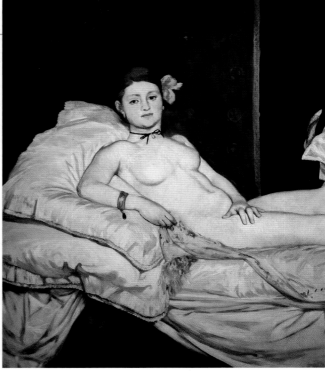

△ *LE DEJEUNER SUR L'HERBE*, 1863

Manet's painting was found unacceptable for its lack of a conventional subject and its apparent obscenity – the mixing of a nude woman with two men in contemporary dress.

△ *OLYMPIA*, 1863

With this image, Manet intended to provoke the bourgeois art world, used to the idealization of the female form. Manet's Olympia is not a Renaissance goddess but a common prostitute.

IN PROFILE
Berthe Morisot and Eva Gonzalès

Manet formed close artistic friendships with two women painters: Berthe Morisot and Eva Gonzalès. He met the former in 1868 while she was copying in the Louvre. She was already a great admirer of his work, and she sat for a number of portraits by him, although that stopped after she married Manet's brother Eugène in 1874 (which has prompted some speculation that Manet and Morisot were lovers).

Morisot's palette was lighter than Manet's and her style more impressionistic. Manet also painted a portrait of Eva Gonzalès at her easel (right) shortly after she became his pupil in 1869. Gonzalès's work reveals Manet's influence in its choice of subject-matter and handling, but her promising career ended with her death at the age of 34.

PORTRAIT OF EVA GONZALES, 1870

Napoleon III may have intended the show to reveal the inferior quality of the rejected works, but these included paintings by such artists as Whistler and Cézanne, who are now regarded as among the most outstanding artists of their generation.

So when Manet's most audacious painting to date, *Le Déjeuner sur l'Herbe*, was exhibited at the Salon des Refusés, it was in distinguished company. The canvas, which shows two men wearing modern suits enjoying a picnic with two women – one nude and the other semi-clad – met with incomprehension and accusations of indecency. Manet may have been paying tribute to Renaissance compositions by

Raphael and Titian that showed such idyllic gatherings, but his picture was shockingly contemporary and appeared to mock its venerable predecessors. Nor was its stylistic treatment acceptable: the traditional subtle gradations from light to dark had been abandoned in favour of stark tonal contrasts, resulting in an odd flatness of form.

Masters reworked

Manet's boldness was carried a stage further in his next major work, *Olympia*, which was actually accepted by the Salon jury in 1865. The subject – a reclining female nude – was familiar enough, but this nude was a common prostitute,

KEY MOMENTS

1863
Manet's *Le Déjeuner sur l'Herbe* is shown at the Salon des Refusés.

1865
The scandal caused by *Olympia* prompts Manet to leave Paris and take a break in Spain.

1867
Not invited to exhibit his work at the Exposition Universelle, Manet sets up a private exhibition of 50 of his works.

1868–69
Paints several marine scenes while on family holidays in Boulogne.

1874
Works alongside Monet and Renoir at Argenteuil, but declines an invitation to join their first group exhibition.

1882
Paints his last major work, *A Bar at the Folies-Bergère*, which depicts a barmaid serving drinks.

◁ **A BAR AT THE**
FOLIES-BERGERE, 1882
Manet's final major work shows the bar of the famous Parisian nightclub where, according to the writer Guy de Maupassant, the barmaids were "vendors of drink and of love". Manet made preparatory sketches on site, but completed the work in his studio.

staring brazenly out at the spectator, while her servant presents her with an an enormous bunch of flowers from an admirer or client. Titian had famously painted a courtesan in his *Venus of Urbino* (1538), which Manet had copied, but the public considered Manet's woman to be vulgar and an insult to tradition.

The Guerbois group

Such scandals reinforced Manet's position as the central figure in a new, "modern" school of painting that included Edgar Degas, younger artists such as Cézanne and Pissarro, and literary figures such as Emile Zola and various art critics. They met at the Café Guerbois on the Avenue Clichy in Paris, where they enjoyed animated and frequently heated debates about art. But while he was held in high regard by this intimate circle, Manet was depressed by the hostile reception *Olympia* had received from some critics and he took himself to Spain, where he was bowled over by the works of Velázquez and Goya. Although he had previously painted

Spanish themes (bullfighters, Spanish dancers, and musicians), he returned to them with renewed vigour.

Goya's monumental *The Third of May 1808* (see p.178), showing the brutal shooting of Spanish insurgents by French occupying troops, formed the basis for Manet's painting of a firing squad, *The Execution of Emperor Maximilian of Mexico* (1867–68), which depicts an event that took place in June 1867. The subject was politically sensitive and so it was never exhibited at the Salon; nor was Manet permitted to publish it as a lithograph.

A reluctant revolutionary

Manet's career – like that of many of his friends – was interrupted by the Franco-Prussian War. He was conscripted into the National Guard in 1870 but, paradoxically, his fortunes started to improve around this time; his work was accepted by the Salon, and the art dealer Paul Durand-Ruel began to buy his paintings. The year marked a watershed in Manet's stylistic development too. While a younger generation of artists

that included Monet and Renoir were influenced by his bold technique and the modernity of his subject-matter, he in turn was influenced by their work. He began to use lighter, brighter colours, handling paint in a freer and more spontaneous manner. He turned increasingly to scenes set out of doors: boating on the river; the streets of Paris; views over a railway cutting; games of croquet; and lunchtime at an open-air restaurant. Some of these canvases were painted in the open air rather than in the studio, a practice that was favoured by the Impressionists.

Manet was invited to show his work with the Impressionists when they mounted their first group exhibition in 1874, but he declined to affiliate himself so closely with them, as he still craved the official recognition that only the Salon could confer.

Manet died from complications of syphilis at the age of just 51. He was a reluctant revolutionary, but his technique and adopted subject-matter were truly radical and modern.

△ **OFFICIAL AWARD**
Manet received approval from the establishment just before the end of his life, when he was awarded the Légion d'Honneur.

" In the figure, look for the **big light** and the **big shadow**; the rest will **follow naturally**. "
EDOUARD MANET

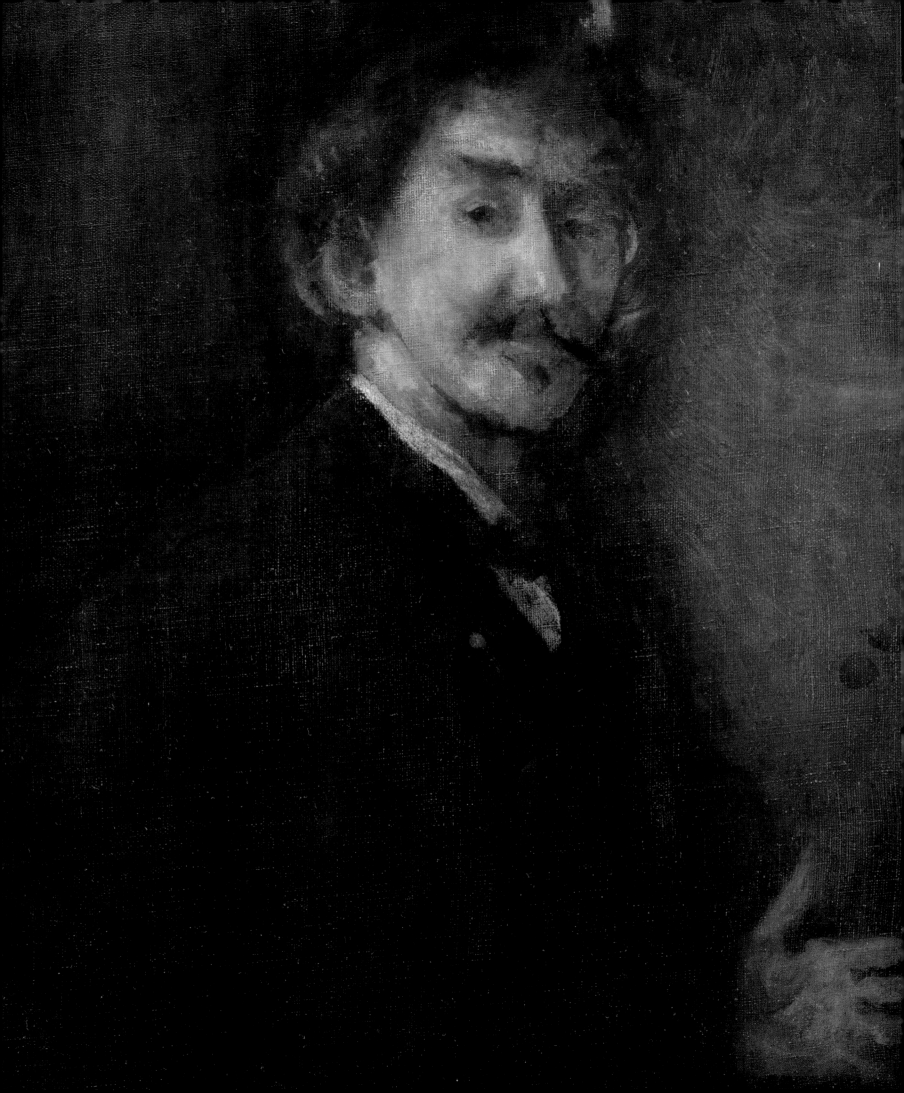

James McNeill Whistler

1834–1903, AMERICAN

An outrageously flamboyant character, Whistler courted fame and notoriety with daringly innovative paintings whose abstract qualities were fully appreciated only after his death.

James Abbott McNeill Whistler was born in Lowell, a mill town in Massachusetts, USA, but spent his formative years in St Petersburg, Russia, where his father was working as a railway engineer. He first took drawing lessons at the age of 10 at the Russian Imperial Academy.

The family returned to America when Whistler was in his teens, and he enrolled at the West Point Military Academy, quitting when it became clear that he was not cut out for military life. Intent on pursuing a career as a painter, he left for Paris – then the centre of the art world – in 1855. Here he enrolled at the studio of Charles Gleyre, where he met the Realist painter Gustave Courbet (see pp.214–17) and others in his circle, to whom he presented an intriguing figure: he was theatrical and witty, his choice of clothes was outlandish, and his curly black hair was frequently crowned by a straw hat with a ribbon.

London life

In 1859, Whistler left bohemian Paris for London, where his work had attracted interest. He took lodgings near the river Thames, which was to become a central subject for his art, and produced a series of etchings

he called "the Thames Set". Just as he had in Paris, Whistler formed friendships with forward-thinking artists in the city, and became particularly close to Dante Gabriel Rossetti (see pp.218–19).

Whistler received commissions to paint the portraits of leading society figures, but his other paintings were dominated by an interest in the manipulation of colour, tone, and mood – art for art's sake rather than with a social or representational purpose. He frequently gave his

◁ **NOCTURNE IN BLACK AND GOLD: THE FALLING ROCKET**, 1875
Whistler evoked fireworks against a night sky with dabs of yellow and orange paint. Critic John Ruskin lambasted the work, and Whistler responded by launching a lawsuit.

compositions musical titles that emphasized their abstract, aesthetic qualities. River scenes were called "Nocturnes"; female portraits were "Symphonies" and "Harmonies"; and portraits made in a restricted palette were "Arrangements". In the 1860s, he began to use long brushstrokes, varying their shape and direction to describe details, but by the 1870s his brushwork had become bolder, sweeping, and expressive. Often, the paint was thinned so that it dripped freely. However, while Whistler's paintings may appear spontaneous or even unfinished, they were the result of endless and very careful deliberation.

Bankrupted by a highly publicized lawsuit against the critic John Ruskin, Whistler retreated to Venice in 1879, where he produced an accomplished series of etchings that revived his fortunes. He divided his later years between Paris and London, where he died in 1903.

ON TECHNIQUE
Japanese influences

Whistler was so enthusiastic about Japanese art that he became known in London as "the Japanese artist". He wove Japanese motifs, such as kimonos, into his compositions, and later absorbed the compositional devices seen in woodblock prints and screen and scroll paintings, adopting their shallow space. Even the stylized "butterfly" symbol with which he signed his works was inspired by a traditional Japanese seal.

SILK CREPE KIMONO, c.1900

◁ **GOLD AND BROWN: SELF-PORTRAIT, 1896-98**
Whistler used self-portraits to define his public persona. Here, he presents himself as a learned man decorated with the ribbon of the Légion d'Honneur.

" As **music** is the poetry of sound, so is painting the **poetry of sight**. "

JAMES McNEILL WHISTLER

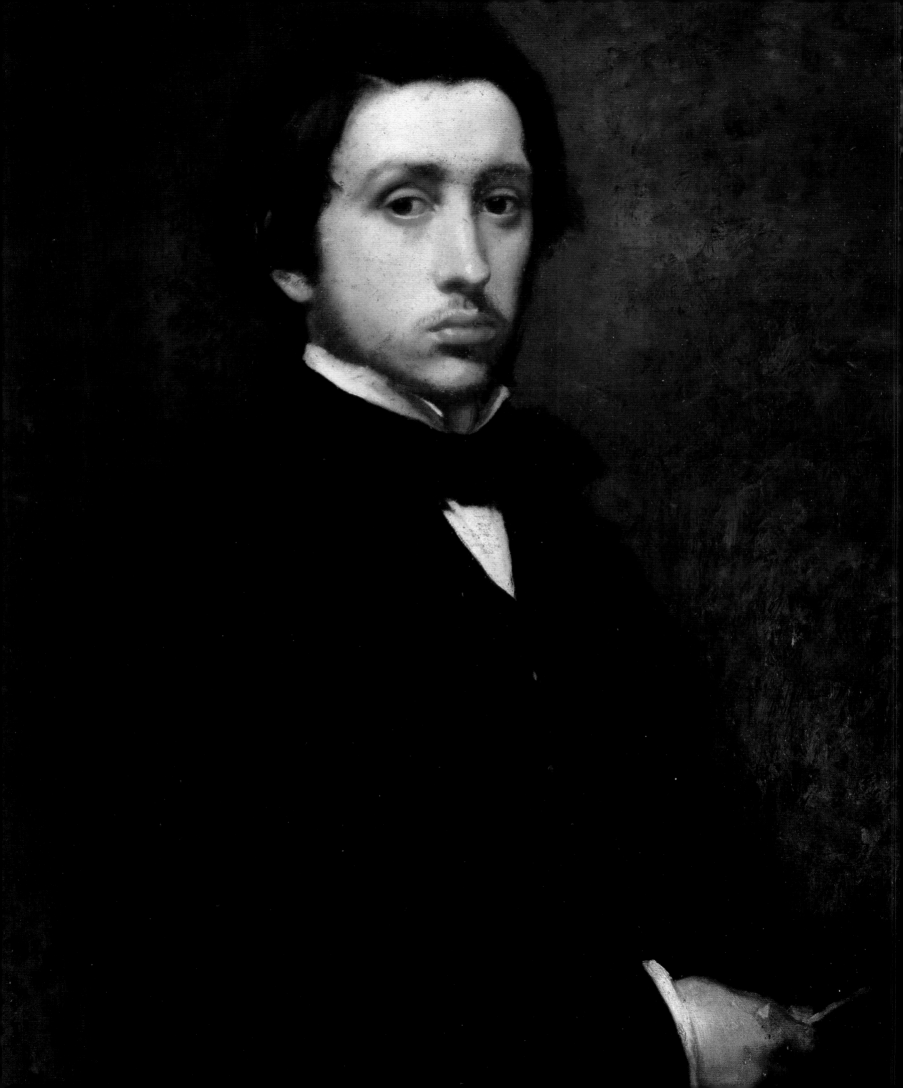

Edgar Degas

1834–1917, FRENCH

Wealthy and well-connected, Degas stood apart from his fellow Impressionists socially and stylistically. A great draughtsman, he learned from the Old Masters, yet took inspiration from modern life.

Hilaire-Germain-Edgar de Gas was born into an affluent, cultured family in Paris on 19 July 1834, the eldest of five children. His father ran the French branch of the bank founded by his grandfather, while his mother came from a French family that had settled in America – her father was a wealthy cotton broker in New Orleans. Her death when Edgar was just 13 years of age was a terrible blow.

After a classical education, Edgar began his law studies in 1853, but he had no enthusiasm for the subject and spent much of his time in the Louvre copying works of the Old Masters. With his father's approval and support, he left the law behind and began training seriously as an artist. Early in his career, he contracted his surname to the less pretentious-sounding Degas.

Early influences and idols

Degas' early teachers are now mainly forgotten – but one, Louis Lamothe, had been a student of the great Neoclassical artist Jean-Auguste-Dominique Ingres, and he taught

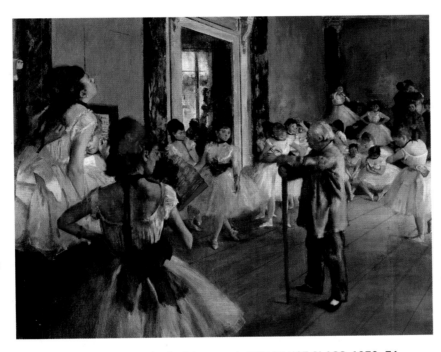

Degas according to Ingres' principles, stressing the importance of drawing. In 1855, the young artist met the great master himself, and Ingres gave him advice he would never forget: "Draw lines, young man, many lines, from memory or from nature." Degas came to idolize Ingres and eventually owned 20 paintings and 88 drawings by the master, which formed the core of his vast art collection.

In the 1850s, Degas made several trips to Italy, visiting his many relatives and copying the works of Renaissance

△ **THE DANCE CLASS**, 1873–76
This bold, asymmetrical composition is influenced by Japanese prints and snapshot photography. Its apparent informality was carefully constructed.

masters in Rome, Florence, and Naples. Portraiture and historical themes (traditionally thought to be the "proper" subjects for painting) were the focus of his early work, as he tried to make a name for himself at the annual Salon, the official showcase of French art. However,

◁ **SELF-PORTRAIT, 1855**
This early portrait shows the haughty-looking Degas soon after he had given up his law studies. Already hugely accomplished, its debt to the Old Masters can be seen in the pose and style.

ON TECHNIQUE
Capturing movement

Degas was fascinated by photography, which was a key influence on his art. To recreate the sense of movement and spontaneity in the accidentally cropped compositions of snapshots, he deliberately created asymmetrical images, in which figures were cut off by the edge of the canvas. Degas was particularly inspired by the pioneering work of Eadweard Muybridge, who produced multiple freeze-framed images of animals and humans that revealed successive stages in movement. When projected through a zoopraxiscope, the frames created cinematic movement. Degas' late drawings, paintings, and sculptures of ballet dancers and horses are all inspired by Muybridge's book *Animal Locomotion*, published in 1887.

A SERIES OF MUYBRIDGE'S PHOTOS BELOW HIS ZOOPRAXISCOPE

" No art was ever **less spontaneous** than mine. What I do is the **result of reflection** and the **study** of the **Great Masters**. "

EDGAR DEGAS

" The **nude** has always been represented in **poses** which **presuppose an audience**, but these women of **mine**... It is as if you looked **through a keyhole**. "

EDGAR DEGAS

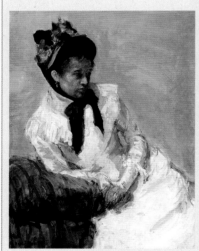
by the early 1860s, his work changed direction – contemporary urban life became his subject-matter.

Meeting Edouard Manet in 1862 had an immense impact on Degas' artistic development. Though Manet was only two years older than Degas, he was already a pivotal figure in the Paris art scene, championing the idea that "modern life" rather than history was the proper subject for artists. Manet introduced Degas to the circle of artists – including Monet, Renoir, Sisley, Pissarro, and Cézanne – who frequented the Café Guerbois in the 1860s, enjoying animated discussions on modern art.

This group of like-minded artists, sometimes known as the Batignolles Group after the district of Paris in which they lived, was scattered by the outbreak of the Franco-Prussian war in 1870. Degas served in the artillery regiment of the National Guard, having been rejected from the infantry for being too short-sighted (an early indication of eye problems that were to plague him later in life). Degas also suffered from a condition called photophobia – an over-sensitivity to light, which may have played a part in his preference for working indoors.

A change in fortune
When the war was over, Degas paid a brief visit to London in 1871, and spent a few months in New Orleans with his mother's side of the family, returning to Paris in 1873. Then came an unexpected blow. His father died, leaving huge debts. To pay off the creditors, Degas sold his house and his collection of Old Master paintings, and for the first time had to think about earning a living through his art.

Impressionist exhibitions
Together with the artists he had met at the Café Guerbois, Degas helped to organize an art exhibition independent of the Salon. It was advertised as the Exhibition of the "Société Anonyme", but following a scathing review that attacked the unfinished appearance of one of Monet's works, *Impression, Sunrise*, it became known as the Impressionist Exhibition. There were eight Impressionist exhibitions between 1874 and 1886, and Degas featured in all but one.

Unlike some of his fellow artists, Degas had no problems selling his work – it had little in common with the controversially sketchy Impressionist landscapes, and his impressive

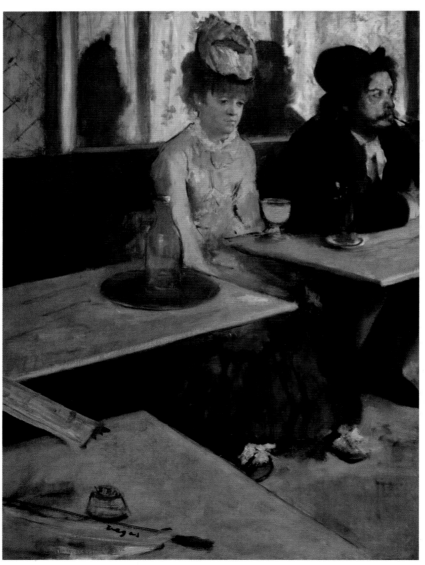

▷ **L'ABSINTHE, 1876**
Viewed as if in passing, this sombre glimpse of Parisian low-life outraged conservative critics, but it became one of Degas' most famous works.

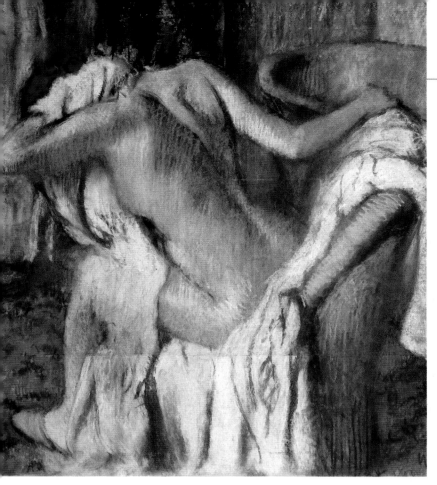

◁ **AFTER THE BATH, WOMAN DRYING HERSELF, c.1890–95**
Degas became obsessed with the subject of women bathers, creating more than 200 pastels as well as charcoal drawings, oil paintings, and sculptures on the theme.

His many other sculptures – of horses, ballerinas, and bathers – were not intended for display or sale, and Degas seems to have thought of them more as three-dimensional sketches exploring movement. Made in wax (sometimes mixed with other materials), they were not cast in bronze until after his death.

Declining health

Degas' late years were isolated and unproductive as his health and eyesight deteriorated. He became more reclusive, and was embittered by the "Dreyfus Affair", a notorious miscarriage of justice in which a Jewish army officer was wrongly convicted of treason. The case divided opinion and split families – the anti-Semitic Degas believed in Dreyfus' guilt, and this cost him a number of friendships.

In 1912, Degas was forced to leave his home in the rue Victor Massé, which was being pulled down for redevelopment. He never got over the move, and gave up work. Looked after by a devoted niece, but deprived of his art, the frail, near-blind Degas was a sorry figure, seen wandering the streets of Paris tapping the pavements with his cane. By the time of his death at 83, he was revered as a giant of French art, but at his request he had a simple funeral attended by old friends, including fellow Impressionist Monet.

draughtsmanship was much admired. Degas soon left his financial worries behind, and after the last Impressionist exhibition, he stopped exhibiting in public, preferring to sell via dealers.

Degas was an obsessive worker and "not an easy man to deal with", as his friend Mary Cassatt remarked. He could have a "bear-like sense of fun", but was also prone to brooding and outbursts of anger, and had an acerbic wit. Although he had numerous friendships, it is thought that he was never seriously involved in a love-affair: "There is love, and there is work," he remarked, "and we only have one heart." He frequented cafés-concerts, the races at Longchamp, and the Paris Opéra, all the while observing and drawing Parisians at leisure and at work. He created calculatedly informal images of jockeys and horses, laundresses, milliners, singers, and the ballerinas who performed at the Opéra.

Multiple media

In the 1880s, as his sight continued to fail, Degas increasingly turned from oil painting to pastel, where he could work closer to the surface. His pastel technique was experimental and bold, as he described form with scribbles and directional slashes of rich colour, sometimes building up layer upon layer of colour, sometimes steaming the surface and blending colour with brush or fingers. In the 1880s and 90s, Degas repeatedly drew and painted the female nude, not formally posed, but women washing and drying themselves, or combing their hair, as if observed "through a keyhole". The experimental nature of Degas' approach is evident in the vast range of media he employed – which included various printmaking techniques. His three-dimensional work was equally original, although he only exhibited one sculpture in his lifetime, the celebrated *Little Dancer Aged 14*.

▷ **LITTLE DANCER AGED 14, 1880–81**
The original of this startlingly naturalistic sculpture was made of wax, with real clothes and a wig of horse hair. It was the talking point of the Impressionist Exhibition of 1881.

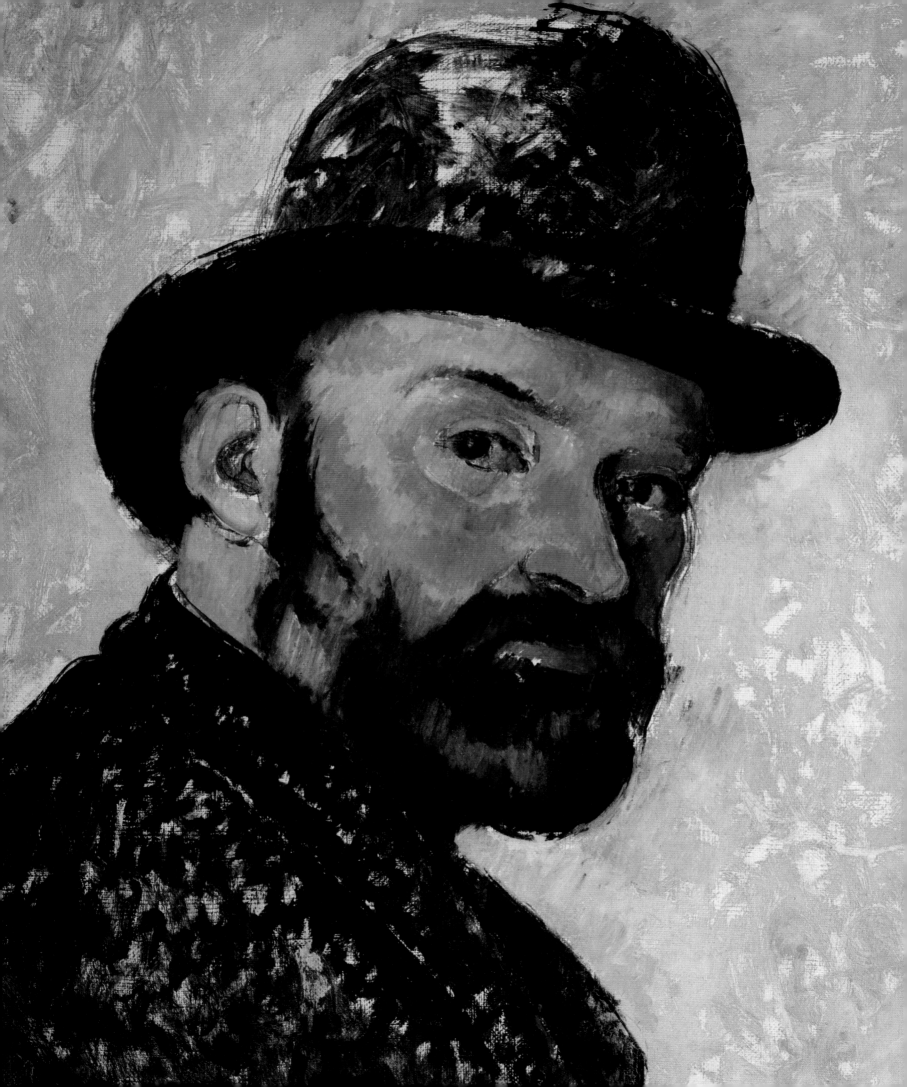

Paul Cézanne

1839–1906, FRENCH

Cézanne has been hailed as one of the founding fathers of modern art. A leading Post-Impressionist painter, his pioneering experiments helped to shape the development of both Cubism and abstract art.

Paul Cézanne was born in Aix-en-Provence, southern France, on 19 January 1839. In his later years, he liked to project an image of himself as a rustic boor, but in reality Aix was no cultural backwater at the time. It boasted a fine public museum and art collection, and a drawing school that matched its status as the capital of Provence. Furthermore, Cézanne came from a wealthy family – his father ran a successful hat-making business and was also part-owner of a bank.

At his father's insistence, Cézanne began to study law in 1859, though it was clear that his true vocation was art. This caused huge ructions at home. Cézanne's father was a strict authoritarian – nevertheless, he eventually relented and, in 1861, Cézanne was allowed to move to Paris to study painting.

The Paris years

Cézanne attended the Académie Suisse in Paris, an unconventional establishment that did not offer any teaching, supervision, or examination, but allowed artists to work with models for a small fee, and provided a place where they could exchange ideas with

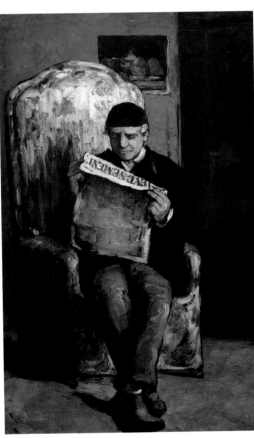

◁ *SELF-PORTRAIT WITH BOWLER HAT* (OIL SKETCH), 1885–86
Cézanne made more than 30 self-portraits during his lifetime. He favoured a pose in which his head was turned sideways, as though he was observing his own features dispassionately.

their peers. It was here that Cézanne met Camille Pissarro, who was to become a friend and major influence. At the time, Cézanne was socially awkward and lacking in confidence, and it took him a while to settle in Paris. He was helped by his friend Emile Zola (see box, right), who was forging a successful career as a novelist and journalist in the city.

Zola introduced Cézanne to a number of his contacts, including several future members of the Impressionist circle, and with Zola's encouragement, Cézanne began going to the Café Guerbois, a favourite haunt of avant-garde painters and writers. He apparently cut rather a strange figure there. Julie Manet (niece of the painter Edouard Manet) remembered that "he looked like a cut-throat, with bloodshot eyes... and a way of talking that could make the dishes rattle", though she also noted that, in spite of his terrible manners, he had the gentlest nature.

◁ *THE ARTIST'S FATHER, READING L'EVENEMENT*, 1866
Cézanne painted this revelatory portrait of his father, who sits rather uncomfortably in front of a still life painted by his son.

" I am the **first** to tread the road that I have **discovered**. "

PAUL CEZANNE

KEY MOMENTS

1867
Starts painting a series of sombre canvases that depict Gothic, macabre, or erotic subjects.

1873
Strongly influenced by Pissarro, he renounces sombre subject-matter in favour of landscapes and a lighter palette.

c.1880
On a visit to Zola, paints *The Château at Médan*, an early example of his growing taste for strict geometrical formats.

1886
Marries Hortense Fiquet; his father dies in the same year. Continues to work in relative isolation in southern France.

1898–1905
Works on his most ambitious painting, *The Large Bathers*. The vast canvas causes a huge stir when exhibited at the Salon d'Automne.

IN PROFILE
Camille Pissarro

Born in the West Indies, Camille Pissarro (1830–1903) was one of the linchpins of the Impressionist movement. He was a great teacher, mentoring some of the younger artists in the complexities of *plein-air* painting, and he participated in all their exhibitions. Pissarro exerted a particularly strong influence on Cézanne in the early 1870s, when he was living near Pontoise, and he was largely responsible for persuading Cézanne to concentrate principally on landscape painting.

PISSARRO (LEFT) WITH CEZANNE IN PONTOISE, c.1875

At first Cézanne's new friends had little impact on his style. His early works were loosely Romantic, owing something to the influence of Eugène Delacroix. Vigorously painted, with sombre colours and broad outlines, his works often had dark, violent undertones, including rapes, orgies, and murder. Needless to say, he won few admirers with these Gothic themes, and his entries at the Salon met with repeated rejection.

Personal affairs

Some of the anger in Cézanne's early works may have reflected tensions in his private life. His relationship with his father became even more awkward after 1869, when he embarked on a clandestine affair with a young model, Hortense Fiquet. The couple had a son in 1872, but he too was kept hidden from Paul's father, who would have strongly disapproved. The secrecy had financial implications, as Cézanne was obliged to support his family on his modest bachelor allowance.

New locations, new styles

In 1870, Cézanne and Fiquet left Paris and moved to L'Estaque, near Marseille, primarily to help Cézanne avoid military conscription during the Franco-Prussian War (1870–71). Later, they settled in Pontoise (1872) and then Auvers-sur-Oise (1873), where Cézanne began painting alongside his friend Camille Pissarro.

This interlude proved crucial. Under Pissarro's guidance, Cézanne's art was transformed. He abandoned the morbid themes of his earlier work, and committed himself instead to painting landscapes. He learned the principal techniques of Impressionism, lightening his palette and shortening his brushstrokes. Most importantly, he developed a passion common to the Impressionists – working in the open air – which he retained for the rest of his career.

Cézanne was involved in the beginnings of the Impressionist movement. He participated in the first and third exhibitions (held in 1874 and 1877), where his work was ridiculed by the public. The venture was not a complete failure, however, as he attracted the interest of two important

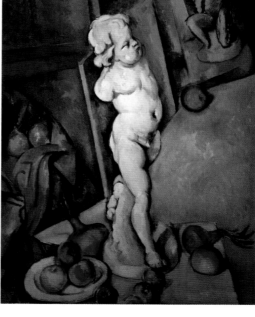

▷ *STILL LIFE WITH PLASTER CUPID*, c.1885
Cézanne subverts Salon still-life painting in this work not only by depicting details of his studio in the background, but also by presenting multiple points of view. The planes of the painting seem to pivot around the twisted pose of the plaster cupid.

collectors – Count Armand Doria and Victor Chocquet – but, even so, Cézanne was disheartened by the criticism and withdrew from exhibiting. He did not show his work in public again for more than a decade.

Cézanne developed his style in isolation. He began to question some of the key tenets of Impressionism. He still painted outdoors, but became less interested in capturing the transient effects of light that so captivated Monet and other members of the movement. Instead, Cézanne attempted to probe deep beneath the surface of his subject in order to reveal its underlying structure.

Like Monet, who painted repeated views of certain subjects (notably haystacks and Rouen Cathedral), Cézanne also returned to the same theme over and over again. In his case, this was the Mont Sainte-Victoire, a great mountain close to the family home in Aix. However, while Monet had painted quickly, striving to capture minute variations in the light and the weather conditions before they disappeared, Cézanne painted slowly and methodically. He did not use conventional sketches. Instead, he located a few of the main forms of his subject with strokes of charcoal, and then gradually bound them together with

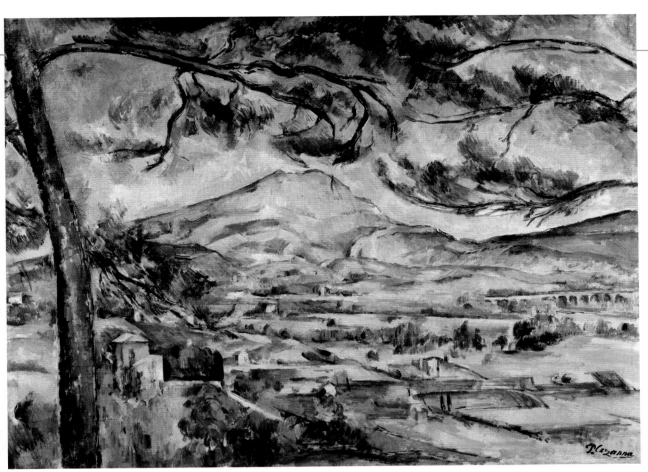

◁ ***MONT SAINTE-VICTOIRE*, 1887**
Blocks of strong colour and strong outlines simplify the contours of the scene. Cézanne painted the mountain more than 60 times, gradually reducing it to the bare essentials of form.

interlocking patches of colour. "Drawing and colour are not distinct," he wrote. "As one paints, one draws... The secret of drawing and modelling lies in contrasts and relations of tones."

As he grew more confident with this approach, Cézanne allowed his concern for tonal relationships to take precedence over naturalistic appearances. As a result, his later versions of Mont Sainte-Victoire veered more towards abstraction, as houses, hedges, and roads dissolved into geometric blocks of colour.

Innovative angles

Cézanne's attitude to perspective was equally adventurous. He did not stick rigidly to a single, fixed viewpoint – the most basic principle of linear perspective. Often he used different viewpoints, in order to present a more rounded view of individual objects. This is most evident in his remarkable still lifes, where items such as jugs, dishes, and fruit can be seen from the side, as well as from above. These experiments would later be taken much further by the Cubists, who regarded Cézanne as a major source of inspiration for their movement.

Acclaim and success

Public recognition came late for Cézanne. His work had not been seen in Paris for many years, until the dealer Ambroise Vollard gave him a one-man show in 1895. This decision had a major impact on a younger generation of artists, who hailed Cézanne as the leader of the avant-garde, and Vollard promptly bought up the entire contents of one of his studios.

In 1901, Maurice Denis displayed his oil painting *Homage to Cézanne* at the Salon and, three years later, there was an exhibition devoted to Cézanne at the Salon d'Automne in Paris. This bandwagon continued after the artist's death in October 1906, with a memorial show at the Salon d'Automne (1907), followed a few years later by ground-breaking Post-Impressionist exhibitions (1910 and 1912), which confirmed Cézanne's status as a pioneer of modern art.

▽ **LES LAUVES STUDIO**
Cézanne bought his final studio at Les Lauves in Aix in 1901 and produced some of his most famous paintings there, including *The Large Bathers*. He worked right up to his death in October 1906.

" I wanted to 'make of **Impressionism** something **solid and enduring**, like the art in museums.' "

PAUL CEZANNE

Auguste Rodin

1840–1917, FRENCH

Rodin initially struggled to achieve recognition but ultimately became the most famous sculptor of his time. The passionate intensity of his works revitalized the art of sculpture.

Auguste Rodin was born in Paris of poor but respectable parents. At 13, he trained at the Ecole Spéciale in Paris, which turned out craftsmen and commercial art workers. Determined to become a sculptor, he applied to the prestigious Ecole des Beaux-Arts but failed the entrance exam no less than three times.

For years he worked as an assistant to established sculptors, or on ornamental or commercial tasks in Paris and Brussels, through which he acquired a valuable range of practical skills.

In 1865, Rodin submitted a work to the official Paris Salon, *The Man with a Broken Nose* – an unconventional, "ugly" portrait in clay of an elderly workman. It was rejected – but 10 years later, this time more discreetly presented in marble, it was accepted.

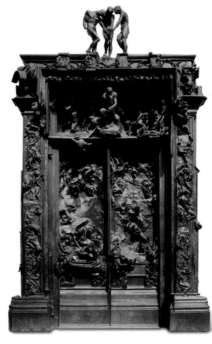

▷ **THE AGE OF BRONZE, 1877**
Rodin's unidealized male nude was based on the figure of a Belgian soldier. Despite the title, the sculpture represents man's bewildered awakening to consciousness of himself and of the world.

Early works

On a visit to Italy in 1875, Rodin was deeply influenced by Michelangelo, whose sculptures had a vitality lacking in the smooth "Academic" work of Rodin's contemporaries. Michelangelo also confirmed Rodin in his liking for "unfinished" pieces – isolated fragments of bodies, or figures that appeared to be struggling free from the still uncarved marble.

While living in Brussels, Rodin made his first, controversial, public impact with *The Age of Bronze* – a work inspired by Michelangelo's *Dying Slave*, which Rodin had seen at the Louvre. It was accepted and shown at the Salon in Paris, but the lifelike treatment of the body offended many who were accustomed to idealized representations of the nude. The attention won by *The Age of Bronze* encouraged Rodin and his lifelong companion Rose Beuret to leave Belgium (where they had lived for six years) and return to Paris in 1877. Initially, Rodin took on skilled but relatively humble jobs – including design work for the Sèvres national porcelain factory – to earn a living, but he had begun to attract a following among both artists and

△ **THE GATES OF HELL, BEGUN 1880**
This magnificent museum door, although unfinished, was Rodin's most ambitious project. This version was cast after his death. *The Thinker*, intended to represent the poet Dante, sits in the horizontal top panel, pondering the fate of the damned.

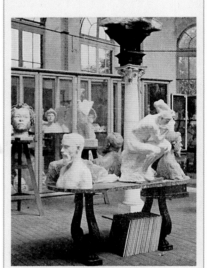

A ROOM IN THE MUSEE RODIN DISPLAYING RODIN'S WORKS

▷ **PORTRAIT OF RODIN**
In this photograph taken in July 1898, Rodin, with his tools arranged on a plank of wood, poses in front of his sculpture *Monument à Sarmiento*.

" In all things I **obey nature** and do not presume to **command** her. My one **ambition** is to be **slavishly faithful** to her. "
AUGUSTE RODIN, CITED IN PAUL GSELL, *ART: CONVERSATIONS WITH RODIN*, 1911

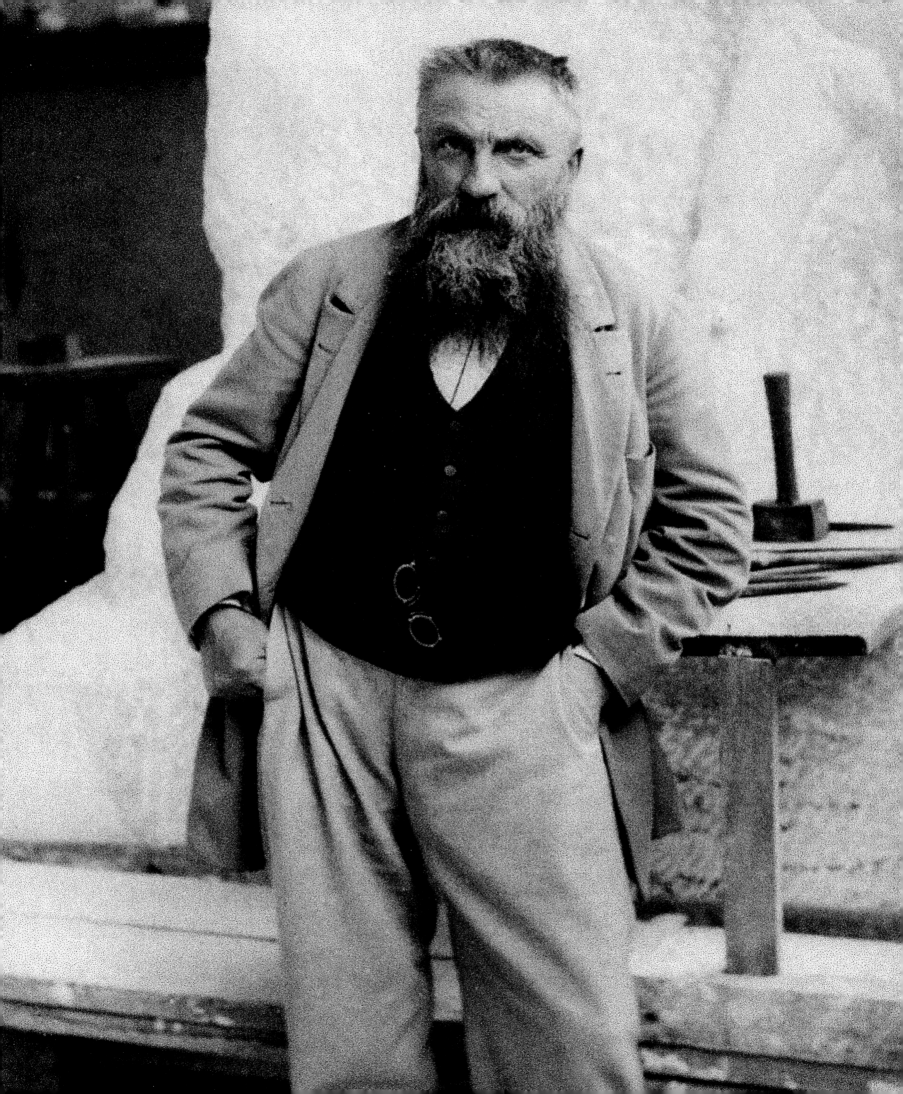

"Every **word** Rodin said seemed **pregnant** with **meaning**, as I watched him working..."

WILLIAM ROTHENSTEIN, *MEN AND MEMORIES*, 1931

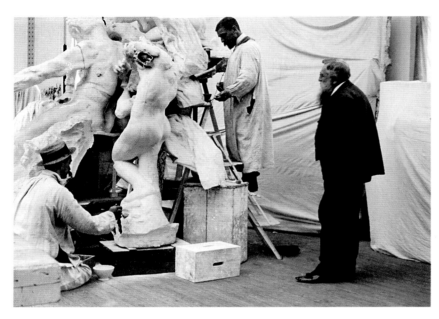

△ **RODIN IN THE STUDIO OF HENRI LEBOSSE, 1896**

Rodin oversees assistants working on his monument to the famous French writer Victor Hugo (1802–85) in the studio of Henri Lebossé – Rodin's principal assistant – in 1896. Although the plaster model of the monument was finished the following year, a bronze cast of the entire work was not installed in Paris until 1964, long after Rodin's death.

intellectuals. In 1880, his contacts in these circles enabled him to rent a permanent studio in Paris and win a major commission from the French government – a turning point in his career.

The Gates of Hell

He set to work on the project – *The Gates of Hell* – which was intended as a bronze door for the entrance to a proposed museum of decorative arts. The subject was taken from the *Inferno*, the masterpiece of the poet Dante, and Rodin worked furiously on the piece for years, creating almost 200 figures of damned sinners inspired by the poem.

On one level the commission was a failure: the museum was never built and Rodin did not finish the piece. However, the wealth of figures he made for the project became a source for many of his most famous works, among them *The Kiss* and *The Thinker*. The present *Gates of Hell* (now on display at the Musée Rodin in Paris, and elsewhere) was assembled after his death, and conveys the teeming, sinister grandeur of his vision.

Artistic virtuosity

From the 1880s, Rodin was an established figure, prolific, much in demand and, towards the end of the decade, honoured by the government and acting as a consultant to it. He was said to work a 14-hour day, often ran several studios at the same time, and scorned the idea that inspiration – rather than sustained effort and a search for truth – was the key to artistic success. Onlookers were astonished by his restless energy and skill. He was unsurpassed as a modeller, his fingers working with seemingly intuitive skill to mould forms to exploit potential effects of light and shade. A master of

the nude, he infused the bodies of his subjects with a vitality and sense of movement beyond anything his competitors could achieve; and when the bodies were female, their erotic nature was often palpable.

Rodin's works were shown in plaster, bronze, or marble, and many were translated into all three. Skilled assistants were an important factor in his productivity, especially in carrying out almost

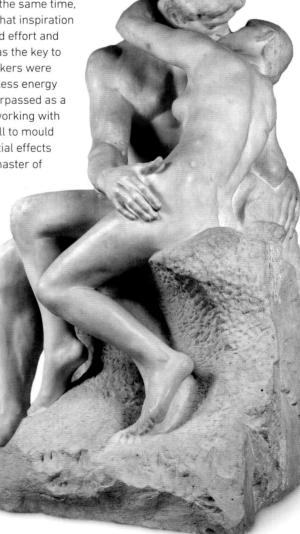

▷ **THE KISS**, 1886

One of Rodin's most famous creations, *The Kiss* originated as the image of a pair of sinful, damned lovers in *The Gates of Hell*. Removed from that context and rendered in smooth marble, it makes a more gently sensual impression.

all of the work on his marble statuary, without affecting their impact or popularity.

Local heroes

In 1884, Rodin was offered a new public commission. The mayor and councillors of Calais asked him for a group to commemorate their 14th-century equivalents – the burghers (citizens) who surrendered themselves to the wrath of the English king Edward III to spare their city from punishment. Rodin's first model found little favour with his clients because he showed the citizens as individuals facing a painful death, rather than undaunted local heroes. The project was beset with difficulties for the next decade.

The Burghers of Calais was not officially unveiled until 1895, but it is now one of Rodin's most admired works. The group consists of six figures advancing to their doom in disarray, their varied gestures and attitudes making up a composition that is intensely dramatic when seen from any angle. As a symbol of sacrifice, it has been installed and appreciated in many countries, from Britain to South Korea.

A literary portrait

The most contentious of all Rodin's commissions was a memorial to Honoré de Balzac (see box, right) for the French Society of Authors. At first, Rodin intended to produce an accurate likeness of the writer, but over time this concept underwent radical change. In 1898, when he showed an almost 3m (9ft) high plaster figure of the novelist at the Salon, viewers were stunned by its appearance. The head was a strange, tragic mask and the body appeared shapeless under the dressing gown.

KEY MOMENTS

1865
Submits *The Man with a Broken Nose* to the Salon. It is rejected, and accepted only ten years later.

1877
Makes *The Age of Bronze*, which attracts attention amid accusations that he used a living body as a cast.

1880
Wins an important commission, *The Gates of Hell*. It is never finished.

1884
Begins work on *The Burghers of Calais*. Finally shown in 1895, it becomes an international success.

1898
His *Balzac*, far in advance of its time, is met with intense hostility. Its greatness is recognized only in 1939.

1919
Two years after Rodin's death, a treasure-house of his works and art collections, the Musée Rodin, opens in Paris.

In fact, Rodin's figure was not a portrait but an evocation of creative power and suffering that was years ahead of its time. The Society of Authors rejected the work, employing another sculptor instead, so Rodin set up the figure in the grounds of his own house at Meudon. In 1939, his *Balzac* was erected in Paris, and it is now regarded as one of his masterworks.

Later years and legacy

By 1900, Rodin was world-famous and could afford to build his own pavilion at the International Exhibition in Paris. He now rarely took on large public commissions, but there were many people in France and abroad who paid handsomely to be immortalized by one of his portrait busts. During his last years, Rodin devoted much of his creative energy to producing rapidly outlined drawings with colour washes, and to making small, lively plaster and terracotta models. Most of these were studies of movement, and especially of dance. The female form had always been a powerful source of inspiration for Rodin, and some drawings, shown in Germany, caused controversy owing to their erotic nature.

Before his death in 1917, Rodin arranged the founding of a museum devoted to his works. Part of Rodin's tremendous achievement was to have made sculpture a major art again after a period when it it had become a vehicle for stereotyped Academic portraits and memorials. Subsequent sculptors would benefit from the new status of their art as well as from the new possibilities that Rodin created for it.

IN PROFILE
Honoré de Balzac

Rodin's memorial to the 19th-century French novelist Balzac (1799–1850) caused controversy (see left). Balzac's huge output – in its entirety entitled "The Human Comedy" – comprised an all-embracing picture of French society, something that had never before been achieved in fiction. The writer's vast workload and vigorous creativity may have suggested the final, symbolic rather than literal form of the Balzac monument. In life, Balzac was very short and stout, and his prodigious, night-long sessions of work, fuelled by huge quantities of coffee, probably contributed to his early death at the age of 51.

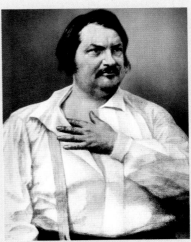

PHOTOGRAPH OF BALZAC BY NADAR, 1842

◁ **THE BURGHERS OF CALAIS**, 1895
Celebrating the men of Calais who faced death to save their city, the group has become a symbol of patriotic sacrifice. This version stands in the sculpture garden of the Hirshhorn Museum in Washington, D.C.

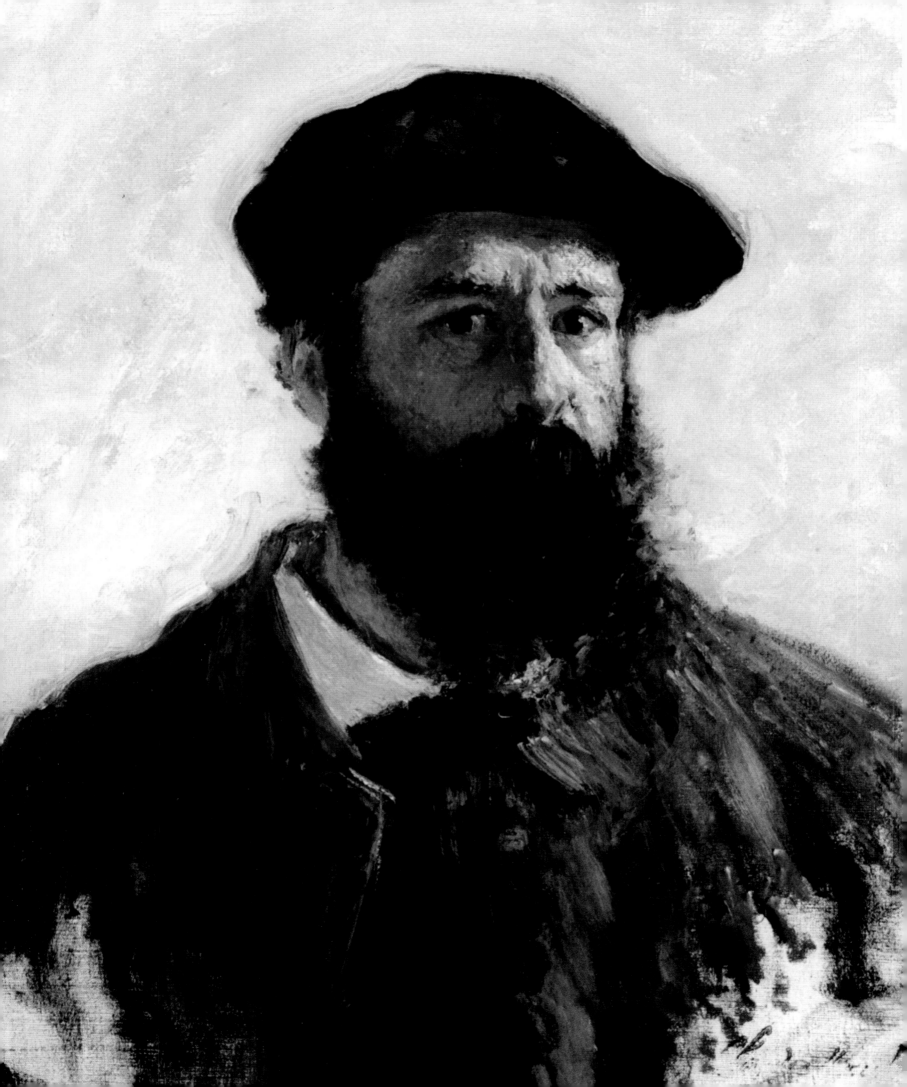

Claude Monet

1840–1926, FRENCH

The quintessential Impressionist, Claude Monet endured years of poverty before achieving recognition, wealth, and fame. His magnificent garden at Giverny became the focus of his life and art for decades.

"I was born in Paris in 1840... in an environment entirely concerned with commerce, where everyone professed a contemptuous disdain for art." This is how Monet began his life story in 1900, by which time he was one of the most celebrated artists in France. When he was just five years old, the Monets moved to Le Havre on the Normandy coast, where they owned a wholesale grocery. Monet showed no interest in the business, or in formal education, but by his teens displayed a talent for drawing caricatures. His

drawings impressed local framer and artist Eugène Boudin, an advocate of *plein-air* painting. Boudin set Monet on his artistic path, encouraging him to paint outside, direct from nature: "Suddenly a veil was torn away...," Monet remembered; "my destiny as a painter opened up to me."

Formal studies

Despite his father's reluctance, Monet was permitted to study art in Paris. His father wanted him to train at the official art school, but the headstrong

19-year-old was already devoted to painting from nature and not interested in "Academic" painting – art based on classical ideals. So in 1859, he enrolled at the Académie Suisse, an independent studio where he could attend life classes without formal tuition. Here he met Camille Pissarro, who became a close friend, and later a fellow Impressionist.

After two years in Paris, Monet was conscripted into the French army and posted to Algiers. His family bought him out of the army on the condition that he studied art with a recognized teacher. So he grudgingly joined the studio of Charles Gleyre, where he met kindred spirits Renoir, Sisley, and Bazille, who were to form the core of the group that would evolve into the Impressionists. The friends made trips to the Forest of Fontainebleau, where an earlier generation of artists, including Daubigny and Corot, had painted in the open air.

Monet continued his studies under Gleyre until 1864, but it was outside the teaching studio that his real

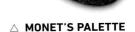

△ **MONET'S PALETTE**
Monet used dabs and flecks of pure, contrasting colours rather than gradations of tone to suggest light and shade. His palette is shown here.

ON TECHNIQUE
Portable colour

Technological developments in paint manufacturing in the 19th century had a huge impact on Monet. The invention of the metal paint tube in 1841 had made *plein-air* painting much easier, enabling him and his friends to paint outdoors, direct from nature. Until then, artists' oil paints were ground by hand, mixed with oil, and stored in pouches made from pigs' bladders, which the painter pierced to squeeze out the paint. Another important innovation was a range of new, vibrant pigments such as the cadmium yellow Monet favoured, which could be bought as ready-made paint, conveniently stored in the new portable tubes.

TUBE OF CADMIUM YELLOW PAINT, 19th CENTURY

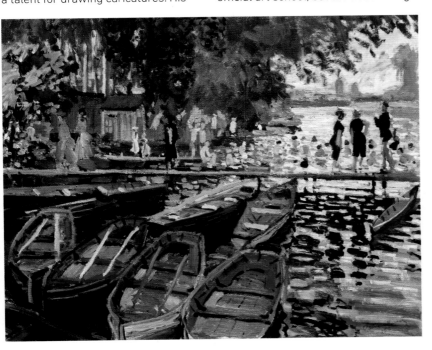

◁ **BATHERS AT LA GRENOUILLERE, 1869–71**
Monet used slab-like blocks and dashes of colour to create the impression of light on rippling water and to capture the informal bustle of modern life.

◁ **SELF-PORTRAIT IN BERET, 1886**
Around the time Monet painted this self-portrait he was beginning to achieve success in both the USA and France.

" For me, **a landscape** doesn't exist in its own right... the surrounding **atmosphere** brings it **to life**. "

CLAUDE MONET

artistic development took place. In 1862, he had met the Dutch landscape artist Johan Barthold Jongkind: "He was my real master," Monet said; "to him I owe the final education of my eye." The young artist also learned from his contemporaries. He frequented the Café Guerbois, where avant-garde artists and writers spent evenings enjoying animated discussions about art – often led by Edouard Manet, whose pioneering ideas about painting "modern life" inspired him greatly.

Towards modern painting

While mythology or history were traditionally considered the "proper" subjects for artists, Monet and his contemporaries rejected both the subject-matter and the smooth, polished technique of Academic art. Echoing Manet's infamous *Le Déjeuner sur l'Herbe* (1863), Monet began a vast, unashamedly contemporary picnic scene (with the same title), using bold, slab-like brushstrokes. He eventually abandoned the work, but continued with his quest for life-size modern images with a picture of his girlfriend Camille, and the monumental *Women in the Garden* (1866).

After his father cut off his allowance, Monet suffered dire financial hardship, especially when Camille gave birth to their son Jean in 1867. The year 1870 proved to be significant for the artist:

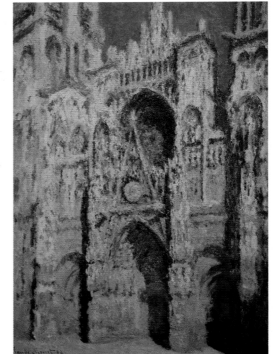

he married Camille; his aunt (his only relative who cared about painting) died; and France declared war on Prussia. Monet's group of friends scattered. Monet, Sisley and Pissarro fled to England. Renoir joined the cavalry regiment, and sadly Bazille was killed in action.

On his return to France in 1871, Monet settled at Argenteuil, on the banks of the Seine, a 15-minute train ride from Paris. His style reached maturity, his palette became brighter, and his canvases of this period show

◁ *HARMONY IN BLUE AND GOLD*, 1894
Monet made more than 30 paintings of the front of Rouen Cathedral, capturing the building under a variety of light conditions.

shimmering river scenes, and his wife and son in the dappled light of their garden or in sunlit meadows.

The Impressionists

Monet had met the art dealer Paul Durand-Ruel in London in 1870, and his work at last began to sell, but he still struggled to make ends meet. Following repeated rejections by the jury of the Salon, France's official annual showcase, he and his fellow artists began to show their work independently, and were gaining a group identity as "the Impressionists" – a term that came into being after their first group exhibition in 1874.

In 1878, Monet moved to the village of Vétheuil, also beside the River Seine. By now, Camille, who had given birth to a second son, was terribly ill and – in addition to Camille, Jean, and the baby Michel – Monet's household included the wife and six children of Monet's former patron, the

KEY MOMENTS

1862
Paints with Jongkind in Normandy. Returns to Paris and attends Gleyre's studio.

1866
Woman in the Green Dress, a life-size portrait of Camille, his wife-to-be, is a hit at the Paris Salon.

1874
Monet's sketchy view of Le Havre, *Impression, Sunrise*, is shown at the exhibition of the "Société Anonyme".

1886
A Monet show in New York opens to rave reviews. This triggers enthusiasm for the artist's work in France.

1889
A major retrospective at George Petit's Paris gallery is a success. Monet's reputation is sealed.

1927
The year after Monet's death, his vast waterlily canvases are installed in the Orangerie in Paris.

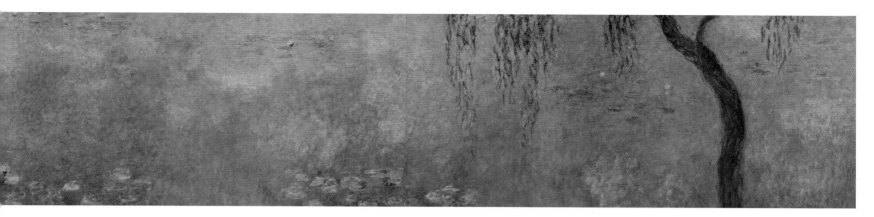

△ THE WATER LILIES: THE TWO WILLOWS, 1914–26

Monet created his garden at Giverny "for the pleasure of the eye, and for motifs to paint". He painted the water lily pond repeatedly, capturing the effects of light on the water at different times of day.

department store magnate Ernest Hoschedé, who had been bankrupted in 1877–78 and lost his collection. After Camille died in 1879, Alice Hoschedé became Monet's lifelong partner – they married in 1892.

To Giverny

In 1883, Monet moved again, to Giverny, a village in Normandy, northern France. During the 1880s, he embarked on a series of trips, finding inspiration in the dramatic coastlines of Normandy and Brittany, the Creuse valley in central France, and the bright sunlight of the Côte d'Azur.

Monet had always painted repeated views of his favourite subjects, but in the 1890s, he began several series of pictures showing the same subjects (most notably, haystacks, poplar trees, and Rouen cathedral) under different lighting conditions. His stated aim was to "render... the *enveloppe*, the same light spread over everything". Working on numerous pieces simultaneously, he changed canvases as the light changed. He intended these series paintings to be viewed together, as a harmonious group, their forms and colours transformed by variations in the surrounding atmosphere.

Although Monet made several trips abroad in his later years, Giverny became his whole world. A passionate gardener, he spent years developing his oriental water garden there; his water lily pond, with its ever-changing reflections, was the focus of his art.

After the death of his beloved Alice and son Jean, the elderly Monet continued painting in the garden, and in the studio built to house his huge canvases. His hundreds of water lily paintings culminated in a decorative scheme that he donated to the nation. He died aged 86, the year before it was installed in the Orangerie in Paris. It has been described as "the Sistine Chapel of Impressionism".

▽ MONET'S SPECTACLES

As Monet grew old, cataracts blurred his vision and distorted his colour perception. Two operations and a special pair of spectacles restored his eyesight.

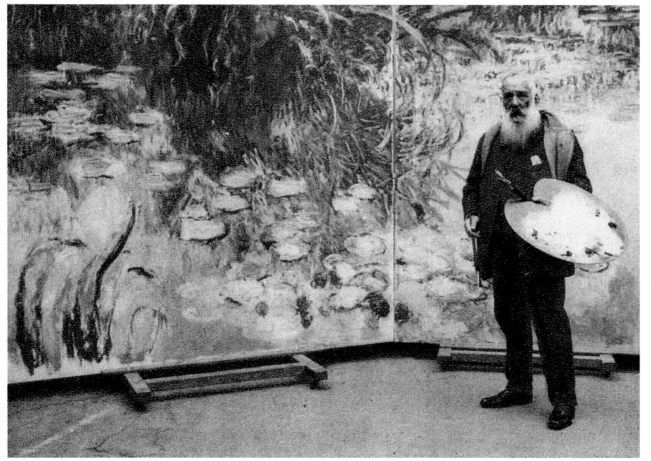

◁ THE WATERLILY MURALS

Monet's waterlily murals were so huge that he needed a vast studio. The canvases were mounted on mobile easels that could be pushed together. Far removed from the small, rapidly executed canvases of his early years, the vast panels, painted slowly and deliberately over many years, show Monet's lifelong commitment to capturing the "most fleeting effects".

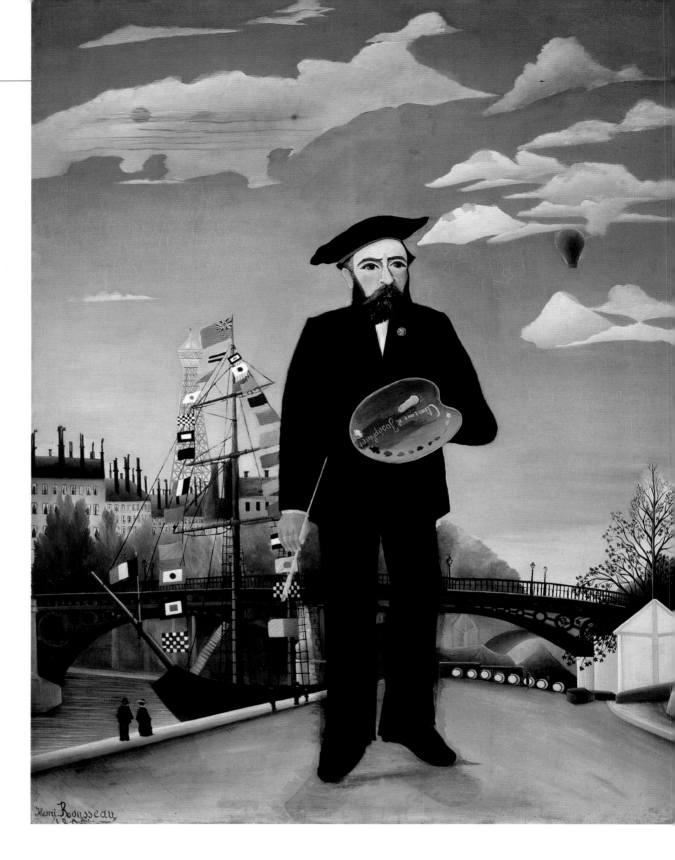

▷ ***MYSELF: PORTRAIT-LANDSCAPE*, 1890**

Rousseau depicts himself, with a Parisian backdrop, as a serious painter in the Academic tradition. He was proud because he thought he had invented a new type of painting – the "portrait-landscape".

Henri Rousseau

1844–1910, FRENCH

Rousseau was a customs officer who took up painting in his spare time. His original art, which attracted widespread ridicule for much of his life, eventually found an appreciative audience among the avant-garde.

Henri Rousseau is one of the best-loved examples of a self-taught "naive" artist. He was born in Laval in northern France, and after an undistinguished school career entered the army. Although he later liked to embellish tales of his military days with dramatic incident, including a fictional trip to Mexico, he probably never left France and his experience of the exotic was limited to the displays he saw at the 1889 Paris Exposition Universelle.

After leaving the army in his mid- 20s, he found a job manning the toll gates in the city walls of Paris to check for smuggled goods – which later gave rise to his nickname *Le Douanier*, meaning "the customs officer". The job was undemanding, but – crucially – left him with enough spare time to take up painting.

IN CONTEXT
Rousseau's jungles

Rousseau claimed that his paintings of jungles were based on those he had seen in Mexico, but he never visited the country. He was actually inspired by the glasshouses in the Jardin des Plantes in Paris, admitting: "When I enter these hot-houses and see these strange plants from exotic countries I feel as if I have stepped into a dream." Many of the wild beasts in his jungle paintings were based on photographs in a book about the Paris zoo.

A TROPICAL GLASSHOUSE IN THE JARDIN DES PLANTES, PARIS

> # " Nothing makes me **happier** than to contemplate **nature** and to **paint it**. "
>
> HENRI ROUSSEAU

Although he never received any formal artistic training, Rousseau took his painting very seriously, never doubting his own talent. He obtained a licence to copy works in the Louvre, and approached the leading artists of the day for advice. He certainly saw himself as following in the grand tradition of Academic art, but he never mastered the conventional rules of scale, proportion, illumination, and perspective – the accepted means by which artists create an illusion of reality. However, his bold, unorthodox sense of colour and expressiveness meant that he produced several works of startling originality.

Rousseau's idiosyncratic manner of painting, established early in his artistic career, hardly changed over the years. He tackled portraiture, landscapes, still life, and – increasingly towards the end of his life – imaginary scenes of forests and jungles.

Avant-garde acceptance
From 1885, Rousseau began to show his work in public, at the Salon des Indépendants in Paris. Although his paintings initially attracted ridicule, he was undeterred, and by 1893 he had retired from the Customs Office to devote all his time to art. He was no doubt encouraged by the fact that while the critics sneered, he was beginning to attract admirers among the Parisian avant-garde.

He struck up a friendship with the poet and playwright Alfred Jarry, and began mixing with the writers August Strindberg and Stéphane Mallarmé, and with artists including Edgar Degas and Paul Gauguin. His new friends were entertained by his innocence and gullibility, but regarded him fondly. Picasso even held a special banquet – a kind of artistic "happening" – for Rousseau in his studio in 1908.

Surrealist legacy
When Rousseau died in 1910, he was buried in an obscure pauper's grave. Yet within a year, exhibitions of his work had been organized in New York and Paris. The Expressionist painter Wassily Kandinsky presented Rousseau's work in his first Blaue Reiter show in Munich (see pp. 266–71), and just over a decade later, the Surrealists were hailing his canvases as marvellous examples of the irrational.

△ **TABLOID VISION**
Rousseau's view of the exotic was informed in part by magazines and pulp novels. He drew inspiration from the Parisian newspaper *Le Petit Journal* and even worked briefly as a sales representative for the publication.

▷ ***THE DREAM,* 1910**
One of Rousseau's more than 25 jungle paintings, this surreal canvas depicts the artist's former mistress, Jadwiga, surveying a lush tropical scene.

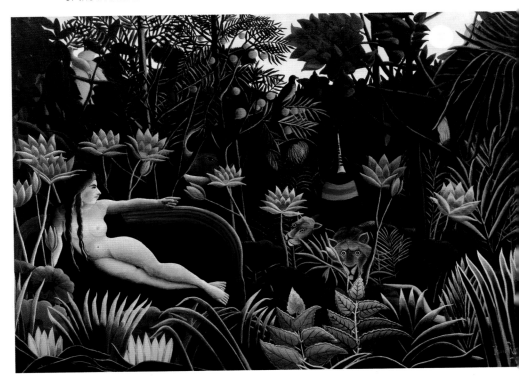

Ilya Repin

1844–1930, RUSSIAN

The greatest Russian painter of the 19th century, Repin depicted his country's history and his own times with vivid imagination, epic sweep, and passionate love of life.

Russian art was largely medieval in spirit until Peter the Great Westernized the country in the early 18th century. Thereafter, Russian artists imitated European styles, and during the 19th century achieved varying degrees of success in the West. However, Ilya Repin was the first Russian artist to acquire a European reputation with specifically Russian themes.

Russian Realism

Repin was born in 1844 in Chuguyev, Ukraine, then part of Russia. He had some training from a painter of icons and earned enough money decorating local churches to begin his studies at the Imperial Academy of Arts in St Petersburg in 1864. He was greatly influenced in his work and his moral principles by the painter and theorist Ivan Kramskoi, who championed the principles of Realism and the democratic duties of art, and was known for his portraits of the nobility as well as the Russian peasantry.

Men and myths

By the time he graduated in 1871 (winning the Grand Gold Medal), Repin had already started work on the painting that made his reputation, *Barge Haulers on the Volga*. His student successes earned him a travelling scholarship and he then spent three years, from 1873 to 1876, in Western Europe, mainly Paris. After his return to Russia, Repin lived in Moscow for

▽ **BARGE HAULERS ON THE VOLGA, 1870–73**
This painting, which in 1873 won an award at an international exhibition in Vienna, demonstrates Repin's strong, supple, and characterful brushwork, and his concern for the common man.

several years before settling in St Petersburg in 1882. However, he also travelled extensively in remote areas, gathering material for his work.

Some of Repin's best-known paintings depict dramatic moments from Russian history and myth, but he was equally concerned with contemporary life, choosing subjects that showed his strong humanitarian streak. He was also the outstanding Russian portraitist of his time, his sitters including many celebrities, notably his friend Leo Tolstoy.

In 1894, Repin accepted a teaching post at the Imperial Academy, where he was revered by his students. He resigned following the revolution of 1905 and in his later years lived at his country estate just over the border in Kuokkala, Finland, with writer Natalia Nordman (his wife, Vera, whom he married in 1872, left him in 1884 because of his womanizing).

Finland declared independence from Russia in 1917, resulting in the closure of the border between the two countries. Repin was unable to return to his homeland. He died at Kuokkala in 1930 and was buried in the grounds of his house. Kuokkala is now part of Russia and has been renamed Repino in honour of the artist; his house is a museum devoted to his life and works.

TOLSTOY RESTING IN THE FOREST, **ILYA REPIN, 1891**

▷ **SELF-PORTRAIT, 1887**
Repin often placed his subjects centrally and added little background to distract the viewer. He reportedly wished to be considered "the Rembrandt of Russia".

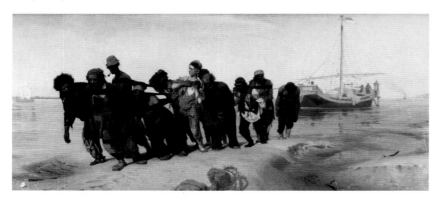

" I love **light**, **truth**, **goodness** and **beauty** as the very best gifts in our life – and most of all **I love art!** "

ILYA REPIN, LETTER TO VLADIMIR STASOV, 1899

Paul Gauguin

1848–1903, FRENCH

Unrecognized in his lifetime, but later hugely influential, Gauguin gave up his job as a stockbroker, abandoned his family, and fled "civilization" for the South Seas to devote his life to his art.

Paul Gauguin was born in Paris on 7 June 1848, the only son of a French journalist and his French/Peruvian wife. Gauguin's travels began early, when his father's radical views made it necessary for the family to seek political exile in Peru. Although his father died on the journey, Paul spent his childhood in Lima, Peru's capital. By the age of seven he was back in France, at a boarding school in Orléans, before enrolling in pre-naval college. He went to sea at the age of 17, travelling the world as a merchant seaman, then in the French navy.

Changing direction

By his early twenties, Gauguin seemed ready to settle down. His mother had died, and his wealthy guardian, Gustave Arosa, helped him secure a position as a stockbroker in Paris. Arosa also introduced Gauguin to art through his extensive private collection of modern French paintings, and soon Gauguin was producing his own works, devoting his Sundays to *plein air* (open air) painting. By 1873, when he married his Danish wife, Mette, he was a man of means and a proficient amateur painter.

The following year, Gauguin saw the first Impressionist exhibition and began to buy works by emerging artists, partly as an investment, and

partly to learn from them. His own paintings from this period show the clear influence of Pissarro, Cézanne, and Degas. Gauguin himself exhibited in the last four Impressionist shows, but though he gained some admirers, many of his fellow painters saw him as opportunistic and egotistical.

After the disastrous crash of the Paris Bourse (stock market) in 1882, Gauguin left his job, confident that he could make a living as an artist. It was a rash move, particularly because he had four children and a fifth on the

way. After a year, Mette returned to her parents' home in Copenhagen. Gauguin initially joined her, but in the summer of 1885, he abandoned his family and returned to Paris.

Even after selling some of his art collection, money remained short. In the summer of 1886, Gauguin set off for Pont-Aven in Brittany (see box, below), a popular haunt for artists. He was inspired by the "primitive" quality of Breton culture, with its traditional costumes and ancient religious beliefs. It was a quality he wanted

△ **VASE SHOWING BRETON WOMAN AND YOUNG BRETON, 1886–87**
Gauguin had been interested in ceramics from the start of his career. His deliberately rough early works, decorated with scenes of Breton life, show the beginnings of Cloisonnism – outlines filled in with flat colour.

> " Do not paint too much from nature. Art is **an abstraction**; derive this abstraction from nature **while dreaming** before it. "
>
> PAUL GAUGUIN, 1888

◁ **SELF-PORTRAIT WITH A PALETTE, 1894**
Painted in Paris after his return from Tahiti, this striking self-portrait shows Gauguin in his usual flamboyant costume – astrakhan cap and blue cloak – looking calm and confident.

IN CONTEXT
The artists of Pont-Aven

Artists flocked to Pont-Aven in Brittany during the summer months, attracted by the landscape, the women in their picturesque Breton costumes, and the cheap lodgings. Already 38 years old by the time of his first visit, Gauguin enjoyed his role as a charismatic leading figure among the mainly younger, more conventional artists. During his second visit in 1888, Gauguin worked closely with Charles Laval, Paul Sérusier, and Emile Bernard, developing a non-naturalistic style with simplified shapes and unnatural colours, based on his principle that "art is an abstraction".

ARTISTS AND A BRETON WOMAN OUTSIDE AN INN AT PONT-AVEN

> " I have decided on **Tahiti**... and hope to cultivate my art there in the **wild and primitive** state. "
>
> PAUL GAUGUIN

to create in his art. Back in Paris in the winter of 1886, he used his drawings of Breton women as designs for ceramic vases.

Tropical journeys

Unable to sell his work, Gauguin set sail for Panama in spring 1887 "to live like a savage". After labouring on the Panama Canal, he spent four months on the Caribbean island of Martinique. The tropical "paradise" inspired a number of dazzling paintings of lush landscapes and languorous women, which were well received once Gauguin had returned to Paris. Several of these works were bought by Theo van Gogh, Vincent's art-dealer brother.

By February 1888, Gauguin was back in Brittany. It was a pivotal time for his art. Along with the young artist Emile Bernard, who joined him at Pont-Aven later in the year, he developed a style known as

Cloisonnism (after *cloison*, French for "compartment"), in which strong outlines enclosed areas of flat colour, as in enamel work and stained glass.

Gauguin had previously used a similar technique in his ceramics, but it was Bernard's painting that seems to have inspired his first masterpiece, *The Vision after the Sermon* (1888), which marks a significant departure from his earlier Impressionist style. Rather than attempting to capture outward reality, and the varying effects of light and atmosphere, Gauguin instead tried to fill his paintings with inner, symbolic meaning.

While in Pont-Aven, Gauguin was invited by Vincent van Gogh to stay with him in Arles. Van Gogh welcomed Gauguin in October, but although it was initially a fruitful time artistically, Gauguin's stay came to a violent end in December when van Gogh threatened him with a razor, and then cut off his own ear. Gauguin fled to Paris, and over the next few years he alternated between the capital and Brittany.

To the South Seas

As Gauguin's art developed, he made increasing use of symbolic imagery and expressively simplified forms. He incorporated elements from diverse sources, such as Japanese prints and pre-Columbian art, into his work, and applied oil paint thinly on coarse canvas to absorb the oil and create the matt, "primitive" surface he desired.

Gauguin resolved to leave Europe "to rid myself of the influence of civilization". In 1891, he sailed for the South Seas, but when he arrived in the Tahitian capital of Papeete, it was not the primitive paradise he had imagined: "It's Europe all over again," he wrote. Tahiti had been occupied by the British and French for a century. European missionaries had eradicated indigenous religion, and the women were clad in frumpy missionary smocks. Disillusioned, Gauguin soon left Papeete for the more remote area of Mataiea, rented a hut, and took a beautiful teenage girl, Tehamana, for his *vahine* (literally, "woman").

It was in Tahiti that Gauguin made the enchanting, exotic paintings on which his reputation rests. However, these images do not reflect the reality of life there. Although inspired by the beautiful women and landscapes he

▽ **THE VISION AFTER THE SERMON, 1888**
The bold composition, which shows Jacob wrestling an angel while watched by Breton women, was influenced by Japanese prints. Abandoning naturalism, Gauguin creates a symbolic image, using areas of flat, unnaturalistic colour to evoke the visionary nature of the women's experience.

△ **GAUGUIN IN ALPHONSE MUCHA'S STUDIO, PARIS, c.1890**
Gauguin had a convivial friendship with Czech artist Mucha. The artists and their friends, including Gauguin's lover Anna, enjoyed posing for the camera.

△ **WHERE DO WE COME FROM? WHAT ARE WE? WHERE ARE WE GOING?, 1897**
Gauguin's giant frieze-like masterpiece follows the human life-cycle, but the symbolic imagery, including the Polynesian idol, is deliberately enigmatic.

saw, they are products of Gauguin's imagination and research. Many of the ideas and motifs in his work were informed by his studies of documents and books about life in Oceania, which described the islands' ancient myths, beliefs, and legends.

Gauguin's Tahitian paintings also give no hint of his own experience: by 1893 he was ill and penniless, and headed back to France with just four francs in his pocket. Soon after his arrival, an inheritance of 13,000 francs gave him a much-needed financial

boost. Flamboyantly unconventional, Gauguin took an exotic mistress, Anna the Javanese, and brought her (and her pet monkey) with him to Brittany.

Back in Paris, success still eluded Gauguin. Pissarro accused him of "stealing from the savages of Oceania" while Monet and Renoir thought his work "simply bad". Even though Degas bought a few of his paintings, sales were disappointing. Gauguin left Europe for good in 1895.

Despair and doubt
Returning to Tahiti, Gauguin continued to create works of paradisal beauty, despite a sense of despair heightened by the news of his daughter's death in 1897. He intended to create one final, great work before ending his own life; after completing *Where Do We Come From? What Are We? Where Are We*

Going?, he (reportedly) climbed a hill, swallowed arsenic, and waited to die. His suicide attempt failed.

A new arrangement with his dealer in Paris improved Gauguin's income, enabling him to journey to the more remote Marquesas Islands, where he hoped to "rekindle my imagination and bring my talent to its conclusion".

Despite failing eyesight and ill health, he continued to draw, sculpt, and paint his hauntingly harmonious masterpieces. He fought for justice for the native Marquesan people against the colonials, earning himself powerful enemies. After being sentenced to imprisonment for slandering the governor, he wrote to a friend, "All these worries are killing me". He died on 8 May 1903, probably of heart disease, aged 54. He had sacrificed everything for his art.

ON TECHNIQUE
Sculptural works

Gauguin was a gifted ceramicist, wood carver, and sculptor. His interest in ceramics was inspired in part by the pre-Columbian pottery he had seen as a child in Peru, but he also thought that his ceramics would earn more money than his paintings. He considered pottery to be high art, capable of being as expressive as painting, and his work contributed to the breaking down of academic distinctions between "fine" and "decorative" works. Gauguin's "primitive" ceramic sculpture of the mythical figure Oviri (savage), a Tahitian god of death, inspired one of the 20th-century's most revolutionary paintings, Picasso's *Les Demoiselles d'Avignon* (1907).

OVIRI, 1894

KEY MOMENTS

1888
Inspired by "primitive" Breton religion, he paints his first mature masterpiece, *The Vision after the Sermon*.

1892
Ships eight paintings to Cophenhagen from Tahiti, including *The Spirit of the Dead Watching*. Only one of the paintings is sold.

1893
His one-man show in Paris gains some positive reviews from critics and Symbolist poets, but sales are poor.

1897
Paints *Where Do We Come From? What Are We? Where Are We Going?* as a final testament before attempting suicide.

1906
A retrospective in Paris shows 227 of Gauguin's works, inspiring a new generation of artists, including Matisse and Picasso.

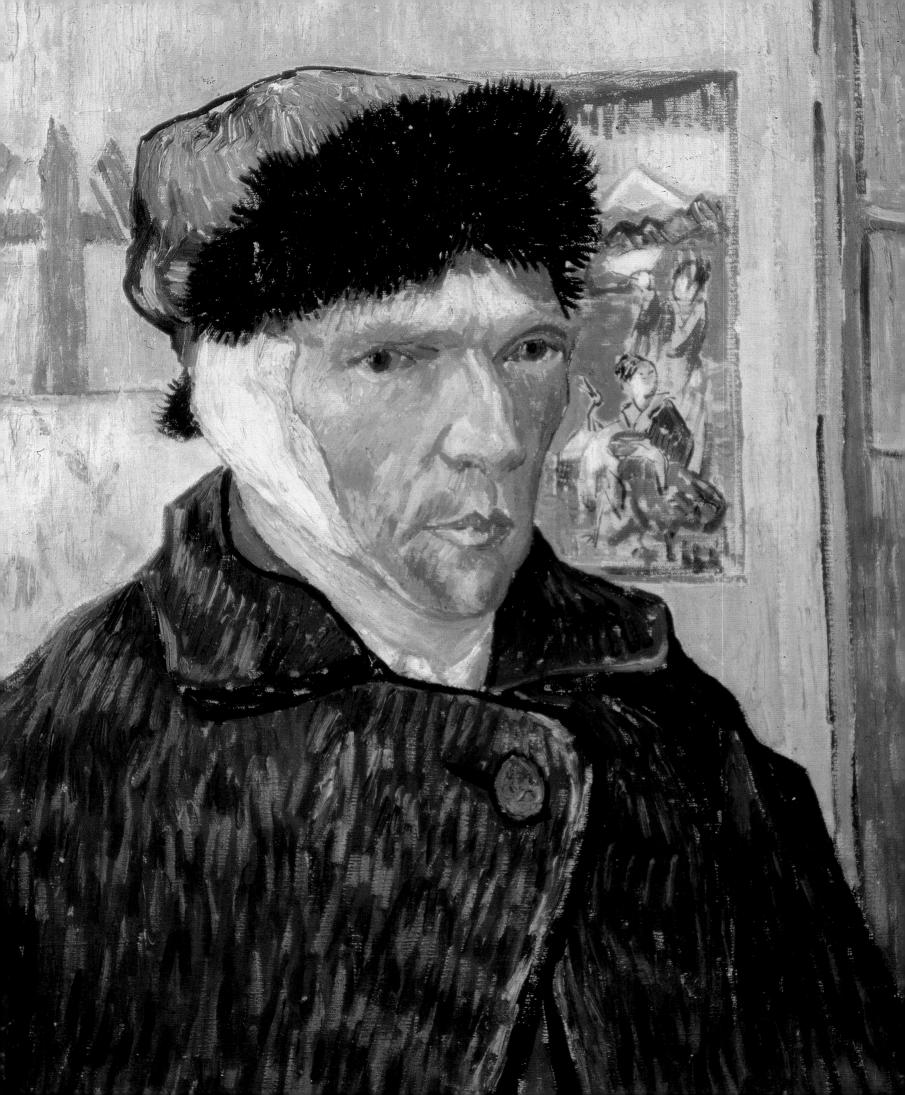

Vincent van Gogh

1853–1890, DUTCH

Van Gogh's artistic career lasted for just a decade and he was plagued by mental illness, yet his output was prodigious. His extraordinary Post-Impressionist works achieved proper recognition only after his death.

Vincent Willem van Gogh was born in Groot Zundert, a Dutch village near the Belgian border, on 30 March 1853, the first surviving child of a pastor and his wife. At 16, he moved to The Hague to work as a clerk in an international firm of art dealers, Goupil & Co., where his uncle was a partner. For the next four years, he seemed settled, and his appreciation of art and literature was already evident in the letters he began writing to his brother Theo in 1872.

This period of calm was to prove short-lived. In 1873, van Gogh was transferred to Goupil's London branch. An unrequited passion for

his landlady's daughter left him distraught and then depressed. He was transferred to Goupil's Paris branch, and his letters began to reveal troubling signs of instability as he became obsessed with religion. He lost interest in his work, and in 1876 he was dismissed.

Van Gogh the evangelist

Back in England, he took an unpaid post as a teacher, and later became an assistant preacher. He returned to the Netherlands to train for the ministry, but abandoned his studies in 1878 and moved to the mining district of Borinage to work as a lay preacher. Inspired by a passionate desire to follow Christ by helping the poor, he threw himself into his evangelical work with fanatical zeal – giving away his worldly goods and leaving his lodgings to sleep in a shack. His ardent behaviour was not approved of, and after two years he was dismissed.

By 1880, art was replacing religion as van Gogh's mission in life. Supported by his brother Theo,

◁ **RICH CORRESPONDENCE**
More than 800 letters written by van Gogh (most to his brother) survive. Some, such as this one from 1888, include drawings of his paintings.

◁ **SELF-PORTRAIT WITH BANDAGED EAR, 1889**
Painted two weeks after van Gogh cut off his own ear, this is an unflinchingly honest self-portrait. Van Gogh's easel and one of his beloved Japanese prints frame the uneasy calm of his face and the melancholy gaze of his unnaturally green eyes.

◁ **SORROW, 1882**
The expressive outlines of van Gogh's drawing of Sien Hoornik reflect his intense compassion. His inscription reads: "How can it be that there is on earth a woman alone, forsaken?"

he set about training as an artist with characteristic fervour. He had sketched since his childhood, and now taught himself by copying from anatomy and perspective books, and practising drawing exercises from Charles Bargue's *Drawing Course*. He also took lessons with the artist Anton Mauve, who was a relative of his mother. Drawings initially dominated van Gogh's work, and he experimented with various media, including black lithographic chalk, which suited the strong contours of his early style. He began painting in oils in 1882.

> " It is only **when** I stand **painting** before my easel that I feel in any way **alive**. "
>
> VINCENT VAN GOGH

IN CONTEXT
Japanese prints

Brightly coloured Japanese prints – *ukiyo-e* (meaning "pictures of the floating world") – began arriving in Europe in the mid-19th century. With their bold compositions and areas of flat, bright colour, often enclosed with sinuous lines, they had a big influence on van Gogh and his contemporaries. Van Gogh was an avid collector of the works, and made copies of prints by Eisen and other Japanese masters. He pinned the prints up in his studio and they appear in several of his paintings, including *Portrait of Père Tanguy* (1888) and *Self-Portrait with Bandaged Ear* (1889).

THE COURTESAN, KEISAI EISEN, c.1820

" I have a **terrible lucidity** at moments when **nature** is so **beautiful.** I am not conscious of myself any more, and the pictures come to me as if **in a dream**. "

VINCENT VAN GOGH

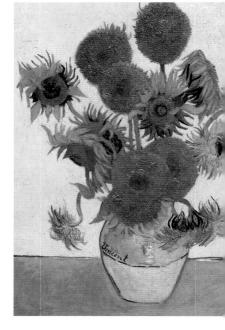

Van Gogh made a series of sunflower paintings for Gauguin's room as he waited to welcome the artist to the Yellow House in 1888.

IN PROFILE
Theo van Gogh

Vincent relied for much of his life on the emotional and financial support of his younger brother Theo, who worked as an art dealer in Paris. Through hundreds of letters to Theo, which often begin with thanks for money and materials, we learn about Vincent's personality, ideas, and interests, and about his creative process. Vincent often illustrated the letters with sketches to describe and explain his compositions. Theo died just six months after Vincent, having suddenly developed bouts of hallucinations and paralysis. The two brothers are buried beside each other in Auvers, near Paris.

PORTRAIT OF THEO VAN GOGH

Dark days

Following another bout of unrequited passion – this time for his widowed cousin Kee Vos – van Gogh began a relationship with Sien Hoornik, an occasional prostitute who was pregnant with her second child. Sien modelled for van Gogh and eventually moved in with him to an apartment in The Hague, along with her baby son and young daughter. The relationship scandalized van Gogh's family and friends, and the couple parted after a year, despite early plans to marry.

When life in The Hague proved too stressful, van Gogh left to draw and paint in the isolated fenlands of Drenthe in northern Holland. Loneliness drove him back to stay with his parents at Nuenen, where he focused on depicting peasant life. After spending "a whole winter painting studies of heads and hands", he created the most ambitious painting of his early career, *The Potato Eaters*, characterized by dark, heavily applied "earth colours" – raw umber, raw sienna, and ochre.

Van Gogh left Holland in 1885 after the death of his father. Following a few months of unsuccessful study at the Royal Academy of Fine Arts in Antwerp, he travelled on to Paris, turning up unexpectedly to live with Theo in March 1886. The move had a transformative effect on his art. He

studied briefly with Fernand Cormon, befriending fellow students Henri de Toulouse-Lautrec and Emile Bernard. Soon he met other members of the Impressionist circle. Under the influence of Monet and Pissarro, and the pointillist technique of Seurat and Signac, as well as the bold, bright Japanese prints that he collected, his painting changed completely. The dark tones of his Dutch paintings first lightened, then brightened into a blaze of colour. Pictures of peasants were replaced by city scenes, flower paintings, bright, bold portraits of friends – and many self-portraits.

Escape from Paris

Van Gogh became overwhelmed by life in Paris and sought solace in the South of France, arriving in Arles in February 1888. He longed for tranquillity, yet worked himself close to breaking point. Unlike the

Impressionist friends he had left behind in Paris, his aim in painting was to go beyond surface appearances of light and atmosphere and to express feelings and ideas through colour and contour: "Instead of trying to reproduce exactly what I have before my eyes, I use colour more arbitrarily so as to express myself more forcibly,"

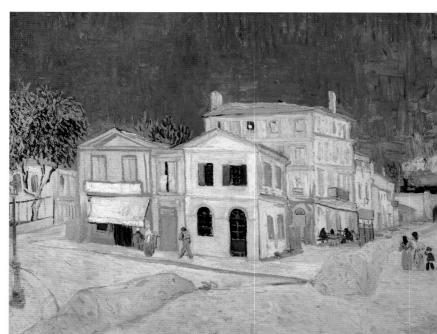

▷ **THE YELLOW HOUSE (THE STREET), 1888**
Van Gogh rented a set of rooms (indicated by the green shutters) in a house in Arles and planned to turn it into a place where like-minded artists could work together.

he wrote. This approach underlies the huge influence his work was to have on 20th-century art, from Fauvism to Expressionism and beyond.

A studio of the south

Van Gogh dreamed of creating an artists' community – a "Studio of the South" – in Arles, based in his rented "Yellow House". He invited Paul Gauguin, whom he had met in Paris, and excitedly prepared for his fellow artist's arrival by painting a series of pictures of sunflowers to decorate his bedroom.

Gauguin arrived in October and – initially – the two shared "exceedingly electric" discussions on art. However, tensions escalated, and on the evening of 23 December, van Gogh was behaving so strangely that Gauguin took refuge at a hotel. It was that night that van Gogh sliced off his ear and presented it to a girl in a local brothel.

He initially tried to make light of the incident, writing, "I hope that I have had no more than a perfectly ordinary attack of artistic temperament", but for the rest of his life his mental state would alternate between lucid periods, when he was able to work, and attacks of confusion, delusions, and hallucinations, the diagnosis of which remains uncertain. His neighbours, fearful of their safety, even signed a petition to prevent him from staying at home. Aware that he could not keep himself "under control", van Gogh committed himself to a mental asylum in St-Rémy, near Arles, in May 1889.

Late intensity

In his lucid periods, van Gogh worked at a frenzied rate, making masterpiece after masterpiece, including *Cornfield*

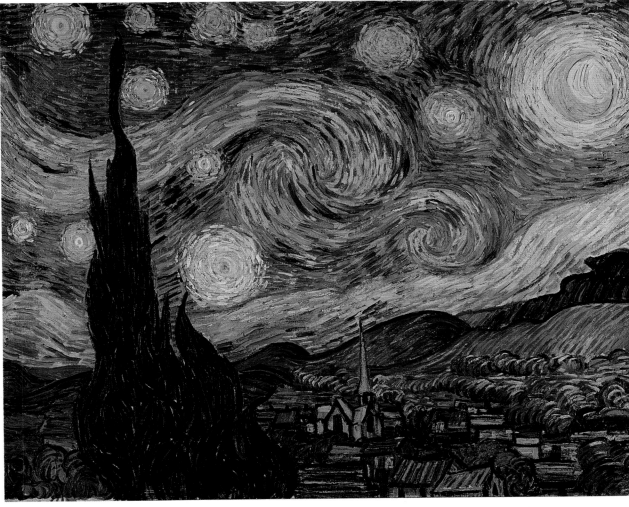

△ **STARRY NIGHT, 1889**
Painted at St-Rémy, this late masterpiece pulsates with an insistent, unsettling energy that expresses the heightened intensity of van Gogh's experience. Repeated dashes of impasto (thickly applied paint) create a powerful rhythm.

and Cypresses, *Irises*, and *Starry Night*. He began to find the asylum oppressive, and in May 1890, he travelled north again. After having visited Theo and his wife and baby in Paris, he moved into lodgings in the peaceful village of Auvers–sur-Oise, where Theo had found the sympathetic though eccentric Doctor Gachet to look after him. Van Gogh continued painting at a

furious pace – more than 70 canvases in 70 days – but this productive period was cut violently short. Perhaps the thought that Theo was considering giving up his job and might no longer be able to support him made van Gogh feel he could not go on. Two months after his arrival in Auvers, on 27 July, he went out into the wheatfields and returned bleeding from a gunshot wound to his chest. He died two days later, with Theo at his side. He was 37.

▷ **STATUE OF THE ARTIST**
This statue of van Gogh stands in the grounds of the St-Rémy asylum where the artist stayed from 1889 until two months before his death.

KEY MOMENTS

1885
After working on a series of studies of peasants' heads, paints the most celebrated work of his Dutch period, *The Potato Eaters*.

1887
Inspired by pointillism, he paints *Garden with Courting Couples*. It features dashes of complementary colours.

1888
Before Gauguin's visit, he paints sunflower pictures and *The Bedroom*, in which he aims to express "absolute restfulness".

1889
Paints in the garden and in the fields surrounding St-Rémy asylum, and also makes copies of pictures by his heroes Millet and Delacroix.

1890
Paints more than 70 works in the final 70 days of his life, including *Church at Auvers* and *Dr Gachet*.

Directory

Bertel Thorvaldsen

1768/1770–1844, DANISH

Thorvaldsen was one of the leading Neoclassical sculptors – his reputation was second only to Canova. Born in Copenhagen, he studied at the Royal Danish Academy of Art from the age of 11, but spent most of his career in Rome. He arrived in the city, after winning a travel scholarship, on 8 March 1797 – a date that he celebrated as his "Roman birthday" (his real birthday was unknown).

He secured his reputation with his statue *Jason with the Golden Fleece*, which was based on a classical figure by Polyclitus (active c.450–c.420 BCE). The fame of this piece brought him many commissions, enabling him to stay on in Rome after his scholarship had expired. By 1820, Thorvaldsen was running a thriving workshop with some 40 assistants, producing portrait busts, statues, and tomb sculpture. In 1838, he returned to Copenhagen, where he was welcomed as a hero and a museum was built in his honour.

KEY WORKS: *Jason with the Golden Fleece*, 1802–03; *Ganymede with the Eagle of Jupiter*, 1817; Tomb of Pope Pius VII, 1824–31

Jean-Auguste-Dominique Ingres

1780–1867, FRENCH

Few artists have inspired opinions as contradictory as Ingres. For much of his career, he was regarded as the champion of conventional values – the "classical" artist as opposed to Delacroix's Romantic one – yet he also had a taste for exotic subjects, ranging from Turkish harems to Celtic myths. Born near Toulouse, Ingres studied

under David, before winning the Prix de Rome in 1801. He enjoyed two lengthy stays in Italy (1806–24 and 1834–41), eventually becoming the director of the French Academy in Rome, but was equally fêted in Paris. Ingres was a superb draughtsman and was always greatly admired for the refined elegance of his portraits and the sensuous quality of his nudes. He was also a highly respected teacher, counting Théodore Chassériau among his many pupils.

KEY WORKS: *Valpinçon Bather*, 1808; *The Vow of Louis XIII*, 1824; *Portrait of Mme Moitessier*, 1856

Sir David Wilkie

1785–1841, SCOTTISH

The son of a minister, Wilkie was trained at the Trustees' Academy in Edinburgh. He also studied briefly at the Royal Academy Schools in London. He is best known for his animated genre scenes, which follow in the tradition of Dutch artists such as Adriaen van Ostade and David Teniers.

In many ways, Wilkie's pictures are the visual equivalent of the poems of his great compatriot Rabbie Burns. They are full of humorous, closely observed detail, but also display a keen eye for social injustice – paintings such as *The Blind Fiddler* and *Distraining for Rent* highlight the problems of rural poverty in Scotland. Wilkie travelled widely in his later years and died at sea. Because of quarantine laws, his body could not be brought ashore, as commemorated in Turner's tribute painting *Peace: Burial at Sea* (1842).

KEY WORKS: *The Blind Fiddler*, 1806; *Distraining for Rent*, 1815; *Chelsea Pensioners Reading the Gazette of the Battle of Waterloo*, 1822

△ **SELF-PORTRAIT, THEODORE GERICAULT, c.1812**

△ Théodore Géricault

1791–1824, FRENCH

In a tragically brief career, Géricault epitomized many aspects of the blossoming Romantic movement. He was restless, neurotic, and impulsive. He could paint elegant ladies and horse races, but was equally drawn to themes of violence, madness, and death. Born into a wealthy family, Géricault had independent means. After training under Carle Vernet and Pierre Guérin, he travelled to Italy, where he was deeply impressed by Michelangelo. Géricault enjoyed early success at the Salon with his *Charging Cuirassier*, but his undoubted masterpiece – the enormous *Raft of the Medusa* – was less popular, largely because it dealt with a controversial political scandal. Fortunately, it fared better when it was shown in England, where crowds of people flocked to see it. Géricault died prematurely from a badly infected abscess, following a fall from his horse.

KEY WORKS: *The Wounded Cuirassier*, 1814; *The Raft of the Medusa*, 1819; *The Derby at Epsom*, 1821

Camille Corot

1796–1875, FRENCH

Corot was the most popular landscape painter of his time, and a source of great inspiration to the Impressionist painters. The son of a textile merchant, he worked initially as a draper before turning his attention to art.

A lengthy stay in Italy (1825–28) gave the artist a taste for painting classical landscapes, following in a tradition that extended back to the 17th-century painters Claude Lorrain and Nicolas Poussin. His gentle, lyrical scenes proved an instant success at the Salon. He won his first medal in 1833, exhibited there regularly, and became a member of the selection panel from 1864.

Corot made sketches in the open air, but assembled his landscapes in the studio. He offered encouragement to younger artists, such as Pissarro and Morisot, despite the fact that their Impressionist style would eventually make his work seem old-fashioned.

KEY WORKS: *La Charrette: Souvenir de Marcoussis*, 1865; *Woman with a Pearl*, 1868–70; *The Wagon*, 1874

Franz Xaver Winterhalter

1805–1873, GERMAN

Winterhalter was the most popular court painter of his day, winning commissions from many of the royal houses of Europe. Born in a small village in the Black Forest, he trained as an engraver before studying painting at the Munich Academy.

For a time, Winterhalter settled in Karlsruhe, where he was employed at the court of Grand Duke Leopold of Baden. By 1834, however, he had moved to Paris, which was to be his principal base for much of his career. He also made regular trips to England, after he was recommended to Queen Victoria in 1841. Winterhalter rapidly became her favourite artist, striking the ideal balance between splendour and informality. He gave the queen painting lessons and, over the years, she commissioned more than a hundred portraits from him.

KEY WORKS: *The First of May, 1851*, 1851; *The Empress Eugénie Surrounded by her Ladies in Waiting*, 1855; *Elisabeth of Bavaria*, 1865

Honoré Daumier

1808–1879, FRENCH

Daumier was an outstanding printmaker – the finest caricaturist of his day – and he also produced remarkable paintings and sculptures, although these received little publicity during his lifetime.

The son of a Marseilles glazier, Daumier worked for a time as a bailiff's clerk – a demoralizing job, which inspired his enduring appetite for social justice. In the 1830s, his biting political cartoons of Louis-Philippe landed him in prison. Undeterred, he later made similar attacks on Napoleon III's regime, creating memorable characters such as the villainous Ratapoil (skinned rat). When political satire was banned, Daumier turned his attention to social commentary. His paintings of crowded railway carriages and weary washerwomen still strike a chord today. In old age, Daumier's failing eyesight prevented him from working, but he was rescued from poverty by the generosity of Corot.

KEY WORKS: *Past, Present, and Future*, 1834; *The Laundress*, 1863; *The Third-Class Carriage*, 1864

▷ Arnold Böcklin

1827–1901, SWISS

Although Swiss by birth, Böcklin travelled widely during his career and probably gained his greatest inspiration in Italy. His evocative subjects, many of them imaginative reworkings of themes from classical mythology, proved an important influence on the development of the Symbolist movement. Böcklin trained in Basel and Düsseldorf, where his teacher was the landscape painter Johann Schirmer. He concentrated on landscapes at first but, following his first visit to Italy in 1850, he gradually began to introduce imaginary figures into his scenes. *Pan in the Reeds* provided Böcklin with his first taste of success and he painted a colourful array of centaurs, mermaids, and satyrs. His landscapes, meanwhile, became increasingly mysterious. The finest of them – *The Island of the Dead* – is both haunting and sinister.

KEY WORKS: *Pan in the Reeds*, 1857; *Self-Portrait with Death*, 1872; *The Island of the Dead*, 1880

△ SELF-PORTRAIT, ARNOLD BÖCKLIN, 1872

Sir John Everett Millais

1829–1896, ENGLISH

Together with Dante Gabriel Rossetti and William Holman Hunt, Millais was a founder member of the Pre-Raphaelite Brotherhood, the group that challenged the British art establishment in the late 1840s. Millais himself was a child prodigy. At the age of 11, he was accepted at the Royal Academy Schools, and became their youngest ever student.

Throughout the 1850s, he remained fully committed to the principles of the Brotherhood, typified by his spirited, minutely detailed paintings *Ophelia* and *The Blind Girl*. In later years, though, Millais lost his radical edge, concentrating far more on society portraits and sentimental scenes in historical costume. He also became something of a specialist in paintings of children. His most famous example, *Bubbles* – which is a portrait of a boy who would grow up to become an admiral – proved so popular that it was used for generations as an advertisement for soap.

KEY WORKS: *Lorenzo and Isabella*, 1849; *The Blind Girl*, 1856; *The Boyhood of Raleigh*, 1870

Winslow Homer

1836–1910, AMERICAN

Homer was a painter and illustrator, best known for his stirring images of the sea. Born in Boston, the son of a businessman, he focused initially on graphic art.

After training as a lithographer, Homer began producing illustrations for popular magazines, including *Ballou's Pictorial* and *Harper's Weekly*. His breakthrough came from one of his Civil War pictures, which was exhibited at the 1867 World's Fair in Paris. Homer used this opportunity to visit France, where he admired the work of the Impressionists. Even so, he became a full-time painter only in 1875. He produced his best work in isolated coastal regions, at Cullercoats in northeastern England and Prout's Neck in Maine. Here, he enjoyed depicting hunters in the wild, or fishermen and sailors battling for survival in hostile seas.

KEY WORKS: *Prisoners from the Front*, 1866; *Snap the Whip*, 1872; *The Gulf Stream*, 1899

Berthe Morisot

1841–1895, FRENCH

Morisot was one of the most loyal members of the Impressionists, participating in seven of their eight exhibitions. She was the daughter of a high-ranking civil servant, who encouraged her talents, and was trained by Joseph Guichard and Camille Corot.

Morisot enjoyed early success at the Salon. In 1864, at her very first attempt, two of her paintings were accepted and garnered high praise. Within the Impressionist group, she was closest to Manet and the pair exerted a mutual influence on each other's work. Her unusual approach to composition owes something to Manet, while she was responsible for persuading him to experiment with *plein air* painting. Morisot also married Manet's brother and her home became the venue for the group's meetings. She is mainly known for her domestic interiors, although she also painted fine landscapes and portraits.

KEY WORKS: *The Cradle*, 1872; *Summer's Day*, 1879; *In the Dining Room*, 1886

▷ Pierre-Auguste Renoir

1841–1919, FRENCH

No artist conjures up the joyous spirit of the Impressionist movement more completely than Renoir. Even at those times when he was living in abject poverty, his paintings emphasize the beauty of a summer's day by the river or the warmth of a convivial meeting with friends. While still a child, Renoir began working in a porcelain factory, to save up for his tuition in the studio of Charles Gleyre. There, he met Monet, Sisley, and Bazille – all core members of the future Impressionist group. Early in his career, Renoir was a keen advocate of painting outdoors, but he later found this too restrictive. In addition to his landscapes, he painted voluptuous nudes, sensitive portraits, and pretty scenes with flowers, women, and young children.

KEY WORKS: *La Grenouillère*, 1869; *Le Moulin de la Galette*, 1876; *Luncheon of the Boating Party*, 1881

△ SELF-PORTRAIT, PIERRE-AUGUSTE RENOIR, 1899

Thomas Eakins

1844–1916, AMERICAN

Eakins was the finest American painter of his day, noted primarily for the penetrating psychological realism of his portraits. He was born in Philadelphia and worked there for most of his career.

After training at the Pennsylvania Academy of the Fine Arts, Eakins spent four years in Europe (1866–70). In Paris, he continued his studies under Jean-Léon Gérôme, but the highlight was a six-month spell in Spain, where he was captivated by the sombre naturalism of Velázquez. On his return to Philadelphia, Eakins combined teaching with painting, although the public response to his work was rather disappointing. His two most famous pictures – *The Gross Clinic* and *The Agnew Clinic* – were poorly received, mainly because of their quite gory medical content. It was only in the last decade of his life that Eakins achieved the recognition that he craved.

KEY WORKS: *Max Schmitt in a Single Scull*, 1871; *The Gross Clinic*, 1875; *Miss Amelia Van Buren*, 1891

Mary Cassatt

1844–1926, AMERICAN

Cassatt was an Impressionist painter and printmaker, born in the United States but active mainly in France. She was introduced into Impressionist circles through her friendship with Degas, participating in four of their exhibitions. Cassatt provided a "female" slant on the group's repertoire: rather than bars and dance-halls, she focused on childcare, visiting the theatre, or shopping for clothes. Her graphic art is outstanding. After visiting an exhibition of Japanese woodcuts in Paris, Cassatt began experimenting with different printing techniques – etching, drypoint, and aquatint. The results can be seen in her *Set of Ten* (1890–91), a magnificent series of coloured prints that feature bold, asymmetrical compositions, unusual viewpoints, and inventive colour schemes. Cassatt also helped to promote the Impressionist movement in the USA, persuading wealthy friends to purchase pictures.

KEY WORKS: *Little Girl in a Blue Armchair*, 1878; *In the Omnibus*, 1890–91; *The Boating Party*, 1894

▷ John Singer Sargent

1856–1925, AMERICAN

Sargent was an American citizen, but spent most of his career in Europe. He was born in Florence, where he received his initial artistic training, before moving to Paris and entering the studio of Carolus-Duran. Sargent made his name as a society portraitist, developing a glamorous style that displayed genuine dash and swagger, which stemmed from his close study of Velázquez and Hals.

Sargent left Paris after his sensuous portrait *Madame X* created a scandal, settling in London instead. In common with many portraitists, he grew tired of his field, announcing in 1907 that he would be painting "no more mugs". Instead, he concentrated on Impressionist-influenced landscapes and on murals for Boston Public Library. Sargent was also a distinguished war artist, as is evident from *Gassed*, his moving image of wounded soldiers.

KEY WORKS: *The Daughters of Edward D. Boit*, 1882; *Carnation, Lily, Lily, Rose*, 1885–86; *Ellen Terry as Lady Macbeth*, 1889

Georges Seurat

1859–1891

One of the leading Post-Impressionists, Seurat is best remembered for his pioneering divisionist (or pointillist) technique. He came from an affluent background and had a private income, which enabled him to experiment with new ideas. Seurat admired the way in which the Impressionists achieved vibrant colour effects by juxtaposing patches of pure colour; possessed of a mathematical mind, he wanted to replace their intuitive approach with more systematic methods.

After studying the latest theories about optics, he began to build up his compositions using tiny coloured dots. His divisionist technique is seen to best effect in his masterpiece, *La Grande Jatte*, which was shown at the final Impressionist exhibition to great acclaim. Seurat was continuing to explore promising new directions in his subsequent works when he died suddenly at the age of 31.

KEY WORKS: *Bathing at Asnières*, 1883–84; *Sunday Afternoon on the Island of La Grande Jatte*, 1884–86; *Woman Powdering Herself*, 1890

△ **SELF-PORTRAIT, JOHN SINGER SARGENT, 1892**

EARLY 20th CENTURY

CHAPTER 6

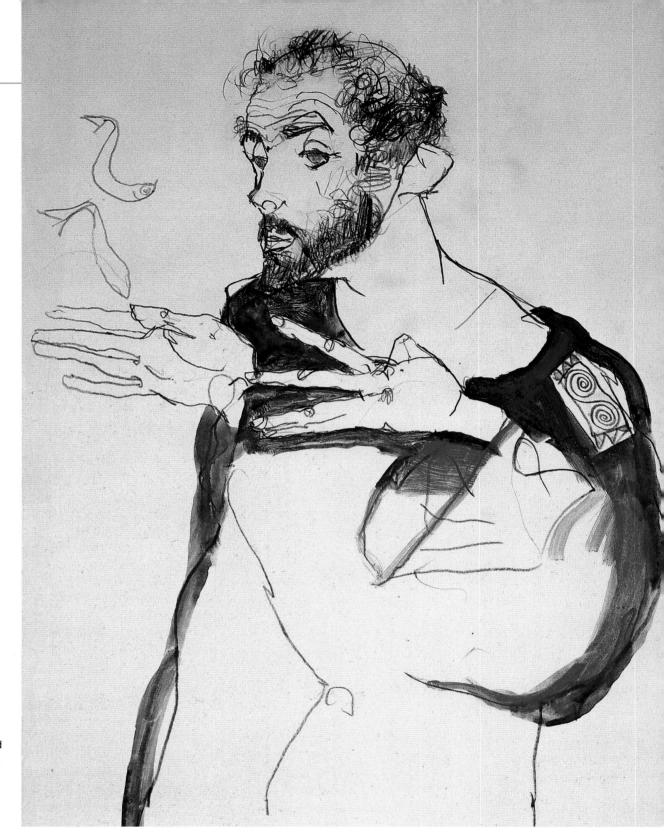

▷ *KLIMT IN A LIGHT BLUE SMOCK*, 1913

Klimt refused to make any self-portraits; this depiction of the artist in gouache and pencil is by his protégé Egon Schiele. In it, he is wearing his characteristic blue smock – unusual dress no doubt influenced by the fact that his main companion, Emilie Floge, was an avant-garde dress designer.

Gustav Klimt

1862–1918, AUSTRIAN

Celebrated for his portrayals of women, erotically charged compositions, and atmospheric landscapes, Klimt was a leading figure in a golden age of Viennese culture that ended with World War I.

> " I am **not interested in myself** as an object of painting. "

GUSTAV KLIMT

Gustav Klimt was born on 14 July 1862 in Baumgarten, a suburb of Vienna, the son of a goldsmith. It was evident from childhood that he had a talent for drawing, and in 1876 he enrolled at Vienna's School of Arts and Crafts, where he quickly became a star student. While still in his teens he formed a partnership with his brother and another student, Franz von Matsch, and they undertook a number of public commissions that culminated in projects to decorate the new Burgtheater (Austrian National Theatre) and the Kunsthistorisches (Art History) Museum.

Towards a new style

These works, in a traditional idiom, won praise, but in 1897 Klimt went from being a pillar of the establishment to a leader of the avant-garde when he and his friends formed a new association of artists that became known as the Secession, because they had "seceded", or broken away from, the Kunstlerhaus (House of Artists).

Klimt moved towards a flatter, moodier, less traditional style. He absorbed a soft, gauzy effect from Impressionism and the sinuous lines of Art Nouveau, as well as the patterns of Oriental art. His experimentation did not sit well with the authorities who commissioned him in 1894 to provide paintings on the themes of philosophy, jursiprudence, and medicine for the Great Hall of Vienna University. When delivered some years later they were criticized for their "nebulous, fantastic imagery", and the nudes were deemed pornographic.

From then on, Klimt worked for private patrons, providing portraits of Vienna's wealthy bourgeoisie and allegorical and mythological works. He undertook two further major fresco cycles – a frieze inspired by Beethoven's Ninth Symphony for the Secession building, and an extravagantly ornamented frieze for the dining room of the (private) Palais Stoclet in Brussels. This last cycle featured one of Klimt's best-known motifs – the embracing couple.

Eroticism and allegory

Vienna was the birthplace of psychoanalysis, which may partly account for Klimt's preoccupation (in work and life) with the erotic in general and female allure in particular. These themes are often present in his allegorical paintings, in which they are shrouded by layers of ornament, but his drawings are more explicit.

Klimt took up landscapes in his mid-thirties, depicting the countryside east of Salzburg, where he spent his holidays. Though he was familiar with Impressionism, his own works were less concerned with the depiction of light effects than with mood and symbolism – one critic described them as "atmospheric landscapes".

Klimt's art was unique, and while he inspired Egon Schiele and Oskar Kokoschka, he had no pupils, founded no school, and produced no manifestos. Although by the time he died other avant-garde art movements such as Cubism had come to the fore, he is regarded as one of the finest decorative artists of the 20th century.

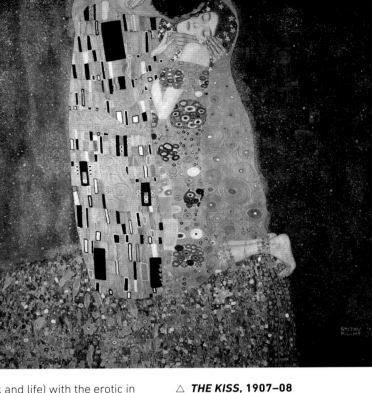

△ *THE KISS*, 1907–08
Klimt's square canvas is one of a series he produced in an extravagantly gilded style. A modern icon, which references Byzantine mosaics, it captures the universal experience of physical love.

▽ **THE SECESSION BUILDING**
Designed by Joseph Maria Olbrich, this building was an architectural manifesto for the Vienna Secession. It houses Klimt's Beethoven Frieze.

ON TECHNIQUE
The art of decoration

The faces in Klimt's pictures are often depicted in a naturalistic way, but other parts – such as the background or costumes – are treated in a highly ornate manner, overwhelmed by pattern and encrusted with gold leaf. Inspired by early Christian mosaics, Klimt experimented with mosaic himself, most notably in his frieze for the Palais Stoclet in Brussels, which incorporates semi-precious gemstones, and his Beethoven Frieze, which includes gold and silver leaf, pieces of mirror-glass, nails, and buttons.

DETAIL FROM *PORTRAIT OF ADELE BLOCHBAUER*, 1907

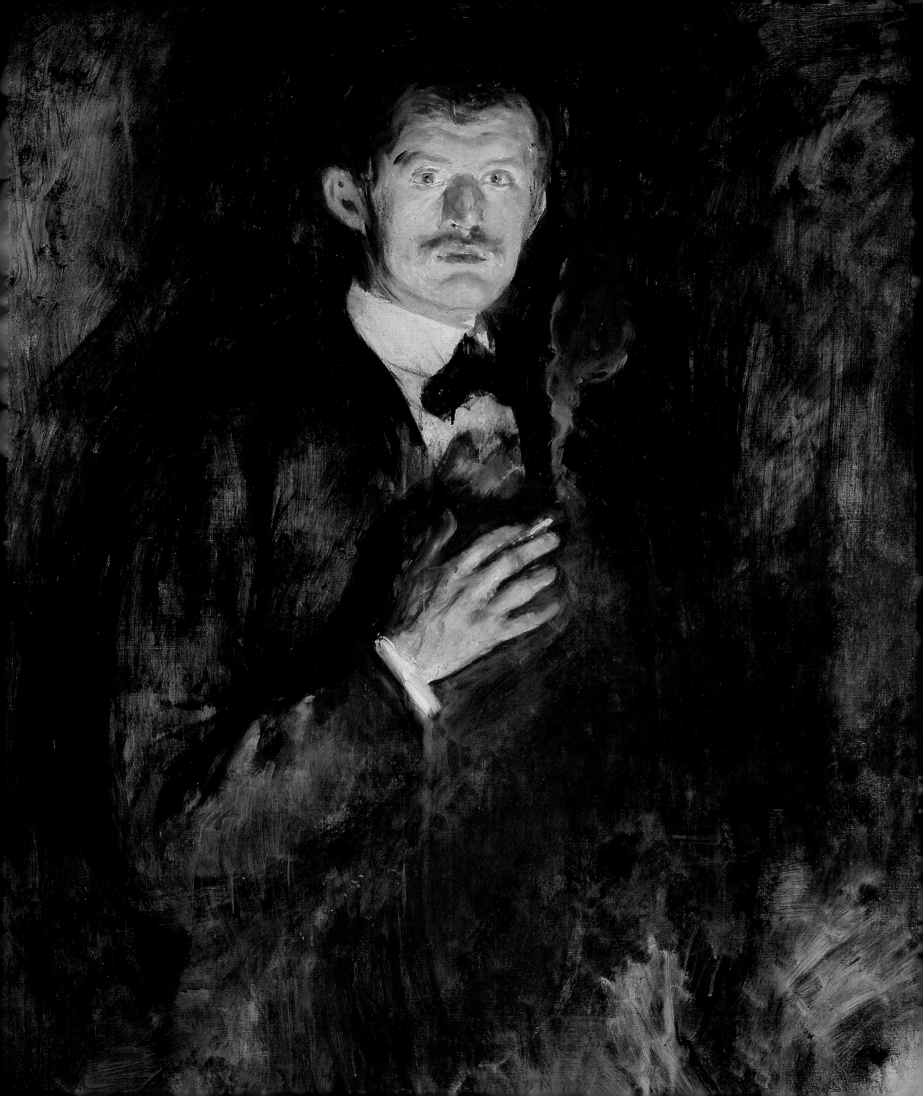

Edvard Munch

1863–1944, NORWEGIAN

Munch is considered one of Norway's greatest artists. His morbidly intense works made him a leading figure of the Symbolist movement and provided a powerful source of inspiration for the Expressionists.

On 12 December 1863, Edvard Munch was born at Løten, a rural district in southern Norway. His father had been an army doctor, but was in the process of becoming a general physician. The family moved to Kristiania (renamed Oslo in 1925), where Dr Munch served the poorest parts of the city. His presence there took a heavy toll on his own family: his wife died of tuberculosis in 1868 and, a few years later, his daughter Sophie perished from the same disease.

These successive tragedies unhinged the doctor, who turned to religion with obsessive zeal and became prone to violent outbursts, which affected the young Munch. The deaths of his father and brother and the mental decline of his younger sister contributed further to Munch's trauma – he later wrote, "Disease, insanity, and death were the dark angels that kept watch over my cradle, and since then they have followed me throughout my life..."

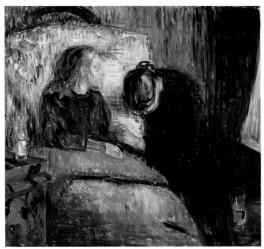

△ *THE SICK CHILD*, 1907
Munch returned repeatedly to the subject of his sister's illness and death from tuberculosis. This is his fourth version of a scene inspired by those events.

◁ *SELF-PORTRAIT WITH CIGARETTE*, 1895
Lit dramatically from below, Munch gazes at the viewer, his head framed by a column of rising smoke, a symbol of the artist's bohemian lifestyle.

The only ray of light in Munch's unfortunate childhood came in the form of his kindly aunt, Karen. She took charge of the household and, as an amateur painter herself, encouraged the children to draw. Munch's talent soon showed, but he initially thought about training as an engineer. He entered a technical college in 1879, but was forced to leave through ill health after barely a year. By the time he recovered, he had decided to switch to art.

Art studies

Munch began his official training at the State School of Art and Design, but learned far more from the informal lessons he received from Christian Krohg, one of the leading Norwegian painters of the time. Krohg was popular with younger artists because he challenged accepted values, tackling controversial themes with his uncompromising brand of naturalism, and through him, Munch began to move in avant-garde circles – specifically, a group known as the "Kristiania Bohème". This shocked Norwegian society by denouncing bourgeois attitudes and advocating sexual freedom. In spite of the controversy, though, Munch's talent was fully apparent. In 1885, he received a travel grant – the first of several – which enabled him to pay a visit to Paris.

Parisian influences

Munch's exposure to the latest artistic developments had an immediate impact on his style. He embarked on his first major canvas, *The Sick Child*, borrowing the theme from Krohg, but treating it in an entirely different manner. Munch abandoned the latter's naturalism, opting instead for bold, simplified

▽ **MUNCH'S EASEL**
In 1898, Munch bought a summer cottage in Asgårdstrand, Norway, and it was here that he painted many of his most famous late works. The cottage is now a museum that houses the artist's personal effects, such as his waistcoat, palette, and easel.

> " Art... demands the **total involvement** of the artist, otherwise it is **nothing but decoration**. "
>
> EDVARD MUNCH, CITED IN *MUNCH AND THE WORKERS* (EXHIBITION CATALOGUE), 1984

▷ **THE SCREAM, 1929**
Munch first mentioned the incident depicted in this painting in his diary in January 1892. It occurred one evening, just as the sun was setting. He made several versions of the scene, both as paintings and prints. On one of them he wrote in pencil: "Can only have been painted by a madman."

IN PROFILE
Tulla Larsen

Munch had a number of fraught relationships with women, but the most disastrous was with Tulla Larsen, the daughter of a wealthy wine merchant. The couple met in 1898 and had a stormy affair until 1902, when Munch tried to end it. At this point, Tulla staged a mock suicide attempt. She produced a revolver and threatened to shoot herself. Munch tried to wrest the gun away from her, but in the ensuing struggle it went off, blowing away the top joint of his middle finger. After this, it was always painful for him to hold a palette, though the episode did inspire a painting – *The Murderess*.

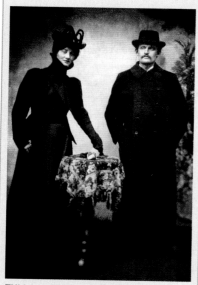

TULLA LARSEN AND EDVARD MUNCH

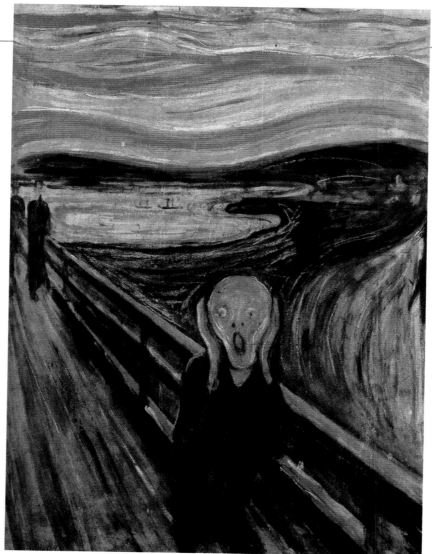

forms and an impressionistic approach to detail. He exhibited it the following year under the title of *Study*, no doubt anticipating the hostile reception that it would attract. Fortunately, he gained better reviews for his one-man show in 1889, which earned him a state scholarship to resume his studies in Paris.

In the French capital, Munch enrolled in the studio of Léon Bonnat but, as before, the discipline of formal training did not suit him and he learned most from his independent studies. It was a period of immense creativity in the art world, with scores of talented painters experimenting in different areas, and Munch absorbed these

new ideas with feverish excitement. From the Post-Impressionists, he discovered that it was possible to modify line, colour, and form in an entirely non-naturalistic manner, in order to heighten the emotional impact of his works. From the Symbolists, he acquired a new approach to subject-matter. He did not attempt to portray realistic scenes or narrative episodes. Instead, he focused on an idea, a mood, or a state of mind.

A move to Germany
In 1892, Munch was invited to display his latest paintings at the Berlin Union of Artists. There, they created such a

scandal that the exhibition closed after only a week and Munch was forced to remove his works. Some members of the Union left the organization in a show of solidarity, and they eventually went on to found the Berlin Secession, which became an important forum for avant-garde art.

Munch revelled in his newfound notoriety and decided to stay on in Germany to capitalize on the publicity he had generated. It was to remain his principal base until 1908, although he made return trips to Norway and exhibited widely throughout Europe. During these years, Munch developed the central project of his career – the *Frieze of Life*. This was a series of pictures, that he hoped to display together. They had a broad linking theme – "the poetry of life, love and death" – although Munch never defined the precise composition of the frieze too closely.

Love, terror, and despair
Many of the paintings in the *Frieze of Life* tackled grandiose, abstract subjects, ranging from awakening love and passion to loneliness and despair. Often, the tone was anguished and neurotic – characteristics vividly on display in Munch's most famous work, *The Scream*. This was inspired by a real incident – probably a panic attack or a bout of agoraphobia – that Munch experienced while he was walking beside a fjord. However, his violent distortions of line and colour turned the painting into a universal image of anxiety and terror. In it, powerful shock waves press in on the man in the foreground, but they appear to have no effect on the two dark figures following behind. This implies that the trauma comes from within the sufferer, rather than from the world outside.

" We want something **more** than a simple copy of **nature**... Art that is created with the **blood of the heart.** "

EDVARD MUNCH, CITED IN *MUNCH AND THE WORKERS* (EXHIBITION CATALOGUE), 1984

KEY MOMENTS

1886

Visits Paris for the first time; the following year, exhibits *The Sick Child* in Oslo, where it causes an uproar.

1893–94

Starts painting pictures for his *Frieze of Life* series – among them *Madonna*, *Death and the Maiden*, and *The Scream*.

1900

Spends time in Germany, Italy, Switzerland, and Oslo; paints the *Dance of Life*, one of the central works in his *Frieze of Life* series.

1908

Recuperates from his breakdown in a Danish clinic but continues painting, embarking on a series of pictures of workmen.

1922

Works on murals for the dining rooms at the Freia Chocolate Factory. The ambitious scheme is never completed.

△ **GRAND CROSS OF THE ORDER OF ST OLAV**
In 1933, the Order of St Olav was conferred on Munch as "a reward for distinguished services rendered to Norway and mankind".

Munch refined his principal motifs by making several versions of his most important paintings, slightly varying the colours or the forms on each occasion. He also repeated the motifs in a number of different media. Munch was a superb graphic artist; he took up etching in 1894 and soon went on to master lithography and woodcut. He excelled at the latter in particular, using the rough grain of the material to emphasize the harsh and raw intensity of his imagery.

Later life

The power and originality of Munch's art gained ever-increasing acclaim. The National Gallery in Kristiania bought two of his pictures in 1899 and, six years later, he was given the distinction of a major retrospective exhibition in Prague. Munch's erratic

lifestyle, however, put a strain on his health. He drank heavily, worked long hours, and travelled constantly, which eventually led to a nervous breakdown in 1908, after which he spent eight months recuperating.

After his illness, Munch decided to change his way of life. He went home to Norway, settling there permanently. He continued to paint, but abandoned the obsessively introspective themes that had made him famous. From this point on, he focused his attention on the world around him.

Munch's later work lacks the intensity of his golden period, but it has many compensating features. He painted fine landscapes and impressive studies of workers, which he hoped to collect into a *Working Man's Frieze*. He continued to travel abroad for exhibitions and to receive honours, but at home he led a solitary, quiet life, surrounded by massive piles of his work.

He died during World War II, when a nearby German ammunition dump exploded, blowing out the windows of his house. The weather at the time was freezing and Munch succumbed to bronchitis, dying on 23 January 1944. He bequeathed his remaining works – around 1,000 paintings, 15,400 prints, and 4,500 watercolours and drawings – to the city of Oslo.

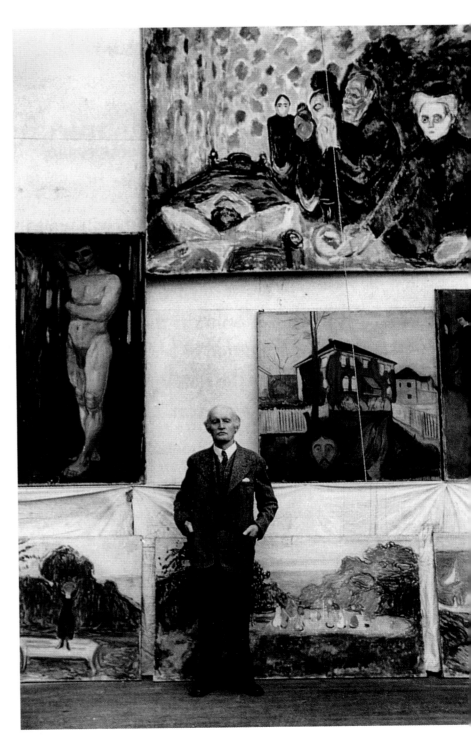

▷ **MUNCH IN HIS STUDIO, 1938**
The elderly artist is pictured standing in front of some of his paintings in the workshop of his estate at Ekely, near Oslo, in Norway.

Wassily Kandinsky

1866–1944, RUSSIAN

Working in turbulent times, Kandinsky lived the life of a cosmopolitan artist and exile. A pioneer of abstract painting, he demonstrated that it could be thrillingly colourful and infinitely varied.

For a man destined to challenge hallowed artistic conventions, Wassily Kandinsky had a conservative personality and background. His father was a wealthy tea merchant, and Wassily grew up in Moscow and Odessa with upper-middle-class values and habits. He was always very well dressed – even, apparently, when painting – and always retained a rather formal manner. After studying at Moscow University he seemed to be set for a distinguished academic career in law and a cultivated, but not necessarily creative, life.

In 1896, Kandinsky was offered a professorship at the prestigious Tartu University in Estonia, and it was at this point that he decided to change direction and pursue a career in painting. Aged nearly 30 and a married man, he set off to become an art student in the German city of Munich and, generously supported by his father, he spent five years in art schools and independent study.

The Phalanx group

Munich was a thriving artistic centre at the time, but only firmly established academic art and some elements of Jugendstil (see box, right) received recognition in official exhibitions; the new artistic movements, from Impressionism to Symbolism, that had scandalized Paris were still little known there. Kandinsky – older and more experienced than many of his fellow artists – took the lead in founding the avant-garde Phalanx group in Munich in 1901; the group staged exhibitions of not only German but foreign artists, such as Monet.

Kandinsky's own work in the 1900s veered from relatively conventional but heavily impasted landscapes to coloured Jugendstil woodcuts and

△ **THE PHALANX EXHIBITION**, 1901
The poster advertising the group's first exhibition was designed by its president, Kandinsky, and is very much in the Jugendstil mode of the time.

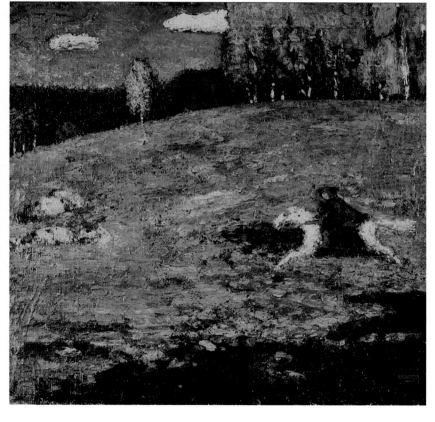

◁ **THE BLUE RIDER** (DETAIL), 1903
The motif of a rider on horseback was one that Kandinsky returned to repeatedly. For him, it represented the striving human spirit.

DIE JUGEND MAGAZINE COVER, DESIGN BY OTTO OCKMANN, 1897

◁ **WASSILY KANDINSKY, 1913**
This photograph was taken in 1913 by Kandinsky's companion, Gabriele Münter. Behind him is *Small Pleasures*, which was painted in the same year.

" The **revolt** from dependence on nature is only **beginning**. "

WASSILY KANDINSKY, *CONCERNING THE SPIRITUAL IN ART*, 1911

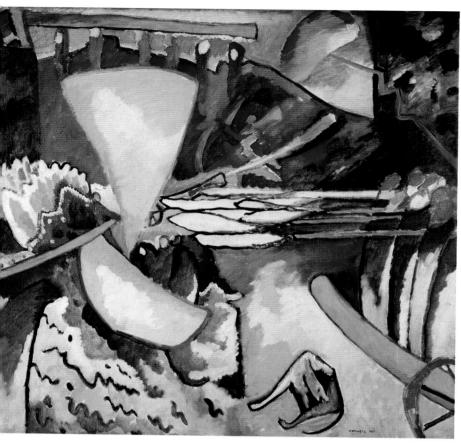

vivid, mosaic-like paintings inspired by Russian and German folk art. Even at this time, he began to use colour in his paintings to express his experience rather than to describe forms.

Travels with Münter

While teaching a class at the Phalanx art school, Kandinsky met pupil Gabriele Münter, a talented painter who subsequently became his companion – a relationship that was initially secret, since Kandinsky was still married. Following the dissolution of the Phalanx group in 1905, the couple travelled widely from their Munich base, spending a year in Paris (1906–07) and six months in Berlin (1907–08). During this time, Kandinsky's artistic development seems to have been stimulated by the Fauves (see p.274), a new French avant-garde group whose strident primary colours and sketchy, seemingly childish scenes made a powerful impact.

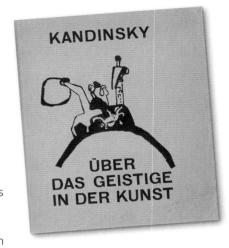

△ **CONCERNING THE SPIRITUAL IN ART, 1911**
The cover of Kandinsky's book shows his woodcut *Standing and Falling Tower with Rider*. The book sold well, despite his publisher's concerns.

Towards abstraction

In 1908–09, Kandinsky entered his first period of artistic greatness and innovation. His new confidence was signalled by the way in which he grouped many of his works in series, as *Improvisations*, *Compositions*, and *Impressions*. His colours grew brighter as well as bolder, and by 1910, the figures and objects in some of his paintings had become so simplified that they were not easily identified. The end of the process, in 1911, would be abstract art – art that made no attempt to copy the visible world, its meaning consisting in its lines, shapes, and colours alone.

Kandinsky's progress can be illustrated by comparing works such as *Improvisation XI*, *Impression III*, and *Composition V*, all from 1910–11, in which the identifiable representational elements are progressively eliminated. The artist described the moment of illumination when he entered his studio in the twilight and saw a

△ **IMPROVISATION XI, 1910**
Kandinsky's bold, brilliant work was an outstanding example of contemporary avant-garde painting, with intense, non-realistic colours and simplified but still recognizable figures and objects.

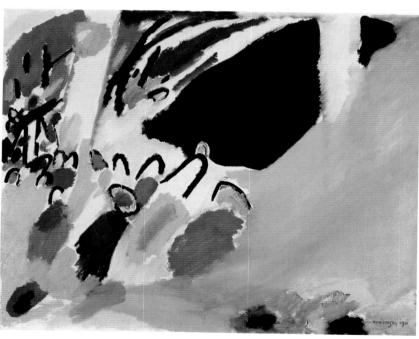

▷ **IMPRESSION III (CONCERT), 1911**
Compared with Kandinsky's *Improvisation XI* (above), this painting looks at first sight like a purely abstract work. Without the help of the subtitle, it would be easy to miss the suggested presence of the grand piano and the audience.

" **Painting**, especially, has **advanced** with almost **fantastic strides** during the last **decades**. "

WASSILY KANDINSKY, *POINT AND LINE TO PLANE*, 1926

KEY MOMENTS

1896
Gives up the law and leaves Russia to become an art student in the German city of Munich.

1901
Establishes the Phalanx group and designs an elegant Jugendstil poster to advertise its first exhibition.

1909
Founds the New Artists' Association and begins to move towards abstraction.

1910
Paints the first three of his *Compositions* series, works later destroyed by the Nazis.

1910–11
Works on a new series, *Impressions*, and paints his first abstract work, *Composition V.*

1913
Produces *Composition VI* and *Composition VII*, the last in the series before the World War I.

1922
After six years in Russia, paints at the Bauhaus in Germany, making many geometric abstract works.

1942
Paints smaller-scale pictures, of increasing variety until shortly before his death in 1944.

painting stacked on its side, glowing with colour; he realized that it was one of his own works, and that his perception of its beauty had been unrelated to its subject-matter.

Spiritual art

Kandinsky's use of radiant colours and non-representational forms could be taken to mean that his art was spontaneous and intuitive. But that was not at all the case. He was a theorist with a mission, which he outlined in his book *Concerning the Spiritual in Art*, written by 1909 but not published until late 1911 (and dated 1912). It expounds Kandinsky's belief that experiencing art is central to the spiritual growth of human beings; this was all the more important since he believed that humankind was about to leave materialism behind and enter an age of spiritual renewal.

He claimed that in painting, colours and forms, not the objects they might be intended to represent, made the physical and psychic impact that acted upon the soul. Each colour had its own inner meaning (red conveyed warmth or anger, etc.), which was modified or intensified by its shade, or by mixing or juxtaposing it with other colours.

Kandinsky's analysis is detailed and, if not incontestable, a well-sustained argument. He extended his ideas to other art forms, believing that music and painting, for example, are interlinked, and that colours in a picture relate to each other in much the same way as chords in music; he was also certain that it was possible to hear the sound of a colour or see the colour of a sound. Such theories might have stifled the creativity of a lesser artist, but Kandinsky reconciled them with what he called "inner and

▽ **COMPOSITION V, 1911**

In this dynamic work, Kandinsky has taken the final step from simplified or suggestive forms to pure abstraction. Even many avant-garde fellow artists were blind to its merits and agreed with the jury who rejected it.

IN PROFILE
Arnold Schoenberg

In 1911, Kandinsky heard music with atonal elements by the great Austrian composer Arnold Schoenberg and became convinced that it was "the music of the future"; he painted *Impression III* as a tribute to the event. The two men then corresponded and became close friends. Schoenberg also painted – though in Expressionist style – and exhibited with the Blue Rider group. Later, Schoenberg devised the revolutionary 12-tone system for which he is best known. Having experienced a painful anti-Semitic incident, in 1923 he broke with Kandinsky, whom he believed to hold similar views. After Hitler came to power, Schoenberg settled in the United States.

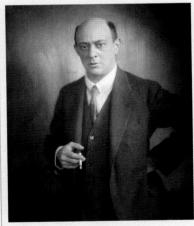

ARNOLD SCHOENBERG, c.1922

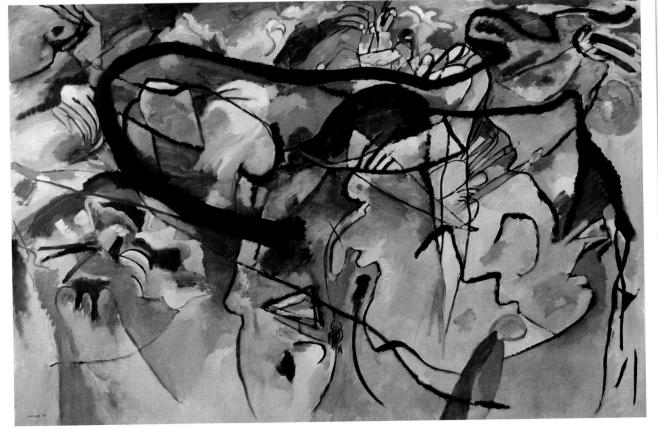

IN CONTEXT
The Blue Rider group

The Blue Rider (Der Blaue Reiter) was a breakaway group of artists that was founded in Munich in 1911 and led by Kandinsky; other members included Franz Marc and August Macke. According to Kandinsky, he and Marc hit upon the name over coffee, prompted by their love of the colour blue and their passionate interest in horses (Marc) and horsemen (Kandinsky). The Blue Rider artists placed emphasis on the pursuit of harmonious spirituality in their work. After two exhibitions – in 1911 and 1912 – the group was dispersed by World War I, during which period Kandinsky emigrated and Marc and Macke were killed.

KANDINSKY (SEATED) WITH ARTISTS FROM THE BLUE RIDER GROUP

essential feelings" to produce a great body of work that was both beautiful and unexpected.

In his writings, Kandinsky did not condemn what he called "objective" art, and during his Munich years his work was widely varied; only in the 1920s did he effectively abandon representation altogether. Pictures in different styles followed one another or were deliberately related, as in the *All Saints' Day* paintings, in which the same scene is presented in intensely coloured, near-abstract style and also in the naive, pious style of folk art. Similarly, in *The Lady in Moscow*, the lady in question stands in the centre of the picture, floating above the street, while a large, mysterious black shape hovers near her – as it does in the aptly named semi-abstract *Black Spot* of the same year (1912).

The Blue Rider group

While his art was evolving, Kandinsky was again becoming involved with societies and exhibitions. In 1909, he founded the New Artists' Association (*Neue Künstlervereinigung* or NKV) and promoted a number of exhibitions of avant-garde art – predominantly by French artists – that failed to please the German public and critics, their nationalist outlook reinforced by growing international tensions.

By 1911, Kandinsky's work and ideas had become too advanced for many NKV members, and when his abstract *Composition V* was submitted to the jury, it was rejected. Kandinsky resigned and he and a younger artist, Franz Marc, set up a rival group, the Blue Rider (*Der Blaue Reiter*). It held only two exhibitions, in 1911 and 1912, but the publication of *The Blue Rider Almanac* had a long-term effect in promoting new art, which gave the group its place in history.

The war years

Kandinsky produced works such as *Composition VI* and *Composition VII* in the Blue Rider period; but in August 1914, World War I broke out and the group dissolved. Now an enemy alien in Germany, he fled to Switzerland with Gabriele Münter, but they broke up soon afterwards and Kandinsky returned to his native Russia.

He got married again – to a young Russian woman, Nina Andreevskaya, 27 years his junior – and managed to weather the revolutions that led to the establishment of the Bolshevik (Communist) state in 1917 and the civil war that followed. For the next four years Kandinsky worked for the regime as an academic and administrator supervising the opening of 22 new museums.

Some avant-garde trends in art were encouraged, and Kandinsky was able to paint and exhibit, but as groups favouring a proletarian art gained the upper hand, he was sidelined. Sent on a mission to Berlin in December 1921, the Kandinskys left Russia and never returned.

The Bauhaus

After a few months in Berlin, Kandinsky started teaching at the Bauhaus in Weimar, the school that was revolutionizing design. He enjoyed the atmosphere, made a close friend in the artist Paul Klee, and devoted himself to teaching and painting.

Geometric elements had appeared in some of Kandinsky's works during his years in Russia, but he disliked the suggestion that he had been influenced by avant-garde Russian painters such as Malevich. At the Bauhaus, the Modernist insistence on clean lines and lack of ornament in design encouraged the use of geometrical forms, and Kandinsky's work moved in the same direction. He himself admitted that the circle had replaced the horseman as the spiritual centre of his art.

In 1925, political pressures forced the Bauhaus to move to Dessau. Kandinsky thrived there, creating hundreds of paintings over the

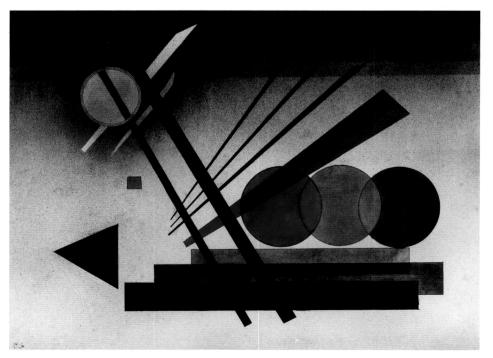

◁ **SUSPENDED FORCE, 1928**
In the 1920s, Kandinsky's work remained abstract and was dominated by mainly geometric forms, as in this watercolour. In this instance, the hard lines are softened by subtly modulated tones, strikingly similar to those used by Kandinsky's close friend Paul Klee.

△ **CAPRICIOUS FORMS**, 1937
△ **CAPRICIOUS FORMS**, 1937
Settled in France from 1933, Kandinsky moved from the dynamic straight lines and geometric shapes of the 1920s to compositions with freer curves and a range of seemingly animated, floating forms, often described as "biomorphic".

▽ **DESSAU MASTER'S HOUSE**
While teaching at the Bauhaus in Dessau, Kandinsky lived in one of the houses of the masters – buildings designed by the school's founder, Walter Gropius.

following years. He was becoming internationally known, and in 1926, an exhibition toured Germany to honour his 60th birthday. The following year, Kandinsky and his wife Nina became German citizens. However, his quiet, studious existence was threatened by the Depression and by the rise of the Nazi Party, which viewed all forms of Modernism as "degenerate". In 1933, the Bauhaus was closed for good; the Kandinskys began a second exile in France, finding a permanent home in Neuilly-sur-Seine, a suburb of Paris.

Kandinsky's paintings of his final period in France freely combined elements from his earlier phases but also introduced new elements, often described as "biomorphic" because they frequently resembled tiny, primitive life forms. Kandinsky and his wife became French citizens in 1939, just before war broke out and the country was defeated by Germany.

Kandinsky refused invitations to move to the USA and, as one of the artists who had been pilloried in the 1937 Nazi exhibition of "Degenerate Art" (see p.287), was lucky to escape the attentions of the Gestapo. Very late paintings such as *Fulfilment* (1943), small-scale but immaculately executed, indicate that his creativity remained undiminished to the end.

" The artist must **train** not only his **eye** but also his **soul**. "

WASSILY KANDINSKY, *CONCERNING THE SPIRITUAL IN ART*, 1911

Henri Matisse

1869–1954, FRENCH

Matisse was one of the most versatile and inventive artists of the 20th century. Best known as the leader of the Fauvist movement, he excelled as a painter, sculptor, printmaker, and designer.

Henri Matisse was born on New Year's Eve, 1869, in the town of Le Cateau-Cambrésis, northern France. The son of a shopkeeper and grain merchant, he grew up in the neighbouring village of Bohain-en-Vermandois. Surprisingly perhaps, he displayed no interest in art in his early years, but worked as a solicitor's clerk before beginning a law degree in Paris in 1887. His passion for art was only awoken in 1890, following a bout of appendicitis. During his convalescence, his mother brought him a box of paints, and it was not long before Matisse found himself "transported into a kind of paradise".

Education and experiment

Grudgingly, Matisse's parents agreed to let him give up a secure future in the law in order to study art. He was disappointed by the cold, Academic approach of his first master, William Bouguereau, but soon found a more sympathetic teacher in Gustave Moreau (see box, right), who took the unusual step of encouraging his students to paint straight away, rather than focusing on drawing, so that they could develop their skills as colourists at an early stage.

Matisse's early work was strongly influenced by Impressionism and he enjoyed some modest success, selling two works at an exhibition in 1896.

▷ **CATALOGUE OF THE 3RD SALON D'AUTOMNE AT THE GRAND PALAIS**
After seeing the work of Matisse at this exhibition, critic Louis Vauxcelles called him and his painter friends *fauves* (wild beasts).

Even so, his progress in his chosen career was slow, hindered no doubt by his chaotic private life. His mistress – the model Caroline Joblau – gave birth to a daughter, Marguerite, in 1894, but the couple parted three years later. In January 1898 Matisse married Amélie Parayre, with whom he had a son in the following year.

Burdened with these new financial responsibilities, Matisse was obliged to take on temporary work. In 1900, for example, he was employed as a decorator, painting endless swathes of garlands in the new Grand Palais, which was to be a centrepiece at the World's Fair in Paris. He also received an allowance from his father – but this was cancelled in 1901, following the extremely negative response to his exhibits that year at the Salon des Indépendants.

By this time, Matisse was beginning to find his true direction. His primary sources of inspiration were Cézanne, from whom he learned the importance of order, balance and energy, and Gauguin, whose Tahitian works showed him that colour could have a greater expressive power when it was freed from its traditional descriptive role. This idea was reinforced in 1904, when Matisse painted with the Neo-Impressionist artists Henri-Edmond Cross and Paul Signac in St-Tropez.

Although Matisse toyed with their Pointillist style – building up compositions with tiny touches of pure, complementary colour – he soon moved beyond it. The following summer, he worked with André Derain, a friend from art school days, at the French coastal town of Collioure, near the Spanish border. One of their neighbours there was Daniel de Monfreid, who showed the pair some late works by Gauguin, who had been his friend. These paintings inspired Matisse and Derain to immerse themselves more fully in their adventures with pure colour.

SALOME DANCING BEFORE HEROD, GUSTAVE MOREAU, 1876

▷ **SELF-PORTRAIT IN A STRIPED T-SHIRT, 1906**
In this strong, direct image, painted with coarse brushstrokes, Matisse presents himself as a primitive, honest man, rather than an Academic artist.

> " I find it **impossible** to copy nature slavishly: I am forced to **interpret it** and **bend it** to the **spirit** of the picture. "

HENRI MATISSSE, *LA GRANDE REVUE*, 25 DECEMBER 1908

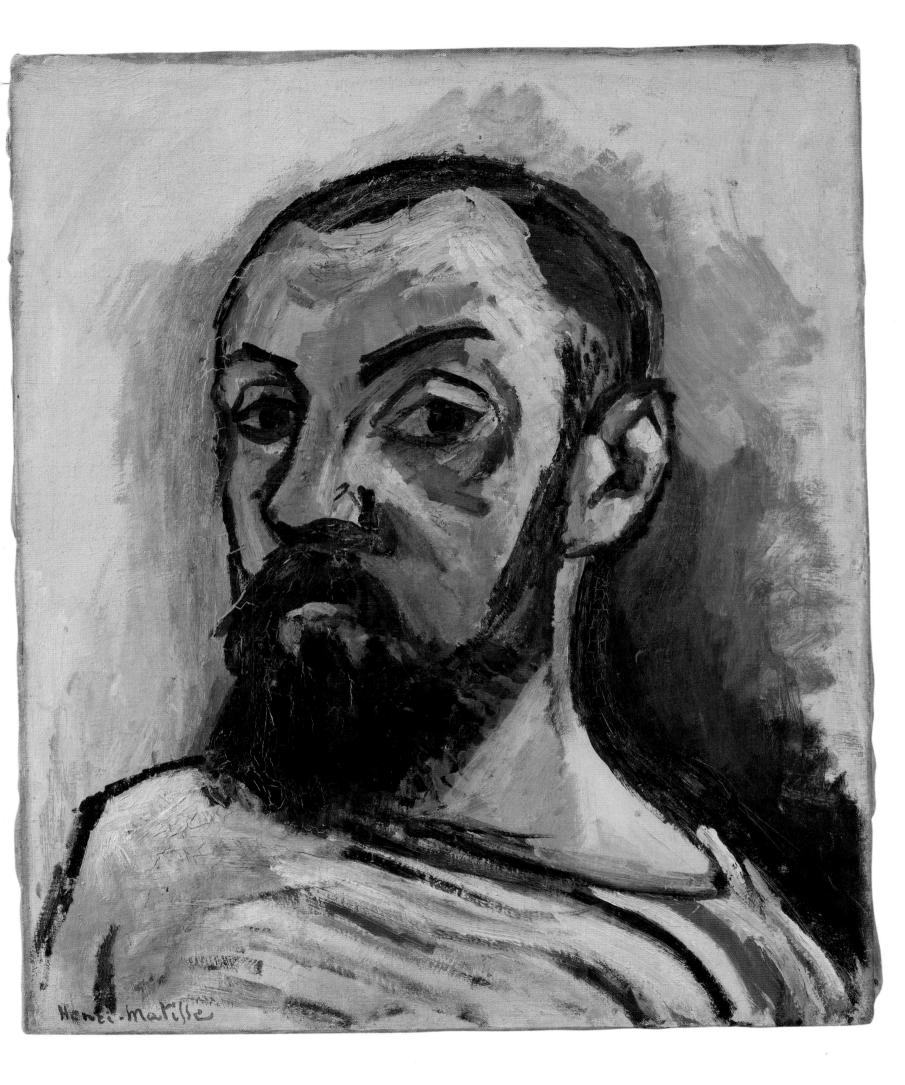

The birth of Fauvism

The results of the experiments of Matisse and Derain were put on display later that year at the Salon d'Automne (the Autumn Salon), a new exhibiting body (founded in 1903) that was far more progressive than the official Salon. Matisse, Derain, and a group of like-minded friends arranged their paintings together, creating an extraordinary array of brilliant, non-naturalistic colours. This caused a sensation, prompting one critic to dub the group *Les Fauves* (wild beasts). Matisse's main contributions to the exhibition were *The Open Window* and a remarkable

portrait of his wife, which is often known simply as *The Green Stripe* (1905), because of the broad slash of colour that divides her face.

The Fauve group included Albert Marquet, Maurice de Vlaminck, Othon Friesz, Georges Rouault, Kees van Dongen, and Raoul Dufy, but it never had a common manifesto. When Matisse analysed his feelings about Fauvism a few years later, he said that it had been "the result of an instinctive need which I felt and not of a deliberate decision"; his aim was to combine colours in "an expressive and constructive manner".

The vogue for Fauvism was brief, lasting only until around 1907. After this, the group disintegrated, as individual members developed their work along different lines. Fauvism was soon eclipsed by new ideas and new movements – especially Cubism, spearheaded by Braque and Picasso – but it was to be a seminal influence on the Expressionists.

Ordered colours

Matisse was briefly affected by Cubism, with compositions such as *The Piano Lesson* (1916), showing a more ordered, geometric structure. Colour remained his primary concern, although he began to place increasing emphasis on harmony and unity, using fewer colours but orchestrating them carefully for optimum aesthetic effect. In *The Blue Window* (1913), for example, Matisse's colours are not naturalistic, but it is the sheer beauty of their tonal relationships that catches the eye. The painting is, in a sense, a symphony in blue, but it is made all the more effective by the isolated splashes of red and yellow. Scholars have questioned whether Matisse used a "black mirror" (also known as a Claude glass, after the 17th-century

painter Claude Lorrain) for this work. This device is a tinted, slightly convex mirror, which works by neutralizing the colours of objects that it reflects, so helping the artist to discern and compare the tones within a scene without the distraction of colour.

By now, Matisse had attracted wealthy patrons, such as the Russian tycoon Sergei Shchukin and the American writer Gertrude Stein. Their support, in addition to a lucrative deal with the Bernheim-Jeune Gallery in Paris, enabled him to travel widely, and over the years, he visited North Africa, Russia, the United States, and much of Europe. This broadened his interests and influences, and gave him

▽ **THE OPEN WINDOW, 1905**
Matisse tackled one of his favourite themes – a view through a window – in this painting, made in the French coastal town of Collioure. The vibrant, unnatural colours were a tool of expression rather than representation, and Matisse likened them to "sticks of dynamite".

" What I **dream** of is an art of **balance,**
of **purity,** and **serenity.** "

HENRI MATISSSE, *LA GRANDE REVUE*, 25 DECEMBER 1908

death. Matisse, however, added more contemporary references. The yellow stars resemble shell-bursts, and the red circle in the figure's chest looks suspiciously like a bullet wound.

Final years

Matisse's last major undertaking before his death at the age of 84 was the decoration of a chapel at Vence for a community of Dominican nuns. One of these, a former model, had nursed the artist during his convalescence. Matisse oversaw every aspect of the design, right down to the details of the priests' vestments. He was too frail to attend the dedication ceremony, but the glorious chapel serves as a fitting memorial to his prodigious talent.

◁ **DANCE, 1910**
The rhythmic arrangement of the figures and the bright and vibrant palette give this painting – made for the Moscow palace of Sergei Shchukin – a tribal, ritualistic, and "primitive" quality.

a particular fascination for decorative Middle Eastern textiles. Matisse developed a repertoire of favourite themes, such as sensual nudes and odalisques, brightly coloured interiors, and lush still lifes with exotic fruit and flowers. He was criticized by some for avoiding subjects that reflected the grim realities of life, but such comments were largely unjustified.

In 1941, Matisse underwent major operations for intestinal cancer, which left him seriously disabled, and the following years were bleak: not only had his wife demanded a formal separation, but he was living in the midst of a war zone, under very stressful circumstances.

It was in this environment that Matisse began producing his paper cut-outs (see box, right), the finest of which were reproduced as stencil prints in a memorable art-book, *Jazz* (1947). With their intense colours and childlike style, these designs appeared at first glance to be joyous and celebratory, but on closer inspection, the imagery displays undercurrents of violence and death. *Icarus*, for example, looks like a straightforward depiction of the ancient Greek legend about the young man who flew too close to the sun, before plummeting to his

ON TECHNIQUE
Paper cut-outs (*gouaches découpées*)

As he grew more infirm, Matisse developed a new technique of producing artworks. He cut shapes out of brilliantly coloured paper and, with the aid of assistants, pinned these onto a base. Matisse then rearranged the forms until he was satisfied, before having them pasted into place. He enjoyed the directness of this process, likening it to a sculptor carving into a block of wood. "It is a simplification for me. Instead of drawing an outline and putting the colour inside it... I draw straight into the colour."

HENRI MATISSE WORKING ON HIS PAPER CUT-OUTS

◁ **ICARUS, 1947**
One of 20 plates in the book *Jazz*, this image was derived from Matisse's cut-outs. It has been interpreted as a metaphor for the artist.

KEY MOMENTS

1904
Joins Paul Signac in St-Tropez, where he briefly experiments with a Pointillist style.

1913
Visits Morocco and paints the exotic and dreamlike *The Arab Coffeehouse*.

1921
Inspired by his travels in the Middle East as well as his meetings with Renoir, he paints *Odalisque with Red Culottes*.

1932–33
Following his visit to the USA, he accepts a commission for a set of murals for the Barnes Foundation.

1948–51
Takes on a project at the Chapel of the Rosary at Vence, for which he designs stained-glass windows, murals, and ceramic tiles.

Piet Mondrian

1872–1944, DUTCH

The paintings of Mondrian reveal his spiritual quest to find a cosmic harmony within his art, a journey that led him from painting the natural world to embracing pure abstraction.

Born in Amersfoort, near Utrecht, in the Netherlands, Pieter Cornelis Mondriaan (he dropped one "a" later in life) had a traditional and somewhat strict Calvinist upbringing. He was initiated in drawing and painting by his father, a school headmaster and amateur artist, and his uncle Fritz, a successful painter. His father encouraged Piet to train as a teacher of drawing – a stable occupation – but after receiving his teaching licence in 1892, Piet determined instead to become a professional artist.

In the same year, he moved to Amsterdam to study at the Academy of Fine Arts. Here, he soon became involved in artistic societies and bohemian social circles. He managed to support himself financially through portrait commissions and by giving lessons to the fashionable rich.

Nature painting

After completing his initial studies, Mondrian applied for the Dutch Prix de Rome – a prestigious scholarship that entitled its holder to a period of study in Italy – but he was rejected in 1898 and again in 1901. The second rejection led him to abandon his paintings of human figures, which had been criticized by the judges. Instead, Mondrian turned his focus towards landscapes – country scenes of farmhouses, trees, and rivers, painted mainly in the open air in the impressionistic style favoured by the French artist Claude Monet.

Although his works became less representational over time, they were hardly radical and showed little of the extreme direction that he was to take later. These canvases, however, did point towards Mondrian's interest in perspective as well as his passion for the natural world, which was cemented during a year's stay in the rural town of Uden in 1904.

Around 1908, Mondrian began to develop a more distinct style, translating his trees, flowers, and windmills into flat, simplified forms painted in intense, sensual colours. His work at this time was influenced by Symbolist painters, who prized the expression of an idea over realistic depictions of nature, and also by his burgeoning interest in theosophy – an esoteric belief system that holds that a single supernatural cosmic force underpins the material reality experienced by humans, and that this higher spirituality can be grasped through personal mystical experiences. The movement, which combined theories from a variety of mystical traditions and religions, became popular in the late 19th and early 20th centuries.

Spiritual searches

Taking nature as his starting point, Mondrian experimented with different artistic approaches in an attempt to

△ **THEOSOPHICAL SYMBOLISM**
This design, attributed to Helena Blavatsky, a key proponent of theosophy, includes a hexagram (representing spirit and matter intertwined) enclosed within a snake swallowing its tail (immortality).

▷ **WILLOWS WITH SUN**, 1902
This painting is more an exploration of the rhythmic relationships between horizontal and vertical lines than a strict attempt at representation. It looks forward to Mondrian's use of line and colour in his later abstract works.

> " I believe it is possible by means of **horizontal** and **vertical** lines... to arrive at a work of art which is **strong** as it is **true.** "
>
> PIET MONDRIAN

▷ **SELF-PORTRAIT, 1918**
Mondrian made numerous self-portraits during his life. This work, commissioned by an admirer, shows the artist in front of one of his compositions of colour panes, in which he was experimenting with the principles of Neo-Plasticism (see over).

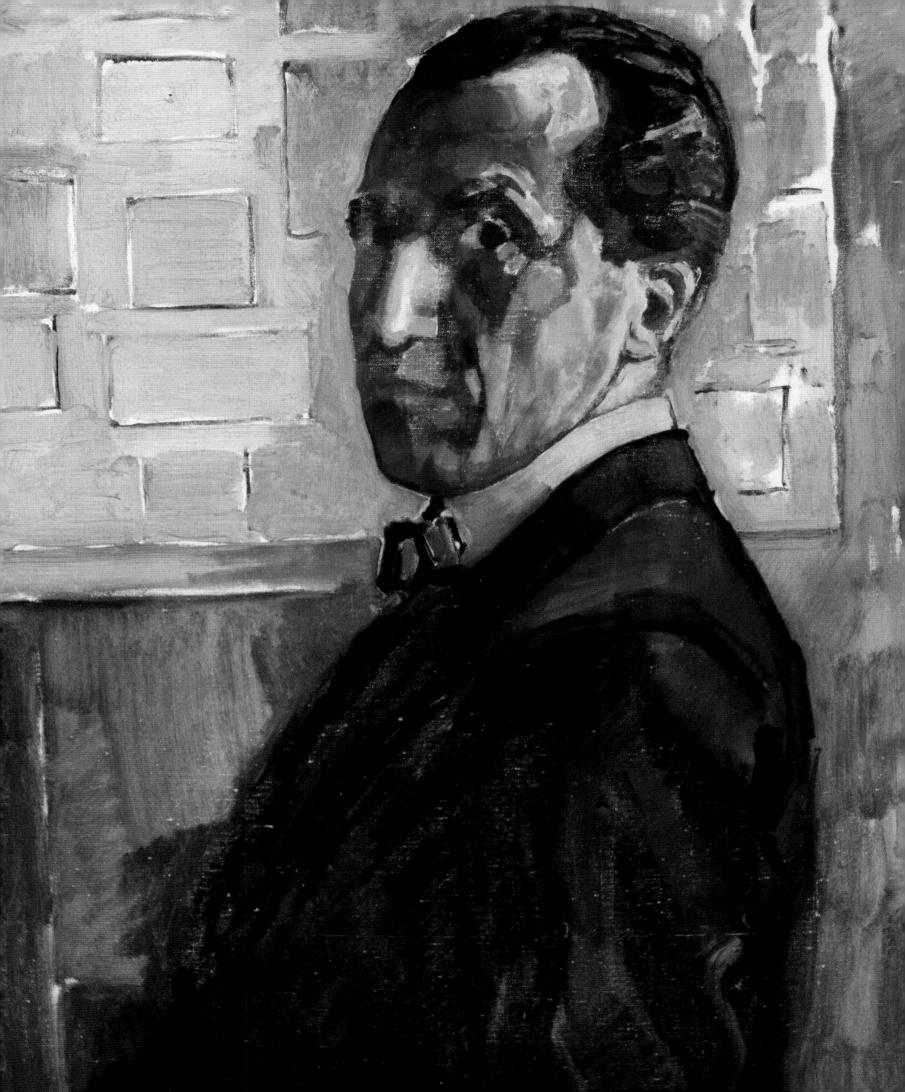

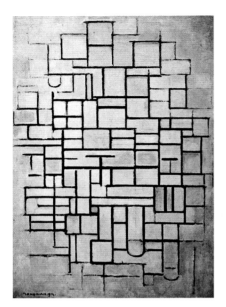

△ **COMPOSITION NO 6, 1914**
Based on an architectural pattern, this delicate equilibrium of vertical and horizontal lines shows Mordrian's move towards total abstraction. By this point in his career, he had almost entirely eliminated curved lines from his work.

connect the earthly world that he encountered with the immaterial, spiritual plane. First, he adopted a Pointillist technique, employing diffuse dabs of luminous colour to build up images of sand dunes and sea views, painted during regular trips he made to the Dutch seaside town of Domburg.

Mondrian thought that he had discovered the visual language needed to express the spiritual message of his theosophical beliefs when he encountered Cubism on a visit to Paris in 1911. This revolutionary form of representation, developed by Pablo Picasso and Georges Braque, put multiple perspectives of a subject into one fragmented, abstract image.

Mondrian moved to Paris – then the art capital of the world – in 1912. He continued to fuse his work with the Cubist approach of transforming visible reality into planes and lines, and linked this "dematerialization" with his theosophical beliefs. This evolution in his work can be seen in a series of compositions in which natural, tree-like forms are all but obliterated by abstraction.

▷ **COVER OF 1917 ISSUE OF DE STIJL**
The journal *De Stijl* (The Style) gave its name to a movement in art and architecture. It advocated simplifying compositions into linear forms using black, white, and primary colours.

▷ **COMPOSITION WITH RED, YELLOW, AND BLUE, 1921**
In this arrangement of simple rectilinear shapes, Mondrian has entirely abandoned naturalistic art in search of a universal visual language.

The birth of *De Stijl*
Mondrian's experiments were interrupted by the outbreak of World War I. He was away from Paris, on holiday in the Netherlands, when the fighting began and was forced to remain in his home country for the duration of the war, staying at an artists' colony in Laren. This unforeseen change in circumstances proved to be productive because at Laren he met two artists, Theo van Doesburg and Bart van der Leck, who, like Mondrian, were interested in new theories on art. Together, in 1917, they published the journal *De Stijl* (The Style), in which they wrote about their ideas.

Neo-Plasticism
While he had made earlier attempts to put his own theosophical theory of art into writing, *De Stijl* gave Mondrian a platform to outline the theoretical basis for all his future work. He had moved away from Cubism, dismissing its homey subjects of violins and jugs, before abandoning figuration altogether by around 1918.

He was no longer looking for an interpretation of visual reality (like the Cubists) but seeking to depict spiritual reality – a way to make his paintings a space in which the cosmic laws might be revealed, with the artist as mediator.

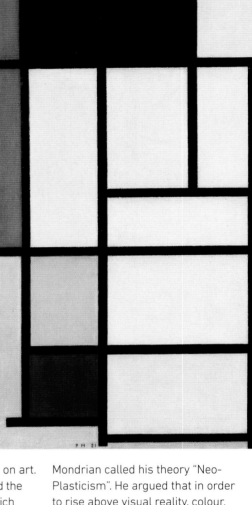

Mondrian called his theory "Neo-Plasticism". He argued that in order to rise above visual reality, colour, line, and form must be simplified and reduced to their essentials until they reached pure abstraction. Composed in a harmonious manner, these elements would provide the means through which viewers could become aware of their connection to the hidden cosmic power that lies beyond appearance.

From the time he returned to Paris after the war in 1919, Mondrian restricted himself to working only with vertical and horizontal lines, with an increasingly narrow range of colours filling the planes in between. This development can be seen in works such as *Composition with Red, Black, Yellow, Blue, and Gray* (1921). His studio at 26 rue du Départ was visited by

" The purer the artist's '**mirror**' is, the more **true reality** reflects in it. "
DORE ASHTON, 1985

other members of the international avant-garde and he himself started to receive wider attention, showing his work in America for the first time.

Throughout the 1920s, Mondrian continued to refine his theories and modify his compositions in his continued search for a language of pictorial harmony; he began using only pure primary colours of red, yellow, and blue alongside black and white; forms and lines were dynamically shifted to the canvas edge; and, between 1924 and 1925, he made several diamond-shaped paintings in which the visual elements were reduced to their most extreme minimum yet. Around this time, he also distanced himself from van Doesburg – Mondrian felt he was not absolute enough in his own pursuit of harmoniously geometrical artworks.

From 1932, Mondrian began to experiment with lines so wide that they became blocks of colour, blurring the distinction between line and form and leading him to search for a new equilibrium in his compositions.

Late works in New York

The rise of Fascism in Europe in the 1930s cast a shadow over many freedoms. Fearing the approach of war, Mondrian left Paris for England in 1938, where his accommodation was arranged by his friend the artist Ben Nicholson. When World War II did finally break out, he moved again, this time to New York. There, along with many other artist refugees from Europe, Mondrian settled down to work influenced by his new surroundings. His *Broadway Boogie Woogie*, for example, was inspired by the jazz "rhythm of America".

Mondrian's studio at 15 East 59th Street became a hive of activity, as he mapped out works using paper tape for the first time. However, many of these works would remain incomplete: in early 1944, Mondrian developed pneumonia and died, aged 71. The long list of émigré artists and New York notables who attended his funeral is testament to his importance, and his position as a major figure of 20th-century art holds firm today.

ON TECHNIQUE
Mondrian's studios

Mondrian sought to erase the distinctions between painting, sculpture, and architecture. He applied to his workspaces the same quest for essential forms and colours that guided his painting. His studios in Paris and New York were painted bright white, with all superfluous objects removed. All that was visible was his work and some simple, home-made, geometric furniture, decorated sparingly with primary colours. He was constantly moving and rearranging to create a harmonious whole. Mondrian's studios were famous in his lifetime. They were carefully photographed and archived after his death.

A RECONSTRUCTION OF MONDRIAN'S STUDIO IN PARIS

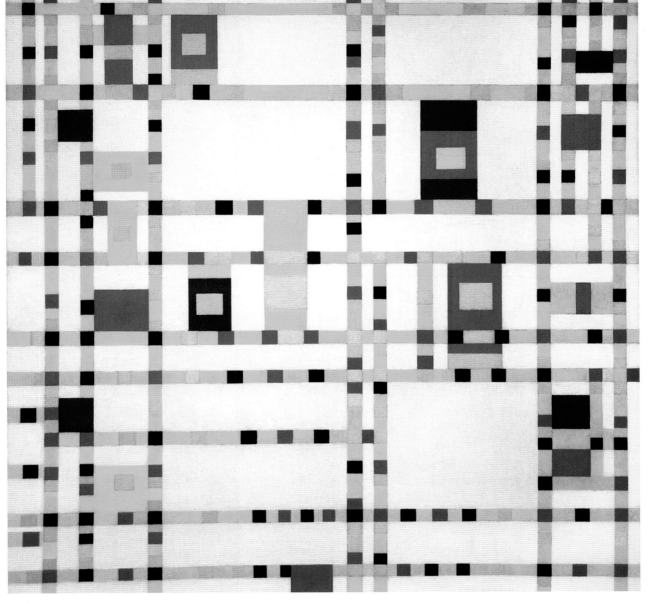

◁ *BROADWAY BOOGIE WOOGIE,* *1942–43*
The pulsating lines and energetic composition of Mondrian's last finished work are a tribute to his adopted home of New York, calling to mind the city's gridded streets.

Constantin Brancusi

1876–1957, ROMANIAN

One of the greatest of all the Modernists, Brancusi revolutionized sculpture with the extreme simplicity of his forms and pioneered the technique of carving directly into the material.

Constantin Brancusi grew up in a peasant family in the village of Hobitza in a rural area of Romania near the Carpathian Mountains. As a young boy, he herded the family's sheep and learned to carve wood – a traditional craft used to decorate household objects – and in his teenage years worked in a variety of jobs in the city of Craiova.

Brancusi taught himself to read and write, and at the age of 18 enrolled at the Craiova School of Arts and Crafts, sponsored by an industrialist who had been impressed by the boy's wood-carving skills. Four years later, he was admitted to the Bucharest School of Fine Arts, where he studied sculpture in the Academic style that was prevalent at the time.

Education in Paris

In 1904, Brancusi travelled to Paris – completing most of the journey on foot – and joined the Ecole des Beaux-Arts. Soon he was accepted into the city's circle of intellectuals and artists, including Henri Matisse, Amedeo Modigliani, Marcel Duchamp, and Jean Cocteau, among others. He worked briefly in Rodin's workshop, but left after a short time, saying that "nothing grows in the shade of great trees". Brancusi's early works showed

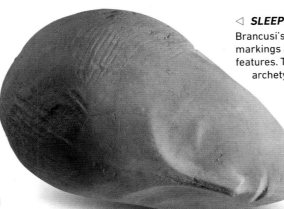

◁ **SLEEPING MUSE I, 1909–10**
Brancusi's marble head has minimal markings and contours to indicate facial features. The sculpture is an elegant, archetypal modern form.

the influence both of his Academic training and of Rodin, and his first pieces were exhibited in 1906 at the Salon d'Automne. After parting ways with Rodin, he started to develop the pared-down, simplified forms that were to revolutionize sculpture.

Direct carving

In 1908, Brancusi made *The Kiss*, carved from a single block of stone. A symmetrical depiction of two lovers facing each other, reduced not quite to the point of abstraction, their torsos fused, their arms entwined, their features incised into the stone, this was the artist's breakthrough into his new style of extreme simplification of subject-matter. This was one of his earliest attempts at the method of direct carving (see box, right) that became his preferred technique.

He went on to make several versions of *The Kiss*, a pattern that he repeated throughout his life, revisiting and reworking the themes that interested him.

In rejecting the representational and emotional qualities in sculpture that typified Rodin, Brancusi turned towards the "primitive" art of Africa and Asia for inspiration, as well as to the folk art of his homeland. References to an archaic, non-Western art allowed him to express timelessness and universality in his work as part of his seeking the essence of things. The influence of traditional folk carving was particularly evident in his wood carvings – he also made most of his own furniture.

Modernist archetypes

Despite the abstract, minimalist style that he evolved, Brancusi claimed that his works addressed the "hidden reality" of his subjects. For example, in *Sleeping Muse I*

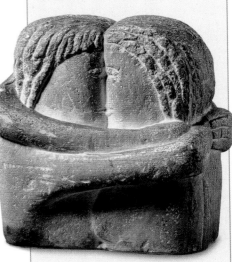

THE KISS, 1908

◁ **PORTRAIT, c.1928**
Brancusi treasured his Romanian peasant roots, dressing and living simply. He celebrated Romanian culture, food, music, and mythology.

> " Simplicity is not an **objective** in art, but one achieves **simplicity** despite one's self by entering into the **real sense** of things. "
>
> CONSTANTIN BRANCUSI

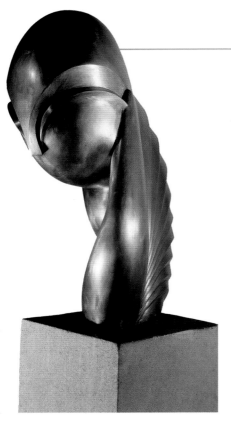

> " Don't look for obscure formulas or **mystery**
> in my work. It is **pure joy** that I offer you.
> Look at my sculptures until you **see them**. "
>
> CONSTANTIN BRANCUSI

(1909–10), he modelled a portrait bust of Baroness Renée-Irana Frachon as a smooth, disembodied head, an oval of polished marble with the features lightly worked, ethereal, and serene, giving it a sense of timelessness and spirituality. He returned to the theme of the head frequently in his work, making numerous variations in marble and bronze, including *Mademoiselle Pogany* (1912–13), a smooth, white, oval, marble head and arms with exaggerated almond-shaped eyes, which he carved from memory. The culmination of these experiments with the oval form was *The Beginning of the World* (1920), in which a marble egg-shape placed on a polished bronze circle evokes fertility and cosmic origins.

Critics and controversy
In 1913, Brancusi took part in the Armory Show in New York – the first American exhibition of modern art;

and in 1914, he had his first solo show in the USA at Alfred Stieglitz's avant-garde gallery "291". Although the radical nature of his work baffled many critics and earned derisive reviews, he became increasingly popular with American, French, and Romanian collectors. In 1920, controversy developed into outright scandal with the display of one of his works in the Salon des Indépendants in Paris: *Princess X* – supposedly a portrait bust of an anonymous sitter (whom he subsequently identified as Princess Marie Bonaparte, great-grandniece of Napoleon) – was a highly polished bronze sculpture of an abstracted human form. However, the phallic shape of the sculpture led to its being deemed offensive, and – despite Brancusi's protestations that the sculpture in fact represented the "essence of womanhood" – he was obliged to withdraw the artwork from the show.

The bird sculptures
Brancusi spent his life exploring certain forms that he returned to again and again, refining and honing numerous variations. Perhaps his most famous series was that of 29 birds, which he created between 1910 and 1944.

His first bird sculpture, *Maiastra* (1910–12), was a recognizable bird form on a succession of plinths that referenced the magical Master Bird, the beautiful messenger of love in Romanian fable. Brancusi's later birds, however, became more abstract. In his many versions of *Bird in Space*, the shape is elongated and elemental – an attempt to represent pure flight, enhanced by the use of highly polished bronze that allows the light to interact with the sculpture.

In 1926, a version of *Bird in Space* was the subject of a celebrated legal case after it was impounded by US customs officers who wanted to charge duty on it as an industrial object rather than a (duty-exempt) work of art. After two years, Brancusi won the case, and the definition of what constituted a work of art – at least in legal terms – was widened.

Monuments
Throughout the 1920s and '30s, Brancusi continued to exhibit in the USA. His growing fame on the international stage led to an exciting commission from the maharaja of Indore, central India, which was

to include a temple made of marble to house the sculptor's works. He spent several years working on this project, but sadly the maharaja lost interest in what would have been a remarkable Modernist monument, and it was never built.

Romanian memorials

In 1938, Brancusi returned to his native Romania to inaugurate his one monumental work, at Târgu Jiu, near his birthplace. This monument to commemorate the Romanian soldiers who died in World War I was formed of three elements: *Table of Silence*, *The Gate of the Kiss*, and *Endless Column*, arranged on an east–west axis 1,300m (4,250ft) long. *Endless Column* was a final variant of another series that had occupied Brancusi for many years, the first, wooden, version dating to 1918. The monument was Brancusi's last major work. In his final years, he carved few pieces but looked after his studio, which he regarded almost as a work of art in itself. He was concerned with the way sculptures were positioned in relation to one another; if he sold one he would make it again in plaster so as to maintain the harmony of the space.

◁ **BIRD IN SPACE, 1940**
Brancusi aimed to embody the pure essence of flight in the slender, curved, tapering, highly polished variants of this work.

KEY MOMENTS

1908
With *The Kiss*, he begins to express his vision of the essence of things.

1910
Begins his series of bird sculptures, which he develops over the following 30 years.

1918
Makes his first version of *Endless Column* in his studio, extending it over several years.

1926
A version of *Bird in Space* is classified as a "utilitarian object" by the US customs.

1937
Travels to India to meet the maharaja of Indore, who is interested in a monumental commission.

1943
Makes *The Seal*, a simple marble form symbolizing a body rising from the ground.

Brancusi became a French citizen in 1952 and bequeathed his unsold works to the state, on condition that it recreate his studio exactly as it was left on his death. He died at the age of 81 and is recognized as a major influence on sculptors such as Isamu Noguchi, Henry Moore, Barbara Hepworth, and Jacob Epstein, in particular for his use of organic shapes and his direct engagement with his materials. The Minimalist movement of the 1960s also owes a debt to his pared-down forms.

▽ **THE STUDIO AS ART**
Brancusi's studio has been recreated at the Pompidou Centre in Paris by the Italian architect Renzo Piano. The sculptures are arranged as they were at the time of Brancusi's death.

Paul Klee

1879–1940, SWISS/GERMAN

Klee drew inspiration from several movements – Cubism, Orphism, Surrealism – but tied himself to none. Instead, his paintings display a unique blend of fantasy, wit, and invention.

◁ **KLEE IN BERNE**
As a student, Klee showed great musical talent. His interest in music continued throughout his adult life.

Paul Klee was born on 18 December 1879 in Münchenbuchsee, a small town near Berne in Switzerland. His father was German and – like him – Paul held on to his German citizenship throughout his life. Both his parents were musical and the boy inherited their gifts. He learned the violin at an early age and played with the Berne Municipal Orchestra from the age of 10. In spite of this ability, there was never any doubt about Klee's future career as an artist, and in 1898 he moved to Munich to begin his training. He attended a private art school before studying under Franz von Stuck at the city's Academy of Fine Arts.

Artistic development
Stuck was an important Symbolist painter, but also a fine graphic artist, and it was this aspect of his work that left the deepest impression on the young Klee. During the first years of his career, he concentrated primarily on etching, producing images that were often humorously grotesque or satirical. Although Klee enjoyed some success with these, his

◁ **THE ARTIST AT THE WINDOW, 1909**
Klee worked extensively in monochrome before developing his sense of colour. This early watercolour is believed to be a self-portrait.

main income still came from playing with the Berne Orchestra. In 1906, he married pianist Lily Stumpf and, for a time, she became chief breadwinner.

Among the avant-garde
Klee's fortunes changed when he started to move in more progressive artistic circles. In 1911, he met Wassily Kandinsky (whose experiments in abstract art fascinated Klee), exhibited with his Expressionist group *Der Blaue Reiter* (The Blue Rider), and became firm friends with the painters Franz Marc and August Macke.

In the autumn of 1912, Klee paid a brief but crucial visit to Paris, where he became acquainted with the latest developments in Cubism, which were being spearheaded by Pablo Picasso and Georges Braque. Klee was particularly excited by Orphism, Robert Delaunay's variant of the style, in which he straightened out Picasso and Braque's tilted planes and replaced their greys and muddy browns with "windows" of bright colour. Klee visited Delaunay's studio and translated an article in which the Frenchman outlined his theories, and had it published in Germany.

Klee's growing commitment to colour was confirmed in 1914, after his trip to Tunisia with Macke and another painter, Louis Moilliet. All

△ **RED AND WHITE DOMES, 1914**
Inspired by his travels in Tunisia, Klee produced paintings comprised of blocks of colour in harmonious arrangements, analagous to musical compositions.

three were dazzled by the strong sunshine and powerful colours, and this experience had a profound effect on their respective palettes. The results were immediately apparent in Klee's watercolours, but his experiments were cut short by

> "**Colour possesses me...** It possesses me forever, I know. **Colour and I are one** – I am a painter."
>
> PAUL KLEE, WRITING DURING HIS VISIT TO TUNISIA, 1914

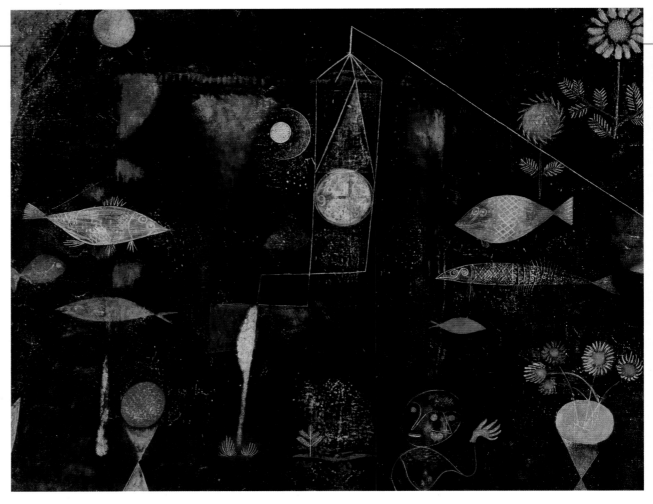

the outbreak of World War I. Klee was not called up until 1916, and even then he was not sent to the Front. He spent most of the time at a pilot-training airfield in Bavaria, serving initially as ground crew and later carrying out office duties. This enabled him to continue painting in his spare time. Sadly, however, he lost some close friends in the fighting – both Macke and Marc were killed in action.

Postwar successes

After the war, Klee made rapid progress. In 1919, a major exhibition in Munich helped to secure his reputation and the first books about his art went into print. Klee's raised profile led to an invitation to join the teaching staff of the newly formed Bauhaus – an art school founded in Weimar in 1919 by the influential German architect Walter Gropius – which proved to be the single most important step in the artist's career. The Bauhaus was to become the most significant cultural hub in Germany in the interwar years, and Klee remained there for a decade, during its most productive period.

Klee took up his post in 1921, teaching initially in the stained-glass, bookbinding, and weaving workshops. Soon, however, he was also asked to provide lectures on drawing, painting, and design for the introductory course. Klee turned out to be a superb teacher, extremely popular with the students, and the work itself was congenial. His friend Kandinsky was also on the staff and, when the Bauhaus relocated from Weimar to Dessau in 1925, the two men set up their homes and studios in adjoining parts of the same building.

> " I want to be as though **newborn**, knowing absolutely **nothing**... almost **primitive** "
>
> PAUL KLEE, CITED IN GEORGE HAMILTON, *PAINTING AND SCULPTURE IN EUROPE, 1880–1940*

▷ **TWITTERING MACHINE, 1922**
In this witty fantasy, Klee demonstrates why the Surrealists were so fond of his work. A row of comical birds perch on a spindly machine, ready to squawk when the handle is turned.

Thought and theory

While at the Bauhaus, Klee defined his personal approach to the purpose and the practice of art, and many of his theories were later published, notably in his *Pedagogical Sketchbook* (1925). The ready exchange of ideas at the school also provided him with a great deal of inspiration – almost half of his entire output was produced during his Bauhaus years.

In 1925, Klee attracted the attention of the Surrealists and was invited to participate in their first group show in Paris. It is easy to see why the offer was forthcoming. Klee had much in common with the movement. His taste for juxtaposing seemingly unconnected objects and his apparent use of automatic drawing were classic Surrealist traits, but Klee played down the role of the subconscious in his work. It was true, he confessed, that he sometimes gained inspiration from a doodle or an accidental flick of paint, but the finished work was always the result of a firm idea.

Changing visions

Klee's style was affected by a second trip to Africa. In the winter of 1928–29, he toured Egypt. This time his interest was piqued by the vastness of the desert and the scale of ancient monuments. He also became fascinated by hieroglyphs and, from this time, his work often featured curious signs and symbols.

Klee had a magpie style, drawing on many influences but steering clear of specific manifestos or movements. At times he came close to abstraction, but he was always adamant that nature was the essential departure point for all forms of artistic creativity. He also maintained that the process of forming a work was more important than the finished product. Certainly, his pictures often appear deceptively simple, masking the complex array of techniques that he employed. In *Fish Magic*, for example, he added a thin layer of black paint over an undercoat of brilliant colours. He then scraped sections of the black away to form his images. He also glued an oblong strip of muslin to the canvas, adorning it with a clock. A long, diagonal line extends away from it like a piece of cord, seeming to imply that the muslin is a veil, which could be torn away to reveal new secrets. This was typical of Klee's playful, theatrical approach.

Oppression and darkness

Klee displayed a fiercely independent attitude in all his dealings. In 1931, he left the Bauhaus, tired of its internal wrangling and politics, and accepted a post at the Düsseldorf Academy. However, the rise of Nazism soon cast a shadow over modern art in Germany (see right). Klee was denounced by a Nazi newspaper and removed from his post, after which he returned to his native Switzerland.

His homecoming was far from trouble-free. From 1935, Klee began to suffer the effects of scleroderma – the rare skin disease that was to kill him. He continued to paint, but his work lost much of its lightness and humour, assuming a gloomier tone. There were problems, too, with the authorities. Klee was still a German citizen and, in spite of his birth, his applications for Swiss citizenship met with stubborn refusal. In the end, permission was only granted on the day after his death, on 29 June 1940.

△ **DEATH AND FIRE, 1940**
As his final illness took hold, Klee's paintings become coarser and gloomier. Here, the letters TOD (the German word for "death") form the features of an ashen face with a rigor-mortis smile.

IN CONTEXT
"Degenerate Art" exhibition

During the 1930s, the careers of many modern artists were blighted by the growing hostility of the Nazi regime. Paintings were confiscated, art schools were closed down, and, in 1937, the hate campaign reached a crescendo with a notorious touring exhibition of "degenerate art". Works by avant-garde artists were placed alongside paintings by the insane, and held up to ridicule and abuse. The show was a huge propaganda coup, which attracted more than two million visitors.

HITLER AND GOEBBELS VISITING THE 1937 EXHIBITION IN MUNICH

KEY MOMENTS

1904
Produces *Comic Actor with Mask*. His early etchings are inspired by the graphic art of Francisco Goya and William Blake.

1919
Experiments with Cubist ideas in *Villa R*, which features multiple perspective, rectangular blocks, and a large stencilled letter R.

1925
Klee's *Pedagogical Sketchbook* is published. It begins with a now famous quote: "An active line on a walk, moving freely, without goal...".

1929
During a trip to Egypt, Klee is inspired by the vast scale of the ancient monuments and the desert to produce near-abstract works.

1933
With the rise of Hitler in Germany, Klee is denounced as a "cultural Bolshevik". His work is deemed to be subversive and he is dismissed.

Pablo Picasso

1881–1973, SPANISH

Endlessly inventive, with an emphatic command of every artistic means he employed, Picasso energetically shaped modern art like no other and became the definitive artist of the 20th century.

◁ **BULLFIGHT MOTIF**
Picasso returned frequently to the subject of bullfighting, and was fascinated by the ancient theme of the triumph of man over beast.

Pablo Ruiz Picasso was born in 1881 in Malaga, Spain. His father, José Ruiz Blasco, was an art teacher and painter of animals (considered to be a lowly genre) who would take his young son to watch traditional Spanish bullfights, which became the subjects of some of Picasso's earliest drawings. His talent developed quickly under his father's tutelage, and when José took a post as a professor at the art school at La Coruña in Galicia, northern Spain, Picasso joined him as a pupil. Here, from 1892 to 1894, he took drawing classes, copying casts of human figures and painting from nature – lessons that formed the basis of a 19th-century artist's Academic instruction. This imbued Picasso with an assured knowledge of form, colour, and line that would create the bedrock of his later experiments.

Studies in Barcelona

After the death of Picasso's younger sister from diphtheria, the family moved to Barcelona in 1895, seeking better fortune. José took a teaching job at La Llotja School of Fine Arts, and – after passing the school's entrance tests – Picasso enrolled there as a student.

The school provided Picasso with a sound technical grounding (evident in the Academic accomplishment of *Science and Charity*, see below) but allowed little room for imagination; by his mid-teens he was tiring of painting conventional genre scenes and anatomically correct nudes (invariably male) from life.

◁ **SCIENCE AND CHARITY, 1897**
Picasso made this genre painting at the age of 15. It shows a doctor (modelled by his father) visiting a patient, and may have been inspired by his sister's illness.

Picasso's father was an artist of limited talent, best known for his paintings of pigeons (which Pablo referenced in several of his later works). However, he was ambitious for his son and steered him towards a more lucrative career in Academic painting. He determined that Pablo – still only 16 years of age – should move to Spain's most prestigious art school, the Royal Academy in Madrid.

Picasso very soon became disenchanted with the hidebound teaching at the Academy, which he found little more progressive than in Barcelona. He stopped attending classes, choosing instead to copy Old Masters by Velázquez and El Greco in the Prado and to paint outdoors in the city's parks. Much to his father's annoyance, Picasso returned to Barcelona, secured a studio in the city in 1899, and determined to start his career as an independent artist.

Key influences

Picasso began to make friends among the Modernistas – the artistic and intellectual circles that inhabited Barcelona's cafés. He befriended another young painter, Carlos Casagemas, with whom he shared a studio and, in 1900, made a trip to Paris – which was the epicentre

> " **Every child is an artist.** The problem is to **remain** an artist once they grow up... "

PABLO PICASSO

▷ **SELF-PORTRAIT WITH PALETTE, 1906**
Picasso's many self-portraits track the evolution of his persona. Here, at the age of 25, he presents himself as a sturdy and determined figure, staring outwards – palette in hand – as if in anticipation of his artistic future.

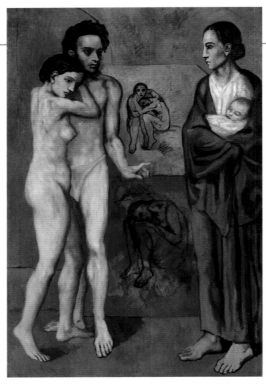

▷ *LA VIE*, 1903

This painting, with its cold blue hues suggestive of night and alienation, marks the culmination of Picasso's "Blue Period". Its complex, ambiguous composition includes the artist's friend Casagemas and a young woman, Germaine, who rebuffed Casagemas and whom he tried to shoot before taking his own life.

IN PROFILE
The artist and his lovers

Picasso's many relationships contributed to his personal legend. His fixation on the female form was evident throughout his career and – with his lovers often becoming his models – his works trace the twists and turns of his love life. Fernande Olivier was the main muse of his Cubist period, Olga Khokhlova of the Neoclassical, and Marie-Thérèse Walter of the Surrealist phase (she is pictured in *Nude in a Garden*). Dora Maar featured in works of the early 1940s and Françoise Gilot in the postwar years, while Jacqueline Roque was the muse of his old age. The themes of the artist and his muse, as well as the darker, animalistic side of lust, were ones that Picasso returned to repeatedly.

NUDE IN A GARDEN, PICASSO, 1934

of the art world at the time. These were restless years for Picasso as he tried to work out his own artistic style, splitting his time between Paris and Barcelona. He encountered the work of Henri Toulouse-Lautrec, whose colourful, sexually charged images of the Parisian demi-monde were worlds apart from the Academic manner Picasso had been trained in. He saw paintings by Paul Cézanne, Pierre Bonnard, and Edgar Degas, whose impressionistic brushwork and intense hues Picasso amalgamated into his own technique. Flat patches of colour and simplified drawings (such as can be seen in the work of Vincent van Gogh and Paul Gauguin) also influenced the diverse works produced in this period, including *Child Holding a Dove* (1901).

Blue and Rose

In February 1901, Casagemas committed suicide. Deeply affected by his friend's death, Picasso embarked upon a series of melancholic pictures of beggars, doomed lovers, and the sick and elderly, in which blue replaced the kaleidoscopic colours with which he had experimented. The despondent, displaced figures in such works as *The Old Guitarist* (1903–04), their features eerily elongated in the style of El Greco, embodied Picasso's reflections on life in this "Blue Period".

The following year, Picasso moved to Paris permanently and became part of the city's vibrant artistic community, which included the poet Guillaume Apollinaire, the collector Gertrude Stein, and artists André Derain and Henri Matisse. At this time, he started a relationship with one of his models, Fernande Olivier, which lasted for seven years. This change in circumstances was accompanied by a change in Picasso's work. Warmer colours of sandy pastel pink, red, and yellow emerged in the pictures of women, travelling artistes, and harlequins that characterized this "Rose Period" from 1904 to 1906. However, despite the changes of hue, these works were in many ways a continuation of his "Blue" paintings, a sense of melancholy underlying the cavalcade of circus folk.

Paths to Cubism

From 1905 onwards, Picasso's work began to move in a radically new direction. It bore some resemblance to the primitive African sculpture being "rediscovered" at the time, which the artist regarded as "the most powerful and most beautiful things the human imagination has ever produced". The simple but weighty forms of these tribal works are echoed in Picasso's paintings, which use expressive brushstrokes and bold, non-naturalistic "Fauvist" colours. Picasso's experiments were also informed by the work of Cézanne (see pp.230–33), who, two decades earlier, had depicted objects from multiple viewpoints within one canvas in order to show their three-dimensional nature.

Picasso's *Les Demoiselles d'Avignon* (1907) brings together these disparate influences in a bold departure from traditional ideas of composition and perspective. In this depiction of five naked prostitutes from a Barcelona

▷ TRIBAL MASK, GABON, AFRICA

Picasso's admiration for African art is echoed in some of the figures in his work (including *Les Demoiselles d'Avignon*), whose heads resemble tribal masks similar to this 19th-century example.

> " It took me four years to paint like Raphael, but a **lifetime** to paint **like a child**. "

PABLO PICASSO

brothel, Picasso strips the bodies of his subjects to their raw essentials in order to create a new primal representation of form. Despite breaching all previously accepted ideas of clarity and order, the composition still follows enough rules of balance to remain a unifying visual experience. The work catapulted Picasso into the spotlight, but it was just the start of his revolutionary journey. In 1907, he met the artist Georges Braque, and together they would push visual representation to its limits.

Analytical and synthetic

Picasso and Braque worked together to analyse and deconstruct their subjects into multiple views and perspectives, which they rendered in overlapping shades of black, grey, and ochre. The subject (typically a human figure or an everyday item such as a vase or guitar) was reduced to a number of geometric, cube-like outlines, and this approach – and the movement it inspired – became known as "Cubism". The first, or "analytical", stage of Cubism (1908–12) was succeeded by "synthetic" Cubism,

◁ *GUITAR*, 1919
Picasso combined oil paint, in flat fields of colour, with sand in this example of "synthetic" Cubism, which experiments with depth and space.

▽ **THE ARTIST AT HOME, 1960**
Picasso examines one of his sculptures at his house near Cannes in France. Versions of his *Les Demoiselles d'Avignon* can be seen, along with other works, on the wall behind the artist.

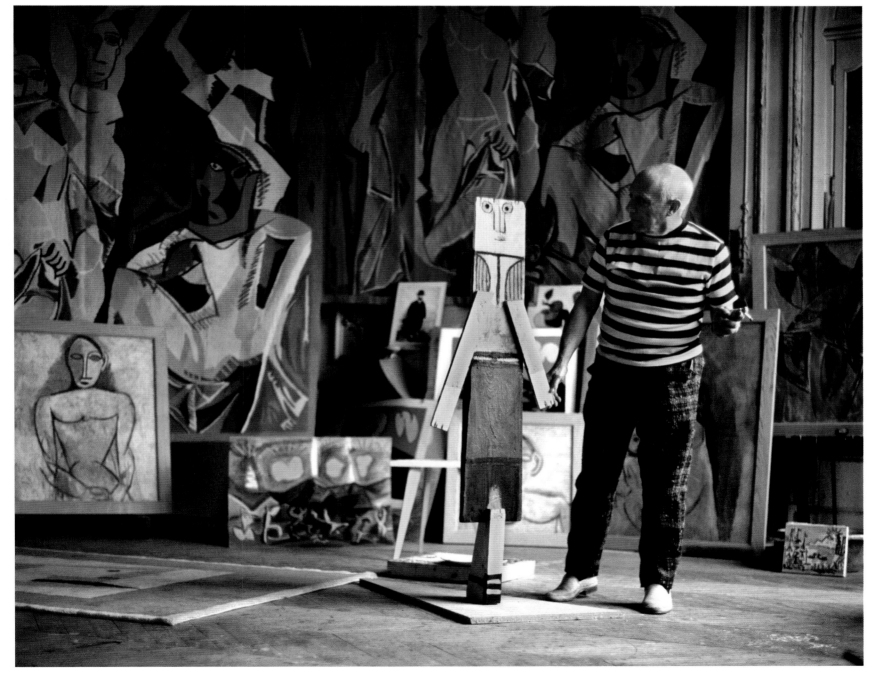

ON TECHNIQUE
Master of forms

Picasso's reputation was built principally on his paintings, but he experimented with many different artistic media throughout his life. He developed collage using found materials, and made sculptures from clay, metal, and a wide range of everyday objects, including (as below) partly recycled and partly carved wooden elements. He also illustrated books and magazines, made posters, created stage designs and costumes for operas and ballets, explored ceramics, and produced thousands of prints, etchings, and engravings – including a seminal series of prints for the French art collector Ambroise Vollard from 1930 to 1937. With everything he did, he showed the same mastery of form, colour, and design, using whatever means he felt necessary to achieve his artistic vision.

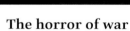

MANDOLIN AND CLARINET
(MIXED MEDIA), 1913

in which Picasso and Braque reduced subjects to even simpler shapes and brighter colours, flattening the image and ending any illusion of three-dimensional space. They also introduced new textures and materials into their works, making collages and "constructed sculpture" from found objects.

Wartime works

Picasso avoided the conflict of World War I, but many of his fellow artists were drafted or enlisted in the army. In wartime Paris, Picasso was part of an avant-garde group that included composer Eric Satie and writer Jean Cocteau. Through such acquaintances, he became involved with designing sets and costumes for Sergei Diaghilev's ballet company in Paris. It was here that he met the dancer Olga Khokhlova, who became his first wife and also his passport into high society.

Picasso continued to produce Cubist works in the 1920s, but also made paintings of human figures that followed more conventional rules of depiction, recalling the draped nudes of classical art. His *Large Bather* (1921), for example, shows a seated nude of exaggerated sculptural proportion, while *Woman in White* (1923) is a calming, romantic portrait, probably of his wife Olga. This "Neoclassical" phase of Picasso's work may have been an attempt to recapture an idyll of calm in reaction to the horror of mechanized war.

Soon, however, Picasso returned to experimenting with new approaches, taking the visual world as a starting point before pushing appearances to extremes. From the mid-1920s, he fell into the gravitational field of the

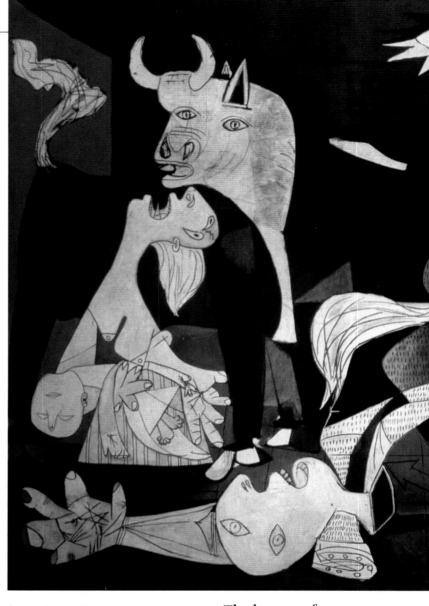

Surrealists, with their emphasis on the unconscious mind in works of the imagination (see pp.322–25). He never completely subscribed to Surrealist philosophy, but his work began to include fantastical and mythological creatures – notably the Minotaur – and primitive emotions of lust, fear, and violence hauled from the unconscious. Enmeshed in these works were Picasso's primal feelings for Marie-Thérèse Walter, his young mistress and model.

The horror of war

The Surrealist juxtaposition of disturbing imagery with a playful style is evident in Picasso's masterpiece *Guernica* (1937), painted in response to the deliberate bombing of civilians in the Basque village of Guernica by the nationalist government in the Spanish Civil War. The large mural of mangled, shrieking humans and animals (including the inevitable bull motif) in stark black, white, and grey, utilized Picasso's personal visual language to

KEY MOMENTS

1897
Enters *Science and Charity* into Madrid's Fine Arts Exhibition, where it receives an honourable mention.

1901
Picasso's friend Casagemas commits suicide; Picasso has his first joint Paris exhibition.

1908–14
Develops Cubism with his collaborator Georges Braque.

1917
Works with the Ballets Russes, producing decoration, costumes, and the curtain for *Parade*.

1925
Takes part in a group exhibition of the Surrealists and attends meetings of Surrealist artists.

1937
The town of Guernica is bombed in April; Picasso makes his painting of the event in May and June.

1945
Continues to experiment with different media, working on lithographs with Fernand Mourlot.

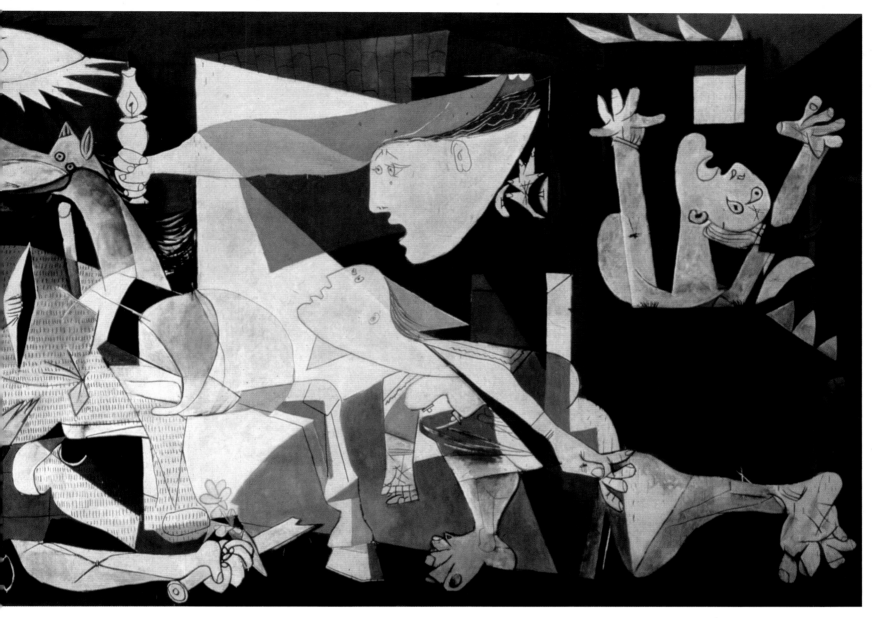

create an image of the terror of war that became world-famous almost as soon as it was produced.

Later life and legacy

Picasso remained in Paris during World War II, keeping a low profile throughout the German occupation of the city. After the conflict, Picasso – now in his sixties – continued to work productively, invigorated by his young muses, including Jacqueline Roque, whom he married in 1961. In his later years, among his constantly increasing output, Picasso made a number of paintings that played with the works of the Old Masters he had first encountered in his youth. Through his versions of Delacroix's *Women of Algiers* (1954), and Velázquez's *Las Meninas* (1957) he confidently positioned himself alongside major figures in art history, although his place there was already beyond doubt. He was the most famous and influential artist in the world in his own lifetime, and both his 80th and his 90th birthdays were marked around the world with awards and major retrospectives.

Pablo Picasso died in 1973, aged 91, leaving a legacy that is still felt today. He produced a staggering 50,000 works during his lifetime – testament to his creative energy, his burning curiosity, and his desire to break the rules of art, at once communing with its past and shaping its future, all with an effortless grasp of the many artistic means to which he put his hand.

Both lionized and criticized, Picasso has been more studied, imitated, and internationally exhibited than any other artist, and his work has been the subject of numerous books and films.

△ *GUERNICA*, 1937

With the monochrome impact of a news photograph, Picasso's violent masterpiece was first shown at the Spanish Pavilion at the 1937 Paris International Exposition, and then toured the world, helping to raise awareness of the Spanish Civil War.

"There is **no abstract art**. You must always start with something. Afterward you can remove all **traces of reality**."

PABLO PICASSO

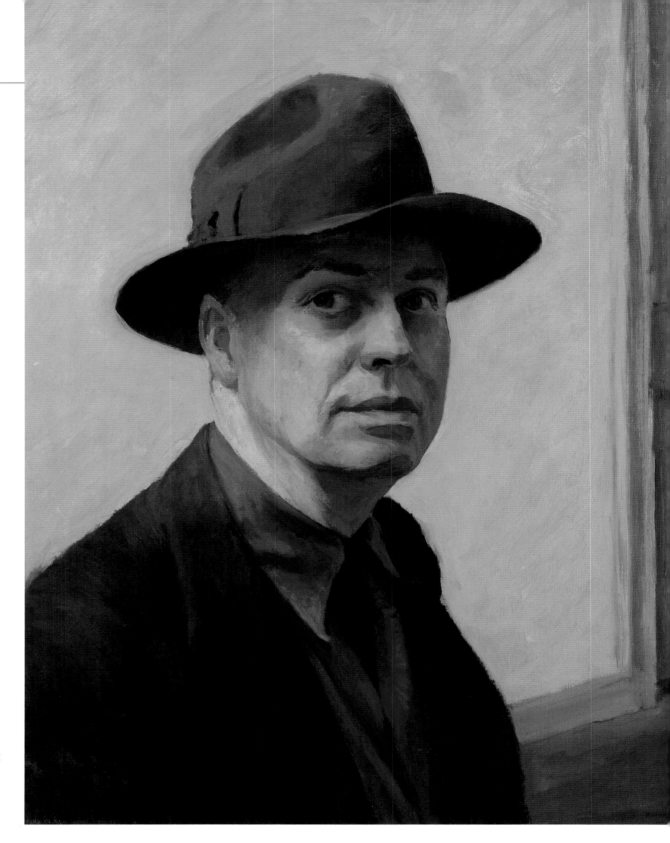

▷ **SELF-PORTRAIT, 1925–30**
Hopper portrays himself as a somewhat anonymous character, set against a background that similarly provides few clues to his life. His hat, worn indoors, suggests a man between destinations, in a state of transition.

Edward Hopper

1882–1967, AMERICAN

Hopper was one of the greatest figurative artists of the 20th century. He was the outstanding exponent of American Scene Painting, recording the spiritual vacuum in his native land with cool detachment.

Edward Hopper was born on 22 July 1882 at Nyack, a town on the Hudson River near New York. In his childhood, he worked occasionally at his father's dry-goods store, but preferred to be down by the river, playing with boats. He built his own single-mast boat at the age of 15 and thought initially about taking up a career in naval architecture, before turning to art.

Hopper's parents did not oppose his wishes, but persuaded him to take a "safer" course of training as a commercial artist. Dutifully, Hopper studied with the Correspondence School of Illustrating, before enrolling at the New York School of Art. Here, he was taught by William Merritt Chase and Robert Henri (see box, right) and met fellow student Jo Nivison, who would later become his wife.

After completing his training, Hopper was anxious to visit Paris, the art capital of the world. He arrived there in 1906, when Picasso and others were revolutionizing modern art; but Hopper never met any of them. His parents had arranged through their church for him to stay with a respectable family, so he had no chance of mixing with the avant-garde crowd. Even so, Hopper adored his time in France and admired the work of the Impressionists.

He made further trips to Paris in the following years, but did not return to Europe after 1910.

Illustrator to artist

After his travels, Hopper found the USA "crude and raw". He worked as a commercial artist, winning a prize for his war poster, *Smash the Hun* (1918), but found the job unsatisfying. He sold a painting at the Armory Show in 1913 (see p.282), but it was years before he achieved his breakthrough. This came in 1924, with an exhibition of his watercolours at Frank Rehn's gallery in New York, after which he abandoned commercial work, married Jo, and became a full-time painter.

American Scene Painting

The work of Hopper and his contemporaries who portrayed the "real" America during the lean inter-war years was often grouped together under the loose heading of American Scene Painting. Hopper depicted people in unglamorous locations: cheap restaurants, shabby apartments, cramped offices, and rural gas stations. His figures look uneasy. They gaze out of windows, lounge uncomfortably on beds, or sit silently and wait. While commentators tried to build narratives around his figures, Hopper denied that his work held any hidden meanings or stories.

After World War II, Hopper's art was overshadowed by the powerful paintings that were being produced by the Abstract Expressionists, but he enjoyed the patronage of Jacqueline Kennedy and represented the USA at the Venice Biennale in 1952. He continued to paint up until his death in New York in 1967.

◁ **HOPPER'S ART MATERIALS**
Edward Hopper lived and worked at the same small studio in Washington Square, New York, from 1913 until his death in 1967.

△ **NIGHTHAWKS, 1942**
Hopper's painting shows four simplified figures, who appear as distant from one another as they are from the viewer. Their strained expressions are blanched under the harsh glare of the artificial light, and they seem dwarfed by space, lost, and isolated.

IN PROFILE
Robert Henri

Referred to as "the silver-tongued Pied Piper", Robert Henri (1865–1929) influenced Hopper and a generation of artists with his simple philosophy. He steered his students away from academic theories, encouraging them to portray the world that they saw around them. Henri was also a fine painter in his own right, and a leading figure in the Ashcan School – a group of artists who focused on the seamier side of New York life.

SNOW IN NEW YORK, ROBERT HENRI, 1902

" I didn't see it as particularly lonely... Unconsciously, probably, I was **painting** the **loneliness** of a **big city**. "

EDWARD HOPPER ON *NIGHTHAWKS*

▷ **SELF-PORTRAIT, 1919**
Modigliani portrays himself with a typical grace and romanticism, his head drawn as an elegant oval – an influence of "primitive" African and Oceanic carving.

Amedeo Modigliani

1884–1920, ITALIAN

Modigliani is the archetypal bohemian artist, as famous for his dissolute lifestyle as for his work. Yet, in a career cut short by illness and excess, he produced paintings and sculptures in a refined and elegant style.

"I put down a line and **this line** will be the **vehicle** of my **passion**."

AMEDEO MODIGLIANI

Amedeo Modigliani was born into a Jewish family in Livorno, Italy, in July 1884. He knew from an early age that he wanted to be an artist, though his education was interrupted by extended bouts of pleurisy and typhoid. He was schooled at home by his mother, and travelled through Italy with her when convalescing, taking in the work of the Renaissance masters.

Modigliani took lessons from Guglielmo Micheli in Livorno, and developed a defiant intellect by reading Nietzsche and Baudelaire. After studying in Florence, he enrolled at the Academy of Fine Arts in Venice, where he spent three years, much of it reportedly in the pursuit of drink, hashish, and women. He attended the Biennales of 1903 and 1905, which fired his enthusiasm for French art.

Work in Paris

In 1906, Modigliani arrived in Paris, the epicentre of the avant-garde, and entered the Académie Colarossi. Initially, his influences were fairly restrained – he was more interested in Cézanne than in the revolutionary movement of Futurism (see box, right) or the advances being made by Picasso and his colleagues. Over time, he became drawn to sculpture and, after meeting Constantin Brancusi (see pp.280–83) in 1909, this became his chief focus.

◁ **HEAD OF A WOMAN, 1910–11**
Only 25 pieces of Modigliani's stone sculptures survive, but their abstracted and elongated forms provided a template for his later portraits and figure paintings.

Modigliani worked mainly in stone, often stealing the material from local building sites. His repertoire was mostly limited to heads, which he planned to exhibit together as a "decorative ensemble". Like Brancusi, he learned how to simplify and stylize his subjects, elongating the heads and removing most of their facial features. In doing so, he drew inspiration from the "primitive" Oceanic and African carvings that had galvanized the experiments of the Cubists.

Defining a style

His sculptural work came to a halt with the outbreak of World War I in 1914, when his supply of materials dried up. But Modigliani transferred the essence of his sculptural style to his paintings. Concentrating again on a limited range of subjects – mostly portraits and nudes – he developed a distinctive "look". Modigliani's figures were slender and elongated, and although the artist often left the eyes blank, his gift for caricature allowed him to suggest the sitter's inner nature through minute distortions or exaggerations of line.

Modigliani's style was based firmly on drawing. He made numerous, rapid sketches, rarely bothering with corrections or details, and worked quickly when painting, aiming to finish a canvas in a single sitting. He applied his paints thinly – largely out of financial necessity – but like his hero Cézanne, gave his figures solid form by conveying volume through advancing and receding tones.

Most of Modigliani's masterpieces were created in an intense five-year period before tuberculosis – and his wayward lifestyle – claimed him at the age of 35. His mistress was so distraught that, two days after the artist's death, she threw herself out of a window, while heavily pregnant with their second child. They are buried together at Père Lachaise cemetery in Paris.

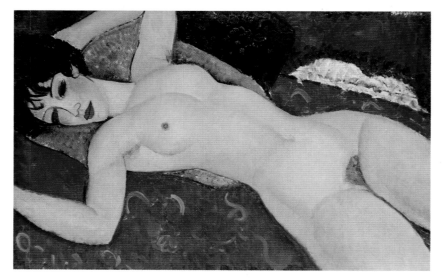

◁ **RECLINING NUDE, 1917–18**
Owing much to Titian's famous *Venus of Urbino*, this painting – a study of sexual desire – caused a scandal when it was first shown in Paris.

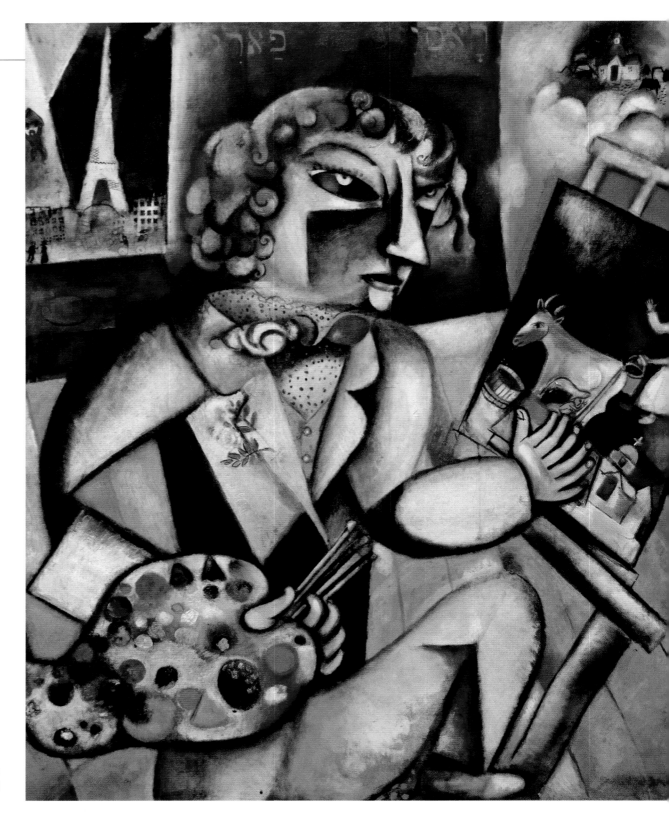

▷ **SELF-PORTRAIT WITH SEVEN FINGERS**, 1913
Chagall painted his first self-portrait – strongly inspired by Cubism – while working in La Ruche, Paris. Its title is a reference to a Yiddish expression "to do something with seven fingers", meaning to accomplish a task quickly and well.

Marc Chagall

1887–1985, RUSSIAN/FRENCH

One of the great individualists of modern art, Chagall celebrated his Russian and Jewish heritage in his paintings, in a style that blended reality with a magical air of fantasy.

Marc Chagall was born on 7 July 1887, near the city of Vitebsk in western Russia (now Belarus). He came from a working-class family of devout Hasidic Jews. His father worked for a herring merchant and his mother ran a small grocery shop. Growing up in Russia had its problems – there were restrictions on where Jews could live, be educated, and work – but none of these blunted Chagall's love of his homeland. Throughout his life, memories of Vitebsk remained a constant theme in his art.

Chagall trained briefly with a local artist, Jehuda Pen, and, from 1906, under Léon Bakst in St Petersburg. Bakst found fame with his sets and costumes for Sergei Diaghilev's Ballets Russes, and when he announced that he was moving to Paris, Chagall followed. He arrived in the city in 1910, a wealthy art collector having paid for his ticket.

◁ **VIOLIN MOTIF**
Violins and fiddlers – key features of Jewish festivals – recur in Chagall's work and reflect the importance that he attached to his heritage.

Life in Paris

Paris was a revelation. The city was a melting pot for the latest artistic theories, which Chagall absorbed. Cubism had an immediate impact on his style, although he had some doubts about its abstract tendencies ("let them choke themselves on their square pears"). He was particularly entranced by Robert Delaunay's lyrical variant of Cubism, and even added the Eiffel Tower – Delaunay's favourite motif – to his *Self-Portrait with Seven Fingers*. While living in La Ruche (see box, right), Chagall made many contacts, who helped him to exhibit his work.

As Chagall's reputation was rising, a love affair drew him away on an ill-advised trip to Russia in 1914. War broke out and he was unable to return to France until 1923. However, he did marry his sweetheart, Bella Rosenfeld, and their long, happy marriage inspired one of the central threads of Chagall's art. They are the blissful lovers who appear repeatedly in his canvases, flying above a village, riding a circus horse, or floating in an enormous, airborne nest of flowers.

The couple moved to France when the art dealer and publisher Ambroise Vollard commissioned Chagall to produce a series of illustrations for *Dead Souls*, a prose-poem by Nikolai Gogol. His return coincided with the rise of Surrealism, and Chagall was invited to join the group. Although his work had obvious affinities with the movement – its dreamlike fantasies and its juxtaposition of seemingly unconnected objects – Chagall turned down the invitation. He always dismissed attempts to look for hidden meanings in his paintings, rejecting any ideas about symbolism.

Apart from an interlude in the USA during World War II, when Chagall's beloved Bella died, he spent the remainder of his career in France. In his later years, he expanded his range of activities, producing designs for ceramics, murals, theatre sets, costumes, mosaics, tapestries and, above all, stained glass. One of the proudest achievements of his long career was a set of 12 windows, illustrating the Tribes of Israel, for a synagogue in Jerusalem.

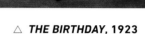

△ *THE BIRTHDAY*, 1923
In this dreamlike image, Chagall pictures himself afloat in the air, turning his neck to kiss his wife, Bella, in an evocation of the euphoria of romantic love.

◁ **THE ARTIST IN HIS STUDIO, 1957**
When he returned to France after World War II, Chagall lived and worked in St Paul-de-Vence, near Nice. He married his secretary, Valentina Brodsky, in 1952 and is buried next to her.

IN CONTEXT
La Ruche

Chagall's style changed rapidly during his first spell in Paris, when he was bombarded with a huge variety of new influences. Many of these came from his fellow inhabitants in the artists' colony of La Ruche (the Beehive), where he stayed from 1912 to 1914. Situated in a run-down part of the city, and reeking from the stench of nearby slaughterhouses, this ramshackle building provided cheap studios for (mostly) foreign artists. The roll-call of future celebrities who crowded into the "coffins" – the tiny wedge-shaped spaces – included Fernand Léger, Chaim Soutine, and Amedeo Modigliani, along with famous poets such as Guillaume Apollinaire and Blaise Cendrars.

THE ARTISTS' COLONY OF LA RUCHE IN MONTPARNASSE, PARIS

" My art is an extravagant art, a **flaming vermilion**, a **blue soul** flooding over my paintings. "

MARC CHAGALL

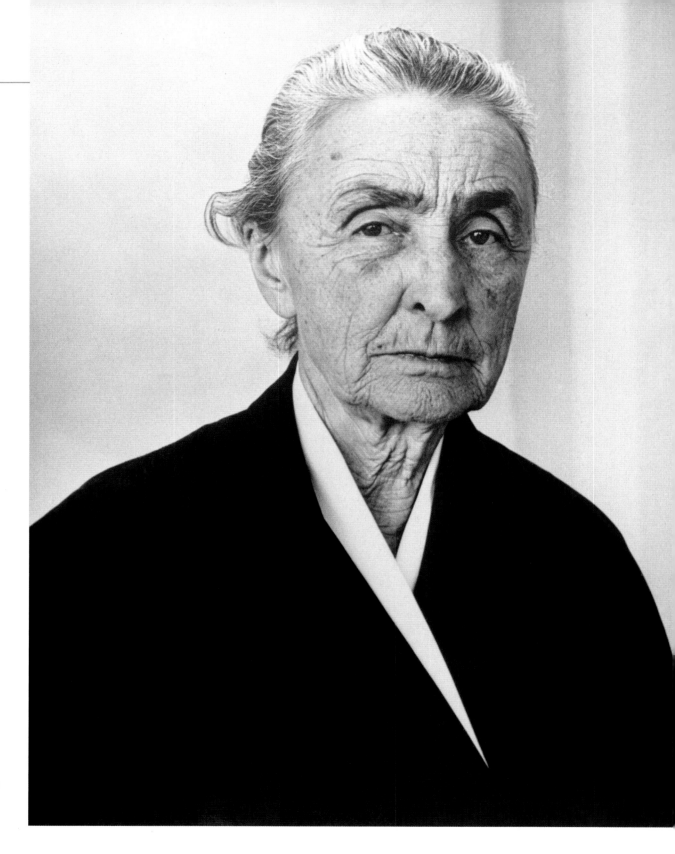

▷ **PORTRAIT OF THE ARTIST**
Georgia O'Keeffe enjoyed a long career. Affected by failing sight, she continued to paint into the 1970s and died at the age of 98.

Georgia O'Keeffe

1887–1986, AMERICAN

A pioneer of Modernism, O'Keeffe is best remembered for bringing together abstract and figurative elements in dazzling close-ups of flowers and in her powerful evocation of the American West.

"I **hate flowers** – I paint them because they are **cheaper than models** and they don't move."

GEORGIA O'KEEFFE

Georgia O'Keeffe was born in Sun Prairie, Wisconsin, on 15 November 1887, the daughter of a farmer. At an early age, she decided she wanted to be an artist and studied for a time at the Art Institute of Chicago and then at the Art Students League in New York under William Merritt Chase. Even so, O'Keeffe's early career path was hesitant – she worked initially as a commercial artist and teacher.

Professional partnership

O'Keeffe's transition to professional artist came about almost by accident. She took a course at Columbia College under Arthur Wesley Dow, whose unusual landscapes were influenced by Japanese woodblock prints. She began producing large, abstract charcoal drawings, which were so striking that a friend took them to Alfred Stieglitz (see box, right), who ran the avant-garde "291" gallery in New York. Without O'Keeffe's knowledge, Stieglitz displayed the drawings and – when she went to remonstrate with him – offered her a one-woman show for the following year. So began a long, often stormy relationship. The couple married in 1924 and remained together until Stieglitz's death in 1946.

The links with Stieglitz proved enormously beneficial. He offered O'Keeffe financial support at the outset and staged exhibitions of her work virtually every year. O'Keeffe's profile was also raised – though not

▷ BLEACHED SKULLS

O'Keeffe drew inspiration from the parched desert, combining it with large, bleached animal skulls to create works that powerfully express loneliness and longing.

always in the most positive way – by the many photographs that he took of her for his own work. Even more importantly, Stieglitz's circle included a number of the leading photographers and painters of the day. O'Keeffe was influenced, for example, by the close-up photography of Paul Strand, who cropped, tilted, and magnified sections of objects, turning them into near-abstract images.

Photographic inspiration

O'Keeffe borrowed from the photographic idiom in several of her works. This can be seen in her paintings of New York skyscrapers, dating from the late 1920s. In *The Shelton with Sunspots*, she mimicked the appearance of lens flare, while the entire composition of her *New York with Moon* is based on halation (the halo-like effect) surrounding a street light. The New York paintings also emphasize O'Keeffe's links with the Precisionists, a loose association of artists who celebrated the urban landscape of the USA. Their city views were clear and ordered, with sharply defined, hard-edged contours and forms that often created striking geometric effects.

In the desert

In 1929, O'Keeffe visited New Mexico for the first time; it became her refuge after she was hospitalized with a nervous disorder that was triggered by Stieglitz's infidelities. The desert soon became the dominant theme in her painting. She spent many summers at the remote Ghost Ranch, north of Abiquiu, eventually buying it in 1940. In her paintings, O'Keeffe often coupled the barren desert landscape with large animal skulls that hovered mysteriously in the air. This unorthodox combination – stylized landscapes, viewed from a distant, aerial perspective, and huge animal bones, seen head-on and painted with Precisionist detail – helped O'Keeffe to produce her most haunting and distinctive masterpieces.

In 1946, New York's Museum of Modern Art honoured O'Keeffe with a retrospective of work – their first ever for a woman artist. She is recognized today as a pioneer of 20th-century art.

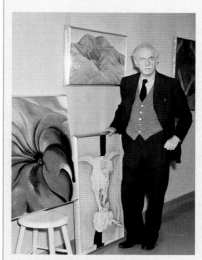

STIEGLITZ AT O'KEEFFE'S SHOW IN 1936

▷ *THE WHITE FLOWER (WHITE TRUMPET FLOWER)*, 1932

O'Keeffe was inspired by close-up photography to produce a series of monumental flower paintings in which she emphasized formal qualities such as shape, colour, and line.

René Magritte

1898–1967, BELGIAN

Magritte was a singularly individual artist who, by continually questioning the way we see images, aimed to evoke the mystery of the world we inhabit – to make the familiar unfamiliar.

René Magritte was born in Lessines, Belgium, the oldest of the three sons of a textile merchant. His early years were punctuated by traumatic events; when he was 13 his mother, who had suffered mental illness, committed suicide by drowning in the River Sambre. Two years later, in 1914, German forces invaded Belgium, starting World War I, and Magritte came of age with his homeland under foreign, and often brutal, occupation.

Magritte showed a talent for art from an early age; he took drawing lessons when he was 12 and began exhibiting his pictures a year later. In 1915, aged 16 and with the war still in progress, he moved to the Belgian capital, Brussels, and within months had enrolled in the Academy of Arts, which he would attend sporadically for the next five years.

Impressionist influences

Magritte's early paintings were strongly influenced by the loose, spontaneous, and colourful style

developed by the Impressionists in the late 19th century. But in Brussels he was exposed to avant-garde art, much of it created in direct response to the conflict still raging across Europe. He moved away from his Impressionist style, and fell under the influence of the Italian Futurists (see p.297), whose art aimed to depict the dynamic energy of a modern age, and of the Cubists, who used multiple views of everyday objects to create

an abstracted representation of the world. He was still to develop his own idiosyncratic style.

The Surrealists

By the time the war ended in 1918, Magritte was working as a commercial artist, producing posters, selling drawings, and designing wallpaper. In 1922, he married his childhood friend, Georgette Berger, who was to became his model and muse.

△ **THE BOWLER HAT**
Magritte's own form, topped with a bowler hat, appeared often in his work. The bowler hat can be read as a symbol of the bourgeoisie, and his work as an attempt to alert its members to the mystery of the world.

◁ **UNTITLED, 1923**
Fractured planes and a dynamic composition with prominent diagonals show the influence of Cubism and Furturism on Magritte's early work.

△ **AN ORDINARY MAN**
Magritte dressed conservatively in a suit and bowler hat. He remained married to Georgette Berger for 45 years. He had promised her "the calm of a nice steady bourgeois life". In life as in art, he challenged definitions of the ordinary.

◁ **THE SON OF MAN, 1964**
In this self-portrait, Magritte addresses themes central to much of his work – what lies beyond the visible? Can people ever comprehend what they see? Magritte repeated and altered this self-portrait several times over his career.

> " I hope I touch something **essential** to man, to **what man is**. "
>
> RENE MAGRITTE

△ **THE TREACHERY OF IMAGES**, 1929
Childlike text is accompanied by an image of a pipe in an illustrative style. The "treachery" is the lies people tell themselves to understand the world.

He continued to paint in a "neo-Cubist" manner until he came into contact with a group of artists – the Surrealists – who were taking their work in a radically new direction.

The Surrealist movement was formed by the French writer and poet André Breton in Paris at the start of the 1920s. With its roots in the earlier satirical, nonsensical artworks of the anti-war Dada movement, Surrealism aimed to release the subconscious imagination and reconcile it with everyday reality. Informed by the work of the psychoanalyst Sigmund Freud, some Surrealists, such as Joan Miró, made works exploring automatism, by drawing, writing, and painting without conscious intention. Others, such as Max Ernst and Salvador Dalí (see pp.322–25), produced uncanny, dreamlike imagery that unsettled the viewer by challenging representational logic. It was this second form of Surrealism that appealed to Magritte.

Key influences

In the early 1920s, Magritte met key members of the Belgian Surrealist group, including Paul Nougé (the group's leader) and the writer Camille Goemans, who would later become Magritte's main dealer; soon, he produced his first self-proclaimed Surrealist work, *The Lost Jockey* (1926). The work was strongly influenced by Max Ernst, whose collages combined images in a seemingly irrational manner, and by Italian artist Giorgio de Chirico, who flattened perspective in a clear break with traditional rules.

Magritte wished to question the established relationship between painting (and its illusory nature) and the objects it represented. He famously did so in *The Treachery of Images* (1929), a carefully painted picture of a tobacco pipe with the script *"Ceci n'est pas une pipe"* (This is not a pipe) painted underneath. By drawing attention to the fact that the painting was not a pipe, but just an image of one, Magritte challenged the viewer's understanding of the relationship between representation and reality. The image also invited the viewer to ponder on the arbitrary nature of the link between language, objects, and images.

The script paintings

The Treachery of Images was one of a number of "script" paintings created after Magritte moved to Paris in 1927. It was at this time that he made contact with André Breton (see box, left) and the other Paris Surrealists, including Dalí and the poet Paul Eluard. However, this productive period in his life was interrupted by the economic crisis that engulfed the world following the Wall Street stock market crash of 1929. Magritte's lack of independent funds meant that he was temporarily forced to give up painting and seek commercial work back in Brussels. Indeed, financial problems were a recurring theme in Magritte's life, and led him to produce copies and replicas of his most successful works simply to make ends meet.

By 1933, Magritte was painting again, composing images in which he sought "solutions" to "problems" posed by a given type of object. Many of these paintings contained optical illusions, like the painting within a painting in *The Human Condition* (1933), or physical impossibilities, such as *Not to Be Reproduced* (1937), in which a figure looks at himself in a mirror only to be presented with the back of his own head. These images, painted in a detached, naturalistic way, present thought-provoking, dreamlike paradoxes and visual puns to the spectator – all of which serve to undermine the concept of reality.

The Renoir and *vache* periods

Magritte remained in Brussels again during World War II and this dark period led to some of his most experimental paintings yet. He returned to a loose, colourful "sunlit" style influenced by the Impressionist Auguste Renoir, feeling the need to make pictures that radiated a sense

" The mind loves **the unknown.** It loves images whose meaning is unknown, since the **meaning of the mind** itself is unknown. "

RENE MAGRITTE

KEY MOMENTS

1926
Paints his first Surrealist work, *The Lost Jockey*, one of a series of images featuring a baluster (pillar) – a favoured motif.

1927
Holds his first exhibition in Brussels, where he shows 61 of his works. The exhibition is a commercial failure.

1943
Becomes influenced by the work of Auguste Renoir, working in a new style until 1947, alongside his Surrealist works.

1947
Begins his *vache* period, exhibiting these works unsuccessfully in Paris in the following year.

1964
Paints *The Son of Man*, along with two related works, *Man in the Bowler Hat* and *The Great War of the Façades*.

of optimism while under German occupation. This "cult of pleasure" reached its peak in 1948, when Magritte produced garish, caricature-like works in what he termed his *vache* (literally, cow) period, named in ironic reference to the Fauve (wild beast) movement (see p.274). However, these deliberately coarse and tasteless paintings were not well received by the critics or buyers.

Magritte soon returned to his more familiar terrain, making cinematic-style images that were composed increasingly of standardized motifs, including men in suits, windows and frames, birds, cloudy skies, and the moon. Objects metamorphosed or obscured one another – as in *The Son of Man* (1964) – or opposite elements were reconciled, as in *The Empire of Light* (1950).

He pursued his interrogation of the resemblance of things into the second half of the 20th century, as his work began to receive more attention, as well as philosophical interest from theorists such as Michel Foucault.

Magritte's technique of juxtaposing seemingly incongruous images influenced many of the artists of the 1960s and beyond, including Andy Warhol, Richard Wentworth, and Robert Rauschenberg.

In 1967, the final year of his life, Magritte started to create wax sculptures that were based on some of his Surrealist paintings, but he died of pancreatic cancer before the sculptures were cast in bronze. Interest in Margritte's work and ideas continues to grow.

ON TECHNIQUE
Symbols

Magritte painted his images in a matter-of-fact, realistic style but with one or more elements dissonantly out of place – subtle disjunctures designed to unsettle viewers' preconceptions. He used certain mundane objects repeatedly in his work – apples, pipes, eggs, and bowler hats were favourites. The apple, for example, appears variously as a hovering orb in the sky, a giant, room-filling bulk, and obscuring the artist's face in the self-portrait *The Son of Man*. By elevating these items to the status of near-mystical symbols, Magritte challenged the viewer to interpret them: "What does that mean? It does not mean anything, because mystery means nothing either, it is unknowable."

A FAVOURITE MAGRITTE SYMBOL

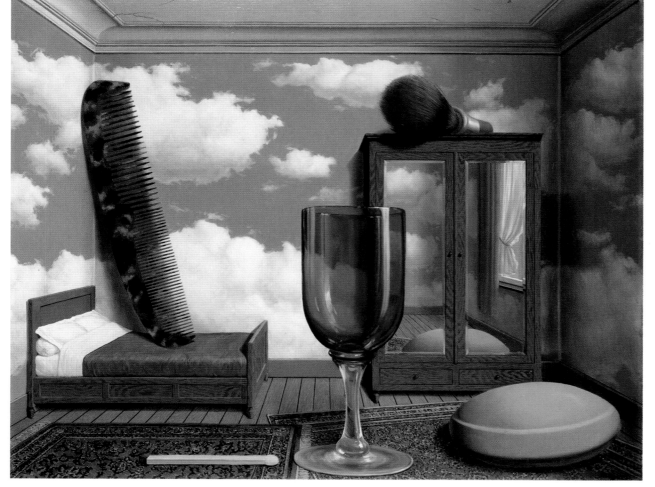

◁ **PERSONAL VALUES, 1952**
Everyday objects are enlarged to huge proportion – rendering them useless and even threatening. The unsettling composition, rendered in typically realistic detail, invites viewers to reassess their relationship with the mundane and the "real".

Henry Moore

1898–1986, ENGLISH

One of the best-known sculptors of the 20th century, Moore is especially celebrated for his family groups and reclining figures, including many that explore space and volume in new ways, using hollows and holes.

Henry Moore was born into a mining family in Castleford, Yorkshire, in 1898, the seventh of eight children. He wanted to be a sculptor from an early age and showed talent as an artist at secondary school, but his father encouraged him to train as a teacher. However, the young man was not inspired by this career path and when he was 18, he joined the army to fight in World War I. He was gassed at the Battle of Cambrai, sent home to England to recover, and returned to France only as the war was coming to an end.

Moore received an ex-serviceman's grant and attended Leeds School of Art, where Barbara Hepworth was also a student. After completing the two-year drawing course in a single year, he studied sculpture before going on to the Royal College of Art in London.

Early influences

At the Royal College, Moore focused on carving directly in wood or stone rather than modelling works in clay that would subsequently be cast in metal. He enjoyed the access London gave him to the ethnological collections of non-Western art in the British Museum – Egyptian, African, and Mexican art exerted a powerful

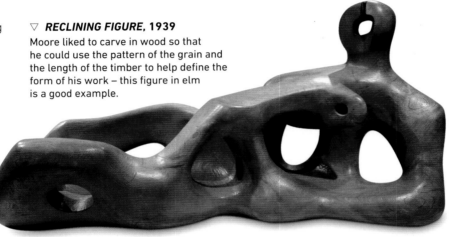

▽ **RECLINING FIGURE, 1939**
Moore liked to carve in wood so that he could use the pattern of the grain and the length of the timber to help define the form of his work – this figure in elm is a good example.

influence on him. He did well, and was appointed as a teacher at the Royal College. By the end of the 1920s, Moore was beginning to receive major commissions, including the high-profile *West Wind* (1928–29), a relief sculpture for the façade of the headquarters of London Underground, above St James's Park tube station.

Artistic development

In 1929, Moore married fellow artist Irina Radetsky, and the couple moved to Hampstead, northwest London, where there was a thriving artistic community. Three years later, he took up a post at the Chelsea School of Art, London, and thereafter began to develop one of his most enduring and celebrated subjects: the reclining figure. Carved directly into stone,

these figures showed the influence of Mexican Mayan sculpture. Moore emphasized the mass of the human body in his work, with reclining figures that often had exaggeratedly large, dense-looking arms and legs.

Modernist and abstract art

Also in the 1930s, Moore became a member of London's Seven and Five Society, a group of artists that included Barbara Hepworth and Ben Nicholson, which was increasingly dedicated to Modernist and abstract work. Visits to Paris gave Moore contact with some of the leading European Modernists, such as Pablo Picasso and Georges Braque, and he was also fascinated by the Surrealists. These artists' method of abstracting a figure, or rendering

ON TECHNIQUE
Carving

While he was at the Royal College, Moore turned his back on the usual Academic technique of modelling a sculpture in clay and casting it in a metal such as bronze. Instead, he favoured direct carving, a technique much used by both Modernist and non-Western artists, whose styles greatly influenced him. Moore felt that carving brought him close to the shape and form of his work, allowing him to "get inside" the form and feel its presence. He also appreciated the fact that carvers tend to be true to their materials, working without another intervening process and allowing the qualities of wood or stone to show in the finished work.

MOORE SCULPTING IN WOOD, c.1965

> " The artist must impose **some of himself** and his **ideas** on the **material.** "

HENRY MOORE, CITED IN DONALD HALL, "HENRY MOORE: THE LIFE AND WORK OF A GREAT SCULPTOR", IN *HORIZON*, 1960

▷ **HENRY MOORE**
The artist is shown here standing in front of his *Draped Reclining Woman* (1956–57). The figure was cast in an edition of six in the artist's lifetime.

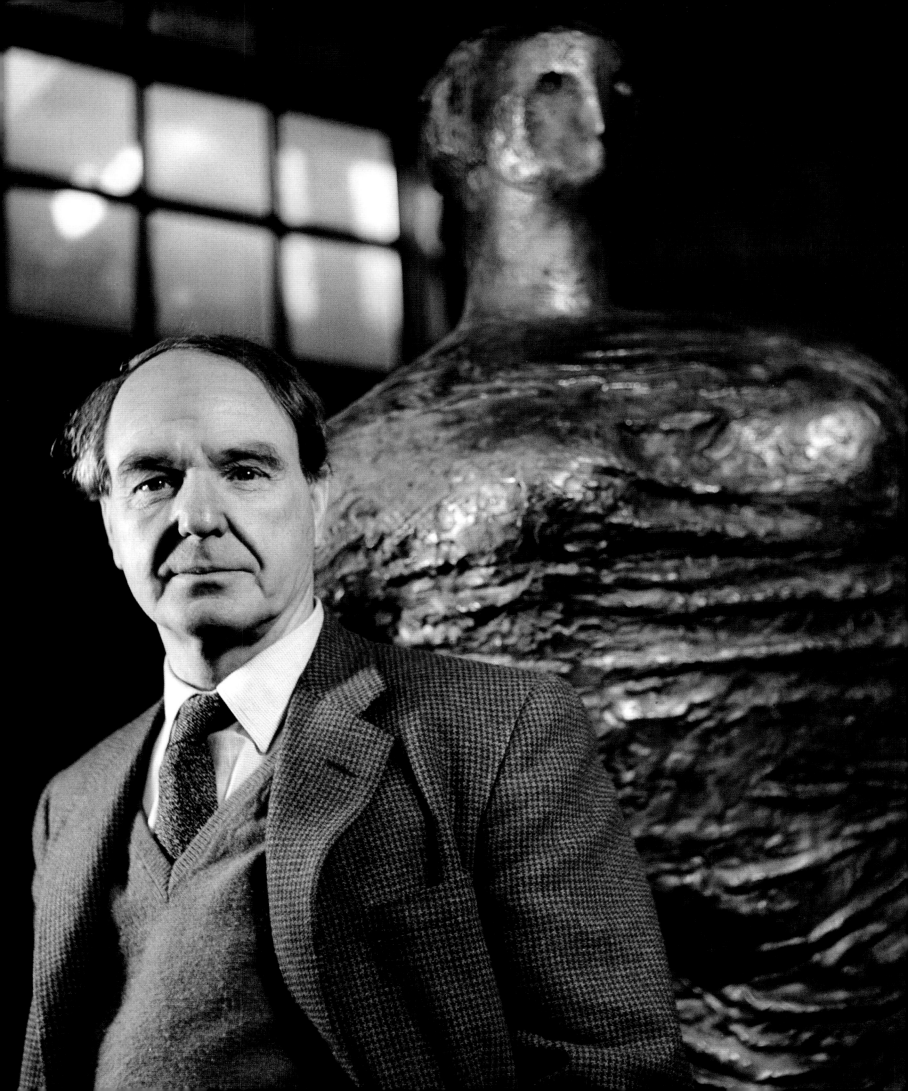

> " The first **hole** made through a **piece of stone** is a **revelation**... A hole can itself have as much **shape-meaning** as a solid mass. "

HENRY MOORE, "THE SCULPTOR SPEAKS", IN *LISTENER*, 18 AUGUST 1937

IN CONTEXT
Biomorphism

During the 1930s, Moore became increasingly interested in images from microscopes and in the form taken by natural structures such as bones, pebbles, shells, and tree roots. He made many drawings of them from different viewpoints, in an attempt to discover the underlying laws that dictated their shape and form. He used these natural forms as the inspiration or starting point for sculptures – an approach that the English critic Geoffrey Grigson referred to as "biomorphism". Moore considered tree trunks to be an ideal form of wood sculpture and bones as exemplars of structural strength. His own sculptures of the human figure sometimes took their cue from these natural forms.

NATURALLY FORMED WOOD SCULPTURE IN THE ROOT OF A TREE

it as a series of fragments, revealed a radically new and highly expressive approach to art. Moore's carvings became increasingly abstract as a direct result of these influences. His work from around this period was sometimes controversial. In 1937, for example, the collector and writer Roland Penrose bought one of Moore's *Mother and Child* sculptures and displayed it in his front garden. Nudity in the work offended his neighbours, however, and the local press launched a fierce campaign against it, and condemned the fact that Moore was allowed to teach young people. Nonetheless, his work was generally well received among fellow artists and collectors.

A new direction

Moore's work took a new direction after the outbreak of World War II in 1939, when he began producing memorable drawings of people sheltering from bombs

▷ **KING AND QUEEN,1952–53**
Moore's bronze sculpture of a man and a woman sitting on a bench conveys a conventional subject in a modern way and reflects his interest in "primitive" art.

in London's tube stations. These drawings seemed to him to be a natural extension of his work as a sculptor and closely related to his reclining figures. Some of his drawings were bought by Kenneth Clark, director of the National Gallery and chair of the War Artists' Advisory Committee. In 1941, Moore was appointed an official war artist and was asked to produce more shelter

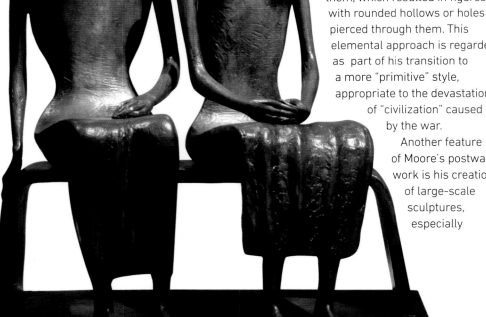

drawings, as well as images of miners at the colliery in Yorkshire where his father had worked.

When the bombing of London got worse, Moore and his wife moved to the country, buying a farmhouse in Hertfordshire. They lived there for the rest of their lives, converting outbuildings to studios so that Moore had space to work on larger projects. In 1943, he produced a large *Madonna and Child* for St Matthew's Church, Northampton. This was to be the first of many family groups; the subject of mother and child became increasingly important to him after the birth of his daughter, Mary, in 1946.

Postwar styles

After the war, Moore's work was less preoccupied with mass, focusing instead on the interplay between solids and the spaces around them, which resulted in figures with rounded hollows or holes pierced through them. This elemental approach is regarded as part of his transition to a more "primitive" style, appropriate to the devastation of "civilization" caused by the war.

Another feature of Moore's postwar work is his creation of large-scale sculptures, especially

bronzes, which he made by creating small maquettes, or models, in clay before scaling them up and having casts made in metal.

This phase of his work was partly a response to numerous high-profile public commissions, such as family groups for the newly created towns of Stevenage (1948–49) and Harlow (1954–55), a reclining figure for the 1951 Festival of Britain in London, and another for the UNESCO building in Paris (1957–58). The fact that Moore still worked on a small scale, moulding the maquettes before creating the full-scale works, means that these large late pieces retain a magnificent sense of handcraft.

The increase in large public commissions meant that Moore became virtually a household name and his work was seen by many as a symbol of postwar renewal and optimism in Britain. The art world also continued to place great value on his work: in 1948, he received the sculpture prize at the Venice Biennale; in the 1960s and 1970s, there were solo exhibitions of his work around the world, and major public collections acquired his sculptures. Many of Moore's artworks were designed for exterior locations: his abstraction of the human form, making it more stylized and piercing it with holes, worked well out of doors, where the sculptures invited comparison with rocks, hills, and other features of the landscape.

Significant donations

Towards the end of his life, Moore made numerous major gifts of his work, particularly to the Art Gallery of Ontario – to which he donated hundreds of works for the gallery's Henry Moore Centre – and to London's Tate Gallery. The artist gave his home

KEY MOMENTS

1928–29
West Wind, his first public commission, is placed alongside work by other major sculptors.

1929
Makes *Reclining Figure*, his first figure in brown Hornton stone; it is typical of his massive early works.

1940–41
Shelter Drawings, in mixed media, show people sheltering in London's Underground during the war.

1957–58
Produces *Reclining Figure* in travertine for the UNESCO building, Paris.

1962–65
Creates the abstract bronze *Knife-Edge Two Piece*, one of his first interlocking, two-piece sculptures.

1971–72
Sheep Piece exemplifies his love of biomorphic forms. Real sheep sometimes graze around it.

◁ **HOGLANDS FARMHOUSE**
The farmhouse at Perry Green was home to Moore from 1940 to the end of his life. Many of his works are exhibited in the studios and grounds of the property.

at Perry Green, Hertfordshire, to the Henry Moore Foundation, which he set up to sell and exhibit his work.

Moore was a prolific artist, known for his exploration of sculpture via key subjects, such as the human figure and the family group, and for devising new approaches to the treatment of three-dimensional forms. Both in his native country and internationally, he remains one of the most celebrated of all 20th-century artists.

▷ **LARGE RECLINING FIGURE, 1984**
This bronze sculpture of an abstracted human figure – enlarged from a model made in 1938 – is displayed in front of the OCBC Bank in Singapore. Around 9m (30ft) long, it is one of the largest works ever produced by Moore.

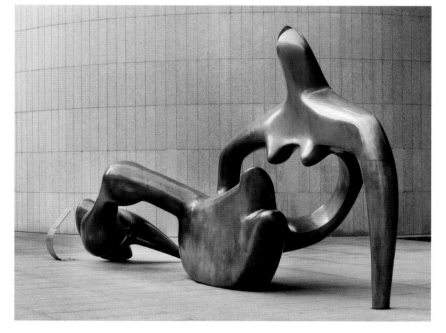

Directory

Walter Sickert

1860–1942, BRITISH

Sickert was born in Munich and moved to London in 1868. Initially, he hoped to become an actor but when his stage career stalled, he enrolled at London's Slade School of Art in 1881. Soon after this, he became a student of James Whistler, who influenced the subtle tones seen in Sickert's paintings. He also worked for a time with Edgar Degas, whose informal compositions also influenced his work. After living in Dieppe from 1899 to 1905, Sickert returned to London, where he painted several muted, interior scenes in thick crusty paint, which came to symbolize the Camden Town group of painters with whom he became associated.

Sickert's writings and teaching provided an important link between British and European art, and his later paintings of music halls and images based on photographs are now seen as some of his most forward-thinking work.

KEY WORKS: *La Hollandaise*, c.1906; *Ennui*, c.1914; *Brighton Pierrots*, 1915

▷ Pierre Bonnard

1867–1947, FRENCH

Painter, printmaker, and designer, Bonnard was born in Fontenay-aux-Roses, near Paris. He gave up law to pursue painting, and met fellow artists Maurice Denis and Edouard Vuillard while studying at art academies in Paris at the end of the 1880s. Along with others, they formed the Nabis (Prophets) group, which aimed to revitalize painting, influenced by the Art Nouveau and Symbolist movements, as well as by Japanese prints. Bonnard's early

work, from 1891 to 1905, was mainly graphic; he designed posters and prints in an economic, dynamic style.

However, from 1905, he focused increasingly on oil painting, creating intimate domestic scenes using bright, rich colours. These paintings, referred to as "intimist", included several nudes and bath scenes featuring his wife, Marthe, his favourite model. In later years, he divided his time between Paris and the south of France. His reputation as a painter has steadily grown in the decades since his death.

KEY WORKS: *Woman Reclining on a Bed*, 1899; *Dining Room in the Country*, 1913; *The Toilet*, 1932

△ SELF-PORTRAIT, PIERRE BONNARD, 1889

Käthe Kollwitz

1867–1945, GERMAN

Kollwitz was born in the Prussian city of Königsberg (now Kaliningrad in Russia) and trained as an artist in Berlin and Munich, between 1885 and 1889. After marrying a doctor, she moved to a deprived area of Berlin where she was exposed to the harsh conditions endured by the urban poor. She made this poverty the subject of her art, producing expressive, unsentimental drawings, etchings, and woodcuts of the suffering she witnessed. After 1910, Kollwitz began to produce sculpture, which also explored human dignity in the face of adversity. Her work displayed pacifist tendencies (her son died in World War I and her grandson in World War II, events that led her also to explore the subject of mourning) and her social awareness and left-wing leanings led her to visit the USSR in 1927. She was forced to resign from the Berlin Academy (of which she had been the first female member) when the Nazis came to power in Germany in 1933.

KEY WORKS: *Weavers' Revolt*, 1893–97; *Grieving Parents*, 1924–32; *Death*, 1934–35

Kasimir Malevich

1878–1935, RUSSIAN

Born in Kiev, Malevich studied art in Moscow from 1903. While living in the city, he became involved with the Russian avant-garde, meeting the artists Natalia Goncharova and Mikhail Larionov, and began painting peasant scenes in a mix of styles influenced by Post-Impressionism, Cubism, and Futurism. However, he became dissatisfied with representational work, and was keen to free art from "the burden of the object" – after designing an abstract backdrop for the opera *Victory over the Sun*, he created works that consisted of simple geometric shapes on white backgrounds. These "Suprematist" paintings, first exhibited in 1915, represented a radical step towards a new abstract art "unrelated to nature".

Malevich spent much of the rest of his life developing, teaching, and writing about his Suprematist theories, although the rise of Stalin as leader of the Soviet Union from 1924 and the imposition of socialist realism caused his career to stall. He did return to painting figuratively in his later years, his pure abstract forms deemed too revolutionary by the Soviet state.

KEY WORKS: *Black Square*, c.1915; *White on White*, 1917–18; *Head of a Peasant*, 1928–29

Ernst Kirchner

1880–1938, GERMAN

Born in Aschaffenburg, Germany, Kirchner trained as an architect in Dresden in 1901 to 1905. He became increasingly drawn to painting, and, with some of his fellow Dresden students, became a founder of Die Brücke (The Bridge) group of German Expressionist artists. Influenced by the art of Vincent van Gogh, Edvard Munch, and Henri Matisse, Kirchner painted mainly figure compositions, employing jagged forms and flattened blocks of heightened colour. In 1911, he settled in Berlin and produced vivid city scenes, later considered to be high-points of Expressionism.

Kirchner suffered a breakdown after being drafted into the army in 1915 and moved to Switzerland, where his paintings – of landscapes and natural forms – became more serene. He continued to paint and produce masterly etchings, woodcuts and lithographs. However, when the Nazis branded his work as "degenerate", and largely banned it in 1937, he suffered a psychological relapse and committed suicide shortly after.

KEY WORKS: *Street, Berlin*, 1913; *Self-Portrait as a Soldier*, 1915; *Blick auf Davos*, 1924

Fernand Léger

1881–1955, FRENCH

Born in Normandy, France, Léger worked as an architectural draftsman while he was studying art in Paris, from 1900. His early artworks were indebted to Paul Cézanne but, from 1909, he was influenced more by Cubism, although his tubular, brightly colourful style differed from the disjointed forms that were employed by Pablo Picasso and Georges Braque. After World War I, Léger focused on capturing "the beauty of machinery", his work becoming flatter and far more stylized, with strong outlines and bold contrasting colour.

△ SELF-PORTRAIT, UMBERTO BOCCIONI, 1904–05

In the 1920s, Léger branched out, painting murals, designing theatre sets, and experimenting with film. During World War II, he taught at Yale University in the USA. On returning to France in 1945, he joined the Communist Party and worked on a number of large, decorative commissions, depicting the human figure in his now trademark style. In 1950, he founded a ceramics workshop, which became a national museum dedicated to Léger in 1967.

KEY WORKS: *The City*, 1919; *Three Women* (*Le Grand Déjeuner*), 1921; *The Grand Parade*, 1954

△ Umberto Boccioni

1882–1916, ITALIAN

Boccioni was born in Reggio Calabria, Italy, and worked as a journalist before turning to painting in around 1900. He travelled for a number of years and then settled in Milan in 1907; it was here that he met the founder of the Futurist movement, Filippo Marinetti. The Futurists aimed to break with art of the past and create a new art that captured the sensations and mood of modern, machine-driven life. Boccioni embraced these ideas wholeheartedly, creating paintings

that broke objects down into lines of force to suggest movement; he also employed a fluid system of perspective and used shimmering complementary colours to embody the dynamic vitality of modernity.

Boccioni took these ideas even further by developing a Futurist form of sculpture, creating multifaceted objects that suggested speed, energy, and movement. However, his work was ultimately cut short: he was killed in an accident in 1916, while serving in World War I.

KEY WORKS: *Street Noises Invade the House*, 1911; *Unique Forms of Continuity in Space*, 1913; *Dynamism of a Human Body*, 1913

Vladimir Tatlin

1885–1953, RUSSIAN

Born in Kharkiv, Ukraine, Tatlin spent time as a sailor, interspersed with periods spent studying art at Moscow and Penza between 1902 and 1910. After viewing Pablo Picasso's Cubist relief-paintings in 1914, he began making his own constructions, using glass, wood, and metal to create highly distinctive, dynamic sculptures that were composed of "real materials in real space". These works became early examples of Constructivism, a movement that believed art could serve a powerful and important social purpose.

After the 1917 revolution, the Bolsheviks embraced Tatlin's ideas and he was established as a leader of the Russian avant-garde, designing furniture, clothing, and other items for mass production. However, his most ambitious plans, including a massive multi-purpose tower, the *Monument to the Third International*, and a flying machine he named *Letatlin*, were ultimately never realized. He spent the later years of his life teaching and designing for the theatre.

KEY WORKS: *Reliefs*, 1915; *Monument to the Third International* (model), 1920; *Letatlin*, 1932

Oskar Kokoschka

1886–1980, AUSTRIAN

Kokoschka was born in Pöchlarn and grew up in Vienna, where he studied at the School of Art in 1905–09. Influenced by the intellectual climate of the capital and, particularly, by the writings of Sigmund Freud, Kokoschka began, from 1910, to make an impression with his "psychological portraits", in which he employed limited colour and light, nervous brushwork to capture the inner intensity of his sitters. Around the same time, he began contributing illustrations to the avant-garde Berlin periodical *Der Sturm*. In 1915, he was wounded while fighting in World War I, and afterwards relocated to Dresden, where he taught from 1919 to 1924.

In the 1920s, Kokoschka began to paint bright, luminous landscapes, and travelled widely. In 1935, he fled from the Nazis, taking refuge in Britain. He finally settled in Switzerland in 1953, where he continued to teach and paint in his highly personal, Expressionist style.

KEY WORKS: *The Dreaming Youths*, 1907; *The Bride of the Wind*, 1913–14; *Prometheus Triptych*; 1950

▷ Diego Rivera

1886–1957, MEXICAN

Born in Guanajuato, Mexico, Rivera studied art in Mexico City from 1896 to 1902. He travelled to Europe, settling in Paris – the epicentre of the artistic avant-garde – in 1911. Here, he befriended several artists, such as Pablo Picasso, whose Cubism initially influenced Rivera's style. On returning to Mexico in 1921, Rivera's work turned towards his native culture and the Pre-Columbian art of the Maya and the Aztecs. He also became drawn into Mexico's revolutionary movement and began the first of the public murals for which he is best known. Informed by Renaissance frescos he had seen in

△ *SELF-PORTRAIT WITH BROAD-BRIMMED HAT*, DIEGO RIVERA, 1907

Europe, Rivera's monumental scenes from Mexico's social and political history combined powerful, decorative colours with simplified flat forms, to create an expressive realism, intended to inform and inspire the common man. Their appeal stretched beyond Mexico, with Rivera working on commissions in the USA from 1930 to 1934. Rivera married fellow artist Frida Kahlo in 1928 and spent his later years painting studio pictures.

KEY WORKS: *Creation*, 1922–23; Detroit Industry fresco cycle, 1932–33; *Man, Controller of the Universe*, 1934

Marcel Duchamp

1887–1968, FRENCH

Born in Normandy, Duchamp moved to Paris in 1903 to seek success as a painter. In 1913, he caused controversy with *Nude Descending a Staircase*, a semi-abstract figure made up of overlapping forms. By 1915, however, he had abandoned painting and was producing "ready-mades" instead, selecting everyday objects, such as bike wheels and bottle racks, and presenting them as art. This process shifted emphasis

from making to thinking: Duchamp is recognized as the progenitor of Conceptual art, in which ideas take precedence over the physical work of art. After moving to New York, he presented his notorious porcelain urinal, *Fountain*, and, in 1920 to 1923, worked on a complex, mysterious window-like structure entitled *The Large Glass*. Duchamp worked at a slow pace, dedicating much of his time to chess. However, his influence on Conceptual art, Kinetic art, Surrealism, Pop art, and Minimalism has made him a central figure of 20th-century art.

KEY WORKS: *Nude Descending a Staircase, No. 2*, 1912; *Fountain*, 1917; *The Bride Stripped Bare by Her Bachelors, Even (The Large Glass)*, 1920–23

Naum Gabo

1890–1977, RUSSIAN

Born in Belarus, Gabo studied medicine and engineering in Munich in 1910–14. He was introduced to avant-garde art after visiting his brother, the artist Antoine Pevsner, in Paris, and made his first Cubist-influenced sculptures in 1915, while living in Scandinavia to avoid World War I. After the war, Gabo and Pevsner returned to Russia and produced a Constructivist manifesto, advocating a purely abstract form of sculpture. From 1923, Gabo made non-figurative, kinetic sculptures, using transparent materials to create seemingly weightless constructions in space. His interest in the emotional and aesthetic aspects of materials was not shared by the Communist government, which maintained that art should be socially useful. After spending time in Berlin, Paris, and England, Gabo moved to the USA, teaching at Harvard University, where he continued to espouse his Constructivist views.

KEY WORKS: *Constructed Head No. 2*, 1916; *Kinetic Construction (Standing Wave)*, 1919–20; *Linear Construction in Space, No. 2*, 1949/1972–73

Aleksander Rodchenko

1891–1956, RUSSIAN

Born in St Petersburg, Rodchenko studied at Kazan art school from 1910 to 1914 and then in Moscow. He rapidly went from painting in an Impressionist style to abstraction.

He was a founder of Constructivism, a movement epitomized by the graphic "line constructions", monochromes in primary colours, and suspended, geometrical sculptures that he created. After the Russian revolution of 1917, he became one of the most politically committed of Russian artists, championing Constructivism through his various teaching posts. In 1921, he renounced fine art, turning instead to industrial design, creating furniture, textiles, typography, and political propaganda posters.

He also became a highly distinctive photographer, documenting the workings of post-revolutionary Russia in his trademark experimental, angular compositions. In 1935, he returned to the medium of painting and, in later life, created abstract "drip" paintings that prefigured the work of Jackson Pollock.

KEY WORKS: *Pure Red Colour, Pure Yellow Colour, Pure Blue Colour*, 1921; *Books* (Lengiz Publishing House poster), 1924; *The Staircase*, 1930

Max Ernst

1891–1976 GERMAN-FRENCH

Born in Brühl, near Cologne, Ernst started painting after abandoning his studies in psychiatry. He befriended August Macke, of the avant-garde Der Blaue Reiter (Blue Rider) group, and became fascinated by paintings made by psychotic patients. After serving in World War I, he formed the Cologne Dada group; in 1922, he moved to Paris, aligning himself with the Surrealists, under André Breton.

Ernst's strange, hallucinatory paintings drew heavily on childhood memories to create dreamlike scenes that irrationally juxtaposed different images. These explorations of a personal mythology led Ernst to develop other working methods, including collage and frottage (making images from rubbings of various surfaces), introducing an element of chance into the work. Ernst continued to be involved with the Surrealists until 1937, moving to the USA in 1941. In his later years, his painting became more lyrically abstract. He won the Venice Biennale painting prize in 1954.

KEY WORKS: *Celebes*, 1921; *Men Shall Know Nothing of This*, 1922; *Angel of the Hearth*, 1937

Joan Miró

1893-1983, SPANISH

Born in Barcelona, Miró studied both business and art in the city from 1907–15 before moving to Paris in 1920, where he met Pablo Picasso and members of the Dada movement. His early paintings were influenced by Fauvism, but in Paris he became involved with André Breton and the Surrealists, and he was included in the first Surrealist exhibition at the Galerie Pierre in 1925. Following the Surrealist principle of releasing the creative forces of the unconscious mind, Miró's paintings veered between the figurative and the abstract, as he created a personal language of signs, symbols, and floating coloured forms, some representing nature. He continually journeyed between Paris and Spain until the outbreak of the Spanish Civil War in 1936, to which he responded in his vivid, nightmarish "wild period" paintings. From 1944, he began to produce ceramic works and in subsequent years, he explored a variety of new techniques, receiving a number of significant commissions for public sculptures. Miró settled on Mallorca in 1956 and continued to experiment into his eighties.

KEY WORKS: *The Farm*, 1921; *Constellations* series, 1940–41; *Lunar Bird*, 1946–49

▽ Alexander Calder

1898–1976, AMERICAN

Calder was born in Lawnton, Pennsylvania, USA; encouraged by his parents, he studied mechanical engineering in New Jersey from 1915–19. From 1923, he turned to art, studying painting in New York and moving to Paris in 1926, where he began making wire sculptures, initially of circus animals, but then of people and objects. These linear sculptures were described as three-dimensional line drawings.

It was his experience of fellow artist Piet Mondrian's studio in 1930 that inspired him to start exploring abstraction and, shortly after, Calder produced the first of his "mobiles" for which he became famous. Made using metal shapes in varying colours, the mobiles were suspended from wire or cord; his early versions were driven by motor or by hand. From 1934, he produced non-powered mobiles, which were moved by air currents.

Dividing his time between France and the USA, Calder carried out several large-scale public commissions from the 1950s onwards. He also produced "stabile" non-moving sculptures throughout his career and, in the 1960s, exhibited paintings alongside his other work.

KEY WORKS: *Cirque Calder*, 1926–31; *Arc of Petals*,1941; *Trois Disques*, 1967

△ *SELF-PORTRAIT, 1957*, ALEXANDER CALDER

1945 to PRESENT

CHAPTER 7

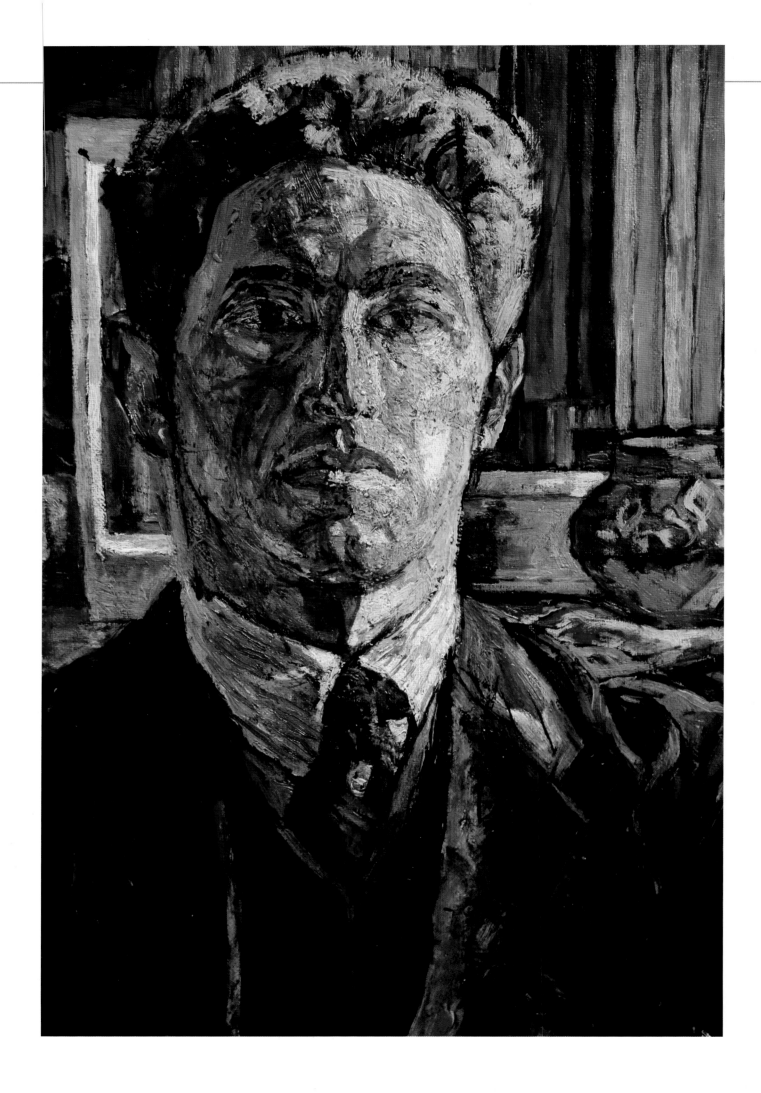

Alberto Giacometti

1901–1966, SWISS

Giacometti was one of the most original sculptors of the 20th century. He grappled with Existentialist notions of perception and isolation both in his paintings and in the elongated sculptures for which he is most famous.

Born in the village of Borgonovo in an Italian-speaking part of eastern Switzerland, Alberto Giacometti was the eldest of four children in an artistically gifted family. Both his father, Giovanni – who exerted a great influence on his artistic development – and his godfather, Cuno Amiet, were prominent Swiss artists, while his brothers, Diego and Bruno, became a furniture designer and an architect respectively.

Early influences
Alberto's talent was evident by his early teens (he completed his first sculpted portrait and his first oil painting in his father's studio aged just 14) and by 1919 he had begun his studies of art in Geneva. Visiting Italy with his father the following year, he became infatuated by the works of Tintoretto and Giotto, and was intrigued by the ancient Egyptian art that he saw at the archaeological museum in Florence.

In 1922, he enrolled at the Académie de la Grande Chaumière in Paris, where he was taught by Antoine Bourdelle, Auguste Rodin's former assistant; here he became interested – like many other artists of the time – in the so-called "primitive" art of Oceania and Africa, and was undoubtedly influenced by the Modernist sculptor Constantin Brancusi (see pp.280–83) and by Cubism, which had emerged in Paris in the previous decade. In 1926, he set up a studio at rue Hippolyte-Maindron, which he would retain for the rest of his life.

The Surrealists
Giacometti signed a contract with Pierre Loeb, the main dealer for Surrealist work in Paris. A series of flat plaster sculptures brought him renown, and he began to move in avant-garde circles, with the likes of Salvador Dalí, René Magritte, Max Ernst, Joan Miró, and Surrealist founder André Breton.

△ *SPOON WOMAN*, 1926–27
Giacometti's life-size bronze draws together his early influences. It inverts the symbolism of spoons of the African Dan culture, whereby the bowl of the spoon represents a woman's womb.

In 1931, he joined the Surrealist group and embraced their agenda, exploring the unconscious mind, including eroticism, trauma, and dreams, through innovative sculptures that often resembled architectural models or toys. He characteristically placed his forms within open-sided cages – which were as much a part of the sculpture as the figures – to create a clearly bounded space of representation, which heightened the power of the elements within.

In 1930, Giacometti's brother Diego, with whom he had a close bond, joined him in his Paris studio. The brothers worked together on decorative household objects, such as lamps, vases, tables and other items, which they sold through the avant-garde interior decorator Jean-Michel Frank or to international collectors. Meanwhile, metaphorical works such as *Suspended Ball* and *The Palace at 4 a.m.* (1933) cemented Giacometti's reputation as a leading Surrealist.

Creative development
Giacometti's father, Giovanni, died in 1933, and Giacometti travelled to Switzerland to help his mother settle his affairs. Freed from his father's influence, and perhaps from his own feelings of rivalry with him, a grieving Alberto started to

ANNETTE, THE ARTIST'S WIFE, 1961

◁ **SELF-PORTRAIT, c.1923**
This early self-portrait predates Giacometti's experiments with Cubism and Surrealism, but presages his obsession with representing the human head and gaze.

" Figures were never for me a **compact** mass, but like a **transparent construction**. "

ALBERTO GIACOMETTI, LETTER TO PIERRE MATISSE, 1947

▷ **THE ARTIST AT WORK**
When painting a portrait, Giacometti would position his own stool and that of his subject at a precise distance from his easel, enabling him to focus on details and at the same time grasp an overview of his sitter.

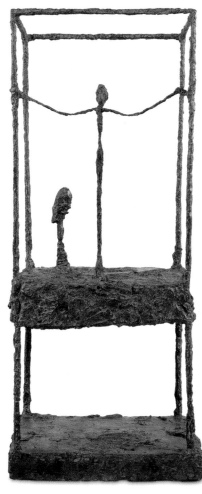

△ *THE CAGE*, 1950
Giacometti used the conceit of the cage in his Surrealist work and returned to it later. The delimiting lines of the cage make space as much a part of the sculpture as the figures themselves.

re-examine his approach to his work, with profound consequences. Giacometti began to drift away from severe abstraction, and indeed from the Surrealist style itself, a transition that was marked in his work in 1934 with *Head-Skull*, a plaster sculpture of a skull in which the artist replaced the contours of the human head with flat planes, to produce an almost crystalline form. And so began a

personal quest on how to represent the human head that would occupy him for the rest of his life.

Conflict and escape

For the Surrealists, Giacometti's move towards a figurative style – and his preference for working from models rather than from his imagination – was unacceptable. In 1935, he was expelled from the group, although

his work continued to be featured in their exhibitions as they toured around the world in the prewar years. When World War II began, Giacometti remained in Paris. He befriended the Existentialist writers Jean-Paul Sartre and Simone de Beauvoir, and American art collector Peggy Guggenheim. The advancing German army forced him to flee to Switzerland, where he lived until the end of the conflict. His work

KEY MOMENTS

1928
Gains the admiration of the Surrealists with *Gazing Head*, a sculpture that reduces the subject of the human head to its abstract essence.

1930–31
Suspended Ball defines a wholly new typology of sculpture called "mobile and mute objects" that bridges the distinction between object and sculpture.

1948
Makes *Three Men Walking I*, a typically Existentialist work. It shows three men who are walking in different directions, close but still isolated.

1956
Makes 15 sculptures of a standing female nude from a single clay figure, on the same armature. Nine of them are cast in bronze.

1961
Paints numerous portraits of "Caroline", a prostitute with whose racy life he is fascinated and whom he draws again and again in different guises.

1965
Makes *Elie Lotar III (Seated)*, showing Lotar, an impoverished former member of the Paris avant-garde who poses immobile for hours at a time.

"The object of art is not to reproduce reality, but to **create a reality** of the same **intensity**."

ALBERTO GIACOMETTI

over this period took a strange turn: in an attempt to express the pure essence of being, and to represent the distance between artist and model, his sculptures became extremely small – no larger than needles. By the time he returned to Paris in 1946, it is said that his work could fit into six matchboxes.

Existential figures

Back in his Paris studio, Giacometti developed the thin, elongated human forms for which he later became famous. The figures of his mature style were simultaneously fragile and rough-hewn, delicate and hard. He created men walking, in groups of two or three, or alone, leaning forward, perhaps into a rainstorm, perhaps in a hurry. Their huge feet anchored them to the earth. His women were depicted standing – again, in groups or single; tall, thin, frontal compositions, immobile and solemn, monumental despite their physical emaciation.

In seeking the essence of the human being, Giacometti pared his sculptures to the bone. Works such as *Three Men Walking*, *Man Walking in the Rain*, and *Standing Woman* (all 1948) conjure a sense of loneliness, isolation, and anxiety that was consistent with the philosophy of the Existentialists. They also spoke to a need in Europe to find a way of remaining human after the brutalities of the war.

Giacometti maintained a close friendship with French philosopher Jean-Paul Sartre, who wrote

extensively on his work in the context of Existentialism, including the preface to the catalogue of his first exhibition in the USA. This took place in 1948 at the Pierre Matisse Gallery in New York and propelled Giacometti to international fame.

Late portraits

In 1947, Giacometti's model and lover, Annette Arm, joined him from Switzerland, and in 1949 the couple were married. Together with his brother Diego, Annette was one of his favourite models and he created numerous portraits of both of them in sculpture and painting, along with portraits of other friends and family members. At a time when the art world was dominated by abstraction, Giacometti remained firmly focused on figurative art,

▷ **BUST OF DIEGO, 1964**
Diego Giacometti was a constant in his brother's life, working in the next-door studio, helping him to cast his works in bronze, and sitting for him as a model. Giacometti made numerous busts of his brother.

and successfully found a way to portray his own experience of seeing. In the mid-1950s, he started a series of portraits in which he was determined to capture the precise likeness of the sitter, each painting requiring countless sittings and constant revisions. His work was displayed in numerous exhibitions, including at the Kunsthalle in Basel and the Galerie Maeght in Paris, and he won many awards. In 1956, he exhibited at the French Pavilion at the Venice Biennale, and in 1962, invited back as a solo artist, he was awarded the Grand Prize for Sculpture.

Final years

Despite an operation for stomach cancer, he worked indefatigably to the end of his life, and in his last years prepared a series of lithographs of Paris, which was published after his death as *Paris sans fin* (*Paris Without End*). He died in 1966 and was buried alongside his parents in the village of Borgonovo, where he was born.

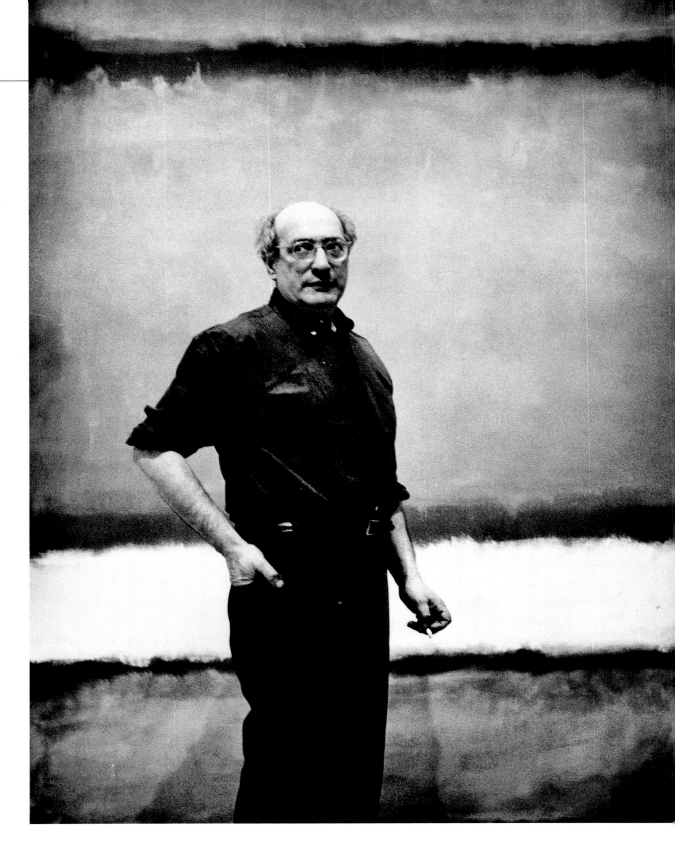

▷ **PORTRAIT WITH *NO. 7***
Rothko is pictured here standing in front of his 1960 painting *No. 7*, which shows his signature style: horizontal swathes of colour, painted on an enormous canvas. It is likely that Rothko – along with other Abstract Expressionists – often did not name his paintings because he was keen to avoid imposing a specific meaning or interpretation on them.

Mark Rothko

1903–1970, RUSSIAN/AMERICAN

A prominent artist in postwar New York, Rothko explored Expressionism and Surrealism before finding his wholly abstract signature style of soft-edged rectangles floating on a saturated ground of colour.

Born Marcus Rothkowitz in Dvinsk, Russia, Mark Rothko emigrated to the United States in 1913, at the age of 10, with his family, settling in Portland, Oregon. He attended Yale University from 1921 to 1923, but left without graduating and moved to New York. There he briefly studied art under Cubist painter Max Weber and the avant-garde artist Arshile Gorky, and met the Modernist painter Milton Avery, with whom he participated in a group show in 1928. In 1929, he began teaching art to children at the Center Academy of the Brooklyn Jewish Center, a job he held until 1959.

In search of the spirit

Although Rothko is known as an Abstract Expressionist – a label he rejected – his early paintings were figurative. His subjects ranged from nudes and portraits to landscapes and scenes of urban isolation, including a series depicting the New York subway.

In his first solo shows in 1933, Rothko mixed Expressionism and Surrealism. He made use of symbolic imagery in his work, drawing on themes from mythology to try to express archetypal human truths and fill a spiritual void. This impulse became all the more urgent during World War II, particularly after he read *The Birth of Tragedy*, by German philosopher Friedrich Nietzsche, in which society is examined through the lens of Greek tragedy.

In 1945, art collector Peggy Guggenheim gave Rothko a one-man show in which he exhibited, among other works, *Slow Swirl at the Edge of the Sea*. Drawing, in the mode of the Surrealists, on his own unconscious for inspiration, the painting shows two figures – perhaps dancing – representing "the principle and passion of organisms".

Towards abstraction

In the late 1940s, Rothko abandoned figurative work and started moving towards his signature style. These transitional abstract paintings – in which indistinct, soft-edged shapes float on a paint-saturated canvas – were referred to as "multiforms". The artist perceived the works as conveying human passion as effectively as – or more effectively than – figurative art, which he saw as a spent force. Around this time, Rothko stopped giving his paintings titles or explanations as he wanted viewers to find their own meaning.

Rothko refined the style until he was painting just two or three vertically stacked rectangles of shimmering colour. The vast size of the canvases was intended not to alienate but to

▽ SLOW SWIRL AT THE EDGE OF THE SEA, 1944
Painted the year before Rothko married his second wife, Mary Alice Beistel, the work depicts two floating figures, who may represent the courting couple.

draw the observer in – to make the paintings intimate. Colour, laid on in thin washes, became inseparable from structure. The artist was aiming for an expression of the sublime; he was insistent that his paintings should be perceived as meaningful and brimming with ideas, rather than as mere games with colour or decorative objects. Indeed, this concern may well have influenced his decision to withdraw from a commission at the Four Seasons restaurant in New York's new Seagram Building in 1958.

In the 1960s, Rothko produced a series of huge panels for what would become the Rothko Chapel. They were darker than his previous paintings, lacking their radiant luminosity, and merging the distinction between foreground shape and background colour. As with all his works, he wanted the viewer to be drawn into a profound meditative state. The darkness of Rothko's late works was seen again in his final, powerful *Black on Gray* series – a set of horizontally divided paintings juxtaposing serenity and turbulence – which evokes a bleak, lunar landscape.

Ill health and depression plagued Rothko's final years. In 1969, he separated from his wife; in February the following year, he took his own life.

△ THE ROTHKO CHAPEL
Rothko created 14 vast works for the non-denominational Rothko Chapel in Houston, Texas. Their subdued hues are intended to enable contemplative viewers to "go beyond" the canvas in a way not possible with bright colours.

IN CONTEXT
Colour field painting

Closely associated with Abstract Expressionism, colour field painting evolved in New York in the 1940s and '50s. Its first major proponents were Clifford Still, Barnett Newman, and Mark Rothko (although he denied adherence to any school). The style consisted of large, flat planes of colour that extended to the edges of the canvas. The predominantly abstract paintings were designed to evoke spiritual or emotional responses in the viewer. A later generation of artists, however, focused on colour for its own sake.

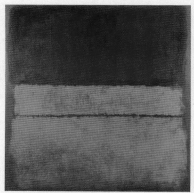

UNTITLED, MARK ROTHKO, 1959

" The people who **weep** before my pictures are having the same **religious experience** I had **when I painted** them. "

MARK ROTHKO, CITED IN *CONVERSATIONS WITH ARTISTS*, SELDEN RODMAN, 1957

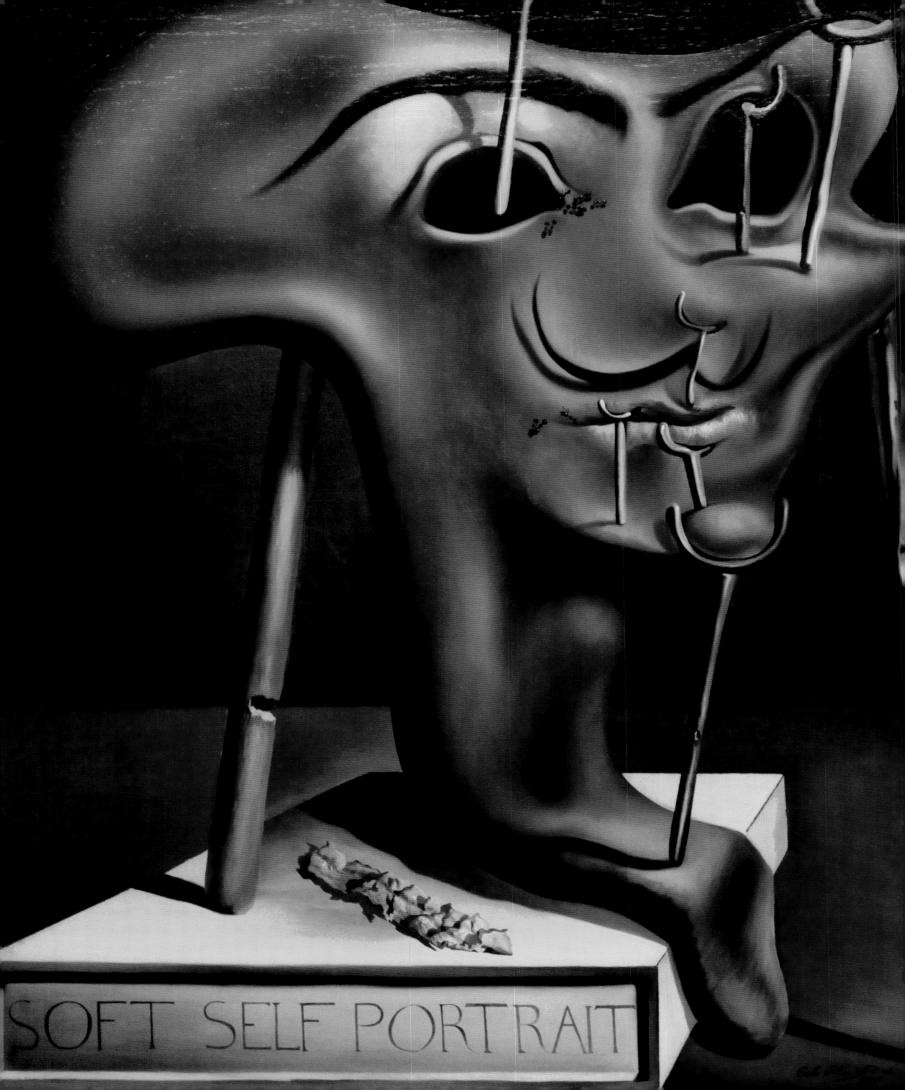

SOFT SELF PORTRAIT

Salvador Dalí

1904–1989, SPANISH

Dalí was known for his meticulously painted works and bizarre imagery. An extraordinary showman, he was also responsible for popularizing Surrealism – and promoting his own image globally.

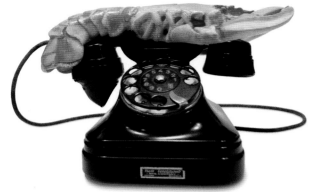

Salvador Dalí was born in 1904 in Figueres, Catalonia, Spain. His father was a lawyer. From 1916, Dalí attended drawing school and in 1917 his father arranged his son's first exhibition – of his drawings – in the Dalí family home. In spite of this support, Dalí and his father had an uneasy relationship, due mainly to tension between the family's middle-class Catholic background and the artist's bohemian leanings. Dalí was closer to his mother, and was deeply distraught when she died in 1921.

Surrealism in Paris

The following year, Dalí left home for Madrid to study at the Real Academia de Bellas Artes de San Fernando. There, he developed a remarkable mastery of oil paint through studies of Raphael, Vermeer, and Velázquez; he experimented with avant-garde forms, notably Cubism, and befriended his fellow students Luis Buñuel and poet Federico García Lorca. Dalí was expelled from the Academy shortly

before he completed his studies – allegedly for fomenting unrest – and soon afterwards he travelled to Paris, the epicentre of European art, where he met his hero Picasso and was introduced into the city's Surrealist circles by his fellow Catalan Joan Miró.

Dalí's work – influenced by Cubist and Futurist principles, and by his reading of Sigmund Freud (see box, right) – became increasingly aligned with the goals of Surrealism, and he joined the group in 1929.

The movement had been launched five years earlier with the publication of a manifesto written by the poet and

former Dadaist André Breton. The Surrealists sought to free their imagination from conscious control to "resolve the previously contradictory conditions of dream and reality". Some of them, notably Max Ernst and André Masson, tried to achieve this through automatism – for example, by allowing the hand to make random

△ **THE LOBSTER TELEPHONE, 1936**
Dalí made this object for the British art collector Edward James, who commissioned four of the working telephones for his house.

▽ **THE PERSISTENCE OF MEMORY, 1931**
Dalí's most famous painting is a highly finished hallucinatory work. The artist used an extremely fine sable brush to paint its minute details.

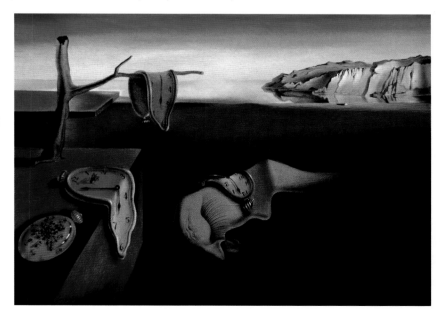

◁ **SOFT SELF-PORTRAIT WITH GRILLED BACON, 1941**
Dalí mocks himself in this painting in which his melting face is held up by crutches (a common motif in his work). The bacon references the breakfasts he ate while living in New York.

IN CONTEXT
Dreams and the unconscious

Dalí and the other Surrealists were fascinated by the work of the great Viennese psychoanalyst Sigmund Freud, particularly his studies of dreams and what they revealed about the unconscious mind. Reading (and eventually meeting) Freud encouraged Dalí to record his own dreams and to include dreamlike images in his paintings, which also reflect many of Freud's key ideas. For example, Dalí's *The Enigma of Desire: My Mother* (1929) relates to the Oedipus complex, while *Autumn Cannibalism* (1936) draws on Freud's ideas about psychosexual development. Such works as this show what Dalí meant when he said that he wanted to give dreams and visions a concrete reality.

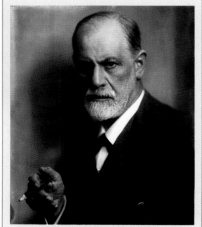

SIGMUND FREUD

" Give me **two hours** a day of **activity** and I'll take the other twenty-two in **dreams**. "

SALVADOR DALI

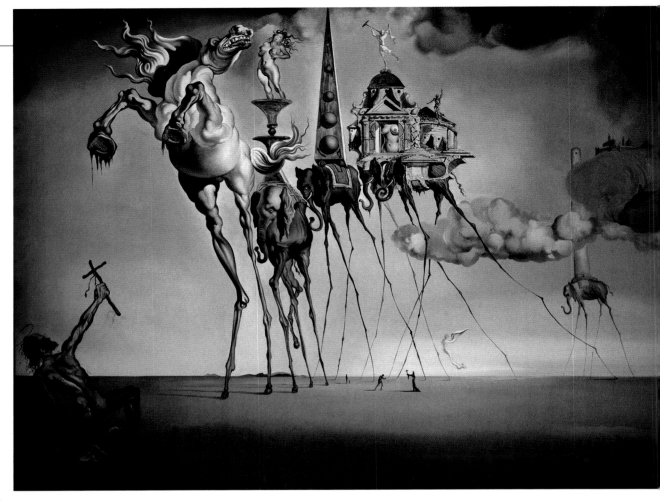

GALA AND DALI, PICTURED SHORTLY AFTER THEIR WEDDING IN 1934

marks on paper. Others, including René Magritte, Yves Tanguy, and Dalí, evoked hallucinatory states in their work by juxtaposing bizarre objects in dreamlike compositions.

Dalí used his meticulous oil technique to paint hyperreal dream images. Employing what he called the "paranoic critical" method, he attempted to free imagery from his subconscious, deliberately cultivating self-induced hallucinations that merged fantasy with reality. His breakthrough work, *The Persistence of Memory* (1931), became one of Surrealism's most famous images, and its symbolic content was endlessly analysed. In common with much of Dalí's work from this time, it explores themes of death, decay, mortality, and eroticism, and it does so using motifs that recur in his

paintings: the sleeping creature at the centre of the image, for example, had appeared in two paintings from 1929.

Collaborative works

The Surrealist group included not just artists but also writers and film-makers, and it was through the group that Dalí was introduced to the poet Paul Eluard and his wife, Gala (see box, left). Dalí was also involved with other members of the group on collaborative projects, such as the Luis Buñuel films *Un Chien Andalou* (1929) and *L'Age d'Or* (1930).

With his distinctive moustache and eccentric behaviour, Dalí was a natural self-publicist. He famously delivered a lecture at an event to mark the great 1936 International Exhibition of Surrealism in London while dressed in a diving suit. He held two dogs on

△ **THE TEMPTATION OF ST ANTHONY, 1946**
Painted as an entry in a competition, this work marks the artist's turn towards religious themes. It combines religious symbolism (the horse representing strength, the naked woman lust) with elements of Surrealism such as the animals' bizarre extended limbs and the empty landscape setting.

leads in one hand, and a snooker cue in the other. The exhibition attracted huge crowds, blocking traffic in the city on the day it opened, and made artists such as Magritte and Dalí into household names.

Later in the 1930s, Dalí began to diverge from the Surrealist group. He adopted a more realistic style under the influence of the Renaissance painters whose work he so admired. His arguments with André Breton and

" The only difference between a madman and me is that **I am not mad**. "

SALVADOR DALI

KEY MOMENTS

1926
Paints highly accomplished realist canvases, such as *Basket of Bread*, which display his mastery of fine brushwork.

1929
Paints *The Great Masturbator*, which features the profile that later appears in his iconic work *The Persistence of Memory*.

1949
Deeply affected by the dropping of the atomic bombs on Hiroshima and Nagasaki, he is inspired to paint *Leda Atomica*.

1951
Paints *Christ of St John of the Cross*, reworking religious imagery by showing Christ on the cross but without nails, blood, or wounds.

1983
Paints *The Swallow's Tail*, one of a series based on the mathematical theories of René Thom.

his politics (Dalí supported Franco in the Spanish Civil War) prompted his expulsion from the movement and his relocation to the USA in 1940.

Travels of the mind

Dalí's move across the Atlantic was also marked by another change of direction: he returned to Catholicism and began to include religious imagery in his paintings. In the USA, he worked in many areas other than oil painting; he created interiors for upmarket shops, produced theatrical designs and jewellery, and wrote a book, *The Secret Life of Salvador Dalí* (1942–44), in which he shocked readers with his frank confessions of, for example, his violence towards women.

By the time he returned to Spain in the late 1940s, Dalí was painting religious subjects, scenes that

explored his childhood memories, and images of Gala. Although painted with his characteristic flair, they failed to impress critics and viewers, and Dalí became more famous for his publicity stunts, writing, and design work.

Dalí's major project in the 1960s and 1970s was in his home town, Figueres, where – with the mayor – he planned to rebuild the theatre, which had been damaged during the Spanish Civil War. The building that resulted houses many of Dalí's works, along with his collection of works by other artists. Converting the building and installing the collection took from 1968 to 1974.

Late projects

During the last decade of his life, Dalí was dogged by illness. He began to suffer from trembling in his right

hand; it is possible that this was due to damage that was caused by the combination of unprescribed medicines he had been taking. Gala died in 1982, leaving the artist depressed. His final painting, *The Swallow's Tail*, was completed the following year; it is an abstract composition made up mainly of curved and straight lines, and is the last of a series of paintings that Dalí produced based on catastrophe theory.

After a fire at his home (which some said was a suicide attempt), friends helped Dalí to move to rooms in his Theatre-Museum, where he spent his last few years. In 1989, he died of heart failure, and was buried in the crypt of the museum. The building remains a shrine to its creator, who – while embracing a range of subjects and styles throughout his life – never completely lost faith in Surrealism and did much to make it popular around the world.

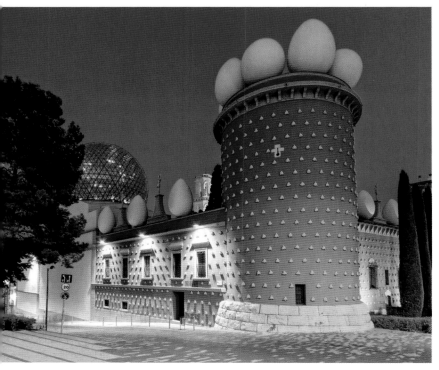

◁ **THE DALI THEATRE-MUSEUM**
The extraordinary architecture of Dalí's theatre-museum in Figueres combines a geodesic dome on the roof with statues and egg-like sculptures along the tops of the outer walls. He added to the museum for the rest of his life, making it his greatest monument and a centre for the appreciation and study of his work.

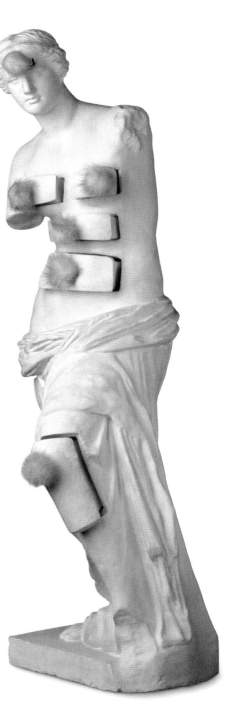

▷ *VENUS DE MILO WITH DRAWERS*, **1936**
This plaster statue incorporates pull-out drawers that have mink pompoms for handles. Its mix of traditional forms and bizarre imagery, together with its sexual content, makes it a memorable and distinctive Surrealist work.

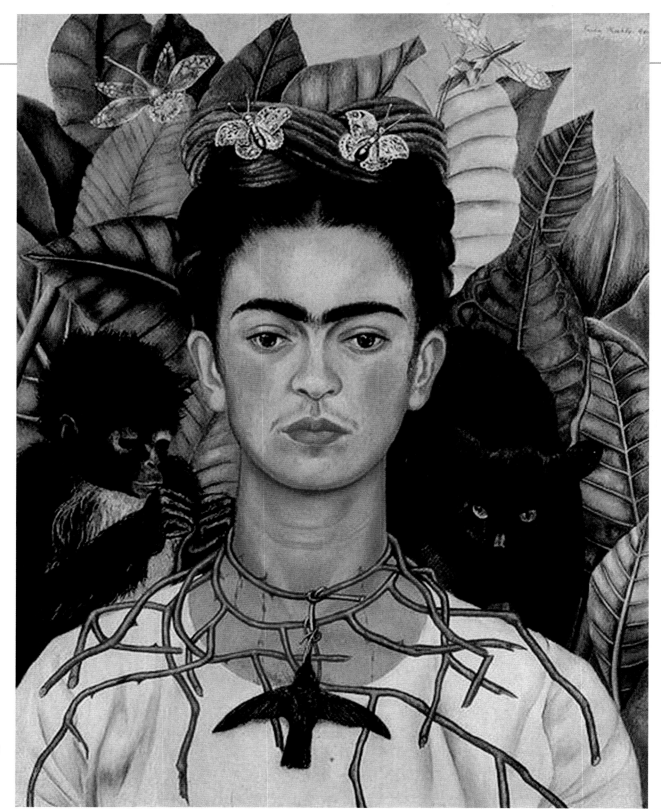

▷ **SELF-PORTRAIT WITH THORN NECKLACE AND HUMMINGBIRDS, 1940**
Frida Kahlo was her own favourite subject. In this self-portrait, her intense suffering is symbolized by the necklace of thorns and the lifeless hummingbird.

Frida Kahlo

1907–1954, MEXICAN

Hailed as a feminist icon, enigmatic Mexican painter Kahlo is best known for her vibrant, startling, sometimes nightmarish self-portraits, often seen as chronicles of physical and emotional anguish.

Magdalena Carmen Frida Kahlo y Calderón was born on 6 July 1907 in Coyoacán, a suburb of Mexico City, to a German-born father and Mexican mother. She contracted polio at the age of six, which left her with a deformed leg. While a teenager, she changed her year of birth to 1910 to indicate solidarity with the Mexican Revolution (1910–20) – she was to be a left-wing political activist all her life. At the age of 18, Kahlo suffered extensive injuries to her spine, leg, and pelvis in a traffic accident. She was unable to have children, endured disability and chronic pain, and underwent numerous operations – including, in 1953, the amputation of part of her right leg.

In 1929, Kahlo married fellow Communist and famous Mexican muralist Diego Rivera, who was twice her age. She referred to her stormy relationship with him as the "second accident" of her life. The couple both had several affairs (Kahlo notably with Russian revolutionary Leon Trotsky) and divorced in 1939, though they remarried the following year.

Versions of the self

Kahlo taught herself to paint while convalescing from her motor accident in 1925. Of her 143 paintings, 55 are self-portraits, and it is for these that she is best known. The carefully posed works are notable for the subject's unchanging, expressionless gaze; they also frequently show her in traditional Mexican dress, with a unibrow, a moustache, and dark hair, often with the head turned slightly to the side

△ *FRIDA Y DIEGO*, 1944
Frida painted this double portrait as a gift for Diego on their wedding anniversary.

and just one ear visible. Her repeated visual exploration of her identity is both personal and political: it takes place in the context of post-revolutionary Mexico and of her own turbulent history, and tackles coming to terms with her relationship with her own body, her sexuality, and her national identity.

Expressions of pain

Extreme physical and psychological torment are often represented in Kahlo's work, as in *The Broken Column*, (1944) and *The Wounded Deer* (1946), in which she paints herself as a hybrid human–animal pierced by hunters' arrows. In still other works, she appears variously as exotic, sensual, resilient, vulnerable, and struggling.

Kahlo's flamboyant, passionate, and disarmingly frank paintings – sometimes terrifying, and often seemingly naive – were described by French writer and Surrealist pioneer André Breton as "absolutely pure and absolutely pernicious... a ribbon around a bomb".

Kahlo's work is of interest to feminists for the issues it raises concerning beauty, gender, and sexual politics – as in *Self-Portrait with Cropped Hair* (1940), painted soon after she divorced her husband for infidelity. Here, she depicts herself with short hair, in male clothing, holding a pair of scissors, and with locks of hair at her feet. Influenced by Mexican folk art, Native American and Aztec culture, Eastern philosophy, and medical discourse, and with an insistent interweaving of fact and fantasy, Kahlo's art has been subject to various categorizations: Breton, for example, was the first to describe her work as Surrealist. Kahlo herself consistently defied such labels: "I never painted dreams," she said, "I painted my own reality."

Posthumous fame

Frida Kahlo died at her house in Coyoacán in 1954, aged just 47, and achieved cult status posthumously. Major exhibitions of her art, as well as numerous documentaries, films, and books, have made her a household name in many countries. In 2016, her *Two Nudes in the Forest* (1939) sold for more than US$8 million, a record for a Latin American artist. Her work is now generally acknowledged as one of the most significant contributions to 20th-century art.

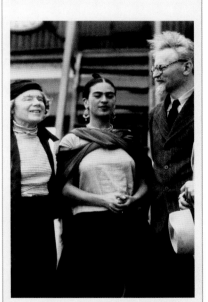

IN CONTEXT
Kahlo, Trotsky, and Communism

Despite their often bitter marital differences, Kahlo and Rivera shared a political vision. As revolutionary socialists, they were eager to welcome exiled Soviet Communist leader Leon Trotsky and his wife to Mexico in the late 1930s. Trotsky moved into Kahlo's family home in Coyoacán in late 1937; he and Kahlo had a brief affair. The Russian and his wife later moved into a house nearby, where he was assassinated in 1940. Kahlo was interrogated by police for complicity but was dropped from their investigations after two days of questioning.

FRIDA WELCOMES TROTSKY AND HIS WIFE, RUTH, TO MEXICO

◁ **THE BLUE HOUSE**
The house where Kahlo was born, lived, and died in the bohemian Coyoacán district is known as the Blue House. Kahlo spent much time painting here.

" I paint myself because I am **so often alone** and because I am the **subject** I know **best.** "

FRIDA KAHLO, 1938

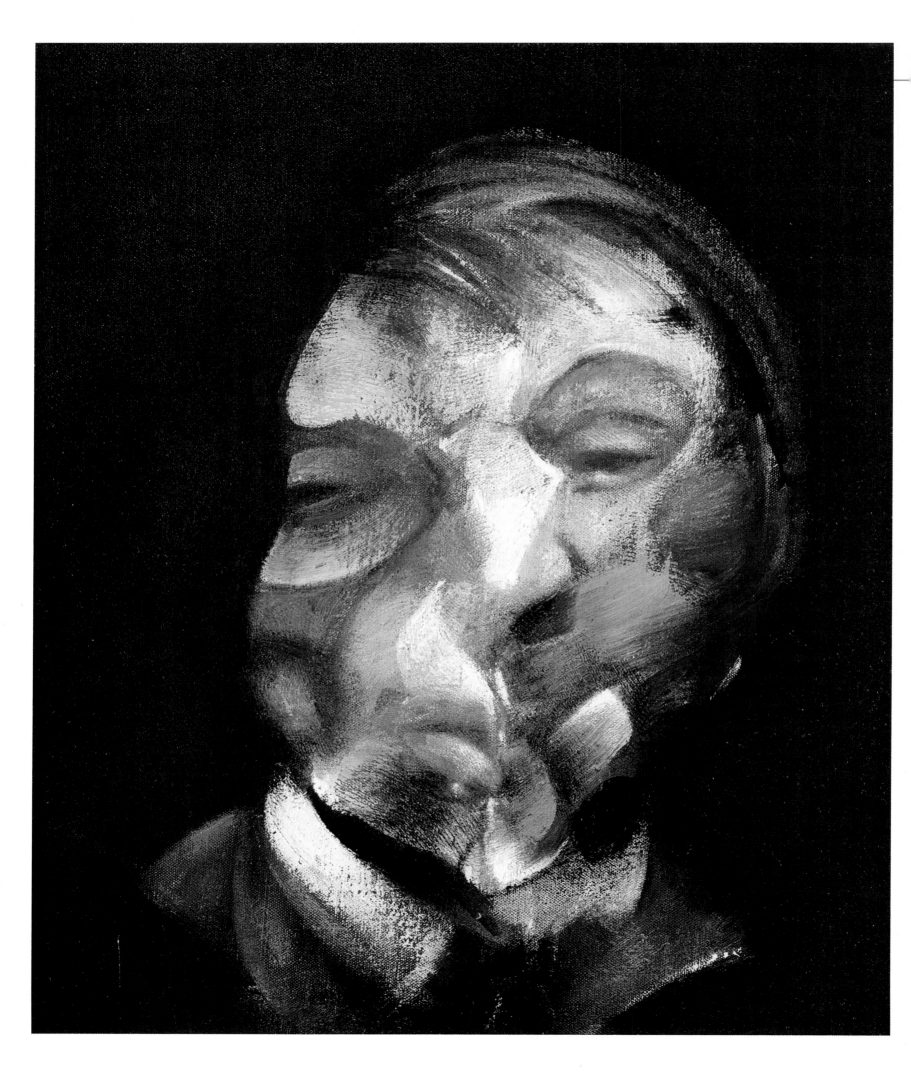

Francis Bacon

1909–1992, IRISH-BORN BRITISH

A towering figure of postwar British painting, Bacon developed a highly distinctive personal artistic language that evoked the bleakness of the human condition through distorted, expressive, and tormented forms.

◁ **THREE STUDIES FOR FIGURES AT THE BASE OF A CRUCIFIXION, 1944**
Despite its strong Christian connotations, the figures in Bacon's triptych were inspired by the Furies (deities of vengeance) in Aeschylus's three-part play the *Oresteia*.

ON TECHNIQUE
Photographic influences

Bacon based many of his paintings on photographs, and was fascinated by the pioneering sequential photographs produced by Eadweard Muybridge (1830–1904) showing animals and humans in motion. He incorporated what he learned from them about movement and position into his paintings. Muybridge's photographs of wrestlers were used as the basis for several works, including the controversial *Two Figures* (1953), which depicts two naked men coupling on a bed – a conflation of violence and the sexual act that was perhaps appropriate given the turbulent nature of Bacon's relationship at the time.

A PHOTOGRAPH FROM MUYBRIDGE'S *ANIMAL LOCOMOTION* COLLECTION

Born in Dublin, Ireland, to English parents, Francis Bacon was brought up in both Ireland and England. His childhood was difficult – he suffered from chronic asthma and was tutored at his home, where his father, in particular, found it hard to deal with Francis's emerging homosexuality, In 1926, Bacon senior threw his son out after discovering him trying on his mother's underwear. The 16-year-old Bacon drifted around London, spent two months in Berlin – sampling its nightlife as well as its artistic and intellectual culture – and then moved to Paris. It was here, influenced by the work of Picasso and the Surrealists, that he decided to become an artist.

In 1928, Bacon returned to London and began to work as a furniture designer and interior decorator in a Modernist style, teaching himself to paint at the same time. His first artistic success came in 1933 with *Crucifixion*, a sombre, stark, Picasso-influenced rendition of the theme, which was exhibited in a group show, published in the book *Art Now* by art critic Herbert Read, and bought by the collector Sir Michael Sadler. Further success eluded him, however, and an attempted solo show was a dismal failure; in 1936, his works were rejected by the International Surrealist Exhibition in London for not being surreal enough. Bacon painted very little for the next few years and what art he did make, he later destroyed.

During World War II, Bacon was exempt from active service because of his asthma and volunteered for the civil defence in London, although he had to give this up too when his asthma worsened. He continued to paint, and in 1945, just before the end of the war, he showed his breakthrough work, *Three Studies for Figures at the Base of a Crucifixion* (1944). With its deformed figures, it was an instant attention-grabber, touching a nerve in the war-frazzled public and eliciting praise and shock in equal measure. Bacon followed with *Painting 1946*, which was initially bought by London's Hanover Gallery and later sold to the Museum of Modern Art in New York.

Travels and London

For the next few years, Bacon divided his time between London and Monte Carlo, where he enjoyed the gambling and nightlife. It was in Monte Carlo that the artist developed the unusual habit of painting on the reverse side of a canvas, finding that he preferred its raw, unprimed surface.

◁ **SELF-PORTRAIT, 1971**
Bacon's self-portrait simultaneously shows multiple facets of his face, but unlike static Cubist works, dynamic brushmarks suggest movement in the artist's tortured features.

" ... an artist must **learn** to be **nourished** by his **passions** and by his **despairs.** "

FRANCIS BACON, IN JOHN GRUEN, *THE ARTIST OBSERVED: 28 INTERVIEWS WITH CONTEMPORARY ARTISTS*, 1991

▷ **LONDON BOHEMIA, 1963**
Bacon was associated with a group of postwar figurative artists who came to be known as "the School of London". He is pictured (centre) with fellow artists (left to right) Timothy Behrens, Lucien Freud, Frank Auerbach, and Michael Andrews.

At the end of 1949, Bacon had his first solo exhibition, at the Hanover Gallery. The successful show included a series of near-monochrome heads, twisted, open-mouthed, smudged, and trapped within geometrical cages or boxes – a stylistic feature that recurs in much of his subsequent work. *Head VI* was based on Diego Velázquez's famous portrait *Pope Innocent X* (1650) (see p.121), and was the first in what would become an ongoing series known as the "screaming popes", in which Bacon obsessively reworked the image.

As well as Old Masters, Bacon frequently used photographs as inspiration for his work. This is seen in the Hanover show's *Study from the Human Body* (1949), which was based on photographs of people in motion by Eadweard Muybridge. (see box, p.329)

Figurative work
At a time when abstraction was becoming increasingly popular, Bacon's paintings remained resolutely figurative, usually showing a single human figure or head against a stark background. Suffering and contorted, the figure is frequently bounded by lines that enhance the atmosphere of entrapment, isolation, and torment.

In the 1950s, his subjects ranged from the Sphinx – following a trip to Egypt – to a series of sombre men in dark suits; he also began to explore the nude form more fully, as well as painting a series of animals, both domestic and exotic. From the middle of the decade, he divided his time between London and Tangier, Morocco, where his then lover, Peter Lacy, lived.

In 1957, he exhibited works at the Hanover Gallery that showed the influence of the strong, searing light of Morocco. He was also inspired by Vincent van Gogh, in particular a painting called *The Painter on the Road to Tarascon* (1988). In a series of six *Studies for a Portrait of van Gogh* he abandoned his dark palette and used bright reds, blues, yellows, and greens, laid on with thick brushstrokes, in a style that was clearly influenced by the Dutch painter's work.

Friends and relationships
In 1962, a retrospective of Bacon's work was held at the Tate Gallery in London, for which he completed the large-scale triptych *Three Studies for a Crucifixion*, marking the first time he had returned to the subject since his *Three Studies* of 1944. Throughout the decade, he painted several triptychs, including another *Crucifixion* (1965).

After the end of his turbulent and often violent affair with Lacy, Bacon took up with a young, working-class petty criminal named George Dyer (see box, right) , in what would be another stormy relationship. Dyer

▽ *HEAD VI*, **1949**
In this work, the pope sits enclosed in a glass box wearing purple vestments. Forceful, broad, vertical brushstrokes in the background suggest curtains or drapes and help create an overwhelming sense of anguish and confinement.

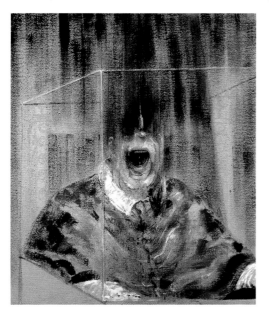

" I paint **for myself**. I don't know how to do **anything else.** "
FRANCIS BACON, IN CONVERSATION WITH FRANCIS GIACOBETTI, 1991–92

became his most frequent subject, featuring in numerous portraits and full-length studies.

Bacon also painted portraits of his friends, many of whom were members of the Soho subculture that he inhabited. His preferred method was to work from photographs rather than from life, and he would crumple, tear, and scrawl on the photos to achieve the distorting effects he wanted, before translating them into oil paint. Bacon sometimes commissioned his friend John Deakin, a *Vogue* photographer, to take the pictures from which he later painted; his portraits of Lucian Freud, Isabel Rawsthorne, and Henrietta Moraes were made in this way.

Simplification of style

Bacon's relationship with Dyer deteriorated as the insecure young man became overtaken by alcoholism. Dyer committed suicide in 1971 on the eve of the opening of Bacon's retrospective at the Grand Palais in Paris. Following the death of Dyer and a number of other friends, Bacon began to paint self-portraits, saying that "people have been dying around me like flies and I've had nobody else to paint". He did, of course, find other subjects, and his passion for portraits continued unabated.

Bacon's work became more simplified, with figures placed in stylized interiors against flat, coloured backgrounds, yet his paintings still conveyed a sense of alienation and discomfort. In the mid-1970s, Bacon met another young working-class Londoner, John Edwards, and began a platonic relationship with him that would last for the rest of his life.

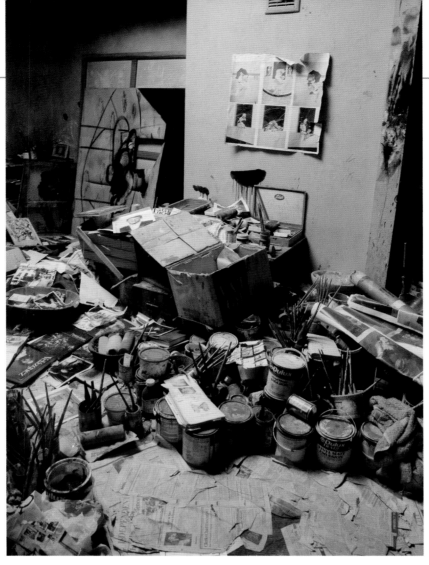

Late works and legacy

By now one of the world's most renowned artists, Bacon was given retrospectives and exhibitions around the world, including in Tokyo, London, Moscow, and Washington, DC. In his last decade he painted with as much energy as ever and began to employ aerosol spray along with oil and emulsion paints to achieve even flatter and more minimal effects.

He used hot orange and pink backgrounds, or cooler tones of light blue, grey, and beige, and continued to imply depth and space by means of sketchy geometric lines or cages. But the violent and haunted quality of his earlier works gave way to greater restraint and composure as he pared away all extraneous content. Along with anonymous muscular nudes and deformed figures on plinths, portraits and self-portraits remained a central focus, a particularly sublime example being *Three Studies for a Portrait of John Edwards* (1984), with its sense of unusual tranquillity and warmth.

Bacon worked right up to the time of his death in 1992, and named John Edwards as his sole heir. His influence can be seen in Neo-Expressionist artists such as Julian Schnabel and conceptual artists, including Damien Hirst.

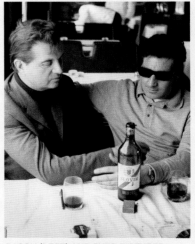

KEY MOMENTS

1944
Paints *Three Studies for Figures at the Base of a Crucifixion*, which catapults him to fame.

1953
Study after Velázquez's Portrait of Pope Innocent X is one of a series of more than 40 works.

1966
Portrait of George Dyer Crouching shows a naked Dyer crouched on the edge of a sofa, gazing into an abyss.

1973
Makes *Triptych, May–June 1973*, which intensely evokes details of Dyer's death.

1982
Study for a Self-Portrait shows the artist seated and introspective, with part of his face erased.

1984
Completes *Three Studies for a Portrait of John Edwards* in a new and quieter style.

Jackson Pollock

1912–1956, AMERICAN

With his distinctive techniques of pouring and dripping paint onto the canvas, Jackson Pollock created an instantly recognizable personal style and became the leading Abstract Expressionist painter in the USA.

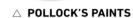

△ **POLLOCK'S PAINTS**
Pollock maintained that in his celebrated poured or dripped paintings he could "control the flow of paint" – his work was far from haphazard or accidental.

Paul Jackson Pollock was born on a ranch in the prairie town of Cody, Wyoming, in 1912. The youngest of five brothers, he was named Jackson after the Wyoming town beloved by his mother, Stella May. His father, LeRoy, was a farmer who also worked for the government as a land surveyor.

Soon after Pollock's birth, the family relocated to San Diego to farm fruit, but their business failed. They moved to Arizona, and then to a string of places in the southwest in a restless search for work. Pollock's unsettled childhood left a deep psychological mark that was compounded by his father's alcoholism and later departure from the family.

Early influences

Pollock sometimes accompanied his father on surveying trips, during which he encountered Native American sand paintings. Made during healing rituals, these images were formed by pouring different-coloured sands onto a horizontal surface. They made a lasting impression on Pollock, and he world later refer to them when describing the origins of his "action painting" technique.

Encouraged by their mother, who claimed an artisanal heritage, Pollock and his brothers developed a taste for art. In 1921, the eldest,

Charles, went to study at the Otis Art Institute in Los Angeles, from where he sent back magazines featuring the latest developments of the European avant-garde to his brothers.

Rejecting convention

Meanwhile, Pollock enrolled at the Manual Arts High School in Los Angeles, where an unusually progressive art teacher introduced him to Eastern mysticism and new ideas in modern art, as well as encouraging his students to paint from life (which was highly irregular at the time). Timid but opinionated, the 18-year-old Pollock sought to

free himself from the conventions of both traditional art and academic authority, and was expelled from high school for breaches of discipline. Soon afterwards, in 1930, he moved to New York City, joining Charles as a student of Thomas Hart Benton at the Art Students League – an informal and unconventional school of art.

Benton's bold realist style and interest in social commentary did not have a guiding influence on Pollock's art; indeed, Pollock said that Benton's work gave him "something to rebel against". However, Benton became something of a touchstone in Pollock's life over the next decade, especially after his father died in 1933.

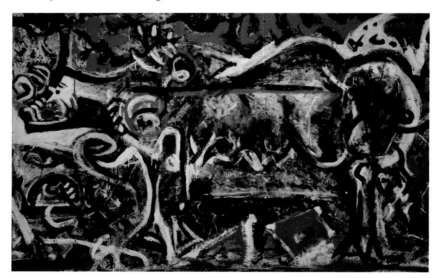

◁ **THE SHE-WOLF, 1943**
This canvas is typical of Pollock's early fascination with primeval subjects. Its strong lines and colours attracted attention when it was shown in New York in 1943 at his first solo exhibition.

▷ **ACTION PAINTING**
Pollock at work in his studio in Long Island in 1949. In his "action painting" technique, splashes, drips, and other marks on the canvas closely reflect the artist's gestures and actions.

" My concern is with the **rhythms of nature...** the way the ocean moves... I work from the inside out, **like nature**. "

JACKSON POLLOCK

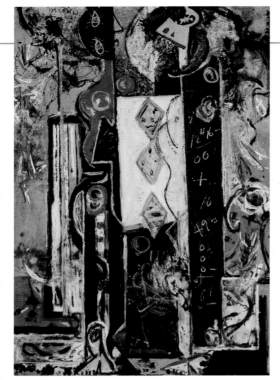

Peggy Guggenheim

Marguerite "Peggy" Guggenheim (1898–1979) advanced Pollock's career considerably. She was a member of a rich American mining family and spent much of her fortune collecting modern art. She opened a gallery in London in 1938, and organized exhibitions for the many artists she had met on her travels in Europe. Her plans for an ambitious museum in Paris were scuppered by the onset of World War II. Instead, she established the Art of This Century gallery in New York – and it was here that Pollock held several exhibitions that helped to launch his career. After the end of World War II, Guggenheim moved to Venice, where her collection can still be seen.

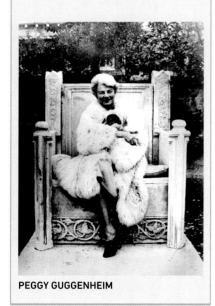

PEGGY GUGGENHEIM

◁ MALE AND FEMALE, 1942–43
With its curvaceous female and linear male forms, this painting shows the influence of Cubist art on Pollock; parts of the work also foreshadow his later, more adventurous ways of applying paint.

Paint experiments
In 1936, Pollock joined a workshop run by Mexican mural painter David Alfaro Siqueiros, who introduced the young artist to new media, such as commercial enamel paint, and showed him how to fling rather than paint it onto a canvas.

From 1938 to 1942, Pollock worked for the WPA Federal Art Project (see box, p.332), which provided him with a small income, and gave him time to develop his own pictorial language. By now, Pollock had become an alcoholic. He turned for help to Jungian therapist Dr Joseph Henderson, who urged his "unverbal" client to communicate through drawing. The drawings that Pollock made depict animals, totems, and human heads morphing into abstract shapes – reflections of his inner torment that presage the frenetic movement of later works.

The New York art world was transformed when patron and curator Peggy Guggenheim (see box, left) opened her gallery, Art of This Century, in 1942. Here, she exhibited work by the European pioneers of Surrealism, Cubism, and abstract art, which was embraced by a generation of US artists, including Pollock, whose personal experiences resonated with the exploration of the unconscious and of universal archetypes evident in the works of the Europeans.

In 1943, Guggenheim staged Pollock's first solo exhibition at the gallery. The catalogue described his paintings – part-figurative, part-abstract – as volcanic, unpredictable, and undisciplined. Later in the same year, Pollock produced a huge work, *Mural*, for Guggenheim's New York home. The painting was essentially abstract, but contained suggestions of human figures and faces (he allegedly contemplated the blank canvas for six months, then painted it in a single session). Critics who had seen *Mural*, and the exhibition, soon began to describe Pollock as a major artist.

▷ CATHEDRAL, 1947
This early drip painting shows the energetic balance between intent and chance that the technique allowed.

Action painting
In 1945, Pollock married the American artist Lee Krasner, bought a property in Springs, Long Island, and converted its rustic barn into a studio. It was here that he made his most celebrated paintings, from 1947 to 1950.

Pollock would tack an unstretched canvas to the studio floor, then pour or drip paint onto it. He used commercial liquid paint and conventional oil paint, and added other materials such as sand to create texture. In the generous space of his barn, Pollock worked all around a painting, building up trails and splashes of different colours, and found that dripping, together with using tools such as sticks, trowels, and knives to apply paint, allowed him to make broader, more continuous gestures than he could with a brush. He worked fast and spoke about being "in" a painting, reflecting the intensity and energy that each work demanded.

Critic Harold Rosenberg coined the phrase "action painting" to describe Pollock's approach, in which the canvas itself became "an arena in which to act". The resulting work was not only a painting, but also a work "about" the process of painting itself.

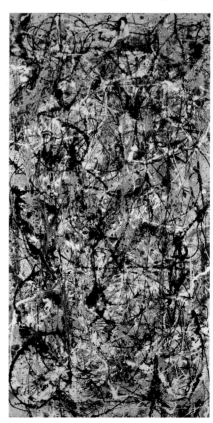

KEY MOMENTS

1930
Moves from the West Coast to New York and studies under Thomas Hart Benton at the Art Students League.

1943
Mural, the painting for Peggy Guggenheim's town house, is his first major large-scale work.

1950
Pollock's work is shown in Venice at his first solo exhibition outside the USA. Pollock never travelled outside his home country.

1952
Paints *Number 5, 1952* – a strong example of his transition to "black" paintings – using purely black pigment on unprimed canvas.

1955
His art takes a new direction in *Search*, a strong composition of thick, poured pigment and clots of black, green, yellow, and red.

Abstract Expressionism

Some of the artists who exhibited at Guggenheim's gallery – including Pollock, Willem de Kooning, and Robert Motherwell – were described as Abstract Expressionists, not for any commonality of style but for the emotional energy of their work. This group – together with colour field painters such as Mark Rothko (see pp.320–21) – produced work that was so new and influential that it made New York the centre of the modern art world. The Abstract Expressionsts became celebrities; Pollock himself became the public face of the avant-garde in the USA. To add to his success, by the autumn of 1949, he had been alcohol-free for two years.

Late works

The paintings that earned Pollock the nickname "Jack the Dripper" continued for a few years, but the artist was always moving on. In 1951, he exhibited a new series that looked very different, painted mostly in black on unprimed canvases, with some figurative elements. But these works failed to sell, and Pollock later reverted to a more colourful style, in which he continued to introduce figurative elements. These late paintings, such as *White Light* and *Search*, combine dripping with very thickly applied paint.

But by the mid-1950s Pollock was in decline. He was producing very little new work, and he had fallen back into patterns of excessive drinking. In August 1956, driving under the influence of alcohol, he crashed his car, killing not only himself but also one of his passengers, Edith Metzger. His career was cut tragically short, but his reputation as one of America's greatest painters and a leading Abstract Expressionist lives on.

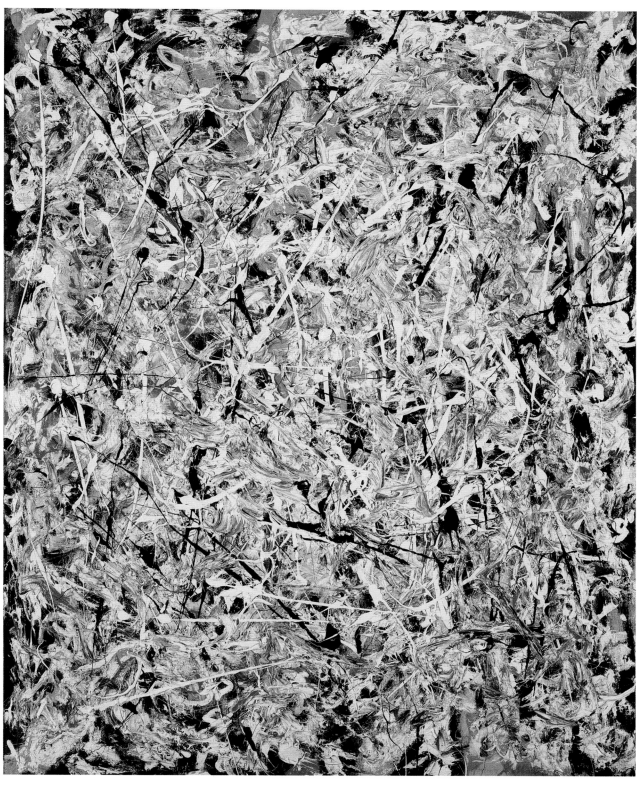

△ **WHITE LIGHT**, 1954
Pollock's last finished work has shards of white dancing across a coloured background. The artist applied paint to the canvas directly from the tube in this painting, and sculpted its surface with the tube itself.

" You've got to **deny, ignore, destroy** a hell of a lot **to get at truth**. "

JACKSON POLLOCK

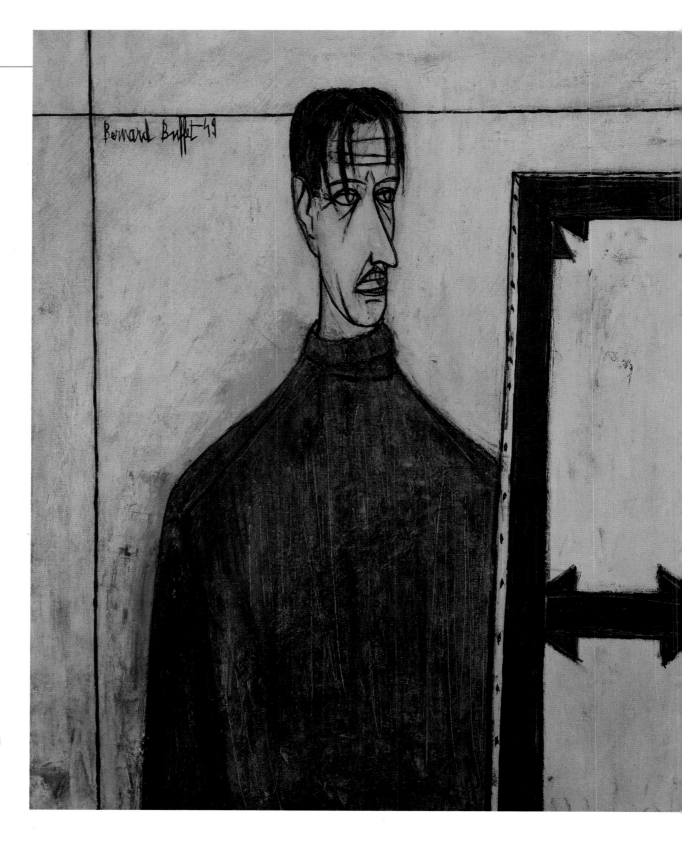

▷ **SELF-PORTRAIT, 1949**

Buffet painted numerous self-portraits throughout his life, many characterized by the use of straight black lines in a spiky, contoured, Expressionist style. He was an incredibly prolific artist: late in his life, he boasted that he had made one painting a day since 1946.

Bernard Buffet

1928–1999, FRENCH

Critically contentious yet wildly popular, Buffet's idiosyncratic, Expressionist paintings depicting war, religion, landscapes, and nudes, made him one of France's most famous painters in his own lifetime.

"I demand to be **judged solely** by my **work** – for which and by which **I live**."

BERNARD BUFFET, CITED IN *THE SECRET STUDIO*, JEAN-CLAUDE LAMY, 2004

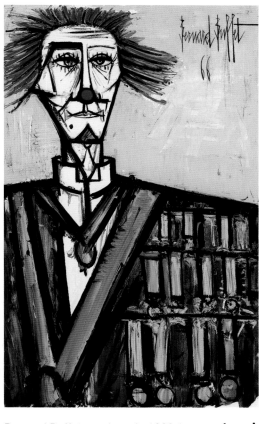

◁ *CLOWN ON YELLOW BACKGROUND*, 1966
Buffet's series of brightly coloured spiky clowns was a commercial success, but was greeted with derision by his critics.

Bernard Buffet was born in 1928, in the Batignolles district of Paris, which was already famous for producing artists such as Max Jacob and Pierre Bonnard. As a child, Buffet struggled at school, but he developed an intense love of painting through the visits he made with his mother to view the work of the Old Masters at the Louvre, and through evening classes he took in drawing. His Catholic upbringing and his relationship with his mother (who died in 1945, when he was still in his teens) would come to affect his work greatly.

Buffet's tranquil childhood was cut short by the outbreak of World War II and the subsequent Nazi occupation of Paris in June 1940. The privation and suffering he witnessed during these difficult years would stay with him for the rest of his life.

Aged just 15, he enrolled at the Ecole des Beaux-Arts in Paris; he had his first solo exhibition in Paris in 1947, and the following year, in conjunction with Bernard Lorjou (see box, right), won the highly prestigious Prix de la Critique at the Galerie Saint-Placide in Paris.

A unique style
By this time, Buffet had already put aside his early experiments with Post-Impressionism and developed a personal style that was dramatically expressive of his inner feelings. Using muted colours of brown, grey, and black, he began painting spiky, flattened, elongated "Expressionist" figures, darkly contoured in a network of structured lines, which appeared to embody a mood of sorrow, solitude, and despair. For many viewers, these works encapsulated the prevailing feelings of the postwar era.

Over the next decade, his distinctive, and highly accessible works – which encompassed landscapes, still lifes, portraits, and religious scenes, such as *The Passion of Christ* (1951), won him success and fame. Handsome, androgynous, and bisexual, he became a star of French mid-century culture: the outsider artist who was part of a group of celebrities that included the actress Brigitte Bardot, designer Yves Saint Laurent, and film director Roger Vadim. His painting series *The Horror of War* (1954) and *Clown's Head* (1956) were considered the zenith of his many artistic achievements.

Critical condemnation
In the 1960s and '70s, Buffet's work remained enormously popular with the public in France and abroad – particularly in Japan, where a Buffet museum opened in 1973 – and his prolific output made him rich. However, his wealth also cut him off from new developments in art, and critics complained that his paintings had become over-stylized, kitsch, and vulgarized through their reproduction as posters. He was condemned by the art elite and famously slated by Pablo Picasso.

Through his life and work, Buffet crafted his public image, turning it into a marketable commodity. For him, the critics were snobs and public acclaim was more important; above all, however, he needed to paint. And, when Parkinson's disease prevented him from being able to do so, at the age of 71, he committed suicide.

◁ A BRIGHTER PALETTE
In 1958, following his marriage to the model Annabel Schwob, who became his muse, Buffet added colour to his previously drab palette, and his work became brighter and more daring.

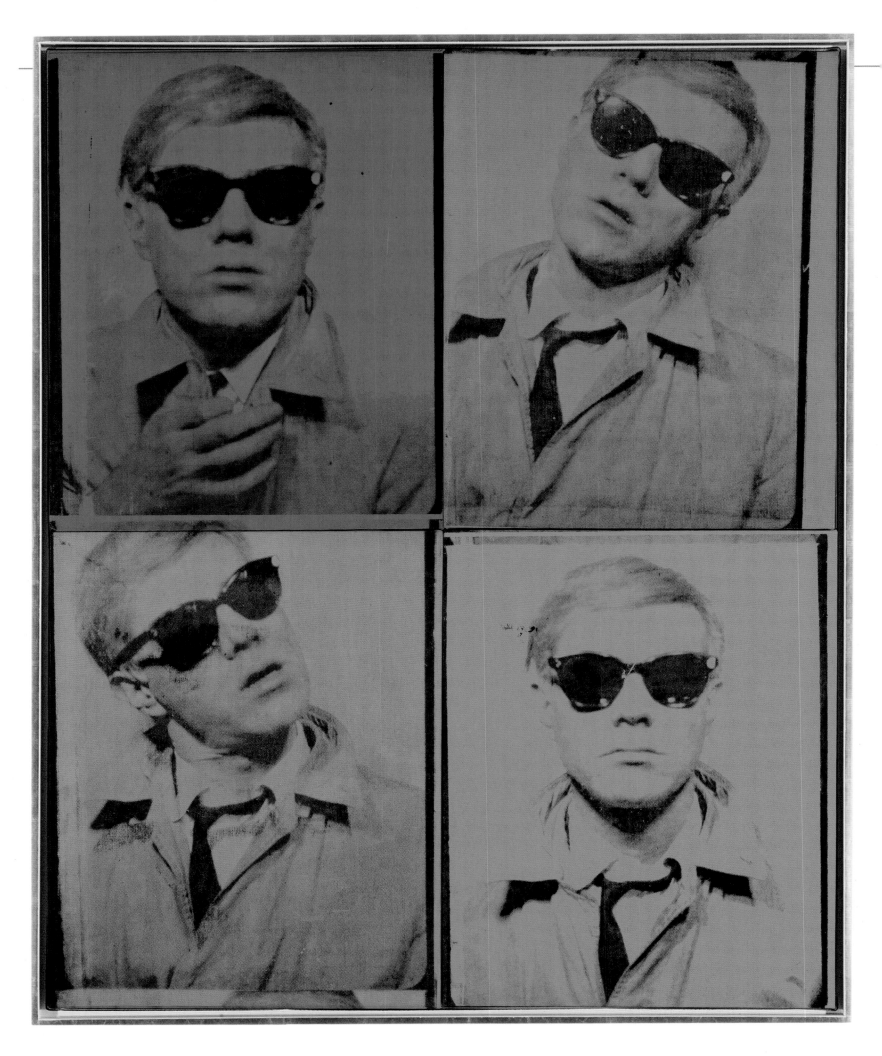

Andy Warhol

1928–1987, AMERICAN

From commercial illustrator to Pop artist, socialite to businessman, Warhol was a ceaseless innovator who transformed visual culture in a way that is still being felt today.

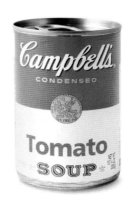

◁ **CAMPBELL'S SOUP**
Warhol painted objects that everyone would recognize. He turned to the bold design of Campbell's soup cans at several stages of his career.

Andy Warhol was born Andrej Warhola in 1928 to Slovakian immigrant parents who had settled in Pittsburgh, USA. He spent months recovering from a childhood illness, during which time he drew obsessively, pored over magazines filled with pictures of glamorous Hollywood stars, and fuelled his early obsession with celebrity. His most prized childhood possession was a signed photograph of child actress Shirley Temple.

His talent for drawing earned him a scholarship at Pittsburgh's Carnegie Institute of Technology, beginning in 1945. Here he developed his own "blotted-line" style of illustration, influenced by the draughtsman Ben Shahn. Warhol was an outstanding student and his drawings gained him plaudits; after graduating with a degree in Fine Arts in 1949, he moved to New York City to pursue a career as a commercial illustrator.

Commercial designer

After just a few days in the city, he received a commission from *Glamour* magazine to provide illustrations of shoes – a subject that would become his speciality. A typographical error credited him as "Andy Warhol" and he adopted the alteration permanently. Illustration jobs continued to come throughout the 1950s, including from

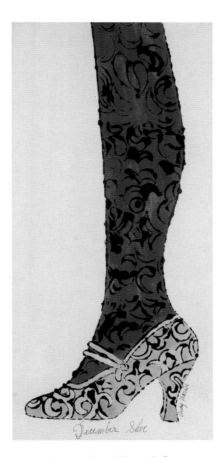

◁ **DECEMBER SHOE, 1955**
Warhol's blotted-line technique involved applying ink over a design on a sheet of non-absorbent paper, then pressing this onto absorbent paper to create an image made of delicate broken lines.

magazines such as *Harper's Bazaar* and *Vogue*. His award-winning graphic design career made him financially secure and enabled him to buy a townhouse, where he lived with his mother. It also helped him to develop the business acumen that would become central in his later work.

The birth of Pop art

By 1958, Warhol's comfortable lifestyle was in jeopardy: his career was waning because his illustrative style had fallen out of fashion, and his commissions dried up. It was at this moment of crisis that he encountered the work of two young painters, Robert Rauschenberg and Jasper Johns. Their art was a significant departure from that of the Abstract Expressionists, who had dominated the American scene for a decade; instead of making painting an emotionally charged, almost transcendental experience, Johns and Rauschenberg used mundane everyday items, such as newsprint, flags, and even old tyres, to assemble their artworks. Warhol was impressed by their work and he wanted to emulate their success.

He began making his own paintings, turning for inspiration to the world of magazines and newspapers that he knew so well. For his 1961 painting *Advertisement*, he collaged images of ads for cosmetics, body-building, and cola, blowing them up in scale

IN CONTEXT
America for sale

Warhol grew up during the Great Depression of the 1930s, a lengthy period of economic uncertainty in the USA when many people struggled to put food on the table. The commercial and industrial boom that the country experienced in the decades after World War II was therefore something to be celebrated: a "golden age" of plenty for all. Warhol's depictions of soup and other consumer goods became emblematic of America's new wealth, confidence, and status as the dominant world superpower of the 20th century.

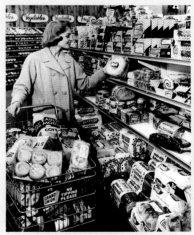

SHOPPING IN THE CONSUMER ERA: 1950s AMERICA

◁ **SELF-PORTRAIT, 1963–64**
A grid of silkscreened portraits – in this case of himself – became Warhol's trademark in the 1960s. He typically combined primary and secondary colours or, as here, used shades of one colour.

" Making **money** is art and **working** is art and good **business** is the **best art.** "
ANDY WARHOL

ON TECHNIQUE
Copy and paste

Warhol selected images from popular culture and reproduced them en masse using photographic screen printing, often subcontracting other companies to carry out the work. By reappropriating images created by others, he challenged the notion that artworks needed to be completely original, and by employing others to make his work using mechanical means – and thereby removing his own hand from the process – he laid the groundwork for cross-media, digital, and Conceptual art. Once Warhol discovered photo screen printing, the content of his output became inextricably linked to the process by which he created his art.

PHOTO SCREEN PRINTING, A PROCESS CENTRAL TO WARHOL'S WORKS

and painting them in black and white in a bold, simple, dispassionately objective style that would come to characterize the new "Pop art".

Repeat success

Warhol's first success as a painter came with what is now seen as one of his most significant works – *Campbell's Soup Cans*. Created in 1962 and taking as its subject "something that everybody recognized", the work continued his use of simple, graphic imagery but marked a transition in his method: whereas previously his paintings had dripped expressively, he now sought the clarity of mechanical reproduction, apparently removing any trace of the artist's hand (although each can in the work was in fact hand-painted). Warhol also grasped

the power of repetition to detach an image from its original meaning. Soon after *Campbell's Soup Cans*, Warhol adopted the photo-silkscreen process, a technique developed for commercial use, which would become his signature medium. He populated new works with more consumer goods, such as Coca-Cola bottles and Brillo pads, as well as images of celebrities, including Elvis Presley and James Dean, creating a visual encyclopaedia of 1960s America. Along with Roy Lichtenstein, Claes Oldenburgh, and other Pop artists, who also made work drawn from mass media, Warhol took popular culture and elevated it to high art.

Warhol also explored the darker side of American consumerism in a number of series made from

photographs of car crashes, suicides, and an empty electric chair. One image that encapsulated the thin line between the glamour of fame and its sometimes tragic consequences was that of Marilyn Monroe, the iconic Hollywood star who died of a drug overdose in 1962, which Warhol returned to again and again in different permutations.

The Factory

In 1964, with demand for his paintings growing quickly, Warhol moved to a larger studio, and – with the help of assistants – began to mass produce large-scale silkscreen works.

Christened "the Factory", his studio attracted a variety of semi-permanent visitors and hangers-on, from rich patrons looking to buy, to the down-

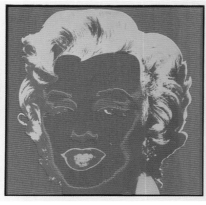
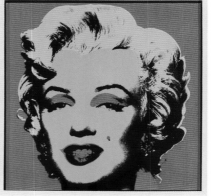
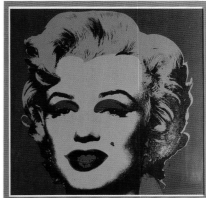
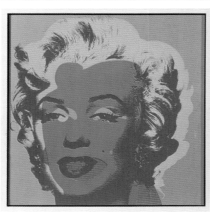
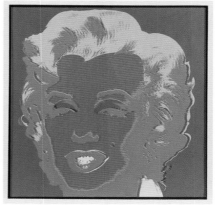
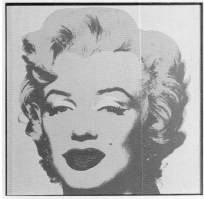

▷ **MARILYN, RIGHT-HAND SIDE, 1964**
Warhol's multiple, "mass-produced" images of Marilyn Monroe were based on photographs of the star following her death from an overdose of drugs in 1962. The repetition referenced Monroe's omnipresence in the media of the day.

" If you want to **know all about** Andy Warhol, just look at the **surface** of my paintings and films and me, and **there I am**. There's nothing behind it. "

ANDY WARHOL

and-out artists, actors, drug pushers, and drag queens of New York's bohemian underworld. Warhol himself cultivated an enigmatic, detached, deadpan persona, content to direct from the sidelines this new social circle, made up of hangers-on hoping to benefit from his own burgeoning fame.

Diversification and business

As the 1960s wore on, Warhol was drawn to the moving image and made several experimental, voyeuristic films, using his "Warhol Superstars", such as the heiress Edie Sedgwick, as amateur actors. Movies such as *Sleep* and *Empire* (1963 and 1964) and his series of *Screen Tests* (1963–66) of Factory visitors, gained a cult following among independent filmmakers, while *Chelsea Girls* (1966) achieved some commercial success.

Warhol diversified his interests further, becoming involved in some of the live-performance art "Happenings" taking place in New York at the time, and starting his own pop culture magazine, *Interview*, in the late 1960s. He even became the temporary "manager" of the proto-punk band the Velvet Underground, designing the cover for their eponymous album.

The hedonistic days of the Factory came to an abrupt end in 1968, when Warhol was shot by Valerie Solanas, a discontented acquaintance who was later diagnosed with schizophrenia. He survived the attempt on his life, but his studio became less open and more businesslike, moving to new premises known as "the Office" in 1974.

For much of the 1970s, Warhol combined his fascination with fame and fortune with a belief that art was essentially a business: he became a society portraitist, producing silkscreen likenesses of anyone who

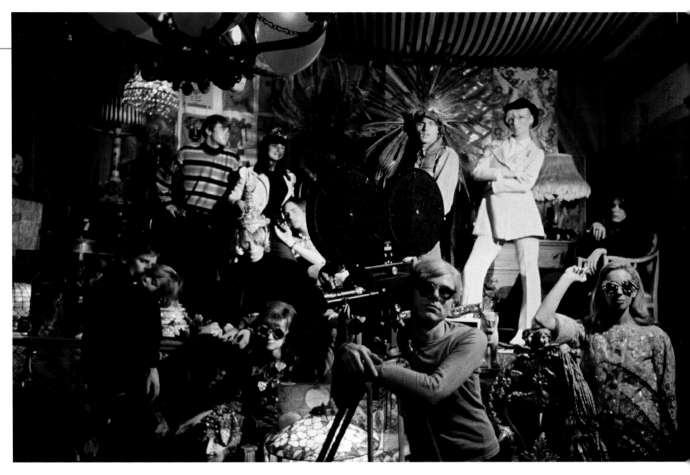

would pay. From rockstar Mick Jagger to actress Liza Minnelli, dozens of subjects were immortalized in what became his signature style of a stark Polaroid silhouette set against vivid coloured backgrounds.

Late works and legacy

Warhol continued to make self-portraits, charting his changing public persona, which, by the 1980s, was a commodity in itself, his fame having surpassed that of many of his sitters. He appeared on television and in public, advertising products or fashions personally. In his final years, he began to consider his own artistic legacy and turned to making more experimental works; his *Oxidation* paintings and *Shadows* series employed a more abstract aesthetic not dissimilar to the work of the Abstract Expressionists whom he had denounced decades earlier.

In 1983, Warhol began collaborating with an emerging New York artist, Jean-Michel Basquiat, on a number of exuberant, brightly coloured paintings. One of his final series of works played with elements of Leonardo da Vinci's *Last Supper*, hinting at a religious aspect to the private life he had always guarded so carefully.

Warhol died unexpectedly in February 1987 following complications of gall-bladder surgery; his death was headline news around the world and his funeral was attended by many of his celebrity friends and admirers. He is remembered for making everyday images into iconic emblems of the time, and for changing the way in which people viewed the relationship between mass media, culture, and art.

△ **FILMS AT THE FACTORY**
Warhol takes centre stage in this image from the making of *Chelsea Girls* (1966), for which the Factory was one of three locations. The "actors" essentially played themselves in the film, which was accused of obscenity and derided by most contemporary critics.

▽ **THE LAST SUPPER, 1985**
Warhol made almost 100 variations of this work, based on an old photograph of an engraving of Leonardo's painting. In some, he superimposed advertising images onto the figure of Christ.

▷ **YELLOW, 1999**
Anish Kapoor stands in front of his
massive, radiant yellow creation.
Although the wall on which the work
has been produced appears at first
to be flat, it is in fact concave – a void.

Anish Kapoor

BORN 1954, BRITISH-INDIAN

Kapoor creates intimate, elemental sculptures and massive, all-
encompassing installations that explore his diverse interests, including
mythologies, metaphysics, and mysticism, using diverse materials.

" I am making **physical things** that are all about **somewhere else**. "

ANISH KAPOOR, CITED IN DAVID ANFAM, *ANISH KAPOOR*, 2009

Anish Kapoor was born in Bombay (Mumbai) in 1954. Between 1970 and 1973 – after completing boarding school – he visited Israel, and it was here that he began painting. He moved to England in 1973 and studied at Hornsey College of Art and the Chelsea School of Art in London, where his focus turned to sculpture.

Kapoor was interested in artists such as Donald Judd and Sol LeWitt, who produced ostensibly simple, minimalist sculptures, which represented or referenced nothing but themselves. He was particularly influenced by the Romanian artist Paul Neagu, whose "tactile objects" focused on form, texture, and their associations; the potential for sculpture to convey esoteric experience, from bodily desire to mystical energy, would later be explored in Kapoor's own work.

Colour and exuberance

By the time he was completing a postgraduate degree at Chelsea School of Art in London, Kapoor was already exhibiting his work publicly.

After a trip to India in 1979, he made the first series of works for which he would become known: *1000 Names* (1979–85) consisted of groups of geometric, architectural forms covered in vibrant coloured pigments. These joyful, exuberant sculptures celebrate colour as an object in itself but also radiate a symbolic significance, suggestive of rituals, mysticism, and the unknown.

Unfilled spaces

Continuing to exhibit internationally during the 1980s, Kapoor became associated with the New British Sculpture group of artists, which included Tony Cragg, Richard Deacon, and Alison Wilding. Their sculptures – a reaction to the minimalism of the previous decade – used a wide range of materials and fabrication techniques.

Kapoor began working with fibreglass, slate, and stone in new pieces that focused on "voids". Unfilled spaces in works such as *At the Hub of Things* (1987) suggested emptiness and oblivion.

Sculpture and architecture

As acclaim for Kapoor's work grew – he represented Britain at the Venice Biennale in 1990 and won the prestigious Turner Prize in 1991 – he began to receive commissions for public installations. His stainless-steel, mirrored sculptures, such as *Cloud Gate* (2004), invited calm contemplation and also interacted with surrounding structures. This interrelation between sculpture and architecture that so fascinates Kapoor was pushed to extremes with the gargantuan stretched-PVC structures *Marsyas* (2002) and *Leviathan* (2011), which filled the huge interiors for which they were designed.

Kapoor's work continues to make its mark: his most widely recognized public artwork was built as the centrepiece of London's Olympic Park, the 115m (377ft) high *Orbit* (2012); and in 2016, Kapoor was granted exclusive artistic use of Vantablack, the blackest substance known. Anish Kapoor's impactful and beguiling sculptures make him one of the world's most important living artists.

△ **ORBIT**, 2012
Kapoor's massive asymmetrical structure for the 2012 Olympics towers above the Olympic Park in Stratford, London – it is the largest public artwork in Britain.

ON TECHNIQUE
Material world

Kapoor has utilized a wide range of materials including stone, metal, paint, pigment, resin, wax, wood, felt, and concrete in his work. For some artists associated with the New British Sculpture group, it is the material itself that is of particular interest. However, for Kapoor, the physical materials he uses are almost always a vehicle for exploring the metaphysical theories that preoccupy him; he describes art as being "about lots of things that are not present".

WAX AND OIL-BASED PAINT WERE USED IN KAPOOR'S *SVAYAMBH*, 2007

◁ **CLOUD GATE**, 2004
This monumental stainless-steel structure, installed in the Millennium Park, Chicago, USA, takes its name from the fact that 80 percent of its surface reflects the sky.

▷ *ME AND MR DOB*, **2009**
In this lithograph, Murakami pictures
his own face alongside that of his iconic
Mr DOB. The character evolved over
the years, first developing an angry
demeanour and sharp teeth, then
becoming (as here) increasingly cute.

Takashi Murakami

BORN 1962, JAPANESE

Japan's complicated relationship with the West has been key to
Murakami's work, as he has tried to untangle the mixture of global
influences and native traditions that make up Japanese culture today.

Takashi Murakami was born in Tokyo in 1962. As he grew up, he became fascinated by the legacy of the nuclear bombing of his homeland in 1945, and by the American rule in Japan after World War II.

Murakami's interest in art drew him initially to characteristically Japanese forms, especially anime films by pioneers such as Yoshinori Kanada and Hayao Miyazaki. It was his desire to follow in their footsteps that led him to enrol at Tokyo University of the Arts, where he completed a doctorate in *nihonga* – a style of painting based on traditional Japanese techniques, which over the years has evolved and embraced more diverse subjects. Over this period, he continued to be interested in animation

Global art
During his 11 years of study, Murakami decided to become a professional artist. He brought together his training in animation, a collaborative mode of working, and his skills in traditional Japanese painting to create an original approach to Pop art, which emerged in 1993 in what was to become his trademark character, Mr DOB. This whimsical cartoon creation was inspired by manga, and often combined with backgrounds executed in *nihonga* style. With a circular head and the letters D and B as ears, Mr DOB was a type of self-portrait, and would feature repeatedly in various guises across Murakami's work.

Studies in the USA
A fellowship allowed Murakami to study for a year at New York's Museum of Modern Art, where he experienced the revolutionary work of conceptual artists such as Anselm Kiefer and Jeff Koons, and to develop his own eye-catching, market-focused, and identifiably Japanese approach. He soon caught the attention of the art world and was seen as part of a new group of international artists, including Maurizio Cattelan, who explored aspects of their national identity on a new global stage.

Murakami's take on his Japanese identity focused on its underground anime and manga "geek" subculture, *otaku*, which he helped to bring into the mainstream, questioning established values of what art could be. On his return to Japan in 1996, following Warhol's template (see box, right) Murakami set up the Hiropon Factory to mass-produce *otaku*-inspired work.

The superflat approach
Murakami continues to produce high-end paintings and statues, as well as luxury items, often collaborating with global brands that

◁ **FLOWER MATANGO, 2001–06**
Murakami's "floral monster" was inspired by a creature that featured in a Japanese film. It was part of an exhibition of his work at the Château de Versailles in France in 2010.

cater to an elite clientele (in 2003, he worked with fashion label Louis Vuitton on a range of handbags). He also makes accessible, affordable merchandise aimed at the everyday public, who can buy accessories, clothing, and toys all featuring characters that make up the Murakami brand – from smiling flowers to bulbous mushrooms.

In 2000, Murakami coined the term "superflat", which described not only the traditional Japanese decorative aesthetic in his work but also the levelling of culture – between the exclusive and the accessible, high and low, traditionally Japanese and Western – that he believes defines contemporary Japanese society. His insightful ideas and mass-market approach to art have made him an internationally recognized artistic tour de force.

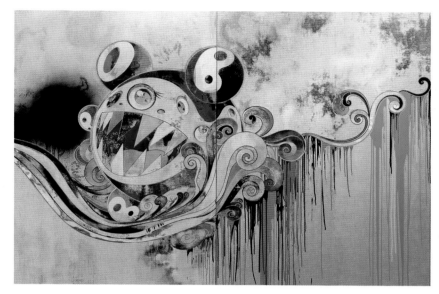

△ **727-272 THE EMERGENCE OF GOD AT THE REVERSAL OF FATE, 2006–09**
Mr DOB appears in this work, which – formed of 16 panels – also includes more traditional elements of Japanese painting.

IN CONTEXT
Murakami and Warhol

Murakami shares many similarities with the American artist Andy Warhol (see pp.338–41). Both were astute businessmen, art world celebrities with provocative profiles, and adept collaborators, making work in every format available to them – with other artists as well as commercial brands. But whereas Warhol elevated everyday images to the status of high art, Murakami's Kaikai Kiki studio refuses to distinguish between high and low at all, treating all its output with the same level of importance, in line with his "superflat" philosophy.

ASSISTANTS WORK ON AN ARTWORK IN MURAKAMI'S STUDIO

" Japanese people **accept** that **art** and **commerce** will be **blended.** "
TAKASHI MURAKAMI, IN AN INTERVIEW WITH MAGDALENE PEREZ, 2007

Directory

Willem de Kooning

1904–1997, DUTCH-AMERICAN

Born in Rotterdam, de Kooning was apprenticed to a commercial art firm in his teens and studied at the Rotterdam Academy of Art in 1916–24. In 1926, he emigrated to America as a stowaway and settled in New York, becoming a full-time painter after working for the Federal Arts Project in the 1930s. De Kooning befriended fellow émigré artist Arshile Gorky and, under his influence, began producing rhythmic, biomorphic abstract paintings in the 1940s. His abstract style brought him into contact with Jackson Pollock, and together they became two leading figures in Abstract Expressionism.

In 1950, de Kooning began the paintings for which he became best known – his *Women* series combined slashing lines with garish colour to suggest the female form in a violent "adventure of painting". He continued exploring abstraction for the rest of his life, also making semi-figurative bronze sculptures in the 1970s.

KEY WORKS: *Pink Angels*, 1945; *Woman I*, 1950–52; *Rider (Untitled VII)*, 1985

▷ Louise Bourgeois

1911–2010, FRENCH-AMERICAN

Born in Paris, Bourgeois attended a number of Parisian art academies and briefly studied under Fernand Léger. In 1938, she married an American art historian and settled in New York. Initially making abstract paintings, Bourgeois increasingly turned to sculpture from the 1940s onwards. Her sculptures veered between abstraction and figuration, often suggestive of human figures, sometimes with sexual undercurrents. By the 1960s, she began incorporating her sculptures into Surrealist-inspired built environments, including cage-like installations. The subject-matter of much of her work is intensely personal and sometimes linked to memories of her traumatic childhood and her father's affair with her governess. Bourgeois continued working into old age, becoming celebrated internationally by both feminist thinkers and the art world.

KEY WORKS: *Filette*, 1968; *The Destruction of the Father*, 1974; *Maman*, 1999

△ **LOUISE BOURGEOIS SITTING ON HER SCULPTURE** *FEMME-MAISON* **(1981), AT MoMA, NEW YORK, 1983**

Sidney Nolan

1917–1992, AUSTRALIAN

Born in Melbourne, Nolan dedicated himself to painting full time in 1938. His early, Modernist-influenced works owed much to Surrealism, but after World War II, he started painting figures and landscapes in what was to become his own signature style, sometimes applying paint with a sponge or finger. His deliberately "unsophisticated" paintings captured the bright light and wide-open space of the outback. His series of works depicting the legends of Australian folk hero Ned Kelly garnered international recognition. After 1950, his travels to Britain, Europe, and the USA provided him with new subject-matter for his paintings, but Nolan always returned to the Australian iconography for which he became famous.

KEY WORKS: *Ned Kelly*, 1946; *Paradise Garden*, 1968–70; *Snake*, 1970–72

▷ Joseph Beuys

1921–1986, GERMAN

Born in Krefeld, Beuys served in World War II, after which he studied at the Düsseldorf Academy of Art, becoming professor of sculpture there in 1961. Throughout the 1960s, he developed his alternative concept of art, creating "social sculptures" that offered a form of "moral, social and psychological therapy" Interested in language, myths, and man's relation to the environment, Beuys made sculptures from a diverse range of materials to reflect life's complexity. He became known for performances, including one in which he spent a week inhabiting a room with a wild coyote. He joined the anti-traditional Fluxus group of artists in the 1960s and became an art cult figure, known internationally for his public talks.

KEY WORKS: *How to Explain Pictures to a Dead Hare*, 1965; *The Pack*, 1969; *I Like America and America Likes Me*, 1974

Lucian Freud

1922–2011, BRITISH

Lucian Freud was the grandson of psychoanalyst Sigmund Freud. Born in Berlin, he moved to England in 1933 and studied art in London and Suffolk. Freud's early paintings of people and plants were meticulously detailed and employed washed-out colours to almost Surrealist effect. From the 1950s onwards, his palette became earthier and his brushstrokes more visible, creating a sensual surface that gave his subjects' flesh an almost tangible feel. Freud's sitters were usually people with whom he had a direct personal relationship, and the painstaking precision of his work meant that sittings could take months. The end results were intensely psychological portraits that led artist Peter Blake to claim, in 1993, that Freud was "certainly the best living British painter".

KEY WORKS: *Girl with a Kitten*, 1947; *Reflection (Self Portrait)*, 1985; *Benefits Supervisor Sleeping*, 1995

△ JOSEPH BEUYS SHOWS HIS WORK *FETTRAUM (FAT ROOM)* DURING AN EVENT IN DARMSTADT, GERMANY, IN 1967

Roy Lichtenstein

1923–1997, AMERICAN

Born in New York, Lichtenstein studied at the Art Students League and then, after serving in World War II, at Ohio State University. Initially working as a teacher and commercial artist, he painted in the Abstract Expressionist style up until the early 1960s, when he began making the work for which he would become popular.

Selecting images from comic books and advertisements, Lichtenstein would enlarge and recreate them precisely on canvas, using unmixed primary colours, thick black outlines, and even hand painting the Ben-Day dots that were used in the original printing process. He soon became one of the main proponents of Pop art, a movement that lionized everyday consumerism and mass-media imagery in a rejection of the tenets of Abstract Expressionism. Lichtenstein continued to paint in his signature style for the rest of his life, branching out into sculpture in his later years.

KEY WORKS: *Drowning Girl*, 1963; *Whaam!*, 1963; *Brushstrokes*, 1967

Robert Rauschenberg

1925–2008, AMERICAN

Rauschenberg was born in Port Arthur, Texas. He began studies in pharmacy and then served in the navy in World War II. After his discharge, he studied at several institutions, including the highly experimental Black Mountain College, before moving to New York. In the 1950s, alongside his close collaborator Jasper Johns, Rauschenberg's work challenged Abstract Expressionism's dominance; by incorporating found objects into his colourful, gestural paintings, he created artworks that he called "combines", which blurred the boundaries between art and the everyday. This experimentation continued into the 1960s, when he produced screen prints and other transfer collages that juxtaposed various art-historical references with mass-media imagery.

Rauschenberg was one of the early exponents of Performance art and also explored the link between art and new technologies. In the 1970s and 80s, he produced sculptures from silk, cardboard boxes and, later, metal, which mirrored his fascination with the multiplicity and interconnectedness of modern life – a theme that runs through the entirety of his work.

KEY WORKS: *Automobile Tire Print*, 1953; *Monogram*, 1955–59, *Retroactive II*, 1963

Donald Judd

1928–1994, AMERICAN

Born in Missouri, Judd studied first philosophy and then art history, and also attended night classes at the Art Students League of New York, before working as an art critic between 1959 and 1965. Initially painting in the Abstract Expressionist style, he soon turned to sculpture, creating geometric objects (usually boxes), originally made from wood, but later industrially manufactured in metal or coloured Perspex. Judd placed these "specific objects" in arrangements that corresponded to mathematical sequences by, for example, spacing them in wall-mounted vertical stacks. Blurring the line between sculpture and the surrounding space, Judd undermined traditions of composition, as well as the idea that a work of art represents a "reality" outside itself. These concepts were key to Minimal art, of which he was a major exponent.

By the 1970s, he was making works specifically for the spaces in which they were exhibited and, in 1973, he relocated to Texas, where he designed his own installation spaces, while continuing to write Minimalist theory.

KEY WORKS: *Untitled (Stack)*, 1967; *Untitled (Progression)*, 1973; *Untitled (Stack)*, 1980

▷ Jasper Johns

BORN 1930, AMERICAN

Born in Augusta, Georgia, Johns moved to New York in 1949. There, along with his close collaborator Robert Rauschenberg, he developed a style of working that moved away from Abstract Expressionism, which was dominant at the time.

Johns began painting banal, commonplace symbols such as flags, targets, numbers, and letters, in a thick, "worked" manner that emphasized the painterly nature of the image. Claiming to want to look at the familiar with "fresh vision", in his works he highlighted the ambiguity of signs and the relationship between artworks and everyday objects. From 1958, Johns produced sculptures of mundane items, such as beer cans, and, during the 1960s, he started incorporating found objects into his work, following the example of Marcel Duchamp. Johns' use of run-of-the-mill imagery would go on to influence Pop art and Minimalism, while his own work became autobiographical and stylized from the 1970s onwards.

KEY WORKS: *Flag*, 1954–55; *Painted Bronze (Ale Cans)*, 1960; *Map*, 1961

Gerhard Richter

BORN 1932, GERMAN

Richter was born in Dresden and grew up in the German countryside. He was apprenticed as a commercial artist before beginning his studies at the Dresden Academy in 1951. In 1961, he moved to Düsseldorf, where he became known for monochrome paintings, based on photographs taken from newspapers or family albums. He soon began intentionally blurring these images, analysing the functions of photography by emphazising the particular nature of paint.

Richter broadened his investigations in the 1970s, painting cityscapes that suggested the war-torn ruins of his youth and landscapes that evoked

△ **JASPER JOHNS IN HIS NEW YORK STUDIO, 1977**

German Romantic art. As well as pursuing photorealist figuration, he also produced abstract paintings, recreating geometric colour charts in the 1960s, as well as producing multi-layered, colour-drenched canvases from the mid-1980s onwards. These were created by dragging and scraping paint with a rubber squeegee. Through his painting and his sculpture work in glass, Richter is recognized as one of the most accomplished living artists.

KEY WORKS: *1024 Colours*, 1973; *Betty*, 1988; *Abstract Painting (809-1)*, 1994

David Hockney

BORN 1937, BRITISH

Born in Bradford, Hockney studied at London's Royal College of Art, where he soon became known for his skilled versatility and personal flair. During the 1960s, he was linked to Pop art, but later explored different media – photography, drawing, and painting – to depict the world around him.

Hockney became infatuated with California, settling there in 1978, and his many images of swimming pools investigate the challenges of representing light and water.

During the 1970s, he painted subtle, simplified photorealist portraits of his bohemian social circle, before experimenting with photographic collage in the 1980s. He turned his attention to vibrantly coloured, Cubist-influenced scenes of multiple perspectives in the 1990s, painting landscapes of the Grand Canyon, and, during the 2000s, the countryside of his native Yorkshire. Popular and globally renowned, Hockney is one of the most successful British artists of the 20th century.

KEY WORKS: *A Bigger Splash*, 1967; *Mr and Mrs Clark and Percy*, 1970–71; *Pearblossom Highway*, 1986

Judy Chicago

BORN 1939, AMERICAN

Painter, installation artist, feminist, and educator, Judy Chicago was born Judith Cohen in Chicago, in 1939. She later replaced her (father's) last name with the name of the city of her birth in repudiation of patriarchy. Chicago graduated from the University of California, Los Angeles, in 1964 with a master's in painting and sculpture. In 1969, she launched Fresno, the nation's first feminist art-education programme and in 1971 co-founded the Feminist Art Program at California Institute of the Arts.

She is most famous for her installation *The Dinner Party* (1974–79), which is regarded by some critics to be an icon of feminist art. The work comprises a vast, triangular table that references Leonardo da Vinci's *Last Supper* (c.1495), but incorporates place settings at the table for 39 key female figures from history and mythology. In 1978, Chicago set up the non-profit organization Through the Flower to raise awareness of art's ability to promote women's achievements. She has spent most of her life in California.

KEY WORKS: *The Birth Project*, 1980–85; *The Holocaust Project: From Darkness to Light*, 1987–93

Anselm Kiefer

BORN 1945, GERMAN

Kiefer was born in Donaueschingen during the closing months of World War II – a conflict that would come to inform much of the artist's work. He attended art schools in Freiburg and Karlsruhe, where he came across the teachings of Joseph Beuys, who introduced him to Conceptual art. Kiefer explored this new form in a series of "actions" performed between 1968 and 1969. His focus in these and other works was the exploration of German identity, with references to folklore and history, including the atrocities of Nazism.

The early 1980s were a time of renewed interest in painting and the rise of Neo-Expressionism. During this period, Kiefer made dense, elemental paintings that incorporated organic matter, informed by his interests in alchemy, runes, poetry and cosmology. In 1993, he moved to a huge studio-estate in the South of France. He became the first living artist since Georges Braque to create a permanent installation at the Louvre in Paris and remains one of the most important artists working today.

KEY WORKS: *Occupations*, 1969; *Varus*, 1976; *Bohemia Lies by the Sea*, 1996

Marina Abramović

BORN 1946, SERBIAN

Abramović studied at the Belgrade Academy of Fine Art in 1965–70 and later in Zagreb, Croatia. From the early 1970s, she has been an important exponent of Performance art – a form of art in which the artist enacts planned or spontaneous actions to create artworks, which are performed with an audience or documented.

Many of Abramović's performances involve the artist pushing herself to physical and mental extremes, and exploring the relationship between artist and audience. Her major works have involved her in cutting, whipping, or burning her own body, probing the limits of personal pain, exploring religious ritual and purification rites, as well as testing the boundaries of public acceptability in art. In 2010 Abramović's focus on audience participation culminated in *The Artist is Present,* a work in which she sat silently with hundreds of members of the public in turn, one-on-one – for a total of 736 hours.

KEY WORKS: *Rhythm Series*, 1973–74; *Balkan Baroque*, 1997; *The Artist is Present*, 2010

▽ Mona Hatoum

BORN 1952, PALESTINIAN

Born in Lebanon to Palestinian parents, Hatoum first studied art in Beirut. While visiting the UK in 1975, war broke out in Lebanon, forcing her to settle in London. After studying at the Slade School of Fine Art in 1979–81, Hatoum began to explore the relationship between politics, gender, and identity through her art. Her early works included video performances that highlighted the great vulnerability and resilience of the body, frequently referencing feminist theory and the politics of Palestine in the process. In the late 1980s, Hatoum started to make Surrealist-inspired installation works, utilizing household items to create sculptures that juxtaposed the domestic with the uncanny; her use of grid structures in works of the 1990s hints at systems of power and control. By combining the familiar with the hostile, the personal with the political, Hatoum creates highly charged works that reflect a world shaped by conflict.

KEY WORKS: *Measures of Distance*, 1988; *Light Sentence*, 1992; *Corps étranger*, 1994

△ **MONA HATOUM, PHOTOGRAPHED IN BERLIN IN 2008**

Damien Hirst

BORN 1965, BRITISH

Born in Bristol, Hirst studied at London's Goldsmiths College in 1986–89, where he was introduced to Conceptual art. Enterprising and precocious, he organized warehouse exhibitions while still a student, and met the collector Charles Saatchi, who began funding his conceptually framed artworks. These included a shark suspended inside a tank of formaldehyde and other sculptures using dead animals. Works such as these combined Hirst's fascination with death with a sensationalist aesthetic that was common to many of the artists – known as the Young British Artists (YBAs) – who dominated the British art scene in the 1990s. Hirst was the most high-profile YBA; his work, including his mass-produced "spin" and "spot" abstract paintings, became highly popular with collectors.

In 2008, Hirst's one-man auction at Sotheby's made an estimated £111 million, while a diamond-encrusted skull created by him in 2007 was reputed to be the most expensive artwork ever sold by a living artist.

KEY WORKS: *The Physical Impossibility of Death in the Mind of Someone Living*, 1991; *Mother and Child, Divided*, 1993; *For the Love of God*, 2007

Index of artworks

General index

Acknowledgments

Cobalt id would like to thank Margaret McCormack for indexing. The publisher would like to thank the following for their kind permission to reproduce their photographs:

(Key: a-above; b-below; c-centre; l-left; r-right; t-top)

1 Bridgeman Images: Musee Marmottan Monet, Paris, France / Bridgeman Images (c). 2 Getty Images: Fine Art / Contributor (c). 3 Alamy Images: SPUTNIK / Alamy Stock Photo (c). 5 Getty Images: Hulton Archive / Staff (c). 12 Getty Images: Mondadori Portfolio / Contributor (c). 13 Getty Images: Alinari Archives / Contributor (bl). Thekla Clark / Contributor (br). 14 Alamy Images: Heritage Image Partnership Ltd / Alamy Stock Photo (tl). 14 Getty Images: O. Louis Mazzatenta (tr). 15 Getty Images: Mondadori Portfolio / Contributor (l). 15 Getty Images: David Collingwood / Alamy Stock Photo (tr). 16 Getty Images: DEA / M. CARRIERI / Contributor (c). DEA / G. DAGLI ORTI / Contributor (cr). 17 Getty Images: Universal History Archive / Contributor (c). 18 Alamy Images: World History Archive / Alamy Stock Photo (bl). 18-19 Getty Images: Universal History Archive / Contributor (b). 19 Alamy Images: Skyfish / Alamy Stock Photo (tr). ART Collection / Alamy Stock Photo (br). 20 Getty Images: DEA / G. DAGLI ORTI (c). 21 Getty Images: Robert Alexander / Contributor (bl). 21 Bridgeman Images: Museo Nazionale del Bargello, Florence, Italy / Bridgeman Images (tr). 21 Getty Images: DEA / G. NIMATALLAH / Contributor (br). 22 Alamy Images: Artokoloro Quint Lox Limited / Alamy Stock Photo (bl). 22 Getty Images: Mondadori Portfolio / Contributor (c). DEA / G. NIMATALLAH / Contributor (br). 23 Bridgeman Images: Ghigo Roli / Bridgeman Images (tl). 23 Getty Images: Mondadori Portfolio / Contributor (br). 24 Alamy Images: Granger Historical Picture Archive / Alamy Stock Photo (bl). World History Archive / Alamy Stock Photo (cr). 25 Getty Images: Mondadori Portfolio / Contributor (c). De Agostini Picture Library / Contributor (br). 27 Getty Images: Universal History Archive / Contributor (c). De Agostini Picture Library / Contributor (br). 28 Alamy Images: Brian Atkinson / Alamy Stock Photo (bl). 28 Getty Images: UniversalImagesGroup / Contributor (t). 29 Getty Images: De Agostini Picture Library / Contributor (b). DEA / G. CIGOLINI / Contributor (br). 30 Alamy Images: Bailey-Cooper Photography / Alamy Stock Photo (cl). 30 Getty Images: Leemage (ca). 30 Bridgeman Images: Louvre (Cabinet de dessins), Paris, France (cr). 31 Bridgeman Images: Musee Conde, Chantilly, France (c). 32 Bridgeman Images: National Gallery, London, UK (bl). 32 Getty Images: DEA / G. NIMATALLAH (tr). 33 Alamy Images: Art Reserve / Alamy Stock Photo (tr). 34 Alamy Images: B Christopher / Alamy Stock Photo (c). 34 Getty Images: Thekla Clark / Contributor (br). 35 Getty Images: Thekla Clark / Contributor (c). 36 Getty Images: Leemage / Contributor (bl). 36 Alamy Images: PAINTING / Alamy Stock Photo (tr). 37 Getty Images: UniversalImagesGroup / Contributor (br). 38 Alamy Images: World History Archive / Alamy Stock Photo (cl). 38 Getty Images: PETIT Philippe / Contributor (cr). 39 Getty Images: Leemage / Contributor (c). 40 Bridgeman Images: Ashmolean Museum, University of Oxford, UK (cl). 40 Getty Images: Heritage Images / Contributor (c). 41 Getty Images: Planet News Archive / Contributor (tc). Joe Cornish/Arcaid Images (bl). Heritage Images / Contributor (br). 42 Bridgeman Images: Baptistery, Florence, Italy / Bridgeman Images (c). 43 Bridgeman Images: Museum of Fine Arts, Boston, Massachusetts, USA / Gift of Mr and Mrs Henry Lee Higginson / Bridgeman Images (tl). 46 Alamy Images: Jakub Krechowicz / Alamy Stock Photo (c). 47 Alamy Images: PAINTING / Alamy Stock Photo (cr). 47 Getty Images: DEA / G. DAGLI ORTI (cr). 48 Getty Images: GraphicaArtis / Contributor (tl). 48-49 Getty Images: Alinari Archives / Contributor (b). 49 Getty Images: DEA / A. DAGLI ORTI / Contributor (br). 50 Getty Images: Print Collector / Contributor (tc). 50 Getty Images: DEA / A. DAGLI ORTI / Contributor (bc). 51 Alamy Images: IanDagnall Computing / Alamy Stock Photo (tl). Photo 12 / Alamy Stock Photo (tr). 52 Bridgeman Images: Private Collection / Photo © Christie's Images (c). 53 Bridgeman Images: Private Collection / Photo © Christie's Images (c). 53 Alamy Images: Lou-Foto / Alamy Stock Photo (bl). Beijing Eastphoto stockimages Co.,Ltd / Alamy Stock Photo (br). 54 Alamy Images: Artepics / Alamy Stock Photo (c). 55 Alamy Images: Granger Historical Picture Archive / Alamy Stock Photo (bl). 55 Getty Images: INTERFOTO / Alamy Stock Photo (cr). 56 Alamy Images: imageBROKER / Alamy Stock Photo (cl). classicpaintings / Alamy Stock Photo (tr). 57 Alamy Images: classicpaintings / Alamy Stock Photo (br). The Print Collector / Alamy Stock Photo (cr). 58 Alamy Images: INTERFOTO / Alamy Stock Photo (bl). PRISMA ARCHIVO / Alamy Stock Photo (br). 59 Alamy Images: Photo Researchers, Inc / Alamy Stock Photo (tc). World History Archive / Alamy Stock Photo (bl). Riccardo Sala / Alamy Stock Photo (br). 60 Getty Images: Mondadori Portfolio (c). 60 Alamy Images: FineArt / Alamy Stock Photo (bl). 61 Alamy Images: FineArt / Alamy Stock Photo (c). 62 Alamy Images: Christine Webb Portfolio / Alamy Stock Photo (cl). hkp (bc). alxpin (br). 62 Getty Images: age fotostock / Alamy Stock Photo (br). 63 Getty Images: DEA / G. NIMATALLAH / Contributor (br). 64 Getty Images: Heritage Images / Contributor (cl). Mondadori Portfolio (br). 65 Bridgeman Images: Museo Petriano, Rome, Italy / Alinari (cl). 65 Getty Images: Gonzalo Azumendi (tr). 66 Alamy Images: classicpaintings / Alamy Stock Photo (c). 66 Getty Images: classicpaintings / Alamy Stock Photo (tc). 67 Getty Images: DEA / G. NIMATALLAH (br). 68 Getty Images: DEA / F. FERRUZZI / Contributor (bl). 68 Getty Images: INTERFOTO / Alamy Stock Photo (br). 69 Getty Images: Heritage Images / Contributor (bl). 69 Alamy Images: Heritage Image Partnership Ltd / Alamy Stock Photo (br). 70 Alamy Images: classicpaintings / Alamy Stock Photo (cl). 70 Getty Images: Fine Art / Contributor (br). 71 Alamy Images: classicpaintings / Alamy Stock Photo (c). 72 Getty Images: Fine Art / Contributor (c). 73 Getty Images: Marka / Contributor (bl). DEA / G. CIGOLINI / Contributor (cr). 74 Getty Images: Leemage / Contributor (tr). Leemage / Contributor (bl). 75 Alamy Images: Jozef Sedmak / Alamy Stock Photo (c). 75 Getty Images: Fine Art / Contributor (bc). 76 Getty Images: DEA PICTURE LIBRARY / Contributor (c). 76 Bridgeman Images: Ashmolean Museum, University of Oxford, UK (cr). 77 Getty Images: Leemage / Contributor (c). 78 Alamy Images: classicpaintings / Alamy Stock Photo (tl). The Archives / Alamy Stock Photo (tc). 78 Getty Images: Photo 12 / Contributor (br). 79 Getty Images: UniversalImagesGroup / Contributor (ca). Fine Art / Contributor (tr). 80 Getty Images: bpk, Bildagentur fuer Kunst, Kultur und Geschichte, Berlin (ca). Photo Scala, Florence (tl). 81 Getty Images: Heritage Images / Contributor (c). 82 Alamy Images: Artepics / Alamy Stock Photo (tl). 83 Getty Images: Ullstein Bild / Contributor (cr). Heritage Images / Contributor (br). 84 Alamy Images: Artokoloro Quint Lox Limited / Alamy Stock Photo (bl). 84 Getty Images: Fratelli Alinari IDEA S.p.A. / Contributor (br). 84 Bridgeman Images: Brooklyn Museum of Art, New York, USA / Gift of A. Augustus Healy (br). 85 Alamy Images: FineArt / Alamy Stock Photo (c). 86 Alamy Images: World History Archive / Alamy Stock Photo (cl). Heritage Image Partnership Ltd / Alamy Stock Photo (br). 87 Alamy Images: Masterpics / Alamy Stock Photo (c). JTB MEDIA CREATION, Inc. / Alamy Stock Photo (br). 88 Getty Images: Leemage / Contributor (c). 89 Alamy Images: Granger Historical Picture Archive / Alamy Stock Photo (br). 92 Getty Images: Heritage Images / Contributor (tr). 92 Alamy Images: ACTIVE MUSEUM / Alamy Stock Photo (br). 93 Scala: Photo Scala, Florence - courtesy of the Ministero Beni e Att. Culturali (tl). Print Collector / Contributor (tr). 95 Alamy Images: Ian Dagnall / Alamy Stock Photo (bc). 95 Shutterstock: Gianni Dagli Orti/REX (cr). 96 Alamy Images: Mary Evans Picture Library / Alamy Stock Photo (bc). 96 Getty Images: DEA / A. DAGLI ORTI / Contributor (tr). 96 Alamy Images: PRISMA ARCHIVO / Alamy Stock Photo (tl). 97 Getty Images: Fine Art / Contributor (c). 98 Getty Images: Imagno / Contributor (tl). Fine Art / Contributor (bl). 98 Alamy Images: Ian Dagnall / Alamy Stock Photo (cr). 99 Bridgeman Images: Onze Lieve Vrouwkerk, Antwerp Cathedral, Belgium / Bridgeman Images (tc). 100 Getty Images: Heritage Images / Contributor (cl). 100 Alamy Images: Mike Booth / Alamy Stock Photo (cr). 101 Alamy Images: FineArt / Alamy Stock Photo (bc). 101 Getty Images: Mark Renders / Stringer (tr). 102 Alamy Images: Archivart / Alamy Stock Photo (bl). Heritage Image Partnership Ltd / Alamy Stock Photo (br). 103 Alamy Images: World History Archive / Alamy Stock Photo (c). 104 Alamy Images: vkstudio / Alamy Stock Photo (c). 105 Alamy Images: Art Collection 2 / Alamy Stock Photo (bc). 105 Bridgeman Images: Museo di Roma, Rome, Italy / Bridgeman Images (br). 106 Alamy Images: Ken Welsh / Alamy Stock Photo (cl). Granger Historical Picture Archive / Alamy Stock Photo (br). 107 Alamy Images: Archivart / Alamy Stock Photo (tl). 107 Getty Images: JNS / Contributor (bl). 108 Bridgeman Images: Galleria Borghese, Rome, Italy / Bridgeman Images (c). 109 Bridgeman Images: Museo Nazionale del Bargello, Florence, Italy / Bridgeman Images (bc). 109 Getty Images: Alinari Archives / Contributor (br). 110 Bridgeman Images: Galleria Borghese, Rome, Italy / Bridgeman Images (bl). 110 Getty Images: De Agostini / Contributor (tr). 111 Getty Images: DEA / G. DAGLI ORTI / Contributor (tl). 111 Scala: Photo Scala, Florence/bpk, Bildagentur fuer Kunst, Kultur und Geschichte, Berlin (cl). 112 Alamy Images: LatitudeStock / Alamy Stock Photo (cl). LatitudeStock / Alamy Stock Photo (tr). 112 Getty Images: DEA PICTURE LIBRARY / Contributor (br). 113 Getty Images: Mondadori Portfolio (cr). PHAS / Contributor (br). 114 Alamy Images: Peter Horree / Alamy Stock Photo (c). 115 Getty Images: Leemage / Contributor (c). 115 Alamy Images: Heritage Image Partnership Ltd / Alamy Stock Photo (cr). 116 British Museum: © The Trustees of the British Museum. (bl). 116 Alamy Images: classicpaintings / Alamy Stock Photo (tr). 117 Alamy Images: FineArt / Alamy Stock Photo (bl). 117 Alamy Images: Granger Historical Picture Archive / Alamy Stock Photo (c). 117 Alamy Images: Riccardo Sala / Alamy Stock Photo (br). 118 Getty Images: Mondadori Portfolio (c). 119 Alamy Images: FineArt / Alamy Stock Photo (c). Prisma by Dukas Presseagentur GmbH / Alamy Stock Photo (cl). Fabrizio Troiani / Alamy Stock Photo (br). 120 Alamy Images: Tomas Abad / Alamy Stock Photo (cl). 120 Alamy Images: World History Archive / Alamy Stock Photo (bl). 121 Alamy Images: Archivart / Alamy Stock Photo (tl). FineArt / Alamy Stock Photo (tr). 122 Alamy Images: Heritage Image Partnership Ltd / Alamy Stock Photo (tc). Granger Historical Picture Archive / Alamy Stock Photo (br). Japanese castles / Alamy Stock Photo (cr). 123 Wiki Commons: http://www.emuseum.jp/ (tl). 124 Alamy Images: Iconotec / Alamy Stock Photo (tl). 124 Alamy Images: Peter Horree / Alamy Stock Photo (br). 125 Getty Images: Rembrandt Harmensz. van Rijn (c). 126 Getty Images: Heritage Images / Contributor (tl). 126 Alamy Images: Heritage Image Partnership Ltd / Alamy Stock Photo (bc). 126-127 Alamy Images: Ian Dagnall / Alamy Stock Photo (c). 127 Alamy Images: PAINTING / Alamy Stock Photo (bl). 128 Alamy Images: Francesco Gavazzeni / Alamy Stock Photo (c). 128 Alamy Images: FineArt / Alamy Stock Photo (bl). 128- 129 Alamy Images: Peter Horree / Alamy Stock Photo (bc). 129 Alamy Images: Scenics & Science / Alamy Stock Photo (br). 130 Getty Images: Fine Art / Contributor (c). 131 Bridgeman Images: Mauritshuis, The Hague, The Netherlands / Bridgeman Images (cb). 131 Alamy Images: Peter Horree / Alamy Stock Photo (tr). 132 Alamy Images: The Print Collector / Alamy Stock Photo (cl). World History Archive / Alamy Stock Photo (tr). 133 Alamy Images: FineArt / Alamy Stock Photo (br). 134 Getty Images: Indianapolis Museum of Art / Contributor (c). 135 Bridgeman Images: National Museums of Scotland / Bridgeman Images (tc). 135 akg-images: akg-images / Erich Lessing (bl). 135 Bridgeman Images: Indianapolis Museum of Art, USA / Thomas W. Ayton Fund / Bridgeman Images (br). 136 Alamy Images: ART Collection / Alamy Stock Photo (cb). 137 Bridgeman Images: Musee des Beaux-Arts, Arles, France / Peter Willi / Bridgeman Images (c). 138 Bridgeman Images: Louvre, Paris, France / Bridgeman Images (c). 139 Alamy Images: Heritage Image Partnership Ltd / Alamy Stock Photo (tr). 142 Alamy Images: ART Collection / Alamy Stock Photo (tr). 143 Alamy Images: Art Collection 2 / Alamy Stock Photo (bl). REUTERS / Alamy Stock Photo (br). 144 Getty Images: DEA / G. FINI / Contributor (c). 145 akg-images: Les Arts Décoratifs, Paris / Jean Tholance (tr). 145 Bridgeman Images: Musee de la Ville de Paris, Musee Carnavalet, Paris, France (br). 146 Alamy Images: PRISMA ARCHIVO / Alamy Stock Photo (tl). Ionut David / Alamy Stock Photo (bl). 147 Getty Images: DEA / J. E. BULLOZ / Contributor (br). 148 Bridgeman Images: Private Collection / Bridgeman Images (c). 149 akg-images: akg-images / MPortfolio / Electa (tl). 149 Getty Images: DEA / A. DAGLI ORTI / Contributor (br). 150 Alamy Images: Granger Historical Picture Archive / Alamy Stock Photo (tl). 151 akg-images: akg-images / Bildarchiv Monheim (tl). 151 Alamy Images: Giovanni Tagini / Alamy Stock Photo (br). 152 Bridgeman Images: Anglesey Abbey, Cambridgeshire, UK / National Trust Photographic Library/Christopher Hurst (c). 153 British Museum: © The Trustees of the British Museum (c). 153 Alamy Images: Artokoloro Quint Lox Limited / Alamy Stock Photo (bl). 154 Alamy Images: INTERFOTO / Alamy Stock Photo (bl). 155 Getty Images: Heritage Images / Contributor (tl). Science & Society Picture Library / Contributor (br). 155 Alamy Images: Artokoloro Quint Lox Limited / Alamy Stock Photo (br). 156 Getty Images: Hulton Archive / Handout (c). 157 Alamy Images: Artokoloro Quint Lox Limited / Alamy Stock Photo (c). Lebrecht Music and Arts Photo Library / Alamy Stock Photo (br). 158 Alamy Images: World History Archive / Alamy Stock Photo (tc). still light / Alamy Stock Photo (bl). 158-159 Getty Images: Universal History Archive / Contributor (bc). 159 Getty Images: © Library and Museum of Freemasonry, London, UK / Reproduced by permission of the Grand Lodge of England (c). 159 Getty Images: Print Collector / Contributor (c). 160 Getty Images: Print Collector / Contributor (c). 161 Getty Images: Heritage Images / Contributor (cl). 161 Bridgeman Images: Pictures from History (cr). 161 Alamy Images: North Wind Picture Archives / Alamy Stock Photo (br). 162 Getty Images: Heritage Images / Contributor (tl). 163 Getty Images: DEA PICTURE LIBRARY / Contributor (bcl). Heritage Images / Contributor (bcr). De Agostini Picture Library / Contributor (cr). 164 Alamy Images: ACTIVE MUSEUM / Alamy Stock Photo (c). 165 Getty Images: Andrew Jankunas / Alamy Stock Photo (bl). FineArt / Alamy Stock Photo (br). 166 Alamy Images: Zoonar GmbH / Alamy Stock Photo (bl). FineArt / Alamy Stock Photo (ct). ART Collection / Alamy Stock Photo (br). 168 Bridgeman Images: Musee Fragonard, Grasse, France (c). 169 Alamy Images: Ros Drinkwater / Alamy Stock Photo (c). JOHN KELLERMAN / Alamy Stock Photo (tc). 170 Getty Images: Leemage / Contributor (c). 171 Alamy Images: Peter Barritt / Alamy Stock Photo (tr). 172 Alamy Images: Niday Picture Library / Alamy Stock Photo (tr). 173 Alamy Images: Granger Historical Picture Archive / Alamy Stock Photo (bl). 173 Bridgeman Images: Private Collection / Archives Charmet (c). 174 Bridgeman Images: Private Collection / © Partridge Fine Arts, London, UK (c). 175 Getty Images: Heritage Images / Contributor (c). Visions of America / Contributor (cr). 175 Alamy Images: Norman Barrett / Alamy Stock Photo (br). 176 Getty Images: PHAS / Contributor (tr). 176 Alamy Images: Classic Image / Alamy Stock Photo (c). 177 Getty Images: Heritage Images / Contributor (c). 178 Alamy Images: Niday Picture Library / Alamy Stock Photo (c). 179 akg-images: Album / Oronoz (c). 179 Getty Images: DEA / G. DAGLI ORTI / Contributor (br). 180 Bridgeman Images: Ecole Nationale Superieure des Beaux-Arts, Paris, France (c). 180 Alamy Images: Tom Hanley / Alamy Stock Photo (br). 181 Alamy Images: Peter Horree / Alamy Stock Photo (br). 182 Alamy Images: World History Archive / Alamy Stock Photo (tl). World History Archive / Alamy Stock Photo (bl). ACTIVE MUSEUM / Alamy Stock Photo (br). 183 Bridgeman Images: Bibliothèque Paul-Marmottan, Ville de Boulogne-Billancourt, Académie des Beaux-Arts, France (cr). 183 Getty Images: Leemage / Contributor (bc). 184 Getty Images: Leemage / Contributor (c). 184 Bridgeman Images: Private Collection / © Partridge Fine Arts, London, UK (c). 184 Getty Images: James L. Stanfield / Contributor (br). 185 Scala: The National Gallery, London (c). 186 Getty Images: Fratelli Alinari IDEA S.p.A. / Contributor (c). Waring Abbott / Contributor (cl). 187 Alamy Images: Classic Image / Alamy Stock Photo (tr). 187 Getty Images: DEA PICTURE LIBRARY / Contributor (br). 188 Alamy Images: vkstudio / Alamy Stock Photo (bl). 188 Alamy Images: V&A Images / Alamy Stock Photo (tr). 189 Alamy Images: LOOK Die Bildagentur der Fotografen GmbH / Alamy Stock Photo (c). 189 Getty Images: Marco Secchi / Stringer (br). 190 Alamy Images: Granger Historical Picture Archive / Alamy Stock Photo (c). 191 Getty Images: Heritage Images / Contributor (tl). 192 Alamy Images: The Archives / Alamy Stock Photo (tr). 193 Alamy Images: ART Collection / Alamy Stock Photo (c). 196 Alamy Images: Photo 12 / Alamy Stock Photo (c). 197 Getty Images: Heritage Images / Contributor (c). 197 Getty Images: Print Collector / Contributor (cr). 198 Bridgeman Images: Musee Marmottan Monet, Paris, France (c). 199 Getty Images: DEA / G. DAGLI ORTI (cr). 199 Bridgeman Images: Private Collection / Photo © Christie's Images (c). 199 Getty Images: Susanna Price / Contributor (br). 200 Alamy Images: INTERFOTO / Alamy Stock Photo (c). 201 Getty Images: Fine Art / Contributor (ca). DEA PICTURE LIBRARY (tr). Fine Art / Contributor (br). 202 Alamy Images: Ian G Dagnall / Alamy Stock Photo (c). 203 Getty Images: Print Collector / Contributor (c). 203 Bridgeman Images: Museum of London, UK / Bridgeman Images (c). 203 Getty Images: Bob Thomas/Popperfoto / Contributor (br). 204 Alamy Images: Hemis / Alamy Stock Photo (cl). GL Archive / Alamy Stock Photo (tr). 205 akg-images: akg-images / Purkiss Archive (bl). 205 Alamy Images: World History Archive / Alamy Stock Photo (cr). 206 Alamy Images: Granger Historical Picture Archive / Alamy Stock Photo (c). 207 Bridgeman Images: Sterling and Francine Clark Art Institute, Williamstown, Massachusetts, USA (tr). 207 Bridgeman Images: Victoria & Albert Museum, London, UK (c). 207 Alamy Images: classicpaintings / Alamy Stock Photo (br). 208 Alamy Images: V&A Images / Alamy Stock Photo (tr). V&A Images / Alamy Stock Photo (br). 209 Rex Features: Eileen Tweedy/REX/Shutterstock (cr). 209 Bridgeman Images: John Constable (tl). 210 Bridgeman Images: Giraudon, studio (1912-53) / Paris, France (c). 210 Alamy Images: MARKA / Alamy Stock Photo (br). 211 Alamy Images: Granger Historical Picture Archive / Alamy Stock Photo (c). 212 Alamy Images: Heritage Image Partnership Ltd / Alamy Stock Photo (bl). 212 Getty Images: Heritage Images / Contributor (bc). 213 Getty Images: DEA / BULLOZ / Contributor (br). 214 Alamy Images: Heritage Image Partnership Ltd / Alamy Stock Photo (cr). 215 Alamy Images: World History Archive / Alamy Stock Photo (c). 216 Getty Images: Heritage Images / Contributor (bl). 216-217 Getty Images: Leemage / Contributor (t). 217 Alamy Images: Mary Evans Picture

Library / Alamy Stock Photo (bc). **217 Bridgeman Images:** Musee Fabre, Montpellier, France (br). **218 Alamy Images:** Archivart / Alamy Stock Photo (c). **219 Bridgeman Images:** Martyn O'Kelly Photography (ca). **219 akg-images:** akg-images / Album / Joseph Martin (tr). **219 Getty Images:** UniversalImagesGroup / Contributor (br). **220 Bridgeman Images:** Private Collection / Photo © Christie's Images / Bridgeman Images (c). **221 Getty Images:** Fine Art / Contributor (tr). **221 Alamy Images:** Artokoloro Quint Lox Limited / Alamy Stock Photo (br). **222 Getty Images:** Leemage / Contributor (tl). **222 Alamy Images:** PRISMA ARCHIVO / Alamy Stock Photo (cl). **223 Alamy Images:** Archivart / Alamy Stock Photo (tr). **223 Bridgeman Images:** National Army Museum, London / Bridgeman Images (cr). **224 akg-images:** Erich Lessing (c). **225 Alamy Images:** FineArt / Alamy Stock Photo (c). **225 Scala:** Christie's Images, London (cr). **226 Getty Images:** Leemage / Contributor (c). **227 Getty Images:** Mondadori Portfolio / Contributor (c). Science & Society Picture Library / Contributor (cr). Science & Society Picture Library / Contributor (br). **228 Alamy Images:** FineArt / Alamy Stock Photo (cl). Masterpics / Alamy Stock Photo (br). **229 Getty Images:** Universal History Archive / Contributor (br). **229 Scala:** Museum of Fine Arts, Boston. All rights reserved (br). **230 Getty Images:** Imagno / Contributor (c). **231 Alamy Images:** Art Reserve / Alamy Stock Photo (c). Granger Historical Picture Archive / Alamy Stock Photo (cr). **232 Getty Images:** Apic / Contributor (bl). **232 Alamy Images:** Peter Barritt / Alamy Stock Photo (bc). **233 Getty Images:** Leemage / Contributor (tl). Alain BENAINOUS / Contributor (br). **234 Alamy Images:** NICK FIELDING / Alamy Stock Photo (cl). Azoor Photo / Alamy Stock Photo (c). Collection PJ / Alamy Stock Photo (cr). **235 Getty Images:** adoc-photos / Contributor (c). **236 Alamy Images:** IanDagnall Computing / Alamy Stock Photo (tl). **236 Getty Images:** Christophel Fine Art / Contributor (br). **237 Getty Images:** Gjon Mili / Contributor (bc). **237 Alamy Images:** Granger Historical Picture Archive / Alamy Stock Photo (br). **238 Alamy Images:** World History Archive / Alamy Stock Photo (c). **239 Bridgeman Images:** Musee Marmottan Monet, Paris, France / Bridgeman Images (tr). **239 Alamy Images:** Digital Image Library / Alamy Stock Photo (bl). **240 Alamy Images:** Peter Barritt / Alamy Stock Photo (cla). **240 Bridgeman Images:** Private Collection / Archives Charmet (bl). **240-241 Getty Images:** Heritage Images / Contributor (t). **241 Dorling Kindersley:** Susanna Price / Musee Marmottan / Bridgeman Art Library (cra). **241 Alamy Images:** The Print Collector / Alamy Stock Photo (bl). **242 Alamy Images:** Heritage Image Partnership Ltd / Alamy Stock Photo (tr). **243 Getty Images:** Leemage (tr). **243 Alamy Images:** FORGET Patrick / SAGAPHOTO.COM / Alamy Stock Photo (bl). FineArt / Alamy Stock Photo (br). **244 Getty Images:** Sovfoto / Contributor (bl). **244 Getty Images:** Ullstein Bild / Contributor (cr). **245 Alamy Images:** SPUTNIK / Alamy Stock Photo (c). **246 Getty Images:** Imagno / Contributor (c). **247 Bridgeman Images:** Private Collection (tr). **247 Alamy Images:** Hemis / Alamy Stock Photo (br). **248 Getty Images:** National Galleries of Scotland / Contributor (bl). adoc-photos / Contributor (c). **249 Alamy Images:** The Artchives / Alamy Stock Photo (tc). **249 Getty Images:** Peter Macdiarmid / Staff (br). **250 Alamy Images:** World History Archive / Alamy Stock Photo (c). **251 Bridgeman Images:** GL Archive / Alamy Stock Photo (cr). **251 Getty Images:** Heritage Images / Contributor (tl). **251 Alamy Images:** V&A Images / Alamy Stock Photo (br). **252 Alamy Images:** © Peter Barritt / Alamy Stock Photo (tr). World History Archive / Alamy Stock Photo (bl). PAINTING / Alamy Stock Photo (br). **253 Alamy Images:** Antiquarian Images / Alamy Stock Photo (tr). Hemis / Alamy Stock Photo (br). **254 Bridgeman Images:** Musee des Beaux-Arts, Rouen, France / Bridgeman Images (c). **255 Alamy Images:** World History Archive / Alamy Stock Photo (br). **256 Bridgeman Images:** Sterling and Francine Clark Art Institute, Williamstown, Massachusetts, USA / Bridgeman Images (br). **257 Bridgeman Images:** Granger Historical Picture Archive / Alamy Stock Photo (tr). **260 Getty Images:** Imagno / Contributor (c). **261 Getty Images:** DEA / E. LESSING / Contributor (tr). Leemage / Contributor (bc). **261 Alamy Images:** Romas_ph / Alamy Stock Photo (br). **262 Alamy Images:** Heritage Image Partnership Ltd / Alamy Stock Photo (c). **263 Alamy Images:** Heritage Image Partnership Ltd / Alamy Stock Photo (c). Art Directors & TRIP / Alamy Stock Photo (br). **264 Getty Images:** Apic / Contributor (bl). **264 Alamy Images:** Artepics / Alamy Stock Photo (ct). **265 Photo by Bjørn Christian Tørrissen, bjornfree.com** (tl). **265 Getty Images:** Apic / Contributor (br). **266 Alamy Images:** INTERFOTO / Alamy Stock Photo (c). **267 Bridgeman Images:** Buhrle Collection, Zurich, Switzerland / Bridgeman Images (bl). **267 Alamy Images:** INTERFOTO / Alamy Stock Photo (tl). **267 Bridgeman Images:** Bibliotheque des Arts Decoratifs, Paris, France / Archives Charmet / Bridgeman Images (br). **268 Getty Images:** DEA / V. PIROZZI / Contributor (tl). **268 Alamy Images:** Heritage Image Partnership Ltd / Alamy Stock Photo (cb). **268 Bridgeman Images:** Private Collection / Joerg Hejkal / Bridgeman Images (tr). **269 Alamy Images:** Heritage Image Partnership Ltd / Alamy Stock Photo (bl). **269 Getty Images:** Imagno / Contributor (br). **270 Alamy Images:** Heritage Image Partnership Ltd / Alamy Stock Photo (lc). **270 Getty Images:** DEA / M. CARRIERI / Contributor (bc). **271 Getty Images:** Heritage Images / Contributor (tl). **271 Alamy Images:** Bildarchiv Monheim GmbH / Alamy Stock Photo (bc). **272 Bridgeman Images:** Private Collection / Archives Charmet / Bridgeman Images / © Succession H. Matisse/ DACS **2017** (cr). **272 Alamy Images:** Granger Historical Picture Archive / Alamy Stock Photo (cr). **273 SMK:** Photograph © Statens Museum for Kunst / © Succession H. Matisse/ DACS **2017** (c). **274 NGA:** National Gallery of Art / NGA Images / © Succession H. Matisse/ DACS **2017** (tl). **274-275 The State Hermitage Museum:** Photograph © The State Hermitage Museum /photo by Vladimir Terebenin / © Succession H. Matisse/ DACS **2017** (tl). **275 Bridgeman Images:** National Galleries of Scotland, Edinburgh / © **2017** Succession H. Matisse/DACS **2017** (bc). **275 akg-images:** akg / Archivio Cameraphoto Epoche (cr). **276 Alamy Images:** Granger Historical Picture Archive / Alamy Stock Photo (tr). Peter Horree / Alamy Stock Photo (br). **277 Alamy Images:** Peter Horree / Alamy Stock Photo (br). **278 Alamy Images:** World History Archive / Alamy Stock Photo (tl). **278 Getty Images:** De Agostini Picture Library / Contributor (tr). DEA PICTURE LIBRARY / Contributor (tr). **279 Alamy Images:** Peter Horree / Alamy Stock Photo (br). **279 Getty Images:** JACQUES DEMARTHON/AFP/Getty Images (c). **280 Alamy Images:** Keystone Pictures USA / Alamy Stock Photo (c). **281 Bridgeman Images:** Hirshhorn Museum & Sculpture Garden, Washington D.C., USA / Photo © Boltin Picture Library / © Succession Brancusi - All rights reserved. ADAGP, Paris and DACS, London 2017 (ca). **281 Bridgeman Images:** Hamburger Kunsthalle, Hamburg, Germany / © Succession Brancusi - All rights reserved. ADAGP, Paris and DACS, London 2017 (br). **282 Bridgeman Images:** Musee National d'Art Moderne, Centre Pompidou, Paris, France / Photo © AISA / © Succession Brancusi - All rights reserved. ADAGP, Paris and DACS, London **2017** (tl). **282 Alamy Images:** Granger Historical Picture Archive / Alamy Stock Photo / © Succession Brancusi - All rights reserved. ADAGP, Paris and DACS, London 2017 (cr). **283 Bridgeman Images:** Musee National d'Art Moderne, Centre Pompidou, Paris, France / © Succession Brancusi - All rights reserved. ADAGP, Paris and DACS, London 2017 (bl). **283 Alamy Images:** Richard Manning / Alamy Stock Photo / © Succession Brancusi - All rights reserved. ADAGP, Paris and DACS, London 2017 (br). **284 Bridgeman Images:** Private Collection (tl). **285 Alamy Images:** INTERFOTO / Alamy Stock Photo (tr). **285 Getty Images:** DEA / E. LESSING / Contributor (cr). **286 Bridgeman Images:** Philadelphia Museum of Art, Pennsylvania, PA, USA / The Louise and Walter Arensberg Collection, 1950 (tr). **286 Getty Images:** Culture Club (bl). **287 Alamy Images:** Granger Historical Picture Archive / Alamy Stock Photo (tc). **287 Alamy Images:** The Artchives / Alamy Stock Photo (tr). **287 Alamy Images:** Mary Evans Picture Library / Alamy Stock Photo (br). **288 Bridgeman Images:** Private Collection / Photo © Boltin Picture Library / © Succession Picasso/DACS, London 2017 (tr). **288 Bridgeman Images:** Museo Picasso, Barcelona, Spain / Index / © Succession Picasso/DACS, London 2017 (bl). **288 Getty Images:** Rob Stothard / Stringer / © Succession Picasso/DACS, London 2017 (br). **289 Bridgeman Images:** Philadelphia Museum of Art, Pennsylvania, PA, USA / A.E. Gallatin Collection, 1950 / © Succession Picasso/DACS, London 2017 (c). **290 Bridgeman Images:** Cleveland Museum of Art, OH, USA / © Succession Picasso/DACS, London 2017 (tr). **290 Alamy Images:** Josse Christophel / Alamy Stock Photo / © Succession Picasso/DACS, London 2017 (br). **291 Alamy Images:** Peter van Evert / Alamy Stock Photo / © Succession Picasso/DACS, London 2017 (tc). **291 Getty Images:** Paul Popper/Popperfoto / Contributor / © Succession Picasso/DACS, London 2017 (bc). **292 Bridgeman Images:** Musee Picasso, Paris, France / © Succession Picasso/DACS, London 2017 (tl). **292-293 Alamy Images:** The Print Collector / Alamy Stock Photo / © Succession Picasso/DACS, London 2017 (t). **294 Whitney Museum:** © Whitney Museum of American Art (c). **295 Getty Images:** Fred W. McDarrah / Contributor (br). **295 Scala Archives:** The Art Institute of Chicago / Art Resource, NY/ Scala, Florence (tl). **295 Alamy Images:** ACTIVE MUSEUM / Alamy Stock Photo (tr). **296 Bridgeman Images:** Museu de Arte Contemporanea da Universidade de Sao Paulo, Sao Paulo, Brazil / Bridgeman Images (c). **297 Alamy Images:** Artokoloro Quint Lox Limited / Alamy Stock Photo (tl). **297 Getty Images:** Barney Burstein / Contributor (cb). **298 Alamy Images:** Peter Horree / Alamy Stock Photo (tr). Peter Horree / Alamy Stock Photo / Chagall ® / © ADAGP, Paris and DACS, London 2017 (br). **299 Dorling Kindersley:** Stephen Oliver (tl). **299 Alamy Images:** Artepics / Alamy Stock Photo / Chagall ® / © ADAGP, Paris and DACS, London 2017 (tr). **299 Getty Images:** Imagno / Contributor (bl). **299 Bridgeman Images:** Photo © Limot (br). **300 Getty Images:** Bettmann / Contributor (tr). **301 Alamy Images:** National Geographic Creative / Alamy Stock Photo (tc). **301 Getty Images:** Bettmann / Contributor / © Georgia O'Keeffe Museum / DACS 2017 (cr). **301 Bridgeman Images:** San Diego Museum of Art, USA / © Georgia O'Keeffe Museum / DACS 2017 (br). **302 Bridgeman Images:** Private Collection / Photo © Christie's Images / Bridgeman Images / © ADAGP, Paris and DACS, London 2017 (c). **303 Bridgeman Images:** De Agostini Picture Library / G. Dagli Orti / Bridgeman Images / © ADAGP, Paris and DACS, London 2017 (c). **303 Bridgeman Images:** Belgian Photographer (20th century) / Private Collection / Photo © PVDE / Bridgeman Images (bl). **303 Alamy Images:** Simon Belcher / Alamy Stock Photo (tr). **304 Alamy Images:** Lipnitzki / Contributor (br). **304 Alamy Images:** Artepics / Alamy Stock Photo (tr). **305 Bridgeman Images:** Private Collection / Photo © Christie's Images / Bridgeman Images / © ADAGP, Paris and DACS, London 2017 (bl). **305 Alamy Images:** redbrickstock.com / Alamy Stock Photo (cr). **306 Getty Images:** Oli Scarff / Staff / © The Henry Moore Foundation. All Rights Reserved, DACS / www.henry-moore.org 2017 (br). **306 Getty Images:** Tony Evans/Timelapse Library Ltd. / Contributor / © The Henry Moore Foundation. All Rights Reserved, DACS / www.henry-moore.org 2017 (tc). **307 Getty Images:** Ullstein Bild / Contributor / © The Henry Moore Foundation. All Rights Reserved, DACS / www.henry-moore.org 2017 (br). **308 Alamy Images:** Park Dale / Alamy Stock Photo / © The Henry Moore Foundation. All Rights Reserved, DACS / www.henry-moore.org 2017 (c). **308 Alamy Images:** Lynette Gram / Alamy Stock Photo (bl). **309 Alamy Images:** Chris Pancewicz / Alamy Stock Photo (c). **309 Alamy Images:** Maximilian Weinzierl / Alamy Stock Photo / © The Henry Moore Foundation. All Rights Reserved, DACS / www.henry-moore.org 2017 (br). **310 Alamy Images:** Josse Christophel / Alamy Stock Photo (c). **311 Getty Images:** Mondadori Portfolio (c). **312 Alamy Images:** Artepics / Alamy Stock Photo / © Banco de México Diego Rivera Frida Kahlo Museums Trust, Mexico, D.F. / DACS 2017 (tc). **313 Alamy Images:** Granger Historical Picture Archive / Alamy Stock Photo / © **2017** Calder Foundation, New York/DACS London 2017 (br). **316 Alamy Images:** Bruce yuanyue Bi / Alamy Stock Photo / © The Estate of Alberto Giacometti (Fondation Giacometti, Paris and ADAGP, Paris), licensed in the UK by ACS and DACS, London 2017 (c). **317 Bridgeman Images:** Collection Fondation Alberto & Annette Giacometti / © The Estate of Alberto Giacometti (Fondation Giacometti, Paris and ADAGP, Paris), licensed in the UK by ACS and DACS, London 2017 (c). **317 Alamy Images:** Peter Horree / Alamy Stock Photo / © The Estate of Alberto Giacometti (Fondation Giacometti, Paris and ADAGP, Paris), licensed in the UK by ACS and DACS, London 2017 (br). **318 Getty Images:** Paul Almasy / Contributor / © The Estate of Alberto Giacometti (Fondation Giacometti, Paris and ADAGP, Paris), licensed in the UK by ACS and DACS, London 2017 (tr). **318 Bridgeman Images:** Collection Fondation Alberto & Annette Giacometti / © The Estate of Alberto Giacometti (Fondation Giacometti, Paris and ADAGP, Paris), licensed in the UK by ACS and DACS, London 2016 (crb). **319 Bridgeman Images:** Collection Fondation Alberto & Annette Giacometti / © The Estate of Alberto Giacometti (Fondation Giacometti, Paris and ADAGP, Paris), licensed in the UK by ACS and DACS, London 2016 (crb). **319 Alamy Images:** Everett Collection Historical / Alamy Stock Photo (br). **320 Getty Images:** Apic / Contributor / © **1998** Kate Rothko Prizel & Christopher Rothko ARS, NY and DACS, London (tr). **321 Alamy Images:** Artepics / Alamy Stock Photo / © 1998 Kate Rothko Prizel & Christopher Rothko ARS, NY and DACS, London (br). **321 Alamy Images:** Arcaid Images / Alamy Stock Photo / © 1998 Kate Rothko Prizel & Christopher Rothko ARS, NY and DACS, London.(tr). **321 Bridgeman Images:** Private Collection / James Goodman Gallery, New York, USA / Bridgeman Images / © 1998 Kate Rothko Prizel & Christopher Rothko ARS, NY and DACS, London (br). **322 Alamy Images:** Peter van Evert / Alamy Stock Photo / © Salvador Dali, Fundació Gala-Salvador Dalí, DACS 2017 (c). **323 Alamy Images:** REUTERS / Alamy Stock Photo / © Salvador Dali, Fundació Gala-Salvador Dalí, DACS 2017 (tr). Peter Horree / Alamy Stock Photo / © Salvador Dali, Fundació Gala-Salvador Dalí, DACS 2017 (cb). GL Archive / Alamy Stock Photo / © Salvador Dali, Fundació Gala-Salvador Dalí, DACS 2017 (bc). **324 Alamy Images:** Josse Christophel / Alamy Stock Photo / © Salvador Dali, Fundació Gala-Salvador Dalí, DACS 2017 (tr). Photo 12 / Alamy Stock Photo / © Salvador Dali, Fundació Gala-Salvador Dalí, DACS 2017 (bl). **325 Alamy Images:** Luca Quadrio / Alamy Stock Photo (bl). **325 Bridgeman Images:** The Art Institute of Chicago, IL, USA / © Salvador Dali, Fundació Gala-Salvador Dalí, DACS 2017 (br). **326 Alamy Images:** The Artchives / Alamy Stock Photo / © Banco de México Diego Rivera Frida Kahlo Museums Trust, Mexico, D.F. / DACS 2017 (tr). **327 akg-images:** akg-images / © Banco de México Diego Rivera Frida Kahlo Museums Trust, Mexico, D.F. / DACS 2017 (tl). **327 Alamy Images:** Heritage Image Partnership Ltd / Alamy Stock Photo (cr). **327 Alamy Images:** Diana Bier Frida Kahlo / Alamy Stock Photo (bc). **328 Bridgeman Images:** Private Collection / Bridgeman Images / © The Estate of Francis Bacon. All rights reserved. DACS 2017 (tl). **329 Alamy Images:** Heritage Image Partnership Ltd / Alamy Stock Photo (br). **329 Tate Images:** © The Estate of Francis Bacon. All rights reserved. DACS 2017 (tl). **330 Alamy Images:** Archivart / Alamy Stock Photo / © The Estate of Francis Bacon. All rights reserved. DACS 2017 (bl). **330 Alamy Images:** The John Deakin Archive / Contributor / © The Estate of Francis Bacon. All rights reserved. DACS 2017 (tc). **331 akg-images:** akg-images / ANA / © The Estate of Francis Bacon. All rights reserved. DACS 2017 (tc). **331 Getty Images:** The John Deakin Archive / Contributor (br). **332 Alamy Images:** M.Flynn / Alamy Stock Photo / © The Pollock-Krasner Foundation ARS, NY and DACS, London 2017 (cb). **332 Getty Images:** Susan Wood / Contributor (tr). **332 Alamy Images:** Blank Archives / Contributor (c). **333 Alamy Images:** Martha Holmes / Contributor (c). **334 Bridgeman Images:** Philadelphia Museum of Art, Pennsylvania, PA, USA / © The Pollock-Krasner Foundation ARS, NY and DACS, London 2017 (tc). Dallas Museum of Art, Texas, USA / © The Pollock-Krasner Foundation ARS, NY and DACS, London 2017 (bl). **334 Alamy Images:** Everett Collection Historical / Alamy Stock Photo (br). **335 Bridgeman Images:** Museum of Modern Art, New York, USA / Leemage / Bridgeman Images / © The Pollock-Krasner Foundation ARS, NY and DACS, London 2017 (br). **336 Bridgeman Images:** Private Collection / Photo © Christie's Images / Bridgeman Images / © ADAGP, Paris and DACS, London 2017 (tr). **337 Bridgeman Images:** Private Collection / Photo © Christie's Images / Bridgeman Images / © ADAGP, Paris and DACS, London 2017 (tl). **337 Getty Images:** Paul Almasy / Contributor (cb). Keystone-France / Contributor / © ADAGP, Paris and DACS, London 2017 (crb). **338 Bridgeman Images:** Private Collection / Photo © Christie's Images / © 2017 The Andy Warhol Foundation for the Visual Arts, Inc. / Artists Rights Society (ARS), New York and DACS, London (c). **339 Alamy Images:** Ian Dagnall / Alamy Stock Photo (tr). **339 Bridgeman Images:** Private Collection / Photo © Christie's Images / © 2017 The Andy Warhol Foundation for the Visual Arts, Inc. / Artists Rights Society (ARS), New York and DACS, London (c). **339 Getty Images:** Popperfoto / Contributor (br). **340 Alamy Images:** Cultura Creative (RF) / Alamy Stock Photo (cl). **340 Bridgeman Images:** Private Collection / © 2017 The Andy Warhol Foundation for the Visual Arts, Inc. / Artists Rights Society (ARS), New York and DACS, London (br). **341 Getty Images:** Herve GLOAGUEN / Contributor (tr). **341 Alamy Images:** Heritage Image Partnership Ltd / Alamy Stock Photo / © 2017 The Andy Warhol Foundation for the Visual Arts, Inc. / Artists Rights Society (ARS), New York and DACS, London (br). **342 Getty Images:** Peter Macdiarmid / Staff / © Anish Kapoor. All Rights Reserved, DACS 2017 (tr). **343 Alamy Images:** Kevin Foy / Alamy Stock Photo / © Anish Kapoor. All Rights Reserved, DACS 2017 (bl). **343 Alamy Images:** Iain Masterton / Alamy Stock Photo / © Anish Kapoor. All Rights Reserved, DACS 2017 (br). **343 Artimage:** © Anish Kapoor. All Rights Reserved, DACS 2017. Photo: Dave Morgan (br). **344 Bridgeman Images:** Private Collection / Photo © Christie's Images / Bridgeman Images / © 2009 Takashi Murakami/Kaikai Kiki Co., Ltd. All Rights Reserved. (tr). **345 Getty Images:** FANTHOMME Hubert / Contributor / © 2006-2009 Takashi Murakami/Kaikai Kiki Co., Ltd. All Rights Reserved. (tr). **345 Getty Images:** Patrick Aventurier / Contributor / © 2001-2006 Takashi Murakami/Kaikai Kiki Co., Ltd. All Rights Reserved. (cb). **345 Getty Images:** Steve Pyke / Contributor © Takashi Murakami/Kaikai Kiki Co., Ltd. All Rights Reserved. (br). **346 Getty Images:** Ted Thai / Contributor / © The Easton Foundation/VAGA, New York/DACS, London 2017 (c). **347 Alamy Images:** dpa picture alliance / Alamy Stock Photo / © DACS 2017 (br). **348 Getty Images:** Allan Tannenbaum / Contributor / © Jasper Johns / VAGA, New York / DACS, London 2017 (bc). **349 Getty Images:** Stephane Grangier - Corbis / Contributor (bc). **Endpaper Alamy Stock Photo:** Natallia Khlapushyna.

All other images © Dorling Kindersley. For more information see:
www.dkimages.com